SUMMARY CATALOGUE OF

EUROPEAN DECORATIVE ARTS

in the J. Paul Getty Museum

Gillian Wilson and Catherine Hess

THE J. PAUL GETTY MUSEUM
Los Angeles, California

© 2001 The J. Paul Getty Trust
1200 Getty Center Drive
Suite 400
Los Angeles, California 90049-1681

The J. Paul Getty Museum
1200 Getty Center Drive
Suite 1000
Los Angeles, California 90049-1687
www.getty.edu

Library of Congress Cataloging-in-Publication Data

The J. Paul Getty Museum.
 Summary catalogue of European decorative arts in the J. Paul Getty Museum / Gillian Wilson and Catherine Hess.
 p. cm.
 Includes bibliographical references and index.
 ISBN 0-89236-632-X
 1. Decorative arts—Europe—Catalogs. 2. Decorative arts—California—Los Angeles—Catalogs. 3. J. Paul Getty Museum—Catalogs. I. Wilson, Gillian, 1941-
II. Hess, Catherine, 1957- III. Title.

NK925.J18 2001

745'.094'07479494—dc21 2001051261

Mollie Holtman, *Editor*
Hillary Sunenshine, *Designer*
Dusty Deyo, *Illustrator*
Rebecca Bogner, *Production Coordinator*
Lou Meluso and Jack Ross, *Photographers*

G&S Typesetters, Inc., *Typographer*
Southern California Graphics, *Printer*

cover: *Cartonnier* with *Bout de Bureau* and Clock (detail). French (Paris), circa 1740s. See entry no. 10, p. 7.

page vi: Table (detail of top). French (Paris), circa 1680. See entry no. 54, p. 31.

page 1: Pair of Lidded Vases (*vases à têtes de bouc*) (detail). French, Sèvres manufactory, circa 1768. See entry no. 240, pp. 118–119.

page 163: Vase with an Allegory of Venice (detail). Italian (Venice), 1769. See entry no. 378, pp. 189–190.

page 257: Tapestry, *The Harvesting of Pineapples* (detail). French, Beauvais manufactory, circa 1697–1705. See entry no. 296, pp. 146–148.

page 277: Pair of Stags (detail). German (Augsburg), circa 1680–1700. See entry no. 512, p. 247.

Previous edition published as *Decorative Arts: An Illustrated Summary Catalogue of the Collection of the J. Paul Getty Museum* (Malibu, 1993).

Summary Catalogue of
European Decorative Arts
in the J. Paul Getty Museum

Contents

Part I

Part I is organized first by country of origin (France), then by type of object.

Part II

Part II is organized first by type of object, then alphabetically by country of origin.

FOREWORD

FRENCH FURNITURE AND DECORATIVE ARTS CONSTITUTE ONE OF THE oldest and most extensive collections in the Getty Museum. Among J. Paul Getty's primary areas of interest, and one to which he was willing to devote substantial sums of money, the French holdings still reflect the taste and passions of the Museum's founder. They equally attest to the enthusiasm and expertise of Gillian Wilson, who came to the Museum as Curator of Decorative Arts in 1971 when Mr. Getty was still alive, and who has continued to develop the French collections, adding numerous key objects, in the many years since his death. However, the collections have also evolved to include areas of concentration unexplored by our founder, namely Italian ceramics, European glass, Italian furniture, European metalwork, and *Kunstkammer* objects that were the pride of noble and royal collectors' cabinets in the sixteenth and seventeenth centuries. This expansion of the Museum's decorative arts was due largely to the efforts of Peter Fusco, now retired, who served as the Curator of Sculpture and Works of Art from 1984 to 2000. Together, Gillian Wilson, Peter Fusco, and their staffs have formed one of the most beautiful and important groupings of European furniture and decorative arts in an American museum.

This *Summary Catalogue* is the second revised edition of the volume published in 1986. Between the 1986 publication and the first revised edition in 1993, 115 objects were added to the decorative arts collection. Since 1993, an additional thirty-eight objects have been acquired, including an elaborate bed, exquisite wall lights, important ceramics, and vivid examples of inlaid hardstone. At that time, the new Museum at the Getty Center was still under construction. Now the decorative arts are displayed in newly conceived, well-appointed galleries that demonstrate the full scope and splendor of the collection. Whether they are exhibited in paneled rooms that convey the rich ambience of eighteenth-century France, or in paintings galleries where they augment our understanding of the art of different periods, the decorative arts form an integral part of the Museum's mission to delight our visitors and deepen their appreciation of the history of European art.

I owe Gillian Wilson and Peter Fusco, whose knowledge and taste can be detected everywhere in this catalogue, my admiration for what they have achieved in building the collection. The staff members who assisted them in this accomplishment, Charissa Bremer-David, Peggy Fogelman, Catherine Hess, and Jeffrey Weaver, have my gratitude for their outstanding work and for the collaboration that made this book possible.

Deborah Gribbon
Director

PREFACE AND ACKNOWLEDGMENTS

THIS BOOK IS A REVISED AND EXPANDED EDITION OF *Decorative Arts: An Illustrated Summary Catalogue of the Collection of the J. Paul Getty Museum*, which was published in 1993. The first section is arranged by country of origin—France—and then by type of object. The second section is arranged by medium, followed by country of origin—other than France—and date of manufacture. This two-part organization is adopted to feature the largest part of the Museum's decorative arts collection in section one, while providing a reference framework for easy access to its diverse decorative arts holdings—comprising works from Italy, Germany, England, Bohemia, Austria, the Netherlands, Spain, and elsewhere—in section two.

Acquisitions made since 1993 have been added, the materials sections have been expanded and amended, and as a result of recent research some dates of manufacture, countries of origin, names of and previous owners have been revised. The bibliography for each object has been brought up to date, and two indexes are provided. The first lists the makers and their life dates; the second, previous owners. A glossary of woods has been added, and a concordance between accession numbers and entry numbers.

It is hoped that this new edition will serve as an interim survey of the Decorative Arts Collection, pending the publication of remaining departmental catalogues. Detailed catalogues devoted to the collections of glass, maiolica, clocks, tapestries, and textiles, and Vincennes, Sèvres, and mounted oriental porcelain have been produced.

The summary catalogue is based on files created by Gillian Wilson, Curator of Decorative Arts, and Peter Fusco, former Curator of European Sculpture and Works of Art, and by Charissa Bremer-David and Catherine Hess, Associate Curators. This book is largely the effort of Gillian Wilson, Catherine Hess, and Charissa Bremer-David.

Many others in the Museum have contributed: Jeffrey Weaver, Assistant Curator of Decorative Arts, contributed information regarding marks, bibliography, and exhibition history. Joe Godla, former Associate Conservator of Decorative Arts, aided in the identification of woods, using in part the work of R. Bruce Hoadley. Departmental interns Lisa Bingham and James Peck composed new entries, checked photography, and assisted in the compilation of the expanded bibliographies. Head Photographer Jack Ross was responsible for the photography. Dana Gorbea-Leon and Ellen South, staff assistants, entered the new entries, amendments, and additions to the provenances and bibliographies.

A number of colleagues have generously given information over the years: Antoine d'Albis, Manufacture Nationale de Sèvres; Alessandro Alinari, Florence; Daniel Alcouffe, Musée du Louvre, Paris; Catherine Arminjon, Ministère de la Culture, France; Kirsten Aschengreen-Piacenti, Palazzo Pitti, Florence; Jean-Dominique Augarde, Paris; Rotraud Bauer, Kunsthistorisches Museum, Vienna; Christian Baulez, Château de Versailles; Sir Geoffrey de Bellaigue, Emeritus Surveyor of the Queen's Works of Art, London; Ruth Blumka,* New York; Michael Bohor, Florence; Fausto Calderai, Florence; Martin Chapman, Los Angeles County Museum of Art; Howard Coutts, Bowes Museum, County Durham; Theodore Dell, New York; Guido Donatone, Naples; Pierre Ennès, Musée d'Ecouen; Carolyn Gay Nieda Gassman, Paris; Giancarlo Gentilini, Florence; Alvar González-Palacios, Rome; Burckhardt Göres, Stiftung Preussische Schlösser, Berlin; Michael Hall, London; John Hardy, London; Henry Hawley, Cleveland Museum of Art; Peter Hughes, formerly of the Wallace Collection, London; Cyril Humphris, Rome; Timothy Husband, Metropolitan Museum of Art, Cloisters, New York; Bertrand Jestaz, École Pratique des Hautes Études, Sorbonne, Paris; Clare Le Corbeiller, New York; Ulrich Leben, Paris; Patrick Leperlier, Paris; Reino Liefkes, London; Bozenna Majewska-Maszkowska, Royal Castle, Warsaw; John Mallet, London; Erroll Manners, London; Stanley Margolis,* University of California, Davis; Anna Maria Massinelli, Florence; Otto Mazzucato, Rome; Jessie McNab, Metropolitan Museum of Art, New York; Sarah Medlam, Victoria and Albert Museum, London; Alain Moatti, Rome; Jeffrey Munger, Metropolitan Museum of Art, New York; Maria Leonor d'Orey, Museu Nacional de Arte Antiga, Lisbon; Bill Pallot, Paris; James Parker,* New York; Bruno Pons,* Paris; Alexandre Pradère, Paris; Tamara Préaud, Manufacture Nationale de Sèvres; Peter Pröschel, Munich; Anne Ratzki-Kraatz, Paris; Pieter Rietsema van Eck, Amsterdam; Jean-Nérée Ronfort, Paris; Carolyn J. Sargentson, Victoria and Albert Museum, London; Adrian Sassoon, London; Béatrix Saule, Château de Versailles; Rosalind Savill, Wallace Collection, London; Marco Spallanzani, Florence; Edith Standen,* Metropolitan Museum of Art, New York; Wendy Watson, Mount Holyoke College Art Museum, South Hadley; Sir Francis Watson*; Timothy Wilson, Ashmolean Museum, Oxford; Christian Witt-Döring, Österreichishes Museum für angewandte Kunst, Vienna; and Rainer Zietz, London.

We are most grateful to Hillary Sunenshine for her fine design and to our patient editor, Mollie Holtman. Production coordinator Rebecca Bogner kept the book on track.

Gillian Wilson
Curator, Department of Decorative Arts

Catherine Hess
Associate Curator, Department of Sculpture and Works of Art

*Deceased

Bibliographical Abbreviations

The following abbreviations have been employed in referring to frequently cited works.

"Acquisitions 1982"
Gillian Wilson, Adrian Sassoon, and Charissa Bremer-David, "Acquisitions Made by the Department of Decorative Arts in 1982," *GettyMusJ*, vol. 11 (Malibu, 1983), pp. 13–66.

"Acquisitions 1983"
Gillian Wilson, Adrian Sassoon, and Charissa Bremer-David, "Acquisitions Made by the Department of Decorative Arts in 1983," *GettyMusJ*, vol. 12 (Malibu, 1984), pp. 173–224.

"Acquisitions 1984"
Gillian Wilson, Charissa Bremer-David, and C. Gay Nieda, "Selected Acquisitions Made by the Department of Decorative Arts in 1984," *GettyMusJ*, vol. 13 (Malibu, 1985), pp. 67–88.

Bremer-David, *Summary*
Charissa Bremer-David et al., *Decorative Arts: An Illustrated Summary Catalogue of the Collections of the J. Paul Getty Museum* (Malibu, 1993).

Bremer-David, *French Tapestries*
Charissa Bremer-David, *French Tapestries and Textiles in the J. Paul Getty Museum* (Los Angeles, 1997).

Fredericksen et al., *Getty Museum*
Burton Fredericksen, Helen Lattimore, and Gillian Wilson, *The J. Paul Getty Museum* (London, 1975).

Getty, *Collecting*
J. Paul Getty, *The Joys of Collecting* (New York, 1965).

GettyMusJ
The J. Paul Getty Museum Journal.

Handbook 1986
The J. Paul Getty Museum Handbook of the Collections (Malibu, 1986).

Handbook 1991
The J. Paul Getty Museum Handbook of the Collections (Malibu, 1991).

Handbook 1997
The J. Paul Getty Museum Handbook of the Collections (Los Angeles, 1997).

Handbook 2001
The J. Paul Getty Museum Handbook of Collections (Los Angeles, 2001).

Hess, *Maiolica*
Catherine Hess, *Italian Maiolica: Catalogue of the Collections, The J. Paul Getty Museum* (Malibu, 1988).

Hess and Husband, *European Glass*
Catherine Hess and Timothy Husband, *European Glass in the J. Paul Getty Museum* (Los Angeles, 1997).

Jackson-Stops, "Boulle by the Beach"
Gervase Jackson-Stops, "Boulle by the Beach: Decorative Arts at the J. Paul Getty Museum," *Country Life* 179 (April 3, 1986).

Kjellberg, *Dictionnaire*
Pierre Kjellberg, *Le Mobilier français du XVIIIe siècle: Dictionnaire des ébénistes et des menuisiers* (Paris, 1989).

Masterpieces
Masterpieces of the J. Paul Getty Museum: Decorative Arts (Los Angeles, 1997).

Miller, "Clockwise"
Carole Ann Lyons Miller, "Clockwise Special Report: The J. Paul Getty Museum," *Clockwise* (August 1979).

Morley-Fletcher and McIlroy, *European Pottery*
Hugo Morley-Fletcher and Roger McIlroy, *Christie's Pictorial History of European Pottery* (Englewood Cliffs, N.J., 1984).

Ottomeyer and Pröschel, *Vergoldete Bronzen*
Hans Ottomeyer and Peter Pröschel, eds., *Vergoldete Bronzen: Die Bronzearbeiten des Spätbarock und Klassizismus* (Munich, 1986), vols. 1–2.

Pallot, *L'Art du Siège*
Bill G. B. Pallot, *L'Art du siège au XVIIIᵉ siècle en France* (Paris, 1987).

Pradère, *Les Ebénistes*
Alexandre Pradère, *Les bénistes français de Louis XIV à la Révolution* (Paris, 1989).

Ramond, *Chefs d'oeuvre* I, II, and III
Pierre Ramond, *Chefs d'oeuvre des marqueteurs, Tome I: Des Origines à Louis XIV* (Doudan, 1994); *Tome II: De la Régence à nos jours* (Dourdan, 1994); *Tome III: Marqueteurs d'exception* (Dourdan, 1999).

Sassoon, *Vincennes and Sèvres Porcelain*
Adrian Sassoon, *Vincennes and Sèvres Porcelain: Catalogue of the Collections, The J. Paul Getty Museum* (Malibu, 1991).

Savill, *Sèvres*
Rosalind Savill, *The Wallace Collection: Catalogue of the Sèvres Porcelain* (London, 1988), vols. 1–3.

Verlet, *Les Bronzes*
Pierre Verlet, *Les Bronzes dorés français du XVIIIᵉsiècle* (Paris, 1987).

Verlet et al., *Chefs d'oeuvre*
Pierre Verlet et al., *Chefs d'oeuvre de la collection J. Paul Getty* (Monaco, 1963).

Wilson, "Acquisitions 1977 to mid-1979"
Gillian Wilson, "Acquisitions Made by the Department of Decorative Arts, 1977 to mid-1979," *GettyMusJ*, vol. 6–7 (Malibu, 1978/1979), pp. 37–52.

Wilson, "Acquisitions 1979 to mid-1980"
Gillian Wilson, "Acquisitions Made by the Department of Decorative Arts, 1979 to mid-1980," *GettyMusJ*, vol. 8 (Malibu, 1990), pp. 1–22.

Wilson, "Acquisitions 1981"
Gillian Wilson, "Acquisitions Made by the Department of Decorative Arts, 1981–1982," *GettyMusJ*, vol. 10 (Malibu, 1982), pp. 63–86.

Wilson, *Clocks*
Gillian Wilson et al., *European Clocks in the J. Paul Getty Museum* (Los Angeles, 1996).

Wilson, "Meubles 'Baroques'"
Gillian Wilson, "The J. Paul Getty Museum, 6ᵉᵐᵉ partie: Les Meubles 'Baroques,'" *Connaissance des arts,* 279 (May 1975).

Wilson, *Mounted Oriental Porcelain*
Gillian Wilson, *Mounted Oriental Porcelain in the J. Paul Getty Museum* (Los Angeles, 1999).

Wilson, *Selections*
Gillian Wilson, *Selections from the Decorative Arts in the J. Paul Getty Museum* (Malibu, 1983).

Wilson, "Sèvres"
Gillian Wilson, "Sèvres Porcelain at the J. Paul Getty Museum," *GettyMusJ*, vol. 4 (Malibu, 1977).

Notes to the Reader: In the provenance sections, the lack of a semicolon before a sale in parentheses indicates that the object was sold from the collection of that person, dealer, or gallery; dealers are set off by brackets. The names of Rothschild family members enclosed in parentheses are those names given at birth but not used by the individual. We have provided all the names to help distinguish one Rothschild from another, because multiple cousins and generations share the same appellations.

Furniture

Boxes, Chests, and Coffers

1.

CHEST

French, late fifteenth century
Walnut
Height: 3 ft. 1 3/8 in. (94.9 cm);
Width: 6 ft. 10 1/4 in. (208.9 cm);
Depth: 2 ft. 3 in. (68.6 cm)
Accession number 78.DA.108

PROVENANCE

[Ugo Bardini, Italy, purchased by J. Paul
Getty, 1960]; J. Paul Getty, Sutton Place, Sur-
rey; distributed by the estate of J. Paul Getty
to the J. Paul Getty Museum.

EXHIBITIONS

Woodside, California, Filoli House, on loan,
1983–1991.

BIBLIOGRAPHY

Bremer-David, *Summary*, no. 1, p. 12, illus.

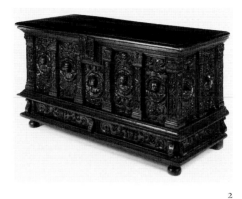

2

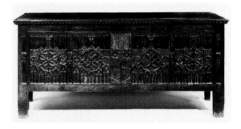

1

2.

COFFER

French, late sixteenth century
Oak and iron
Height: 3 ft. 1 3/4 in. (95.5 cm);
Width: 5 ft. 10 3/4 in. (179.7 cm);
Depth: 2 ft. 5 5/8 in. (75.2 cm)
Accession number 78.DA.124

PROVENANCE

Oliver Vernon Watney, Cornbury Park,
Chequered Hall, Charlbury, Oxfordshire,
England (sold, Christie's, Cornbury Park,
May 22, 1967, lot 93, to J. Paul Getty); pur-
chased by J. Paul Getty for Sutton Place,
Surrey; distributed by the estate of J. Paul
Getty to the J. Paul Getty Museum.

EXHIBITIONS

Woodside, California, Filoli House, on loan,
1983–1992.

BIBLIOGRAPHY

Bremer-David, *Summary*, no. 2, p. 12, illus.

3.

Box

Paris, circa 1675–1680
Attributed to André-Charles Boulle
Oak veneered with ebony, boxwood, natural
and stained maple, mahogany, padouk, wal-
nut, amaranth, cedar, pear, satinwood, brass,
horn, and pewter stringing
Height: 1 ft. 4 1/2 in. (31.9 cm);
Width: 2 ft. 2 in. (66.1 cm);
Depth: 1 ft. 5 in. (43.2 cm)
Accession number 84.DA.971

PROVENANCE

[B. Fabre et Fils, Paris, 1984].

BIBLIOGRAPHY

"Acquisitions/1984," *GettyMusJ* 13 (1985),
no. 46, p. 175, illus.; Bremer-David, *Summary*,
no. 3, p. 12, illus.; Ramond, *Chefs d'oeuvre 1*,
pp. 59–61, illus.

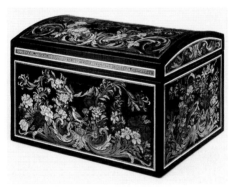

3

4.

Two Coffers on Stands

Paris, circa 1684–1689
Attributed to André-Charles Boulle
Oak, Mediterranean cypress and walnut
veneered with ebony, rosewood, padouk,
plain and red painted tortoiseshell, blue
painted horn, pewter, and brass; set with
mirror glass; gilt-bronze mounts
One stand is stamped with HY.RASKIN
at top of back for Henry Raskin, an early
twentieth-century French restorer. Some
mounts on each coffer and stand are stamped
with the crowned C for 1745–1749.
Coffer .1: Overall Height: 5 ft. 1 ⁵/₈ in.
(156.6 cm); Coffer (*première-partie*): Height:
2 ft. 2 ³/₈ in. (67 cm); Width: 2 ft. 11 ³/₈ in.
(89.9 cm); Depth: 1 ft. 10 in. (55.8 cm);
Stand: Height: 2 ft. 11 ¹/₄ in. (89.6 cm);
Width: 2 ft. 7 ⁷/₈ in. (80.9 cm); Depth:
1 ft. 9 ¹/₂ in. (54.7 cm); Coffer .2: Overall
Height: 5 ft. 1 ¹/₂ in. (156.2 cm); Coffer
(*contre-partie*): Height: 2 ft. 2 ³/₈ in. (67 cm);

Width: 2 ft. 11 ¹/₄ in. (89.4 cm); Depth:
1 ft. 10 in. (55.8 cm); Stand: Height:
2 ft. 11 ¹/₈ in. (89.2 cm); Width: 2 ft.
7 ¹/₄ in. (79.4 cm); Depth: 1 ft. 8 in.
(50.7 cm)
Accession number 82.DA.109.1.a–.b
and .2.a–.b

PROVENANCE

Coffer .1: C. F. Julliot (?) (sold, Paris, Novem-
ber 20, 1777, no. 706, to M. de Luneville for
590 *livres*). Coffer .1–.2: Anatole Demidov,
Prince of San Donato (1813–1870), San Donato
Palace, Pratolino (near Florence) (offered for
sale by his nephew Paul Demidoff, Prince of
San Donato [died 1885], San Donato Palace,
March 15, 1880, nos. 1421–1422, bought in);
marquis da Foz, Lisbon; Mortimer L. Schiff,
New York (sold by his heir John M. Schiff,
Christie's, London, June 22, 1938, lot 68, to
Gaston Bensimon for 1,080 guineas); Anna
Gould (duchesse de Talleyrand, 1875–1961),
Palais Rose, Paris; Violette de Talleyrand

(Mme Gaston Palewski), Château de Marais,
Seine-et-Oise (offered for sale, Sotheby's,
Monaco, May 26, 1980, no. 619, bought in).

BIBLIOGRAPHY

Alfred de Champeaux, *Le Meuble* (Paris,
1885), vol. 2, p. 78, illus. p. 65, fig. 12;
A. Genevay, *Le Style Louis XIV: Charles Le Brun,
decorateur: Ses oeuvres, son influence, ses collaborateurs
et son temps* (Paris, 1886), p. 241, fig. 31; Henry
Havard, *Les Boulle* (Paris, 1892), p. 40, illus.
pp. 41, 45; Émile Molinier, *Histoire générale
des arts appliqués à l'industrie*, vol. 3, *Le Mobilier
au XVIIᵉ et au XVIIIᵉ siècle* (Paris, 1896–1911),
p. 74, illus.; Gerald Reitlinger, *The Economics
of Taste*, vol. 2 (London, 1963), p. 415; Pierre
Verlet, "A Propos de Boulle et du Grand Dau-
phin," *Nederland Kunsthistorisch Jaarbuch 1980*,
vol. 31, pp. 285–288, illus.; Wilson, "Acqui-
sitions 1982," no. 1, pp. 13–18, illus.; Wilson,
Selections, no. 6, pp. 12–13, illus. (89.DA.109.2
only); Jackson-Stops, "Boulle by the Beach,"
pp. 854–856; "J. Paul Getty Museum," *Ven-
tura* (September–November, 1988), p. 164,
illus.; Gillian Wilson, "Dalla Raccolta del
Museo Paul Getty, una selezione di pezzi
acquisti dal 1979," *Casa Vogue Antiques* 6
(November 1989), pp. 110–115, illus. p. 113;
Pradère, *Les Ebénistes*, p. 68, nos. 131–132,
p. 104, illus. p. 68, fig. 14 (89.DA.109.2 only);
Bremer-David, *Summary*, no. 4, pp. 13–14,
illus.; Ramond, *Chefs d'oeuvre 1*, pp. 9, 103–
109, illus.; Philip Jodidio, "Le Monastère de
Brentwood," *Connaissance des arts* 511 (Novem-
ber 1994), p. 134, illus.; *Masterpieces*, no. 41,
p. 56, illus. (82.DA.109.2); *Handbook* 2001,
p. 189, illus. (82.DA.109.1).

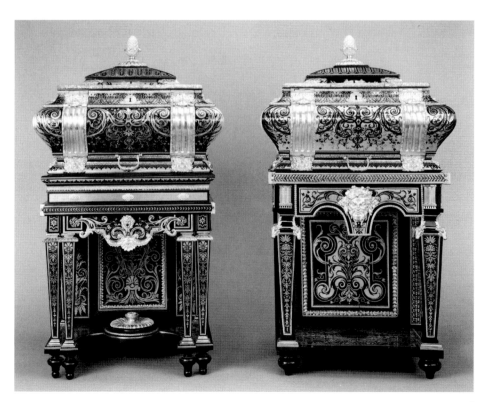

5

5.
PIPE BOX

Lorraine, circa 1710–1715
"Bois de Sainte-Lucie" (*cerasus mahaleb*)
Height: 2 9/16 in. (6.5 cm); Width: 1 ft.
10 5/8 in. (59.5 cm); Depth: 8 1/4 in. (21 cm)
Accession number 88.DA.61

PROVENANCE

[Didier Aaron, Paris].

BIBLIOGRAPHY

Chantal Humbert, "Une curiosité, les sculp-
tures en bois de Sante Lucie," *Gazette de l'Hôtel
Drouot* 36 (October 17, 1980), p. 39, illus.;
"Acquisitions/1988," *GettyMusJ* 17 (1989),
no. 69, p. 141, illus.; Chantal Humbert, *Les
Arts décoratifs en Lorraine: De la fin du XVIIᵉ siècle à
l'ère industrielle* (Paris, 1993), p. 135; Bremer-
David, *Summary*, no. 5, p. 14, illus.

Cabinets

6.
CABINET

Burgundy, 1580, with a nineteenth-
century addition
Carving attributed to Hugues Sambin
Based on engraved designs by
Jacques I Androuet Du Cerceau
and Hans Vredeman de Vries
Painting attributed to Evrard Bredin
Walnut set with painted panels
Painted with 1580 on one panel.
Overall Height: 10 ft. 1 1/8 in. (308.3 cm);
Width: 5 ft. 5 3/8 in. (166.2 cm); Depth:
1 ft. 10 1/2 in. (57.1 cm)
Accession number 71.DA.89

PROVENANCE

Gauthiot d'Ancier, Governor of Besançon,
by 1596; Debruge-Dumenil, Paris (sold,
Hôtel des Ventes Mobilières, Paris, January
23–March 12, 1850, tenth session, February
2, no. 1500, to Prince D. Soltykoff); Prince
Dimitri Soltykoff (sold, Hôtel Drouot, Paris,
April 8, 1861, no. 275, to the Duke of
Marlbourough); Duke of Marlbourough,
Blenheim Palace, Woodstock, Oxfordshire,
England, sold to Baron A. Seillière; Baron
Achille Seillière, Château de Mello, Oise,
France (sold, Galerie Georges Petit, Paris,
May 9, 1890, no. 540, to Duveen); [Duveen
Brothers, New York, acquired by Norton
Simon as part of the purchase of the remain-
ing Duveen inventory, March 1965]; Norton
Simon Foundation, Fullerton (sold, Parke-
Bernet, New York, May 5, 1971, lot 193, to
J. Paul Getty); J. Paul Getty, Sutton Place,
Surrey, England; distributed by the estate of
J. Paul Getty to the J. Paul Getty Museum, 1971.

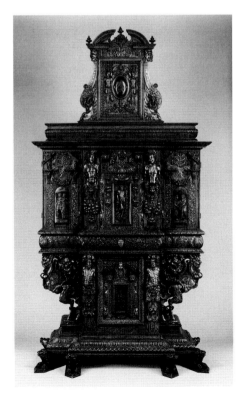

6

BIBLIOGRAPHY

Edmond Bonnaffé, "Le Meuble en France au
XVIᵉ siècle," *Gazette des beaux-arts* (1886),
pp. 60–63, illus.; Edmond Bonnaffé, *Le Meu-
ble en France au XVIᵉ siècle* (Paris, 1887), pp. 84–
85, 166–167, illus.; Georg Hirth, *Formenschatz*
(French ed.: *L'Art pratique*) (Munich, 1891),
pl. 7; Bremer-David, *Summary*, no. 6, p. 14,
illus; Alain Erlande-Brandenburg et al,
Hugues Sambin: Un créateur au XVIᵉ siècle (Ecouen,
2001), pp. 95–100, illus. pp. 43, 49.

7.
CABINET ON STAND

Paris, circa 1675–1680
Attributed to André-Charles Boulle; medals
after Jean Varin
Oak veneered with ebony, tortoiseshell,
pewter, brass, ivory, horn, boxwood, pear,
stained maple, maple, beech, amaranth, Cey-
lon satinwood, juniper, walnut, mahogany,
and ash; with drawers of snakewood; painted
and gilded wood; bronze mounts
Height: 7 ft. 6 1/2 in. (229.9 cm); Width:
4 ft. 11 1/2 in. (151.2 cm); Depth: 2 ft. 2 1/4 in.
(66.7 cm)
Accession number 77.DA.1

PROVENANCE

William Ward (?), 11th Baron Ward (born
1817, created 1st Earl of Dudley 1860, died
1885), Witley Court, Worcestershire (house
acquired, with contents, in 1838, from
Lord Foley); William Humble (?), 2nd Earl
of Dudley (born 1867, died 1932), Witley
Court, Worcestershire, circa 1920 (sold
with the house); Sir Herbert Smith, (sold,
Jackson-Stops and Staff, Witley Court,
September 29, 1938, lot 582); Violet van der
Elst, Harlaxton Manor, Lincolnshire (sold,
Christie's, London, April 8, 1948, lot 142);
John Prendergast, 6th Viscount Gort, Ham-
sterley Hall, County Durham (sold by his
heirs, 1976).

EXHIBITIONS
Barnard Castle, County Durham, The
Bowes Museum, on loan, 1950s; London,
The Victoria and Albert Museum, on loan,
August 1978–February 1979.

BIBLIOGRAPHY
"A la découverte," *Connaissance des arts* 35 (January 15, 1955), p. 58, illus.; Stéphane Faniel et al., *Le XVIIIᵉ siècle français* (Collection Connaissance des arts, Paris, 1958), illus. p. 53; Alfred and Jeanne Marie, *Versailles: Son Histoire, Tome II: Mansart à Versailles* (Paris, 1972), pp. 631 and 634; "Current and Forthcoming Exhibitions," *Burlington Magazine* 120 (December 1978), p. 93, illus.; Wilson, "Acquisitions 1977 to mid-1979," no. 1, p. 37, illus.; Marvin D. Schwartz, "Boulle Furniture," *Art and Antiques* 6 (April 1983), illus. p. 72; Wilson, *Selections*, no. 3, pp. 6–7, illus.; Gillian Wilson, "A Late Seventeenth-Century French Cabinet at the J. Paul Getty Museum," *The Art Institute of Chicago Centennial Lecture: Museum Studies* 10 (1983), pp. 119–131, illus.; Lorenz Seelig, "Eine Reiterstatuette urfürst Max Emanuels von Bayern aus dem Jahr 1699," *Anzeiger des germanischen Nationalmuseums* (1986), note 34, p. 73; Jackson-Stops, "Boulle by the Beach," pp. 854–856, illus. p. 855, fig. 3; Pradère, *Les Ebénistes*, p. 94, p. 104, no. 103, illus. p. 93, fig. 49; Monique Riccardi-Cubitt, *The Art of the Cabinet* (London, 1992), p. 177, illus. p. 69, pl. 45; Bremer-David, *Summary*, pp. 14–16, illus. p. 15; Mary Anne Staniszewski, *Believing Is Seeing: Creating the Culture of Art* (New York, 1995), p. 92, detail of cupboard door illustrated only; Ramond, *Chefs d'oeuvre 1*, pp. 114–121; Leora Auslander, *Taste and Power: Furnishing Modern France* (Berkeley, 1996), p. 46, illus.; *Masterpieces*, no. 40, pp. 54–55, illus.; Aaron Betsky, "Sitting between Craft and Form," *Sitting on the Edge: Modernist Design from the Collection of Michael and Gabrielle Boyd* (San Francisco, 1998), p. 23, fig. 18; John Morley, *Furniture: The Western Tradition, History, Style, Design* (London, 1999), p. 137, illus. p. 143, fig. 255; *Handbook 2001*, pp. 186–187, illus. p. 187.

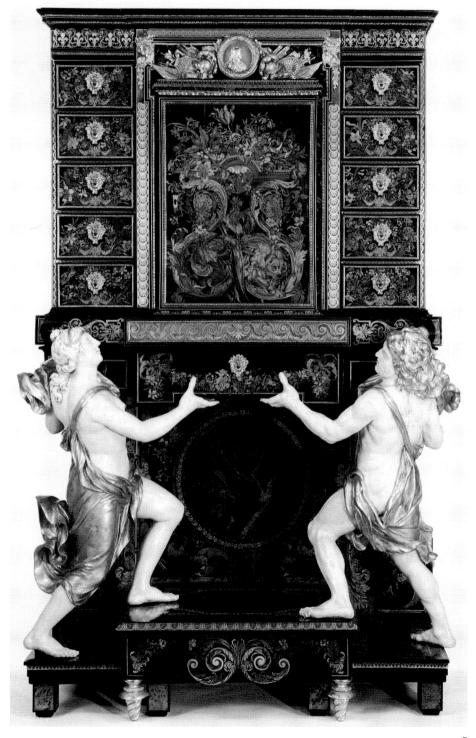

8.

CABINET (*CABINET DES MÉDAILLES*)
Paris, circa 1710–1715
Attributed to André-Charles Boulle
Oak and fir veneered with ebony, amaranth, kingwood, brass, and tortoiseshell; gilt-bronze mounts; *sarrancolin des Pyrénées* marble top
Height: 2 ft. 8$^{1}/_{2}$ in. (82.5 cm); Width: 4 ft. 7$^{1}/_{4}$ in. (140 cm); Depth: 2 ft. 4$^{1}/_{2}$ in. (72.5 cm)
Accession number 84.DA.58

PROVENANCE
Suzanne de Launay and Jules-Robert de Cotte, Paris, inventoried after their deaths as one of a pair of medal cabinets on November 20, 1767; by descent to their son, Jules-François de Cotte; inventoried in his collection on May 13, 1782 (sold, Paris, March 8, 1804, no. 34); Baron Gustave (Samuel James) de Rothschild (1829–1911), Paris; Sir Philip Sassoon, Bt., London (1888–1934), by descent, 1912; Sybil Sassoon (Marchioness of Cholmondeley, wife of the 5th Marquess [1894–1989], married 1913), Houghton Hall, Norfolk, by inheritance, after 1939 (sold, Christie's, London, April 12, 1984, lot 164).

EXHIBITIONS
London, 25 Park Lane, *Three French Reigns*, February–April 1933, no. 519, illus. p. 71.

BIBLIOGRAPHY
F. J. B. Watson, "The Marquess of Cholmondeley," *Great Family Collections*, Douglas Cooper, ed. (Zurich, 1963), p. 228, illus.; Pierre Verlet, *La Maison du XVIIIe siècle en France: Société, décoration, mobilier* (Paris, 1966), p. 38, fig. 21; Pierre Verlet, *French Furniture and Interior Decoration of the Eighteenth Century* (Paris, 1967), fig. 21; Wilson, "Acquisitions 1984," pp. 67–71, illus.; "Acquisitions/1984," *GettyMusJ* 13 (1985), no. 47, pp. 175–176, illus.; Pradère, *Les Ebénistes*, no. 157, p. 104, illus. p. 109, fig. 65; Frank Davis, "Talking about Salerooms," *Country Life* (May 24, 1984); Bremer-David, *Summary*, no. 8, p. 16, illus.; *Masterpieces*, no. 49, p. 67; *Handbook* 2001, p. 193, illus.

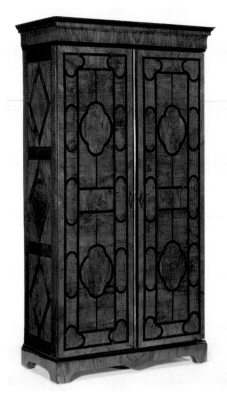

9

9.

ARMOIRE
Paris, circa 1720–1725
Oak, Scots pine, beech, and chestnut veneered with rosewood, olive, yew, and cherry
Height: 5 ft. 9$^{1}/_{4}$ in. (176 cm); Width: 3 ft. 2$^{3}/_{8}$ in. (97.5 cm); Depth: 1 ft. 5$^{1}/_{4}$ in. (43.5 cm)
Accession number 84.DA.852

PROVENANCE
Private collection, France; [La Cour de Varenne, Paris].

BIBLIOGRAPHY
"Acquisitions/1984," *GettyMusJ* 13 (1985), no. 50, pp. 176–177, illus.; Bremer-David, *Summary*, no. 9, p. 17, illus.

case are stamped with the crowned C for 1745–1749. The clock dial is enameled with ETIENNE LE NOIR A PARIS and the movement is engraved with *Etienne Le Noir Aparis*. The spring of the striking train is inscribed with *Buzot 9BRE 1746*, and the back of the dial bears the enameled inscription *decla.1746*. Metal plaque on the rear of *cartonnier* is engraved with *Angela's 1835*; also a torn typed label with M....*xandrine de*....... Height: 6 ft. 3 5/8 in. (192 cm); Width: 3 ft. 4 9/16 in. (103 cm); Depth: 1 ft. 4 1/8 in. (41 cm)
Accession number 83.DA.280

PROVENANCE
Possibly Harriot Mellon Coutts (1777–1837), widow of Thomas Coutts and later Duchess of St. Albans; Angela Georgina, Baroness Burdett-Coutts (1814–1906, step-granddaughter of Harriot, Duchess of St. Albans), London, probably given to her in 1835 on her twenty-first birthday; Hon. William Bartlett Burdett-Coutts, M. P. (husband of Angela, Baroness Burdett-Coutts), by descent, 1906 (sold, Christie's, London, May 9, 1922, lot 144, for 4,200 guineas to H. J. Simmons); Baronne Miriam (Caroline) Alexandrine de Rothschild (1884–1965), Paris; confiscated after the German occupation of Paris in 1940 and later restituted; by descent to her nephew and heir, Baron Edmond (Adolphe Maurice Jules Jacques) de Rothschild (1926–1997), Paris, 1972; José and Vera Espirito Santo, Lausanne, Switzerland, after 1972.

BIBLIOGRAPHY
Sassoon, "Acquisitions 1983," no. 6, pp. 193–197, illus.; "Acquisitions/1983," *GettyMusJ* 12 (1984), no. 8, pp. 263–264, illus.; Jackson-Stops, "Boulle by the Beach," pp. 854–856; Jean-Dominique Augarde, "1749 Joseph Baumhauer, ébéniste privilegié du roi," *L'Estampille* 204 (June 1987), p. 25; Pradère, *Les Ebénistes*, illus. p. 196, fig. 188; Bremer-David, *Summary*, no. 10, pp. 17–18, illus. p. 17; Wilson, *Clocks*, pp. 78–85, illus.; *Masterpieces*, no. 59, pp. 78–79, illus.; *Handbook* 2001, p. 205, illus.

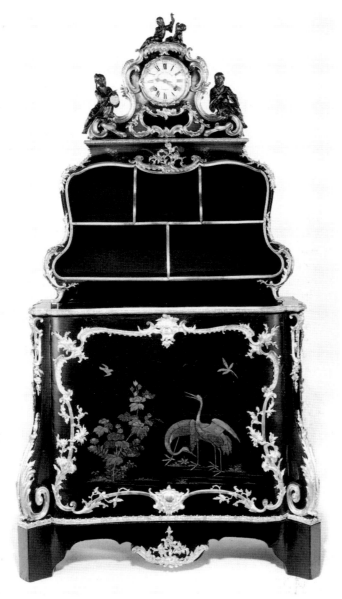

10

10.
CARTONNIER WITH BOUT DE BUREAU AND CLOCK
Paris, *cartonnier* and *bout de bureau*: circa 1740; clock: 1746
Cartonnier and *bout de bureau* by Bernard II van Risenburgh. Maker of the clock case unknown. The clock movement by Étienne II Le Noir. The clock dial enameled by Jacques Decla

Oak and poplar veneered with alder, amaranth, and cherry and painted with *vernis Martin*; enameled and painted metal; glass; gilt-bronze mounts
Cartonnier and *bout de bureau* are stamped with BVRB on the back; *cartonnier* is also stamped with the name of E. J. CUVELLIER, who possibly restored it. Several mounts on clock

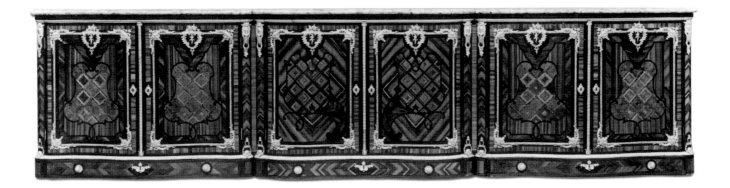

11

CABINET

Paris, circa 1735–1740
Attributed to Bernard II van Risenburgh
Oak veneered with bloodwood, cherry, cururu, and amaranth; gilt-bronze mounts; brèche d'Alep top
Inscribed DAVAL twice on the back.
Height: 3 ft. 9⅝ in. (115.8 cm); Width: 15 ft. 4½ in. (468.6 cm); Depth: 1 ft. 9½ in. (54.5 cm)
Accession number 77.DA.91

PROVENANCE

Daval (marchand-mercier, died circa 1821), Paris, before 1822; comte Henri de Greffulhe (1848–1932), Paris (sold by his widow, Sotheby's, London, July 23, 1937, lot 50, to both [Arnold Seligmann] and [Trevor and Co.], for £1,400); [David Drey, London, 1950s]; [Maurice Aveline, Paris, 1950s]; Antenor Patiño, Paris, circa 1957; [Aveline et Cie, Paris and Geneva].

BIBLIOGRAPHY

Charles Guellette, "Les Cabinets d'amateurs à Paris—La Collection de M. Henri de Greffulhe, Part 2: Ameublement," Gazette des beaux-arts 15 (1877), p. 466; Gerald Reitlinger, The Economics of Taste (London, 1963), vol. 2, p. 426; Wilson, "Acquisitions 1977 to mid-1979," no. 3, p. 37, illus.; Pradère, Les Ebénistes, p. 190, illus. pp. 184–185, fig. 168; Bruno Pons et al., L'Art décoratif en Europe: Classique et baroque, Alain Gruber, ed. (Paris, 1992),

illus. p. 377; Bremer-David, Summary, no. 11, p. 18, illus.; Jean-Nérée Ronfort et al., "Nouveaux Aspects de la Vie et de L'Oeuvre de Bernard (II) Vanrisamburgh (c. 1700–1766)," L'Estampille/L'Objet d'art 290 (April 1995), p. 45, illus.

12.

PAIR OF CABINETS

Paris, circa 1745–1750
By Bernard II van Risenburgh
Oak veneered with bloodwood, kingwood, and cherry; wire mesh screens; gilt-bronze mounts
Each cabinet is stamped with B.V.R.B. on back.
Height: 4 ft. 10⅝ in. (149 cm); Width: 3 ft. 3¾ in. (101 cm); Depth: 1 ft. 7 in. (48.3 cm)
Accession number 84.DA.24.1–.2

PROVENANCE

Sir John Hobart Caradoc (?), 2nd Baron Howden, Grimston Park, Tadcaster, Yorkshire, circa 1840; Albert Denison (?), 1st Baron Londesborough, Grimston Park, 1850; William Henry Forester (?), created Earl of Londesborough, Grimston Park (sold with the contents of Grimston Park in 1872 to John Fielden); Captain John Fielden (great-nephew of John Fielden) (sold, Henry Spencer and Sons, at Grimston Park, Tadcaster, Yorkshire, May 29–31, 1962, no. 372); [Etienne Lévy and René Weiller, Paris, 1962]; [Raymond Kraemer, Paris, 1960s]; [Kraemer et Cie, Paris, 1970s].

BIBLIOGRAPHY

"Acquisitions/1984," GettyMusJ 13 (1985), no. 54, pp. 178–179, illus.; Pradère, Les Ebénistes, illus. p. 188, fig. 174; Kjellberg, Dictionnaire, p. 139; Bremer-David, Summary, no. 12, pp. 18–19, illus. p. 19 (one); Masterpieces, no. 63, p. 83, illus.; Handbook 2001, p. 207, illus.

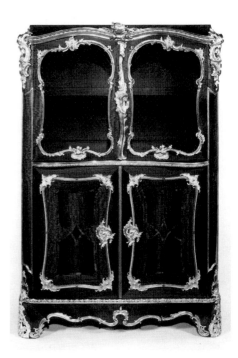

12 One of a pair

13.
CABINET

Paris, circa 1765
By Joseph Baumhauer
Oak veneered with ebony, tulipwood, maple, Japanese cedar, and amaranth; set with panels of seventeenth-century Japanese *kijimaki-e* lacquer; gilt-bronze mounts; yellow jasper top
Stamped with JOSEPH between two fleur-de-lys under the apron.
Height: 2 ft. 11 ¼ in. (89.6 cm); Width: 3 ft. 11 ⅜ in. (120.2 cm); Depth: 1 ft. 11 ⅛ in. (58.6 cm)
Accession number 79.DA.58

PROVENANCE

[Kraemer et Cie, Paris, 1930–1939]; private collection, Brussels; [Lucien Delplace, Brussels]; [Claude Levy, La Cour de Varenne, Paris]; [Didier Aaron, Les Antiquaires de Paris, circa 1976]; [Alexander and Berendt, Ltd., London, 1977].

BIBLIOGRAPHY

Wilson, "Acquisitions 1979 to mid-1980," pp. 6–7, illus.; Wilson, *Selections*, no. 34, pp. 68–69, illus.; Jean-Dominique Augarde, "1749 Joseph Baumhauer, ébéniste privilegié du roi," *L'Estampille* 204 (June 1987), pp. 15–45, figs. 26, 28; Pradère, *Les Ebénistes*, no. 16, p. 244.; Kjellberg, *Dictionnaire*, p. 450; Alexandre Pradère, "Quand le Getty Vise Juste," *Connaissance des arts* 449/450 (July/August 1989), pp. 111–119, illus. p. 115; John Whitehead, *The French Interior in the Eighteenth Century* (London, 1992), p. 62, illus.; Bremer-David, *Summary*, no. 13, pp. 19–20, illus. p. 19; *Masterpieces*, no. 79, p. 102, illus.; *Handbook* 2001, p. 219, illus.

14.
CABINET

Paris, circa 1765
By Roger Vandercruse Lacroix
Oak and fir veneered with tulipwood, amaranth, and holly; gilt-bronze mounts; white marble interior shelf
Stamped with RVLC and JME inside the drawer at top right-hand side. Paper label glued underneath is printed with a ducal coronet above the typed inscription CLUMBER, 4049.
Height: 3 ft. 1 in. (94 cm); Width: 1 ft. 11 ¼ in. (59.5 cm); Depth: 1 ft. 5 ¼ in. (43.8 cm)
Accession number 70.DA.81

PROVENANCE

Dukes of Newcastle, Clumber, Nottinghamshire; Henry Pelham Archibald Douglas, 7th Duke of Newcastle (1864–1928), Clumber, Nottinghamshire, by descent (sold by his heir, Christie's, London, June 9, 1937, lot 253); [J. M. Botibol, London]; purchased by J. Paul Getty, 1938.

BIBLIOGRAPHY

Verlet et al., *Chefs d'oeuvre*, p. 125, illus.; Getty, *Collecting*, illus. p. 155; Bremer-David, *Summary*, 1993, no. 14, p. 20, illus.

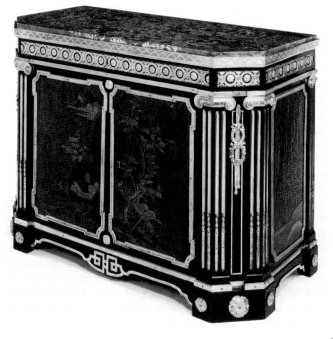

13

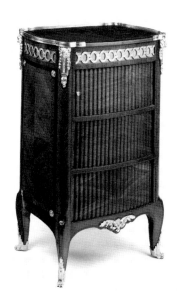

14

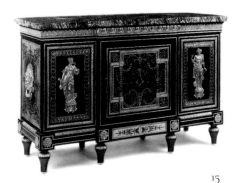

15

15.
CABINET
Paris, circa 1785–1790; marquetry panels, some gilt-bronze mounts, late seventeenth century
Oak and walnut veneered with ebony, amaranth, brass, pewter, and tortoiseshell; gilt-bronze mounts; *bianco e nero antico* marble top
Height: 3 ft. 5 1/4 in. (104.8 cm); Width: 5 ft. 4 5/8 in. (164.2 cm); Depth: 1 ft. 10 1/2 in. (57.1 cm)
Accession number 72.DA.71

PROVENANCE
George Granville, 1st Duke of Sutherland (1758–1833, English ambassador to France 1789–1792) or George Granville Sutherland-Leveson-Gower, 2nd Duke of Sutherland (1786–1861), in the Picture Gallery, Stafford House, London, by 1848, and still present in 1895; [Arnold Seligmann, Paris] (sold, Galerie Jean Charpentier, Paris, June 4–5, 1935, no. 192); [François-Gérard Seligmann, Paris]; [French and Co., 1972]; purchased by J. Paul Getty.

BIBLIOGRAPHY
F. J. B. Watson, *Louis XVI Furniture* (London, 1960), no. 236, illus.; Jean Meuvret and Claude Frégnac, *Ebénistes du XVIIIᵉ siècle français* (Paris, 1963), p. 37, illus.; Michael Stürmer, *Handwerk und höfische Kultur: Europäische Möbelkunst im 18. Jahrhundert* (Munich, 1982), illus. pp. 156, 288; Marvin D. Schwartz, "Boulle Furniture," *Art and Antiques* 6 (April 1983), illus. p. 67; Alexandre Pradère, "Boulle de Louis XIV sous Louis XVI," *L'Objet d'art* 0 (June 1987), pp. 56–57, 118; illus. p. 62; Bremer-David, *Summary*, no. 15, p. 20, illus.

16.
CABINET
Paris, 1788
By Guillaume Benneman; gilt-bronze mounts cast by Forestier (either Etienne-Jean or his brother Pierre-Auguste) and Denis Bardin from models by Gilles-François Martin, chased by Pierre-Philippe Thomire and gilded by Claude Galle; marble top supplied by Lanfant
Oak veneered with ebony, mahogany, and lacquer, set with *pietre dure* plaques of seventeenth- and eighteenth-century date; gilt-bronze mounts; *bleu turquin* marble top
Stamped with G.BENEMAN twice on top of the carcass and stenciled with a partial mark, possibly for the Château de Saint-Cloud, on back.
Height: 3 ft. 1/4 in. (92.2 cm); Width: 5 ft. 5 1/8 in. (165.4 cm); Depth: 2 ft. 1 1/4 in. (64.1 cm)
Accession number 78.DA.361

PROVENANCE
Louis XVI, one of a pair costing 5,954 *livres* in the *Chambre à coucher du Roi*, Château de Saint-Cloud (near Paris), from October 4, 1788, until at least *an II* (1793–1794); Earls of Powis, Powis Castle, Wales, by 1848 (sold, Sotheby's, London, May 11, 1962, lot 262, for £33,000); John Allnat (sold, Sotheby's, London, June 21, 1974, lot 109, to [Didier Aaron, Paris]); [Aveline et Cie, Paris].

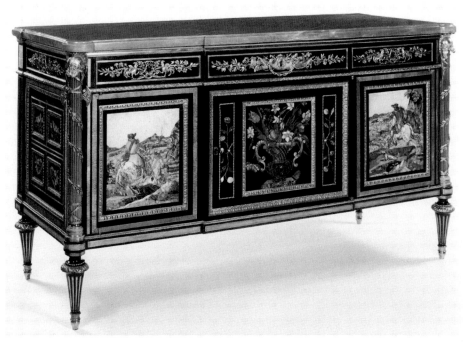

EXHIBITIONS
London, The Victoria and Albert Museum, on loan, 1969–1974.

BIBLIOGRAPHY
"Powis Castle, Montgomeryshire, the Seat of the Earl of Powis," *Country Life* 23 (May 9, 1908), illus. p. 670; Jean Meuvret and Claude Frégnac, *Les Ebénistes du XVIIIᵉ siècle français* (Paris, 1963), pp. 306–307, illus.; G. Reitlinger, *The Economics of Taste* (London, 1963), vol. 2, p. 429; Anthony Coleridge, "Clues to the Provenance of an Outstanding French Commode," *Connoisseur* 162 (July 1966), pp. 164–166, illus.; Wilson, "Acquisitions 1977 to mid-1979," no. 11, pp. 46–49, illus.; Gillian Wilson, "A Pair of Cabinets for Louis XVI's Bedroom at Saint-Cloud: Their Present Appearance," *Journal of the Furniture History Society* 21 (1985), pp. 39–47; Verlet, *Les Bronzes*, p. 213, illus. p. 46, fig. 39; Alexandre Pradère, "Quand le Getty Vise Juste," *Connaissance des arts* 449/450 (July/August 1989), pp. 111–119, illus. p. 114, fig. 9; Pradère, *Les Ebénistes*, illus. p. 406, fig. 502; Pierre Verlet, *Le Mobilier royal français, vol. 4: Meubles de la couronne conservés en Europe et aux États-Unis* (Paris, 1990), pp. 116–121, illus.; Ulrich Leben, *Molitor: Ebéniste from the Ancien Régime to the Bourbon Restoration* (London, 1992), p. 150, fig. 153; Bremer-David, *Summary*, no. 16, p. 21, illus.; Ramond, *Chefs d'oeuvre 1*, pp. 66–68, illus.; Leora Auslander, *Taste and Power: Furnishing Modern France* (Berkeley, 1996), p. 265, illus.; *Masterpieces*, no. 93, p. 118, illus.; *Handbook* 2001, p. 231, illus.

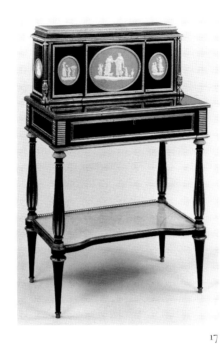

17

17.
BONHEUR DU JOUR
Paris, circa 1785–1790
Attributed to Adam Weisweiler; Wedgwood jasperware plaques designed by Elizabeth, Lady Templetown, and modeled by William Hackwood
Oak and mahogany veneered with amboyna, ebony, green stained harewood, and sycamore; set with five jasperware plaques with a green ground; gilt-bronze mounts; white marble top and shelf
Height: 3 ft. 6 3/8 in. (107.6 cm); Width: 2 ft. 3 1/4 in. (69.2 cm); Depth: 1 ft. 4 1/4 in. (41.3 cm)
Accession number 72.DA.59

PROVENANCE
Baronne de Gunzburg (?), Paris (sold, Palais Galliera, Paris, March 2, 1972, no. 121); purchased at that sale by J. Paul Getty.

EXHIBITIONS
The Los Angeles Country Museum of Art, *Wedgwood from California Collections: Georgian through Victorian, 1760–1901*, January 27–March 21, 1976.

BIBLIOGRAPHY
Fredericksen et al., *Getty Museum*, p. 179, illus.; Patricia Lemonnier, *Weisweiler* (Paris, 1983), no. 211, illus. p. 28; Kjellberg, *Dictionnaire*, p. 872; Bremer-David, *Summary*, no. 17, pp. 22, illus.

18.
PAIR OF CABINETS
Paris, Cabinet .1: circa 1785;
Cabinet .2: circa 1810
Pietre dure plaques: Italian (and perhaps French), mid-seventeenth to late eighteenth century
Both cabinets attributed to Adam Weisweiler
Oak, pine, and beech veneered with ebony and mahogany; pewter stringing; set with *pietre dure* plaques and micromosaic roundels; gilt-bronze mounts; *portor d'Italie* tops
Cabinet .1 is stamped with JME.
Height: 3 ft. 4 in. (101.6 cm); Width: 4 ft. 11 1/8 in. (150.5 cm); Depth: 1 ft. 9 1/2 in. (54.5 cm)
Accession number 76.DA.9.1–.2

PROVENANCE
Cabinet .1: M. Marin, Paris (sold, Paris, March 22, 1790, no. 712, for 3,100 livres); Vincent Donjeux, Paris (sold, Paris, April 29 et seq., 1793, no. 554, for 3,200 livres).
Cabinets .1–.2: (?) Alexander Archibald Douglas, the 10th Duke of Hamilton and 7th Duke of Brandon, Hamilton Palace, Lanarkshire, Scotland; William, 12th Duke of Hamilton and 9th Duke of Brandon, Hamilton Palace, by descent (sold, Christie's, London, June 19, 1882, lots 185–186); Christopher Beckett-Denison, London (sold, Christie's London, June 6, 1885, lot 817, to Maclean for 195 guineas, and lot 818, to Donaldson for 205 guineas); [Moss Harris, London]; Maharanee of Baroda, Paris (sold, Palais Galliera, Paris, November 29, 1973, no. 114 A–B); [Aveline et Cie, Paris]; purchased by J. Paul Getty.

Commodes

BIBLIOGRAPHY
Ronald Freyberger, "Hamilton Palace," *Apollo*
114, no. 238 (December 1981), pp. 401–409;
Alvar González-Palacios, *Mosaici e Pietre dure:
Mosaici a piccole tessere, Pietre dure a Parigi e a Napoli*
(Milan, 1982), illus. p. 48; Kjellberg, *Dic-
tionnaire*, p. 872; Alvar González-Palacios,
"Capricci Gusto: Vecchio Barocco e Nuovo
Classicismo," *Casa vogue antiques* 13 (May
1991), p. 77, illus. p. 79 (76.DA.9.1); Anna
Maria Giusti, *Pietre Dure: Hardstone in Furniture
and Decorations* (London, 1992), p. 218, illus.
figs. 75–76; Ronald Freyberger, "The Duke
of Hamilton's Porphyry Tables," *The Magazine
Antiques* (September 1993), pp. 348–355,
illus. p. 354, pl. 1x; Bremer-David, *Summary*,
no. 18, pp. 22–23, illus.; Ramond, *Chefs d'oeu-
vre* 1, p. 68, illus.; Carolyn Sargentson, *Mer-
chants and Luxury Markets: The Marchands Merciers
of Eighteenth-Century Paris* (Malibu, 1996),
pp. 180–181, illus. p. 47.

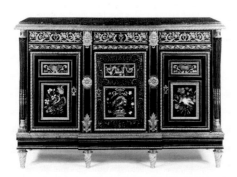

18 *Cabinet .1*

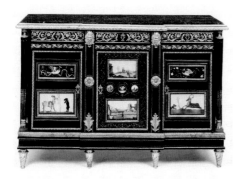

18 *Cabinet .2*

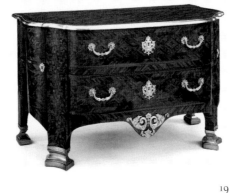

19

19.
COMMODE
Paris, circa 1710–1715
Fir and oak veneered with bloodwood; draw-
ers of walnut; gilt-bronze mounts
Stamped on the back with a crowned M,
probably for the Château de Maisons, and
an interlaced *AT* over *G.M* for the *garde-meuble*
of the comte d'Artois.
Height: 2 ft. 9$^{1}/_{16}$ in. (83.9 cm); Width:
4 ft. 7$^{1}/_{4}$ in. (140.3 cm); Depth: 1 ft.
11$^{1}/_{2}$ in. (59.7 cm)
Accession number 78.DA.87

PROVENANCE
Marquis de Longueil, Château de Maisons;
comte d'Artois, Château de Maisons, after
1777; [Léon Lacroix, Paris, 1938 (?)]; pur-
chased by J. Paul Getty, 1938; distributed by
the estate of J. Paul Getty to the J. Paul Getty
Museum.

BIBLIOGRAPHY
Pascal Dauphin, "À propos du mobilier du
comte d'Artois au château de Maisons, 2ème
partie: quelques éléments d'ameublement ici
ou là," *Les Cahiers de Maisons* 23 (Spring 1994),
pp. 58–59, illus. pp. 54, 55, and 58; Bremer-
David, *Summary*, no. 19, p. 23, illus.

20.
COMMODE
Paris, circa 1710–1715
Fir and oak veneered with rosewood; drawers
of walnut; gilt-bronze mounts; *rouge griotte de
Félines* marble top
Height: 2 ft. 9$^{1}/_{2}$ in. (85.1 cm); Width: 4 ft.
(121.9 cm); Depth: 1 ft. 10$^{3}/_{8}$ in. (56.8 cm)
Accession number 73.DA.66

PROVENANCE
M. d'Eustache Bonnemet, Paris (sold, Paris,
December 4–14, 1771, no. 164, for 210 *livres*);
ducs d'Arenberg, Palais d'Arenberg,
Brussels, until 1914; duchesse Mathildis
d'Arenberg, Monaco; [Gérard Gallet,
Cannes]; [French and Co., New York]; pur-
chased by J. Paul Getty.

BIBLIOGRAPHY
Bremer-David, *Summary*, no. 20, p. 23, illus.

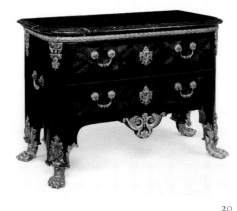

20

21.
COMMODE
Paris, circa 1710–1715
Attributed to André-Charles Boulle
Oak and fir veneered with cururu and blood-
wood; gilt-bronze mounts; *brocatelle violette du
Jura* marble top
The top of the carcass is stamped with C. M.
COCHOIS and printed in black ink with
55406. The underside of the marble top is
marked with 55406/19 in black wax pencil.

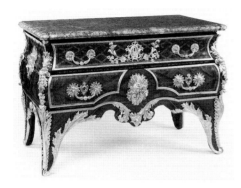

21

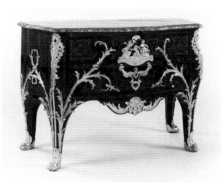

23

Many mounts are stamped with the crowned C for 1745–1749.
Height: 2 ft. 9 ³/₄ in. (85.7 cm); Width: 4 ft. 3 ³/₄ in. (131.4 cm); Depth: 1 ft. 11 in. (58.4 cm)
Accession number 70.DA.80

PROVENANCE
Henry Peter (?), 1st Lord Brougham (1778–1868), Cannes, 1840s or 1850s; William (?), 2nd Lord Brougham (died 1886), England, after 1868; Hon. Wilfred Brougham (?), England, after 1886; Maria Sophia Faunce (Hon. Mrs. Wilfred Brougham), England, after 1904; [J. M. Botibol, London, 1938]; purchased by J. Paul Getty, 1938.

BIBLIOGRAPHY
J. Paul Getty, *Europe in the Eighteenth Century* (Chicago, 1949), illus. unnumbered pl. between pp. 60–61; Paul Wescher, "French Furniture of the Eighteenth Century in the J. Paul Getty Museum," *Art Quarterly* 18, no. 2 (Summer 1955), p. 117, illus. p. 120, fig. 4; Kjellberg, *Dictionnaire*, p. 184; Bremer-David, *Summary*, no. 21, pp. 23–24, illus. p. 23; Peter Hughes, *The Wallace Collection Catalogue of Furniture* (London, 1996), vol. 2, p. 648.

22.
COMMODE
Paris, circa 1725–1730
By Etienne Doirat
Fir and oak veneered with kingwood and amaranth; drawers of walnut; gilt-bronze

mounts; *brèche d'Alep* top
Stamped with E. DOIRAT on top of carcass.
Height: 2 ft. 10 in. (86.4 cm); Width: 5 ft. 6 ¹/₂ in. (168.9 cm); Depth: 2 ft. 4 ¹/₄ in. (71.7 cm)
Accession number 72.DA.66

PROVENANCE
George Durlacher, London (sold, Christie's, London, April 6–7, 1938, lot 176, for 273 guineas to Sutch); ("Property of a Gentleman," sold, Christie's, London, December 1, 1966, lot 70, for 5,500 guineas to Perman); [Aveline et Cie, Paris, 1972]; purchased by J. Paul Getty.

BIBLIOGRAPHY
Christie's Review of the Year (London, October 1966–July 1967), p. 247, illus.; Jean-Dominique Augarde, "Etienne Doirat, Menuisier en Ebène," *GettyMusJ* 13 (1985), pp. 33–52, illus. p. 45; Pradère, *Les Ebénistes*, illus. p. 122, fig. 78; Kjellberg, *Dictionnaire*, p. 264; L'Abbé d'Arrides, "Les Commodes Tombeaux," *L'Estampille/L'Objet d'art* 260 (July/August 1992), pp. 50–65, illus. p. 60; Bremer-David, *Summary*, no. 22, p. 24, illus.; *Handbook* 2001, p. 196, illus.

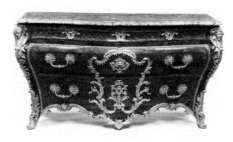

22

23.
COMMODE
Paris, circa 1735–1740
By Charles Cressent
Fir, oak, and Scots pine veneered with bloodwood and amaranth; drawers of walnut; gilt-bronze mounts; *brèche d'Alep* top
Corner mounts are stamped with the

crowned C for 1745–1749.
Height: 2 ft. 11 ¹/₂ in. (90.2 cm); Width: 4 ft. 5 ³/₄ in. (136.5 cm); Depth: 2 ft. 1 ¹/₂ in. (64.8 cm)
Accession number 70.DA.82

PROVENANCE
George Jay Gould (1864–1923), New York, by 1914; [Duveen Brothers, New York, from the estate of Edith Kingdom Gould, 1924–1925]; [Arnold Seligmann, Rey and Co., New York]; purchased by J. Paul Getty, 1938.

BIBLIOGRAPHY
Cressent sale catalogue, January 15, 1757, no. 132; Marie-Juliette Ballot, *Charles Cressent: Sculpteur, ébéniste, collectionneur, Archives de l'art français: Nouvelle période* 10 (Paris, 1919), no. 132, p. 215; André Boutemy,"Essais d'attributions de commodes et d'armoires à Charles Cressent," *Bulletin de la Société de l'histoire de l'art français* (1927), pp. 77–79; J. Paul Getty, *Europe in the Eighteenth Century* (Chicago, 1949), illus. unnumbered pl. between pp. 60–61; Paul Wescher, "French Furniture of the Eighteenth Century in the J. Paul Getty Museum," *Art Quarterly* 18, no. 2 (Summer 1955), pp. 114–135; J. Paul Getty, *Collector's Choice* (London, 1956), pp. 78 and 165; Verlet et al., *Chefs d'œuvre*, p. 114, illus.; Getty, *Collecting*, p. 144, illus.; Fredericksen et al., *Getty Museum*, p. 152, illus.; Wilson, *Selections*, no. 19, pp. 38–39, illus.; Kjellberg, *Dictionnaire*, p. 204; Bremer-David, *Summary*, no. 23, p. 24, illus.; *Masterpieces*, no. 55, p. 74, illus.

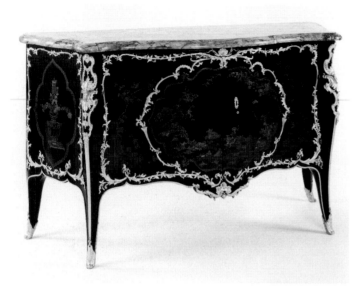

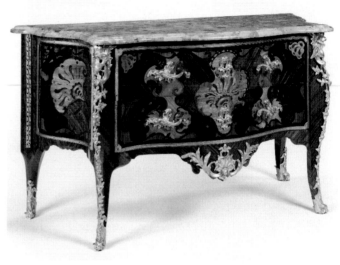

24

25

24.

COMMODE

Paris, circa 1737

By Bernard II van Risenburgh

Oak set with panels of black Japanese lac-
quer and painted with *vernis Martin*; veneered
with cherry and amaranth on interior of the
doors; gilt-bronze mounts; *sarrancolin* marble
top; eighteenth-century silk fabric lining and
silver metal *galon*

Stamped with BVRB on top of carcass.

Height: 2 ft. 10 3/4 in. (88.3 cm); Width:
4 ft. 11 3/4 in. (151.9 cm); Depth: 1 ft. 10 3/4
in. (57.8 cm)

Accession number 65.DA.4

PROVENANCE

Colbert family, France, by repute, from the
eighteenth to the twentieth century; [René
Weiller, Paris]; [Rosenberg and Stiebel, Inc.,
New York]; purchased by J. Paul Getty, 1953.

BIBLIOGRAPHY

Paul Wescher, "French Furniture of the Eigh-
teenth Century in the J. Paul Getty Museum,"
Art Quarterly 18, no. 2 (Summer 1955),
pp. 121–122, 128, illus. fig. 11; F. J. B. Wat-
son, *The Wrightsman Collection* (New York,
1966), vol. 1, p. 152; Hans Huth, *Lacquer of the*

*West: The History of a Craft and an Industry, 1550–
1950* (Chicago and London, 1971), p. 91,
caption p. 145, illus. fig. 238; Fredericksen
et al., *Getty Museum*, p. 159, illus.; Wilson,
"Meubles 'Baroques,'" p. 113, illus.; Wilson,
Selections, no. 14, pp. 28–29, illus.; Daniel
Alcouffe, "La commode du Cabinet de
retraite de Marie Leczinska à Fontainebleau
entre au Louvre," *La Revue du Louvre* 4 (1987),
pp. 281–284, illus. p. 282; Pradère, "1737, La
Première Commode en Laque du Japon,"
Connaissance des arts 436 (June 1988), pp. 108–
113; Kjellberg, *Dictionnaire*, p. 139; Daniel
Alcouffe, "Bernard Van Risen Burgh: Com-
mode," *Louvre: Nouvelles acquisitions du département
des objets d'art 1985–1989* (Paris, 1990), p. 144;
Bremer-David, *Summary*, no. 24, p. 25, illus.

25.

COMMODE

Paris, circa 1735

Oak veneered with kingwood, walnut,
amaranth, and padouk; gilt-bronze mounts;
brèche d'Alep top

Stamped with DF (possibly for Jean Des-
forges) on top of carcass.

Height: 2 ft. 10 1/4 in. (87 cm); Width:
5 ft. 1 1/4 in. (155.5 cm); Depth: 2 ft. 1 in.
(63.5 cm)

Accession number 76.DA.15

PROVENANCE

Mrs. S. Shrigley-Feigel, Crag Hall, Wray,
Lancashire, England; [Alexander and
Berendt, Ltd., London, 1976]; purchased
by J. Paul Getty.

BIBLIOGRAPHY

Calin Demetrescu, "Un Ébéniste Identifié
D. F.," *L'Estampille/L'Objet d'art* 262 (Octo-
ber 1992), p. 67, illus.; Bruno Pons et al.,
L'Art décoratif en Europe: Classique et baroque, Alain
Gruber, ed. (Paris, 1992), illus. p. 377;
Bremer-David, *Summary*, no. 25, p. 25, illus.

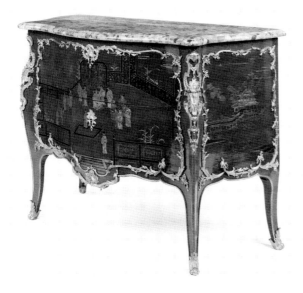

26

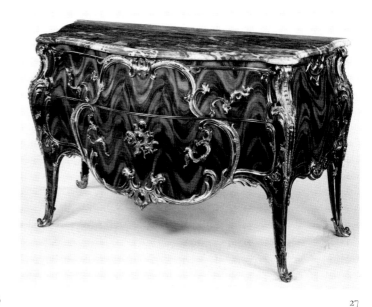

27

26.
COMMODE

Paris, circa 1740
By Bernard II van Risenburgh
Oak set with panels of red Chinese lacquer
and painted with *vernis Martin*; gilt-bronze
mounts; *brèche d'Alep* top
Stamped with B.V.R.B. once and JME twice
on top of carcass.
Height: 2 ft. 9 in. (83.8 cm); Width: 3 ft. 9 in.
(114.3 cm); Depth: 1 ft. 9 3/8 in. (54.9 cm)
Accession number 72.DA.46

PROVENANCE
Private collection, Paris (sold, Palais Galliera,
Paris, March 2, 1972, no. 109); purchased at
that sale by J. Paul Getty.

BIBLIOGRAPHY
Fredericksen et al., *Getty Museum*, p. 155,
illus.; "Le Prix des commodes en lacque,"
Plaisir de France (Paris, 1979), pp. 45–47, illus.;
Daniel Alcouffe, "La commode du Cabinet de
retraite de Marie Leczinska à Fontainebleau

entre au Louvre," *La Revue du Louvre* 4 (1988),
pp. 281–284, illus. p. 282; Kjellberg, *Diction-naire*, p. 139; Daniel Alcouffe, "Bernard
Van Risen Burgh: Commode," *Louvre: Nouvelles
acquisitions du département des objets d'art 1985–
1989* (Paris, 1990), p. 144; Bremer-David,
Summary, no. 26, p. 26, illus.

27.
COMMODE

Paris, circa 1745–1749
Attributed to Jean-Pierre Latz
Oak and poplar veneered with bloodwood;
drawers of walnut; gilt-bronze mounts; *fleur de
pêcher* marble top
Stamped with RESTAURE par P. SPOHN
on top of carcass; one mount is stamped with
the crowned C for 1745–1749.
Height: 2 ft. 10 1/2 in. (87.7 cm); Width:
4 ft. 11 5/8 in. (151.5 cm); Depth: 2 ft. 2 5/8 in.
(65 cm)
Accession number 83.DA.356

PROVENANCE
Sir Anthony (Nathan) de Rothschild, Bt.
(1810–1876), England; Hon. Mrs. Eliot Yorke
(née Annie Henriette de Rothschild [1844–
1926], daughter of Sir Anthony de Roth-

schild), England, by descent (sold, Christie's,
London, May 5, 1927, lot 138, for 980 guineas
to S. Founès); Mme Duselschon, Château de
Coudira, Prégny, Switzerland; Mme Rouvière,
Lausanne, Switzerland; [Maurice Segoura,
Paris, 1983].

BIBLIOGRAPHY
Wilson, "Acquisitions 1983," pp. 196–199,
illus.; Acquisitions/1983," *GettyMusJ* 12
(1984), no. 9, p. 264, illus.; Pradère, *Les Ebé-
nistes*, fig. 136, p. 160; Gillian Wilson, "Dalla
Raccolta del Museo J. Paul Getty," *Casa Vogue
Antiques* 8 (May 1990), pp. 114–119, illus.
p. 116; Bremer-David, *Summary*, no. 27, p. 26,
illus.; Ramond, *Chefs d'oeuvre* II, p. 109, illus.;
Masterpieces, no. 61, p. 81; *Handbook 2001*,
p. 206, illus.

28.
PAIR OF COMMODES

Paris, circa 1750
By Bernard II van Risenburgh
Oak and spruce veneered with bloodwood,
kingwood, and amaranth; drawers of walnut;
gilt-bronze mounts; *campan rouge* marble tops
Each commode is stamped with B.V.R.B.
twice on top of carcass.

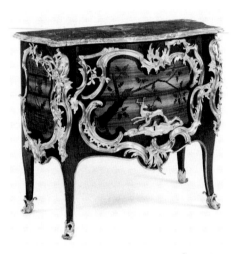

28 *One of a pair*

Height: 2 ft. 10 3/8 in. (87.3 cm); Width:
3 ft. 4 1/8 in. (101.9 cm); Depth: 1 ft. 10 in.
(55.9 cm)
Accession number 71.DA.96.1–.2

PROVENANCE

By tradition made as part of a set ordered
by Louis, Dauphin of France (1729–1765),
and given to Frederick Augustus III, Elector
of Saxony and King of Poland (1696–1763),
the father of his second wife, Maria Josepha
of Saxe (1731–1767); listed in inventories of
the Residenz, Dresden, in 1794 and 1798;
Prince Ernst Heinrich von Wettin, Schloss
Moritzburg (near Dresden), Saxony, and
installed in the Tower Room circa 1924 (sold
early 1930s); [C. Ball, Paris, 1934]; Anna
Thomson Dodge, Rose Terrace, Grosse Pointe
Farms, Michigan (sold, Christie's, London,
June 24, 1971, lot 102); purchased at that
sale by J. Paul Getty.

BIBLIOGRAPHY

Adolf Feulner, *Kunstgeschichte des Möbels* (Ber-
lin, 1927), pp. 324–325; Anthony Coleridge,
"Works of Art with a Royal Provenance from
the Collection of the Late Mrs. Anna Thomson

Dodge of Detroit," *Connoisseur* 177, no. 711
(May 1971), p. 36, illus.; Frank Davis, "Likes
and Dislikes," *Antique Collector* (August/
September 1971), p. 156, illus.; Frederick-
sen et al., *Getty Museum*, p. 190, illus.; Wilson,
"Meubles 'Baroques,'" p. 113, illus.; Michael
Stürmer, *Handwerk und höfische Kultur: Europäische
Möbelkunst im 18. Jahrhundert* (Munich, 1982),
illus. p. 67; Wilson, *Selections*, no. 20, pp. 40–
41, illus.; *Handbook 1986*, p. 163, illus. (one);
Pradère, *Les Ebénistes*, illus. p. 189, fig. 175;
Kjellberg, *Dictionnaire*, p. 139; Bruno Pons
et al., *L'Art décoratif en Europe: Classique et baroque*,
Alain Gruber, ed. (Paris 1992), illus. p. 388;
Bremer-David, *Summary*, no. 28, p. 27, illus.;
Ramond, *Chefs d'oeuvre* II, pp. 128–129, illus.

29.
COMMODE

Paris, circa 1750
Attributed to Joseph Baumhauer
Oak veneered with ebony, set with panels
of Japanese lacquer on Japanese arborvitae,
and painted with *vernis Martin*; gilt-bronze
mounts; *campan mélangé vert* marble top
One trade label of the *marchand-mercier*
François-Charles Darnault pasted on top
of carcass and another pasted underneath.
Height: 2 ft. 10 3/4 in. (88.3 cm); Width:
4 ft. 9 1/2 in. (146.1 cm); Depth: 2 ft. 5/8 in.
(62.6 cm)
Accession number 55.DA.2

PROVENANCE

Edith and Sir Alfred Chester Beatty (1875–
1968), London; purchased by J. Paul Getty,
1955, through Sir Robert Abdy, Bt.

BIBLIOGRAPHY

J. Paul Getty, *Collector's Choice* (London, 1955),
illus. unnumbered pl. between pp. 336–337;
"Vingt Mille Lieues dans les musées," *Con-
naissance des arts* 57 (November 1956), pp. 76–
81, illus. p. 81; Verlet et al., *Chefs d'oeuvre*,
p. 115, illus.; André Boutemy, "L'Ebéniste
Joseph Baumhauer," *Connaissance des arts* 157
(March 1965), pp. 83–85; Getty, *Collecting*,
pp. 144–145, illus.; Fredericksen et al., *Getty
Museum*, p. 154, illus. pp. 145, 154; Wilson,

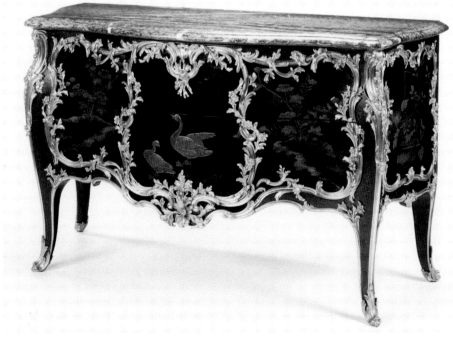

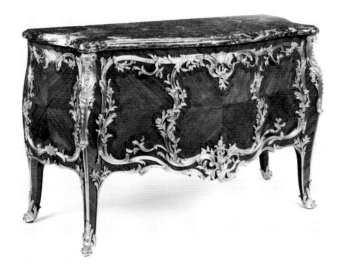 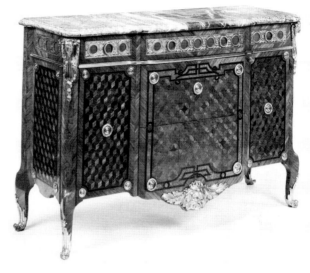

30

31

"Meubles 'Baroques,'" p. 106., illus.; Wilson, *Selections*, no. 23, pp. 46–47, illus.; Jean-Dominique Augarde, "1749 Joseph Baumhauer, ébéniste privilegié du roi," *L'Estampille* 204 (June 1987), p. 36; Pradère, *Les Ebénistes*, no. 2, p. 244, illus. p. 233, fig. 236; Kjellberg, *Dictionnaire*, p. 454; Bremer-David, *Summary*, no. 29, p. 27, illus.; Carolyn Sargentson, *Merchants and Luxury Markets: The Marchands Merciers of Eighteenth-Century Paris* (Malibu, 1996), illus. pl. 2, p. 171; *Masterpieces*, no. 73, p. 95, illus.; *Handbook 2001*, p. 211, illus.

30.
COMMODE

Paris, circa 1755
By Adrien Faizelot Delorme
Fir, poplar, and oak veneered with tulipwood and kingwood; gilt-bronze mounts; *lumachella pavonazza* marble top
Stamped with DELORME, JME, and N. PETIT on top of carcass.
Height: 2 ft. 11 1/2 in. (90.1 cm); Width: 4 ft. 9 in. (144.8 cm); Depth: 2 ft. 2 1/4 in. (66.6 cm)
Accession number 70.DA.79

PROVENANCE
Cécile Sorel, Paris; [Germain Seligman, Paris] (sold, April 1933, to Mrs. Landon K. Thorne, New York); [J. M. Botibol, London, 1938]; purchased by J. Paul Getty, 1938.

EXHIBITIONS
Williamstown, Massachusetts, Sterling and Francine Clark Art Institute, on loan, 1998–present.

BIBLIOGRAPHY
Paul Wescher, "French Furniture of the Eighteenth Century in the J. Paul Getty Museum," *Art Quarterly* 18, no. 2 (Summer 1955), p. 118, illus. p. 124, fig. 8; J. Paul Getty, *Collector's Choice* (London, 1955), illus. unnumbered pl. between pp. 208–209; André Boutemy, "L'Ebéniste Joseph Baumhauer," *Connaissance des arts* 157 (March 1965), p. 85, illus. p. 84; Fredericksen et al., *Getty Museum*, p. 145, illus.; Wilson, "Meubles 'Baroques,'" p. 106, illus.; Jean-Dominique Augarde, "1749 Joseph Baumhauer, ébéniste privilegié du roi," *L'Estampille* 204 (June 1987), p. 32; Kjellberg, *Dictionnaire*, p. 246; Alexandre Pradère, "Quand le Getty Vise Juste," *Connaissance des arts* 449/450 (July/August 1989), pp. 111–119; Bremer-David, *Summary* no. 30, p. 28, illus.

31.
COMMODE

Paris, circa 1760
By Jean-François Oeben
Oak veneered with maple, tulipwood, amaranth, and Ceylon satinwood; gilt-bronze mounts; *campan mélangé vert* marble top
Stamped with J. F. OEBEN and JME twice on top of carcass.
Height: 3 ft. 1/4 in. (92 cm); Width: 4 ft. 7 3/8 in. (140.6 cm); Depth: 1 ft. 6 1/2 in. (47 cm)
Accession number 72.DA.54

PROVENANCE
Private collection, Paris (possibly Goupil de Douilla); [Frank Partridge, Ltd., London]; Guedes de Souza, Paris; [Etienne Lévy, Paris, and Frank Partridge, Ltd., London, 1972]; purchased by J. Paul Getty.

BIBLIOGRAPHY
Fredericksen et al., *Getty Museum*, p. 164, illus.; Pradère, *Les Ebénistes*, illus. p. 261, fig. 278; Kjellberg, *Dictionnaire*, pp. 614, 619; Alexandre Pradère, "Quand le Getty Vise Juste," *Connaissance des arts* 449/450 (July/August 1989), pp. 111–119; Bremer-David, *Summary* no. 31, p. 28, illus.; Ramond, *Chefs-d'oeuvre* 11, p. 110, illus.

32.

COMMODE

Paris, 1769
By Gilles Joubert
Oak veneered with kingwood, bloodwood,
tulipwood, holly, and ebony; gilt-bronze
mounts; *sarrancolin* marble top
Painted with the inventory number
du No 2556.2 of the *Garde-meuble de la Couronne*
in black ink on the back.
Height: 3 ft. ³/₄ in. (93.5 cm); Width:
5 ft. 11 ¹/₄ in. (181 cm); Depth: 2 ft. 3 in.
(68.5 cm)
Accession number 55.DA.5

PROVENANCE

Made for the *chambre à coucher* of Mme Louise
of France (1737–1787, youngest daughter
of Louis XV), Château de Versailles, 1769;
in the *chambre à coucher* of Madame Victoire,
Château de Versailles, 1776; Emmanuel-
Felicité, duc de Duras, Maréchal de France,
Palais de Fontainebleau, 1785; Baron Lionel
(Nathan) de Rothschild (1808–1879), Gun-
nersbury Park, Middlesex; by descent to his
son, Leopold de Rothschild (1845–1917),
Hamilton Place, London; by descent to his
son, Lionel (Nathan) de Rothschild (1882–
1942), Exbury House, Hampshire; by descent
to his son, Edmund (Leopold) de Rothschild
(born 1916), Inchmery House, Exbury, Hamp-
shire (sold by him in 1947); Edith and Sir
Alfred Chester Beatty (1875–1968), London;
purchased by J. Paul Getty.

EXHIBITIONS

Paris, Hôtel de la Monnaie, *Louis XV: Un
Moment de perfection de l'art français*, 1974,
no. 422, pp. 320–321, illus.

BIBLIOGRAPHY

Paul Wescher, "A Commode by Gilles Jou-
bert for Versailles in the J. Paul Getty
Museum," *Art Quarterly* 19, no. 3 (Autumn
1956), pp. 324–325, illus.; "Vingt Mille
Lieues dans les musées," *Connaissance des arts*
57 (November 1956), pp. 76–81, illus. p. 78;
Pierre Verlet, "Peut-on remeubler Versailles?,"
Le Jardin des arts (February 1958), p. 256, illus.
p. 255; F. J. B. Watson, *Louis XVI Furniture*
(London, 1960), no. 24, p. 105, illus.; Gerald
Messadié, "J. Paul Getty, Malibu, Califor-
nia," *Great Private Collections*, Douglas Cooper,
ed. (Zurich, 1963), pp. 180–191, illus. p. 187;
Pierre Verlet, *French Royal Furniture* (London,
1963), pp. 77, 111, fig. 7; Verlet et al., *Chefs
d'oeuvre*, p. 122, illus.; Getty, *Collecting*, p. 152,
illus.; Jean Meuvret and Claude Frégnac,
Les Ebénistes du XVIIIᵉ siècle français (Paris, 1963),
p. 68, fig. 1; Svend Eriksen, *Early Neo-
Classicism in France* (London, 1974), p. 321,
pl. 120; Fredericksen et al., *Getty Museum*,
p. 166, illus.; Gillian Wilson, "The J. Paul
Getty Museum, 7ᵉᵐᵉ partie: Le Mobilier
Louis XVI," *Connaissance des arts* 280 (June
1975), p. 93, illus.; Pierre Verlet, *Les Meubles
français du XVIIIᵉ siècle* (Paris, 1982), p. 27, illus.
(detail) pl. 4; Wilson, *Selections*, no. 30,
pp. 60–61, illus.; Pradère, *Les Ebénistes*, no. 17,
p. 216; Kjellberg, *Dictionnaire* (Paris, 1989),
pp. 456, 758, illus. p. 759; Alexandre
Pradère, "Quand le Getty Vise Juste," *Connais-
sance des arts* 449/450 (July/August 1989),
pp. 111–119; Pierre Verlet, *French Furniture
of the Eighteenth Century*, trans. by Penelope
Hunter-Stiebel (Charlottesville, 1991), fig. 4,
p. 17; Bremer-David, *Summary*, no. 32, p. 29,
illus.; Pierre Verlet, *Le Mobilier royal français*,
vol. 3: *Meubles de la couronne conservés en Angleterre
et aux États-Unis* (Paris, 1994), pp. 128–130,
illus.; Leora Auslander, *Taste and Power: Furnish-
ing Modern France* (Berkeley, 1996), p. 69, illus.;
Masterpieces, no. 80, p. 103, illus.; *Handbook
2001*, p. 222, illus.

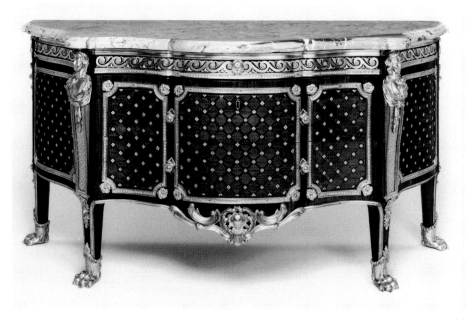

Corner Cupboards

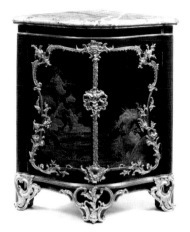

33 *Corner Cupboard .1*

34 *One of a pair*

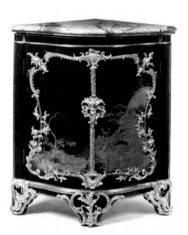

33 *Corner Cupboard .2*

33.
PAIR OF CORNER CUPBOARDS
Paris, circa 1740
By Bernard II van Risenburgh
Oak and maple veneered with amaranth and
cherry, set with panels of black Japanese lac-
quer on Japanese arborvitae and painted
with *vernis Martin*; gilt-bronze mounts; *sarran-
colin* marble tops

Each cupboard is stamped with B.V.R.B.
twice on top of carcass.
Height: 3 ft. 3 1/8 (99.4 cm); Width:
2 ft. 10 3/4 in. (88.3 cm); Depth: 2 ft. 1/8 in.
(61.2 cm)
Accession number 72.DA.44.1–.2

PROVENANCE
[Kraemer et Cie, Paris]; purchased by J. Paul
Getty.

BIBLIOGRAPHY
Fredericksen et al., *Getty Museum*, p. 156,
illus.; Kjellberg, *Dictionnaire*, p. 139; Bremer-
David, *Summary*, no. 33, p. 30, illus.

34.
PAIR OF CORNER CABINETS
Paris, circa 1745
Attributed to Charles Cressent
Oak veneered with tulipwood, kingwood,
and amaranth; gilt-bronze mounts
Height: 6 ft. 3 1/2 in. (191.8 cm); Width:
10 ft. 11 in. (332.7 cm); Depth: 1 ft. 3 1/2 in.
(39.4 cm)
Accession number 79.DA.2.1–.2

PROVENANCE
Possibly Baron (Mayer) Alphonse de Roth-
schild (1827–1905), Paris, by 1905; Baron
Edouard (Alphonse James) de Rothschild
(1868–1949), Paris; Baron Guy (Edouard
Alphonse Paul) de Rothschild (born 1909),
Paris; by descent to Baron David (René
James) de Rothschild (born 1942), Paris.

BIBLIOGRAPHY
Marie-Juliette Ballot, *Charles Cressent: Sculpteur,
ébéniste, collectionneur*, Archives de l'art français: Nou-
velle période 10 (Paris, 1919), pp. 128, 151–152;
Jean Meuvret and Claude Frégnac, *Les Ebé-
nistes du XVIIIᵉ siècle français* (Paris, 1963), p. 46,
illus.; Claude Frégnac and Wayne Andrews,
The Great Houses of Paris (New York, 1979),
p. 257, illus.; Wilson, "Acquisitions 1977 to
mid-1979," no. 15, p. 52, illus. (one) p. 51;
Pradère, *Les Ebénistes*, illus. (detail) cover;
Bremer-David, *Summary*, no. 34, p. 30, illus.

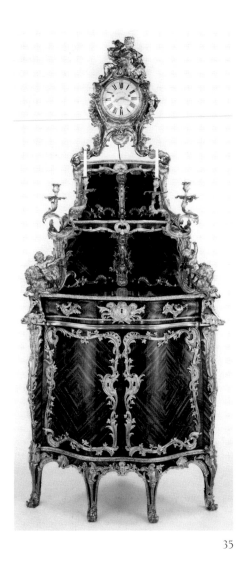

35

35.
CORNER CUPBOARD AND CLOCK
Paris, cupboard: circa 1744–1755; clock: 1744
By Jacques Dubois after a drawing by Nicolas Pineau; clock movement by Étienne II
Le Noir; enamel dial by Antoine Nicolas
Martinière
Mahogany, spruce, and oak veneered with bloodwood, tulipwood, cururu, and kingwood; enameled metal; glass; gilt-bronze mounts
Back of carcass is stamped with I.DUBOIS three times and bears one paper label inscribed in ink with the Rothschild inventory

number AR 653. Painted twice with
AR 653 on the back. Signed ETIENNE
LE NOIR A PARIS on dial and inscribed
with *Etienne Le Noir Æaris* on movement.
Back of dial is signed and dated *a.n. martinière.*
1744.–7.bre.
Height: 9 ft. 6 in. (289.5 cm); Width:
4 ft. 3 in. (129.5 cm); Depth: 2 ft. 4¹/₂ in.
(72 cm)
Accession number 79.DA.66

PROVENANCE
Ordered by General Mokronowski through
the *marchand-mercier* Lullier of Warsaw
in circa 1744 for Count Jan Klemens Branicki
(1689–1772), Warsaw, Poland; Christine
Branicka (?) (sister of Count Branicki),
by descent; Marianna Szymanowska (?) (née
Potocka, granddaughter of Christine Branicka); Baron Nathaniel (Mayer) von Rothschild (1836–1905), Vienna, before 1896;
Baron Alphonse (Mayer) von Rothschild
(1878–1942), in the Régence (or *Rote*) Salon,
Theresianum Gasse 16–18, Vienna, 1905;
confiscated by the Nazis in March 1938 and
destined for the planned Hitler Museum in
Linz; restituted to Baronin Clarice von Rothschild (1874–1967), Vienna, in 1947 and sent
to New York soon afterward; [Rosenberg and
Stiebel, Inc., New York]; [Wildenstein and
Co., New York, March 16, 1950, stock no.
18018]; [Georges Wildenstein, New York];
[Daniel Wildenstein, New York]; Akram
Ojjeh, 1978 (sold, Sotheby's, Monaco,
June 25–26, 1979, no. 60).

BIBLIOGRAPHY
Émile Molinier, *Le Mobilier au XVIIᵉ et au XVIIIᵉ
siècle* (Paris, 1896), pp. 146–147, pl. 13; Baron
Nathaniel Mayer de Rothschild, *Notizen über
einige meiner Kunstgegenstände* (Vienna, 1903),
no. 80; Robert Schmidt, *Möbel* (Berlin, 1920),
illus. p. 169; Adolf Feulner, *Kunstgeschichte des
Möbels* (Berlin, 1926), p. 445, illus. p. 321;
François de Salverte, *Les Ebénistes du XVIIIᵉ
siècle* (Paris, 1927), pp. 104–105, pl. 18; (1953
ed.), p. 197, pl. 19; (1962 ed.), p. 100, pl. 18;
Adolf Feulner, *Kunstgeschichte des Möbels seit dem
Altertum* (Berlin, 1927), pp. 330–331, Pineau
design illus. p. 321; Charles Packer, *Paris*

Furniture by the Master Ebénistes (Newport,
Monmouthshire, 1956), p. 34, fig. 40; F. J. B.
Watson, *Wallace Collection Catalogues: Furniture*
(London, 1956), p. 69; André Boutemy, "Des
Meubles Louis XV à grands succès: Les
Encoignures," *Connaissance des arts* 91 (September 1959), p. 36, illus. p. 41; Jean Meuvret
and Claude Frégnac, *Les Ebénistes du XVIIIᵉ siècle
français* (Paris, 1963), pp. 101–102, illus.
p. 100; Pierre Verlet, *French Cabinetmakers of the
Eighteenth Century* (Paris, 1963), p. 102; F. J. B.
Watson, *The Wrightsman Collection* (New York,
1966), vol. 1, p. 231; vol. 2, p. 544; Alvar
González-Palacios, *Gli ebanisti del Luigi XV*
(Milan, 1966), p. 67; Claude Frégnac, *Les
Styles français* (Paris, 1975), p. 100, pl. 2; Pierre
Kjellberg, *Le Mobilier français du moyen age à
Louis XV* (Paris, 1978), p. 192, illus. p. 193,
no. 217; Pierre Kjellberg, "Jacques Dubois,"
Connaissance des arts 334 (December 1979),
p. 115, illus.; Adolf Feulner, *Kunstgeschichte des
Möbels* (Frankfurt am Main, 1980), pp. 180–
181, illus. no. 292, caption p. 358; Wilson,
"Acquisitions 1979 to mid-1980," no. 1, pp. 1–
3, illus.; Wilson, *Selections*, no. 21, pp. 42–43,
illus.; William Kingsland, "Collecting French
Furniture," *Art and Auction* (December 1983),
p. 79, illus.; Penelope Hunter-Stiebel,
"Exalted Hardware, the Bronze Mounts of
French Furniture, Part 1," *Magazine Antiques*
(January 1985), p. 236, illus.; Jackson-Stops,
"Boulle by the Beach," pp. 854–856; Pradère,
Les Ebénistes, figs. 153–154, p. 173; Kjellberg,
Dictionnaire, pp. 267, 273, illus. p. 275;
Gillian Wilson, "Dalla Raccolta del Museo
J. Paul Getty," *Casa Vogue Antiques* 8
(May 1990), pp. 114–119, illus. p. 117;
Stéphane Boiron, "Jacques Dubois, maître du
style Louis XV," *L'Estampille/L'Objet d'art* 236
(June 1990), pp. 42–59, illus. pp. 52–53;
Jonathan Bourne and Vanessa Brett, *Lighting in
the Domestic Interior: Renaissance to Art Nouveau*
(London, 1991), illus. p. 83, fig. 258; Bremer-
David, *Summary*, no. 35, pp. 31–32, illus.
p. 31; Wilson, *Clocks*, no. 10, pp. 70–77, illus.;
Pierre Kjellberg, *Encyclopédie de la pendule française
du moyen age au XXᵉ siècle* (Paris, 1997), fig. B,
p. 165, illus.; *Masterpieces*, no. 71, pp. 92–93;
Handbook 2001, pp. 208–209, illus.

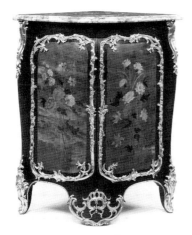

36 Corner Cupboard .1

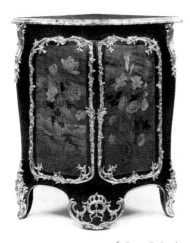

36 Corner Cupboard .2

36.
PAIR OF CORNER CUPBOARDS

Paris, circa 1750–1755
Carcass and mounts attributed to Jean-Pierre Latz; marquetry panels attributed to the workshop of Jean-François Oeben
Oak veneered with amaranth, stained sycamore, boxwood, and rosewood; gilt-bronze mounts; *brèche d'Alep* tops
One cupboard once had two paper labels on the back: one is stamped with *Zollstück*, the other from the Victoria and Albert Museum with the notation DEPT. OF WOOD-WORK ON LOAN FROM *L. Currie, Esq. No. 5 / 15.V.1917*.

Height: 3 ft. 2 1/4 in. (97.2 cm); Width: 2 ft. 9 3/4 in. (85.7 cm); Depth: 1 ft. 11 1/8 in. (58.7 cm)
Accession number 72.DA.39.1–.2

EXHIBITIONS
London, The Victoria and Albert Museum, on loan, 1917–1920, from Laurence Currie.

BIBLIOGRAPHY
Henry Hawley, "Jean-Pierre Latz, Cabinet-maker," *Bulletin of the Cleveland Museum of Art* 57/7 (September/October 1970), no. 49, p. 254, illus. (one), fig. 49; Fredericksen et al., *Getty Museum*, p. 160, illus. (one); Wilson, *Selections*, no. 24, pp. 48–49, illus.; Bremer-David, *Summary*, no. 36, pp. 32–33, illus. p. 32.

37.
PAIR OF CORNER CUPBOARDS

Paris, circa 1750–1755
Carcass and mounts attributed to Jean-Pierre Latz; marquetry panels attributed to the workshop of Jean-François Oeben
Oak veneered with amaranth, maple, stained maple, and walnut; gilt-bronze mounts; *brèche d'Alep* tops
Height: 3 ft. 1/4 in. (92.1 cm); Width: 2 ft. 8 1/4 in. (81.9 cm); Depth: 2 ft. (61 cm)
Accession number 72.DA.69.1–.2

EXHIBITIONS
Williamstown, Massachusetts, Sterling and Francine Clark Art Institute, on loan, 1998–present.

BIBLIOGRAPHY
Henry Hawley, "Jean-Pierre Latz, Cabinet-maker," *Bulletin of the Cleveland Museum of Art* 57/7 (September–October 1970), no. 50, p. 255, illus. (one), fig. 50; Bremer-David, *Summary*, no. 37, p. 33, illus, p. 32.

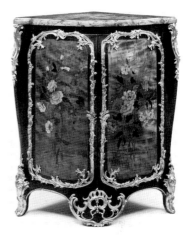

37 Corner Cupboard .1

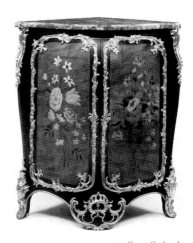

37 Corner Cupboard .2

38.

Pair of Corner Cupboards

Paris, circa 1755
By Jacques Dubois
Oak painted with *vernis Martin*; gilt-bronze
mounts; *brèche d'Alep* tops
Cupboard .2 is stamped with I.DUBOIS and
JME twice on top of carcass.
Height: 3 ft. 2 1/4 in. (97.1 cm); Width:
2 ft. 7 1/2 in. (80 cm); Depth: 1 ft. 11 1/8 in.
(58.6 cm)
Accession number 78.DA.119.1–.2

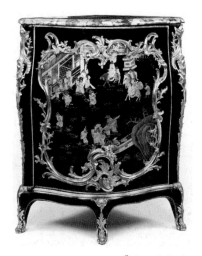

38 *Corner Cupboard .1*

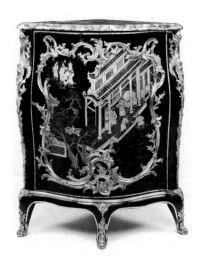

38 *Corner Cupboard .2*

PROVENANCE

Baron Nathaniel (Mayer) von Rothschild
(1836–1905), Vienna; Baron Alphonse (Mayer)
von Rothschild (1878–1942), Vienna;
confiscated by the Nazis in March 1938; resti-
tuted to Baronin Clarice von Rothschild
(1874–1967), Vienna, in 1947; [Frank Par-
tridge and Sons, Ltd., London, 1950];
purchased by J. Paul Getty for Sutton Place,
Surrey; distributed by the estate of J. Paul
Getty to the J. Paul Getty Museum.

BIBLIOGRAPHY

J. Paul Getty, *Collector's Choice* (London, 1955),
p. 167; Paul Wescher, "French Furniture of
the Eighteenth Century in the J. Paul Getty
Museum," *Art Quarterly* 18, no. 2 (Summer
1955), pp. 121–122; "Vingt Mille Lieues dans
les musées" *Connaissance des arts* 57 (November
1956), pp. 76–81, illus. p. 81; *Antique Collector*
(August 1962), p. 153, illus.; Verlet et al.,
Chefs d'oeuvre, p. 120, illus.; Getty, *Collecting*,
p. 150, illus.; Hans Huth, *Lacquer of the West:
The History of a Craft and an Industry, 1550–1950*
(Chicago and London, 1971), caption p. 145,
fig. 234; Kjellberg, *Dictionnaire*, p. 273;
Stéphane Boiron, "Jacques Dubois, maître
du style Louis XV," *L'Estampille/L'Objet d'art*
236 (June 1990), pp. 42–59, illus. p. 56;
Bremer-David, *Summary*, no. 38, pp. 33–34,
illus. p. 33.

39.

Pair of Corner Cupboards

Paris, circa 1765
By Pierre Garnier
Fir and oak veneered with ebony, tulipwood,
amaranth, and willow; gilt-bronze mounts;
gray-veined white marble tops
Each cupboard is stamped with P. GAR-
NIER on top of carcass; one carcass is
incised with I on top; the other carcass is
incised with 4.
Height: 4 ft. 5 1/4 in. (135.2 cm); Width:
2 ft. (61 cm); Depth: 1 ft. 4 1/2 in. (41.9 cm)
Accession number 81.DA.82.1–.2

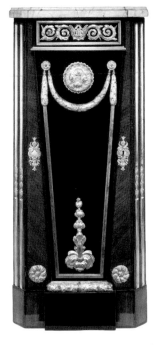

39 *One of a pair*

PROVENANCE

Auguste-Gabriel Godefroy (*ancien controleur de
la Marine*; 1730–1813), Paris (sold, Hôtel de
Bullion, Paris, November 15, 1785, no. 238 bis,
to Harcourt [?]); Espirito Santo Family, Portu-
gal, and Lausanne, Switzerland (sold circa
1976); [Didier Aaron, Inc., New York].

BIBLIOGRAPHY

Wilson, "Acquisitions 1981," no. 3, pp. 71–
73, illus.; "Some Acquisitions (1981–82) in
the Department of Decorative Arts, The
J. Paul Getty Museum," *Burlington Magazine*
125, no. 962 (May 1983), illus. p. 325;
Wilson, *Selections*, no. 31, pp. 62–63,
illus. figs. 14–15; Penelope Hunter-Stiebel,
"Exalted Hardware: The Bronze Mounts of
French Furniture, Part II," *Magazine Antiques*
(February 1985), p. 454, illus.; *Handbook*
1986, p. 170, illus. (one); Pradère, *Les Ebénistes*,
no. 238 bis, p. 250; Bremer-David, *Summary*,
no. 39, p. 34, illus.

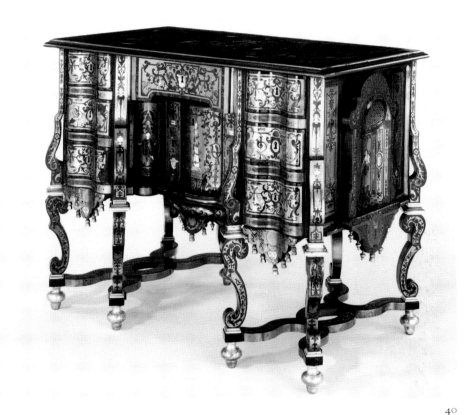

40

Desks

40.
DESK (*BUREAU* "*MAZARIN*")
Paris, after 1692–circa 1700
Oak, walnut, fir, cherry and beech veneered with ebony, brass, tortoiseshell, mother-of-pearl, pewter, copper, painted and unpainted horn, and painted paper; silvered-bronze mounts; steel key
Top is engraved with unidentified arms (later replacement) beneath an electoral bonnet, surrounded by the Collar and the Order of the *Toison d'Or*, supported by crowned lions.
Height: 2 ft. 3 ³/₄ in. (70.5 cm); Width: 2 ft. 11 in. (89 cm); Depth: 1 ft. 8 in. (51 cm)
Accession number 87.DA.77

PROVENANCE

Maximilian Emanuel, Elector of Bavaria (1662–1726); Captain Thomas Leyland, London, circa 1854; William Cornwallis West, Ruthin Castle, Denbighshire; by descent around 1917 to his daughter, Mary-Theresa Olivia, Princess of Pless (died 1943); David Style, Esq. (sold, Christie's, Wateringbury Place, Maidstone, Kent, June 1, 1978, lot 545); private collection, London (sold, Sotheby's, Monaco, June 21, 1987, no. 1097).

EXHIBITIONS

London, Gore House, Kensington, *French Decorative Arts*, 1854, lent by Captain Leyland; London, The South Kensington Museum, *Special Exhibition of Works of Art of the Mediaeval, Renaissance, and More Recent Periods*, June 1862, no. 812, lent by Captain Leyland.

BIBLIOGRAPHY

T. A. Strange, *French Interiors: Furniture, Decoration, Woodwork and Allied Arts* (London, circa 1920), p. 147; *Sotheby's Art at Auction 1986–1987* (London, 1987), p. 262, illus.; "Acquisitions/1987," *GettyMusJ* 16 (1988), no. 66, pp. 176–177, illus.; Jean-Nérée Ronfort and Jean-Dominique Augarde, "Le Maître du Bureau de l'Electeur," *L'Estampille/L'Objet d'art* 243 (January 1991), pp. 42–74, illus. p. 59; Bremer-David, *Summary*, no. 40, p. 34–35, illus.; Ramond, *Chefs d'oeuvre* 1, frontispiece and pp. 47, 134–141, illus.; *Masterpieces*, no. 47, pp. 64–65, illus.; *Handbook* 2001, p. 191, illus.

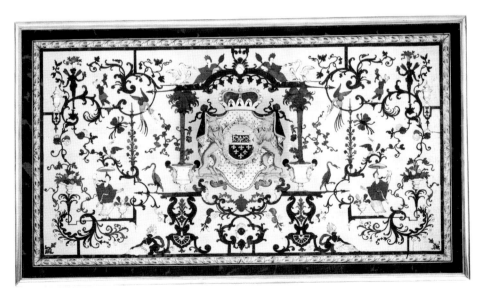

40 *Top*

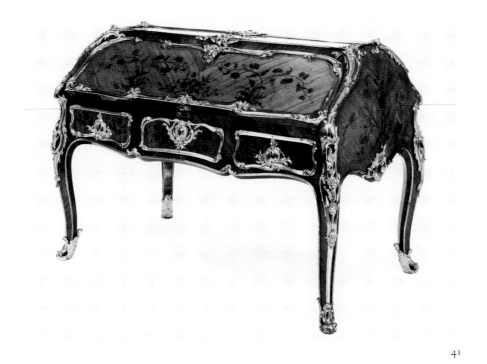

41

41.
DOUBLE DESK

Paris, circa 1750
By Bernard II van Risenburgh
Oak veneered with tulipwood, kingwood,
and bloodwood; drawers of mahogany; gilt-
bronze mounts
Stamped with JME B.V.R.B. JME under-
neath and on interior of carcass. Underside
of carcass bears several red wax seals of the
Duke of Argyll.
Height: 3 ft. 6¹/₂ in. (107.8 cm); Width:
5 ft. 2¹/₂ in. (158.7 cm); Depth: 2 ft. 9³/₈ in.
(84.7 cm)
Accession number 70.DA.87

PROVENANCE
François-Balthazar Dangé du Fay (?), fermier
général, Hôtel de Villemare, Place Vendôme,
Paris, recorded in the inventory after the
death of his wife Anne (née Jarry), March 27,
1772, and also in the inventory after his own
death, March 6, 1777 (sold, September 1,
1777, Paris); purchased by his nephew and heir
Louis-Balthazar Dangé de Bagneux (fermier

général, 1739–1794), recorded in the inventory
after his death in 1795; by inheritance to his
wife Anne-Marie Sanson and recorded in her
inventory after death; by descent to her daugh-
ter Marie-Emilie-Françoise Dangé, married to
Augustin Creuzé, in rue Saint-Honoré; Dukes
of Argyll, Inveraray Castle, Argyll, Scotland,
by about the mid-nineteenth century (sold by
Ian, 11th Duke of Argyll, 1951); Sir Robert
Abdy, Bt., London, 1951; [Rosenberg and
Stiebel, Inc., New York, 1952]; purchased by
J. Paul Getty, 1952.

EXHIBITIONS
Paris, Hôtel de la Monnaie, Louis XV: Un
Moment de perfection de l'art français, 1974, no. 430,
pp. 327–328, illus.

BIBLIOGRAPHY
Paul Wescher, "French Furniture of the Eigh-
teenth Century in the J. Paul Getty Museum,"
Art Quarterly 18, no. 2 (Summer 1955), p. 121,
illus. p. 78; J. Paul Getty, Collector's Choice (Lon-
don, 1955), pp. 261–263; "Vingt Mille Lieues
dans les musées," Connaissance des arts 57
(November 1956), pp. 76–81, illus. p. 78;

André Boutemy, "Les vraies formes du bureau
dos d'ane," Connaissance des arts 77 (July 1958),
p. 43, illus.; Jean Meuvret and Claude Fré-
gnac, Les Ebénistes du XVIIIᵉ siècle français (Paris,
1963), p. 78, illus.; Gerald Messadié, "J. Paul
Getty, Malibu, California," Great Private Col-
lections, Douglas Cooper, ed. (Zurich, 1963),
pp. 180–191, illus. p. 188; Verlet et al., Chefs
d'oeuvre, pp. 116–117, illus.; Claude Frégnac,
Les Styles français (Paris, 1975), pl. 4; Frederick-
sen et al., Getty Museum, p. 157, illus.; Wilson,
"Meubles 'Baroques,'" p. 112, illus.; Pierre
Verlet, Les Meubles français du XVIIIᵉ siècle
(Paris, 1982), p. 27, pl. 3 (detail); Wilson,
Selections, no. 22, pp. 44–45, illus.; "The Great
Collections," French Connections: Scotland and the
Arts of France (Edinburgh, 1985), p. 66,
fig. 30; Jackson-Stops, "Boulle by the Beach,"
pp. 854–856, illus. p. 854, fig. 2; Pierre
Cabanne, L'Art du XVIIIᵉ siècle (Paris, 1987),
p. 97, illus.; Kjellberg, Dictionnaire, pp. 135,
139, illus. p. 130; Daniel Alcouffe, "Bernard
Van Risen Burgh: Commode," Louvre: Nouvelles
Acquisitions du départment des objets d'art, 1985–
1989 (Paris 1990), p. 142; Pierre Verlet, French
Furniture of the Eighteenth Century (Charlottes-
ville, 1991), fig. 3 opposite p. 16; Bremer-
David, Summary, no. 41, pp. 36–37, illus.
p. 36; Ramond, Chefs d'oeuvre II, pp. 124–126,
illus.; Masterpieces, no. 72, p. 94, illus.; Hand-
book 2001, p. 210, illus.

42.
ROLLTOP DESK

Paris, circa 1788
By Bernard Molitor; some mounts cast by the
bronziers Baligant and Lesueur after designs
by Gambier and François Rémond
Fir and oak veneered with mahogany and
ebony; gilt-bronze mounts; griotte de Flandre
marble top
Stamped with B. MOLITOR on lip of one
interior drawer.
Height: 4 ft. 6 in. (137 cm); Width:
5 ft. 11¹/₄ in. (181 cm); Depth: 2 ft. 10¹/₄ in.
(87 cm)
Accession number 67.DA.9

Secrétaires

43

Louis XVI (?), listed in the inventory of the Château de Saint-Cloud (near Paris), *an II* (1793–1794); [Vandyck, London] (offered for sale, Christie's, London, May 16, 1800, lot 101, and again February 12, 1801, lot 70, bought in); Octavius E. Coope (?), London; Mortimer L. Schiff, New York (sold by his heir John M. Schiff, Christie's, London, June 22, 1938, lot 59); purchased at that sale by J. Paul Getty.

BIBLIOGRAPHY

J. Paul Getty, *Europe in the Eighteenth Century* (Chicago, 1949), illus. unnumbered pl. between pp. 58–59; J. Paul Getty, *Collector's Choice* (London, 1955), pp. 74, 76, 107, 113, illus. unnumbered pl. between pp. 128–129; Paul Wescher, "French Furniture of the Eighteenth Century in the J. Paul Getty Museum," *Art Quarterly* 18, no. 2 (Summer 1955), p. 125, illus. p. 133; Gerald Messadié, "J. Paul Getty, Malibu, California," *Great*

Private Collections, Douglas Cooper, ed. (Zurich, 1963), pp. 180–191, illus. p. 186; Verlet et al., *Chefs d'oeuvre*, p. 131, illus.; Getty, *Collecting*, illus. p. 161; Fredericksen et al., *Getty Museum*, p. 182, illus; Jackson-Stops, "Boulle by the Beach," pp. 854–856; Ulrich Leben, "Die Werkstatt Bernard Molitors," *Kunst und Antiquitäten* 4 (1987), pp. 52–60, detail illus. p. 52, fig. 1; Ulrich Leben, *Bernard Molitor (1755–1833): Leben und Werk, eines Pariser Kunsttischlers*, Ph.D. diss. (Bonn, 1989), p. 108; Kjellberg, *Dictionnaire*, p. 582; Ulrich Leben, *Molitor: Ebéniste from the Ancien Régime to the Bourbon Restoration* (London, 1992), p. 153, pp. 190–191, figs. 8–9, 81–82, 154; Ulrich Leben, "Bernard Molitor, cabinetmaker," *Antiques* (September 1995), pp. 306–15, pl. XI; Christian Baulez, "Toute l'Europe tire ses bronzes de Paris," *Bernard Molitor (1755–1833)*, Ulrich Leben, ed. (Luxemborg 1995), pp. 77–88, 97–101, illus. figs. 8–10; Bremer-David, *Summary*, no. 42, p. 37, illus. p. 36.

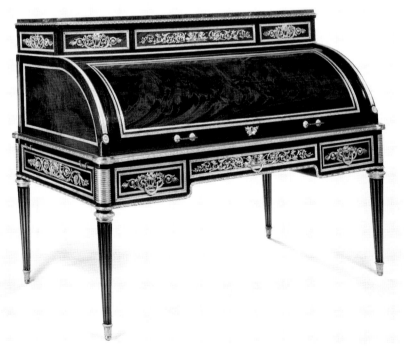

42

43.
SECRÉTAIRE

Paris, circa 1755
By Jacques Dubois
Maple and oak veneered with panels of red Chinese lacquer on Japanese arborvitae and painted with *vernis Martin*; interior drawers of Japanese arborvitae; gilt-bronze mounts; *brèche d'Alep* top
Stamped with I.DUBOIS and JME at top of right rear stile.
Height: 3 ft. 4½ in. (102.8 cm); Width: 3 ft. 9 in. (114.3 cm); Depth: 1 ft. 3⅛ in. (38.4 cm)
Accession number 65.DA.3

PROVENANCE

[Rosenberg and Stiebel, Inc., New York]; purchased by J. Paul Getty, 1951.

BIBLIOGRAPHY

Paul Wescher, "French Furniture of the Eighteenth Century in the J. Paul Getty Museum," *Art Quarterly* 18, no. 2 (Summer 1955), p. 122, illus. p. 130; Gerald Messadié, "J. Paul Getty, Malibu, California," *Great Private Collections*, Douglas Cooper, ed. (Zurich, 1963), pp. 180–191, illus. p. 189; Verlet et al., *Chefs d'oeuvre*, p. 121, illus.; Getty, *Collecting*, pp. 150–151, illus.; Kjellberg, *Dictionnaire*, p. 273; Stéphane Boiron, "Jacques Dubois, maître du style Louis XV," *L'Estampille-L'Objet d'art* 236 (June 1990), pp. 42–59, illus. p. 56.; Bremer-David, *Summary*, no. 43, p. 37, illus.

44.
SECRÉTAIRE
Paris, circa 1765–1770
By Joseph Baumhauer
Maple, mahogany, beech, and oak veneered
with tulipwood, amaranth, ebony, and holly;
gilt-bronze mounts; possibly *portor d'Italie* top
Stamped with JOSEPH between two fleur-
de-lys three times—twice on the left fore-
corner and once on the right forecorner.
Height: 4 ft. 6 in. (137 cm); Width: 3 ft. 5 in.
(104 cm); Depth: 1 ft. 3 in. (38 cm)
Accession number 84.DA.969

PROVENANCE
Mrs. Orme Wilson (sold by her executors,
Parke-Bernet, New York, March 25, 1949,
lot 339); Paul Rosenberg, Paris; [Didier
Aaron, Inc., New York, 1984].

EXHIBITIONS
New York, The Cooper-Hewitt Museum,
Writing and Reading, September 1981–January
1982; Richmond, Virginia, *Experts' Choice:
One Thousand Years of the Art Trade*, April 22–
June 12, 1983, p. 131, illus., lent by Didier
Aaron, Inc., New York.

44

BIBLIOGRAPHY
F. Lewis Hinckley, *Directory of the Historic Cabi-
net Woods* (New York, 1960), p. 103, illus.
p. 102, fig. 96; Bremer-David, "Acquisitions
1984," no. 4, pp. 81–83, illus.; Acquisitions/
1984," *GettyMusJ* 13 (1985), no. 62, p. 181,
illus.; Jean-Dominique Augarde, "1749
Joseph Baumhauer, ébéniste privilegié du roi,"
L'Estampille 204 (June 1987), pp. 15–45, figs. 1,
36; Pradère, *Les Ebénistes*, no. 53, p. 245;
Kjellberg, *Dictionnaire*, p. 450, illus. p. 448;
Bremer-David, *Summary*, no. 44, p. 38, illus.;
Ramond, *Chefs d'oeuvre* II, p. 112, illus.

45.
SECRÉTAIRE
Paris, circa 1770
Attributed to Jean-François Leleu
Oak veneered with amaranth, bloodwood,
tulipwood, and holly; gilt-bronze mounts;
steel fittings; *brèche d'Alep* top
Penciled with 1770 inside the carcass.
Label printed with EARL OF ROSEBERY
pasted on back.
Height: 3 ft. 6 1/8 in. (107.3 cm); Width:
3 ft. 11 1/4 in. (120 cm); Depth: 1 ft. 5 1/4 in.
(43.6 cm)
Accession number 82.DA.81

PROVENANCE
Baron Mayer (Amschel) de Rothschild (1818–
1874), Mentmore Towers, Buckinghamshire;
Hannah de Rothschild (1851–1890) (Countess
of Rosebery, wife of the 5th Earl, married
1878), Mentmore Towers, Buckinghamshire;
(Albert) Harry Primrose, 6th Earl of Rose-
bery, Mentmore Towers, Buckinghamshire;
Neil Primrose, 7th Earl of Rosebery, Ment-
more Towers, Buckinghamshire (sold,
Sotheby's, Mentmore Towers, May 18, 1977,
lot 24); private collection, London, 1977;
[Mallett's, London].

BIBLIOGRAPHY
"Some Acquisitions (1981–82) in the Depart-
ment of Decorative Arts, The J. Paul Getty
Museum," *Burlington Magazine* 125, no. 962
(May 1983), illus. p. 325; Philippe Jullian,
"Mentmore," *Connaissance des arts* 303 (May

1977), p. 82, illus.; Wilson, "Acquisitions
1982," no. 12, pp. 56–60, figs. 79, 81–84;
Wilson, *Selections*, no. 37, pp. 56–57, illus.;
Pradère, *Les Ebénistes*, p. 334, illus. p. 337,
fig. 392; Kjellberg, *Dictionnaire*, illus. p. 509;
Bremer-David, *Summary*, no. 45, p. 38, illus.

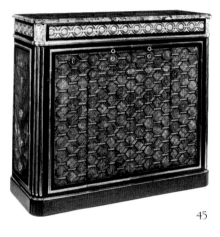

45

46.
SECRÉTAIRE
Paris, circa 1770–1775
By Philippe-Claude Montigny
Oak veneered with bloodwood, ebony, tor-
toiseshell, brass, and pewter; gilt-bronze
mounts
Stamped with MONTIGNY JME on
the back.
Height: 4 ft. 7 1/2 in. (141.5 cm); Width:
2 ft. 9 in. (84.5 cm); Depth: 1 ft. 3 3/4 in.
(40.3 cm)
Accession number 85.DA.378

PROVENANCE
Monsieur de Billy, Paris (sold through the
marchand-mercier A.-J. Paillet, Hôtel de Bul-
lion, Paris, November 15–19, 1784, no. 171, for
860 *livres* to Desmarest); Joseph-Hyacinthe-
François de Paule de Rigaud, comte de Vau-
dreuil, Paris (sold under the direction of Le
Brun in the Grande Salle, rue de Cléry,
Paris, November 26, 1787, no. 368, for 1,305
livres to Lerouge); [Kraemer et Cie, Paris,

early 1960s]; Mme Jorge Ortiz-Linares, Paris (offered for sale, Sotheby's, Monaco, June 14, 1982, no. 423, bought in); [B. Fabre et Fils, Paris].

BIBLIOGRAPHY
Gillian Wilson, "A Secrétaire by Philippe-Claude Montigny," GettyMusJ 14 (1986), pp. 121–126, figs. 1, 4, 7; "Acquisitions/1985," GettyMusJ 14 (1986), no. 200, p. 246, illus.; Jean-Dominique Augarde, "1749 Joseph Baumhauer, ébéniste privilegié du roi," L'Estampille 204 (June 1987), p. 30; Pradère, "Boulle, du Louis XIV sous Louis XVI," L'Estampille-L'Objet d'art 4 (June 1987), pp. 56–67, 118, illus.; Pradère, Les Ebénistes, p. 305, illus. p. 307, fig. 347; Gillian Wilson. "Dalla Raccolta del Museo J. Paul Getty," Part 3, Casa Vogue Antiques 10 (November 1990), pp. 90–95, illus. p. 93; Bruno Pons et al., L'Art décoratif en Europe: Classique et baroque, Alain Gruber, ed. (Paris, 1992), illus. p. 183; Bremer-David, Summary, no. 46, p. 39, illus.; Ramond, Chefs d'oeuvre II, pp. 176–177, illus.; Masterpieces, no. 83, p. 106, illus.; Handbook 2001, p. 223, illus.

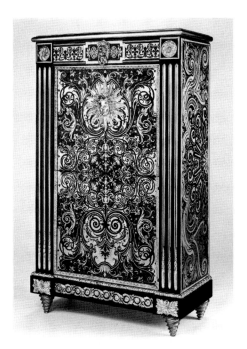

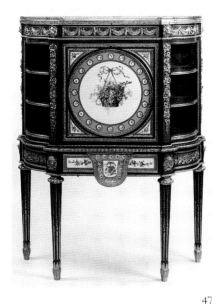

47

47.
SECRÉTAIRE

Secrétaire: Paris, circa 1775; porcelain: Sèvres manufactory, 1775
By Martin Carlin; circular Sèvres porcelain plaque painted by Jean-Jacques Pierre le jeune; two of the frieze plaques and two of the spandrel plaques painted by Claude Couturier; central frieze plaque gilded by Etienne-Henri Le Guay
Oak veneered with ebony, holly, stained holly, amaranth and tulipwood, incised with colored mastics; set with eight soft-paste porcelain plaques; gilt-bronze mounts; white marble top
Stamped with M. CARLIN and JME twice on lower back. All the plaques except for two of the spandrels are painted in blue on their reverses with the crossed L's of the Sèvres manufactory. On all but the central frieze plaque the crossed L's enclose the date letter x for 1775; the circular plaque bears the painter's mark in blue of P' for Pierre le jeune, and in black, 216; two spandrel and the two frieze plaques bear the painter's mark in blue. The central frieze plaque bears the gilder's mark LG in gold, partly rubbed. Rothschild inventory numbers are chalked twice on back of each carcass: KKU 859,

AR 542, Iv1120, and 3.
Height: 3 ft. 11 1/4 in. (120 cm); Width: 3 ft. 1 in. (94 cm); Depth: 1 ft. 1 1/4 in. (34 cm)
Accession number 65.DA.2

PROVENANCE
Baron Nathaniel (Mayer) von Rothschild (1836–1905), Vienna, by 1903; Baron Alphonse (Mayer) von Rothschild (1878–1942), Vienna; confiscated by the Nazis in March 1938; restituted to Baronin Clarice von Rothschild (1874–1967), Vienna, in 1947 and sent to New York shortly afterward (sold privately, 1950); [Rosenberg and Stiebel, Inc., New York, 1950]; purchased by J. Paul Getty, 1950.

BIBLIOGRAPHY
Baron Nathaniel Mayer de Rothschild, Notizen über einige meiner Kunstgegenstände (1903), no. 319, p. 128; J. Paul Getty, Collector's Choice (London, 1955), pp. 76–77, 81, illus. unnumbered pl. between pp. 152–153; Paul Wescher, "French Furniture of the Eighteenth Century in the J. Paul Getty Museum," Art Quarterly 18, no. 2 (Summer 1955), p. 131, illus. p. 134; Charles Packer, Paris Furniture by the Master Ebénistes (Newport, Monmouthshire, 1956), p. 59, fig. 175A; "Vingt Mille Lieues dans les musées," Connaissance des arts 57 (November 1956), pp. 76–81, illus. p. 77; Verlet et al., Chefs d'oeuvre, p. 127, illus.; G. Reitlinger, The Economics of Taste (London, 1963), vol. 2, p. 426; Getty, Collecting, p. 156, illus. p. 157; F. J. B. Watson, The Wrightsman Collection (New York, 1966), vol. 1, p. 190; Fredericksen et al., Getty Museum, pp. 176–177, illus.; Gillian Wilson, "The J. Paul Getty Museum, 7ème partie: Le Mobilier Louis XVI," Connaissance des arts 280 (June 1975), p. 97, illus.; Michael Stürmer, Handwerk und höfische Kultur: Europäische Möbelkunst im 18. Jahrhundert (Munich, 1982), p. 47, illus.; Adrian Sassoon, "Sèvres Plaques," Techniques of the World's Great Masters of Pottery and Ceramics, Hugo Morley-Fletcher, ed. (Oxford, 1984), pp. 62–63, illus.; Gisela Zick, "Die russische Wahrsagerin, Ein Tisch für Marie Karoline von Neapel," Kunst und Antiquitäten 4–5 (1984), pp. 36–52, pl. 4, p. 39; Reinier J. Baarsen, "Rond een Neder-

landse Lodewijk XVI secretaire op Het Loo," *Antiek* 7 (February 1986), pp. 384–395; Savill, *Sèvres*, vol. 2, pp. 612, 877, 879; note 45, p. 613; notes 45–46, p. 901; Pradère, *Les Ebénistes*, no. 29, p. 356; Kjellberg, *Dictionnaire*, p. 162; Daniel Alcouffe, "Secrétaire à abbattant," *Louvre: Nouvelles acquisitions du département des objets d'art, 1985–1989* (Paris, 1990), no. 71, p. 154, illus.; Gillian Wilson, "Dalla Raccolta del Museo J. Paul Getty," Part 3, *Casa Vogue Antiques* 10 (November 1990), pp. 90–95; Sassoon, *Vincennes and Sèvres Porcelain*, no. 35, pp. 174–176, illus. pp. 175–177; Bremer-David, *Summary*, no. 47, pp. 39–40, illus.

48.
SECRÉTAIRE

Paris, circa 1775
By René Dubois
Oak veneered with kingwood, tulipwood, holly, hornbeam, and ebony; incised with colored mastics; set with mother-of-pearl; gilt-bronze mounts; white marble top
Stamped with I. DUBOIS and JME on back.
Height: 5 ft. 3 in. (160 cm); Width: 2 ft. 3⁵/₈ in. (70.2 cm); Depth: 1 ft. 1¹/₄ in. (33.7 cm)
Accession number 72.DA.60

PROVENANCE

Sir Richard Wallace, Paris; Lady Wallace, Paris, by inheritance, 1890; Sir John Murray Scott, London, by inheritance, 1897 (sold after his death, Christie's, London, June 24, 1913, lot 54); E. M. Hodgkins; [Jacques Seligmann, Paris]; Henry Walters, New York (sold by his widow, Parke-Bernet, New York, April 26, 1941, lot 712); Baron and Baronne Cassel van Doorn, Paris (sold, Galerie Jean Charpentier, Paris, March 9, 1954, no. 90); Guedes de Souza, Paris; [Frank Partridge and Sons, Ltd., London, 1972]; purchased by J. Paul Getty.

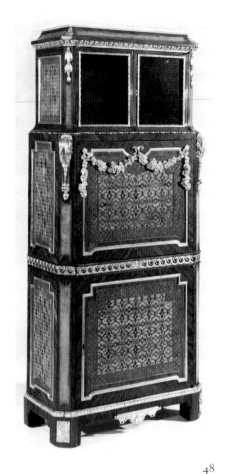

48

BIBLIOGRAPHY

Jean Nicolay, *L'Art et la Manière des Maitres Ebénistes français au XVIII^{ème} siècle* (Paris, 1956), p. 153, illus.; F. J. B. Watson, *Louis XVI Furniture* (London, 1960), no. 89, illus.; Pierre Verlet, *French Cabinetmakers of the Eighteenth Century* (Paris, 1963), p. 221, illus.; Jean Meuvret and Claude Frégnac, *Les Ebénistes du XVIII^e siècle français* (Paris, 1963), p. 221, illus.; F. Lewis Hinckley, *A Directory of Antique French Furniture 1735–1800* (New York, 1967), p. 69, illus.; Fredericksen et al., *Getty Museum*, p. 167, illus.; Bremer-David, *Summary*, no. 48, p. 40, illus.; Ramond, *Chefs d'oeuvre* II, pp. 39, 114, illus.; Peter Hughes, *The Wallace Collection Catalogue of Furniture* (London, 1996), vol. 3, p. 1566, no. 54; *Masterpieces*, no. 89, p. 112, illus.

49.
SECRÉTAIRE

Secrétaire: Paris, circa 1777; porcelain: Sèvres manufactory, 1776–1777
By Martin Carlin; the two large Sèvres porcelain plaques on the fall front painted by Edmé-François Bouillat, and the two smaller ones on the drawer painted by Raux *fils aîné*
Oak veneered with tulipwood, amaranth, holly and ebony stringing; set with five soft-paste porcelain plaques; enameled metal; gilt-bronze mounts; white marble top
Stamped with M. CARLIN and JME twice under the drawer front. All porcelain plaques are painted on their reverses with the blue crossed L's of the Sèvres manufactory. On the two large plaques the crossed L's are flanked by a Y on each side: one is the date letter for 1776, the other is the painter's mark; on the drawer front the two small plaques are each painted in black with the painter's mark of a circle of dots; the small plaque on the right bears the date letter Z for 1777 in blue and the marks X and 10 in gold; the long plaque in the center bears an unidentified painter's mark in blue and the date letter Z for 1777 in blue with a paper price label printed with crossed L's and inked with 36 [*livres*].
Height: 3 ft. 6¹/₄ in. (107.9 cm); Width: 3 ft. 4¹/₂ in. (103 cm); Depth: 1 ft. 2 in. (35.5 cm)
Accession number 81.DA.80

PROVENANCE

Don Francesco de Borja Alvarez de Toledo (?), 16th Duke of Medina-Sidonia and 12th Marquess of Villafranca; Don Pedro de Alcantara Alvarez de Toledo, 17th Duke of Medina-Sidonia (sold by his heir the Marquess of Villafranca, Hôtel Drouot, Paris, April 21, 1870, no. 23); purchased at that sale by Richard, 4th Marquess of Hertford, Paris [through Nieuwenhuys]; Sir Richard Wallace, Château de Bagatelle, Paris, by inheritance, 1870; Lady Wallace, Château de Bagatelle, Paris, by inheritance, 1890; Sir John Murray Scott, Paris, by inheritance, 1897; Victoria, Lady Sackville, Paris, inherited 1912; [Jacques Seligmann, Paris]; Baron (1868–1949) and Baronne Edouard (Alphonse

James) de Rothschild (1868–1949), Paris; Baron Guy (Edouard Alphonse Paul) de Rothschild (born 1909), Paris, by descent; Mr. and Mrs. Habib Sabet, Paris, early 1970s.

BIBLIOGRAPHY
F. J. B. Watson, *Wallace Collection Catalogues: Furniture* (London, 1956), p. 159; Wilson, "Acquisitions 1981," no. 1, pp. 63–66, illus.; Dorothée Guilleme-Brulon, "Les Plaques en porcelaine de Sèvres dans le mobilier," *L'Estampille* 163 (November 1983), pp. 42–43, illus.; Wilson, *Selections*, no. 39, pp. 78–79; Jackson-Stops, "Boulle by the Beach," pp. 854–856, fig. 7; Frederic Edelmann, "Musée Getty, Le Trust de l'art," *Beaux-arts magazine* (September 1987), no. 49, illus. p. 75; Savill, *Sèvres*, vol. 2, p. 877; note 45, p. 901; vol. 3, p. 1063; note 3, p. 1064; Pradère, *Les Ebénistes*, no. 28, p. 356; Kjellberg, *Dictionnaire*, p. 160; Sassoon, *Vincennes and Sèvres Porcelain*, no. 38, pp. 184–186, illus. pp. 184, 186; Bremer-David, *Summary*, no. 50, pp. 41–42, illus. p. 41; Peter Hughes, *The Wallace Collection Catalogue of Furniture* (London, 1996), vol. 3, note 1, p. 1535; *Masterpieces*, no. 90, p. 113, illus.; *Handbook* 2001, p. 225, illus.

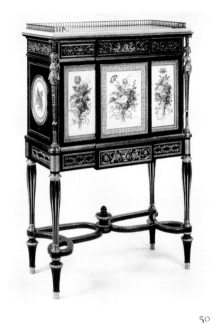

50.

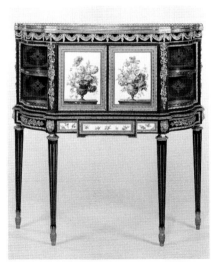

49

50.

SECRÉTAIRE

Secrétaire: Paris, circa 1783; porcelain: Sèvres manufactory, circa 1783
Attributed to Adam Weisweiler; three of the Sèvres porcelain plaques gilded by Henry-François Vincent *le jeune*
Oak veneered with yew burl, mahogany, ebony and maple; drawers of mahogany and juniper; set with five soft-paste porcelain plaques; gilt-bronze mounts; white marble top
One of the oval plaques and the two smaller rectangular plaques are marked in gold on the reverse with the crossed *L*'s of the Sèvres manufactory, adjacent to the gilder's mark *2000*; the central plaque is inscribed *No 353*. The central rectangular plaque and one of the oval plaques have paper Sèvres price labels printed with the crossed *L*'s; the label of the oval plaque is inked with *72* [*livres*].
Height: 4 ft. 1 in. (124.5 cm); Width: 2 ft. 8¼ in. (81.9 cm); Depth: 1 ft. 2¾ in. (37.5 cm)
Accession number 70.DA.83

PROVENANCE
Jules Lowengard, Paris, before 1908; Baron Nathaniel (Mayer) von Rothschild (1836–1905), Vienna, by 1913; Baron Alphonse (Mayer) von Rothschild (1878–1942), Vienna; confiscated by the Nazis in March 1938; restituted to the Baronin Clarice von Rothschild (1874–1967), Vienna, in 1947, and sent to New York soon afterward (sold privately, 1950); [Rosenberg and Stiebel, Inc., New York]; purchased by J. Paul Getty, 1950.

BIBLIOGRAPHY
Seymour de Ricci, *Louis XVI Furniture* (London, 1913), p. 127, illus.; J. Paul Getty, *Collector's Choice* (London, 1955), p. 77, illus. unnumbered pl. between pp. 152–153; Paul Wescher, "French Furniture of the Eighteenth Century in the J. Paul Getty Museum," *Art Quarterly* 18, no. 2 (Summer 1955), p. 126, illus. p. 134; Charles Packer, *Paris Furniture by the Master Ebénistes* (Newport, Monmouthshire, 1956), fig. 209; "Vingt Mille Lieues dans les musées," *Connaissance des arts* 57 (November 1956), pp. 76–81, illus. p. 80; F. J. B. Watson, *Louis XVI Furniture* (London, 1960), no. 86, pp. 121–122, illus.; Jean Meuvret and Claude Frégnac, *Les Ebénistes du XVIIIᵉ siècle français* (Paris, 1963), p. 286, illus. (erroneously described as being in the Metropolitan Museum of Art, New York); Gerald Reitlinger, *The Economics of Taste* (London, 1963), vol. 2, p. 426; Verlet et al., *Chefs d'oeuvre*, p. 129, illus.; Getty, *Collecting*, pp. 158–159, illus.; Fredericksen et al., *Getty Museum*, p. 178, illus.; Patricia Lemonnier, *Weisweiler* (Paris, 1983), p. 109 illus.; Savill, *Sèvres*, vol. 2, p. 888, and note 92, p. 901; Kjellberg, *Dictionnaire*, p. 872; Gillian Wilson, "Dalla Raccolta del Museo J. Paul Getty," Part 3, *Casa Vogue Antiques* 10 (November 1990), pp. 90–95; Sassoon, *Vincennes and Sèvres Porcelain*, no. 40, pp. 193–196, illus. pp. 194–197; Bremer-David, *Summary*, no. 51, pp. 42–43, illus. p. 42.

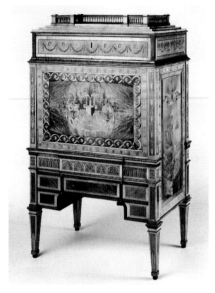

51

51.

SECRÉTAIRE

Paris (?), circa 1780

Oak veneered with satinwood, fruitwoods, tulipwood, and ebony; incised with mastics

The back of the *secrétaire* bears six wax seals with the date *1830* and the word CHARTE; the back is inscribed with the Dalva Brothers inventory number *10697*.

Height: 4 ft. 11 ⁷/₈ in. (152 cm); Width: 3 ft. ¹/₄ in. (92.2 cm); Depth: 1 ft. 9 ⁷/₈ in. (55.6 cm)

Accession number 85.DA.147

PROVENANCE

Unknown collection, Paris, circa 1830; private collection, Belgium (sold, Galerie Moderne, Brussels, March 15, 1976, no. 1305); [La Cour de Varenne, Paris, late 1970s–1982]; [Dalva Brothers, Inc., New York, 1982].

BIBLIOGRAPHY

Jean Bedel, *Les Antiquités et la brocante* (Paris, 1981), illus. on the front and back covers; "Acquisitions/1985," *GettyMusJ* 14 (1986), no. 210, p. 250, illus.; Pierre Ramond, *Marquetry* (Newtown, Connecticut, 1989), p. 85, illus.; Bremer-David, *Summary*, no. 52, p. 43, illus.

52.

SECRÉTAIRE

Paris, circa 1785

Attributed to Jean-Henri Riesener

Oak veneered with amaranth and ebony, set with panels of black Japanese lacquer on Japanese arborvitae; interior fittings of mahogany; gilt-bronze mounts; black marble top

There are two paper labels inked with *Hamilton Palace* on the back.

Height: 5 ft. 1 in. (155 cm); Width: 3 ft. 8 ¹/₄ in. (112.5 cm); Depth: 1 ft. 6 ¹/₂ in. (47 cm)

Accession number 71.DA.104

PROVENANCE

George Watson Taylor, Erlestoke Mansion, Devizes, Wiltshire (sold, Erlestoke Mansion, July 9 et seq., 1832, lot 26); Alexander Archibald Douglas, the 10th Duke of Hamilton and 7th Duke of Brandon (1767–1852), Hamilton Palace, Lanarkshire, Scotland; listed in the Duke's Dressing Room in an inventory of 1835–1840; William Alexander Douglas, 12th Duke of Hamilton and 9th Duke of Brandon (1845–1885), Hamilton

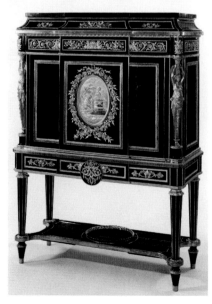

52

Palace, by descent (sold, Christie's, London, July 10, 1882, lot 1296, to Samson Wertheimer); Cornelius Vanderbilt II (1843–1899), The Breakers, Newport, Rhode Island, by about the 1890s; Alice Vanderbilt (1846–1934, wife of Cornelius Vanderbilt II), The Breakers, Newport, Rhode Island; Gladys Moore Vanderbilt (Countess Laszlo Széchényi, 1886–1965), by descent (sold by her heirs, Sotheby's, London, November 26, 1971, lot 71); purchased at that sale by J. Paul Getty.

BIBLIOGRAPHY

William Roberts, *Memorials of Christie's* (London, 1897), vol. 2, illus. p. 37; Seymour de Ricci, *Louis XVI Furniture* (London, 1913), p. 147, illus.; Fredericksen et al., *Getty Museum*, p. 175, illus.; Gillian Wilson, "The J. Paul Getty Museum, 7ᵉᵐᵉ partie: Le Mobilier Louis XVI," *Connaissance des arts* 280 (June 1975), p. 91, illus.; Frances Buckland, "Die Karriere eines Kunstschreiners: Johann Heinrich Riesener, Ebenist am Hofe Ludwigs XVI," *Kunst und Antiquitäten* 6 (1980), p. 37, illus. p. 28, fig. 7; Ronald Freyberger, "Eighteenth-Century French Furniture from Hamilton Palace," *Apollo* 114, no. 238 (December 1981), pp. 407–408, illus. p. 405, pl. 20; Wilson, *Selections*, no. 41, pp. 82–83, illus.; "The Great Collections," *French Connections: Scotland and the Arts of France* (Edinburgh, 1985), pp. 78, 81, 84, illus. p. 83, fig. 47; Kjellberg, *Dictionnaire*, p. 712, illus. p. 707; Bremer-David, *Summary*, no. 53, pp. 43–44, illus. p. 43.

Tables

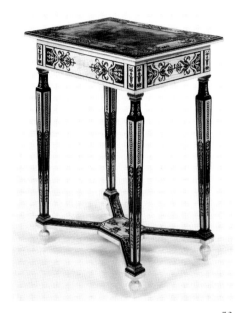

53

53.
READING AND WRITING TABLE
Paris, circa 1670–1675
Oak veneered with amaranth, ebony, and rose-
wood; ivory and blue painted horn; drawers
of walnut; gilt-bronze moldings; steel; modern
silk velvet
Height: 2 ft. 1 in. (63.5 cm); Width:
1 ft. 7 1/8 in. (48.5 cm); Depth: 1 ft. 2 in.
(35.5 cm)
Accession number 83.DA.21

PROVENANCE

Made for Louis XIV; Dupille de Saint-Severin
(?), Paris (sold, Paris, February 21, 1785,
no. 323); [Bernard Steinitz, Paris, 1982].

BIBLIOGRAPHY

"Acquisitions/1983," *GettyMusJ* 12 (1984),
p. 261, no. 1, illus.; Gillian Wilson, "Two
Newly Discovered Pieces of Royal French
Furniture," *Antologia di belli arti* 27–28 (1985),
pp. 61–66, illus.; Jackson-Stops, "Boulle by
the Beach," pp. 854–856; Jacques Charles
et al., *De Versailles à Paris: Le Destin des collections
royales* (Paris, 1989), illus. p. 22, fig. 12;
Pradère, *Les Ebénistes*, p. 47, illus. p. 46, fig. 2;
Pamela Cowen, "The Trianon de Porcelaine at

Versailles," *Magazine Antiques* (January 1993),
pp. 136–143, illus. p. 138; Bremer-David, *Sum-
mary*, no. 56, p. 45, illus.; Ramond, *Chefs
d'oeuvre 1*, pp. 34–36, illus.; *Liselotte von der
Pfalz, Madame am Hofe des Sonnenkönigs* (Heidel-
berg, 1997), p. 180, fig. 1.; *Western Furniture:
1350 to the Present Day*, Christopher Wilk, ed.
(London, 1996), p. 66, fig. 2.; *Masterpieces*,
no. 38, p. 52; Richard Pascale, *Versailles: The
American Story* (Paris, 1999), p. 21, illus.; *Hand-
book 2001*, p. 185, illus.

54.
TABLE
Paris, circa 1680
Attributed to Pierre Golle
Oak and fruitwood veneered with walnut,
ebony, tortoiseshell, pewter, and brass;
gilded wood; drawers of oak and rosewood;
gilt-bronze mounts
One drawer bears a paper label inked with
N. 55/48005.
Height: 2 ft. 6 1/2 in. (76.7 cm); Width:
1 ft. 4 1/2 in. (42 cm); Depth: 1 ft. 2 1/4 in.
(36.1 cm)
Accession number 82.DA.34

PROVENANCE

Louis, Grand Dauphin of France (?)
(1661–1711); H. Burgess (?) (sold, Christie's,
London, May 30, 1899, lot 49, for £22 1s.);
Henry James Laird, Ardmore House, Black-

54 *Detail of top (open)*

heath Park, Middlesex (sold, Christie's, Lon-
don, March 19, 1936, lot 147); private collec-
tion, Scotland (sold, Phillips, Glasgow,
April 16, 1981, lot 305); [Alexander and
Berendt, Ltd., London, 1981].

BIBLIOGRAPHY

"Some Acquisitions (1981–82) in the Depart-
ment of Decorative Arts, The J. Paul Getty
Museum," *Burlington Magazine* 125, no. 962
(May 1983), illus. p. 325; *Gazette des beaux-arts*
51 (March 1983), illus. p. 34; Wilson,
"Acquisitions 1982," no. 2, pp. 18–23, illus.;
Wilson, *Selections*, no. 5, pp. 10–11, illus.;
Jackson-Stops, "Boulle by the Beach,"
pp. 854–856; Jacques Charles et al., *De Ver-
sailles à Paris: Le Destin des collections royales* (Paris,
1989), illus. p. 22, fig. 13; Bremer-David,
Summary no. 57, p. 46, illus.; Ramond, *Chefs
d'oeuvre 1*, pp. 88–93, illus.; *Masterpieces*, no.
39, p. 53, illus.; *Handbook 2001*, p. 186, illus.

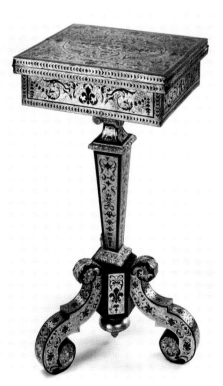

54

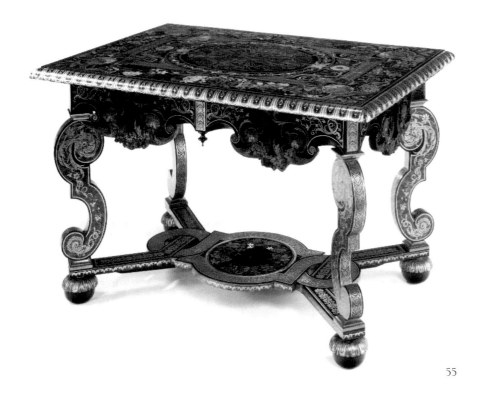

55

[Alexander and Berendt, Ltd., London, 1971]; purchased by J. Paul Getty.

EXHIBITIONS
The Minneapolis Institute of Arts, *The J. Paul Getty Museum*, June–September 1972, no. 55.

BIBLIOGRAPHY
Henry R. Forster, *The Stowe Catalogue: Priced and Annotated* (London, 1848), no. 256, p. 16; Fredericksen et al., *Getty Museum*, p. 146, illus.; Wilson, "Meubles 'Baroques,'" p. 108, illus.; Michael Stürmer, *Handwerk und höfische Kultur: Europäische Möbelkunst im 18. Jahrhundert* (Munich, 1982), pp. 35, 215, illus.; Marvin D. Schwartz, "Boulle Furniture," *Arts and Antiques* (April 1983), illus. p. 68; Gillian Wilson, "A Late Seventeenth-Century French Cabinet at the J. Paul Getty Museum," *The Art Institute of Chicago Centennial Lecture: Museum Studies* 10 (1983), pp. 119–131, illus.; Wilson, *Selections*, no. 4, pp. 8–9, illus.; Alvar González-Palacios, *Il Tempio del gusto: Le Arti decorative in Italia fra classicismi e barocco: Il Granducato di Toscana e gli stati settentrionali* (Milan, 1986), vol. 1, p. 28, and vol. 2, pp. 52–53, fig. 54, illus.; Pradère, *Les Ebénistes*, no. 301, p. 108; Bremer-David, *Summary*, no. 58, pp. 46–47, illus. p. 47; Ramond, *Chefs d'oeuvre* 1, pp. 40–43, illus.; Peter Thorton, *Form and Decoration 1470–1870: Innovation in the Decorative Arts* (London, 1998), p. 121, illus.; *Masterpieces*, no. 43, pp. 58–59, illus.; *Handbook 2001*, p. 188, illus.

55.
TABLE
 Paris, circa 1680
 Attributed to André-Charles Boulle
 Oak veneered with boxwood, cherry, maple, stained maple, fruitwood, juniper, Ceylon satinwood, beech, amaranth, ebony, tortoiseshell, pewter, brass, horn and ivory; gilt-bronze mounts
 Height: 2 ft. 4³/₈ in. (72 cm); Width: 3 ft. 7¹/₂ in. (110.5 cm); Depth: 2 ft. 5 in. (73.6 cm)
 Accession number 71.DA.100

PROVENANCE
Lord Thomas Stapleton (?), Le Despencer family, Mereworth Castle, Kent (sold, circa 1831, to Levy, Maidstone, Kent, £35); London art market, 1831; Richard Plantagenet, 2nd Duke of Buckingham and Chandos, Stowe House, Buckinghamshire (sold, Christie's, Stowe House, August 15 et seq., 1848, lot 256, to [Redfern] for £59); William Humble, 11th Baron Ward (created 1st Earl of Dudley, 1860, died 1885), 1848; William Humble, 2nd Earl of Dudley (died 1932), Dudley House, Park Lane, London; Sir Joseph B. Robinson, Bt., purchased with the contents of Dudley House; Count Joseph Labia (son-in-law of Sir Joseph C. Robinson), London (sold, Sotheby's, London, May 17, 1963, lot 137); [Ronald Lee, London, 1970];

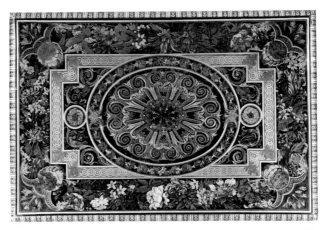

56.
TABLE

Paris, circa 1680
Attributed to André-Charles Boulle
Oak and mahogany veneered with ebony,
boxwood, walnut, mahogany, amaranth,
stained maple, tortoiseshell, horn, pewter,
brass, and ivory; gilt-bronze mounts
Height: 2 ft. 8 1/4 in. (82 cm); Width: 3 ft.
9 7/8 in. (116.5 cm); Depth: 2 ft. 2 in. (66 cm)
Accession number 83.DA.22

PROVENANCE
[Bernheimer, Munich, 1920s]; Hermann, Graf
von Arnim, Schloss Muskau, Saxony, taken
by him to Munich, 1945.

BIBLIOGRAPHY
Hermann, Graf von Arnim and Willi
Boelcke, *Muskau: Standesherrschaft zwischen Spree
und Neiße* (Berlin, 1978), illus. p. 27; "Acquisi-
tions/1983," *GettyMusJ* 12 (1984), no. 2,
p. 261, illus.; Pradère, *Les Ebénistes*, no. 302,
p. 108, illus. p. 99, fig. 56; Bremer-David,
Summary, no. 59, p. 47, illus.; Ramond, *Chefs
d'oeuvre* 1, pp. 96–101, illus.

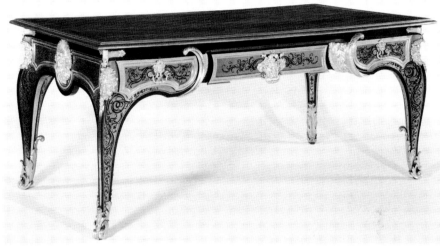

57

57.
TABLE (*BUREAU PLAT*)

Paris, circa 1710–1715
Attributed to André-Charles Boulle
Oak veneered with ebony, tortoiseshell, and
brass; drawers of walnut; gilt-bronze mounts;
leather top

Height: 2 ft. 7 11/16 in. (80.5 cm); Width:
6 ft. 4 9/16 in. (195.4 cm); Depth: 3 ft. 2 3/4 in.
(98.5 cm)
Accession number 85.DA.23

PROVENANCE
Alexandre de Flahaut, comte de la Billarderie
(1726–1793), or Charles-Claude de Flahaut,
comte d'Angiviller (1730–1809), Paris; by
descent to Auguste-Charles-Joseph, comte de
Flahaut de la Billarderie (1785–1870), Paris,
and French ambassador to England 1860–
1862; by descent to Emily de Flahaut,
Baroness of Nairne (died 1895), Paris and
London; Lady Emily Fitzmaurice (?), Lon-
don; A. E. H. Digby, Esq. (sold, Sotheby's,
London, June 22, 1951, lot 70); [Michel
Meyer, Paris, 1985].

BIBLIOGRAPHY
"Le Meuble Boulle," *Connaissance des arts* 2
(April 1952), p. 20; Stéphane Faniel et al.,
Le XVIII^e siècle français (Collection Connais-
sance des arts, Paris, 1958), p. 60, fig. 6;
"Acquisitions/1985," *GettyMusJ* 14 (1986), no.
193, p. 243, illus.; Jackson-Stops, "Boulle
by the Beach," pp. 854–856, illus. p. 854,
fig. 1; Pradère, *Les Ebénistes*, no. 82, p. 102,
illus. p. 78, fig. 27; Bremer-David, *Summary*,
no. 60, p. 48, illus.

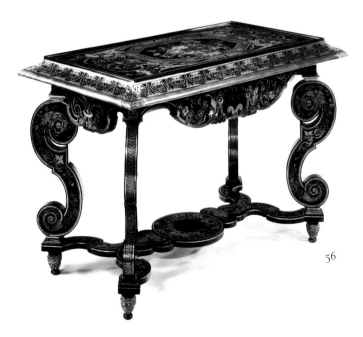

56

58.

TABLE (BUREAU PLAT)

Paris, circa 1725
Attributed to Charles Cressent
Oak and pine veneered with *satiné rouge*
and amaranth; gilt-bronze mounts; modern
leather top
Black and white chalk drawing, possibly for a
corner mount, on an interior panel.
Height: 2 ft. 6$^{1}/_{8}$ in. (76.5 cm); Width: 6 ft.
7$^{7}/_{8}$ in. (202.2 cm); Depth: 2 ft. 11$^{1}/_{4}$ in.
(89.5 cm)
Accession number 67.DA.10

PROVENANCE

H. H. A. Josse, Paris (sold, Galerie Georges
Petit, Paris, May 29, 1894, no. 152); pur-
chased at that sale by Edouard Chappey, Paris
(sold privately after 1900); Ernest Cronier,
Paris (sold, Galerie Georges Petit, Paris,
December 4–5, 1905, no. 135, to [Jacques
Seligmann, Paris]); François Coty, Paris (sold,
Galerie Jean Charpentier, Paris, Novem-
ber 30–December 1, 1936, no. 84, to [B. Fabre
et Fils, Paris]); confiscated by or sold to the
Reichsbank, 1941, and presumably restituted
or returned; [Cameron in partnership with B.
Fabre et Fils, London, 1949]; purchased by J.
Paul Getty, 1949.

EXHIBITIONS

Paris, Petit Palais, *Exposition universelle de 1900,
L'Exposition rétrospective de l'art français des origines à
1800*, 1900, vol. 1, no. 2904, p. 299, illus.
p. 188 (lent by Edouard Chappey).

BIBLIOGRAPHY

Alfred de Champeaux, *Portefeuille des arts déco-
ratifs 7ème année* (Paris, 1884–1885), pl. 578;
Émile Molinier, *Histoire générale des arts appliqués
à l'industrie du vc à la fin du XVIIIc siècle*, vol. 3, *Le
Mobilier au XVIIc et au XVIIIc siècle* (Paris, 1896),
illus. p. 99; Émile Moliner and Frantz Mar-
cou, *Exposition rétrospective de l'art français des ori-
gines à 1800* (Paris, 1901), pp. 113–114 and
illus. unnumbered pl.; *Exposition universelle de
1900, Le Mobilier à travers les âges au Grand et
Petit Palais: Intérieurs XVIIIc et XIXc siècles: Exposi-
tion centenale* (Paris, 1902), illus. pl. 41; Marie-
Juliette Ballot, *Charles Cressent: Sculpteur, ébéniste,
collectionneur, Archives de l'art français: Nouvelle péri-
ode 10* (Paris, 1919), pp. 113–114, 136–137, 145;
Adolf Feulner, *Kunstgeschichte des Möbels seit dem
Altertum* (Berlin, 1927), p. 314; Paul Wescher,
"French Furniture of the Eighteenth Century
in the J. Paul Getty Museum," *Art Quarterly*
18, no. 2 (Summer 1955), pp. 116–117 and fig.
2, p. 119; J. Paul Getty, *Collector's Choice* (Lon-
don, 1955), pp. 168–169, illus. unnumbered
pl. between pp. 160–161; Getty, *Collecting,*

pp. 142–143, illus.; Pierre Verlet, *La Maison
du XVIIIc siècle en France: Société, décoration, mobilier*
(Paris, 1966), no. 133, pp. 168–169, illus.;
Claude Frégnac, *Les Styles français* (Paris,
1975), vol. 1 p. 179, illus.; Fredericksen et al.,
Getty Museum, pp. 145, 153, illus.; Wilson,
"Meubles 'Baroques,'" p. 106, illus.; Wilson,
Selections, no. 10, pp. 20–21, illus.; Kjellberg,
Dictionnaire, p. 202; Bremer-David, *Summary,*
no. 61, pp. 48–49, illus. p. 49.

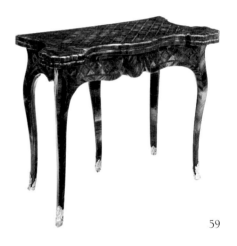

59

59.

WRITING AND CARD TABLE

Paris, circa 1725
Oak and fir veneered with bloodwood
and cururu; drawers of walnut; gilt-bronze
mounts; modern silk velvet
Closed Height: 2 ft. 6$^{1}/_{4}$ in. (76.8 cm);
Width: 3 ft. 3$^{7}/_{8}$ in. (101.3 cm); Depth:
1 ft. 8$^{1}/_{4}$ in. (51.4 cm); Opened Height:
2 ft. 5$^{1}/_{8}$ in. (74 cm); Width: 3 ft. 3$^{7}/_{8}$ in.
(101.3 cm); Depth: 3 ft. 4 in. (101.6 cm)
Accession number 75.DA.2

PROVENANCE

Jane, Countess of Westmorland (wife of the
10th Earl, married 1800, died 1857), Cotter-
stock Hall, Northamptonshire, from the late
eighteenth century; Lieutenant Colonel Hon.
Henry Fane (son of Jane, Countess of West-
morland; died 1904), Cotterstock Hall; Henry
Dundas, 5th Viscount Melville (cousin of

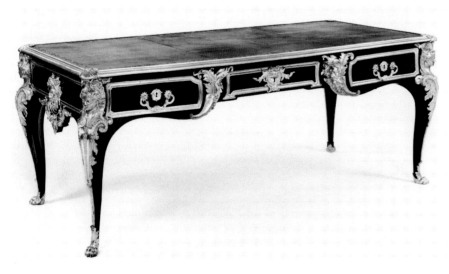

Hon. Henry Fane), Cotterstock Hall; Dundas family, Melville Castle, Scotland, until 1967; [Alexander and Berendt, Ltd., London]; [French and Co., New York]; purchased by J. Paul Getty.

BIBLIOGRAPHY

Bremer-David, *Summary*, no. 62, p. 49, illus.

60.
TABLE (*BUREAU PLAT*)
 Paris, circa 1735
 Attributed to Charles Cressent
 Oak veneered with tulipwood; gilt-bronze mounts; modern leather top
 Height: 2 ft. 7⁷/₈ in. (81 cm); Width: 6 ft. 4¹/₄ in. (193.7 cm); Depth: 3 ft. 1¹/₂ in. (95.2 cm)
 Accession number 55.DA.3

PROVENANCE

F. F. Uthemann, St. Petersburg, late nineteenth century; in Helsinki by 1921; Sir Robert Abdy; Edith and Sir Alfred Chester Beatty (1875–1968), London; purchased by J. Paul Getty.

EXHIBITIONS

Oslo, Norway, The Nasjonalgalleriet, on loan, 1921–1923.

BIBLIOGRAPHY

Alexandre Benois, "La collection de M. Utheman à St.-Petersbourg," *Starye gody* (April 1908), p. 181, illus.; Getty, *Collecting*, p. 143, illus. p. 142; Fredericksen et al., *Getty Museum*, p. 153, illus.; Kjellberg, *Dictionnaire*, p. 204; Alexandre Pradère, "Le Maître aux Pagodes," *L'Estampille/L'Objet d'art* 256 (March 1992), pp. 22–44, illus. p. 35, fig. 17, p. 36, and no. 22, p. 43; L'Abbé d'Arrides, "Les Commodes Tombeaux," *L'Estampille/L'Objet d'art* 260 (July/August 1992), pp. 50–65, illus.; Bremer-David, *Summary*, no. 63, p. 50, illus.

61.
TABLE (*BUREAU PLAT*)
 Paris, circa 1745
 Attributed to Joseph Baumhauer
 Oak and ash veneered with bloodwood; gilt-bronze mounts; modern leather top
 All mounts are stamped with the crowned C for 1745–1749.
 Height: 2 ft. 7¹/₁₆ in. (78.9 cm); Width: 5 ft. 11³/₈ in. (181.3 cm); Depth: 3 ft. 3⁵/₈ in. (100.7 cm)
 Accession number 71.DA.95

PROVENANCE

Empress Elizabeth of Russia (?), given to her by Louis XV, 1745, or purchased by Count Vorontsov, St. Petersburg, in Paris, 1745; Empress Catherine II of Russia by descent, 1762, or purchased with the Vorontsov Palace; Helen, Duchess of Mecklenburg-Strelitz (Princess of Saxe-Altenburg), *Cabinet de la Souveraine*, Chinese Palace, Oranienbaum (near St. Petersburg), by 1904; sold by the Soviet government to [Duveen Brothers, New York, 1931]; Anna Thomson Dodge, Rose Terrace, Grosse Pointe Farms, Michigan, by 1935 (sold, Christie's, London, June 24, 1971, lot 98); purchased at that sale by J. Paul Getty.

EXHIBITIONS

St. Petersburg, *Exposition rétrospective d'objets d'art à Saint-Petersbourg*, Adrien Prachoff, 1904, pp. 229, 231, illus. p. 232.

BIBLIOGRAPHY

Denis Roche, *Le Mobilier français en Russie* (Paris, 1912), vol. 1, pl. 18; Duveen and Co., *A Catalogue of Works of Art of the Eighteenth Century in the Collection of Anna Thomson Dodge* (Detroit, 1933), p. ix, illus.; André Boutemy, "B.V.R.B. et la morphologie de son style," *Gazette des beaux-arts* 49 (March 1957), pp. 165–174, illus. p. 174; André Boutemy, "L'Ebéniste Joseph Baumhauer," *Connaissance des arts* 157 (March 1965), illus. p. 88; Anthony Coleridge, "Works of Art with a Royal Provenance from the Collection of the late Mrs. Anna Thomson Dodge," *Connoisseur* 177, no. 711 (May 1971), pp. 34–36, illus. p. 35; Fredericksen et al., *Getty Museum*, p. 186, illus.; Jean-Dominique Augarde, "1749 Joseph Baumhauer, ébéniste privilegié du roi," *L'Estampille* 204 (June 1987), pp. 15–45, fig. 3; Bremer-David, *Summary*, no. 64, pp. 50–51, illus. p. 50.

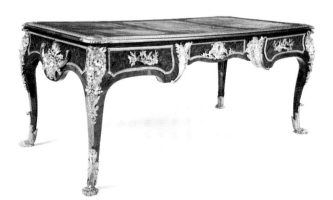

60

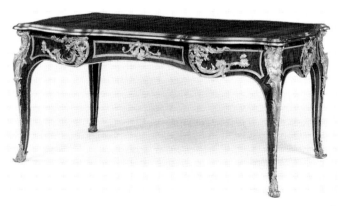

61

62

62.

TABLE (BUREAU PLAT)

Paris, circa 1745–1749
By Bernard II van Risenburgh
Oak veneered with tulipwood and ebony;
gilt-bronze mounts; modern leather top
Stamped with B.V.R.B. underneath; some
mounts are stamped with the crowned C for
1745–1749.
Height: 2 ft. 7 in. (78.7 cm); Width: 5 ft.
4½ in. (163.8 cm); Depth: 2 ft. 7⅜ in.
(79.6 cm)
Accession number 78.DA.84

PROVENANCE

Henry Hirsch, London (sold, Christie's, London, June 11, 1931, lot 171); [J. M. Botibol, London, 1931]; purchased by J. Paul Getty, by 1940; distributed to the estate of J. Paul Getty to the J. Paul Getty Museum.

BIBLIOGRAPHY

J. Paul Getty, Europe in the Eighteenth Century (Chicago, 1949), illus. unnumbered pl. between pp. 56–57; J. Paul Getty, Collector's Choice (London, 1955), p. 171; André Boutemy, "B.V.R.B. et la morphologie de son style," Gazette des beaux-arts 49 (March 1957), pp. 165–167; Barry Shifman, "A Newly Found Table by Edward Holmes Baldock," Apollo 119 (January 1984), pp. 38–42, illus.; Kjellberg, Dictionnaire, p. 139; Bremer-David, Summary, no. 65, p. 51, illus.

63.

MECHANICAL WRITING AND TOILET TABLE

Paris, circa 1750
By Jean-François Oeben
Oak veneered with bloodwood, amaranth,
kingwood, holly, and ebony; drawer of
juniper; iron mechanism; gilt-bronze mounts
Stamped with J. F. OEBEN and JME underneath.
Height: 2 ft. 4¾ in. (73 cm); Width:
2 ft. 5⅛ in. (73.9 cm); Depth: 1 ft. 2⅞ in.
(37.8 cm)
Accession number 70.DA.84

PROVENANCE

[B. Fabre et Fils, Paris]; [Cameron in partnership with B. Fabre et Fils, London]; purchased by J. Paul Getty, 1949.

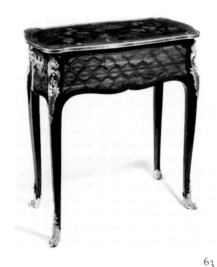

63

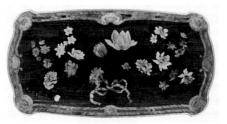

63 Top

BIBLIOGRAPHY

Paul Wescher, "French Furniture of the Eighteenth Century in the J. Paul Getty Museum," Art Quarterly 18, no. 2 (Summer 1955), no. 1, p. 118, illus. p. 124; J. Paul Getty, Collector's Choice (London, 1955), pp. 167–168, illus. unnumbered pl. between pp. 88–89; "Vingt Mille Lieues dans les musées," Connaissance des arts 57 (November 1956), pp. 76–81, illus. p. 80; André Boutemy, "Les Tables-Coiffeuses de Jean-François Oeben," Bulletin de la Société de l'Histoire de l'Art français (December 1962), pp. 101–116; Verlet et al., Chefs d'oeuvre, p. 123, illus.; André Boutemy, "Jean-François Oeben Méconnu," Gazette des beaux-arts 63 (April 1964), pp. 207–224, illus. p. 215, fig. 23; Getty, Collecting, p. 153, illus.; Fredericksen et al., Getty Museum, p. 163, illus.; Kjellberg, Dictionnaire, p. 619; Bremer-David, Summary, no. 66, p. 51, illus.; Ramond, Chefs d'oeuvre III, pp. 15–19, illus.

64.

WRITING AND TOILET TABLE

Paris, circa 1754
By Jean-François Oeben
Oak veneered with kingwood, tulipwood, amaranth, boxwood, holly, barberry, stained hornbeam, Ceylon satinwood, fruitwood, padouk, natural and stained maple; leather; silk fabric lining; gilt-bronze mounts
Stamped with J. F. OEBEN twice underneath table and inscribed in ink No. 4. Label underneath table printed Mrs John D. Rockefeller, Jr.; label inside drawer is inked with C. 6478/J.D.R.JNR/10 West Fifty-fourth Street, New York.
Height: 2 ft. 4 in. (71.1 cm); Width:
2 ft. 7½ in. (80 cm); Depth: 1 ft. 4⅞ in.
(42.8 cm)
Accession number 71.DA.103

PROVENANCE

John George Murray (1871–1917), Marquess of Tullibardine, 8th Duke of Atholl, Scotland; Mary Gavin (Hon. Mrs. Robert Baillie-Hamilton), by inheritance; Lady Harvey, London, by inheritance; [Lewis and Simmons, Paris]; Judge Elbert H. Gary (1846–1927),

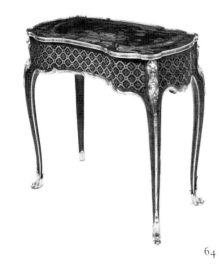

64

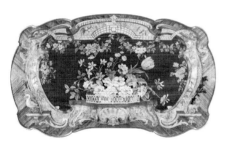

64 *Top*

New York (sold, American Art Association, April 21, 1928, lot 272, when the above provenance was given); [Duveen Brothers, New York]; [Raymond Kraemer, Paris]; Mrs. John D. Rockefeller, Jr. (sold, Parke-Bernet, New York, October 23, 1971, lot 712); [The Antique Porcelain Co., New York]; purchased by J. Paul Getty.

BIBLIOGRAPHY

Fredericksen et al., *Getty Museum*, p. 162, illus.; Wilson, "Meubles 'Baroques,'" p. 111, illus.; Wilson, *Selections*, no. 27, pp. 54–55, illus.; Pradère, *Les Ebénistes*, illus. p. 255, fig. 264; Kjellberg, *Dictionnaire*, p. 619; Bremer-David, *Summary*, no. 67, p. 52, illus.; Ramond, *Chefs d'oeuvres* II, pp. 31, 148–153, illus.; Joseph Godla and Gordon Hanlon, "Some Applications of Adobe Photoshop for the Documentation of Furniture Conserva-

tion," *Journal of the American Institute for Conservation* 34 (Fall/Winter 1995), fig. 12, p. 169, illus.; Leora Auslander, *Taste and Power: Furnishing Modern France* (Berkeley, 1996), p. 55, illus.; *Masterpieces*, no. 75, p. 97, illus.; *Baroque and Rococo Lacquers*, Katherina Walch and Johann Koller, eds. (Munich, 1997), p. 256, illus.; Ramond, *Chefs d'oeuvres* III, pp. 12–13, illus.; *Handbook* 2001, p. 216, illus.

65.
WRITING TABLE

Paris, circa 1755
By Bernard II van Risenburgh
Oak and pine veneered with tulipwood, kingwood, amaranth, and laburnum; gilt-bronze mounts; modern leather panel
Stamped with B.V.R.B. and JME twice under the front rail. A label pasted underneath is printed with *Londesborough* under a coronet. Another label is printed with J. J. ALLEN, Ltd., Furniture Depositories, LONDON and stenciled with Countess Londesborough.
Height: 2 ft. 5 1/2 in. (74.9 cm); Width: 3 ft. 1 7/8 in. (96.2 cm); Depth: 1 ft. 10 11/16 in. (57.6 cm)
Accession number 65.DA.1

PROVENANCE

Lady Grace Adelaide Fane (Countess of Londesborough, wife of the 2nd Earl, married 1887, died 1933), London (sold by her heirs, Hampton and Sons, London, July 24, 1933, lot 123); [J. M. Botibol, London, by 1937]; purchased by J. Paul Getty, 1938.

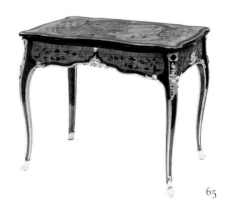

65

BIBLIOGRAPHY

J. Paul Getty, *Europe in the Eighteenth Century* (Chicago, 1949), illus. unnumbered pl. between pp. 56–57; J. Paul Getty, *Collector's Choice* (London, 1955), pp. 147–148; Paul Wescher, "French Furniture of the Eighteenth Century in the J. Paul Getty Museum," *Art Quarterly* 18, no. 2 (Summer 1955), p. 121, illus. p. 124; Verlet et al., *Chefs d'oeuvre*, p. 119, illus.; Gerald Messadié, "J. Paul Getty, Malibu, California," *Great Private Collections*, Douglas Cooper, ed. (Zurich, 1963), pl. 189, illus.; Getty, *Collecting*, p. 149, illus.; F. J. B. Watson, *The Wrightsman Collection* (New York, 1966), vol. 2, p. 309; Pierre Verlet, *Styles, meubles, décors, du Moyen Âge à nos jours* (Paris, 1972), Tome 1, pl. 234, illus.; Fredericksen et al., *Getty Museum*, p. 189, illus.; Kjellberg, *Dictionnaire*, p. 139; Bremer-David, *Summary*, no. 68, pp. 52–53, illus. p. 52.

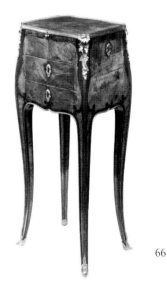

66

66.
TABLE

Paris, circa 1760
By Adrien Faizelot-Delorme
Oak veneered with amaranth and green-stained burr yew; modern silver fittings in drawer for ink, sand, and sponge; gilt-bronze mounts
Stamped with DELORME twice and JME once on drawer panel.

Height: 2 ft. 3¹/₈ in. (68.9 cm); Width: 11⁵/₈ in. (29.4 cm); Depth: 9⁵/₈ in. (24.4 cm)
Accession number 72.DA.64

PROVENANCE

Paris art market, early 1970s; [Rosenberg and Stiebel, Inc., New York, 1972]; purchased by J. Paul Getty.

BIBLIOGRAPHY

Wilson, "Meubles 'Baroques,'" p. 110, illus.; Bremer-David, *Summary*, no. 69, p. 53, illus.

67.
CARD TABLE

Paris, circa 1760
By Jean-François Oeben
Oak veneered with bloodwood, kingwood, maple, tulipwood, walnut, holly, and maple burl; gilt-bronze mounts
Stamped with J. F. OEBEN.
Height: 2 ft. 3³/₄ in. (70.5 cm); Width: 2 ft. 9¹/₂ in. (85 cm); Depth: 1 ft. 2¹/₂ in. (36.8 cm)
Accession number 71.DA.105

PROVENANCE

Probably purchased by Sir Charles Mills or his son Charles Henry, created Lord Hillingdon in 1886, Essex; Charles, 4th Lord Hillingdon (born 1922), Essex, by descent

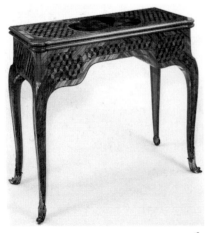

67

(sold, Christie's, London, May 14, 1970, lot 102); [Frank Partridge, Ltd., London, 1970]; [French and Co., New York]; purchased by J. Paul Getty.

BIBLIOGRAPHY

Fredericksen et al., *Getty Museum*, p. 161, illus.; Bremer-David, *Summary*, no. 70, p. 53, illus.; Ramond, *Chefs d'oeuvre* II, pp. 108–109, illus.

68.
TOILET TABLE

Paris, circa 1760–1765
Attributed to Jean-François Leleu
Oak veneered with amaranth, holly, walnut, spindle tree wood, maple, tulipwood, and bloodwood; gilt-bronze mounts
The number 499 is cast into the reverse of each corner mount. A paper label inked with B.F.A.C. 1913 Meyer Sassoon Esq. is inside drawer. There is a paper label printed with BURLINGTON FINE ARTS CLUB EXHIBITION OF THE FRENCH SCHOOL OF THE XVIIITH CENT. 1913, and another label inked with *Mr. A. Barker présenté par M. Chenue, 24 Ruedes petits Champs.....* underneath the table.
Height: 2 ft. 3⁵/₈ in. (70.2 cm); Width: 1 ft. 10³/₈ in. (56.9 cm); Depth: 1 ft. 3⁷/₈ in. (40.3 cm)
Accession number 72.DA.49

PROVENANCE

[Alexander Barker], probably acquired in Paris (sold, Christie's, London, June 11, 1874, lot 693); Edmund (?), 1st Lord Grimsthorpe (1816–1905); Leopold George Frederick, 5th Viscount Clifden (sold, Robinson and Fisher, May 21 et seq., 1895, lot 606, to [Seligmann, Paris] for 750 guineas); Mr. and Mrs. Meyer Sassoon, Pope's Manor, Berkshire; Violet Sassoon (Mrs. Derek C. Fitzgerald), Heathfield Park, Sussex (offered for sale, Sotheby's, London, November 22, 1963, lot 132, bought in); (sold, Christie's, London, March 23, 1972, lot 88); purchased at that sale by J. Paul Getty.

EXHIBITIONS

London, Burlington Fine Arts Club, 1913; London, Morton Lee and Mallet and Sons, *The Royal Cabinetmakers of France*, July 1951, no. 8, illus.

BIBLIOGRAPHY

F. Lewis Hinckley, *Directory of the Historic Cabinet Woods* (New York, 1960), p. 166 illus.; Bremer-David, *Summary*, no. 72, pp. 54–55, illus. p. 55; Ramond, *Chefs d'oeuvre* II, pp. 158–159, illus.

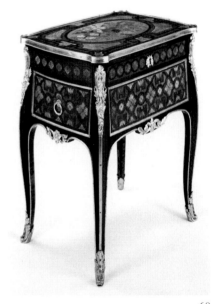

68

69.
CONSOLE TABLE

Paris, circa 1765–1770
After a model by Pierre Deumier, following a design by Victor Louis
Silvered and gilt bronze; *bleu turquin* marble top; modern marbelized base
Each gilt-bronze element is stamped with the letter B.
Height: 2 ft. 8⁷/₈ in. (83.5 cm); Width: 4 ft. 3 in. (129.5 cm); Depth: 1 ft. 8¹/₂ in. (52 cm)
Accession number 88.DF.118

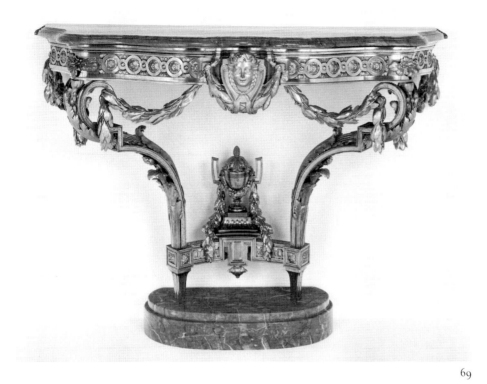

69

[French and Co., New York, 1919]; Morti-
mer L. Schiff, New York, 1919 (sold by his
heir John M. Schiff, Christie's, London,
June 22, 1938, lot 52); purchased at that sale
by J. Paul Getty.

BIBLIOGRAPHY
J. Paul Getty, *Europe in the Eighteenth Century*
(Chicago, 1949), illus. unnumbered pl.
between pp. 56–57; J. Paul Getty, *Collector's
Choice* (London, 1955), illus. unnumbered pl.
between pp. 176–177; Verlet et al., *Chefs
d'oeuvre*, p. 128, illus.; F. J. B. Watson, *The
Wrightsman Collection* (New York, 1968), vol. 1,
p. 282; Savill, *Sèvres*, vol. 2, p. 877, notes 35,
38, p. 900; Pradère, *Les Ebénistes*, no. 70,
p. 359; Kjellberg, *Dictionnaire*, pp. 158, 162;
Gillian Wilson, "Dalla Raccolta del Museo
J. Paul Getty," part 3, *Casa Vogue Antiques* 10
(November, 1990), pp. 90–95; Sassoon, *Vin-
cennes and Sèvres Porcelain*, no. 33, pp. 166–169,
illus. pp. 167–169; Bremer-David, *Summary*,
no. 74, p. 56, illus.; Catherine Faraggi, "Le
Goût de la Duchess de Mazarin," *L'Estampille/
L'Objet d'art* 287 (January, 1995), p. 95,
pl. 20, illus.

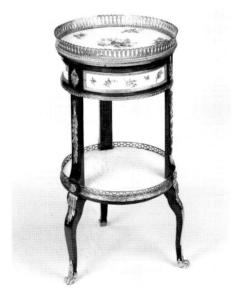

70

PROVENANCE
Arturo Lopez-Willshaw, Paris (sold,
Sotheby's, Monaco, June 23, 1976, no. 108);
purchased at that sale by The British Rail
Pension Fund.

BIBLIOGRAPHY
François-Georges Pariset, "Jeszcze o Pracach
Wiktora Louisa Dla Zamku Warszaw-
skiego," *Biuletyn Historii Sztuki*, Nr. 2, Rok 24
(1962), pp. 141, 154; Svend Eriksen, *Early
Neo-Classicism in France* (London, 1974), p. 391;
"Acquisitions/1988," *GettyMusJ* 17 (1989),
no. 73, p. 142, illus.; Gillian Wilson, "Dalla
Raccolta del Museo J. Paul Getty," Part 3,
Casa Vogue Antiques 10 (November 1990),
pp. 90–95, illus. p. 94; David Harris Cohen,
"The Chambre des Portraits Designed by
Victor Louis for the King of Poland,"
GettyMusJ 19 (1991), pp. 75–98, illus. p. 89,
fig. 23a; Bremer-David, *Summary*, no. 73,
p. 55, illus.; *Masterpieces*, no. 81, p. 104, illus.;
Handbook 2001, p. 218, illus.

70.
TABLE

Table: Paris, circa 1770; porcelain: Sèvres
manufactory, 1764
Attributed to Martin Carlin
Oak veneered with tulipwood, ebony, and
holly; set with four soft-paste porcelain
plaques; gilt-bronze mounts; white marble
lower shelf
The circular porcelain plaque is painted on
the reverse with the blue crossed L's of the
Sèvres manufactory enclosing the date letter
L for 1764.
Height: 2 ft. 3 3/4 in. (70.5 cm); Diameter:
1 ft. 3 3/8 in. (39.1 cm)
Accession number 70.DA.74

PROVENANCE
Alfred (Charles) de Rothschild (1842–1918),
Halton, Buckinghamshire, after 1884; Almina
Wombwell (daughter of Alfred de Roth-
schild, Countess of Carnarvon, wife of
the 5th Earl, married 1895, died 1969), 1918;
[Henry Symons and Co., London, 1919];

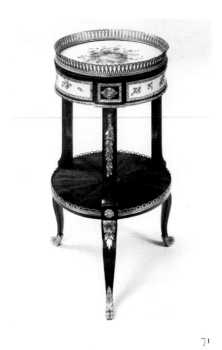

71

71.
TABLE

Table: Paris, circa 1773; porcelain: Sèvres
manufactory, 1773
Table by Martin Carlin; circular porcelain
plaque attributed to Jacques-François Micaud
Oak veneered with tulipwood, holly,
and ebony; set with four soft-paste porcelain
plaques; gilt-bronze mounts
Table is stamped with M. CARLIN and JME
underneath. Circular plaque is painted with
the blue crossed L's of the Sèvres manufac-
tory, the date 1773, and the painter's mark X.
Height: 2 ft. 5 in. (73.5 cm); Diameter:
1 ft. 3 3/4 in. (40 cm)
Accession number 70.DA.75

PROVENANCE
Alfred (Charles) de Rothschild (1842–1918),
Halton, Buckinghamshire, after 1884; Almina
Wombwell (daughter of Alfred de Roth-
schild; Countess of Carnarvon, wife of the
5th Earl, married 1895, died 1969), 1918;
[Henry Symons and Co., London, 1920];
[French and Co., New York, 1920]; Morti-
mer L. Schiff, New York, 1920 (sold by his

heir John L. Schiff, Christie's, London,
June 22, 1938, lot 51); purchased at that sale
by J. Paul Getty.

BIBLIOGRAPHY
J. Paul Getty, *Europe in the Eighteenth Century*
(Chicago, 1949), illus. unnumbered pl.
between pp. 56–57; J. Paul Getty, *Collector's
Choice* (London, 1955), p. 82, illus. unnum-
bered pl. between pp. 176–177; Verlet et al.,
Chefs d'oeuvre, p. 128, illus.; Getty, *Collecting*,
p. 158; F. J. B. Watson, *The Wrightsman Collec-
tion* (New York, 1968), vol. 1, p. 282; Fred-
ericksen et al., *Getty Museum*, p. 165, illus.;
Dorothée Guillemé-Brulon, "Un décor pour
les meubles," *L'Estampille* 165 (January, 1984),
pp. 18–30, illus. p. 24; Pradère, *Les Ebénistes*,
no. 69, p. 359; Kjellberg, *Dictionnaire*,
pp. 158, 162; Gillian Wilson, "Dalla Rac-
colta del Museo J. Paul Getty," Part 3, *Casa
Vogue Antiques* 10 (November, 1990), pp. 90–
95; Sassoon, *Vincennes and Sèvres Porcelain*,
no. 34, pp. 170–172, illus. pp. 171–173;
Bremer-David, *Summary*, no. 75, pp. 56–57,
illus. p. 56; Ramond, *Chefs d'oeuvre* II,
pp. 124–126, illus.; Carolyn Sargentson, *Mer-
chants and Luxury Markets: The Marchands Merciers
of Eighteenth-Century Paris* (Malibu, 1996),
pp. 49 and 182, illus. p. 50.

72.
MUSIC STAND

Paris, circa 1770–1775
Attributed to Martin Carlin
Oak veneered with tulipwood, amaranth,
holly, and fruitwood; incised with colored
mastics; gilt-bronze mounts
Stamped with JME under oval shelf.
Maximum Height: 4 ft. 10 1/2 in. (148.6 cm);
Minimum Height: 3 ft. 1 in. (94.2 cm);
Width: 1 ft. 7 3/4 in. (50.2 cm); Depth:
1 ft. 2 1/2 in. (36.8 cm)
Accession number 55.DA.4

PROVENANCE
Sir Robert Abdy, Bt., London; Edith and Sir
Alfred Chester Beatty (1875–1968), London;
purchased by J. Paul Getty.

BIBLIOGRAPHY
Paul Wescher, "An Inlaid Music Stand by
Martin Carlin and Related Pieces," *Bulletin of
the J. Paul Getty Museum of Art*, vol. 1, no. 2
(1959), pp. 16–32, illus.; F. J. B. Watson,
Louis XVI Furniture (New York, 1960), no. 125,
pp. 130–131, illus.; Verlet et al., *Chefs d'oeuvre*,
pp. 125–126, illus.; Getty, *Collecting*, p. 156,
illus.; Fredericksen et al., *Getty Museum*,
p. 177, illus.; Bremer-David, *Summary*, no. 76,
p. 57, illus.; Ramond, *Chefs d'oeuvre* II,
pp. 178–179, illus.; *Masterpieces*, no. 83,
p. 106, illus.

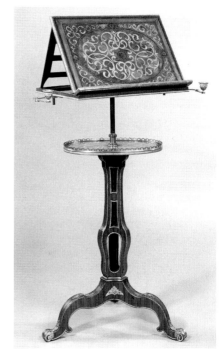

72

73.

TABLE (*BUREAU PLAT*)

Paris, 1777
By Jean-Henri Riesener
Oak and fir veneered with bloodwood, amaranth, and stained maple; gilt-bronze mounts; modern leather top
Underside of table is painted in black with the partly obliterated French royal inventory mark No. 2905. Stamped under same panel, in the form of a circle that is half cut away, with [GARDE-MEUB]LE DE LA REINE enclosing the monogram MA. Also painted underneath table is a crown that originally appeared over the letters CT, which are now cut away.
Height: 2 ft. 5 1/2 in. (74.9 cm); Width: 4 ft. 5 1/2 in. (135.9 cm); Depth: 2 ft. 3 7/8 in. (70.8 cm)
Accession number 71.DA.102

PROVENANCE

Ordered by Marie-Antoinette for the cabinet of Louis XVI in the Petit Trianon, Versailles, and delivered on August 6, 1777 (sold, Versailles, August 25, 1793 to August 11, 1794, no. 828, for 600 *livres* to Dumont); [Frank Partridge and Sons, Ltd., London, 1967–1971]; purchased by J. Paul Getty.

BIBLIOGRAPHY

Geoffrey de Bellaigue, *The James A. de Rothschild Collection at Waddesdon Manor: Furniture, Clocks and Gilt Bronzes* (Fribourg, 1974), vol. 1, no. 69, p. 351; vol. 2, no. 103, p. 508; Fredericksen et al., *Getty Museum*, p. 174, illus.; Gillian Wilson, "The J. Paul Getty Museum, 7^ème partie: Le Mobilier Louis XVI," *Connaissance des arts* 280 (June 1975), p. 94, illus.; Christian Baulez and Denise Ledoux-Lebard, *Il Mobile Francese dal Luigi XVI all'art decó* (Milan, 1981), p. 12, fig. 12; Jacques Charles et al., *De Versailles à Paris: Le Destin des collections royales* (Paris, 1989), illus. p. 191; Kjellberg, *Dictionnaire*, p. 712; Pierre Verlet, *Le Mobilier royal français, vol. 4: Meubles de la couronne conservés en Europe et aux États-Unis* (Paris, 1990), pp. 80–82, illus. pp. 11, 81; Bremer-David, *Summary*, no. 77, pp. 57–58, illus. p. 57.

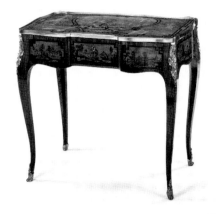

74

74.

TOILET TABLE

Paris, circa 1777–1780
Fir and pine veneered with tulipwood, bloodwood, walnut and holly; gilt-bronze mounts
Height: 2 ft. 4 1/8 in. (71.3 cm); Width: 2 ft. 7 3/4 in. (80.6 cm); Depth: 1 ft. 4 3/4 in. (42.5 cm)
Accession number 72.DA.67

PROVENANCE

(Albert) Harry Primrose, 6th Earl of Rosebery; (sold, Christie's, London, December 2, 1971, lot 112); [French and Co., New York, 1971]; purchased by J. Paul Getty.

EXHIBITIONS

Williamstown, Massachusetts, Sterling and Francine Clark Art Institute, on loan, 1998–present.

BIBLIOGRAPHY

Geoffrey de Bellaigue, *The James A. de Rothschild Collection at Waddesdon Manor: Furniture, Clocks and Gilt Bronzes* (Fribourg, 1974), vol. 2, pp. 498–499; Bremer-David, *Summary*, no. 78, p. 58, illus.; Ramond, *Chefs d'oeuvre 11*, pp. 172–175, illus.; Leora Auslander, *Taste and Power: Furnishing Modern France* (Berkeley, 1996), p. 74, illus.

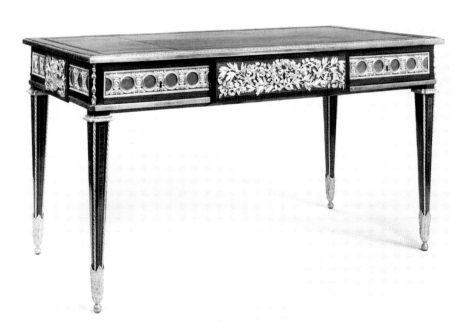

75.
WRITING TABLE (*BUREAU PLAT*)

Table: Paris, circa 1778; porcelain: Sèvres manufactory, circa 1778
The table by Martin Carlin; at least seven Sèvres porcelain plaques gilded by Jean-Baptiste-Emmanuel Vandé *père*
Oak veneered with tulipwood; set with fourteen soft-paste porcelain plaques; gilt-bronze mounts; modern leather top
Stamped with M. CARLIN (partly effaced) and JME under front right rail. Printed paper trade label of Dominique Daguerre underneath left rear rail; three Russian inventory numbers are painted on carcass; central drawer contains a paper label inked with the twentieth-century Duveen inventory number 29615. Porcelain plaques are marked variously (not all are marked) with the crossed L's of the Sèvres manufactory in red, the date letters AA for 1778, Vandé's mark VD, and paper labels printed with the crossed L's and inked with the prices of 30 and 96 [*livres*].

Height: 2 ft. 6 1/2 in. (77.5 cm); Width: 4 ft. 3 5/8 in. (131.2 cm); Depth: 2 ft. 3/8 in. (62 cm)
Accession number 83.DA.385

PROVENANCE
Grand Duchess Maria Feodorovna of Russia (later czarina to Paul I), purchased in 1782 from the *marchand-mercier* Dominique Daguerre in Paris, installed in her *chambre à coucher* at Pavlovsk Palace (near St. Petersburg), Russia; Russian Imperial Collections, Palace of Pavlovsk; [Duveen and Co., New York], purchased in 1931 from the Soviet government; Anna Thomson Dodge, Rose Terrace, Grosse Pointe Farms, Michigan, 1931 (sold, Christie's, London, June 24, 1971, lot 135); Habib Sabet, Geneva, 1971 (sold, Christie's, London, December 1, 1983, lot 54).

BIBLIOGRAPHY
Alexandre Benois, *Les Trésors d'art en Russie* (St. Petersburg, 1907), vol. 7, p. 186, pl. 20;

Denis Roche, *Le Mobilier français en Russie* (Paris, 1913), vol. 2, pl. 55; Duveen and Co., *A Catalogue of Works of Art of the Eighteenth Century in the Collection of Anna Thomson Dodge* (Detroit, 1933), introduction p. vii and non-paginated entry, illus.; Duveen and Co., *A Catalogue of Works of Art in the Collection of Anna Thomson Dodge* (Detroit, 1939), vol. 1, introduction pp. xv–xvi and non-paginated entry, illus.; Carl Dauterman et al., *Decorative Art from the S. H. Kress Collection at the Metropolitan Museum of Art* (London, 1964), pp. 112, 114, 130; F. J. B. Watson, *The Wrightsman Collection* (New York, 1966), vol. 1, pp. 189 and 190; Jean-Luc de Rudder, "Martin Carlin: Ébéniste Précieux," *L'Estampille* 22 (April 1971), p. 65, illus.; Anthony Coleridge, "Works of Art with a Royal Provenance from the Collection of the Late Mrs. Anna Thomson Dodge," *Connoisseur* 177, no. 711 (May, 1971), pp. 34–36, illus.; Sassoon, "Acquisitions 1983," no. 10, pp. 201, 204–207, illus.; "Acquisitions/1983" *GettyMusJ* 12 (1984), no. 12, pp. 265–266, illus.; Jackson-Stops, "Boulle by the Beach," pp. 854–856; *Handbook 1986*, p. 174, illus.; Savill, *Sèvres*, vol. 2, p. 887; notes 83, 87 on p. 901; Pradère, *Les Ebénistes*, no. 39, p. 358; Kjellberg, *Dictionnaire*, pp. 160, 162, illus. p. 157; Daniel Alcouffe, "Secrétaire à abbattant," *Louvre: Nouvelles Acquisitions du département des objets d'art, 1985–1989* (Paris, 1990), p. 154, illus.; Gillian Wilson, "Dalla Raccolta del Museo J. Paul Getty," Part 3, *Casa Vogue Antiques* 10 (November, 1990), pp. 90–95; Sassoon, *Vincennes and Sèvres Porcelain*, no. 39, pp. 188–192, illus. pp. 189–192; John Whitehead, *The French Interior in the Eighteenth Century* (London, 1992), p. 46 [illus. trade label only]; Bremer-David, *Summary*, no. 79, pp. 58–59, illus. p. 59; Carolyn Sargentson, *Merchants and Luxury Markets: The Marchands Merciers of Eighteenth-Century Paris* (London, 1996), pp. 48–49, 181 and pl. 6, illus.

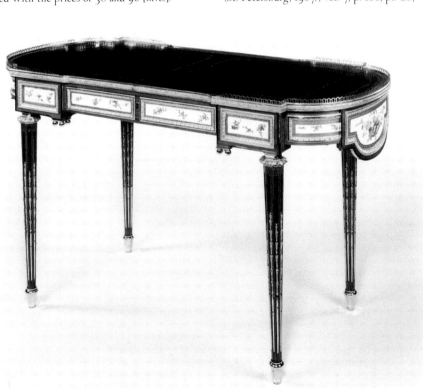

Carved Tables

76.
TABLE

French, circa 1660–1670
Gessoed and gilded walnut; modern paint
Height: 2 ft. 8 1/2 in. (82.5 cm); Width:
3 ft. 3 1/2 in. (100.3 cm); Depth: 2 ft. 3 in.
(68.5 cm)
Accession number 87.DA.7

PROVENANCE
[Bernard Steinitz, Paris, 1986].

BIBLIOGRAPHY
"Acquisitions/1987," *GettyMusJ* 16 (1988),
no. 65, p. 176; Bremer-David, *Summary*,
no. 80, p. 59, illus.

76

77.
TABLE OR STAND

Paris, circa 1700–1715
Gessoed and gilded oak, ash and Scots pine;
modern top
Height: 2 ft. 4 1/2 in. (72.5 cm); Width: 2 ft.
6 1/2 in. (77 cm); Depth: 1 ft. 8 1/2 in. (52 cm)
Accession number 90.DA.23

PROVENANCE
Private collection, England; London art mar-
ket; [B. Fabre et Fils, Paris, 1989].

BIBLIOGRAPHY
"Acquisitions/1990," *GettyMusJ* 19 (1991),
no. 55, p. 161, illus.; Bremer-David, *Summary*,
no. 81, p. 60, illus.

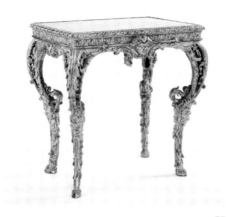

77

78.
CONSOLE TABLE

Paris, circa 1725
Gessoed and gilded oak; *lumachella pavonazza*
marble top
Pasted under back rail, the remains of a
printed label, *102, George Street, Portman
Square, W 1*.
Height: 2 ft. 10 3/8 in. (87.3 cm); Width:
4 ft. 11 7/8 in. (152.1 cm); Depth: 1 ft. 11 1/4 in.
(59.1 cm)
Accession number 72.DA.68

PROVENANCE
Christie Robert, London, circa 1885–1916;
Baronne Marguerite Marie van Zuylen van
Nyevelt van de Haar (d. 1970), Paris by 1964
(sold, Palais Galliera, Paris, June 8, 1971,
no. 77); [Rosenberg and Stiebel, Inc., New
York, 1972]; purchased by J. Paul Getty.

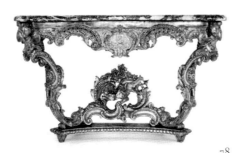

78

BIBLIOGRAPHY
Eveline Schlumberger, "En Hommage à
Gérard Mille: l'appartement qui illustre le
mieux le style baroque qui couronna sa car-
rière de décorateur," *Connaissance des arts* 146
(April 1964), illus. p. 71; Bremer-David,
Summary, no. 82, p. 60, illus.

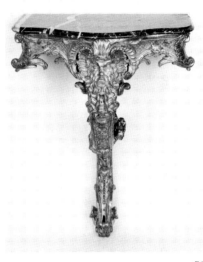

79

79.
CONSOLE TABLE

Paris, circa 1725–1730
Gessoed and gilded oak and pine; marble top
Height: 2 ft. 10 7/8 in. (87.5 cm); Width:
2 ft. 3 in. (68.5 cm); Depth: 1 ft. 3 3/4 in.
(40 cm)
Accession number 85.DA.125

PROVENANCE
[Gerard Kerin, London] (sold, Christie's,
London, July 1, 1982, lot 42); [Didier
Aaron, Paris]; [Rosenberg and Stiebel, Inc.,
New York].

BIBLIOGRAPHY
"Acquisitions/1985," *GettyMusJ* 14 (1986),
no. 194, p. 244, illus.; Bremer-David, *Sum-
mary*, no. 83, p. 60, illus.

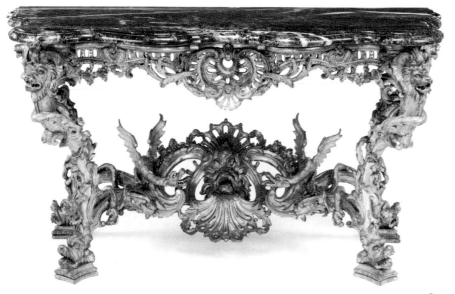

80

80.
SIDE TABLE
 Paris, circa 1730
 Gessoed and gilded oak; *brèche violette* top
 Height: 2 ft. 11 ⅛ in. (89.3 cm); Width:
 5 ft. 7 in. (170.2 cm); Depth: 2 ft. 8 in.
 (81.3 cm)
 Accession number 79.DA.68

PROVENANCE
Vicomtesse de B . . . , Paris (sold, Hôtel
Drouot, Paris, April, 26, 1923, no. 21);
[François-Gérard Seligmann, Paris].

BIBLIOGRAPHY
Wilson, "Acquisitions 1979 to mid-1980,"
no. 3, pp. 5–6, illus.; Bremer-David, *Summary*,
no. 84, p. 61, illus.; *Masterpieces*, no. 53, p. 72,
illus.; Handbook 2001, p. 198, illus.

81.
CENTER TABLE
 Top: See entry no. 412 in the Furniture, Ital-
 ian section
 Support: Paris, circa 1745
 Gessoed and gilded wood; plaster
 Height: 2 ft. 10½ in. (87.6 cm); Width:
 6 ft. 5⅝ in. (197.1 cm); Depth: 3 ft. 9⅝ in.
 (115.8 cm)
 Accession number 72.DA.58.1

PROVENANCE
Possibly Charlotte de Rothschild (1819–
1884) (Baroness Lionel Nathan, née von
Rothschild), Gunnersbury Park, Middlesex;
Alfred (Charles) de Rothschild (1842–1918),
Halton, Buckinghamshire, by 1884; by
inheritance to Lionel (Nathan) de Rothschild
(1882–1942), Exbury House, Hampshire; by
descent to Edmund (Leopold) de Rothschild
(born 1916), Exbury, Hampshire; [Frank
Partridge and Sons, Ltd., London, 1972]; pur-
chased by J. Paul Getty.

EXHIBITIONS
Los Angeles, The J. Paul Getty Museum,
Departures: Eleven Artists at the Getty, Febru-
ary 29–May 7, 2000 (support only).

BIBLIOGRAPHY
Anna Maria Giusti, *Pietre Dure: Hardstone in
Furniture and Decorations* (London, 1992),
p. 32, illus. p. 29, fig. 13; Bremer-David, *Sum-
mary*, nos. 85 and 320, pp. 61 and 189, illus.;
Anna Maria Giusti, *Pietra Dure* (Torino,
1993), p. 29, illus.; Leora Auslander, *Taste
and Power: Furnishing Modern France* (Berkeley,
1996), p. 57, illus.; Lisa Lyons, "Adrian Saxe,
1-900-ZEITGEIST," *Departures: Eleven Artists
at the Getty* (Los Angeles, 2000), pp. 52–53,
illus. p. 52.

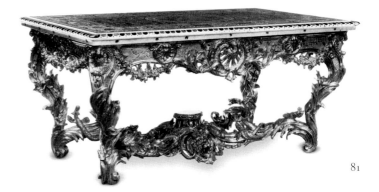

81

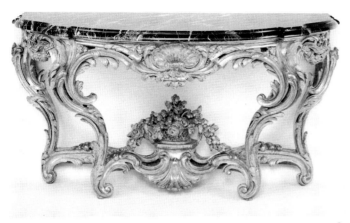

82

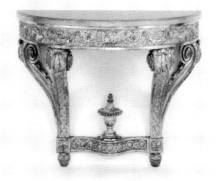

83

84

82.

CONSOLE TABLE

Paris, circa 1750–1755
Design closely related to the work of Pierre
Contant d'Ivry
Gessoed and gilded oak: modern marble top
Height (without top): 3 ft. ¹/₄ in. (92.1 cm);
Width: 5 ft. 8³/₄ in. (174.6 cm); Depth: 2 ft.
3³/₄ in. (70.5 cm)
Accession number 91.DA.21

PROVENANCE

The Barons of Hastings, Melton Constable,
Norfolk; by descent to the 21st Baron,
Sir Albert Edward Delaval (sold with the
house in 1940 to the Duke of Westminster);
Roger Gawn, Melton Constable, Norfolk
(sold, Christie's, London, December 4, 1986,
lot 96); [Jonathan Harris, London].

BIBLIOGRAPHY

Pallot, L'Art du siège, illus. p. 155; "Acquisi-
tions/1991," GettyMusJ 20 (1992), no. 77,
p. 174, illus.; "Museum Acquisitions in the
Decorative Arts: Determination and Benefi-
cence," Apollo 137, no. 371 (January 1993),
p. 32, illus.; Bremer-David, Summary, no. 86,
pp. 61–62, illus. p. 61.

83.

CONSOLE TABLE

Paris, circa 1775
Gessoed, painted, and gilded oak; bleu turquin
marble top
Height: 2 ft. 9³/₄ in. (85.7 cm); Width:
3 ft. 5¹/₄ in. (104.7 cm); Depth: 1 ft. 6¹/₄ in.
(46.3 cm)
Accession number 89.DA.29

PROVENANCE

[Kraemer et Cie, Paris].

BIBLIOGRAPHY

"Acquisitions/1989," GettyMusJ 18 (1990),
no. 56, p. 195, illus.; Bremer-David, Summary,
no. 87, p. 62, illus.

84.

CONSOLE TABLE

Paris, circa 1780
After designs by Richard de Lalonde
Painted walnut
Height: 2 ft. 9 in. (84 cm); Width: 2 ft. 9 in.
(84 cm); Depth: 1 ft. ³/₄ in. (32.5 cm)
Accession number 91.DA.16

PROVENANCE

[B. Fabre et Fils, Paris, 1990].

BIBLIOGRAPHY

"Acquisitions/1991," GettyMusJ 20 (1992),
no. 73, p. 173, illus.; Bremer-David, Summary,
no. 88, p. 62, illus.

Seat Furniture

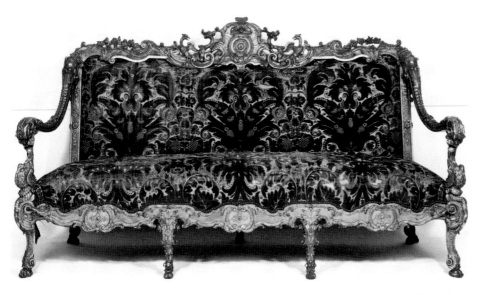

85 *One of a pair*

85.

PAIR OF SETTEES

Settee .1: French, circa 1700
Settee .2: English, circa 1830
Gessoed and gilded walnut; modern upholstery
Height: 3 ft. 10¹/₈ in. (117.1 cm); Width: 6 ft. 11³/₄ in. (212.7 cm); Depth: 2 ft. 1 in. (63.6 cm)
Accession number 78.DA.100.1–.2

PROVENANCE

Sir Ivor Churchill Guest, Viscount Wimbourne (born 1873), Ashby St. Ledgers, Northampton, England; [Frank Partridge, Ltd., London]; purchased by J. Paul Getty for Sutton Place, Surrey, 1968; distributed by the estate of J. Paul Getty to the J. Paul Getty Museum.

EXHIBITIONS

London, 25 Park Lane, *Three French Reigns*, February–April 1933, no. 529 p. 75, illus.; Woodside, California, Filoli House, on loan, 1979–1991.

BIBLIOGRAPHY

Bremer-David, *Summary*, no. 89, pp. 62–63, illus. p. 63 (one).

86.

STOOL (*TABOURET*)

Paris, circa 1710–1720
Gessoed and gilded walnut; modern leather upholstery
Stamped with GHC under each side rail.
The stool bears two paper labels, one glued to the inside of each side rail, printed with FROM THE DAVID ZORK COMPANY / *EXCLUSIVE FURNITURE AND DECORA-TION* / 201–207 North Michigan Boulevard / CHICAGO, ILLINOIS. Both paper labels are partially covered by a second, round label printed with A LA VIELLE RUSSIE / 781 FIFTH AVENUE / NEW YORK 10022 / (212) 752-1727.
Height: 1 ft. 6¹/₂ in. (47 cm); Width: 2 ft. 1 in. (63.5 cm); Depth: 1 ft. 6⁷/₈ in. (48 cm)
Accession number 84.DA.970

PROVENANCE

Pierre Crozat (1665–1740), *trésorier de France à Paris* in 1704; by descent to his niece Antoinette-Louise-Marie Crozat de Thiers, comtesse de Béthune-Pologne (1731–1809); by descent to the families of La Tour du Pin and de Chabrillan; by descent to la comtesse Armand de Caumont La Force, née Anne-Marie de Chabrillan (1894–1983) and her son, le comte Robert-Henry de Caumont La Force, at the Château de Thugny (Ardennes); [David Zork Co., Chicago, Illinois]; [A La Vieille Russie, New York, 1984].

EXHIBITIONS

Reims, France, Palais archiepiscopal, 1876, no. 267 (?), lent by M. le comte de Chabrillan.

BIBLIOGRAPHY

"Acquisitions/1984," *GettyMusJ* 13 (1985), no. 48, p. 176, illus.; Jean Feray, "Le Mobilier Crozat," *Connaissance des arts* 429 (November 1987), pp. 67–68, note 2; "The Crozat Suite," *Christie's Review of the Season 1988* (Oxford, 1989), pp. 214–215; Daniel Alcouffe, "Les Récentes acquisitions des musées nationaux, Musée du Louvre, 'Deux fauteuils du mobilier Crozat,'" *La Revue du Louvre et des musées de France* 4 (1989), p. 264; Daniel Alcouffe, "Paire de Fauteuils," *Louvre: Nouvelles acquisitions du département des objets d'art, 1985–1989* (Paris, 1990), no. 67, pp. 140–142; Bremer-David, *Summary*, no. 90, p. 63, illus.; Bill G. B. Pallot, *Furniture Collections in the Louvre* (Dijon, 1993), vol. 2, p. 33; *Masterpieces*, no. 48, p. 66, illus.

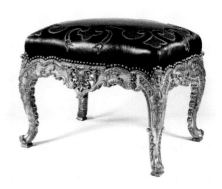

86

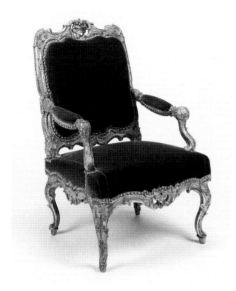

87 *One of four*

87.
FOUR ARMCHAIRS (*FAUTEUILS À LA REINE*)
 Paris, circa 1735
 Gessoed and gilded beech; modern silk velvet
 upholstery
 Height: 3 ft. 5 1/4 in. (104.8 cm); Width:
 2 ft. 1 1/4 in. (64.1 cm); Depth: 1 ft. 10 3/4 in.
 (57.8 cm)
 Accession number 75.DA.8.1–.4

 PROVENANCE
 Hubert de Givenchy, Paris; [Jacques Kugel,
 Paris]; purchased by J. Paul Getty.

 BIBLIOGRAPHY
 Pallot, *L'Art du siège*, p. 108, illus.; Bremer-
 David, *Summary*, no. 91, p. 64, illus.

88.
DESK CHAIR (*FAUTEUIL DE CABINET*)
 Paris, circa 1735
 Attributed to Etienne Meunier
 Walnut; leather upholstery; velvet pocket lin-
 ings; brass studs
 Height: 2 ft. 11 3/8 in. (89.8 cm); Width:
 2 ft. 4 in. (71.1 cm); Depth: 2 ft. 1 1/4 in.
 (64.1 cm)
 Accession number 71.DA.91

 PROVENANCE
 [Duveen Brothers, New York]; Anna Thomson
 Dodge, Rose Terrace, Grosse Pointe Farms,
 Michigan (sold, Christie's, London, June 24,
 1971, lot 48); purchased at that sale by
 J. Paul Getty.

 BIBLIOGRAPHY
 Fredericksen et al., *Getty Museum*, p. 145,
 illus.; Wilson, "Meubles 'Baroques,'"
 p. 106, illus.; Bremer-David, *Summary*, no. 92,
 p. 64, illus.

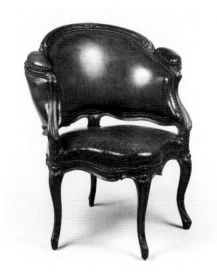

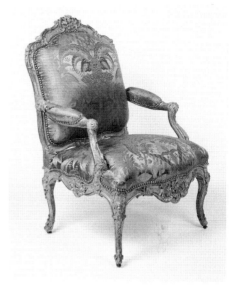

89 *One of a pair*

89.
PAIR OF ARMCHAIRS (*FAUTEUILS À LA REINE*)
 French, circa 1730–1735
 Gessoed and gilded beech; brass casters;
 modern silk upholstery
 One chair is marked with *No.* 5 on the inner
 side of the back chair rail and the other is
 stamped with *VI* in the same location.
 Height: 3 ft. 6 3/4 in. (108.5 cm); Width:
 2 ft. 4 1/2 in. (72.3 cm); Depth: 2 ft. 1 in.
 (63.4 cm)
 Accession number 94.DA.10.1–.2

 PROVENANCE
 (Sold, Christie's, New York, April 7, 1993,
 lot 180) [purchased at the sale by Bernard
 Steinitz, Paris].

 BIBLIOGRAPHY
 "Acquisitions/1994," *GettyMusJ* 23 (1995),
 no. 3, p. 63, illus. (one); *Handbook* 2001,
 p. 198, illus. (one).

90.

Two Armchairs (FAUTEUILS À LA REINE) AND
Two Side Chairs (CHAISES)

Paris, circa 1735–1740
Gessoed and gilded beech; modern silk
upholstery
Armchairs: Height: 3 ft. 7 1/2 in. (110.5 cm);
Width: 2 ft. 6 1/8 in. (76.6 cm); Depth: 2 ft.
8 7/8 in. (83.7 cm); Side Chairs: Height: 3 ft.
1 in. (94.1 cm); Width: 2 ft. 3/8 in. (62 cm);
Depth: 2 ft. 3 3/8 in. (69.4 cm)
Accession number 82.DA.95.1–.4

PROVENANCE

Private collection, England, from the eigh-
teenth century until 1979; [William Redford,
London]; [Alexander and Berendt, Ltd.,
London, 1979].

BIBLIOGRAPHY

Sassoon, "Acquisitions 1982," no. 4, pp. 28–
33, illus.; Pallot, L'Art du siège, p. 102, illus.;
Bremer-David, Summary, no. 93, pp. 64–65,
illus. p. 64; Leora Auslander, Taste and Power:
Furnishing Modern France (Berkeley, 1996),
p. 107, illus.; Handbook 1997, p. 201, illus.

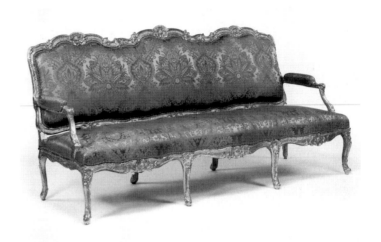

91

91.

PAIR OF ARMCHAIRS (FAUTEUILS À LA REINE) AND
ONE SETTEE

Paris, circa 1750–1755
By Jean Avisse
Gessoed and gilded beech; modern silk
upholstery
Each chair is stamped with IAVISSE beneath
rear rail; settee is stamped with IAVISSE
twice beneath rear rail.
Chairs: Height: 3 ft. 5 1/4 in. (104.7 cm);
Width: 2 ft. 6 in. (76.2 cm); Depth: 1 ft.
11 7/16 in. (59.6 cm); Settee: Height: 3 ft.
6 in. (106.7 cm); Width: 7 ft. 1/2 in.
(214.5 cm); Depth: 3 ft. (91.4 cm)
Accession numbers: Chairs: 83.DA.230.1–.2;
Settee: 84.DA.70

PROVENANCE

Chairs: Private collection, New York (sold,
Sotheby's, New York, October 1981, lot 314);
[Matthew Schutz, Ltd., New York, 1982].
Settee: Mrs. Rose Freda, New York; [Edward
de Pasquale, New York, 1983] (sold, Sothe-
by's, New York, May 4, 1984, lot 41).

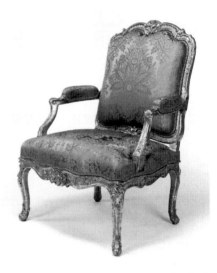

91 One of a pair

BIBLIOGRAPHY

Bremer-David, "Acquisitions 1983," GettyMusJ
12 (1984), no. 8 (armchairs), pp. 198–199,
illus. pp. 200–201 (one); "Acquisitions/
1983," GettyMusJ 12 (1984), no. 10 (arm-
chairs), p. 265, illus. (one); "Acquisitions/
1984," GettyMusJ 13 (1985), no. 56 (settee),
p. 179, illus.; Pallot, L'Art du siège, p. 278,
illus. (settee and one chair) and p. 300; Kjell-
berg, Dictionnaire, pp. 33, 37; Bremer-David,
Summary, no. 94, p. 65, illus. (settee and
one chair).

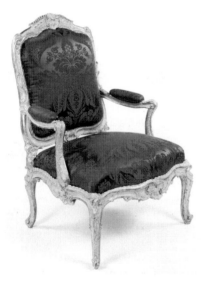

90 One of two

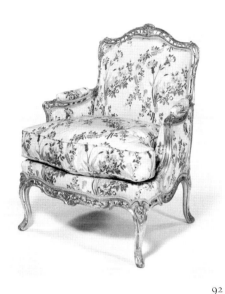

92

92.

ARMCHAIR (*BERGÈRE À LA REINE*)

Paris, circa 1755
By Nicolas Heurtaut
Gessoed and gilded wood; modern silk
upholstery
Stamped with N. HEURTAUT under
rear rail.
Height: 3 ft. 3³/₄ in. (101 cm); Width:
2 ft. 7³/₄ in. (80.6 cm); Depth: 2 ft. 5³/₄ in.
(75.5 cm)
Accession number 84.DA.69

PROVENANCE

Private collection, New York; [Matthew
Schutz, Ltd., New York, circa 1960] (sold,
Sotheby's, New York, May 4, 1984, lot 59).

BIBLIOGRAPHY

"Acquisitions/1984," *GettyMusJ* 13 (1985),
no. 59, p. 180, illus.; Kjellberg, *Dictionnaire*,
p. 403; Bremer-David, *Summary*, no. 95,
p. 66, illus.

93.

PAIR OF ARMCHAIRS (*BERGÈRES À LA REINE ET À
CHÂSSIS, ASSISE CANNÉE*)

Paris, circa 1750
By Nicolas-Quinibert Foliot
Gessoed and gilded beech; caning; modern
silk upholstery
Armchair .1: is stamped with N. Q.
FOLIOT on the side of the back seat rail;
Armchair .2: is stamped with FOLIOT.
Height: 3 ft. 2¹/₂ in. (97.8 cm); Width: 2 ft.
6¹/₂ in. (77.5 cm); Depth: 2 ft. (61 cm)
Accession number 95.DA.90.1–.2

PROVENANCE

(Sold, Sotheby's, New York, May 7, 1983, lot
198); (offered for sale, Sotheby's, New York,
May 21, 1992, lot 70, bought in); (sold,
Christie's, London, December 8, 1994,
lot 516); purchased by Gordon and Ann
Getty at this sale; given to the J. Paul Getty
Museum, 1995.

BIBLIOGRAPHY

Pallot, *L'Art du Siège*, pp. 136 and 138, illus.
p. 138; "Acquisitions/1995," *GettyMusJ* 24
(1996), no. 12, p. 91, illus. (one).

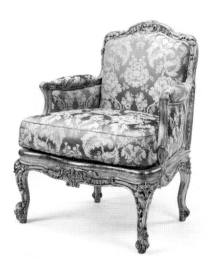

93 One of a pair

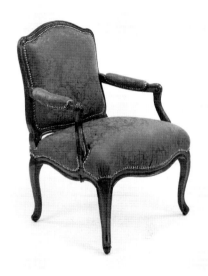

94 One of a pair

94.

PAIR OF ARMCHAIRS (*FAUTEUILS À LA REINE*)

Paris, 1762
By Nicolas-Quinibert Foliot
Beech; modern silk upholstery
Each armchair is stamped with N. Q.
FOLIOT inside rear rail and stenciled in the
same place with a crowned F for the Palais
de Fontainebleau and the number 832.
Height: 3 ft. ³/₄ in. (93.3 cm); Width:
2 ft. 2⁵/₈ in. (67.6 cm); Depth: 1 ft. 9⁷/₈ in.
(55.5 cm)
Accession number 70.DA.70.1–.2

PROVENANCE

Château de Versailles, 1762; Palais de
Fontainebleau; listed as in the lodgings of
Charles-Claude de Taillepied, *seigneur de la
Garenne*, on November 1, 1786, and again in
1787; Annette Lefortier, Paris (sold, Ander-
son Galleries, American Art Association,
New York, November 20, 1937, lot 151); pur-
chased at that sale by J. Paul Getty.

BIBLIOGRAPHY

Pallot, *L'Art du siège*, pp. 284, illus., and 308–
309; Kjellberg, *Dictionnaire*, p. 317; Bremer-
David, *Summary*, no. 96, p. 66, illus.

95.
ARMCHAIR (BERGÈRE)
Paris, circa 1765–1770
By Georges Jacob
Painted oak; silk upholstery; brass nails
The frame of the chair is stamped with
G IACOB and with an anchor flanked by
C and P beneath a crown, the mark of the
Château de Chanteloup. The dust cover of
the seat and the underside of the cushion are
stenciled with the mark of the Château de
Chanteloup.
Height: 3 ft. 3 in. (99 cm); Width: 3 ft. 1 in.
(94 cm); Depth: 2 ft. 6 in. (76 cm)
Accession number 88.DA.123

PROVENANCE
Etienne-François de Stainville (?), duc de
Choiseul (1718–1785), Château de Chante-
loup; Louis de Bourbon, duc de Penthièvre
(1725–1793), Château de Chanteloup, 1785;
"Poitevin Joubert et femme Fleury," after
1794, purchased at the sale of the contents of
the château; [Bernard Steinitz, Paris, 1988].

BIBLIOGRAPHY
Alfred Gabeau, "Le Mobilier d'un château à
la fin du XVIIIᵉ siècle: Chanteloup," *Réunion
des sociétés des beaux-arts des départements* (April

1898), pp. 529, 541; Jehanne d'Orliac, *La Vie
merveilleuse d'un beau domaine français — Chanteloup
du XIIIᵉ siècle au XXᵉ siècle* (Paris, 1929), p. 231;
"Acquisitions/1988," *GettyMusJ* 17 (1989),
no. 74, pp. 142–143, illus; Bremer-David,
Summary, no. 97, pp. 66–67, illus. p. 67.

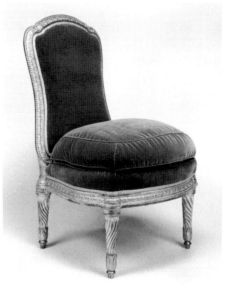

96 *One of a pair*

96.
PAIR OF SIDE CHAIRS (*CHAISES À LA REINE*)
Paris, circa 1765–1770
By Jean Boucault
Gessoed and gilded beech; modern silk velvet
upholstery
Each chair is stamped with J. BOUCAULT
and branded with a crowned double V, the
mark of the Château de Versailles, under the
seat rail. Each chair is stenciled with various
royal inventory numbers.
Height: 2 ft. 11 ³/₄ in. (91 cm); Width:
1 ft. 10 ¹/₂ in. (57 cm); Depth: 2 ft. 2 ¹/₄ in.
(66.5 cm)
Accession number 71.DA.92.1–.2

PROVENANCE
Part of a suite of seat furniture acquired by
the order of baron de Breteuil and delivered

by the *tapissier* Capin to the *garde-meuble* in
1783; Château de Versailles (sold, Novem-
ber 25, 1793 [5 *frimaire, an 11*], no. 5672, to
Gastinet for 1,610 *livres*); Jacques, comte de
Béraudière (sold, Paris, May 18–30, 1885,
part of no. 902); [Duveen Brothers, New
York]; Anna Thomson Dodge, Rose Terrace,
Grosse Pointe Farms, Michigan (sold,
Christie's, London, June 24, 1971, lot 65);
purchased at that sale by J. Paul Getty.

BIBLIOGRAPHY
Anthony Coleridge, "Works of Art with a
Royal Provenance from the Collection of the
Late Mrs. Anna Thomson Dodge of Detroit,"
Connoisseur 177, no. 711 (May 1971), p. 34;
Gillian Wilson, "The J. Paul Getty Museum,
7ᵉᵐᵉ partie: Le Mobilier Louis XVI," *Connais-
sance des arts* 280 (June 1975), p. 92, illus.;
The Master Chair-Maker's Art: France, 1710–1800
(New York, 1984) p. 24, illus.; Pallot, *L'Art du
siège*, p. 192, illus., and p. 301; Kjellberg,
Dictionnaire, pp. 84–85; Bremer-David, *Sum-
mary*, no. 98, p. 67, illus.

97.
FOUR ARMCHAIRS (*FAUTEUILS À LA REINE*)
AND ONE SETTEE
Paris, circa 1770–1775
By Jacques-Jean-Baptiste Tilliard
Gessoed and gilded walnut; modern silk
velvet upholstery
Each piece is stamped with TILLIARD
under rear seat rail.
Chairs: Height: 3 ft. 4 in. (101.6 cm);
Width: 2 ft. 5 ¹/₄ in. (75 cm); Depth:
2 ft. 5 ¹/₂ in. (74.9 cm); Settee: Height: 3 ft.
11 ³/₈ in. (120.3 cm); Width: 7 ft. 6 ¹/₂ in.
(229.7 cm); Depth: 3 ft. 1 ¹/₄ in. (94.6 cm)
Accession number 78.DA.99.1–.5

PROVENANCE
Mortimer L. Schiff, New York (sold by his
heir John M. Schiff, Christie's, London,
June 22, 1938, lot 55); purchased at that sale
by J. Paul Getty for Sutton Place, Surrey;
distributed by the estate of J. Paul Getty to
the J. Paul Getty Museum.

95

BIBLIOGRAPHY
Wilson, *Selections*, no. 46, pp. 92–93, illus.;
Pallot, *L'Art du siège*, p. 218, illus., and p. 318;
Kjellberg, *Dictionnaire*, p. 840; *Handbook* 1991,
p. 190, illus. (one); Bremer-David, *Summary*,
no. 99, p. 68, illus. (settee and one armchair).

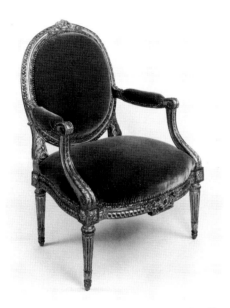

97 *One of four*

98.
FOUR SIDE CHAIRS (*CHAISES À LA REINE*)
 Paris, 1780–1781
 By François-Toussaint Foliot after designs by
 Jacques Gondoin
 Gessoed and gilded beech; modern silk
 upholstery
 One chair is stenciled with GARDE
 MEUBLE DE LA REINE under seat rail.
 Another bears a label inscribed with *Ex museo
 L.Double.*
 Height: 2 ft. 11 in. (89 cm); Width:
 1 ft. 9 3/4 in. (55 cm); Depth: 1 ft. 10 1/4 in.
 (56.5 cm)
 Accession number 71.DA.93.1–.4

PROVENANCE
Marie-Antoinette, *Salon du Rocher*, Hameau
de la Reine, Petit Trianon, Versailles, ordered
from the *menuisier* François-Toussaint Foliot
on November 29, 1780; possibly removed
from the Château de Versailles, 1791; Léo-
pold Double, Paris (sold, Paris, May 30–
June 1, 1881, no. 427); comte Henri de Gref-
fulhe, Paris; [Duveen Brothers, New York];
Anna Thomson Dodge, Rose Terrace, Grosse
Pointe Farms, Michigan (sold, Christie's,
London, June 24, 1971, lot 66); purchased
at that sale by J. Paul Getty.

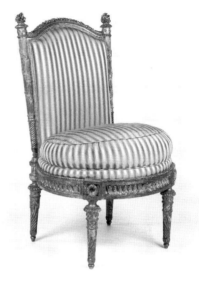

98 *One of four*

EXHIBITIONS
Jackson, Mississippi, Mississippi Arts Pavil-
ion, *Splendors of Versailles*, Claire Constans and
Xavier Salmon, eds., April–August 1998,
no. 99, pp. 150, 193, illus.

BIBLIOGRAPHY
Anthony Coleridge, "Works of Art with a
Royal Provenance from the Collection of the
Late Mrs. Anna Thomson Dodge of Detroit,"
Connoisseur 177, no. 711 (May, 1971), p. 34,
illus.; Fredericksen et al., *Getty Museum*, p. 165,
illus.; Gillian Wilson, "The J. Paul Getty
Museum, 7ᵉᵐᵉ partie: Le Mobilier Louis XVI,"
Connaissances de arts 280 (June 1975), p. 94,
illus.; Kjellberg, *Dictionnaire*, p. 426; Jean-
Pierre Babelon, "Un magnifique enrichisse-
ment des collections nationales-Musée
national du Château de Versailles," *La Revue du
Louvre et des Musées de France* 5 (1990), p. 350;
Christian Baulez, "Deux Sièges de Foliot et
de Sené pour Versailles," *Revue du Louvre*
(March 1991), p. 79, illus.; Barbara Scott,
"The Rothschild Room in the Louvre," *Apollo*
134, no. 356 (October 1991), pp. 270–271;
Bremer-David, *Summary*, no. 100, pp. 68–69,
illus. p. 69.

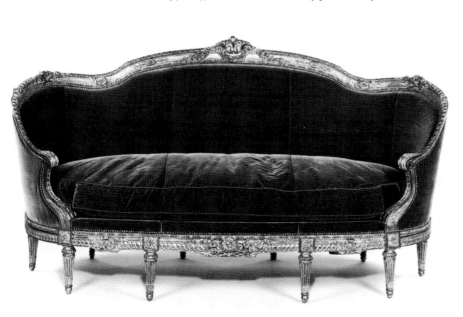

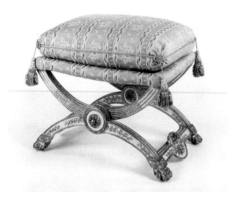

99 *One of a pair*

99.
PAIR OF FOLDING STOOLS (PLIANTS)
Paris, circa 1786
By Jean-Baptiste-Claude Séné; carved by
Nicolas-François Vallois, originally gilded
by Chatard and Chaudron and upholstered
by Capin
Gessoed, painted, and gilded beech; modern
upholstery
Each stool is branded with three fleur-de-lys
beneath a crown and with TH, the mark of
the Palais des Tuileries.
Height (without cushion): 1 ft. 4 1/4 in.
(42 cm); Width: 2 ft. 4 1/2 in. (72.5 cm);
Depth: 1 ft. 9 in. (53 cm)
Accession number 71.DA.94.1–.2

PROVENANCE
Marie-Antoinette, from a set of sixty-four
ordered in two groups by Jean Hauré in 1786,
at the cost of 720 *livres* for each stool, for the
gaming rooms in the Palais de Fontainebleau
and the Château de Compiègne; Palais du
Luxembourg or Palais des Tuileries, Paris,
1797–circa 1806; [Michel, Paris, 1933]; Anna
Thomson Dodge, Rose Terrace, Grosse Pointe
Farms, Michigan (sold, Christie's, London,
June 24, 1971, lot 69); purchased at that sale
by J. Paul Getty.

BIBLIOGRAPHY
Pierre Verlet, "Les Meubles sculptés du
XVIII⁰ siècle: Quelques identifications," *Bul-
letin de la Société de l'histoire de l'art français* (1937),
pp. 259–263; Pierre Verlet, *French Royal Furni-*
ture (London, 1963), pp. 35–36; Anthony Cole-
ridge, "Works of Art with a Royal Provenance
from the Collection of the Late Mrs. Anna
Thomson Dodge of Detroit," *Connoisseur* 177,
no. 711 (May 1971), p. 34; Fredericksen
et al., *Getty Museum*, p. 165, illus.; Gillian
Wilson, "The J. Paul Getty Museum, 7ᵉᵐᵉ
partie: Le Mobilier Louis XVI," *Connaissance
des arts* 280 (June 1975), p. 92, illus.; Pierre
Verlet, *Les Meubles français du XVIIIᵉ siècle* (Paris,
1982), p. 227; Kjellberg, *Dictionnaire*, p. 818;
Bremer-David, *Summary*, no. 101, p. 69, illus.

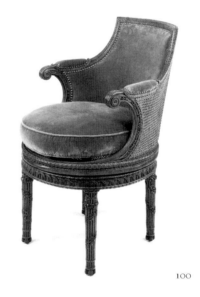

100

100.
CHAIR (FAUTEUIL DE TOILETTE)
Paris, circa 1787
By Georges Jacob; carved by Pierre-Claude
Triquet and Jean-Baptiste Simon Rode; origi-
nally painted by Chaillot de Prusse and
upholstered with fabric by Marie-Olivier
Desfarges of Lyon
Beech, oak, unidentified tropical hardwood;
modern caning; modern silk velvet upholstery
Painted with the Dalva Brothers' inventory
number 8758 under the rail.
Height: 2 ft. 9 1/4 in. (84.5 cm); Width:
1 ft. 10 1/8 in. (56.2 cm); Depth: 2 ft. 1 5/8 in.
(65 cm)
Accession number 72.DA.51

PROVENANCE
Marie-Antoinette, ordered by Bonnefoy-
Duplan for the *chambre à coucher du treillage* in
the Petit Trianon, Versailles, 1787 (sold
with the contents of the Petit Trianon, Ver-
sailles, August 25 et seq., 1793, no. 2477,
to the *marchand-mercier* Rocheux, Paris,
through the agent *citoyen* Hébert); Senator G.
P. Wetmore, circa 1920, Edith M. K. Wet-
more and Maude A. K. Wetmore, Château-
sur-Mer, Newport, Rhode Island (offered for
sale, Parke-Bernet, Château-sur-Mer, Sep-
tember 16–18, 1969, lot 1037, bought in);
(sold, Parke-Bernet, New York, February 20,
1971, lot 122); [Dalva Brothers, Inc.,
New York, 1971]; purchased by J. Paul Getty.

EXHIBITIONS
Jackson, Mississippi, Mississippi Arts Pavilion,
Splendors of Versailles, Claire Constans and
Xavier Salmon, eds., April–August 1998,
no. 97, p. 191, illus.

BIBLIOGRAPHY
Fredericksen et al., *Getty Museum*, p. 191,
illus.; Wilson, Gillian. "The J. Paul Getty
Museum, 7ᵉᵐᵉ partie: Le Mobilier Louis
XVI," *Connaissance des arts* 280 (June 1975),
p. 92, illus.; Michel Beurdeley, *La France à l'en-
can* (Fribourg, 1981), p. 109; Kjellberg, *Dic-
tionnaire*, p. 426; Bremer-David, *Summary*,
no. 102, p. 70, illus.; R. Pascale, *Versailles: The
American Story* (Paris, 1999), p. 72, illus.

101.
PAIR OF ARMCHAIRS (FAUTEUILS À LA REINE)
Paris, circa 1790–1792
By Georges Jacob
Painted beech; modern silk upholstery
Each armchair is stamped with G IACOB
under the front seat rail.
Height: 3 ft. 1 in. (94 cm); Width: 1 ft. 11 1/2
in. (59 cm); Depth: 1 ft. 11 3/4 in. (60.5 cm)
Accession number 91.DA.15.1–.2

PROVENANCE
Private collection, Paris (sold, Sotheby's,
Monaco, March 3, 1990, no. 205); [Kraemer
et Cie, Paris, 1990].

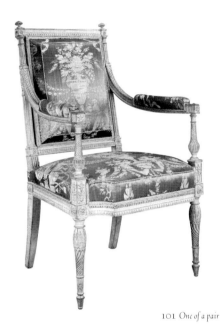

101 *One of a pair*

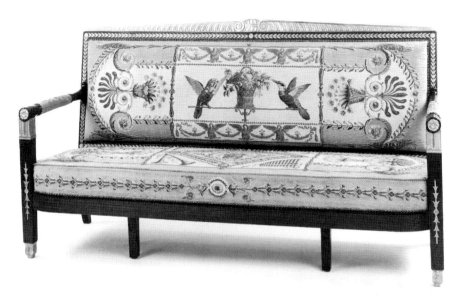

102 *Settee*

BIBLIOGRAPHY

"Acquisitions/1991," *GettyMusJ* 20 (1992), no. 72, p. 172, illus. (one); Bremer-David, *Summary*, no. 103, p. 70, illus.

102.

ONE SETTEE AND TEN ARMCHAIRS
(TWO *BERGÈRES* AND EIGHT *FAUTEUILS*)
 Paris, circa 1810
 Frames attributed to Jacob Desmalter et Cie; tapestry upholstery woven at the Beauvais manufactory
 Mahogany and beech; gilt-bronze mounts; silk and wool tapestry upholstery
 Settee: Height: 3 ft. 4¹/₂ in. (102.9 cm); Width: 6 ft. 2⁷/₈ in. (190.2 cm); Depth: 2 ft. ¹/₈ in. (61.3 cm); Chairs: Height: 3 ft. 3⁵/₈ in. (100.6 cm); Width: 2 ft. 1 in. (63.5 cm); Depth: 1 ft. 7 in. (48.2 cm)
 Accession number 67.DA.6.1–.11

PROVENANCE

Private collection, Paris, by 1908; [Jacques Seligmann, Paris]; Grand Duke Nicolai Michailoff, Palais Michailoff, St. Petersburg, purchased December 4, 1912; Museums and Palaces Collections, Palais Michailoff, St. Petersburg (sold, Lepke, Berlin, November 7, 1928, no. 73, with a fire screen); Ives, comte de Cambacérès, Paris; Edouard Mortier, 5th duc de Trévise, Paris (sold, Galerie Charpentier, Paris, May 19, 1938, no. 47); purchased at that sale by J. Paul Getty.

EXHIBITIONS

New York, The Cooper-Hewitt Museum, *L'Art de Vivre: Decorative Arts and Designs in France 1789–1989*, Catherine Arminjon et al., February–September 1989, illus. p. 19, fig. 10 (*fauteuil* 67.DA.6.10 only).

BIBLIOGRAPHY

Décorations intérieurs et meubles des epoques Louis XV, Louis XVI et Empire, Revue d'art décoratif, Armond Guérinet, ed. (1908–1909), illus. no. 17, pl. 7; J. Paul Getty, *Collector's Choice* (London, 1955), p. 68, illus. unnumbered pl. between pp. 176–177; Gillian Wilson, "The J. Paul Getty Museum, 7ᵉᵐᵉ partie: Le Mobilier Louis XVI," *Connaissance des arts* 280 (June 1975), p. 95, illus. (armchair 67.DA.6.10 only); Bremer-David, *Summary*, no. 104, p. 71, illus. (settee and armchair 67.DA.6.10 only).

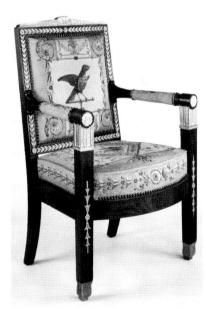

102 *One of eight*

Beds

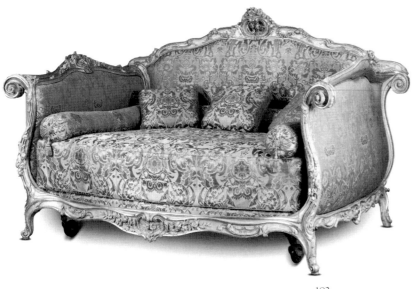

103

103.
BED (*LIT À LA TURQUE*)

Paris, circa 1750–1760
Attributed to Jean-Baptiste Tilliard
Gessoed and gilded beech and walnut; modern silk upholstery
Height: 5 ft. 8¹/₂ in. (174 cm); Width: 8 ft. 8¹/₄ in. (264.8 cm); Depth: 6 ft. 2 in. (188 cm)
Accession number 86.DA.535

PROVENANCE

Private collection, England, since the end of the eighteenth century; [Alexander and Berendt, Ltd., London, 1986].

BIBLIOGRAPHY

"Acquisitions/1986," *GettyMusJ* 15 (1987), no. 106, p. 213, illus.; Pallot, *L'Art du siège*, p. 75, illus.; Bremer-David, *Summary*, no. 105, p. 72, illus.; Perrin Stein, "Madame de Pompadour and the Harem Imagery at Bellevue," *Gazette des beaux-arts* 123 (January 1994), pp. 29–44, illus.; Philip Jodidio, "Le Monastère de Brentwood," *Connaissance des arts* 511 (November 1994), p. 132, illus. p. 133; Alexandre Pradère, "France, Furniture, 1716–93," *The Dictionary of Art*, Jane Turner, ed. (London, 1996), vol. 11, p. 594, illus.; *Handbook* 2001, pp. 210–211, illus.

104.
BED (*LIT À LA POLONAISE*)

Paris, circa 1775–1780
Original silk upholstery fabric designed by Philippe Lasalle
Gilded and painted wood; iron; original silk upholstery panels (removed); modern silk upholstery, *passementerie*, feathers
Height: 9 ft. 11 in. (302 cm); Width: 7 ft. 5 in. (226 cm); Depth: 5 ft. 10¹/₂ in. (179 cm)
Accession number 94.DA.72.1–.2

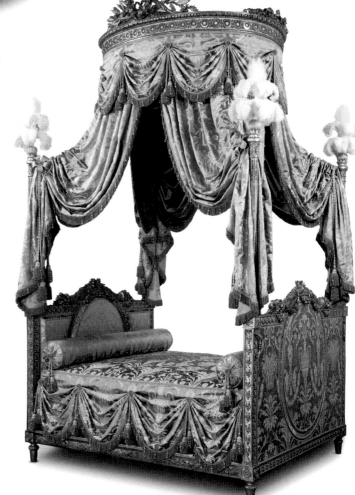

Supports

PROVENANCE

Alexandre-Edmond de Talleyrand-Périgord (?), 3rd duc de Dino (1813–1894), Place Vendôme, Paris, or his son, Maurice de Talleyrand-Périgord, 4th duc de Dino (1843–1917); [Duveen Brothers, Paris, and sent temporarily to Carlhian et Beaumetz, Paris]; Mlle Gilda Darthy (sold, Galerie Georges Petit, Paris, May 18, 1923, no. 77); acquired at that sale by F. Schutz, Paris; Espirito Santo Family (?), Europe; (sold, Sotheby's, London, July 8, 1983, lot 96); acquired at that sale by Barbara Piasecka Johnson (offered for sale, Sotheby's, London, June 26, 1987, lot 76, bought in); (sold, Sotheby's, New York, May 21, 1992, lot 88); Karl Lagerfeld, Paris.

EXHIBITIONS

Paris, Musée Carnavalet, *La Vie Parisienne au XVIIIᵉ siècle*, March 20–April 30, 1928, no. 285, p. 51, illus. (lent by F. Schutz).

BIBLIOGRAPHY

Frédéric Contet, *Meubles et sièges d'art: époques Louis XIV, Louis XV, Louis XVI, empire* (Paris, 1924), pl. 10, illus.; Daryl M. Hafter, "Philipe de Lasalle: From mise-en-carte to Industrial Design," *Winterthur Portfolio* 12 (1977), p. 155, illus.; Marie-Jo de Chaignon, "Philipe de Lasalle, dessinateur et fabricant d'étoffes de soie à Lyon au XVIIIᵉ siècle," *Monde Alpin et Rhodanien* 2–3 (1991), p. 71, illus.; Andrea Disertori et al., *Il Mobile del Settecento* (London, 1991), p. 114, illus.; Amy Page, "Voulez-Vous Coucher?" *Art and Auction* (November, 1994), pp. 146–151, illus. p. 147; "Acquisitions/1994," *GettyMusJ* 23 (1995), no. 4, p. 64, illus.; *Handbook* 2001, pp. 228–229.

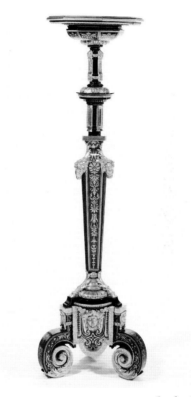

105 *One of a pair*

105.
PAIR OF GUERIDONS
Paris, circa 1680
Attributed to André-Charles Boulle
Oak, cherry, and walnut veneered with ebony, tortoiseshell, blue painted horn, brass, and pewter; gilt-bronze mounts
Height: 4 ft. 8⁵/₈ in. (143.8 cm); Width (at base): 1 ft. 4¹/₂ in. (41.9 cm); Depth (at base): 1 ft. 5¹/₈ in. (43.5 cm)
Accession number 87.DA.5.1–.2

PROVENANCE

Pierre-Louis Randon de Boisset (?) (1709–1776), Paris (sold, Paris, February 27 to March 25, 1777, no. 796, for 1,000 *livres*, to Sr. Platrier); Pierre-Nicolas, baron Hoorn van Vlooswyck (?), Paris (sold, Paris, November 22, 1809, no. 593, [to the dealer Hennequart]); Baron S. de Lopez Tarragona, Paris; [Maurice Segoura, Paris, 1986].

BIBLIOGRAPHY

Geneviève Mazel, "1777, La Vente Randon de Boisset et le marché de l'art au 18ᵉ s[iècle]," *L'Estampille* 202 (April 1987), p. 41, illus.; Michel Beurdeley, "Paris 1777: La Vente Randon de Boisset ou le mécanisme secret des ventes publiques au XVIIIᵉ siècle," *Trois siècles de ventes publiques* (Fribourg, 1988), p. 53, illus.; "Acquisitions/1987," *GettyMusJ* 16 (1988), no. 67, p. 177, illus.; Pradère, *Les Ebénistes*, nos. 255–256, p. 106; Bremer-David, *Summary*, no. 106, pp. 72–73, illus. p. 73 (one).

106.
PAIR OF PEDESTALS
Paris, circa 1700
Attributed to André-Charles Boulle
Oak, fir, and walnut veneered with fruitwood, ebony, brass, and tortoiseshell; gilt-bronze mounts
Height: 3 ft. 11¹¹/₁₆ in. (121.2 cm); Width: 1 ft. 9⁷/₈ in. (55.5 cm); Depth: 1 ft. 9⁷/₈ in. (55.5 cm)
Accession number 88.DA.75.1–.2

106 *One of a pair*

PROVENANCE

Antoine-Alexandre Dubois, Paris (sold, Paillet, Paris, December 18, 1788, no. 168, to "Berotaire" for 5599 *livres*); (sold, Paillet et Delaroche [?], Paris, July 11, 1803, no. 41); Baron James (Mayer) de Rothschild (1792–1868), Paris, before 1860; Baron Gustave (Samuel James) de Rothschild (1829–1911), Paris; Baron Robert (Philippe Gustave) de Rothschild (1880–1946), Paris; Baron (James Gustave Jules) Alain de Rothschild (1910–1982), Paris; Baron Eric (Alain Robert David) de Rothschild, Paris (sold, Hôtel Drouot, Paris, December 4, 1987, no. 112); [Same Art, Ltd., Zurich].

EXHIBITIONS

Paris, *L'Exposition de l'art français sous Louis XIV et sous Louis XV au profit de l'oeuvre de l'hospitalité de nuit,* 1888, no. 94.

BIBLIOGRAPHY

"Le Feu des enchères de Fin d'Automne," *Connaissance des arts* 431 (January 1988), pp. 18–19; "Vive la crise," *L'Objet d'art* 3 (January 1988), p. 95; *Il Giornale dell'Arte* 53 (February 1988), p. 84; Souren Melikian, "Surprise, Surprise," *Art and Auction* (February 1988), pp. 84, 86; "Acquisitions/1988," *GettyMusJ* 17 (1989), no. 68, pp. 140–141, illus.; Pradère, *Les Ebénistes,* nos. 189–190, p. 105; Bremer-David, *Summary,* no. 107, p. 73, illus. (one).

107

107.
WALL BRACKET
 Paris, circa 1715–1720
 Gessoed and gilded oak
 Height: 1 ft. 6 in. (45.7 cm); Width: 1 ft. 9 1/2 in. (54.6 cm); Depth: 8 1/2 in. (21.6 cm)
 Accession number 84.DH.86

PROVENANCE

Private collection, New York; [Matthew Schutz, Ltd., New York, 1984].

BIBLIOGRAPHY

"Acquisitions/1984," *GettyMusJ* 13 (1985), no. 49, p. 177, illus.; Bremer-David, *Summary,* no. 108, p. 73, illus.

108.
PAIR OF TORCHÈRES
 Paris, circa 1725
 Oak; modern gesso, gilding
 Height: 5 ft. 8 1/4 in. (173.3 cm); Diameter (at top): 1 ft. 3 3/4 in. (40 cm); Diameter (at base): 1 ft. 10 1/2 in. (57.1 cm)
 Accession number 71.DA.98.1–.2

PROVENANCE

[Duveen Brothers, New York]; Anna Thomson Dodge, Rose Terrace, Grosse Pointe Farms, Michigan (sold, Christie's, London, June 24, 1971, lot 75); purchased at that sale by J. Paul Getty.

BIBLIOGRAPHY

Fredericksen et al., *Getty Museum,* p. 145, illus.; Wilson, "Meubles 'Baroques,'" p. 106, illus.; Bremer-David, *Summary,* no. 109, p. 74, illus. (one).

108 *One of a pair*

Fire Screen

Decorative Reliefs

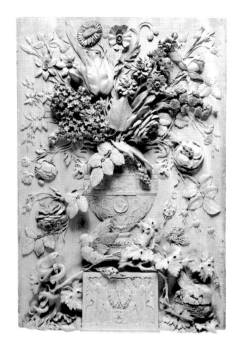

111

110.

FIRE SCREEN (ÉCRAN COULISSE)
> Paris, circa 1785–1790
> Attributed to Georges Jacob
> Walnut
> One upright of the screen is carved with the monogram *JH* and the other with *C(T?)*.
> Height: 4 ft. 2 in. (127 cm); Width: 2 ft. 7 1/2 in. (80 cm); Depth: 1 ft. 5 in. (43 cm)
> Accession number 88.DA.124

PROVENANCE

Madame Beaumont, Cap d'Antibes; (sold, Sotheby's, Monaco, February 5–6, 1978, no. 13); [Bernard Steinitz, Paris, 1988].

BIBLIOGRAPHY

"Acquisitions/1988," *GettyMusJ* 17 (1989), no. 80, pp. 144–145, illus.; Bremer-David, *Summary*, no. 111, p. 74, illus. p. 75.

109

109.

PAIR OF SUPPORTS (GAINES)
> French, circa 1770
> After designs by Jean-Charles Delafosse
> Fir with traces of gesso and paint
> Height: 4 ft. 2 in. (127 cm); Width: 1 ft. 4 in. (40.7 cm); Depth: 1 ft. (30.5 cm)
> Accession number 89.DA.2.1–.2

PROVENANCE

[Galaries Heilbrönner]; [French and Co., New York, 1912–1925 (stock no. 5174)]; Mrs. James B. Haggin, New York, 1925; [Midtown Antiques, New York, 1950]; [Frederick P. Victoria and Son, Inc., New York, circa 1950–1988]; [Michel Otin, Paris]; [Patrick Perrin, Paris].

BIBLIOGRAPHY

"Acquisitions/1989," *GettyMusJ* 18 (1990), no. 55, p. 194, illus.; Bremer-David, *Summary*, no. 110, p. 74, illus. 110

110

111.

CARVED RELIEF
> Paris, 1789
> By Aubert-Henri-Joseph Parent
> Limewood
> Incised with AUBERT PARENT FECIT AN. 1789 under the base.
> Height: 2 ft. 3 3/8 in. (69.4 cm); Width: 1 ft. 6 7/8 in. (47.9 cm); Depth: 2 3/8 in. (6.2 cm)
> Accession number 84.SD.76

PROVENANCE

David Peel, London; Paul Mellon (sold, Christie's, New York, November 22, 1983, lot 275); [Dalva Brothers, Inc., New York, 1983].

BIBLIOGRAPHY

Colin Streeter, "Two Carved Reliefs by Aubert Parent," *GettyMusJ* 13 (1985), pp. 53–66, figs. 1a–d; "Acquisitions/1984," *GettyMusJ* 13 (1985), no. 65, p. 183, illus.; Bremer-David, *Summary*, no. 112, p. 75, illus.; *Masterpieces*, no. 97, pp. 122–123, illus.; *Handbook* 2001, p. 232, illus.

ARCHITECTURAL WOODWORK
AND FIXTURES

Frames

112.

CARVED RELIEF

Paris, 1791
By Aubert-Henri-Joseph Parent
Limewood
Incised with AUBERT PARENT. 1791 under
the base. Stenciled with 172n, an inventory
number, in black on the back.
Height: 1 ft. 11 1/8 in. (58.7 cm); Width: 1 ft.
3 5/8 in. (39.7 cm); Depth: 2 1/4 in. (5.7 cm)
Accession number 84.SD.194

PROVENANCE
[Jacques Kugel, Paris, 1984].

BIBLIOGRAPHY
Colin Streeter, "Two Carved Reliefs by
Aubert Parent," *GettyMusJ* 13 (1985), pp. 53–
66, figs. 3a–b; "Acquisitions/1984," *GettyMusJ*
13 (1985), no. 66, p. 183, illus.; Bremer-David,
Summary, no. 113, p. 75, illus.

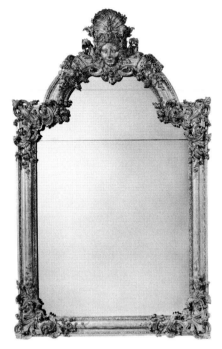

113

113.

FRAME FOR A MIRROR

Paris, circa 1690–1700
Gessoed and gilded oak; modern mirror glass
Height: 6 ft. 8 in. (183.5 cm); Width: 4 ft.
2 in. (127 cm); Depth: 4 in. (10.2 cm)
Accession number 87.DH.78

PROVENANCE
Private collection, Switzerland, 1980s;
[Rainer Zietz, Ltd., London]; [Rosenberg and
Stiebel, Inc., New York].

BIBLIOGRAPHY
"Acquisitions/1987," *GettyMusJ* 16 (1988),
no. 68, p. 177, illus.; Bremer-David, *Summary*,
no. 114, p. 76, illus.

114.

FRAME FOR A MIRROR

Paris, 1700–1710
Gessoed and gilded oak and limewood;
modern mirror glass
Height: 10 ft. 2 1/2 in. (313 cm); Width: 4 ft.
(122 cm)
Accession number 97.DH.5

PROVENANCE
[Carlhian, Paris, 1907]; [Robert Carlhian,
Neuilly-sur-Seine]; purchased by the J. Paul
Getty Trust, 1986.

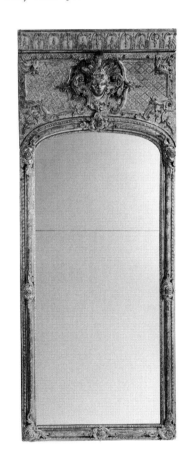

114

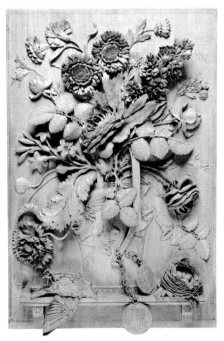

112

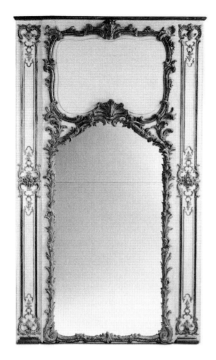

115

115.
FRAME FOR A MIRROR WITH TWO PARCLOSES

Paris, 1751–1753

Gessoed, gilded, and painted oak; modern mirror glass

One paper trade label of the *marchand-mercier* François-Charles Darnault is pasted on the face of the back board of the mirror frame; one paper trade label of *marchand-mercier* François-Charles Darnault is pasted on the back of the right *parclose* panel.

Height: 10 ft. 9 $^3/_4$ in. (329.6 cm); Width: 6 ft. 5 $^3/_4$ in. (197.5 cm)

Accession number 97.DH.4

PROVENANCE

François-Charles Darnault, "A la Ville de Versailles," Paris, circa 1751–1753; [Carlhian, Paris, circa 1932]; [Robert Carlhian, Neuilly-sur-Seine]; purchased by the J. Paul Getty Trust, 1986.

BIBLIOGRAPHY

Carolyn Sargentson, *Merchants and Luxury Markets: The Marchands Merciers of Eighteenth-Century Paris* (London, 1996), p. 180, illus. p. 22, pls. 10, 11; Cynthia Moyer and Gordon Hanlon, "Conservation of the Darnault Mirror: An Acrylic Emulsion Compensation System," *Journal of the American Institute for Conservation* 35 (1996), pp. 185–96, illus.

116.
FRAME

Paris, circa 1775–1780

Possibly by Paul Georges

Gessoed and gilded oak; modern mirror glass

Height: 6 ft. 10 in. (208.3 cm); Width: 5 ft. $^1/_4$ in. (152.4 cm)

Stamped with P. GEORGES on back and inked with 61 across the top.

Accession number 88.DA.49

PROVENANCE

George Baillie-Hamilton, 12th Earl of Haddington, Tyninghame House, East Lothian, Scotland (sold after his death, Sotheby's, Tyninghame House, September 28–29, 1987, lot 551); [Christopher Gibbs, London].

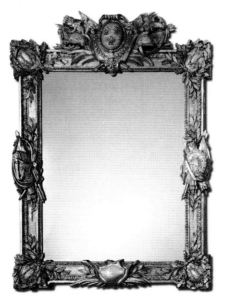

116

BIBLIOGRAPHY

"Acquisitions/1988," *GettyMusJ* 17 (1989), no. 75, p. 143, illus.; John Whitehead, *The French Interior in the Eighteenth Century* (London, 1992), p. 61, illus.; Bremer-David, *Summary*, no. 115, p. 76, illus.

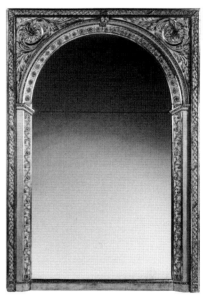

117

117.
FRAME FOR A MIRROR

Paris, circa 1775–1780

Painted and gilded oak; modern mirror glass

Height: 6 ft. 1 $^3/_4$ in. (187.2 cm); Width: 4 ft. 3 $^1/_2$ in. (131 cm); Depth: 3 $^3/_4$ in. (9.5 cm)

Accession number 92.DH.20

PROVENANCE

[Kraemer et Cie, Paris].

BIBLIOGRAPHY

"Acquisitions/1992," *GettyMusJ* 21 (1993) no. 65, p. 140, illus.; Bremer-David, *Summary*, no. 116, p. 77, illus. p. 76

Paneling and Mantelpieces

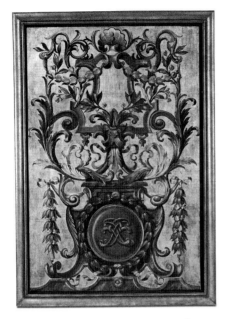

118 *One of ten*

118.
TEN PANELS

Paris, circa 1661
Design attributed to Charles Le Brun
Painted and gilded oak; modern wooden frames
Panel .1: Height: 6 ft. 11 in. (202.5 cm);
Width: 2 ft. 7 1/8 in. (77.8 cm); Panel .2:
Height: 6 ft. 10 7/8 in. (202.2 cm); Width:
2 ft. 7 1/8 in. (77.8 cm); Panel .3: Height: 6 ft.
10 1/4 in. (200.6 cm); Width: 2 ft. 3 3/4 in.
(69.4 cm); Panel .4: Height: 6 ft. 11 1/8 in.
(202.8 cm); Width: 2 ft. 3 7/8 in. (69.7 cm);
Panel .5: Height: 4 ft. 1 1/8 in. (122.8 cm);
Width: 2 ft. 10 in. (85 cm); Panel .6: Height:
4 ft. 1 in. (122.5 cm); Width: 2 ft. 9 3/4 in.
(84.4 cm); Panel .7: Height: 4 ft. 1 3/4 in.
(124.8 cm); Width: 3 ft. (90 cm); Panel .8:
Height: 4 ft. 1 in. (122.5 cm); Width: 2 ft.
11 7/8 in. (89.7 cm); Panel .9: Height: 1 ft.
9 7/8 in. (54.7 cm); Width: 6 ft. 2 1/8 in.
(185.3 cm); Panel .10: Height: 3 ft. 11 1/8 in.
(117.8 cm); Width: 1 ft. 7 1/2 in. (48.7 cm)
Accession number 91.DH.18.1–.10

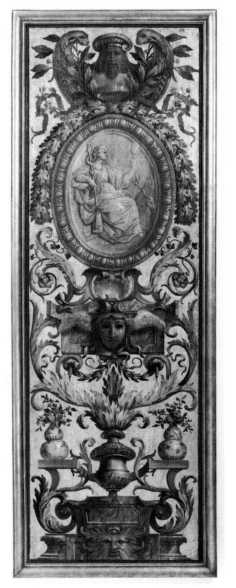

118 *One of ten*

PROVENANCE
Felix Harbord, England, 1950s; Felix
Fenston, England (sold by his widow,
Sotheby's, London, May 25, 1990, lot 50,
to [Christopher Gibbs, London]).

BIBLIOGRAPHY
"Style in Interior Decoration: Some Contem-
porary Decorators—II Felix Harbord," *Apollo*
(October 1956), pp. 107–110, illus. pp. 107–
108; "Acquisitions/1991," *GettyMusJ* 20
(1992), no. 76, p. 174, illus. (two); Bremer-
David, *Summary*, no. 117, p. 77, illus. (two);
"Museum Acquisitions in the Decorative
Arts: Determination and Beneficence," *Apollo*
137, no. 371 (January 1993), p. 38, illus.;
Masterpieces, no. 35, p. 49, illus.; *Handbook*
2001, p. 184, illus. (one).

119

119.
MANTELPIECE

Paris (?), circa 1690–1700
Sarrancolin des Pyrénées marble (also known as
marbre d'Antin) and *brèche violette*
Height: 5 ft. 10 1/2 in. (179.1 cm); Width:
7 ft. 10 1/4 in. (240 cm); Depth: 1 ft. 1 1/2 in.
(34.3 cm)
Accession number 89.DH.30

PROVENANCE
[B. Fabre et Fils, Paris].

BIBLIOGRAPHY
"Acquisitions/1989," *GettyMusJ* 18 (1990),
no. 52, p. 193, illus.; Bremer-David, *Summary*,
no. 118, p. 78, illus.

120

BIBLIOGRAPHY

F. de Saint-Simon, "No 7 Hôtel Le Bas de Montargis," *La Place Vendôme* (Paris, 1982), pp. 113–115; Bruno Pons, "Bibliothèque de l'Hôtel Le Bas de Montargis (vers 1719)," *French Period Rooms 1650–1800 Rebuilt in England, France, and the Americas* (Paris, 1995), pp. 173–184; Rochelle Ziskin, *The Place Vendome: Architecture and Social Mobility in Eighteenth-Century Paris* (Cambridge, 1999), fig. 57, p. 73, illus.; Lisa Lyons, "Judy Fiskin: My Getty Center," *Departures: Eleven Artists at the Getty* (Los Angeles, 2000), p. 24, illus.

121.

PANELING

Paris, 1725–1726
By Jacques Gaultier, *menuisier*, after the designs of Armand-Claude Mollet
Painted and gilded oak and walnut; *brèche d'Alep* mantelpiece; modern mirror glass
Height: 13 ft. (396.2 cm); Width: 26 ft. 9 in. (815 cm); Depth: 22 ft. (670.6 cm) (as installed)
Accession numbers 71.DH.118 and 88.DH.59

PROVENANCE

Guillaume Cressart, Hôtel Cressart, installed in 1725 and 1726 in the *chambre à coucher* of 18 place Vendôme, Paris; Louis-Auguste Duché, 1733; Jean-Baptiste Duché (brother of Louis-Auguste Duché), by 1743; Elisabeth-Louis Duché (wife of Jacques Bertrand, marquis de Scépeaux et de Beaupreau), after 1743; Elisabeth-Louise-Adélaïde de Scépeaux de Beaupreau (wife of the comte de La Tour d'Auvergne), 1769; Jean-Louis Milon d'Inval, Paris, 1774; by inheritance to his wife, Antoinette Bureau Seraudey (Mme d'Inval), in an III (1794–1795) (sold by her heirs in 1836); Sophie Dawes (baronne de Feuchères), 1836; the *chambre à coucher* became the *salon* at this time (sold by her heirs after her death in 1841); the marquise de Las Marismas del Guadalquivir (Mme Alexandre Aguado), 1842; Union Artistique, Paris, 1865; [André Carlhian, Paris; *boiseries* removed in 1936]; [Duveen Brothers, New York, 1939; stored in Paris until removed to New York in 1959];

120.

PANELING

Paris, circa 1720
Attributed to the scupltor Jules Degoullons and his collaborators of the *Société pour les bâtiments du roi*; probably after designs by Robert de Cotte
Painted and gilded oak
Height: 10 ft. (305 cm); Width: 23 ft. 4 1/2 in. (712.2 cm); Depth: 14 ft. 11 1/2 in. (179.5 cm) (as installed)
Accession number 97.DH.2.1–.38

PROVENANCE

Claude le Bas de Montargis (*trésorier général de l'extraordinaire des Guerres*) and Catherine-Henriette Hardouin (daughter of Jules Hardouin Mansart), 7 Place Vendôme, Paris, installed as a *bibliothèque en armoire* in a cabinet circa 1720; by inheritance to their daughter, marchioness Anne-Charlotte Hardouin (widow of Louis, marquis d'Arpajon), who sold the *hôtel* in 1759; Nicolas Dedelay de la Garde (*fermier général*, died 1783), by inheritance to his widow, Elisabeth de Ligniville (later comtesse de Polleresky, died 1791); Jean-Jacques Claret de Fleurieu, 1823; paneling removed to the family's *hôtel*, Hôtel Claret de Fleurieu, in Saint Germain-en-Laye before 1861; [André Carlhian, Paris, before 1926]; [Robert Carlhian, Neuilly-sur-Seine]; purchased by the J. Paul Getty Trust, 1986.

Norton Simon, New York, 1965; purchased by J. Paul Getty. 88.DH.59 (only): separated from 71.DH.118 in the 1960s; [Therien and Co., Inc., San Francisco, 1987].

BIBLIOGRAPHY
René Colas, "Les Hôtels de la place Vendôme," *Paris qui reste: vieux hôtels, vieilles demeures, rive droite* (Paris, 1914), pp. 105–106, pl. 94; Fredericksen et al., *Getty Museum*, p. 145, illus.; Wilson, "Meubles 'Baroques,'" p. 106, illus.; Bruno Pons, "Les boiseries de l'Hôtel Cressart au Getty Museum," *GettyMusJ* 11 (1983), pp. 67–88, illus.; Jackson-Stops, "Boulle by the Beach," pp. 854–856, illus. p. 854, fig. 1; Bremer-David, *Summary*, no. 119, pp. 78–79, illus. p. 78; Bruno Pons, "Chambre à Coucher de l'Hôtel Duché (Cressart) (1725), 18, Place Vendôme, *French Period Rooms Rebuilt in England, France and the Americas* (Paris, 1995) pp. 209–220, illus.; Joseph Godla and Gordon Hanlon, "Some Applications of Adobe Photoshop for the Documentation of Furniture Conservation," *Journal of the American Institute for Conservation* 34 (Fall/Winter 1995), pp. 157–172, illus. (detail) p. 165, fig. 10; Katie Scott, *The Rococo Interior: Decoration and Social Spaces in Early Eighteenth-Century Paris* (New Haven, 1995), p. 36, illus.; Pratapaditya Pal, "Getty and Asian Art," *Orientations* (April 1998), pp. 58–63, p. 59, illus.

122 Detail of one

122.

ELEVEN PANELS

Paris, circa 1730–1735

Oak

Panels .1–.2: Height: 9 ft. 2 1/4 in. (280 cm); Width: 4 ft. 1/2 in. (123 cm); Panels .3–.4: Height: 9 ft. 2 1/4 in. (280 cm); Width: 4 ft. 6 1/2 in. (139 cm); Panels .5–.7: Height: 9 ft. 2 in. (279.4 cm); Width: 1 ft. 3 3/4 in. (40 cm); Panel .8: Height: 9 ft. 2 in. (279.4 cm); Width: 1 ft. 6 1/4 in. (46.3 cm); Panel .9: Height: 9 ft. 2 in. (279.4 cm); Width: 1 ft. 10 in. (55.9 cm); Panels .10–.11: Height: 6 ft. 1 in. (185.4 cm); Width: 10 in. (25.4 cm)

Accession number 84.DH.52.1–.11

PROVENANCE

Château de Marly-Le-Roi, Yvelines, by repute; Mallett family, Louveciennes, early nineteenth century; Mme Claude Melin, Louveciennes, 1984, by descent.

BIBLIOGRAPHY
Bremer-David, *Summary*, no. 120, p. 79, illus.

121

123.

MANTELPIECE

Paris, circa 1730–1735
Brecciated marble of a variety of *sarrancolin des Pyrénées*; modern brick
Height: 3 ft. 7 1/2 in. (110.5 cm); Width:
5 ft. 9 in. (175.3 cm); Depth: 11 1/2 in.
(29.2 cm)
Accession number 85.DH.92

PROVENANCE

Private residence, Paris; [François Léage, Paris].

BIBLIOGRAPHY

"Acquisitions/1985," *GettyMusJ* 14 (1986),
no. 195, p. 244, illus.; Bremer-David, *Summary*, no. 121, p. 79, illus.

123

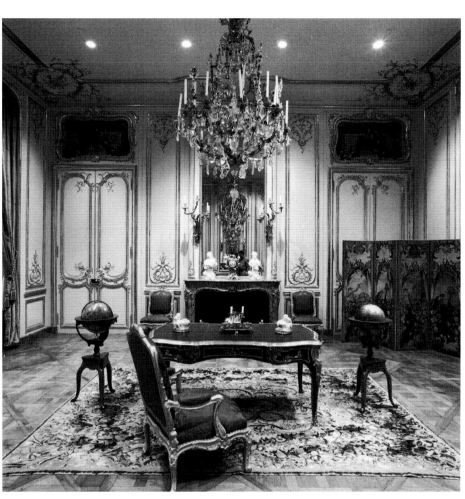

124

124.

PANELED ROOM

Paris, circa 1755
Painted and gilded oak; four oil-on-canvas
overdoor paintings; *brèche d'Alep* mantelpiece;
modern mirror glass; gilt-bronze hardware
Height: 14 ft. 4 in. (436.9 cm); Width:
23 ft. 6 1/2 in. (718 cm); Depth: 25 ft. 6 in.
(777 cm)
Accession number 73.DH.107

PROVENANCE

An unidentified *hôtel* on the quai Malaquais,
Paris, until 1900; Mme Doucet, Paris,
1900–1907; comte Henri de Greffulhe, 8, rue
d'Astorg, Paris; duc de Gramont, 42 bis
avenue Georges Mandel, Paris, 1909 (offered
for sale in situ, Ader Picard, Paris, October 9, 1969, no. 14, bought in); [R. and M.
Carlhian, Paris]; purchased by J. Paul Getty.

BIBLIOGRAPHY

La comtesse Jean Louis de Maigret, "Un
demi-siècle à l'Hôtel Gramont," *Connaissance
des arts* 141 (November 1963), p. 92, illus.;
Jackson-Stops, "Boulle by the Beach,"
pp. 854–856, illus. p. 854, fig. 2; "J. Paul
Getty Museum," *Ventura*, September–November (1988), p. 165, illus.; Bremer-David,
Summary, no. 122, p. 80, illus.; Philip Yenawine, *Key Art Terms for Beginners* (New York
1995), p. 66, illus.

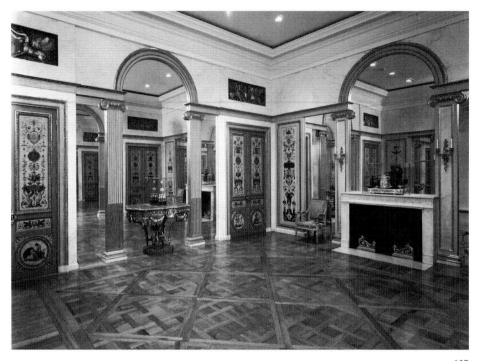

125

125.

PANELED ROOM (SALON DE COMPAGNIE)
Paris, circa 1790–1795
Panels painted by Jean-Siméon Rousseau de la
Rottière and plaster overdoors attributed to
Jean-Guillaume Moitte, after designs by
Claude-Nicolas Ledoux
Painted and gilded oak; painted and gilded
plaster; modern mirror glass; modern gilt-
bronze hardware; white marble mantelpiece
Various pieces of moldings bear the stenciled
number 8032.
Four Double Doors: Height: 9 ft. 5 1/4 in.
(287.7 cm); Width (of one door): 2 ft. 3 3/4 in.
(70.5 cm); Four Large Panels: Height: 9 ft.
5 1/8 in. (287.3 cm); Width: 2 ft. 8 3/4 in.
(83.2 cm); Five Panels: Height: 9 ft. 3 1/2 in.
(283.2 cm); Width: 1 ft. 6 1/2 in. (46.9 cm);
Four Panels: Height: 9 ft. 3 1/2 in. (285.1 cm);
Width: 1 ft. 1/2 in. (31.8 cm); Four Over-
doors: Height: 2 ft. 11 3/4 in. (90.8 cm);
Width: 5 ft. 3/4 in. (167 cm)
Accession numbers 98.DH.149 and 91.DH.60
(moldings only)

PROVENANCE
"Grand salon," Maison Hosten, 38 rue
Saint-Georges, Paris, until around 1892;
Mme C. Lelong, Paris, after 1892; Fournier,
Paris, before 1897 (?); [L'antiquaire Levy,
15 rue Pigalle, Paris;] Prince d'Essling, duc de
Rivoli, 8 rue Jean Goujon, Paris, 1897 to May
1913 (?); [in storage with Maison Carlhian
from May 1913 to January 1920, when con-
signed to both Maison Carlhian and Jacques
Seligmann]; [Maison Carlhian and Jacques
Seligmann, Paris, 1921]. Panels only: Otto
Wolff, Cologne, 1925; private collection,
Cologne, until 1969; [Joachim Kaiser and
Georg Fahrbach, Cologne, 1969–1986];
[Axel Vervoordt, Belgium, 1986]; moldings
only: [R. and M. Carlhian, Paris]; purchased
by the J. Paul Getty Trust, 1987.

BIBLIOGRAPHY
Krafft and Ransonette, Choix des plus belles
maisons de Paris (Paris, 1805), pl. 5; Alfred de
Champeaux, L'Art décoratif dans le vieux Paris
(Paris, 1898), p. 319; Lady Dilke, French Fur-
niture and Decoration in the Seventeenth Century
(London, 1901) pp. 67–68, 70, illus.; René
Destailleur, Documents de Décoration au XVIII*
siècle, Peinture et Sculpture Décoratives-Tapisseries
(Brussels, 1906), pls. 60–63; Ville de Paris,
Commission Municipale du Vieux Paris, Année 1921,
Procès-Verbaux (Paris, 1924), p. 84; Paul Mar-
mottan, Le Style empire: Architecture et décors d'in-
térieurs (Paris, 1927), vol. 4, pp. 1–2, pls. 1–7;
Marcel Raval, Claude-Nicolas Ledoux 1736–
1806 (Paris, 1945), p. 51, pls. 50–59; Louis
Hautecoeur, Histoire de l'architecture classique en
France, vol. 5, Révolution et l'empire (Paris, 1953),
pp. 347, 371; Jacques Hillairet, Dictionnaire
historique des rues de Paris (Paris, 1963), vol. 2,
p. 408; "Ledoux et Paris," Cahiers de la rotonde
3 (Paris, 1979), pp. 128–129, illus. p. 181,
fig. 106; Michel Gallet, Claude-Nicolas Ledoux
1736–1806 (Paris, 1980), pp. 209–213,
figs. 372–383; La Nouvelle Athènes: Le Quartier
Saint-Georges de Louis XV à Napoleon III (Musée
Carnavalet, Paris, 1984), no. 22, p. 20;
Bremer-David, Summary, no. 124, pp. 80–81,
illus. p. 81; Bruno Pons, "In memorium David
Harris Cohen, Salon de l'Hôtel Hosten
(1792), 38 rue Saint-Georges," French Period
Rooms Rebuilt in England, France and the Americas
(Paris, 1995), pp. 395–410, illus.; Alexia
Lebeurre, "Le 'genre arabesque': nature et dif-
fusion des modèles dans le décor intérieur à
Paris, 1760–1790," Architecture et décor 42/43
(October 1998), p. 86, illus. p. 87.

CLOCKS AND BAROMETERS

Newel Post

127.
NEWEL POST
Paris, circa 1735
Painted and gilded iron
Height: 2 ft. 11 ⁵/₈ in. (90.5 cm); Width:
11 ¹/₂ in. (29.2 cm); Depth: 1 ft. 3 ³/₄ in.
(40 cm)
Accession number 79.DH.164

PROVENANCE
A. Gignoux, Paris; purchased by J. Paul
Getty, circa 1950.

BIBLIOGRAPHY
J. Paul Getty, *Collector's Choice* (London, 1955)
pp. 155, 237; Bremer-David, *Summary*, no.
126, p. 82, illus.

126

126.
WALL LIGHT
Lorraine (Nancy), circa 1700
"Bois de Sainte-Lucie" (cerasus mahaleb)
Height: 1 ft. 5 in. (43.2 cm); Width:
11 ⁵/₈ in. (29.4 cm); Depth: 5 in. (12.6 cm)
Accession number 85.DH.284

PROVENANCE
[Neidhardt Antiquitäten GmbH, Munich,
1985].

BIBLIOGRAPHY
"Acquisitions/1985," *GettyMusJ* 14 (1986),
no. 190. p. 242, illus.; Bremer-David, *Sum-
mary*, no. 125, p. 82, illus.

127

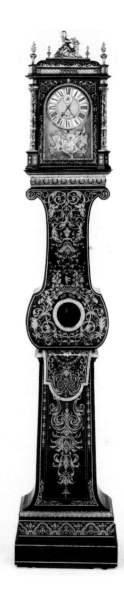

128

128.
LONG-CASE CLOCK (RÉGULATEUR)
Paris, circa 1680–1690
Case attributed to André-Charles Boulle; the
movement by Antoine 1 Gaudron
Oak veneered with ebony, tortoiseshell,
brass, and pewter; enameled metal; gilt-
bronze mounts; glass
Inscribed *Gaudron ÆParis* on clock face and
movement and *Solem Audet Dicere Falsum* (It
dares the sun to tell a lie) on face.

BIBLIOGRAPHY

Wilson, "Meubles 'Baroques,'" p. 109, illus.;
Fredericksen et al., *Getty Museum*, p. 185,
illus.; Miller, "Clockwise," pp. 15–21, fig. 1,
p. 18, illus.; Wilson, *Selections*, no. 7, pp. 14–
15, illus.; Verlet, *Les Bronzes*, illus. p. 164,
fig. 200; C. E. Zonneyville-Heyning,
"Gilden," *Visuele Kunsten: Kunstgeschiedenis
van de nieuwe tijd* 3 (1989), p. 44, illus.; Gian
Giotto Borelli, *Antiquités et objets d'art — horloges
et pendules* (Paris, 1992), p. 65, illus. p. 48;
William Park, *The Idea of Rococo* (Newark,
Delaware, 1992), p. 103, illus.; Bremer-David,
Summary, no. 128, pp. 82–83, illus. p. 83;
Jean-Dominique Augarde, *Les Ouvriers du temps:
La Pendule à Paris de Louis XIV à Napoléon 1er*
(Geneva, 1996), pp. 165–166, illus. p. 166;
Wilson, *Clocks*, no. 3, pp. 14–19, illus.; *Mas-
terpieces*, no. 45, p. 61, illus.; *Handbook 2001*,
pp. 192–193, illus.

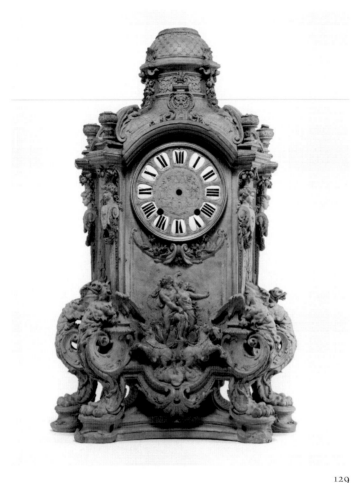

129

130.
WALL CLOCK (PENDULE D'ALCOVE)

Paris, circa 1710
Case attributed to André-Charles Boulle;
maker of later English movement unknown
Gilt bronze; blue painted horn; enameled
metal; glass
The back bears a label inked with *Vernon
House, Staircase*.
Height: 2 ft. 4 in. (71.1 cm); Width:
11 1/4 in. (28.6 cm); Depth: 4 1/2 in. (11.4 cm)
Accession number 73.DB.74

PROVENANCE

Charles William, 2nd Lord Hillingdon,
Vernon House, London; Charles, 4th Lord
Hillingdon, by descent (sold, Christie's, Lon-
don, June 29, 1972, lot 56); [French and Co.,
New York, 1972]; purchased by J. Paul Getty.

Height: 8 ft. 1 5/16 in. (246.5 cm); Width:
1 ft. 6 7/8 in. (48 cm); Depth: 7 1/2 in. (19 cm)
Accession number 88.DB.16

PROVENANCE

[Jean Durier, Paris, circa 1945]; private
collection, Burgundy, 1948–1988; [Alain
Moatti, Paris].

BIBLIOGRAPHY

"Acquisitions/1988," *GettyMus J* 17 (1989), no.
66, p. 140, illus.; *Handbook 1991*, p. 160,
illus.; Bremer-David, *Summary*, no. 127,
pp. 82–83, illus. p. 83; Wilson, *Clocks*, no. 1,
pp. 2–9; Ramond, *Chefs d'oeuvre 1*, pp. 27–29,
illus.; *Masterpieces*, no. 42, p. 57, illus.

129.
MODEL FOR A MANTEL CLOCK

Paris, circa 1700–1715
Terracotta; enameled metal plaques
Height: 2 ft. 7 in. (78.7 cm); Width: 1 ft.
8 1/2 in. (52.1 cm); Depth: 9 1/2 in. (24.2 cm)
Accession number 72.DB.52

PROVENANCE

[Dalva Brothers, Inc., New York]; purchased
by J. Paul Getty.

EXHIBITIONS

New York, The Metropolitan Museum of Art,
Magnificent Time-Keepers, January 1971–
March 1972, no. 67.

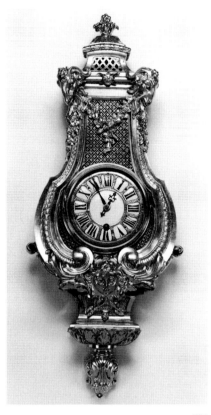

130

BIBLIOGRAPHY

Miller, "Clockwise," pp. 15–21, fig. 3, p. 19, illus.; Bremer-David, *Summary*, no. 129, pp. 83–84, illus. p. 83; Wilson, *Clocks*, no. 2, pp. 10–13.

131.

LONG-CASE MUSICAL CLOCK

Paris, circa 1712
Case and stand attributed to Alexandre-Jean Oppenordt, possibly after a design by Gilles-Marie Oppenord; movement by Jean-François Dominicé; musical movement by Michel Stollenwerck; movement repaired and dial and hands replaced by Pierre-Bazile Lepaute
Oak veneered with brass and red painted tortoiseshell; enameled metal; bronze mounts; glass

Movement is engraved with *J. F. Dominicé APâris* and *Fait par Stollenwerck dans l'abbaye St. Germain APâris*; dial is engraved with *LEPAUTE*.
Height: 8 ft. 9 in. (266.7 cm); Width: 3 ft. 5 in. (104.1 cm); Depth: 1 ft. 3 1/2 in. (39.4 cm)
Accession number 72.DB.40

PROVENANCE

Vincent Donjeux (?), Paris (sold, Paris, April 29, 1793, no. 562); Peter Burrell, 1st Lord Gwydir (1754–1820), Grimsthorpe Castle, Cokayne; by descent to Peter Burrell, 2nd Lord Gwydir (1782–1865) (sold, Christie's, London, March 11–12, 1829, lot 103, to [Samuel Fogg, London]); William Allenye Cecil, 3rd Marquess of Exeter; by descent Henry George Brownlow, 4th Marquess of Exeter, Burghley House (sold, Christie's, London, June 7–8, 1888, lot 261, to [Charles Davis, London]); Cornelius Vanderbilt II (1843–1899), New York; Gladys Moore Vanderbilt (Countess Laszlo Széchényi, 1886–1965) New York and The Breakers, Newport, Rhode Island (circa 1926–1927), (sold by her heirs in 1971 to [Rosenberg and Stiebel, Inc., New York]); [French and Co., New York, 1971]; purchased by J. Paul Getty, 1971.

BIBLIOGRAPHY

Fredericksen et al., *Getty Museum*, p. 151, illus.; Miller, "Clockwise," pp. 15–21, fig. 5, p. 19, illus.; Jean-Nérée Ronfort, "André-Charles Boulle: Die Bronzearbeiten und seine Werkstatt im Louvre," Ottomeyer and Pröschel, *Vergoldete Bronzen*, vol. 2, p. 491; Gian Giotto Borelli, *Antiquités et objets d'art — horloges et pendules* (Paris, 1992), illus. p. 48; Bremer-David, *Summary*, no. 130, p. 84, illus.; Joseph Godla and Gordon Hanlon, "Some Applications of Adobe Photoshop for the Documentation of Furniture Conservation," *Journal of the American Institute for Conservation* 34 (Fall/Winter 1995), fig. 11, p. 167, illus.; Wilson, *Clocks*, no. 5, pp. 28–41, illus.

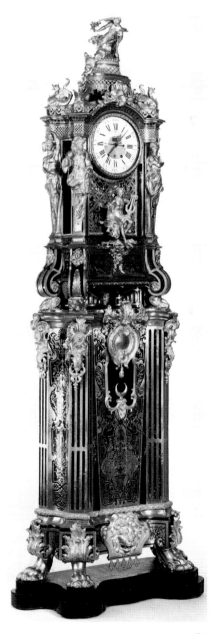

131

132.

MANTEL CLOCK

Paris, circa 1715–1725

Case attributed to André-Charles Boulle; movement by Paul Gudin, called Gudin *le jeune*; figure of Chronos after a model by François Girardon

Oak veneered with tortoiseshell, blue painted horn, brass, and ebony; enameled metal; gilt-bronze mounts; glass movement is engraved with *Gudin le jeune à Paris*; dial is painted with GUDIN LE JEUNE A PARIS. Height: 3 ft. 4 in. (101.6 cm); Width: 1 ft. 8 in. (50.8 cm); Depth: 11 ³/₄ in. (29.8 cm)

Accession number 72.DB.55

PROVENANCE

Count János Pálffy (1829–1908), (sold, Bad Pistyan, Czechoslovakia, June 30, 1924, no. 285); [Etienne Lévy et Cie, Paris, 1971]; [French and Co., New York]; purchased by J. Paul Getty.

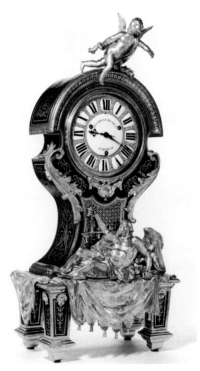

132

EXHIBITIONS

Paris, Hôtel George V, *Haute Joaillerie de France*, June 1971; New York, The Frick Collection, *French Clocks in North American Collections*, November 1982–January 1983, no. 38, p. 45, illus. p. 46.

BIBLIOGRAPHY

Fredericksen et al., *Getty Museum*, p. 150, illus.; Wilson, "Meubles 'Baroques,'" p. 106, illus.; Miller, "Clockwise," pp. 15–21, fig. 4, p. 19, illus.; *The Country Life International Dictionary of Clocks*, Alan Smith, ed. (New York, 1979), p. 90, fig. 6; Marvin D. Schwartz, "Boulle Furniture," *Arts and Antiques* (April 1983), illus. p. 75; Winthrop Edey, "Time for Boulle," *House and Garden* (March 1985), p. 82, illus.; Ottomeyer and Pröschel, *Vergoldete Bronzen*, vol. 1, p. 40, fig. 1.2.5, and Jean-Nérée Ronfort, "André-Charles Boulle: Die Bronzearbeiten und seine Werkstatt im Louvre," vol. 2, p. 478; Bremer-David, *Summary*, no. 132, pp. 85–86, illus. p. 85; Wilson, *Clocks*, no. 4, pp. 20–27, illus.

133.

WALL CLOCK (*PENDULE DE RÉPÉTITION*)

Paris, circa 1735–1740

Case by an unknown maker, possibly after a design by Juste-Aurèle Meissonnier; movement by Jean-Jacques Fiéffé *père*

Gilt bronze; enameled metal; wood carcass; glass

Dial is painted with FIEFFÉ DELOBSERVATOIR; movement is engraved with *Fieffé à Paris*.

Height: 4 ft. 4¹/₂ in. (133.4 cm); Width: 2 ft. 2¹/₂ in. (67.3 cm); Depth: 5⁵/₈ in. (14.4 cm)

Accession number 72.DB.89

PROVENANCE

Baron (Mayer) Alphonse de Rothschild (1827–1905), Château de Ferrières, Tarn; Baron Edouard (Alphonse James) de Rothschild (1868–1949), Château de Ferrières, by descent; Baron Guy (Edouard Alphonse Paul) de Rothschild (born 1909), Château de

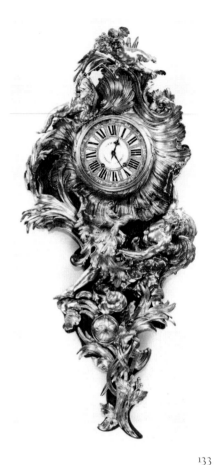

133

Ferrières (sold, Sotheby's, London, November 24, 1972, lot 7); purchased at that sale by J. Paul Getty.

BIBLIOGRAPHY

Eveline Schlumberger, "Caffiéri, le bronzier de Louis XV," *Connaissance des arts* 159 (May 1965), illus. p. 83; Gérard Mabille, *Le Style Louis XV* (Paris, 1978), p. 175, illus.; Miller, "Clockwise," pp. 15–21, fig. 6, p. 19, illus.; Ottomeyer and Pröschel, *Vergoldete Bronzen*, vol. 1, p. 111, fig. 2.3.4; Gian Giotto Borelli, *Antiquités et objets d'art — horloges et pendules* (Paris, 1992), p. 57, illus. p. 49; Bremer-David, *Summary*, no. 133, p. 86, illus.; Wilson, *Clocks*, no. 8, pp. 58–64; Jean-Dominique Augarde, *Les Ouvriers du Temps: La Pendule à Paris de Louis XIV à Napoléon I*ᵉʳ (Geneva, 1996), pp. 314–315, illus. fig. 238; *Masterpieces*, no. 60, p. 80, illus.

134.
WALL CLOCK (PENDULE D'ALCOVE)
 Paris and Chantilly manufactory, circa 1740
 Movement by Charles Voisin
 Soft-paste porcelain, polychrome enamel deco-
 ration; gilt bronze; enameled metal; glass
 Movement is engraved with C^{les} Voisin Æparis
 and dial is painted with CHARLES
 VOISIN APARIS.
 Height: 2 ft. 5 1/2 in. (74.9 cm); Width:
 1 ft. 2 in. (35.6 cm); Depth: 4 3/8 in. (11.1 cm)
 Accession number 81.DB.81

PROVENANCE
[Jacques Kugel, Paris, 1980].

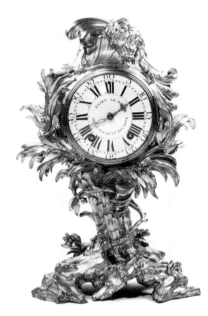

135

BIBLIOGRAPHY
Wilson, "Acquisitions 1981," no. 2, pp. 66–
71, illus.; "Some Acquisitions (1981–82) in
the Department of Decorative Arts, The
J. Paul Getty Museum," *Burlington Magazine*
125, no. 962 (May 1983), illus. p. 326;
Wilson, *Selections*, no. 13, pp. 26–27, illus.;
Jackson-Stops, "Boulle by the Beach,"
pp. 854–856; "J. Paul Getty Museum," *Ven-
tura* (September/November 1988), p. 166,
illus.; Gillian Wilson, "Dalla Raccolta del
Museo J. Paul Getty," *Casa Vogue Antiques* 8
(May 1990), pp. 114–119, illus. p. 119; Bre-
mer-David, *Summary*, no. 135, p. 87, illus.;
Wilson, *Clocks*, no. 6, pp. 42–47; Geneviève
Le Duc, *Porcelaine tendre de Chantilly au XVIIIe
siècle* (Paris, 1996), pp. 166–67, ill. pp. 166–
67; *Masterpieces*, no. 56, p. 75, illus.; Genvieve
Le Duc, "The Rocaille Style at Chantilly: A
Different Aspect of French Porcelain circa
1750," *Apollo* 147, no. 431 (January 1998),
pp. 37–41, illus. p. 39, fig. 6; *Handbook* 2001,
p. 200, illus.

135.
MANTEL CLOCK
 Paris, circa 1742
 Movement by Julien II Le Roy; enamel dial
 by Antoine-Nicolas Martinière
 Gilt bronze; enameled metal; glass
 Dial is painted with JULIEN·LE ROY·DE
 LA SOCIÉTÉ DES ARTS·; movement is
 engraved with *Julien Le Roy Æparis* on back;
 dial is enameled with *a.n. martiniere 1742* on
 reverse.
 Height: 1 ft. 6 1/8 in. (47 cm); Width:
 1 ft. 1/2 in. (32 cm); Depth: 8 1/8 in. (20.6 cm)
 Accession number 79.DB.4

PROVENANCE
[Jacques Kugel, Paris, 1978].

EXHIBITIONS
New York, The Frick Collection, *French Clocks
in North American Collections*, November 1982–
January 1983, no. 52, p. 58, illus. p. 13.

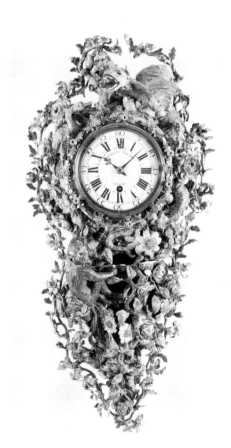

134

BIBLIOGRAPHY
Wilson, "Acquisitions 1977 to mid-1979,"
no. 14, pp. 50–52, illus; Miller, "Clockwise,"
pp. 15–21, fig. 15, p. 21, illus.; Bremer-
David, *Summary*, no. 136, pp. 87–88, illus.
p. 87; Wilson, *Clocks*, no. 9, pp. 65–69.

136.
WALL CLOCK
 Paris, circa 1747
 Case by Jacques Caffieri; movement by
 Julien II Le Roy; enamel dial by Antoine-
 Nicolas Martinière
 Gilt bronze; enameled metal; glass
 Case is engraved with *fait par Caffiery* and
 stamped with the crowned C for 1745–1749.
 Dial is inscribed with ·JULIEN·LE·ROY·
 and on reverse, with *a.n. martiniere Privilégié Du
 Roi 1747*. Movement is engraved with *Julien
 Le Roy Æparis*.
 Height: 2 ft. 6 1/2 in. (77.5 cm); Width:
 1 ft. 4 in. (40.6 cm); Depth: 4 1/2 in.
 (11.4 cm)
 Accession number 72.DB.45

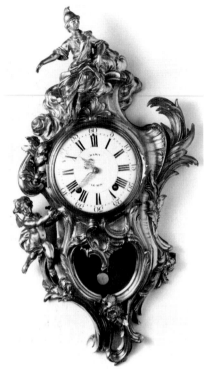

136

PROVENANCE
(Sold anonymously, Christie's, London,
July 15, 1971, lot 21); [French and Co., New
York]; purchased by J. Paul Getty.

BIBLIOGRAPHY
Miller, "Clockwise," pp. 15–21, fig. 10, p. 21,
illus.; *The Country Life International Dictionary of
Clocks*, Alan Smith, ed. (New York, 1979),
p. 237, fig. 2; Ottomeyer and Pröschel, *Ver-
goldete Bronzen*, vol. 1, p. 114, fig. 2.5.2;
Bremer-David, *Summary*, no. 137, p. 88, illus.;
Wilson, *Clocks*, no. 12, pp. 86–91.

137.

PLANISPHERE CLOCK
 Paris, circa 1745–1749
 Case attributed to Jean-Pierre Latz; move-
 ment (now missing) by Alexandre Fortier
 Oak veneered with kingwood; bronze
 mounts; glass; gilt paper
 Dial is engraved with *Inventé par A. FORTIER*;
 mounts of lower sections are stamped with
 the crowned C for 1745–1749.

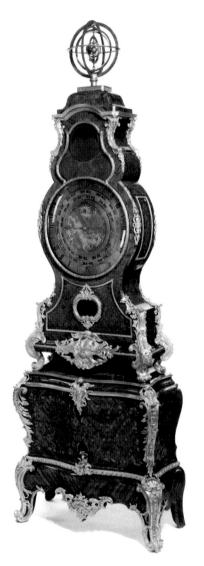

Height: 9 ft. 3 in. (282 cm); Width: 3 ft.
1 in. (94 cm); Depth: 1 ft. 3 in. (38.1 cm)
Accession number 74.DB.2

PROVENANCE
Louis-François de Bourbon, prince de Conti
(sold, Paris, April 8–June 6, 1777, no. 2008);
Baron Gustave (Samuel James) de Rothschild
(1829–1911), Paris; [Charles Davis] (sold,
Christie's, London, June 29, 1906, lot 132,
for £577 to Stettiner); Maurice Ephrussi,
Paris (offered for sale, Galerie Georges Petit,
May 22, 1911, no. 63, bought in [?]); (sold,
"Property of a Lady of Title," Sotheby's, Lon-
don, November 24, 1972, lot 34); [Rosenberg
and Stiebel, Inc., New York, 1974]; purchased
by J. Paul Getty.

EXHIBITIONS
New York, The Metropolitan Museum
of Art, *The Grand Gallery*, La Confederation
internationale des negociants en oeuvres
d'art (CINOA), October 1974–January 1975,
no. 44, p. 50.

BIBLIOGRAPHY
"The Grand Gallery," *Connoisseur* (October
1974), p. 122; Miller, "Clockwise," pp. 15–
21, fig. 7, p. 19, illus.; Wilson, *Selections*,
no. 18, pp. 36–37, illus., fig. 144; Verlet, *Les
Bronzes*, p. 115, illus. fig. 144; Bremer-David,
Summary, no. 138, pp. 88–89, illus. p. 89;
Jean-Dominique Augarde, *Les Ouvriers du Temps:
La Pendule à Paris de Louis XIV à Napoléon I^er*
(Geneva, 1996), pl. 182, pp. 228–229; Wil-
son, *Clocks*, no. 13, pp. 92–101.

138.

BAROMETER ON BRACKET
 Paris, circa 1755
 Clock case attributed to Charles Cressent;
 bracket attributed to Jean-Joseph de
 Saint-Germain; maker of the modern move-
 ment unknown
 Gilt bronze; enameled metal; wood car-
 cass; glass
 Dial is enameled with DIGUE A PARIS.

137

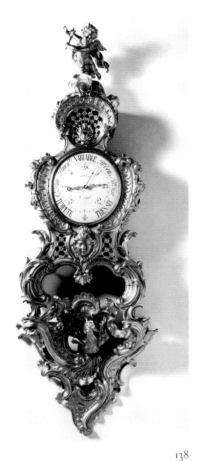

138

Height: 4 ft. 3 in. (129.4 cm); Width: 1 ft. 6 in. (45.7 cm); Depth: 7 1/4 in. (18.4 cm)
Accession number 71.DB.116

PROVENANCE

[B. Fabre, Paris]; [Duveen Brothers, New York, 1933]; Anna Thomson Dodge, Rose Terrace, Grosse Pointe Farms, Michigan by 1933 (sold, Christie's, London, June 24, 1971, lot 40 [together with no. 139 in this book]); purchased at that sale by J. Paul Getty.

BIBLIOGRAPHY

Duveen and Co., A Catalogue of Works of Art of the Eighteenth Century in the Collection of Anna Thomson Dodge (Detroit, 1933), non-paginated entry, illus.; Theodore Dell, "The Gilt-Bronze

Cartel Clocks of Charles Cressent," Burlington Magazine 109 (April 1967), pp. 210–217; Fredericksen et al., Getty Museum, p. 187, illus.; Miller, "Clockwise," pp. 15–21, fig. 9, p. 19, illus.; Bremer-David, Summary, no. 134, pp. 86–87, illus. p. 87; Wilson, Clocks, no. 7, pp. 48–57; Pierre Kjellberg, Encyclopédie de la pendule française du moyen age au xxe siècle (Paris, 1997), fig. B, p. 92, illus.

139.

CLOCK ON BRACKET

Paris, circa 1758
Movement by Jean Romilly; clock case attributed to Charles Cressent; bracket by Jean-Joseph de Saint-Germain
Gilt bronze; enameled metal; wood carcass; glass
Bracket is stamped with ST GERMAIN; movement is engraved with Romilly Æaris and dial is enameled with ROMILLY A PARIS; one spring is inscribed with William II Blakey and dated 1758; all gilt-bronze elements are stamped with an E on reverse.
Height: 4 ft. 1 1/2 in. (125.7 cm); Width: 1 ft. 6 1/2 in. (47 cm); Depth: 8 in. (20.3 cm)
Accession number 71.DB.115

PROVENANCE

George Jay Gould, in the "Foyer Hall" of 857 Fifth Avenue, New York; [Duveen Brothers, New York]; Anna Thomson Dodge, Rose Terrace, Grosse Pointe Farms, Michigan, by 1932 (sold, Christie's, London, June 24, 1971, lot 40 [together with no. 138 in this book]); purchased at that sale by J. Paul Getty.

BIBLIOGRAPHY

Duveen and Co., A Catalogue of Works of Art of the Eighteenth Century in the Collection of Anna Thomson Dodge (Detroit, 1933), non-paginated entry, illus.; Theodore Dell, "The Gilt-Bronze Cartel Clocks of Charles Cressent," Burlington Magazine 109 (April 1967), pp. 210–217; Fredericksen et al., Getty Museum, p. 187; Ottomeyer and Pröschel, Vergoldete Bronzen, vol. 1, p. 79, fig. 1.12.7; Bremer-David, Sum-

mary, no. 139, p. 89, illus.; Alvar González-Palacios, Il Patrimonio artistico del Quirinale, Gli Arredi Francesi (Milan, 1995), no. 80, p. 297; Wilson, Clocks, no. 7, pp. 48–57, illus.; Jean-Dominique Augarde, "Jean-Joseph de Saint Germain Bronzier (1719–1791): Inédits sur sa Vie et son Oeuvre," L'Estampille/L'Objet d'art 308 (December 1996), pp. 62–82, illus. p. 67, fig. 7; Pierre Kjellberg, Encyclopédie de la pendule française du moyen age au xxe siècle (Paris, 1997), p. 92, fig. B, illus.

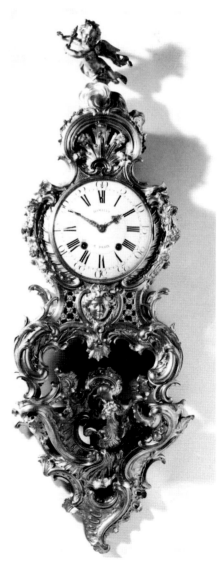

139

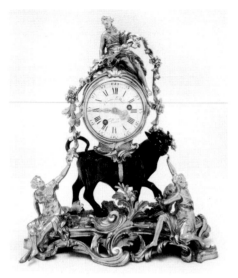

140

140.

MANTEL CLOCK

Paris, circa 1763

Case attributed to Robert Osmond; movement by Étienne II Le Noir in partnership with his son Pierre-Étienne Le Noir

Patinated and gilt bronze; enameled metal; glass

Dial is painted with *Etienne Le Noir Æparis* and movement is engraved with *Etienne le Noir Æparis No. 396*; springs are inscribed with *Masson 1763*.

Height: 1 ft. 9 1/2 in. (54.6 cm); Width: 1 ft. 5 3/4 in. (45.1 cm); Depth: 9 1/4 in. (23.5 cm)

Accession number 73.DB.85

PROVENANCE

Louis-François-Armand de Vignerot du Plessis, duc de Richelieu (?); (sold, Paris, December 18, 1778, no. 692); (sold, "Property of a Nobleman," Christie's, London, July 5, 1973, lot 31); purchased at that sale by J. Paul Getty.

BIBLIOGRAPHY

Miller, "Clockwise," pp. 15–21, fig. 11, p. 21, illus.; Bremer-David, *Summary*, no. 140, p. 90, illus.; Wilson, *Clocks*, no. 14, pp. 102–107.

141.

WALL CLOCK ON BRACKET

Paris, circa 1764

Case by Antoine Foullet; movement by Lapina

Oak veneered with panels of green, red, and cream painted horn; brass; enameled metal; gilt-bronze mounts; glass

Stamped with ANT·FOVLLET *JME* on back of case and bracket. Movement is engraved with *Lapina A PARIS*; one spring is inscribed *Richard x de 1764 Mouvement foulé M Ebeniter* and a second spring is engraved with *Richard x de 1764 Sonnerie A foulé Eben.*

Height: 3 ft. 10 3/4 in. (118.7 cm); Width: 1 ft. 7 1/2 in. (49.5 cm); Depth: 11 1/4 in. (28.6 cm)

Accession number 75.DB.7

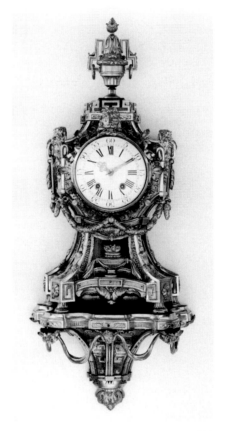

141

PROVENANCE

Private collection, Cornwall; [Alexander and Berendt, Ltd., London, 1974].

BIBLIOGRAPHY

Miller, "Clockwise," pp. 15–21, fig. 12, p. 21; Ottomeyer and Pröschel, *Vergoldete Bronzen*, vol. 1, p. 158, fig. 3.2.6; Verlet, *Les Bronzes*, p. 112, illus. p. 113, fig. 137; Pradère, *Les Ebénistes*, p. 275, illus.; Pierre Arizzoli-Clémentel, "Néoclassicisme," *L'Art décoratif en Europe du Néoclassicisme à L'Art Deco*, Alain Gruber, ed. (Paris, 1994), p. 55, illus.; Jean-Dominique Augarde, *Les Ouvriers du temps: La Pendule à Paris de Louis XIV à Napoléon Iᵉʳ* (Geneva, 1996), p. 188, fig. 152, illus.; Wilson, *Clocks*, no. 15, pp. 108–113.

142.

MANTEL CLOCK

Paris, circa 1772

Movement by Etienne-Augustin Le Roy; case by Etienne Martincourt

Gilt bronze; enameled metal; glass

Painted with CHARLES LE ROY A PARIS on dial; movement is engraved with *Ch les Le Roy Æparis* and stamped with *2417* on backplate; two movement springs are signed and dated *Richard fevrier 1772*.

Height: 2 ft. 4 in. (66 cm); Width: 1 ft. 11 1/2 in. (59.7 cm); Depth: 12 3/4 in. (32.4 cm)

Accession number 73.DB.78

PROVENANCE

Louis XVI, *Salle du Conseil* of the Palais des Tuileries, 1790; the marquis de Saint-Cloud (?) (sold, Hôtel Drouot, Paris, February 25–26, 1861, no. 1); [Kraemer et Cie, Paris]; [French and Co., New York, 1973].

EXHIBITIONS

New York, The Frick Collection, *French Clocks in North American Collections*, November 1982– January 1983, no. 63, illus. p. 67.

June 10, 1892, lot 65); Mrs. Orme Wilson (sold by her executors, Parke-Bernet, New York, March 25–26, 1949, lot 386); Mme Lucienne Fribourg (sold, Parke-Bernet, New York, April 19, 1969, lot 189); [Alexander and Berendt, Ltd., London]; Frau Quandt, Bad Homburg, Germany; [B. Fabre et Fils, Paris], owned jointly with [Jeremy, Ltd., London, 1986].

BIBLIOGRAPHY
"Acquisitions/1986," no. 108, p. 214, illus.; Bremer-David, *Summary*, no. 143, p. 91, illus.

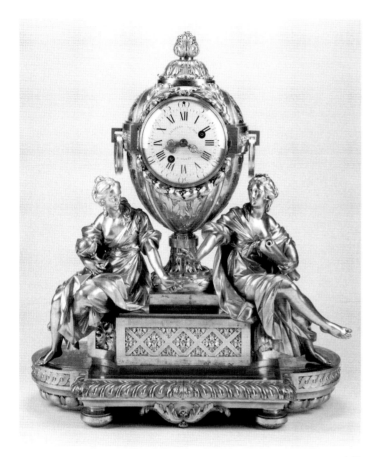

142

BIBLIOGRAPHY
Fredericksen et al., *Getty Museum*, p. 165, illus.; Miller, "Clockwise," pp. 15–21, fig. 13, p. 21, illus.; Wilson, *Selections*, no. 32, pp. 64–65, illus.; Ottomeyer and Pröschel, *Vergoldete Bronzen*, vol. 1, p. 181, fig. 3.7.10; Jacques Charles et al., *De Versailles à Paris: Le Destin des collections royales* (Paris, 1989), illus. p. 140, fig. 1; Bremer-David, *Summary*, no. 142, p. 91, illus.; Wilson, *Clocks*, no. 16, pp. 114–123; Jean-Dominique Augarde, *Les Ouvriers du temps: La Pendule à Paris de Louis XIV à Napoléon Ier* (Geneva, 1996), pp. 241, pl. 188 (p. 238); *Masterpieces*, no. 82, p. 105, illus.; *Handbook 2001*, p. 220, illus.

143.
BAROMETER
Paris, circa 1770–1775
Oak veneered with ebony; gilt-bronze mounts; enameled metal; ivory and glass barometrical tube
Height: 4 ft. 1/2 in. (123.2 cm); Width: 9 1/2 in. (24.1 cm); Depth: 1 7/8 in. (4.8 cm)
Accession number 86.DB.632

PROVENANCE
Tristao Guedes Correira de Queiroz e Castello-Branco, 1st marquis and 2nd comte da Foz (1849–1917); probably removed from Lisbon to London (sold, Christie's, London,

143

144.

MANTEL CLOCK

Paris, circa 1785
Case attributed to Pierre-Philippe Thomire;
design attributed to Jean-Guillaume Moitte;
rings enameled by H. Fr. Dubuisson
Gilt and patinated bronze; enameled metal;
vert Maurin des Alpes marble; white marble
Enameled clock ring is inscribed on the
interior with *Dubuisson*; movement scratched
with *Sweden 1811*.
Height: 1 ft. 8⁷/₈ in. (53 cm); Width: 2 ft.
1¹/₈ in. (63.8 cm); Depth: 9¹/₄ in. (23.5 cm)
Accession number 82.DB.2

PROVENANCE

Baron de Klingspor, Stora Sundby Castle,
Sweden, by 1811; (sold, Sotheby's, London,
December 11, 1981, lot 99).

BIBLIOGRAPHY

Wilson, "Acquisitions 1981," pp. 79–84,
illus.; "Some Acquisitions (1981–82) in the
Department of Decorative Arts, The J. Paul
Getty Museum," *Burlington Magazine* 125,
no. 962 (May 1983), illus. cover and p. 322;
Alvar González-Palacios, *The Adjectives of
History* (P. and D. Colnaghi and Co., London,
1983), pp. 44–45; Wilson, *Selections*, no. 42,
pp. 84–85, illus.; Ottomeyer and Pröschel,
Vergoldete Bronzen, vol. 1, p. 299, fig. 4.18.8;
Bremer-David, *Summary*, no. 144, p. 92, illus.;
Wilson, *Clocks*, no. 17, pp. 124–130, illus.

145.

MANTEL CLOCK (PENDULE SQUELETTE)

Paris, circa 1790–1800
Movement by Nicolas-Alexandre Folin;
enamel plaques by Georges-Adrien Merlet
Gilt bronze; enameled metal; white marble
base; glass and gilded metal case
Painted with *Folin L'aîné A PARIS* below
the dial; painted with *G. Merlet* on one enam-
eled ring.
Height: 1 ft. 7³/₈ in. (49.2 cm); Width:
10³/₄ in. (27.3 cm); Depth: 5¹/₂ in. (14 cm)
Accession number 72.DB.57

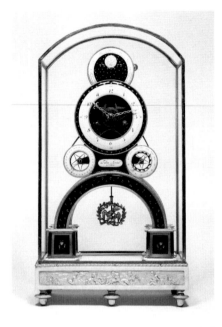

145

PROVENANCE

(Sold, Palais Galliera, Paris, Decem-
ber 10, 1971, no. 35); [French and Co., New
York, 1971].

BIBLIOGRAPHY

Fredericksen et al., *Getty Museum*, pp. 180–181,
illus.; Gillian Wilson, "The J. Paul Getty
Museum, 7ᵉᵐᵉ partie: Le Mobilier Louis XVI,"
Connaissance des arts 280 (June 1975), p. 96,
illus.; Miller, "Clockwise," pp. 15–21, fig. 14,
p. 21, illus.; Gian Giotto Borelli, *Antiquités et
objets d'art – horloges et pendules* (Paris, 1992), illus.
p. 7; Bremer-David, *Summary*, no. 145, p. 92,
illus.; Wilson, *Clocks*, no. 19, pp. 140–147.

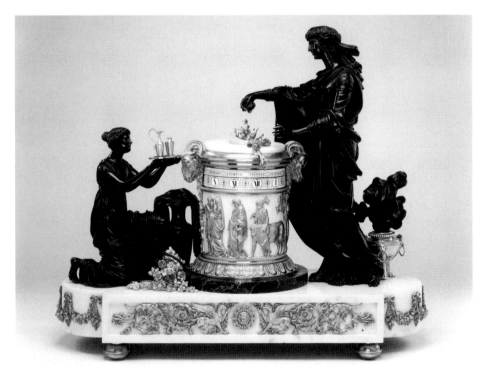

144

Scientific Instruments

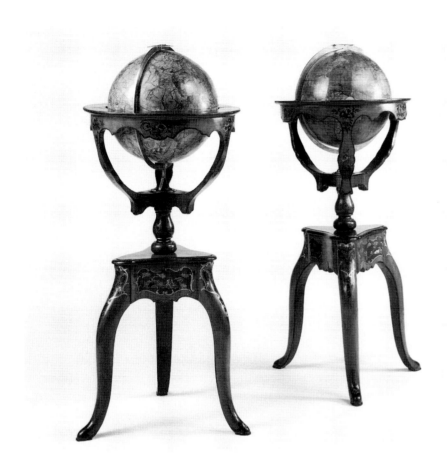

146

to duc de Dino Andia~ y Talleyrand-
Périgord, Château de Saint-Brice-sous-
Forêt, Pavillon Colombe, Val d'Oise;
[Maurice Segoura, Paris].

BIBLIOGRAPHY

Wlaldimir d'Ormesson, *Merveilles des Châteaux
de l'Île de France: Collection réalités* (Paris, 1965),
p. 131, illus.; "Acquisitions/1986," *GettyMusJ*
15 (1987), no. 101, p. 211, illus.; Jean-Nérée
Ronfort, "Science and Luxury: Two Acquisi-
tions by the J. Paul Getty Museum," *GettyMusJ*
17 (1989), pp. 47–82, figs. 13–17; Gillian
Wilson, "Dalla Raccolta del Museo J. Paul
Getty," *Casa Vogue Antiques* 8 (May 1990),
pp. 114–119, illus. p. 116; Bremer-David,
Summary, no. 146, p. 93; *Masterpieces*, no. 54,
p. 73, illus.; *Handbook* 2001, p. 197, illus.

147.
Compound Microscope and Case
Paris, circa 1751
Micrometric stage invented by Michel-
Ferdinand d' Albert d' Ailly, duc de
Chaulnes (1714–1769); gilt bronze attributed
to Jacques Caffieri
Gilt bronze; enamel; shagreen; glass; case of
wood; gilded leather; brass; velvet; silver
galon and lace; various natural specimens in
slides; and a number of extra lenses

146.
Pair of Globes
Paris, terrestrial globe: circa 1728; Paris,
celestial globe: circa 1730
Globes made by the Abbé Jean-Antoine
Nollet; terrestrial map engraved by Louis
Borde and celestial map engraved by Nicolas
Bailleul, called Bailleul *le jeune*; *camomille*
and *capucin* lacquered decoration attributed
to the workshop of Guillaume and Etienne-
Simon Martin
Printed paper; *papier mâché*; poplar, spruce and
alder painted with *vernis Martin*; bronze; glass
The terrestrial globe is inscribed *Dedie et pré-
senté a S.A.S. MADAME LA DUCHESSE DU
MAINE par [son] très humble et très obéissant [servi-
teur] Nollet.Lic. en Theologie. [1728], Borde exc.,* and
*GLOBE TERRESTRE DRESSÉ sur les observa-
tions les plus nouvelles et les plus exactes approuvées par*
*Mrs. de l'Academie Roïale des sciences ÆParis avec
privilege du Roi. 1728 Monté par l'auteur.* The
celestial globe is inscribed *DEDIÉ et présenté
à S.A.S. Monseigneur le Comte de [Cle]rmont [par
son très] humble [et] tres [obéi.ssent] servi[teur] [Nollet
de la So]c[iété des Arts 173]0.* and *Globe celeste
[c]alculé pour l'année [17]30 sur les observa[tions]
les plus nouvelles [et le]s plus exactes. [Pa]ris avec
privileg[e] du Roy. Bailliéul le je[u]ne sculpsit. Monté
par l'auteur.]* Each stand is painted with *N. 32*
underneath in yellow and *3323* in blue,
perhaps stenciled.
Height: 3 ft. 7¹/₄ in. (110 cm); Width: 1 ft.
5¹/₂ in. (45 cm); Depth: 1 ft. ¹/₂ in. (32 cm)
Accession number 86.DH.705.1–.2

PROVENANCE
Guillaume de Gontaut-Biron, 12th marquis de
Biron, Paris; duc de Talleyrand and by descent

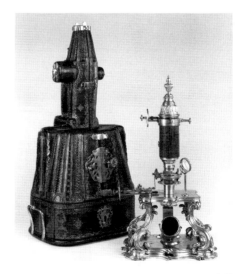

147

Curiosity Cabinet Object

Microscope: Height: 1 ft. 6 7/8 in. (48 cm);
Width: 11 in. (28 cm); Depth: 8 1/16 in.
(20.5 cm); Case: Height: 2 ft. 2 in. (66 cm);
Width: 1 ft. 1 3/4 in. (34.9 cm); Depth:
10 5/8 in. (27 cm)
Accession number 86.DH.694

PROVENANCE
Private collection, Paris (sold, Sotheby's,
Monaco, February 23, 1986, no. 901);
Mrs. Kila Kugel, New York, 1986.

EXHIBITIONS
Los Angeles, The J. Paul Getty Museum,
Devices of Wonder, November 13, 2001–
February 3, 2002.

BIBLIOGRAPHY
"Acquisitions/1986," *GettyMusJ* 15 (1987),
no. 102, p. 212, illus.; Jean Perfettini, *Le
Galuchat* (1988), pp. 62–63, illus.; Jean-
Nérée Ronfort, "Science and Luxury: Two
Acquisitions by the J. Paul Getty Museum,"
GettyMusJ 17 (1989), pp. 47–82, figs. 18–19,
21, 23, 25, 28–29, 35; Gillian Wilson,
"Dalla Raccolta del Museo J. Paul Getty,"
Casa Vogue Antiques 8 (May 1990), pp. 114–119,
illus. p. 118; Bremer-David, *Summary*,
no. 147, p. 94, illus.; *Masterpieces*, no. 65,
p. 86, illus.; *Handbook* 2001, p. 209, illus.

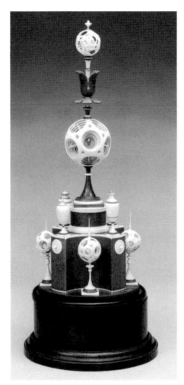

148

148.
CURIOSITY CABINET OBJECT
(*OBJET DE CURIOSITÉ*)
Paris, circa 1800
By François Barreau
Thuya wood and ivory
Stamped with BARREAU A PARIS
five times.
Height: 1 ft. 7 1/2 in. (49.5 cm); Diameter (at
base): 8 1/8 in. (20.6 cm)
Accession number 92.DH.75

PROVENANCE
H. C. Randier, Paris; [Jacques Kugel, Paris].

EXHIBITIONS
Los Angeles, The J. Paul Getty Museum,
Devices of Wonder, November 13, 2001–
February 3, 2002.

BIBLIOGRAPHY
"Acquisitions/1992," *GettyMusJ* 21 (1993),
no. 67, p. 142, illus.

*M*ETALWORK
Gilt Bronze: Candelabra and Candlesticks

149.
PAIR OF GIRANDOLES
Paris, circa 1680–1690
Gilt bronze; beads and drops of rock crystal,
coral, jasper, amethyst, carnelian, agate, and
garnet
Height: 1 ft. 3 in. (38 cm); Width: 10 in.
(25.5 cm); Diameter (at base): 5 in. (13 cm)
Accession number 85.DF.382.1–.2

PROVENANCE
[Bernard Steinitz, Paris].

BIBLIOGRAPHY
"Acquisitions/1985," *GettyMusJ* 14 (1986),
no. 188, p. 241, illus.; Bremer-David, *Summary*, no. 148, p. 94, illus.

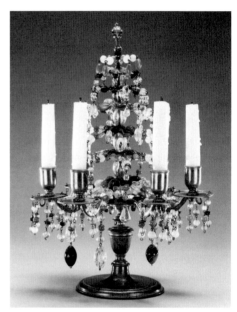

149 *One of a pair*

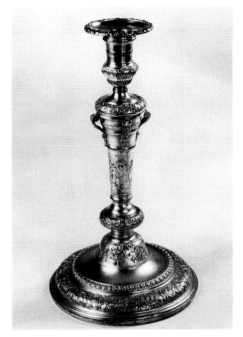

150 One of a pair

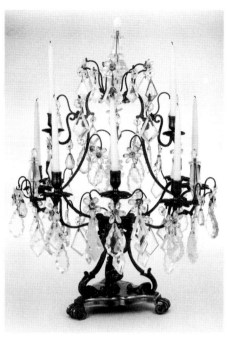

152 One of a pair

151.
PAIR OF GIRANDOLES
> Paris, circa 1700
> Gilt bronze; rock crystal; glass
> Height: 1 ft. 11 ¼ in. (59 cm); Diameter:
> 1 ft. 4 ⅜ in. (41.5 cm)
> Accession number 99.DF.46.1–.2

PROVENANCE
Baron Guy (Edouard Alphonse Paul) de
Rothschild (born 1909), Hôtel Lambert, Paris
(sold, Sotheby's, Monaco, May 25–26, 1975,
no. 219); (Sotheby's, London, July 1, 1977,
lot 50, bought in); private collection; [Holland Fine Arts, Ltd., London, 1999].

BIBLIOGRAPHY
Claude Frégnac and Wayne Andrews, *The
Great Houses of Paris* (New York, 1979), p. 77,
illus.; Jean Feray, *Architecture intérieure et décoration en France des origines à 1875* (Paris, 1988),
p. 123, illus.

150.
PAIR OF CANDLESTICKS
> Paris, circa 1680–1690
> Gilt bronze
> Height: 10 in. (25.4 cm); Diameter: 5 ¾ in.
> (14.6 cm)
> Accession number 72.DF.56.1–.2

PROVENANCE
Baron Nathaniel (Mayer) von Rothschild
(1836–1905), Vienna; Baron Alphonse
(Mayer) von Rothschild (1878–1942),
Vienna; confiscated by the Nazis in
March 1938; restituted to Baronin Clarice
von Rothschild (1874–1967), Vienna, in 1947
and sent to New York soon afterward;
[Rosenberg and Stiebel, Inc., New York,
1971]; purchased by J. Paul Getty.

BIBLIOGRAPHY
Fredericksen et al., *Getty Museum*, p. 145,
illus.; Wilson, "Meubles 'Baroques,'" p. 106,
illus.; Ottomeyer and Pröschel, *Vergoldete
Bronzen*, vol. 1, p. 58, illus.; Bremer-David,
Summary, no. 149, pp. 94–95, illus. p. 94.

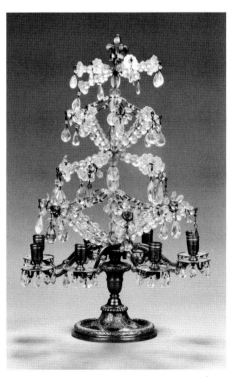

151 One of a pair

152.
PAIR OF GIRANDOLES
> Paris, circa 1730
> Rock crystal; gilt bronze
> Height: 2 ft. 10 in. (86.3 cm); Width:
> 2 ft. ½ in. (62.3 cm); Depth: 1 ft. 2 ¾ in.
> (37.5 cm)
> Accession number 75.DF.53.1–.2

PROVENANCE
[Kraemer et Cie, Paris]; purchased by J. Paul
Getty.

BIBLIOGRAPHY
Bremer-David, *Summary*, no. 150, p. 95, illus.

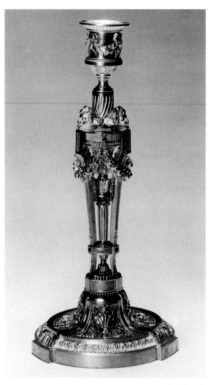

153 *One of a pair*

153.

PAIR OF CANDLESTICKS

Paris, circa 1780
By Etienne Martincourt
Gilt bronze
Each candlestick is stamped with MARTIN-
COURT under base. One is inscribed with
Louis Antoine Blois and *LA* inside base.
Height: 11 3/4 in. (29.9 cm); Diameter:
5 3/8 in. (13.7 cm)
Accession number 72.DF.48.1–.2

PROVENANCE

Mr. and Mrs. Meyer Sassoon, Pope's
Manor, Berkshire, by 1914; Violet Sassoon
(Mrs. Derek C. Fitzgerald) (sold, Christie's,
London, March 23, 1972, lot 59); purchased
at that sale by J. Paul Getty.

EXHIBITIONS

London, Burlington Fine Arts Club, 1914,
no. 117.

BIBLIOGRAPHY

F. J. B. Watson, *Wallace Collection Catalogues:
Furniture* (London, 1956), p. 95; Gillian Wil-
son, "The J. Paul Getty Museum, 7ème partie:
Le Mobilier Louis XVI," *Connaissance des arts*
280 (June 1975), p. 94, illus.; Ottomeyer and
Pröschel, *Vergoldete Bronzen*, vol. 1, p. 230,
illus.; Pierre Verlet, *Les Bronzes*, pp. 382–383;
Bremer-David, *Summary*, no. 151, p. 95, illus.

154.

PAIR OF CANDELABRA

Elephants: German (Meissen manufactory),
circa 1741–1745
Flowers: perhaps Vincennes manufactory,
circa 1745–1750
Mounts: Paris, circa 1750
Elephants modeled by Peter Reinicke in 1741
Hard-paste porcelain elephants; soft-paste
porcelain flowers; polychrome enamel decora-
tion, gilding; gilt-bronze mounts
Height: 9 1/8 in. (23.2 cm); Width: 9 3/4 in.
(24.7 cm); Depth: 4 1/8 in. (10.5 cm)
Accession number 75.DI.68.1–.2

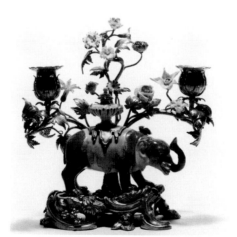

154 *One of a pair*

PROVENANCE

Baron Maximilian von Goldschmidt-
Rothschild, Frankfurt am Main; [Rosenberg
and Stiebel, Inc., New York, 1975]; purchased
by J. Paul Getty.

BIBLIOGRAPHY

Bremer-David, *Summary*, no. 152, p. 96, illus.

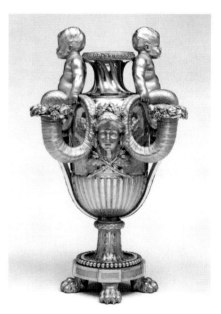

155 *One of a pair*

155.

PAIR OF CANDELABRA

Paris, circa 1775
Attributed to Pierre Gouthière
Gilt bronze
Height: 1 ft. 3 in. (38.3 cm); Width: 8 1/2 in.
(21.6 cm); Depth: 7 7/8 in. (19.9 cm)
Accession number 72.DF.43.1–.2

PROVENANCE

Possibly Baron Henri (James Nathaniel
Charles) de Rothschild (1872–1949), Paris;
[François-Gérard Seligmann, Paris,
circa 1948]; Carreras Savedra, Buenos Aires;
[Jacques Helft, Buenos Aires]; [French and
Co., New York]; purchased by J. Paul Getty.

BIBLIOGRAPHY
Frederickson, *Getty Museum*, p. 192, illus.;
Ottomeyer and Pröschel, *Vergoldete Bronzen*,
vol. 1, p. 230, illus.; Bremer-David, *Summary*,
no. 153, p. 96, illus.

156.
PAIR OF CANDELABRA
Paris, circa 1785
Attributed to Pierre-Philippe Thomire after
a model by Louis-Simon Boizot
Patinated and gilt bronze; white and *griotte*
marble
Height: 2 ft. 10 ³/₄ in. (83.2 cm); Diameter:
11 ¹/₂ in. (29.2 cm)
Accession number 86.DF.521.1–.2

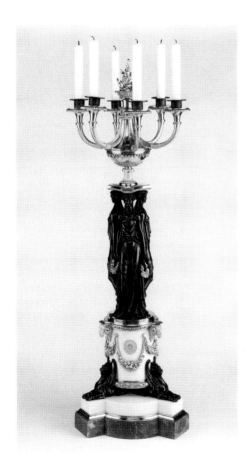

156 *One of a pair*

PROVENANCE
Anatole Demidov (?), Prince of San Donato,
San Donato Palace, Pratolino (near Florence),
(sold, San Donato Palace, March 15, 1880,
no. 804, en suite with a mantel clock);
(sold, Palais Galliera, Paris, March, 14, 1975,
no. 81); [Bernard Steinitz, Paris].

BIBLIOGRAPHY
"Acquisitions/1986," *GettyMusJ* 15 (1987),
no. 109, p. 214, illus.; Bremer-David,
Summary, no. 154, pp. 96–97 illus. p. 97;
Handbook 2001, p. 229, illus.

157.
PAIR OF CANDELABRA
Paris, circa 1786
Blued metal; gilt bronze
Height: 3 ft. 8³/₄ in. (113.7 cm); Width: 1 ft.
5³/₄ in. (45.1 cm); Depth: 10¹/₂ in. (26.7 cm)
Accession number 71.DF.99.1–.2

PROVENANCE
Palazzo Litta, Florence; Baron Mayer
(Amschel) de Rothschild (1818–1874), Ment-
more Towers, Buckinghamshire, by 1884;
Hannah de Rothschild (1851–1890) (Count-
ess of Rosebery, wife of the 5th Earl, married
1878), Mentmore Towers; (Albert) Harry
Primrose, 6th Earl of Rosebery, Mentmore
Towers, by inheritance (sold, Sotheby's, Lon-
don, April 17, 1964, lot 25); [Claude Sère,
Paris, 1964]; private collection, Paris, late
1960s; [Frank Partridge and Sons, Ltd., Lon-
don, 1971]; purchased by J. Paul Getty.

EXHIBITIONS
London, 25 Park Lane, *Three French Reigns*,
February–April 1933, no. 485, illus.

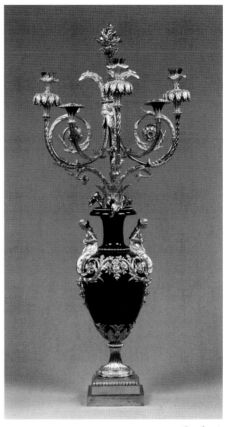

157 *One of a pair*

BIBLIOGRAPHY
"French Furniture at the Exhibition of 'Three
French Reigns,' 25 Park Lane," *Country Life*
73–1884 (February 25, 1933), p. 206, figs. 5,
7; Ottomeyer and Pröschel, *Vergoldete Bronzen*,
vol. 1, p. 261, caption 4.8.3; Jonathan Bourne
and Vanessa Brett, *Lighting in the Domestic
Interior: Renaissance to Art Nouveau* (London,
1991), illus. p. 101, fig. 321; Bremer-David,
Summary, no. 155, p. 97, illus.

Gilt Bronze: Chandeliers

158.

CHANDELIER

Paris, circa 1700
Lead glass and rock crystal; gilt bronze
Height: 3 ft. 6 1/8 in. (107 cm); Diameter:
2 ft. 5 1/8 in. (74 cm)
Accession number 88.DH.17

PROVENANCE

[Kraemer et Cie, Paris].

BIBLIOGRAPHY

"Acquisitions/1988," *GettyMusJ* 17 (1989),
no. 67, p. 140, illus.; Bremer-David, *Summary*,
no. 156, p. 98, illus.; Martin Mortimer, "The
Crystal Chandelier from the King's Audience
Chamber Now the King's Privy Chamber,
Hampton Court Palace," *Glass Circle Journal* 8
(1993), fig. 10, p. 31, illus.

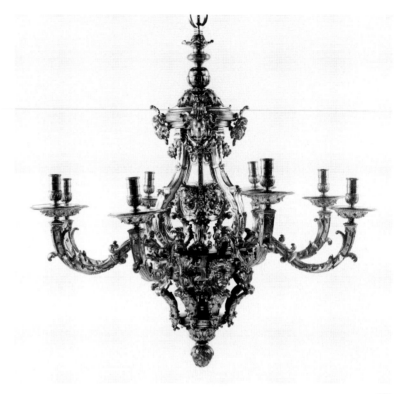

159

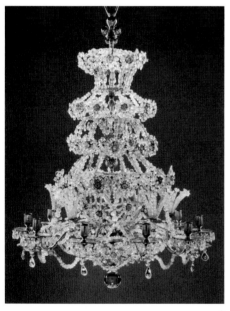

158

159.

CHANDELIER

Paris, circa 1700
Gilt bronze
Height: 3 ft. 9 1/4 in. (115 cm); Diameter:
3 ft. 6 1/4 in. (110 cm)
Accession number 87.DF.28

PROVENANCE

Edouard Chappey, Paris, circa 1900; [Michel
Meyer, Paris, 1986].

EXHIBITIONS

Paris, Petit Palais, *Exposition universelle de 1900,
L'Exposition rétrospective de l'art l'histoire de l'art fran-*
çais des origines a 1800, 1900, vol. 1, no. 2891,
p. 299, illus. p. 190 (lent by Edouard
Chappey).

BIBLIOGRAPHY

*Exposition universelle de 1900, Le Mobilier à travers
les âges au Grand et Petit Palais: Intérieurs* XVIII*
et XIX*e siècles: Exposition centennale* (Paris, 1902),
illus. pl. 20; "Acquisitions/1987," *GettyMusJ*
16 (1988), no. 69, p. 177, illus.; Bremer-
David, *Summary*, no. 157, p. 98, illus.

160.

CHANDELIER

> Paris, circa 1710
> Attributed to André-Charles Boulle
> Gilt bronze
> Each element is stamped with the crowned
> C for 1745–1749.
> Height: 2 ft. 6½ in. (77.5 cm); Diameter:
> 2 ft. 8 in. (81.3 cm)
> Accession number 76.DF.13

PROVENANCE

> Antenor Patiño, Paris; [Kraemer et Cie, Paris,
> 1976]; purchased by J. Paul Getty.

BIBLIOGRAPHY

> Ottomeyer and Pröschel, *Vergoldete Bronzen*,
> vol. 1, p. 51, illus., and Jean-Nérée Ronfort,
> "André-Charles Boulle: Die Bronzearbeiten
> und seine Werkstatt im Louvre," vol. 2,
> p. 505; Verlet, *Les Bronzes*, p. 91, fig. 98,
> and p. 269; Bremer-David, *Summary*, no. 158,
> p. 98, illus.

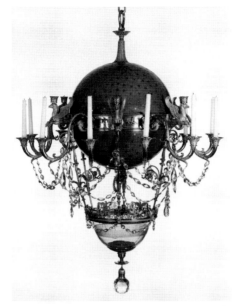

161

161.

CHANDELIER

> Paris, circa 1818–1820
> By Gérard-Jean Galle
> Glass; enameled metal; gilt bronze
> Height: 4 ft. 3 in. (129.5 cm); Diameter:
> 3 ft. 2 in. (96.5 cm)
> Accession number 73.DH.76

PROVENANCE

> (Sold, Hôtel Drouot, Paris, early 1960s);
> (sold, Hôtel Drouot, Paris, February 7, 1972,
> no. 83); [Kraemer et Cie, Paris, 1972];
> [French and Co., New York]; purchased
> by J. Paul Getty.

BIBLIOGRAPHY

> Fredericksen et al., *Getty Museum*, p. 165, illus.;
> Michael Shapiro, "Monsieur Galle, Bronzier
> et Doreur," *GettyMusJ* 6–7 (1978–1979),
> pp. 61–66, illus. figs. 3–5, 8; Jackson-Stops,
> "Boulle by the Beach," pp. 854–856;
> Ottomeyer and Pröschel, *Vergoldete Bronzen*, vol.
> 1, p. 359, illus.; Bremer-David, *Summary*, no.
> 160, p. 99, illus.; *Masterpieces*, no. 98, pp. 124–
> 125, illus.; *Handbook* 2001, p. 179, illus.

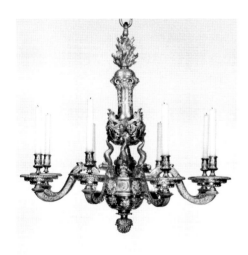

160

Gilt Bronze: Wall Lights and Brackets

162.

PAIR OF WALL LIGHTS

> Paris (?), circa 1710
> Silvered bronze; mirror glass; oak support
> Light .1 is painted with 22 in black on
> the wooden backing; its *bobèche* is stamped
> with the crowned C for 1745–1749. Light .2
> is painted with 20 in black on the wooden
> backing, and its *bobèche* is indistinctly
> stamped with the crowned C.
> Height: 1 ft. 7½ in. (50 cm); Width:
> 11½ in. (29.5 cm); Depth: 6¾ in. (17.2 cm)
> Accession number 85.DG.49.1–.2

PROVENANCE

> Swedish art market, circa 1980 [Michel
> Meyer, Paris, 1984].

EXHIBITIONS

> New York, The Cooper-Hewitt Museum, and
> Pittsburgh, The Carnegie Museum, *Courts
> and Colonies: The William and Mary Style in Holland,
> England, and America*, November 1988–May
> 1989, no. 126, p. 169, illus.

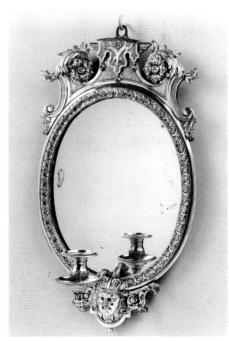

162 *One of a pair*

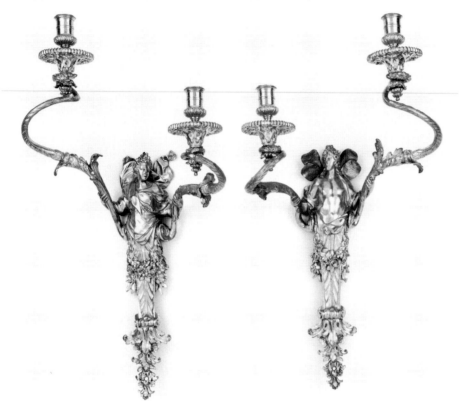

BIBLIOGRAPHY
John A. Cuadrado, "Antiques: Lighting and Style," *Architectural Digest* (April 1983), p. 106, illus.; "Acquisitions/1985," *GettyMusJ* 14 (1986), no. 209, p. 249, illus.; Bremer-David, *Summary*, no. 161, pp. 99–100, illus. p. 99; Charissa Bremer-David, "An Overview of French Eighteenth-Century Wall Lights in the J. Paul Getty Museum," *Rushlight* 63 (June 1997), pp. 2–5, illus. p. 2, fig. 1; Peter Thornton, *Form and Decoration: Innovation in the Decorative Arts, 1470–1870* (London, 1998), p. 104, illus.

163.

PAIR OF WALL LIGHTS
Paris, circa 1700–1715
Gilt bronze
Height: 1 ft. 9 1/2 in. (54.6 cm); Width: 1 ft. (30.5 cm); Depth: 9 in. (22.9 cm)
Accession number 85.DF.383.1–.2

PROVENANCE
[François Léage, Paris].

BIBLIOGRAPHY
"Acquisitions/1985," *GettyMusJ* 14 (1986), no. 191, p. 242, illus.; Bremer-David, *Summary*, no. 162, p. 100, illus.

164.

PAIR OF WALL LIGHTS
Paris, circa 1715–1720
Attributed to André-Charles Boulle
Gilt bronze
Height: 1 ft. 8 1/16 in. (51 cm); Width: 1 ft. 2 in. (35.5 cm); Depth: 9 13/16 in. (25 cm)
Accession number 83.DF.195.1–.2

PROVENANCE
Pierre de Faucigny-Lucinge, Vaux-le-Penil (near Melun); [François-Gérard Seligmann, Paris]; Samuel Kahn, Verbere (Oise) and Nice; [Bernard Steinitz, Paris, 1982].

BIBLIOGRAPHY
Jean-Nérée Ronfort, "Le Fondeur Jean-Pierre Mariette et la Fin de l'Atelier d'André-Charles Boulle," *L'Estampille* 173 (September 1984), pp. 72–73, illus.; Bremer-David, "Acquisitions 1983," no. 4, p. 187, illus. p. 186 (one); "Acquisitions/1983," *GettyMusJ* 12 (1984), no. 6, p. 263, illus. (one); Ottomeyer

163

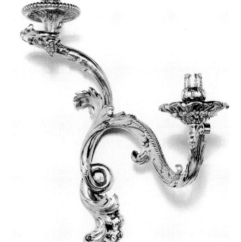

164 *One of a pair*

and Pröschel, *Vergoldete Bronzen*, vol. 1, p. 62, illus. pp. 62 (one), 83 (two), and Jean-Nérée Ronfort, "André-Charles Boulle: Die Bronzearbeiten und seine Werkstatt im Louvre," vol. 2, p. 495; note 229, p. 519; Anna Saratowicz, "Apliki do Sali Rycerskiej," *Kronika Zamkowa* 3–17 (1988), pp. 18–30, illus. p. 20; Bremer-David, *Summary*, no. 163, p. 101, illus. (one); Charissa Bremer-David, "An Overview of French Eighteenth-Century Wall Lights in the J. Paul Getty Museum," *Rushlight* 63 (June 1997), pp. 2–5, illus. (one) p. 3, fig. 2.

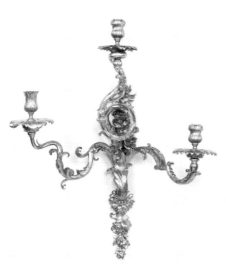

165 *One of a pair*

165.
PAIR OF WALL LIGHTS
Paris, circa 1715–1720
Attributed to André-Charles Boulle
Gilt bronze
Height: 2 ft. 1 in. (62.5 cm); Width: 1 ft. 9 in. (52.5 cm); Depth: 10 in. (25 cm)
Accession number 97.DF.16.1–2

PROVENANCE
[Kraemer et Cie, Paris, 1997]

BIBLIOGRAPHY
"Selected Acquisitions Made by the J. Paul Getty Museum, 1995–1997," *Burlington Magazine* 139 (November 1997), p. 831, pl. 29.

166.
PAIR OF WALL LIGHTS
Paris (?), circa 1735
Gilt bronze
Height: 1 ft. 11 in. (58.5 cm); Width: 11 1/8 in. (28.3 cm); Depth: 8 in. (20.3 cm)
Accession number 78.DF.89.1–.2

PROVENANCE
[Cameron, London, 1950]; purchased by J. Paul Getty, 1950; distributed by the estate of J. Paul Getty to the Getty Museum.

BIBLIOGRAPHY
Wilson, "Meubles 'Baroques,'" p. 100, illus.; Ottomeyer and Pröschel, *Vergoldete Bronzen*, vol. 1, p. 109, illus.; Bremer-David, *Summary*, no. 164, p. 101, illus.; Charissa Bremer-David, "An Overview of French Eighteenth-Century Wall Lights in the J. Paul Getty Museum," *Rushlight* 63 (June 1997), pp. 2–5, illus. p. 3, fig. 13.

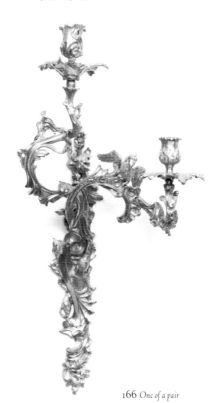

166 *One of a pair*

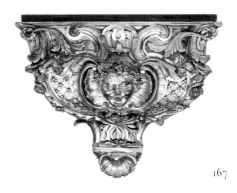

167

167.
WALL BRACKET
Paris, circa 1730–1735
Gilt bronze and brass, with an oak core
Height: 1 ft. 3/4 in. (32.5 cm); Width: 1 ft. 3 3/8 in. (39 cm); Depth: 6 3/4 in. (17.2 cm)
Accession number 87.DF.136

PROVENANCE
Paul Wallraf, London (sold, Sotheby's, London, December 8, 1983, lot 579); [La Cour de Varenne, Paris, 1987].

BIBLIOGRAPHY
"Acquisitions/1987," *GettyMusJ* 16 (1988), no. 70, pp. 177–178, illus.; Bremer-David, *Summary*, no. 165, pp. 101–102, illus. p. 101.

168.

FOUR WALL LIGHTS

Paris, circa 1740

Soft-paste porcelain flowers; gilt bronze

Height: 1 ft. 6 in. (45.7 cm); Width: 1 ft.
1 1/2 in. (34.3 cm); Depth: 7 3/4 in. (19.7 cm)

Accession number 75.DF.4.1–.4

PROVENANCE

[Henry Symons and Co., London (with
another pair)]; [French and Co., New York
(six)]; four lights to Rita Lydig, New York (?),
1927; two lights to [Arnold Seligmann, Rey,
and Co., New York, 1941 (firm operated from
1912 to 1947)]; Sidney J. Lamon, New York
(sold, Christie's, London, November 29, 1973,
lot 69); [Partridge (Fine Arts), Ltd., London,
1973]; purchased by J. Paul Getty.

BIBLIOGRAPHY

Bremer-David, *Summary*, no. 166, p. 102, illus.

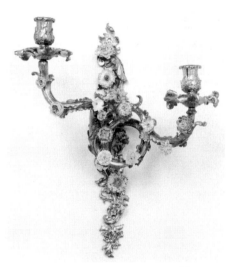

168 *One of four*

169.

PAIR OF WALL LIGHTS

Paris, circa 1745–1749

Gilt bronze

Each light bears one crowned C for
1745–1749.

Height: 2 ft. 4 1/2 in. (72.4 cm); Width: 1 ft.

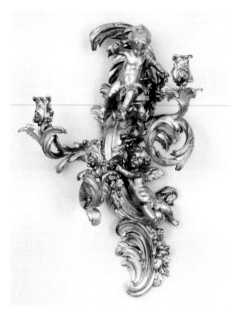

169 *One of a pair*

6 3/4 in. (47.6 cm); Depth: 10 1/2 in. (26.7 cm)

Accession number 89.DF.26.1–.2

PROVENANCE

Private collection, Europe; [Alexander and
Berendt, Ltd., London].

BIBLIOGRAPHY

"La Chronique des Arts, principales
acquisitions des musées en 1989," *Gazette des
beaux-arts* 1454 (March 1990), no. 250,
p. 51; "Acquisitions/1989," *GettyMusJ* 18
(1990), no. 53, p. 193, illus.; Bremer-David,
Summary, no. 167, p. 102, illus.; *Handbook*
2001, p. 206, illus.

170.

FOUR WALL LIGHTS

Paris, circa 1751

Attributed to Jacques Caffieri

Gilt bronze

Two lights are stamped with a crown flanked
by CR for *Casa Reale* and with the inventory
numbers C.562.1 and C.562.2 on front near
base. Two other lights are stamped similarly,
C.1068.1 and C.1068.2.

Height: 3 ft. 1 in. (94 cm); Width: 1 ft.

10 3/4 in. (57.8 cm); Depth: 1 ft. 1 3/8 in.
(34 cm)

Accession number 84.DF.41.1–.4

PROVENANCE

Mme Louise-Elisabeth of France, duchesse
de Parme (1727–1759), Palazzo di Colorno
(near Parma), circa 1753; ducal collection of
Parma until 1860; Italian royal household,
probably sold in Turin after 1862; [Stein (?),
Paris by November 1871]; Adolphe Carl de
Rothschild (?) (1823–1900); private collec-
tion, France (sold, Ader, Picard et Tajan,
Paris, December 12, 1978, no. 48); [Partridge
(Fine Arts), Ltd., London, 1978]; private
collection, London; [Partridge (Fine Arts),
Ltd., London, 1983].

BIBLIOGRAPHY

Bremer-David, "Acquisitions 1984," no. 3,
pp. 76–79, illus.; "Acquisitions/1984,"
GettyMusJ 13 (1985), no. 57, p. 180, illus.;
Jackson-Stops, "Boulle by the Beach,"
pp. 854–856, illus. p. 854, fig. 1; Ottomeyer

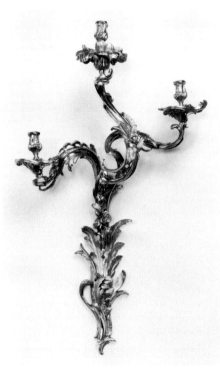

170 *One of four*

and Pröschel, *Vergoldete Bronzen*, vol. 1, pp. 100, 140, illus.; Alvar González-Palacios, *Il Tempio del Gusto: Le Arti decorative in Italia fra Classicismi e barocco: Il Granducato di Toscana e gli stati settentrionali* (Milan, 1986), vol. 1, p. 206; vol. 2, pp. 230–231, fig. 453, illus.; *Handbook 1986*, p. 161, illus. (one); Gillian Wilson, "Dalla Raccolta del Museo J. Paul Getty," *Casa Vogue Antiques* 8 (May 1990), pp. 114–119; Bremer-David, *Summary*, no. 168, pp. 102–103, illus. p. 103 (one); Alvar González-Palacios with Roberto Valeriani, *Gli arredi francesi* (Milan, 1996), p. 250, illus.; Peter Hughes, *The Wallace Collection: Catalogue of Furniture* (London, 1996), vol. 3, p. 1320.

171.
FOUR WALL LIGHTS
Paris, 1756
By François-Thomas Germain
Gilt bronze
Two wall lights are engraved with FAIT PAR F.T.GERMAIN.SCULP.ORF.DU ROI AUX GALLERIES DU LOUVRE.1756 at lower right and left. Two are stamped with Palais du Luxembourg inventory number 1051 LUX 1 and two with 1051 LUX 2. All punched with Château de Compiègne inventory marks CP under a crown and N° 28, at lower rear. Various numbers are stamped on *bobèches* and drip pans.
81.DF.96.1.a: Height: 3 ft. 3 3/4 in. (99.6 cm); Width: 2 ft. 7/8 in. (63.2 cm); Depth: 1 ft. 4 1/8 in. (41 cm); .1.b: Height: 3 ft. 1 1/4 in. (94.6 cm); Width: 1 ft. 10 5/8 in. (57.5 cm); Depth: 1 ft. 1 5/8 in. (34.6 cm);.2.a: Height: 3 ft. 4 1/2 in. (102.9 cm); Width: 2 ft. 1 in. (63.5 cm); Depth: 1 ft. 1 1/2 in. (34.3 cm); .2.b: Height: 2 ft. 11 1/8 in. (89.2 cm); Width: 1 ft. 10 3/8 in. (56.8 cm); Depth: 1 ft. 3 7/8 in. (40.3 cm)
Accession number 81.DF.96.1.a–.b and .2.a–.b

PROVENANCE
Made for Louis-Philippe, duc d'Orléans; four pairs installed in the *chambre de Parade* and the *salon des Jeux* of the Palais Royal, Paris, circa 1756; sold privately in 1786 by Louis-Philippe-Joseph, duc d'Orléans, and purchased by the *bronzier* Feuchère (probably Pierre-François Feuchère) for Louis XVI; four pairs purchased by the *Mobilier Royal*, Paris, August 30, 1786, and described as having damaged gilding; two pairs regilded by Feuchère in the first six months of 1787 for 500 *livres* a pair and installed in the *salon des Nobles de la Reine*, Château de Compiègne, until 1791; government of France, Palais du Luxembourg, Paris, after 1792; Archibald Primrose, 5th Earl of Rosebery, Main Drawing Room, 38 Berkeley Square, London, by 1929; (Albert) Harry Primrose, 6th Earl of Rosebery (sold, Sotheby's, London, April 17, 1964, lot 18); [François-Gérard Seligmann, Paris]; private collection, Argentina and Switzerland (offered for sale, Sotheby's, Monaco, June 14–15, 1981, no. 148a–b, bought in).

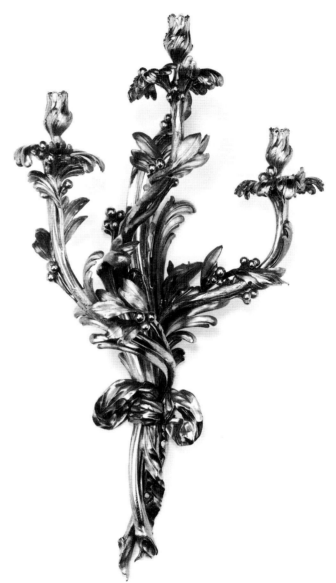

171 *One of four*

BIBLIOGRAPHY
Denis Diderot and Jean d'Alembert, *Encyclopédie ou Dictionnaire raisonné des sciences, planches* (Paris, 1762), vol. 1, *s.v.* "architecture," pls. 32–33; Gerald Reitlinger, *The Economics of Taste* (New York, 1963), vol. 2, p. 443; Axelle de Broglie de Gaigneron, "Le 3ᵉᵐᵉ Témoin de l'art de François-Thomas Germain, bronzier," *Connaissance des arts* 199 (September 1968), pp. 76–77, illus.; Max Terrier, "L'Appliqué: Sa Provenance," *Connaissance des arts* 201 (November 1968), pp. 32–33; Svend Eriksen, *Early Neo-Classicism in France* (London, 1974), p. 349, pl. 202; Pierre Verlet, "Bronzes d'ameublement français du XVIIIᵉ siècle: Notes et documents," *Bulletin de la Société de l'histoire de l'art français* (1980), pp. 200–201, illus. p. 203; Michel Beurdeley, *La France à l'encan 1789–1799* (Fribourg, 1981), p. 167, pls. 177–178; Wilson, "Acquisitions 1981," no. 4, pp. 73–78 (with a note on conservation by Barbara Roberts); "Some Acquisitions (1981–82) in the Department of Decorative Arts, The J. Paul Getty Museum," *Burlington Magazine* 125, no. 962 (May 1983), illus. p. 322; Wilson, *Selections*, no. 25, pp. 50–51, illus.; Jackson-Stops, "Boulle by the Beach," pp. 854–856, illus. p. 854, fig. 2; Ottomeyer and Pröschel, *Vergoldete Bronzen*, vol. 1, p. 145, illus.; Jean-Louis Baritou and Dominique Foussand, *Chevolet-Contant-Chaussard: Un Cabinet d'architectes au siècle des lumières* (Lyon, 1987), pp. 135–140, illus. p. 182; Verlet, *Les Bronzes*, pp. 296–299, illus. p. 30, fig. 18; p. 171, fig. 209; p. 256, fig. 275; p. 297, figs. 327–329; p. 298, figs. 330–331; Pallot, *L'Art du siège*, p. 160, illus.; Anna Saratowicz, "Apliki do Sali Rycerskiej," *Kronika Zamkowa* 3–17 (1988), pp. 18–30; Jacques Charles et al., *De Versailles à Paris: Le Destin des collections royales* (Paris, 1989), illus. p. 143, fig. 2; Gillian Wilson, "Dalla Raccolta del Museo J. Paul Getty," *Casa Vogue Antiques* 8 (May 1990), pp. 114–119, illus. pp. 114–115; Jonathan Bourne and Vanessa Brett, *Lighting in the Domestic Interior: Renaissance to Art Nouveau* (London, 1991), illus. p. 75, fig. 237; Christiane Perrin, *François-Thomas Germain: Orfèvre des rois* (Saint-Remy-en-l'Eau, 1993), pp. 230–231, illus.; Bremer-David, *Summary*, no. 169, pp. 103–104, illus. p. 103; Charissa Bremer-David, "An Overview of French Eighteenth-Century Wall Lights in the J. Paul Getty Museum," *Rushlight* 63 (June 1997), pp. 2–5, illus. p. 4, fig. 4; *Masterpieces*, no. 68, pp. 88–89, p. 89, illus.; *Handbook* 2001, p. 212, illus.

172.
SIX WALL LIGHTS
Paris, circa 1765–1770
By Philippe Caffieri
Gilt bronze
Wall Lights 78.DF.263.1 and 82.DF.35.1 are stenciled with No 151 on back. Wall Light 82.DF.35.1 is engraved with *fait par Caffiery* on one drip pan and stamped with 2 and 3 on back. Wall Light 82.DF.35.2 is stamped with 4 on back.
Height: 2 ft. 1 1/2 in. (64.8 cm); Width: 1 ft. 4 1/2 in. (41.9 cm); Depth: 1 ft. 1/4 in. (31.1 cm)
Accession numbers 78.DF.263.1–.4 and 82.DF.35.1–.2

PROVENANCE
(Sold, Hôtel Drouot [?], Paris, May 26–27, 1921, no. 99, to de Friedel); private collection, Paris (sold, Etude Couturier Nicolaÿ, Paris, April 6, 1978, no. 52); [Alexander and Berendt, Ltd., London, 1978]. 82.DF.35.1–.2: Henri Smulders, Amsterdam (sold, two from a set of four, Frederik Muller and Co. [Mensing et Fils], Amsterdam, June 26–27, 1934, no. 98); private collection, Los Angeles, probably purchased in Paris; Lee Greenway, Los Angeles (sold, Sotheby's, Los Angeles, October 21, 1980, lot 787A); [Alexander and Berendt, Ltd., London, 1980].

BIBLIOGRAPHY
Wilson, "Acquisitions 1977 to mid-1979," no. 7, pp. 42–43, illus. (one); Sassoon, "Acquisitions 1982," no. 10, pp. 52–53, illus.; Wilson, *Selections*, no. 35, pp. 70–71, illus. (one); Ottomeyer and Pröschel, *Vergoldete Bronzen*, vol. 1, pp. 190–191, illus.; Verlet, *Les Bronzes*, p. 293, illus. p. 199, fig. 228, and p. 253, fig. 267; Bremer-David, *Summary*, no. 170, p. 104, illus. (one); 82.DF.35.1–2: Charissa Bremer-David, "An Overview of French Eighteenth-Century Wall Lights in the J. Paul Getty Museum," *Rushlight* 63 (June 1997), pp. 2–5, illus. p. 5, fig. 6; "The Alexander Collection: Important French Furniture, Gold Boxes and Porcelain," *Christie's* (New York, April 30, 1999), p. 246, illus.; *Handbook* 2001, p. 220, illus.

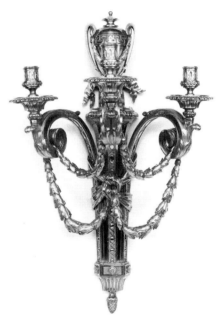

172 *One of six*

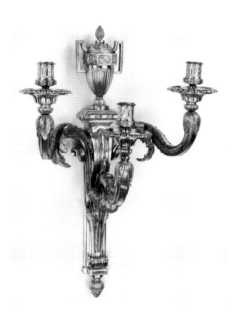

173 *One of four*

173.
FOUR WALL LIGHTS

Paris, circa 1765–1770
Attributed to Philippe Caffieri
Gilt bronze
Height: 1 ft. 10¹/₄ in. (56.5 cm); Width: 1 ft.
3³/₄ in. (40 cm); Depth: 10¹/₄ in. (26 cm)
Accession number 92.DF.18.1–.4

PROVENANCE

(Sold, Palais Galliera, Paris, March 29, 1966,
no. 45); [B. Fabre et Fils, Paris, circa 1977];
private collection, Paris, circa 1977; [Maurice
Segoura, Paris].

BIBLIOGRAPHY

"Acquisitions/1992," *GettyMusJ* 21 (1993),
no. 63, p. 139, illus.; Bremer-David, *Summary*,
no. 171, p. 105, illus. (one).

174.
SIX WALL LIGHTS

Paris, circa 1775
Attributed to Jean-Louis Prieur
Gilt bronze
Height: 2 ft. 3 in. (68.6 cm); Width: 1 ft.
1 ¹/₄ in. (33.7 cm); Depth: 10¹/₂ in. (26.7 cm)
Accession numbers 74.DF.3.1–.2 and
77.DF.29.1–.4

PROVENANCE

74.DF.3.1–.2: [Alexander and Berendt, Ltd.,
London, 1974]; purchased by J. Paul Getty.
77.DF.29.1–.4: (Sold, Christie's, London,
December 2, 1976, lot 3); [Alexander and
Berendt, Ltd., London, 1976].

BIBLIOGRAPHY

Ottomeyer and Pröschel, *Vergoldete Bronzen*,
vol. 1, p. 173, illus. p. 172, fig. 3.5.4; Jonathan
Bourne and Vanessa Brett, *Lighting in the
Domestic Interior: Renaissance to Art Nouveau*
(London, 1991), note 84, p. 110; Bremer-
David, *Summary* no. 172, p. 105, illus.

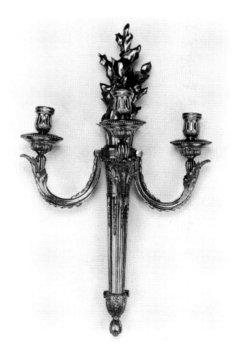

174 *One of six*

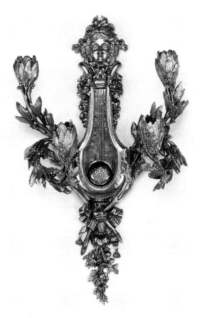

175 *One of a pair*

175.
PAIR OF WALL LIGHTS

Paris, circa 1781
Attributed to Pierre Gouthière, after a design
by François-Joseph Bélanger
Gilt bronze
Height: 1 ft. 8¹/₂ in. (52.1 cm); Width:
10¹⁵/₁₆ in. (27.8 cm); Depth: 7 in. (17.8 cm)
Accession number 74.DF.5.1–.2

PROVENANCE

[Kraemer et Cie, Paris, 1974]; purchased by
J. Paul Getty.

BIBLIOGRAPHY

Ottomeyer and Pröschel, *Vergoldete Bronzen*,
vol. 1, p. 243, illus., fig. 4.5.12; Bremer-
David, *Summary*, no. 173, pp. 105–106, illus.
p. 105.

176.
FOUR WALL LIGHTS
Paris, circa 1781
Model by Claude-Jean Pitoin; casting and
chasing attributed to Louis-Gabriel Féloix
Gilt bronze
Height: 1 ft. 10 in. (55.9 cm); Width: 10 in.
(25.4 cm); Depth: 4 1/2 in. (11.4 cm)
Accession number 99.DF.20.1–.4

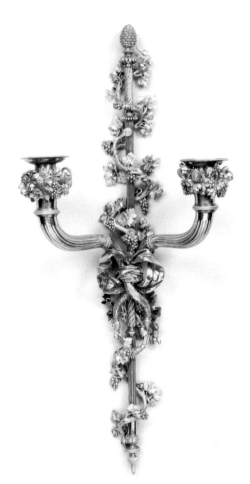

176 One of four

PROVENANCE
Marie Antoinette, *cabinet de la Méridienne*,
Château de Versailles, supplied on May 25,
1781, by the *marchand-ciseleur-fondeur* Claude-
Jean Pitoin to the Garde Meuble; (sold, Palais
de Congrès, Versailles, May 13–14, 1970, no.
110); Knud Abildgaard (1901–1986),
Smidstrupøre, Denmark (sold, Arne Bruun
Rasmussen, Copenhagen, April 22, 1987,
no. 28/53a); Martin and Pauline Alexander,
New York (sold, Christie's, New York,
April 30, 1999, lot 15).

BIBLIOGRAPHY
Eileen Kinsella, "Object of the Week,"
Weekend Section, *Wall Street Journal* (May 25,
1999); "Donnera-t-on enfin à Versailles les
moyens d'assumer son histoire prestigieuse?"
L'Estampille/L'Objet d'art 337 (June 1999), p. 17;
Handbook 2001, p. 230, illus. (one).

177.
PAIR OF WALL LIGHTS
Paris, circa 1787
Attributed to Pierre-Philippe Thomire
Gilt bronze
Height: 3 ft. 6 1/2 in. (107.9 cm); Width: 1 ft.
10 7/16 in. (57 cm); Depth: 11 7/8 in. (30.1 cm)
Accession number 83.DF.23.1–.2

PROVENANCE
Ducs de Mortemart, Château de Saint-Vrain,
Seine-et-Oise, from the eighteenth century,
by descent until 1982; [Maurice Segoura,
Paris, 1982].

BIBLIOGRAPHY
Adrian Sassoon, "Acquisitions 1983,"
pp. 207–211, illus.; "Acquistions/1983,"
GettyMus J 12 (1984), no. 13, p. 266, illus.
(one); "Some Acquisitions (1983–1984) in
the Department of Decorative Arts, the J.
Paul Getty Museum," *Burlington Magazine* 126,
no. 975 (June 1984), pp. 384–388, illus.
p. 384, fig. 66; Ottomeyer and Pröschel,
Vergoldete Bronzen, vol. 1, p. 290; Bremer-
David, *Summary*, no. 174, p. 106, illus. (one).

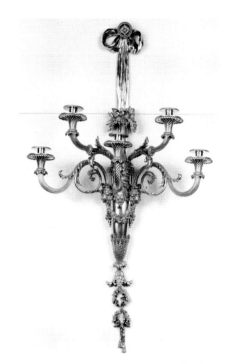

177 One of a pair

178.
PAIR OF WALL LIGHTS
Paris, circa 1787–1788
Attributed to Pierre-François Feuchère and/
or Jean-Pierre Feuchère
Gilt bronze
Height: 2 ft. 1/4 in. (61.6 cm); Width:
1 ft. 9/16 in. (32 cm); Depth: 7 1/4 in.
(18.5 cm)
Accession number 78.DF.90.1–.2

PROVENANCE
[Rosenberg and Stiebel, Inc., New York];
purchased by J. Paul Getty, Sutton Place,
Surrey, 1953; distributed by the estate of J.
Paul Getty to the J. Paul Getty Museum.

Gilt Bronze and Bronze: Firedogs

BIBLIOGRAPHY

Ottomeyer and Pröschel, *Vergoldete Bronzen*, vol. 1, p. 292, illus.; Verlet, *Les Bronzes*, pp. 336, 378–379, illus. p. 383, fig. 393; Bremer-David, *Summary*, no. 175, p. 106, illus.; Charissa Bremer-David "An Overview of French Eighteenth-Century Wall Lights in the J. Paul Getty Museum," *Rushlight* 63 (June 1997), pp. 2–5, illus. p. 5, fig. 7; *Masterpieces*, no. 99, p. 126, illus.; "The Alexander Collection: Important French Furniture, Gold Boxes and Porcelain," *Christie's* (New York, April 30, 1999), p. 156, illus.

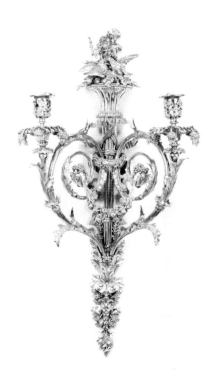

178 *One of a pair*

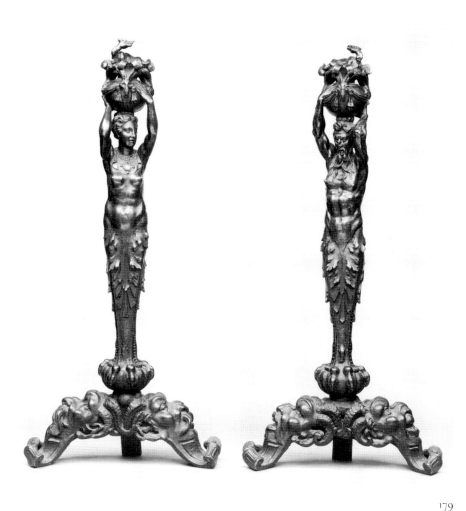

179

179.
PAIR OF FIREDOGS
 Fontainebleau, 1540–1545
 By an Italian artist
 Bronze
 Height: 2 ft. 9 1/2 in. (82.5 cm); Width (at base): 1 ft. 4 in. (41 cm)
 Accession number 94.SB.77.1–.2

PROVENANCE
Probably from the collection of Francis 1, King of France (1494–1547), Palais de Fontainebleau; Baron Gustave (Samuel James) de Rothschild (1829–1911), Paris; by inheri-
tance in the same family (sold, Hôtel Drouot, Paris, June 17, 1994, no. 117, to A. Moatti); [Alain Moatti, Paris].

BIBLIOGRAPHY

"Acquisitions/1994," *GettyMusJ* 23 (1995), p. 120; *Masterpieces*, no. 11, p. 18; Peter Fusco, *Summary Catalogue of European Sculpture in the J. Paul Getty Museum* (Los Angeles, 1997), p. 61; *Handbook 2001*, p. 240, illus.

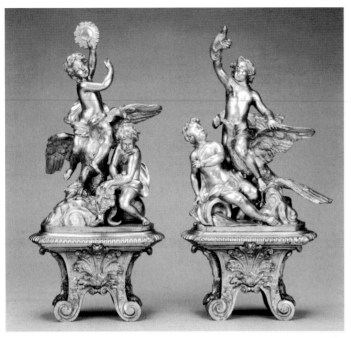

180

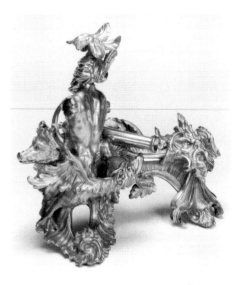

181 *Firedog .1*

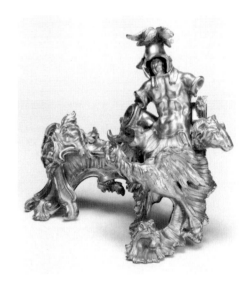

181 *Firedog .2*

180.

PAIR OF FIREDOGS
French, circa 1690–1715
Gilt bronze
Height: 1 ft. 7 1/4 in. (48.9 cm); Width: 9 in.
(22.8 cm); Depth: 6 1/4 in. (15.9 cm)
Accession number 93.DF.49.1–.2

PROVENANCE
[Bernard Steinitz, Paris].

BIBLIOGRAPHY
"Acquisitions/1993," *GettyMusJ* 22 (1994),
no. 12, p. 66, illus.; "Principales acquisitions
des musées en 1993," *Gazette des beaux-arts* 123
(March 1994), no. 237, p. 54, illus.

181.

PAIR OF FIREDOGS
Paris, circa 1735
Gilt bronze
Firedog .1: Height: 1 ft. 2 1/8 in. (35.9 cm);
Width: 1 ft. 3 in. (38.1 cm); Depth: 9 5/8 in.
(24.4 cm); Firedog .2: Height: 1 ft. 3/4 in.
(32.3 cm); Width: 1 ft. 3 1/4 in. (38.7 cm);
Depth: 8 7/8 in. (22.6 cm)
Accession number 71.DF.114.1–.2

PROVENANCE
[Duveen Brothers, New York]; Anna Thomson
Dodge, Rose Terrace, Grosse Pointe Farms,
Michigan (sold, Christie's, London, June 24,
1971, no. 18); purchased at that sale by
J. Paul Getty.

BIBLIOGRAPHY
Fredericksen et al., *Getty Museum*, p. 189,
illus.; Bruno Pons et al., *L'Art décoratif en Europe:
Classique et baroque*, Alain Gruber, ed. (Paris,
1992), illus. p. 380; John Whitehead, *The
French Interior in the Eighteenth Century* (London,
1992), p. 150, illus.; Bremer-David, *Summary*,
no. 176, p. 107, illus.

182.

PAIR OF FIREDOGS
Paris, circa 1735
By Charles Cressent
Gilt bronze
Height: 1 ft. 3 1/4 in. (38.7 cm); Width: 1 ft.
2 3/8 in. (36.4 cm); Depth: 8 1/8 in. (20.6 cm)
Accession number 73.DF.63.1–.2

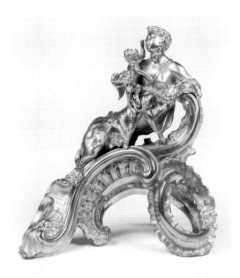

182 *One of a pair*

PROVENANCE
Private collection, Paris; [Didier Aaron, Paris, by 1971]; [French and Co., New York, 1972]; purchased by J. Paul Getty.

EXHIBITIONS
Amsterdams Historisch Museum, *Fourth International Exhibition Presented by CINOA, La Confederation internationale des negociants en oeuvres d'art,* March–May 1970, no. 237.

BIBLIOGRAPHY
Marie-Juliette Ballot, *Charles Cressent: Sculpteur, ébéniste, collectionneur,* Archives de l'art français: Nouvelle période 10 (Paris, 1919), p. 218; Wilson, *Selections,* no. 17, p. 34, illus.; Ottomeyer and Pröschel, *Vergoldete Bronzen,* vol. 1, p. 112; Bremer-David, *Summary,* no. 177, p. 107, illus.

183.
PAIR OF FIREDOGS
 Paris, circa 1770
 Gilt bronze; silver; iron
 Height: 1 ft. ⅝ in. (32 cm); Width: 1 ft. 6½ in. (47 cm); Depth: 1 ft. 11⅝ in. (60 cm)
 Accession number 97.DF.15.1–.2

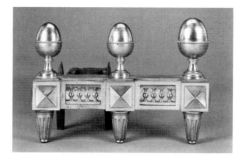

183 *One of a pair*

PROVENANCE
[Kraemer et Cie, Paris, 1997].

184.
PAIR OF FIREDOGS
 Paris, circa 1775
 Attributed to Pierre Gouthière
 Gilt bronze; dark blue enamel panels
 Stamped with either the letters A, E, or EA in various places.
 Height: 1 ft. 3¾ in. (40 cm); Width: 1 ft. 3 in. (38 cm); Depth: 5½ in. (14 cm)
 Accession number 62.DF.1.1–.2

PROVENANCE
Louise-Jeanne de Durfort (?), duchesse de Mazarin, Paris (sold, Paris, December 10–15, 1781, no. 285); comtesse de Clermont-Tonnerre, Paris (sold, Hôtel Drouot, Paris, October 10–13, 1900, no. 290); private collection, Paris (sold, Hôtel Drouot, Paris, February 4, 1909, no. 96); Mortimer L. Schiff, New York (sold by his heir John M. Schiff, Christie's, London, June 22, 1938, lot 45); purchased at that sale by J. Paul Getty.

BIBLIOGRAPHY
Verlet et al., *Chefs d'oeuvre,* p. 130, illus.; Getty, *Collecting,* p. 150; Fredericksen et al., *Getty Musum,* p. 192, illus.; Ottomeyer and Pröschel, *Vergoldete Bronzen,* vol. 1, p. 272, illus.; John Whitehead, *The French Interior in the Eighteenth Century* (London, 1992), illus. (one) p. 151; Bremer-David, *Summary,* no. 178, p. 108, illus.; Christian Baulez, "Le Mobilier et les objets d'art de madame Du Barry," *Madame du Barry: De Versailles à Louveciennes* (Paris, 1992), note 125, p. 80.

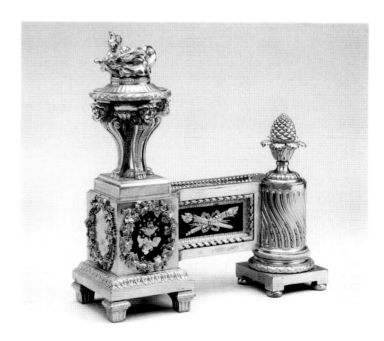

184 *One of a pair*

Gilt Bronze: Inkstands

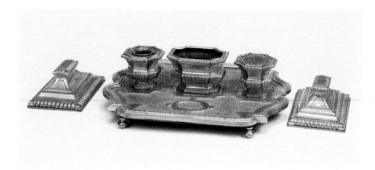

185

185.

INKSTAND AND PAPERWEIGHTS

Paris, circa 1715
Gilt bronze
Inkstand: Height: 4 1/4 in. (10.8 cm); Width:
1 ft. 2 11/16 in. (37.2 cm); Depth: 11 1/8 in.
(28.2 cm); Paperweights: Height: 2 5/8 in.
(6.7 cm); Width: 6 3/8 in. (16.2 cm); Depth:
4 1/2 in. (11.4 cm)
Accession number 75.DF.6.1–.3

PROVENANCE

[Michel Meyer, Paris]; [Kraemer et Cie,
Paris, 1975]; purchased by J. Paul Getty.

BIBLIOGRAPHY

Jackson-Stops, "Boulle by the Beach,"
pp. 854–856, illus. p. 854, fig. 1; Bremer-
David, *Summary*, no. 179, p. 108, illus.

186.

INKSTAND

Porcelain: Chinese (Dehua), Kangxi reign
(1662–1722), early eighteenth century
Lacquer: French (Paris), circa 1750
Mounts: French (Paris), circa 1750
Hard-paste porcelain; wood lacquered with
vernis Martin; gilt-bronze mounts
Height: 8 in. (20.3 cm); Width: 1 ft. 2 in.
(35.6 cm); Depth: 10 1/2 in. (26.7 cm)
Accession number 76.DI.12

PROVENANCE

[B. Fabre et Fils, Paris, 1976]; purchased by
J. Paul Getty.

BIBLIOGRAPHY

Bremer-David, *Summary*, no. 180, p. 108 illus.;
Carolyn Sargentson, *Merchants and Luxury
Markets: The Marchands Merciers of Eighteenth-
Century Paris* (Malibu, 1996), p. 174, illus. pl.
13; Wilson, *Mounted Oriental Porcelain*, no. 17,
pp. 85–87.

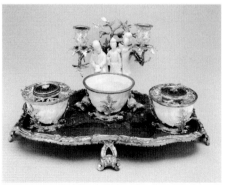

186

187.

INKSTAND

Paris, circa 1810
White marble; gilt bronze; velvet
Height: 3 1/2 in. (8.9 cm); Width:
1 ft. 6 1/2 in. (47 cm); Depth: 9 1/2 in.
(24.1 cm)
Accession number 73.DJ.67

PROVENANCE

Adolphe Lion, Paris, 1929; Mrs. Benjamin
Stern, New York (sold, American Art Associ-
ation, New York, April 4–7, 1934, lot 848);
[Frederick Victoria, Inc., New York]; [Mal-
lett and Son, Ltd., London, 1973]; purchased
by J. Paul Getty.

BIBLIOGRAPHY

Bremer-David, *Summary*, no. 181, p. 109, illus.

187

188.

INKSTAND

Paris (?), late nineteenth century
Oak veneered with rosewood; set with hard-
paste porcelain plaques; gilt-bronze mounts
One plaque bears an unidentified mark
in script. Base is pasted with a paper label
printed with *Palace of Pavlovsk* in Russian,
inked with the inventory number 1004, and
overstamped with a French customs stamp.
Another paper label is inked with the
Duveen inventory number 29652, and
another is stenciled with a French customs
stamp. Base is painted with 1044 in white
and *Uh.*6522 in blue.
Height: 3 7/8 in. (9.8 cm); Width: 11 1/4 in.
(28.6 cm); Depth: 7 1/4 in. (18.4 cm)
Accession number 71.DH.97

Painted Bronze: Figural Bronzes

PROVENANCE

Russian Imperial Collections, Palace of Pavlovsk (near St. Petersburg), until the early twentieth century; [Duveen Brothers, New York]; Anna Thomson Dodge, Rose Terrace, Grosse Pointe Farms, Michigan (sold, Christie's, London, June 24, 1971, lot 33); purchased at that sale by J. Paul Getty.

EXHIBITIONS

The Detroit Institute of Arts, *French Taste in the Eighteenth Century*, April–June 1956, no. 174, illus. p. 50.

BIBLIOGRAPHY

Duveen and Company, *A Catalogue of Works of Art of the Eighteenth Century in the Collection of Anna Thomson Dodge* (Detroit, 1933), illus.; Fredericksen et al., *Getty Museum*, p. 165, illus.; Savill, *Sèvres*, vol. 2, note 15, p. 860; Bremer-David, *Summary*, no. 182, p. 109, illus.

188

189 *L'Etude*

189 *La Philosophie*

189.

PAIR OF FIGURES

Figure .1: *L'Etude*; Figure .2: *La Philosophie*
Paris, circa 1780–1785
Attributed to Pierre-Philippe Thomire after models by Louis-Simon Boizot
Patinated and gilt bronze
L'Etude: Height: 1 ft. 1 in. (33 cm); Width: 1 ft. 2 in. (35.7 cm); Depth: 4⅝ in. (11.7 cm);
La Philosophie: Height: 1 ft. 1 in. (33 cm); Width: 1 ft. 1⅞ in. (35.2 cm); Depth: 4⅝ in. (11.7 cm)
Accession number 88.SB.113.1–.2

PROVENANCE

Private collection, Château de la Chesaie, Eaubonne (sold, Sotheby's, Monaco, February 5, 1978, no. 20); purchased at that sale by The British Rail Pension Fund.

BIBLIOGRAPHY

"Acquisitions/1988," *GettyMusJ* 17 (1989), no. 78, p. 144, illus.; Bremer-David, *Summary*, no. 183, pp. 109–110, illus. p. 109.

190.

PAIR OF DECORATIVE BRONZES

Paris; silver: 1738–1750; bronzes: 1745–1749
The lacquer painting of the figures is attributed to Etienne-Simon Martin and Guillaume Martin
Painted bronze; silver
The base of each bronze is stamped with the crowned C for 1745–1749. Each silver ele-

ment is marked with a crowned Y (the warden's mark used between October 4, 1738, and October 12, 1739); a fox's head (the Paris discharge mark for small works in silver and gold used between October 4, 1738, and October 12, 1744); and a helmet with open visor (the Paris discharge mark for works in gold and small works in old silver used between October 13, 1744, and October 9, 1750). The silver also bears an obliterated mark that might be a charge or maker's mark
Height: 9 in. (22.8 cm); Diameter: 6 in. (15.2 cm)
Accession number 88.DH.127.1–.2

190 *One of a pair*

Silver

PROVENANCE
Gabriel Bernard de Rieux, Paris (*Président à la deuxième chambre des enquêtes du Parlement de Paris*, d. 1745); Madame de Pompadour (?), Paris, before 1752; [Kraemer et Cie, Paris]; private collection, Paris, purchased circa 1910; [Jean-Luc Chalmin, Paris, 1988].

EXHIBITIONS
Memphis, Dixon Gallery and Gardens and New York, Rosenberg and Stiebel, Inc., *Louis XV and Madame Pompadour: A Love Affair with Style*, 1990, no. 36, pp. 54–55, 93, illus. fig. 36.

BIBLIOGRAPHY
Livre-Journal de Lazare Duvaux, Marchand-Bijoutier ordinaire du Roy, 1748–1758 (?), Louis Courajod, ed. (Paris, 1873), vol. 2, p. 135, no. 1213; "Acquisitions/1988," *GettyMus J* 17 (1989), no. 72, p. 142, illus.; John Whitehead, *The French Interior in the Eighteenth Century* (London, 1992), p. 23, illus.; Bremer-David, *Summary*, no. 184, p. 110, illus.; Musée du Louvre, *Nouvelles acquisitions du département des objets d'art 1990–1994* (Paris, 1995), no. 61, pp. 163–165; Carolyn Sargentson, *Merchants and Luxury Markets: The Marchands Merciers of Eighteenth-Century Paris* (London, 1996), p. 176 and illus. pl. 18.; *Handbook 2001*, p. 203, illus.

191

191.
FOUNTAIN
> Paris, 1661–1663, with English alterations of 1695, 1758, and circa 1762
> Jean IV Le Roy, probably altered in London in 1695 by Ralph Leeke, in 1758 by Phillips Garden, and again later in the eighteenth century
> Silver
> Marked on body with the maker's stamp of J. L. R. flanking a scepter and the device of a laurel wreath and two grains below a fleur-de-lys; a crowned R (the warden's mark used between December 30, 1661, and January 26, 1663). Scratched with N° 2 and the weights 348 14 (partially obliterated) and 362 13 under base. Engraved with the arms of Curzon and Colyear on central cartouche.
> Height: 2 ft. 1 ⁵/₈ in. (65.2 cm); Width: 1 ft. 2 ¹/₈ in. (35.9 cm); Depth: 1 ft. 2 ¹/₄ in. (36.2 cm)
> Accession number 82.DG.17

PROVENANCE
In England by 1694, when probably adapted from a lidded one-handled vase with a spout mounted higher, and when a matching fountain and two basins were made by Ralph Leeke; Sir Nathaniel Curzon, 1st Baron Scarsdale (born 1726, married Caroline Colyear 1750, died 1804), Kedleston Hall, Derbyshire, by 1750; Earls of Scarsdale, Kedleston Hall, by descent (offered for sale, Christie's, London, July 16, 1930, lot 42, bought in); (offered for sale, Christie's, London, November 7, 1945, bought in); [Jacques Helft, New York, 1946]; Arturo Lopez-Willshaw, Paris, before 1948; Patricia Lopez-Willshaw (widow of Arturo Lopez-Willshaw), Paris (offered for sale, Sotheby's, Monaco, June 23, 1976, no. 48, bought in).

EXHIBITIONS
Paris, Musée des Arts Décoratifs, *Louis XIV: Faste et décors*, May–October 1960, no. 378, illus. pl. LVII.

BIBLIOGRAPHY
Jacques Helft, *French Master Goldsmiths and Silversmiths* (New York, 1966), pp. 60–61, illus.; "Some Acquisitions (1981–1982) in the Department of Decorative Arts, The J. Paul Getty Museum," *Burlington Magazine* 125, no. 962 (May 1983), illus. p. 324; Wilson, *Selections*, no. 2, pp. 4–5, illus.; Gillian Wilson, "The Kedleston Fountain: Its Development from a Seventeenth-Century Vase," *GettyMus J* 11 (1983), pp. 1–12, figs. 1–4, 6–7, 9, 11, 16–17; Bremer-David, *Summary*, no. 185, pp. 110–111, illus. p. 111; John Cornforth, "A Splendid Unity of Arts," *Country Life* 190, no. 24 (June 13, 1996), pp. 128–131; Michael Snodin, "Adam Silver Reassessed," *Burlington Magazine* 139, no. 1126 (January 1997), pp. 17–25.

192.
PAIR OF TUREENS, LINERS, AND STANDS
> Paris, 1726–1729
> By Thomas Germain, with arms added in 1764 by his son François-Thomas Germain
> Silver
> Marked variously on tureens, liners, and stands with a crowned K (the warden's mark used between August 13, 1726, and August 13, 1727); a crowned M (the warden's mark used between August 12, 1728, and August 26,

and Paris, by descent; (sold, Christie's, Geneva, November 11, 1975, no. 230); Jean Rossignol, Geneva, 1975.

EXHIBITIONS
Lisbon, Museu Nacional de Arte Antiga, *Exposição de arte francesa*, May–June 1934, nos. 230–231; Paris, Musée des Arts Décoratifs, *Les Trésors de l'orfèvrerie du Portugal*, November 1954–January 1955, no. 453.

BIBLIOGRAPHY
Daniel Alcouffe, *Louis XV: Un Moment de perfection de l'art français*, Hôtel de la Monnaie (Paris, 1974), no. 484, p. 358; Thomas Milnes-Gaskell, "Thomas Germain," *Christie's Review of the Season 1975* (London and New York, 1976), pp. 219–221, illus.; Wilson, "Acquisitions 1982," no. 3, pp. 24–28, illus.; Armin B. Allen, *An Exhibition of Ornamental Drawings* (New York, 1982), no. 53, illus.; Wilson, *Selections*, no. 11, pp. 22–23, illus.; *Handbook* 1986, p. 157, illus. (one); Jackson-Stops, "Boulle by the Beach," pp. 854–856, fig. 5; Bruno Pons, "Hôtel Jacques-Samuel Bernard," *Le Faubourg Saint-Germain: la rue du Bac, Etudes offertes à Colette Lamy-Lasalle* (Paris, 1990), pp. 126–153; Gillian Wilson, "Dalla Raccolta del Museo J. Paul Getty," *Casa Vogue Antiques 8* (May 1990), pp. 114–119; Leonor d'Orey, *The Silver Service of the Portuguese Crown* (Lisbon, 1991), pp. 24–25, illus. p. 25; Bremer-David, *Summary*, no. 186, pp. 111–112, illus. p. 111

192 *One of a pair*

1729); a crowned A overlaid with crossed L's (the charge mark used between May 6, 1722, and September 3, 1727, under the *fermier* Charles Cordier); a crowned A on its side (the charge mark used between September 3, 1727, and December 22, 1732, under the *fermier* Jacques Cottin); possibly a chancellor's mace (the discharge mark used between September 3, 1727, and December 22, 1732); an artichoke mark (for old works in silver to which new parts have been added, used between November 22, 1762, and December 23, 1768); and with three obliterated marks, probably of Thomas Germain. One tureen, stand, and liner are engraved with N°.1, the others N°.2; tureens are engraved with the weights .48^m.1^oz.2^d. and .48^m.3^oz.2^d.; stands are engraved with the weights .48^m.2^d. and .48^m.5^d. Both stands, one with the added date 1764, are engraved with FAIT.PAR.F.T.GERMAIN.ORF.SCULP. DU.ROY.AUX GALLERIES.DU LOUVRE. APARIS. The coat of arms of the Mello e Castro family is engraved on stands and applied on tureens.

Tureens: Height: 6⅞ in. (17.4 cm); Width: 1 ft. 6½ in. (47 cm); Depth: 10 in. (25.4 cm); Stands: Height: 1⁷⁄₁₆ in. (3.7 cm); Width: 1 ft. 10⅞ in. (57 cm); Depth: 1 ft. 4 in. (40.6 cm)
Accession number 82.DG.12.1–.2

PROVENANCE
Jacques-Samuel Bernard (?), comte de Coubert (1686–1753), in the *salle à manger* of his *hôtel*, 46 rue du Bac, Paris; altered by François-Thomas Germain in 1764 for D. Martinho de Mello e Castro, Count of Galveias, the Portuguese ambassador in London, 1755, and in Paris from 1760–1761 (temporarily residing in the *hôtel* of Jacques-Samuel Bernard in the rue du Bac), and later Secretary of State to King José I and subsequently to Queen Maria I, listed in the September 14, 1796, posthumous inventory of his possessions with their lids decorated with artichokes, cauliflowers, birds, shells, and shrimp (these lids were probably lost at the beginning of the nineteenth century); Mello e Castro de Vilhena family, Portugal

193.
LIDDED BOWL (ECUELLE)

Paris, 1727
By Claude-Gabriel Dardet
Silver gilt
Marked on bowl with the maker's stamp
of C. G. D., a dart, and two grains below a
crowned fleur-de-lys; a crowned L (the war-
den's mark used between August 13, 1727,
and August 12, 1728); a crowned A (the
charge mark used between September 3, 1727,
and December 22, 1732, under the *fermier*
Jacques Cottin); a fleur-de-lys within a pome-
granate (the discharge mark used on large sil-
ver objects between September 3, 1727, and
December 22, 1732); an unidentified flower,
possibly a lily of the valley (a discharge mark
used to indicate a minimum standard of silver
between 1727 and 1732); and a boar's head
(the restricted warranty of .800 minimum sil-
ver standard used in Paris exclusively from
May 10, 1838). Bowl is engraved with the
coat of arms of the Moulinet family, probably
in the nineteenth century.
Height: 4 1/4 in. (10.8 cm); Width: 11 3/4 in.
(29.9 cm); Depth: 7 3/8 in. (18.7 cm)
Accession number 71.DG.77.a–.b

PROVENANCE

Moulinet family, Île-de-France; M. Marquis,
Paris (sold, Hôtel Drouot, Paris, February
10–18, 1890, no. 110 [?]); David David-Weill,
Paris (sold, Palais Galliera, Paris, Novem-
ber 24, 1971, no. 17); purchased at that sale
by J. Paul Getty.

BIBLIOGRAPHY

Emile Dacier, *L'Art au XVIII ème siècle en France*
(Paris, 1951), no. 192, p. 110, illus.; Bremer-
David, *Summary*, no. 187, p. 112, illus.

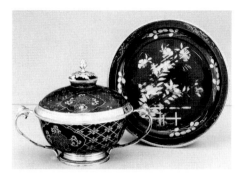

194

194.
LIDDED BOWL AND STAND

Lacquer: Japanese, early eighteenth century
Mounts: Paris, circa 1727–1738
Mounts by Paul Le Riche
Wood lacquered with red and brown pig-
ments; gold powder; silver-gilt mounts
Lid, bowl, and stand mounts variously
marked with the maker's stamp P. L. R. with
a crescent, two grains, and a fleur-de-lys; a
crowned bell (the Paris countermark used
between September 3, 1727, and Decem-
ber 22, 1732, under the *fermier* Jacques Cottin);
a crowned S (the warden's mark used
between September 18, 1734, and Septem-
ber 23, 1735); and an unidentified mark.
Overall Height: 5 9/16 in. (14.1 cm); Bowl:
Height: 5 3/16 in. (13.2 cm); Width: 7 3/8 in.
(18.7 cm); Depth: 5 3/8 in. (13.6 cm); Stand:
Height: 7/8 in. (2.3 cm); Diameter: 7 3/16 in.
(18.2 cm)
Accession number 84.DH.74.1.2a–.2b

PROVENANCE

Hans Backer, London; Martin Norton,
London.

BIBLIOGRAPHY

Nieda, "Acquisitions 1984," no. 2, pp. 72–76,
illus.; "Acquisitions/1984," *GettyMusJ* 13
(1985), no. 52, p. 177, illus.; Bremer-David,
Summary, no. 188, pp. 112–113, illus. p. 113;
*Discovering the Secrets of Soft-Paste Porcelain at the
Saint-Cloud Manufactory, circa 1690–1766*,
Bertrand Rondot, ed. (New Haven and Lon-
don, 1999), p. 297.

195.
PAIR OF SUGAR CASTORS

Paris, 1743
By Simon Gallien
Silver
Each castor is marked with the maker's
stamp of S. G., a sun and two grains below a
crowned fleur-de-lys; a crowned C (the war-
den's mark used between May 30, 1743, and
July 6, 1744); a crowned A (the charge mark
used between October 4, 1738, and Octo-
ber 13, 1744, under the *fermier* Louis Robin); a
fox's head (the discharge mark used on small
silver objects between October 4, 1738, and
October 13, 1744); a salmon's head (the
discharge mark used on small silver objects
between October 13, 1744, and October 10,
1750, under the *fermier* Antoine Leschaudel);
a fly (the countermark used between Octo-
ber 13, 1744, and October 10, 1750, under the
fermier Antoine Leschaudel); a laurel leaf (the
countermark used between October 13, 1756,
and November 22, 1762, under the *fermier*
Eloy Brichard); an open right hand (the coun-
termark used between November 22, 1762,
and December 23, 1768, under the *fermier*

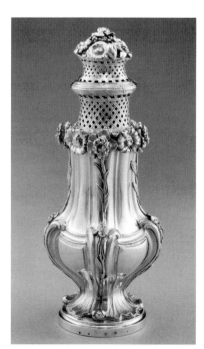

193

195 *One of a pair*

Jean-Jacques Prévost); an N inscribed in an oval (the Dutch date letter for 1822 for works in precious metal); and an ax (a Dutch standard mark used since 1852 for old silver objects returned to circulation). The base of castor .1 is inscribed with 409; the base of castor .2 is inscribed with 409A. Castor .1: Height: 10$^1/_4$ in. (26 cm); Diameter: 4$^1/_2$ in. (11.5 cm); Castor .2: Height: 10$^1/_2$ in. (26.6 cm); Diameter: 4$^5/_8$ in. (11.7 cm)
Accession number 84.DG.744.1–.2

PROVENANCE
F. J. E. Horstmann (sold, Frederik Müller, Amsterdam, November 19–21, 1929, no. 178); Jean-Louis Bonnefoy, Paris; Sir Robert Abdy, Bt., Newton Ferrers, Cornwall; by descent to Sir Valentine Abdy; [S. J. Phillips, London].

BIBLIOGRAPHY
"Acquisitions/1984," GettyMusJ 13 (1985), no. 53, p. 178, illus.; Bremer-David, Summary, no. 189, p. 113, illus. (one).

196.
PAIR OF LIDDED TUREENS, LINERS, AND STANDS
Paris, circa 1744–1750
By Thomas Germain
Silver
Marked variously on the tureens, liners, lids, and stands with a crowned D (the warden's mark used between July 6, 1744, and November 27, 1745); a crowned I (the warden's mark used between July 18, 1749, and July 15, 1750); a crowned K (the warden's mark used between July 15, 1750, and January 22, 1751); an indistinct mark, possibly a crowned A (the charge mark used between October 4, 1738, and October 13, 1744, under the fermier Louis Robin); a crowned A (the charge mark used between October 13, 1744, and October 10, 1750, under the fermier Antoine Leschaudel); a hen's head (the discharge mark used on small silver objects between October 10, 1750, and October 13, 1756, under the fermier Julien Berthe); a boar's head (the discharge mark used on large silver objects between October 10, 1750, and October 13,

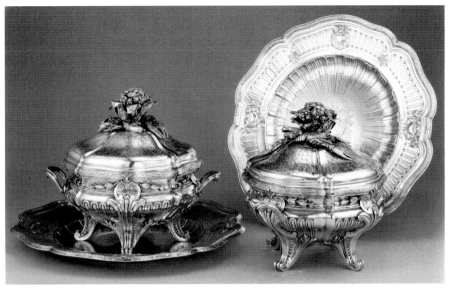

196

1756); and a laurel leaf (the countermark used between October 13, 1756, and November 22, 1762, under the fermier Eloy Brichard); and several obliterated marks. One stand and tureen are engraved with DU N° 3; one stand, tureen, and liner are engraved with DU N° 4; one liner is engraved with DU No 5. Stands are scratched with various dealers' marks of twentieth-century date. Originally engraved with an archbishop's coat of arms surrounded by the collar and cross of the Order of Christ, now partly erased and replaced with the arms of Robert John Smith, 2nd Lord Carrington.
Tureens: Height: 11$^3/_{16}$ in. (30 cm); Width: 1 ft. 1$^3/_4$ in. (34.9 cm); Depth: 11$^1/_8$ in. (28.2 cm); Stands: Height: 1$^5/_8$ in. (4.2 cm); Width: 1 ft. 6$^3/_{16}$ in. (46.2 cm); Depth: 1 ft. 6$^9/_{16}$ in. (47.2 cm)
Accession number 82.DG.13.1–.2

PROVENANCE
Archbishop Dom Gaspar de Bragança (?) (1716–1789, archbishop of Braga 1757), Braga, Portugal; Robert John Smith, 2nd Lord Carrington (succeeded to the title in 1838), England; [S.J. Phillips, London, 1920s or 1930s]; Mr. and Mrs. Meyer Sassoon, Pope's Manor, Berkshire, by the 1930s; [sometime

after 1935, S. J. Phillips, London, in partnership with Jacques Helft, Paris (until 1940) and New York (1940–1948)]; José and Vera Espirito Santo, Paris, by 1954 (sold, Christie's, Geneva, April 27, 1976, no. 446); private collection, Geneva, 1976.

EXHIBITIONS
Paris, Musée des Arts Décoratifs, Les Trésors de l'orfèvrerie du Portugal, November 1954–January 1955, no. 455, illus.

BIBLIOGRAPHY
Thomas Milnes-Gaskell, "Thomas Germain," Christie's Review of the Season 1975 (London and New York, 1976), pp. 219–221, illus.; "Some Acquisitions (1981–1982) in the Department of Decorative Arts, The J. Paul Getty Museum," Burlington Magazine 125, no. 962 (May 1983), illus. p. 324; Wilson, "Acquisitions 1982," no. 7, pp. 39–45, illus.; Storia degli Argenti, Kirsten Aschengreen-Piacenti, ed. (Novara, 1987), p. 129, illus.; Gillian Wilson, "Dalla Raccolta del Museo J. Paul Getty," Casa Vogue Antiques 8 (May 1990), pp. 114–119, illus. p. 119; Bremer-David, Summary, no. 190, p. 114, illus.; Masterpieces, no. 67, p. 88, illus.; Handbook 2001, p. 204, illus.

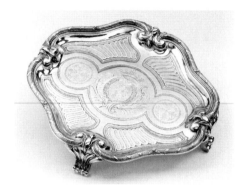

197

197.
TRAY

Paris, 1750

By François-Thomas Germain

Silver

Marked underneath with the maker's stamp of F. T. G., a lamb's fleece, two grains, and a crowned fleur-de-lys; a crowned K (the warden's mark used between July 15, 1750, and January 22, 1751); a crowned A with palm and laurel branches (the charge mark used between October 10, 1750, and October 13, 1756, under the *fermier* Julien Berthe); a boar's head (the "restricted warranty" of .800 minimum silver standard used in Paris exclusively from May 10, 1838); and a swan inside an oval (the standard mark for silver of unknown origin that is sold at auction as used by contracting countries between July 1, 1893, and 1970). Engraved with the arms of the marquis de Menars in the center.

Height: 1 3/8 in. (3.8 cm); Width: 8 5/8 in. (21.9 cm); Depth: 7 7/8 in. (20 cm)

Accession number 71.DG.78

PROVENANCE

Marquis de Menars; Junius Spencer Morgan (?), New York; [Puiforcat, Paris, by 1926, and through 1938]; David David-Weill, Paris (sold, Palais Galliera, Paris, November 24, 1971, no. 24); purchased at that sale by J. Paul Getty.

EXHIBITIONS

Paris, Musée des Arts Décoratifs, *Exposition d'orfèvrerie française civile du XVI^e siècle au début du*

XIX^e, April–May 1926, no. 91; London, 25 Park Lane, *Three French Reigns*, February–April 1933, no. 388; New York, The Metropolitan Museum of Art, *French Domestic Silver*, May–September 1938, no. 149, pl. 85.

BIBLIOGRAPHY

S. Brault and Y. Bottineau, *L'Orfèvrerie française du XVIII^e siècle* (Paris, 1959), p. 186, pl. 17; Faith Dennis, *Three Centuries of French Domestic Silver: Its Makers and Its Marks* (New York, 1960), vol. 1, p. 16, fig. 149; Henry Nocq, *Le Poinçon de Paris* (Paris, 1968), vol. 2, p. 243, illus. p. 245; John Whitehead, *The French Interior in the Eighteenth Century* (London, 1992), p. 229, illus.; Bremer-David, *Summary*, no. 191, p. 115; Christiane Perrin, *François Thomas Germain: Orfèvre des rois* (Saint-Remy-en-l'Eau, 1993), illus. p. 111.

198.
SAUCEBOAT ON STAND

Paris, 1762

By Jean-Baptiste-François Cheret

Silver; silver gilt

Sauceboat and stand are marked with the maker's stamp of J. B. C., a key and two grains below a crowned fleur-de-lys; a crowned Y (the warden's mark used between July 1, 1762, and July 13, 1763); a crowned A with laurel leaves (the charge mark used between November 22, 1762, and December 23, 1768, under the *fermier* Jean-Jacques Prévost); crossed laurel branches (the charge mark used on small silver objects between November 22, 1762, and December 23, 1768, under the *fermier* Jean-Jacques Prévost); a pointer's head (the discharge mark used on small silver objects between November 22, 1762, and December 23, 1768); a hunting horn (the countermark used between December 23, 1768, and September 1, 1775, under the *fermier* Julien Alaterre); a man's slipper (the countermark used between September 1, 1775, and April 7, 1781, under the *fermier* Jean-Baptiste Fouache); boar's head (the restricted warranty of .800 minimum silver

standard used in Paris exclusively from May 10, 1838); and a swan in an oval (the standard mark on silver of unknown origin that is sold at auction as used by contracting countries between July 1, 1893, and 1970). A coat of arms has probably been burnished off the cartouche on the sauceboat.

Height: 4 3/4 in. (12.1 cm); Width: 5 5/8 in. (14.3 cm); Depth: 7 3/4 in. (19.8 cm)

Accession number 71.DG.76.1–.2

PROVENANCE

Dukes of Buckingham and Chandos, London (sold 1903); J. H. Fitzhenry, London (sold, Christie's, London, November 20, 1913, lot 214); [Gaston Bensimon, Paris]; A. M. David-Weill, Paris; David David-Weill, Paris (sold, Palais Galliera, Paris, November 24, 1971, no. 14); purchased at that sale by J. Paul Getty.

EXHIBITIONS

Paris, Musée des Arts Décoratifs, *Exposition d'orfèvrerie française civile du XV^e siècle au début du XIX^e*, April–May 1926, no. 108, on loan from A. M. David-Weill.

BIBLIOGRAPHY

Storia degli Argenti, Kirsten Aschengreen-Piacenti, ed. (Novara, 1987), p. 128, illus.; John Whitehead, *The French Interior in the Eighteenth Century* (London, 1992), p. 234, illus.; Bremer-David, *Summary*, no. 192, pp. 115–116, illus. p. 115.

Gold: Jewelry

200

199.

PAIR OF CANDELABRA

Paris, 1779–1782

By Robert-Joseph Auguste

Silver

Marked variously with maker's stamp of
R. J. A., a palm branch and two grains, below
a crowned fleur-de-lys; a crowned Y (the
warden's mark used between July 18, 1778,
and July 21, 1781); a crowned S (the warden's
mark used between August 1, 1781, and
July 13, 1782); the letters P.A.R.I.S. (the
charge mark used between September 1, 1775,
and April 7, 1781, under the *fermier* Jean-
Baptiste Fouache); crossed L's (the charge
mark used between April 7, 1781, and June 4,
1783, under the *fermier* Henry Clavel); a jug
(the discharge mark used on works destined
for export between April 7, 1781, and June 4,
1783); an ant in a rectangle (the mark of .800
minimum standard for works imported into
France from contracting countries as used
since July 1, 1893); and the letter G (of
unknown meaning). Each base is engraved
with the monogram GR III beneath a crown.
Height: 1 ft. 10 1/8 in. (56.1 cm); Width:
1 ft. 3 1/8 in. (38.5 cm); Depth: 1 ft. 2 3/8 in.
(36.5 cm)

Accession number 84.DG.42.1–.2

PROVENANCE

From a service made for George III, King of
England (1760–1820); Ernst Augustus (?),
Duke of Cumberland and Brunswick-Lüne-
burg, King of Hanover (1771–1851), 1837;
Ernst Augustus, Duke of Cumberland and
Brunswick-Lüneburg, 1851 (sold after his
death, circa 1924); Cartier, Ltd., London, by
1926; Louis Cartier, Paris, by the 1960s;
Claude Cartier, Paris, 1970s (sold, Sotheby's,
Monaco, November 25–27, 1979, no. 824,
with another pair of matching candelabra);
Veronique Cartier, Paris, 1979.

EXHIBITIONS

Paris, Musée des Arts Décoratifs, *Exposition
d'orfèvrerie française civile du XV^e siècle au début du
XIX^e*, April–May 1926, no. 144, on loan from
Cartier, Ltd., London; Paris, Galerie Melle-
rio, *L'Orfèvrerie et le bijou d'autrefois*, 1935, no. 70.

BIBLIOGRAPHY

Faith Dennis, *Three Centuries of French Domestic
Silver: Its Makers and Its Marks* (New York, 1960),
vol. 1, no. 20, p. 45, illus., vol. 2, p. 31;
Claude Frégnac et al., *Les Grands orfèvres de
Louis XIII à Charles X* (Collection Connaissance
des arts, Paris, 1965), pp. 240–241, fig. 2;
Jacques Helft, *French Master Goldsmiths and Sil-
versmiths* (New York, 1966), p. 240, fig. 2;
Acquisitions/1984," *GettyMus J* 13 (1985),
no. 63, p. 182, illus. (one); Jonathan Bourne
and Vanessa Brett, *Lighting in the Domestic Inte-
rior: Renaissance to Art Nouveau* (London, 1991),
illus. p. 108, fig. 344; Bremer-David, *Sum-
mary*, no. 193, p. 116, illus.

199 *One of a pair*

200 *Back view*

200.

HERCULES PENDANT

French, circa 1540

Gold, enamel, and a baroque pearl

Height: 2 3/8 in. (6 cm); Width: 2 1/8 in.
(5.4 cm)

Accession number 85.SE.237

PROVENANCE

Baron Alphonse (Mayer) von Rothschild
(1878–1942), Vienna; by inheritance to his
brother, Baron Louis (Nathaniel) von Roth-
schild (1882–1955), Vienna; possibly
confiscated from Rothschild's collection by the
Nazis and then restituted after World War II

by the Austrian government; C. Ruxton Love, New York (sold, Christie's, Geneva, November 13, 1984, no. 45); [David, Inc., Vaduz].

EXHIBITIONS

New York, À La Vieille Russie, *The Art of the Goldsmith and the Jeweller*, November 6–23, 1968, no. 8, p. 15; Los Angeles, The J. Paul Getty Museum, *Devices of Wonder*, November 13, 2001–February 3, 2002.

BIBLIOGRAPHY

Yvonne Hackenbroch, "Bijoux de l'Ecole de Fontainebleau," *Actes du Colloque International sur l'art de Fontainebleau* (Paris, 1975), p. 71, figs. 1–2; Yvonne Hackenbroch, *Renaissance Jewellery* (London, 1979), illus. dust jacket and pp. 63–64, pl. 7, nos. 140A–B; *Christie's Review of the Season 1984* (Oxford, 1985), p. 338; Souren Melikian, *Art and Auction* 7 (January 1985), p. 144; "La Cote du Mois," *L'Estampille* 177 (January 1985), p. 67; "Acquisitions/1985," *GettyMusJ* 14 1986), no. 216, pp. 252–253, illus.; Bremer-David, *Summary*, no. 194, p. 117, illus.; *Masterpieces*, no. 9, p. 17, illus., illus. p. 2 (detail); *Handbook* 2001, p. 239.

201.

PRUDENCE COMMESSO HAT BADGE (ENSEIGNE)
French, circa 1550–1560
Gold, enamel, chalcedony, and a table-cut stone (possibly rock crystal)
Height: 2 1/4 in. (5.7 cm)
Accession number 85.SE.238

PROVENANCE

Betty de Rothschild (1805–1886), Paris, by 1866; Thomas F. Flannery, Jr. (1926–1980), Winnetka, Illinois, acquired after 1965; by inheritance to his widow, Joanna Flannery, Winnetka, Illinois (sold, Sotheby's, London, December 1, 1983, lot 288); [David, Inc., Vaduz].

EXHIBITIONS

Loyola University of Chicago, *The Art of Jewelry, 1450–1600*, 1975, no. 9; The Fine Arts Museums of San Francisco, *The Triumph of Humanism: Three Phases of Renaissance Decorative Arts 1450–1600*, October 1977–January 1978, no. 99; Darmstadt, Hessisches Landesmuseum, *Faszination Edelstein: aus den Schatzkammern der Welt* (The Fascination of Precious Stones), Sybille Ebert-Schifferer and Martina Harms, November 27, 1992–April 25, 1993, no. 146, p. 225; Los Angeles, The J. Paul Getty Museum, *Devices of Wonder*, November 13, 2001–February 3, 2002.

201

BIBLIOGRAPHY

Edouard Lièvre, *Les Collections célèbres d'oeuvres d'art* (Paris, 1866), pl. 49; Donald F. Rowe, "The Art of Jewellery, 1540–1650," *Connoisseur* 188 (April 1975), p. 293, pl. 4; Yvonne Hackenbroch, *Renaissance Jewellery* (London, 1979), pp. 90–92, pl. 8, fig. 236; *Art at Auction: The Year at Sotheby's 1983–1984* (London, 1984), p. 202; "Acquisitions/1985," *GettyMusJ* 14 (1986), no. 217, p. 253, illus.; Bremer-David, *Summary*, no. 195, pp. 117–118, illus. p. 118; *Masterpieces*, no. 10, p. 16 (detail), p. 17, illus.

Enamels

202.

TWELVE PLAQUES WITH SCENES FROM THE PASSION OF CHRIST
Limoges, 1530s
By Jean II Pénicaud
Polychrome enamel on copper with gold highlights
Each plaque is stamped with a P surmounted by a crown (Pénicaud workshop stamp) on back under clear counter enamel. Also inscribed with *SANCT. PETER.* on Saint Peter's robe in *The Entry into Jerusalem* plaque and *IOSEP. DABAR* on robe of Joseph in *The Entombment* plaque.
Height (each): approx. 3 7/10 in. (9.4 cm); Width: approx. 2 4/5 in. (7.3 cm)
Accession number 88.SE.4.1–.12

PROVENANCE

Alessandro Castellani, Rome (sold, Hôtel Drouot, Paris, May 12–16, 1884, no. 472); Mante collection, Paris, 1884; by inheritance to Robert Mante, Paris, until 1986; [Same Art, Ltd., Zurich].

EXHIBITIONS

Lille, *Exposition rétrospective de l'art français au Trocadéro*, 1889, no. 1037.

202

BIBLIOGRAPHY

Hippolyte Mireur, *Dictionnaire des ventes d'art faites en France et à l'étranger…* (Paris, 1901–1912; rpr. Hildesheim, 1971), p. 522; "Acquisitions/1988," *GettyMusJ* 17 (1989), no. 89, pp. 148–150, illus.; Peggy Fogelman, "The Passion of Christ: Twelve Enamel Plaques in the J. Paul Getty Museum," *GettyMusJ* 18 (1990), pp. 127–140; Bremer-David, *Summary*, no. 196, p. 118, illus.

203.
TWO ALLEGORIES
Allegory .1: *Allegory of Charles IX as Mars*; Allegory .2: *Allegory of Catherine de' Medici as Juno*
Limoges, 1573
By Léonard Limosin
Polychrome enamel on copper and silver with painted gold highlights; modern frames
Signed LL on sword of Mars, dated 1573 in center of cloud at left of Mars. Signed LL at bottom of cloud in bottom center of Juno.

Inscribed on backs at a later date *C DE MEDICIS* and *CHARLES IX*.
Height (each plaque, without frames): 6⅝ in. (17.5 cm); Width: 9 in. (23 cm)
Accession number 86.SE.536.1–.2

PROVENANCE
Debruge-Dumenil, France, by 1847 (sold, Hôtel des Ventes Mobilières, Paris, March 5, 1850, nos. 704 and 705); (Albert) Harry Primrose, 6th Earl of Rosebery, Mentmore Towers, Buckinghamshire; by inheritance to Neil Primrose, 7th Earl of Rosebery, Mentmore Towers, Buckinghamshire (sold, Sotheby's, London, May 20, 1977 [*hors catalogue*]); Lord Astor, Hever Castle, Kent (sold, Sotheby's, London, May 6, 1983, lot 296); [Cyril Humphris, London].

BIBLIOGRAPHY
Joseph Laborde, *Déscription des objets d'art qui composent la collection Debruge Dumenil* (Paris, 1847), nos. 704–705; Joseph Laborde, *Notice des émaux, bijoux, et objets divers exposés dans les galeries du Musée du Louvre* (Paris, 1853), pp. 186–187; Louis Dimier, *Histoire de la peinture de portrait en France au XVIᵉ siècle*, (Paris and Brussels, 1926), vol. 3, no. 33, p. 250; Philippe Verdier, *The Frick Collection*, (New York, 1977), vol. 8, no. 13, pp. 124, 126; "Acquisitions/1986," *GettyMusJ* 15 (1987), no. 199, pp. 218–219, illus.; Bremer-David, *Summary*, no. 197, p. 119, illus.

203 *Charles IX as Mars*

203 *Catherine de' Medici as Juno*

CERAMICS

204.
PILGRIM FLASK
Puisaye area of Burgundy, early sixteenth
century
Cobalt-glazed stoneware
Inscribed on one side of the neck with a
mark resembling an A with the cross stroke
at the right.
Height: 1 ft. 1 $^3/_{16}$ in. (33.5 cm); Width:
9 $^1/_4$ in. (23.5 cm); Depth: 5 $^1/_8$ in. (13 cm)
Accession number 95.DE.1

PROVENANCE
Chabrières-Arlès, France, sold to Alain
Moatti; [Alain Moatti, Paris].

EXHIBITIONS
Lille, *Exposition rétrospective de l'art français au
Trocadéro*, 1889, no. 1227 (incorrectly
described as from Beauvais dating to the end
of the fifteenth century).

BIBLIOGRAPHY
R. Clément, "Les Grès Bleus de Puisaye:
Origine, Histoire et Technique," *Bulletin de
la Société des sciences historiques et naturelles de l'Yonne*
123 (1991), p. 146; "Acquisitions/1995,"
GettyMusJ 24 (1996), no. 79, p. 133, illus.;
Masterpieces, no. 7, p. 14.

204

205

205.
OVAL BASIN
Saintes, late sixteenth century
By Bernard Palissy
Lead-glazed earthenware
Height: 2 $^5/_8$ in. (6.6 cm); Length: 1 ft. 7 in.
(48.2 cm); Width: 1 ft. 2 $^1/_2$ in. (36.8 cm)
Accession number 88.DE.63

PROVENANCE
Carl Becker, Cologne, sold 1898; private col-
lection, England; [Antony Embden, London].

BIBLIOGRAPHY
J. M. Heberle, *Katalog der Kunst-Sammlung,
Consul Carl Becker*, Versteigerung zu Köln
(Cologne, 1898), no. 12, p. 2; Alan Gibbon,
Céramiques de Bernard Palissy (Paris, 1986), book
jacket; "Acquisitions/1988," *GettyMusJ* 17
(1989), no. 84, p. 146, illus.; Bremer-David,
Summary, no. 198, p. 119, illus.; Leonard
Amico, *Bernard Palissy* (Paris, 1996), p. 101,
fig. 90; *Masterpieces*, no. 8, p. 15, illus.; *Hand-
book 2001*, p. 241, illus.

206.
OVAL PLATE
Saintes, second half of the sixteenth century
Attributed to Bernard Palissy
Lead-glazed earthenware
Height: 2 $^7/_{16}$ in. (6.2 cm); Width: 1 ft. 1 in.
(33 cm); Depth: 10 in. (25.3 cm)
Accession number 97.DE.46

PROVENANCE
Baron Gustave (Samuel James) de Rothschild
(1829–1911), Paris; by inheritance (probably
through Robert [Philippe Gustave] de Roth-
schild [1880–1946] and [James Gustave Jules]
Alain de Rothschild [1910–1982]) to Robert
James de Rothschild (born 1947), Paris (sold,
Piasa, Paris, June 11, 1997, no. 50) [Alain
Moatti, Paris].

206

207.
POSSIBLY A MODEL FOR A CERAMIC VESSEL
Paris, circa 1725–1730
Terracotta
Incised with *EX MUSEO PC. DE.
MONCREIFFE. DOCT. ET. SOC. SORBONICI.
ECLE AE DUEN (?)SI DECANUS* under the
base. Modeled with the arms, monogram, and
coronet (now partly missing) of Louis-Henri,

Nivernois

207

prince de Condé, duc de Bourbon.
Height: 1 ft. ³/₄ in. (32.4 cm); Width:
11 ³/₄ in. (29.8 cm); Depth: 11 ³/₄ in.
(29.8 cm)
Accession number 83.DE.36

PROVENANCE

Louis-Henri, 7th prince de Condé, duc de
Bourbon (1692–1740), Château de Chantilly;
François-Augustin Paradis de Moncrif (?)
(1687–1770); Pierre-Charles de Moncrif
(born circa 1700–1771), archbishop of the
cathedral church d'Autun, recorded as item 6
in Moncrif's *cabinet de curiosités* in the inven-
tory taken after his death on September 25,
1771; David David-Weill, Paris; [Didier
Aaron, Paris, 1981].

BIBLIOGRAPHY

Wilson, "Acquisitions 1983," no. 5, pp. 187,
194, illus. pp. 189–192; "Acquisitions/1983,"
GettyMusJ 12 (1984), no. 7, p. 263, illus.;
Bremer-David, *Summary*, no. 199, p. 120,
illus.; Geneviève Le Duc, *Porcelaine tendre de
Chantilly au XIIIᵉ siècle* (Paris, 1996), pp. 166–
167, illus. pp. 166–167.

208.
LIDDED JUG
Nivernois, circa 1680–1690
Tin-glazed earthenware
Height: 7¹/₂ in. (19.1 cm); Width: 7¹/₈ in.
(18.1 cm); Depth: 4 in. (10.2 cm)
Accession number 88.DE.126

PROVENANCE

De Jouvenal collection, France; [Georges
Lefebvre, Paris, 1988].

BIBLIOGRAPHY

"Acquisitions/1988," *GettyMusJ* 17 (1989),
no. 65, p. 140, illus.; Bremer-David, *Summary*,
no. 200, p. 120, illus.

208

Saint-Cloud

209

209.
LIDDED EWER AND BASIN
Porcelain: Saint-Cloud manufactory, early
eighteenth century
Mounts: modern (?)
Soft-paste porcelain, underglaze blue decora-
tion; silver mounts
The base of the ewer bears a paper label
5.L. 4338.8 and *Charles E. Dunlap.*
Each silver mount has a fleur-de-lys without
a crown (the Paris discharge mark for small
silver works used between October 23, 1717,
and May 5, 1722) and an indistinct mark.
Ewer: Height: 6⁵/₈ in. (17 cm); Width: 5 in.
(12.8 cm); Depth: 4 in. (10.2 cm); Basin:
Height: 3³/₁₆ in. (8.1 cm); Diameter: 8¹/₄ in.
(20.8 cm)
Accession number 88.DI.112.1–.2

PROVENANCE

Mrs. H. Dupuy, New York (sold, Parke-
Bernet, New York, April 3, 1948, lot 358);
estate of Mrs. Charles E. Dunlap, New York
(sold, Sotheby Parke Bernet, New York,
December 3, 1975, lot 231); purchased at that
sale by The British Rail Pension Fund.

EXHIBITIONS

New York, The Metropolitan Museum
of Art, *Masterpieces of European Porcelain*, 1949,
no. 144; New York, The Bard Graduate

Center for Studies in the Decorative Arts, *Discovering the Secrets of Soft-Paste Porcelain at the Saint-Cloud Manufactory, circa 1690–1766*, Bertrand Rondot, ed., July–October 1999, no. 51, p. 150, illus.

BIBLIOGRAPHY

"Acquisitions/1988," *GettyMusJ* 17 (1989), no. 70, p. 141, illus.; Bremer-David, *Summary*, no. 201, pp. 120–121, illus. p. 121; Geneviève Le Duc, *Porcelain tendre de Chantilly au XVIIIᵉ siècle* (Paris, 1996), p. 77, illus.

Moustiers

210

210.
LIDDED JAR

Moustiers, possibly Clérissy manufactory, circa 1723–1725
Tin-glazed earthenware
Painted with the arms of Jean d'Arlatan, marquis de la Roche and baron de Lauris, on the jar and lid. The base is painted with *FA* (?) in blue.

Height: 10¼ in. (26 cm); Diameter: 8¾ in. (22.5 cm)
Accession number 84.DE.917.a–.b

PROVENANCE

Jean d'Arlatan, marquis de la Roche and baron de Lauris, circa 1723; [Nicolier, Paris].

BIBLIOGRAPHY

"Acquisitions/1984," *GettyMusJ* 13 (1985), no. 51, p. 177, illus.; Bremer-David, *Summary*, no. 202, p. 121, illus.

211.
PLATE

Moustiers, Olerys manufactory, circa 1740–1760
Tin-glazed earthenware, polychrome enamel decoration
Height: 1⁷⁄₁₆ in. (3.7 cm); Diameter: 1 ft. 5⅝ in. (44.8 cm)
Accession number 87.DE.25

PROVENANCE

[Georges Lefebvre, Paris, 1986].

BIBLIOGRAPHY

"Acquisitions/1987," *GettyMusJ* 16 (1988), no. 72, p. 178, illus.; Bremer-David, *Summary*, no. 203, p. 121, illus.

211

Chantilly

212.
TEA SERVICE

Chantilly manufactory, circa 1730–1735
Soft-paste porcelain, polychrome enamel decoration
Tray: Height: ¹³⁄₁₆ in. (2.1 cm); Width: 8¹³⁄₁₆ in. (22.4 cm); Depth: 8¹⁵⁄₁₆ in. (22.7 cm); Cups: Height: 1⁹⁄₁₆ in. (4 cm); Width: 3¼ in. (8.2 cm); Depth: 2⅝ in. (6.7 cm); Saucers: Height: ¹⁵⁄₁₆ in. (2.3 cm); Width: 4⁹⁄₁₆ in. (11.6 cm); Depth: 4¹⁷⁄₃₂ in. (11.5 cm); Sugar Bowl: Height: 3⅛ in. (7.7 cm); Width: 4⅜ in. (11.1 cm); Depth: 4¹⁄₁₆ in. (10.3 cm); Teapot: Height: 3½ in. (8.9 cm); Width: 5⅛ in. (13.1 cm); Depth: 3⁵⁄₁₆ in. (8.4 cm)
Accession number 82.DE.167.1–.5

PROVENANCE

[Klaber and Klaber, London, 1980]; [Winifred Williams, Ltd., London, 1982].

EXHIBITIONS

New York, The Cooper-Hewitt Museum, *Design in the Service of Tea*, August–October 1984.

BIBLIOGRAPHY

Sassoon, "Acquisitions 1982," no. 5, pp. 33–36, illus.; "Some Acquisitions (1983–1984) in the Department of Decorative Arts, the J. Paul Getty Museum," *Burlington Magazine* 126, no. 975 (June 1984), pp. 384–388, illus. p. 384, fig. 68; John Whitehead, *The French Interior in the Eighteenth Century* (London, 1992), p. 167, illus.; Bremer-David, *Summary*, no. 204, p. 122, illus.

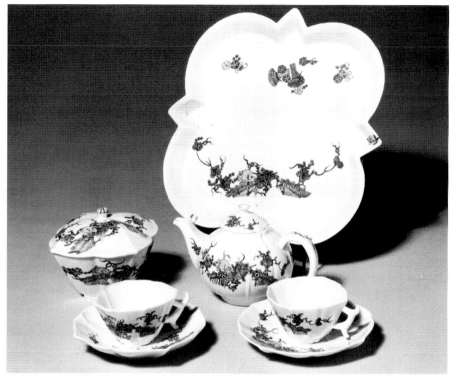

212

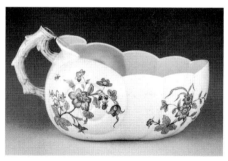

214

214.

CHAMBER POT (BOURDALOUE)

Chantilly manufactory, circa 1740
Soft-paste porcelain, polychrome enamel
decoration
Painted on the base with the iron-red hunt-
ing horn mark of the Chantilly manufactory

Height: 3 13/16 in. (9.8 cm); Width: 7 11/16 in.
(19.6 cm); Depth: 4 5/8 in. (11.8 cm)
Accession number 82.DE.9

PROVENANCE

Pierre de Regainy, Paris, 1957; Wilfred J.
Sainsbury, England; [Kate Foster, Ltd., Rye,
England]; [Rosenberg and Stiebel, Inc., New
York, 1977].

BIBLIOGRAPHY

Rosenberg and Stiebel, Inc., *European Works
of Art* (New York, 1978), p. 46, illus.; Sassoon,
"Acquisitions 1982," no. 6, pp. 36–38, illus.;
Bremer-David, *Summary*, no. 206, p. 123, illus.

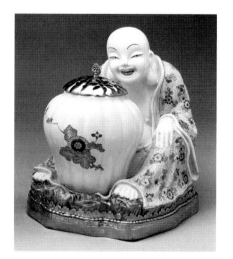

213 *One of a pair*

213.

PAIR OF MAGOT FIGURES

Chantilly manufactory, circa 1740
Soft-paste porcelain, polychrome enamel dec-
oration; gilt-bronze mounts
Height: 7 in. (18 cm); Width: 7 in. (18 cm);
Depth: 7 in. (18 cm)
Accession number 85.DI.380.1–.2

PROVENANCE

Miss A. Phillips, London (sold, Sotheby's,
London, February 28, 1961, lot 56);
[Winifred Williams, Ltd., London]; [Par-
tridge (Fine Arts), Ltd., London].

BIBLIOGRAPHY

"Acquisitions/1985," *GettyMus J* 14 (1986),
no. 197, p. 245, illus.; Bremer-David, *Sum-
mary*, no. 205, pp. 122–123, illus. p. 122;
Geneviève Le Duc, *Porcelaine tendre de Chantilly
au XVIII^e siècle* (Paris, 1996), illus. p. 91.

Rue de Charenton

Mennecy

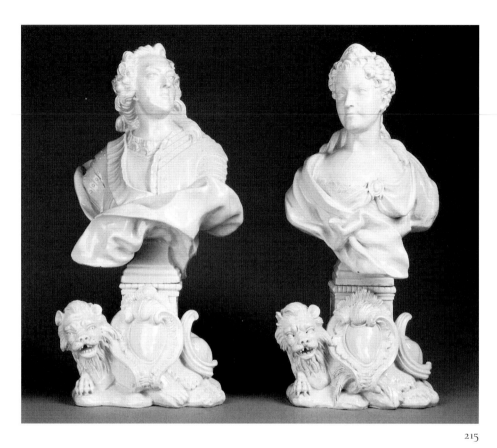

215

215.
PAIR OF BUSTS

Bust .1: Louis xv; Bust .2: Marie Leczinska
Rue de Charenton manufactory, circa 1755
Lead-glazed earthenware (*faïence fine*)
Louis xv: Height: 1 ft. 8 7/8 in. (53 cm);
Width: 9 7/16 in. (24 cm); Depth: 9 7/8 in.
(25 cm); Marie Leczinska: Height: 1 ft.
8 7/8 in. (53 cm); Width: 6 1/8 in. (15.5 cm);
Depth: 9 7/8 in. (25 cm)
Accession number 86.DE.668.1–.2

PROVENANCE
[Michel Vandermeersch, Paris].

BIBLIOGRAPHY
"Acquisitions/1986," *GettyMus J* 15 (1987),
no. 103, pp. 212–213, illus.; Bremer-David,
Summary, no. 207, pp. 123–124, illus. p. 123.

216.
LIDDED BOWL

Mennecy manufactory, circa 1735
Soft-paste porcelain, polychrome enamel
decoration
Height: 6 1/8 in. (15.5 cm); Width: 10 3/4 in.
(27.3 cm); Depth: 7 5/8 in. (19.4 cm)
Accession number 2000.20

PROVENANCE
[Mme Henry, Versailles]; purchased Febru-
ary 17, 1870 by Charles and Charlotte Schrei-
ber (1812–1895); by bequest to Blanche
Ponsonby (died 1919, née Guest), Lady Dun-
cannon, later Countess of Bessborough, 1895;
by descent to Vere, 9th Earl of Bessborough
(1880–1956), 1920; by descent to Eric,
10th Earl of Bessborough (1913–1993), 1956;
Stansted Park Foundation Collection, 1983;
(sold, Sotheby's, Stansted Park, October 5,
1999, lot 291); [Adrian Sassoon, London];
Michael Hall, London.

BIBLIOGRAPHY
Lady Charlotte Schreiber's Journals, Montague J.
Guest, ed. (London, 1911), vol. 1, p. 71.

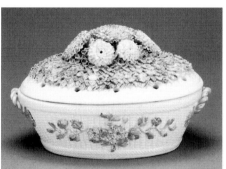

216

217.
BUST OF LOUIS XV

Mennecy manufactory (?), circa 1750–1755
Soft-paste porcelain
Height: 1 ft. 5 in. (43.2 cm); Width: 9 9/16 in.
(24.5 cm); Depth: 5 11/16 in. (14.5 cm)
Accession number 84.DE.46

Niderviller

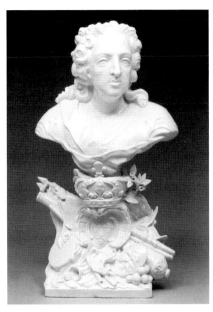

217

218.
FIGURE OF A STREET VENDOR
Mennecy manufactory, circa 1755–1760
Soft-paste porcelain
Impressed on the right side of the base with
the Mennecy manufactory mark DV.

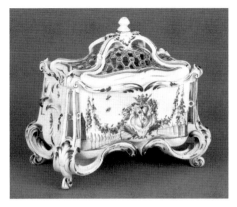

219

Height: 9 3/8 in. (23.9 cm); Width: 4 1/2 in.
(11.5 cm); Depth: 4 1/4 in. (10.7 cm)
Accession number 86.DE.473

PROVENANCE
Mr. and Mrs. William Brown Meloney,
Riverdale, New York; [The Antique Porcelain
Co., New York, 1986].

BIBLIOGRAPHY
Babette Craven, "French Soft Paste Porcelain
in the Collection of Mr. and Mrs. William
Brown Meloney," *Connoisseur* 143 (May 1959),
p. 142; "Acquisitions/1986," *GettyMusJ* 15
(1987), no. 104, p. 213, illus.; Bremer-David,
Summary, no. 209, p. 124, illus.; Geneviève Le
Duc, *Porcelain tendre de Chantilly au XVIIIᵉ siècle*
(Paris, 1996), p. 319, illus.

219.
LIDDED BULB VASE (CAISSE À OIGNONS)
Niderviller manufactory, circa 1768
Possibly painted by Joseph Deutsch
Hard-paste porcelain, polychrome enamel
decoration, gilding
Marked BN for Beyerlé Niderviller and
signed *J.D.*; incised with *IH*.

Height: 6 3/4 in. (17 cm); Width: 7 3/4 in.
(19.5 cm); Depth: 4 1/4 in. (11 cm)
Accession number 99.DE.11

PROVENANCE
Christian Moritz Eugen Franz, Graf zu
Königsegg, circa 1768; W. M. A. Moseley,
London; [John Whitehead, London, 1999].

EXHIBITIONS
London, Victoria and Albert Museum, 1957–
1995, lent by W. M. A. Moseley.

BIBLIOGRAPHY
W. B. Honey, *French Porcelain of the Eighteenth
Century* (London, 1972), p. 46, pl. 88a.; *Hand-
book* 2001, p. 214, illus.

PROVENANCE
Private collection, Paris (sold, Hôtel Drouot,
Paris, March 14, 1910, no. 44); [Vander-
meersch, Paris, 1948]; Mr. and Mrs. William
Brown Meloney, Riverdale, New York, by
1953; [The Antique Porcelain Co., Zurich,
from late 1950s].

BIBLIOGRAPHY
Babette Craven, "French Soft Paste Porcelain
in the Collection of Mr. and Mrs. William
Brown Meloney," *Connoisseur* 143 (May 1959),
pp. 135–142, fig. 10; "Acquisitions/1984,"
GettyMusJ 13 (1985), no. 55, p. 179, illus.;
Recent Ceramic Acquisitions by Major Muse-
ums," *Burlington Magazine* 127, no. 986 (May
1985), no. 54, p. 345, illus.; Bremer-David,
Summary, no. 208, p. 124, illus.; Geneviève Le
Duc, *Porcelaine tendre de Chantilly au XVIIIᵉ siècle*
(Paris, 1996), pp. 194–197, illus. pp. 195–196;
Linda H. Roth and Clare Le Corbeiller, *French
Eighteenth Century Porcelain at the Wadsworth
Atheneum: The J. Pierpont Morgan Collection* (Hart-
ford, 2000), pp. 46, 48, notes 5, 16, p. 49;
Handbook 2001, p. 212, illus.

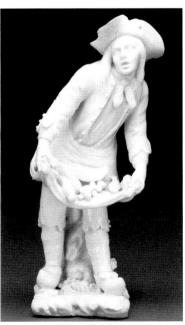

218

Sceaux

220.
VASE (POT-POURRI)

Sceaux manufactory, circa 1755
Attributed to Jacques Chapelle
Glazed earthenware, polychrome enamel
decoration
Height: 1 ft. 1 in. (33 cm); Width: 9¹/₂ in.
(24.1 cm); Depth: 6 in. (15.2 cm)
Accession number 85.DE.347

PROVENANCE
Florence J. Gould, Villa El Patio, Cannes
(sold, Sotheby's, Monaco, June 27, 1984,
no. 1588); [The Antique Porcelain Co.,
London].

BIBLIOGRAPHY
"Acquisitions/1985," GettyMusJ 14 (1986),
no. 198, p. 245, illus.; Bremer-David, Sum-
mary, no. 210, p. 125, illus.

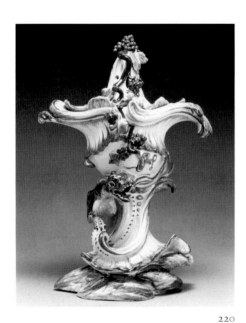

220

Vincennes

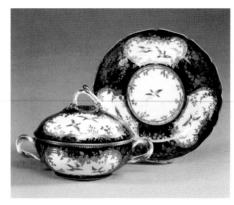

221

221.
LIDDED BOWL AND DISH (ÉCUELLE RONDE ET PLATEAU ROND)

Vincennes manufactory, circa 1752–1753
Soft-paste porcelain, bleu lapis ground color,
polychrome enamel decoration, gilding
Bowl and stand are both painted underneath
with the blue crossed L's of the Vincennes
manufactory; both are incised with I.

Bowl: Height: 5¹/₂ in. (14 cm); Width:
8³/₄ in. (22.2 cm); Depth: 6⁵/₈ in. (16.7 cm);
Stand: Height: 1⁵/₈ in. (4.1 cm); Diameter:
8¹⁵/₁₆ in. (22.8 cm)
Accession number 89.DE.44.a–.b

PROVENANCE
Private collection, England; [Alexander and
Berendt, Ltd., London, 1988].

BIBLIOGRAPHY
"Acquisitions/1989," GettyMusJ 18 (1990),
no. 51, p. 192, illus.; Bremer-David, Summary,
no. 211, p. 125, illus.

222.
WATERING CAN (ARROSOIR, DEUXIÈME GRANDEUR)

Vincennes manufactory, 1754
Painted by Bardet
Soft-paste porcelain, polychrome enamel
decoration, gilding

Painted underneath with the blue crossed
L's of the Vincennes manufactory (with a
dot at their apex) enclosing the date letter B
for 1754, and with the painter's mark of two
short parallel lines. Incised with 4.

Height: 7³/₄ in. (19.7 cm); Width: 9⁹/₁₆ in.
(24.5 cm); Depth: 5¹/₈ in. (13 cm)
Accession number 84.DE.89

PROVENANCE
Florence, Countess of Northbrook (wife of
the 2nd Earl, married 1899, died 1946)
(sold, Christie's, London, November 28, 1940,
part of lot 78); Hugh Burton-Jones, England,
1940; Kathleen Burton-Jones (Mrs. Gifford
Scott) (sold, Sotheby's, London, June 12, 1984,
lot 172); [Winifred Williams, Ltd., London,
1984].

BIBLIOGRAPHY
Adrian Sassoon, "Vincennes and Sèvres Porce-
lain Acquired by the J. Paul Getty Museum in
1984," GettyMusJ 13 (1985), pp. 89–91, illus.;
"Acquisitions/1984," GettyMusJ 13 (1985), no.
58, p. 180, illus.; Jackson-Stops, "Boulle by
the Beach," pp. 854–856, illus. p. 856, fig. 6;
Sotheby's Concise Encyclopedia of Porcelain, David
Battie, ed. (London, 1990), p. 107, illus.; Sas-
soon, Vincennes and Sèvres Porcelain, no. 1, pp. 4–
7, illus. pp. 5, 7; Bremer-David, Summary, no.
212, pp. 125–126, illus. p. 125.

222

223

223.
VASE (*CUVETTE À TOMBEAU, PREMIÈRE GRANDEUR*)
Vincennes manufactory, 1754–1755
Painted by the crescent mark painter, possibly
Louis Denis Armand *l'aîné*
Soft-paste porcelain, *bleu céleste* ground color,
polychrome enamel decoration, gilding
Painted underneath with the blue crossed L's
of the Vincennes manufactory enclosing the
date letter A for 1753, and with the painter's
mark of a crescent.

Height: 9¼ in. (23.4 cm); Width: 11⅞ in.
(30 cm); Depth: 8½ in. (21.6 cm)
Accession number 73.DE.64

PROVENANCE
Sold by the Vincennes manufactory (?)
between January 1 and August 20, 1756, to
the *marchand-mercier* Lazare Duvaux, Paris, for
840 *livres*; sold by Lazare Duvaux (?) on
March 1, 1756, to Count Joachim Godske
Moltke of Copenhagen, Denmark, as part of
a garniture of five vases (sold by his descen-
dants in Paris in the nineteenth century);
[Gilbert Lévy, Paris, early twentieth century
(?)]; private collection, Paris; [Rosenberg
and Stiebel, Inc., New York, early 1970s];
purchased by J. Paul Getty.

BIBLIOGRAPHY
*Le Livre-Journal de Lazare Duvaux, marchand-
bijoutier ordinaire du roy, 1748–1758*, Louis
Courajod, ed. (Paris, 1873), vol. 2, no. 2420,
p. 274; Fredericksen et al., *Getty Museum*,
p. 165, illus.; Gillian Wilson, "The J. Paul
Getty Museum, 7ème partie: Le Mobilier
Louis XVI," *Connaissance des arts* 280 (June
1975), p. 97, illus.; Savill, *Sèvres*, vol. 1, p. 33;
note 2a, p. 40; Tamara Préaud and Antoine
d'Albis, *La Porcelaine de Vincennes* (Paris, 1991),
p. 67, illus.; and no. 195, p. 180, illus.; Sas-
soon, *Vincennes and Sèvres Porcelain*, no. 2,
pp. 8–10, illus. pp. 9, 11; Bremer-David, *Sum-
mary*, no. 213, p. 126, illus.

224.
PAIR OF POT-POURRI VASES (*POTS-POURRIS
POMPADOUR, TROISIÈME GRANDEUR*)
Vincennes manufactory, 1755
Model design by Jean-Claude Duplessis, *père*;
painted by Jean-Louis Morin after engraved
designs by François Boucher
Soft-paste porcelain, *bleu lapis* ground color,
carmine red decoration, gilding
Each vase is painted under the base with
blue crossed L's of the Vincennes manufactory
enclosing the date letter C for 1755, also
with Morin's mark M in blue and two
blue dots. Each vase is incised with 2 under
the base.

Height: 10 in. (25.5 cm); Diameter: 6 in.
(15.2 cm)
Accession number 84.DE.3.1–.2

PROVENANCE
Sold by the Sèvres manufactory (?) between
August 20, 1756, and September 1756 to the
marchand-mercier Lazare Duvaux, Paris, for 180
livres each; sold by Lazare Duvaux (?) in
September 1756 to Frederick, 3rd Viscount
Saint John, 2nd Viscount Bolingbroke, Lydi-
ard Park, Wiltshire, as two of a set of four;
anonymous collection (sold, Sotheby's, Lon-

don, March 5, 1957, lot 96); [The Antique
Porcelain Co., London, 1957]; private collec-
tion; [The Antique Porcelain Co., London,
1983].

BIBLIOGRAPHY
*Le Livre-Journal de Lazare Duvaux, marchand-
bijoutier ordinaire du roy, 1748–1758*, Louis
Courajod, ed. (Paris, 1873), vol. 2, no. 2590,
p. 295; Adrian Sassoon, "Vincennes and
Sèvres Porcelain Acquired by the J. Paul
Getty Museum in 1984," *GettyMusJ* 13 (1985),
pp. 91–94, illus.; "Acquisitions/1983,"
GettyMusJ 13 (1985), no. 60, p. 181, illus.;
Savill, *Sèvres*, vol. 1, p. 129; note 3k, p. 132;
notes 26, 32, p. 134; vol. 2, p. 851; note 59,
p. 857; Sassoon, *Vincennes and Sèvres Porcelain*,
no. 3, pp. 12–18, illus. pp. 13–15, 18; Bremer-
David, *Summary*, no. 214, pp. 126–127,
illus. p. 126.

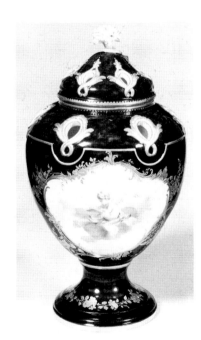

224 *One of a pair*

Sèvres

225.
BASKET (PANIER, DEUXIÈME GRANDEUR)

> Sèvres manufactory, 1756
> Soft-paste porcelain, green ground color, gilding
> Painted under the base with the blue crossed L's of the Sèvres manufactory enclosing the date letter D for 1756, and with three dots. Incised with the *répareur's* mark PZ under the base.

> Height: 8⁵/₈ in. (22 cm); Width: 7⁷/₈ in. (20.1 cm); Depth: 7¹/₈ in. (18 cm)
> Accession number 82.DE.92

PROVENANCE

Private collection, France (sold, Christie's, London, June 28, 1982, lot 19); [Armin B. Allen, New York, 1982].

BIBLIOGRAPHY

"Some Acquisitions (1981–82) in the Department of Decorative Arts, The J. Paul Getty Museum," *Burlington Magazine* 125, no. 962 (May 1983), illus. p. 323; Sassoon, "Acquisitions 1982," no. 8, pp. 45–47, illus.; Wilson, *Selections*, no. 26, pp. 52–53, illus.; Adrian Sassoon, "Sèvres: Luxury for the Court," *Tech-*

niques of the World's Great Masters of Pottery and Ceramics, Hugo Morley-Fletcher, ed. (Oxford, 1984), pp. 52–57, illus.; Jackson-Stops, "Boulle by the Beach," pp. 854–856; Antoine d'Albis, "Le Marchand Mercier Lazare Duvaux et la Porcelaine de Vincennes," *Les Décors des boutiques parisiennes,* La Delegation à l'Action Artistique de la Ville de Paris, eds., (Paris, 1987), pp. 76–88; Savill, *Sèvres*, vol. 2, p. 752; note 3d, p. 756; Sassoon, *Vincennes and Sèvres Porcelain*, no. 4, pp. 20–22, illus. pp. 21–22; Bremer-David, *Summary*, no. 215, p. 127, illus.; *Handbook* 1997, p. 214, illus.

226.
EWER AND BASIN (BROC ET JATTE FEUILLE D'EAU, PREMIÈRE GRANDEUR)

> Sèvres manufactory, 1757
> Possibly modeled after a design by Jean-Claude Duplessis, *père*
> Soft-paste porcelain, pink ground color, polychrome enamel decoration, gilding
> Basin is painted underneath with the blue crossed L's of the Sèvres manufactory enclosing the date letter E for 1757, and with an unidentified painter's mark. Ewer is incised with T.m; basin is incised with C.N.

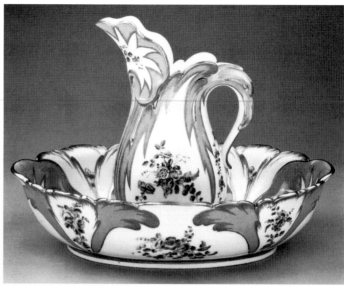

226

> Ewer: Height: 7⁹/₁₆ in. (19.2 cm); Width: 5⁵/₈ in. (14.1 cm); Depth: 3³/₁₆ in. (8.1 cm); Basin: Height: 2³/₄ in. (7.1 cm); Width: 11¹/₂ in. (29.1 cm); Depth: 8⁷/₁₆ in. (22.1 cm)
> Accession number: 84.DE.88.a–.b

PROVENANCE

William John Cavendish-Bentinck-Scott (?), 5th Duke of Portland (died 1879); Dukes of Portland, by descent, Welbeck Abbey, Nottinghamshire (sold, Henry Spencer and Sons, Retford, Nottinghamshire, July 23, 1970, lot 288); [Winifred Williams, Ltd., London, 1970]; Eric Robinson, Mereworth Castle, Kent (sold, Sotheby's, London, June 12, 1984, lot 213); [Winifred Williams, Ltd., London, 1984].

BIBLIOGRAPHY

Best, Son, and Carpenter, *Catalogue of the Ornamental Furniture, Works of Art, and Porcelain at Welbeck Abbey* (London, 1897), no. 296, p. 52; Adrian Sassoon, "Vincennes and Sèvres Porcelain Acquired by the J. Paul Getty Museum in 1984," *GettyMusJ* 13 (1985), pp. 95–98,

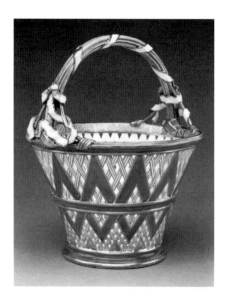

illus.; "Acquisitions/1984," *GettyMusJ* 13 (1985), no. 61, p. 181, illus.; "Recent Ceramic Acquisitions by Major Museums," *Burlington Magazine* 127 no. 986 (May 1985), no. 55, p. 345, illus.; James Sassoon, "The Art Market/Sèvres and Vincennes," *Apollo* 125, no. 304 (June 1987), pp. 440–441; *Sotheby's Concise Encyclopedia of Porcelain*, David Battie, ed. (London, 1990), p. 109, illus.; Sassoon, *Vincennes and Sèvres Porcelain*, no. 5, pp. 24–28, illus. pp. 25–27; Bremer-David, *Summary*, no. 216, p. 128, illus.

227.

PAIR OF FIGURE GROUPS

Group .1: *The Flute Lesson* (*Le Flûteur*);
Group .2: *The Grape Eaters* (*Les Mangeurs de Raisins*)
Sèvres manufactory, circa 1757–1766
Modeled under the direction of Etienne-Maurice Falconet after designs by François Boucher
Soft-paste biscuit porcelain, traces of red pigment
The Flute Lesson is incised with F on back.

The Flute Lesson: Height: 8³/₄ in. (22.3 cm); Width: 10 in. (25.4 cm); Depth: 6 in. (15.2 cm); *The Grape Eaters*: Height: 9 in. (22.9 cm); Width: 9³/₄ in. (24.8 cm); Depth: 7 in. (17.8 cm)
Accession number 70.DE.98.1–.2

PROVENANCE

Goury de Rosland, Paris (sold, Galerie Georges Petit, Paris, May 29–30, 1905, no. 108); Mortimer L. Schiff, New York (sold by his heir John M. Schiff, Christie's, London, June 22, 1938, lot 27); purchased at that sale by J. Paul Getty.

BIBLIOGRAPHY

Antoine d'Albis, "Le Marchand Mercier Lazare Duvaux et la Porcelaine de Vincennes," *Les Décors des boutiques parisiennes*, La Delegation à l'Action artistique de la Ville de Paris, eds., (Paris, 1987), pp. 76–88, *The Flute Lesson*, illus. p. 83; Sassoon, *Vincennes and Sèvres Porcelain*, no. 6, pp. 29–34, illus. pp. 31–35; Bremer-David, *Summary*, no. 217, pp. 128–129, illus. p. 128.

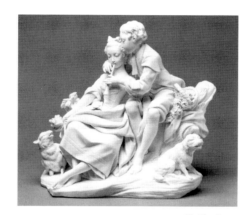

227 The Flute Lesson

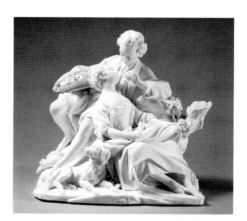

227 The Grape Eaters

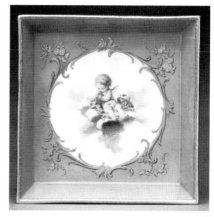

228

228.

TRAY (*PLATEAU CARRÉ, DEUXIÈME GRANDEUR*)
Sèvres manufactory, 1758
Soft-paste porcelain, pink ground color, polychrome enamel decoration, gilding
Painted underneath with the blue crossed *L*'s of the Sèvres manufactory enclosing the date letter F for 1758, and with an unidentified painter's mark of a blue E. Incised with 60 underneath.

Height: ¹⁵/₁₆ in. (2.3 cm); Width: 5 in. (12.7 cm); Depth: 5¹/₁₆ in. (12.8 cm)
Accession number 72.DE.75

PROVENANCE

Anne and Deane Johnson, Los Angeles (sold, Sotheby's, New York, December 9, 1972, lot 27); purchased at that sale by J. Paul Getty.

BIBLIOGRAPHY

Savill, *Sèvres*, vol. 2, note 3m, p. 589; Sassoon, *Vincennes and Sèvres Porcelain*, no. 7, pp. 36–38, illus. p. 37; Bremer-David, *Summary*, no. 218, p. 129, illus.

229.

PAIR OF CUPS AND SAUCERS (GOBELETS CALABRE ET SOUCOUPES)

Sèvres manufactory, 1759
Painted by Charles Buteux *père*
Soft-paste porcelain, pink and green ground
colors, polychrome enamel decoration, gilding
Saucers are painted underneath with the
blue crossed L's of the Sèvres manufactory
enclosing the date letter g for 1759, and with
the painter's mark of a blue anchor. One
cup is incised under the base with *h*; the
other cup is incised with an indecipherable
mark in script.

Cups: Height: 3 1/4 in. (8.3 cm); Width: 4 in.
(10.2 cm); Depth: 3 1/8 in. (7.9 cm); Saucers:
Height: 1 5/8 in. (4.1 cm); Diameter: 6 3/16 in.
(15.7 cm)
Accession number 72.DE.74.1–.2

PROVENANCE

Otto and Magdalena Blohm, Hamburg
(sold, Sotheby's, London, July 5, 1960, lots
126–127); Anne and Deane Johnson, Los
Angeles (sold, Sotheby's, New York, Decem-
ber 9, 1972, lot 21); purchased at that sale
by J. Paul Getty.

BIBLIOGRAPHY

E. S. Auscher, *A History and Description of French
Porcelain* (London and New York, 1905), pl. 4;
Robert Schmidt, *Early European Porcelain as Col-
lected by Otto Blohm* (Munich and London, 1953),
p. 101, illus.; Savill, *Sèvres*, vol. 2, pp. 629,
652; note 2, p. 637; note 134, p. 666; Sas-
soon, *Vincennes and Sèvres Porcelain*, no. 8,
pp. 39–40, illus. pp. 40–41; Bremer-David,
Summary, no. 219, pp. 129–130, illus. p. 129.

230.

PAIR OF VASES (POT-POURRI À BOBÈCHES)

Sèvres manufactory, 1759
Painted by Charles-Nicolas Dodin after
engraved designs by David Teniers *le jeune*
Soft-paste porcelain, pink and green ground
colors, polychrome enamel decoration, gilding
One is painted underneath with the blue-
crossed L's of the Sèvres manufactory
enclosing the date letter G for 1759, and
with Dodin's mark *k*. Various paper collec-
tors' labels pasted under the bases; one
vase unmarked.

Height: 9 13/16 in. (24.9 cm); Width:
5 11/16 in. (14.4 cm); Depth: 3 11/16 in.
(9.4 cm)
Accession number 75.DE.65.1–.2

PROVENANCE

[Duveen Brothers, New York]; J. Pierpont
Morgan, London and New York; J. Pierpont
Morgan, Jr., New York (sold, Parke-Bernet,
New York, March 25, 1944, lot 647); Paula
de Koenigsberg, Buenos Aires, 1945; Claus
de Koenigsberg, Buenos Aires; [Rosenberg
and Stiebel, Inc., New York, 1975]; purchased
by J. Paul Getty.

EXHIBITIONS

New York, The Metropolitan Museum of
Art, on loan 1914–1915 from J. Pierpont Mor-
gan; Buenos Aires, Museo Nacional de Bellas
Artes, *Exposición de obras maestras: Colección Paula
de Koenigsberg*, October 1945, no. 206, illus.;
Buenos Aires, Museo Nacional de Arte Deco-
rativo, *El Arte de vivir en francia del siglo XVIII*,
September–November 1968, no. 427, pl. 211.

BIBLIOGRAPHY

P. G. Konody, "Die Kunsthistorische Samm-
lung Pierpont Morgans," *Kunst und Kunsthand-
werk* (Vienna, 1903), no. 6, p. 158; comte
Xavier de Chavagnac, *Catalogue des porcelaines
françaises de M. J. Pierpont Morgan* (Paris, 1910),
no. 107, pl. 32; C. C. Dauterman, J. Parker,
E. A. Standen, *Decorative Art from the Samuel H.
Kress Collection at the Metropolitan Museum of Art*
(London, 1964), p. 205; Gillian Wilson,
"Sèvres Porcelain at the J. Paul Getty
Museum," *GettyMus J* 4 (1977), pp. 5–24, illus.
pp. 20–21; Adrian Sassoon, "Sèvres Vases,"
*Techniques of the World's Great Masters of Pottery and
Ceramics*, Hugo Morley-Fletcher, ed. (Oxford,
1984), pp. 64–67, illus. p. 31; Pierre Ennès,
"Essai de réconstitution d'une garniture de
Madame de Pompadour," *Journal of the Walters
Art Gallery* 42–43 (1984/1985), pp. 70–82;
*J. Pierpont Morgan, Collector: European Decorative
Arts from the Wadsworth Atheneum*, Linda Hor-
vitz Roth, ed. (Hartford, 1987), p. 203; Barry
Shifman, "Eighteenth-Century Sèvres Porce-
lain in America," *Madame de Pompadour et la
floraison des arts* (Montreal, 1988), pp. 118–123;

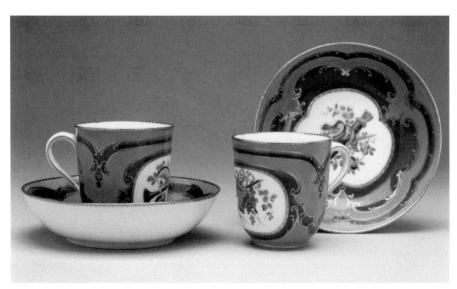

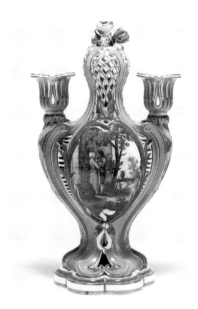

230 Vase .1

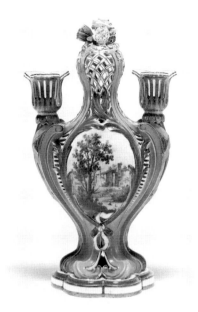

230 Vase .1 back view

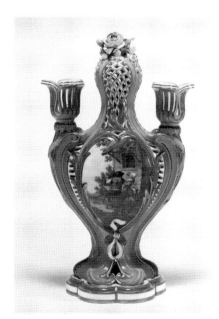

230 Vase .2

230 Vase .2 back view

Sassoon, *Vincennes and Sèvres Porcelain*, no. 9, pp. 42–48, illus. pp. 42–45; Bremer-David, *Summary*, no. 220, pp. 130–131, illus. p. 130; Musée du Louvre, *Nouvelles acquisitions du départment des objets d'art 1990–1994* (Paris

1995) no. 81, pp. 196–197; Theodore Dell, "J. Pierpont Morgan, Master Collector: Lover of the Eighteenth Century French Decorative Arts," *International Fine Art and Antiques Dealers Show* (New York, 1995), pp. 25–34.

231.
LIDDED POT-POURRI VASE (*VASE OR POT-POURRI VAISSEAU À MÂT, DEUXIÈME GRANDEUR*)

Sèvres manufactory, circa 1760
Painting attributed to Charles-Nicolas Dodin
Soft-paste porcelain, pink and green ground colors, polychrome enamel decoration, gilding
Painted underneath with the blue crossed L's (partially abraded) of the Sèvres manufactory.
Height: 1 ft. 2 3/4 in. (37.5 cm); Width: 1 ft. 1 11/16 in. (34.8 cm); Depth: 6 13/16 in. (17.4 cm)
Accession number 75.DE.11.a–.b

PROVENANCE

George William (?), 6th Earl of Coventry, Croome Court, Worcestershire; George William, 7th Earl of Coventry, Croome Court, Worcestershire (sold, Christie's, London, June 12, 1874, part of lot 150, for £10,500); William Humble, 1st Earl of Dudley, Dudley House, London, 1874; (sold privately, 1885–1886); William J. Goode, London (offered for sale, Christie's, London, July 17, 1895, part of lot 147, bought in for £8,400); sold, Christie's, London, May 20, 1898, part of lot 94b, for £6,450 to Pilkington); [Asher Wertheimer, London, 1898]; [Duveen Brothers, New York]; J. Pierpont Morgan, New York, 1908–1910 (purchased for £15,500); J. Pierpont Morgan, Jr., New York, 1913 (sold, Parke-Bernet, New York, January 8, 1944, lot 486); Paula de Koenigsberg, Buenos Aires, 1945; Claus de Koenigsberg, Buenos Aires; [Rosenberg and Stiebel, Inc., New York, 1975]; purchased by J. Paul Getty.

EXHIBITIONS

New York, The Metropolitan Museum of Art, on loan 1914–1915 from J. Pierpont Morgan; Buenos Aires, Museo Nacional de Bellas Artes, *Exposición de obras maestras: Colección Paula de Koenigsberg*, October 1945, no. 205, illus.; Buenos Aires, Museo Nacional de Arte Decorativo, *El arte de vivir en francia del siglo XVIII*, September–November 1968, no. 247.

BIBLIOGRAPHY

George Redford, *Art Sales 1628–1887* (London, 1888), vol. 1, pp. 400, 438; comte Xavier de

231

231 *Back view*

Chavagnac, *Catalogue des porcelaines françaises de M. J. Pierpont Morgan* (Paris, 1910), no. 109, pl. 33; Frederick Litchfield, "Imitations and Reproductions: Part I—Sèvres Porcelain," *Connoisseur* (September 1917), p. 6; Gerald Reitlinger, *The Economics of Taste* (New York, 1963), vol. 2, pp. 582–585. C. C. Dauterman, J. Parker, and E. A. Standen, *Decorative Art from the S. H. Kress Collection in the Metropolitan Museum of Art* (London, 1964), p. 195; Gillian Wilson, "Sèvres Porcelain at the J. Paul Getty Museum," *GettyMusJ* 4 (Malibu, 1977), pp. 5–24, illus. pp. 6–7; Wilson, *Selections*, no. 29, pp. 58–59, illus.; Pierre Ennès, *Nouvelles acquisitions du département des objets d'art, 1980–1984* (Musée du Louvre, Paris, 1985), p. 135; Sir John Plumb, "The Intrigues of Sèvres," *House and Garden* 158, no. 1 (U.S., January 1986), pp. 44–45; *J. Pierpont Morgan, Collector: European Decorative Arts from the Wadsworth Atheneum*, Linda Horvitz Roth, ed. (Hartford, 1987), p. 34, illus. p. 162, fig. 8, and p. 203; Barry Shifman, "Eighteenth-Century Sèvres Porcelain in America," *Madame de Pompadour et la floraison des arts* (Montreal, 1988), pp. 118–123; Savill, *Sèvres*, vol. 1, p. 192; notes 43–44, p. 55; note 25, p. 117; note 3h, p. 196; note 23, p. 197; Sassoon, *Vincennes and Sèvres Porcelain*, no. 10, pp. 49–56, illus. pp. 51, 53–55; Bremer-David, *Summary*,

no. 221, pp. 131–132, illus. p. 131; Theodore Dell, "J. Pierpont Morgan, Master Collector: Lover of the Eighteenth-Century French Decorative Arts," *International Fine Art and Antiques Dealers Show* (New York, 1995), pp. 25–34; *Masterpieces*, no. 77, p. 99, illus.; *Handbook 2001*, pp. 214–215, illus.

232.
PAIR OF VASES (POTS-POURRIS FONTAINE OR POTS-POURRIS À DAUPHINS)

Sèvres manufactory, circa 1760
Painting attributed to Charles-Nicolas Dodin
Soft-paste porcelain, pink, green, and *bleu lapis* ground colors, polychrome enamel decoration, gilding
Painted underneath the central section of one vase with the blue crossed *L*'s of the Sèvres manufactory.

Height: 11 3/4 in. (29.8 cm); Width: 6 1/2 in. (16.5 cm); Depth: 5 3/4 in. (14.6 cm)
Accession number 78.DE.358.1–.2

PROVENANCE
Marquise de Pompadour, Hôtel Pompadour, Paris, 1760–1764; Mme Legère, Paris (sold,

Paris, December 15–17, 1784, part of no. 152); Grace Caroline (?), Duchess of Cleveland (married the 3rd Duke 1815, died 1883); William Goding, before 1862 (sold, Christie's, London, March 19, 1874, lot 100, to [E. Rutter, Paris] for the Earl of Dudley, for £6,825); William Humble, 1st Earl of Dudley (offered for sale, Christie's, London, May 21, 1886, lot 194, bought in for £2,625, returned to Dudley House, London); Sir Joseph C. Robinson, Bt., acquired circa 1920 with the contents of Dudley House, London; Count Joseph Labia (son-in-law of Sir J. C. Robinson, Bt.), London (sold, Sotheby's, London, February 26, 1963, lot 23); [The Antique Porcelain Co., London and New York, 1963]; Nelson Rockefeller, New York, 1976–1977; The Sloan-Kettering Institute for Cancer Research, New York, 1976–1977.

EXHIBITIONS
London, The South Kensington Museum, *Special Loan Exhibition of Works of Art*, June 1862, nos. 1281–1282, lent by William Goding; Memphis, Dixon Gallery and Gardens, and New York, Rosenberg and Stiebel, Inc., *Louis XV and Madame de Pompadour: A Love Affair with Style*, 1990, no. 57, p. 97 and p. 84, illus. p. 85, fig. 60; Paris, Musée du Louvre, *Un défi au goût*, 1997, no. 12, p. 76, illus.

BIBLIOGRAPHY
George Redford, *Art Sales 1628–1887* (London, 1888), vol. 1, pp. 193, 440; Jean Cordey, *Inventaire des biens de Madame de Pompadour rédigé après son décès* (Paris, 1939), p. 39, no. 380; G. Reitlinger, *The Economics of Taste* (London, 1963), vol. 2, pp. 582–583; Ronald Freyberger, "Chinese Genre Painting at Sèvres," *American Ceramic Circle Bulletin* (1970–1971), pp. 29–44, illus.; Marcelle Brunet and Tamara Préaud, *Sèvres: Des origines à nos jours* (Fribourg, 1978), p. 68, illus. (one) pl. 22; Wilson, "Acquisitions 1977 to mid-1979," p. 44, illus.; Rosalind Savill, "Two Pairs of Sèvres Vases at Boughton House," *Apollo* 110, no. 210 (August 1979), pp. 128–133, illus.; Madeleine Jarry, *Chinoiserie* (New York, 1981), p. 120, illus. (detail of one); Wilson, *Selections*, no. 28, pp. 56–57, illus.; Adrian Sas-

soon, "Sèvres Vases," *Techniques of the World's Great Masters of Pottery and Ceramics*, Hugo Morley-Fletcher, ed. (Oxford, 1984), pp. 64–67, illus.; Pierre Ennès, "Essai de réconstitution d'une garniture de Madame de Pompadour," *Journal of the Walters Art Gallery* 42–43 (1984–1985), pp. 70–82; Pierre Ennès, *Nouvelles Acquisitions du départment des objets d'art, 1980–1984* (Musée du Louvre, Paris, 1985), p. 135; Jackson-Stops, "Boulle by the Beach," pp. 854–856; Hugo Morley-Fletcher, "The Earl of Dudley's Porcelain, 1886," *Christie's International Magazine* (April/May 1986), illus. inside front cover (one); Barry Shifman, "Eighteenth-Century Sèvres Porcelain in America," *Madame de Pompadour et la floraison des arts* (Montreal, 1988), pp. 118–123, illus. p. 123; Savill, *Sèvres*, vol. 1, p. 192; note 29, p. 68; notes 24, 33, p. 197; Sassoon, *Vincennes and Sèvres Porcelain*, no. 11, pp. 57–63, illus. pp. 58–62; Bremer-David, *Summary*, no. 222, pp. 132–134, illus. p. 133; *Masterpieces*, no. 76, p. 98; *Handbook* 2001, p. 215, illus.

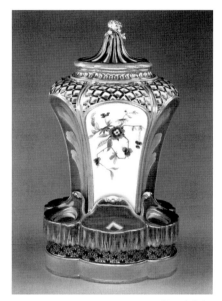

232 *Vase* .1

232 *Vase* .1 *back view*

233.
PAIR OF LIDDED CHESTNUT BOWLS (*MARRONNIÈRES À OZIER*)

Sèvres manufactory, circa 1760
Molding attributed to the *réparcur* François-Firmin Dufresne [Fresne] or to François-Denis Roger
Soft-paste porcelain, *bleu céleste* ground color, polychrome enamel decoration, gilding
Bowl .1 is incised underneath with the mark *j* and with *FR* for the *réparcur*.

Bowl .1: Height: 5 1/4 in. (13.4 cm); Width: 10 9/16 in. (27 cm); Depth: 8 5/16 in. (21.1 cm); Bowl .2: Height: 5 1/4 in. (13.4 cm); Width: 10 1/2 in. (26.7 cm); Depth: 8 3/16 in. (20.8 cm)
Accession number 82.DE.171.1–.2

PROVENANCE
Swiss art market, 1980; [Armin B. Allen, New York, 1980].

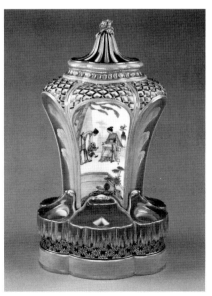

232 *Vase* .2

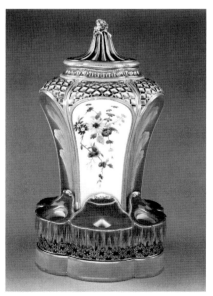

232 *Vase* .2 *back view*

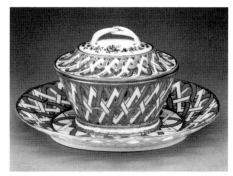

233 *One of a pair*

BIBLIOGRAPHY

Sassoon, "Acquisitions 1982,", no. 9, pp. 48–53, illus.; Savill, *Sèvres*, vol. 2, p. 759; note 4f, p. 761, note 29, p. 762; Sassoon, *Vincennes and Sèvres Porcelain*, no. 12, pp. 64–68, illus. pp. 65, 67; Bremer-David, *Summary*, no. 223, p. 134, illus. (one).

234.
JARDINIÈRE

Sèvres manufactory and Paris, circa 1760
Painting of the narrative reserve attributed to Charles-Nicolas Dodin
Soft-paste porcelain, green ground color, polychrome enamel decoration, gilding; gilt-bronze frame
Height: 6 9/16 in. (16.6 cm); Width: 11 1/2 in. (29.2 cm); Depth: 5 5/8 in. (14.3 cm)
Accession number 73.DI.62

PROVENANCE

Miss Botham (sold after her death, Christie's, London, May 5, 1817 et seq., lot 96, for £61 10s to the Earl of Yarmouth, later 3rd Marquess of Hertford); (sold, M. Maëlrondt, Paris, November 15, 1824, no. 198); private collection, Paris; [Gaston Bensimon, Paris]; purchased by J. Paul Getty.

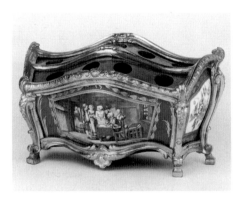

234

BIBLIOGRAPHY

Savill, *Sèvres*, vol. 1, note 18, p. 191; vol. 2, p. 838; note 11, p. 841; Sassoon, *Vincennes and Sèvres Porcelain*, no. 13, pp. 69–70, illus. pp. 69, 71; Bremer-David, *Summary*, no. 224, p. 134, illus.; Marie-Laure de Rochebrune, "Acquisitions du Louvre: Sept nouveaux vases de la manufacture royale de porcelaine de Sèvres," *L'Estampille/L'Objet d'art* 344 (February 2000), p. 26.

235.
VASE (*CUVETTE MAHON, TROISIÈME GRANDEUR*)

Sèvres manufactory, 1761
Painted by Jean-Louis Morin
Soft-paste porcelain, pink ground color overlaid with blue enamel, polychrome enamel decoration, gilding
Painted under one foot with the blue crossed L's of the Sèvres manufactory enclosing the date letter I for 1761, and with Morin's mark M.

Height: 5 7/8 in. (15 cm); Width: 9 1/16 in. (23 cm); Depth: 4 11/16 in. (11.9 cm)
Accession number 72.DE.65

PROVENANCE

Sold, March 30, 1763, by the Sèvres manufactory to Lemaître, as part of a garniture with another *cuvette Mahon*, for 264 *livres* each, and with a *cuvette à masques*; de Bargigli collection (offered for sale, Christie's, Geneva, April 22, 1970, no. 18, bought in); (sold, Christie's, London, October 4, 1971, lot 42); [Olivier Lévy, Paris, 1971]; [French and Co., New York, 1971]; purchased by J. Paul Getty.

BIBLIOGRAPHY

Gillian Wilson, "Sèvres Porcelain at the J. Paul Getty Museum," *GettyMusJ* 4 (1977), pp. 19–24, illus.; Savill, *Sèvres*, vol. 1, pp. 38, 93; notes. 40, 43, p. 42; note 44, p. 55; notes 15, 22, p. 97; Sassoon, *Vincennes and*

Sèvres Porcelain, no. 14, pp. 72–77, illus. p. 73; Bremer-David, *Summary*, no. 225, p. 135, illus.; Marie-Laure de Rochebrune, "Acquisitions du Louvre: Sept nouveaux vases de la manufacture royale de porcelaine de Sèvres," *L'Estampille/L'Objet d'art* 344 (February 2000), p. 26.

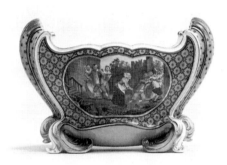

235

236.
TRAY (*PLATEAU COURTEILLE OU DE CHIFFONIÈRE*)

Sèvres manufactory, 1761
Painted by Charles-Nicolas Dodin after a design by François Boucher
Soft-paste porcelain, pink ground color overlaid with blue enamel, polychrome enamel decoration, gilding
Painted underneath with the blue crossed L's of the Sèvres manufactory enclosing the date letter I for 1761 and with the painter's mark k.

Height: 1 in. (2.5 cm); Width: 1 ft. 1 1/2 in. (34.3 cm); Depth: 10 in. (24.5 cm)
Accession number 70.DA.85

PROVENANCE

Miss H. Cavendish-Bentinck (?) (offered for sale, Christie's, London, March 3, 1893, lot 123, bought in); John Cockshut, Esq. (?), (sold posthumously, Christie's, London, March 11, 1913, lot 92, to Harding); then

mounted to a table bearing the false stamp B.V.R.B.; private collection, England; [Rosenberg and Stiebel, Inc., New York, 1949]; purchased by J. Paul Getty, 1949; plaque removed from table in 1991.

BIBLIOGRAPHY
Paul Wescher, "French Furniture of the Eighteenth Century in the J. Paul Getty Museum," *Art Quarterly* 18, no. 2 (Summer 1955), no. 1, p. 121, illus. p. 129; J. Paul Getty, *Collector's Choice* (London, 1955), pp. 77, 145–147, 167, 171, illus. unnumbered pl. between pp. 176–177; "Vingt Mille Lieues dans les musées" *Connaissance des arts* 57 (November 1956), pp. 76–81, illus. p. 79; Verlet et al., *Chefs d'oeuvre*, p. 118, illus.; Getty, *Collecting*, p. 148, illus.; C. C. Dauterman, J. Parker, E. A. Standen, *Decorative Art from the Samuel H. Kress Collection at the Metropolitan Museum of Art* (London, 1964), p. 165; F. J. B. Watson, *The Wrightsman Collection* (New York, 1966), vol. 1, no. 3, p. LVII; Hans Huth, *Lacquer of the West: The History of a Craft and an Industry, 1550–1950* (Chicago and London, 1971), p. 93, caption p. 145, fig. 231; Adrian Sassoon, "New Research on a Table Stamped by Bernard van Risenburgh," *GettyMusJ* 9 (1981), pp. 167–174, figs. 1–5, 8–9; Dorothée Guillemé-Brulon, "Un Décor pour les meubles," *L'Estampille* 165 (January 1984), p. 28; Antoinette Fäy-Hallé et al., *François Boucher* (The Metropolitan Museum of Art, New York, 1986), no. 97, p. 355; Savill, *Sèvres*, vol. 1, pp. 354–355 and vol. 2, note 2f, p. 812; Kjellberg, *Dictionnaire*, p. 139; Sassoon, *Vincennes and Sèvres Porcelain*, no. 32, pp. 162–165, illus. pp. 163, 165; Bremer-David, *Summary*, no. 71, p. 54, illus.; Marie-Laure de Rochebrune, "À Propos de quelques plaques de porcelaine tendre de Sèvres peintes par Charles Nicolas Dodin (1734–1803)," *Bulletin de la Société de l'histoire de l'art français* (1998), pp. 113–115, illus. p. 114.

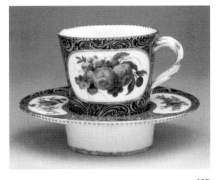

237.

237.
CUP AND SAUCER (*GOBELET ET SOUCOUPE ENFONCÉ, PREMIÈRE GRANDEUR*)
Sèvres manufactory, 1761
Soft-paste porcelain, pink ground color overlaid with blue enamel, polychrome enamel decoration, gilding
Cup and saucer are both painted underneath with the blue crossed L's of the Sèvres manufactory enclosing the date letter I for 1761, the cup also with a dot. Saucer is incised with *oo* underneath. Cup is incised with *DU* underneath in two places.

Cup: Height: 3 9/16 in. (9.1 cm); Width: 4 3/16 in. (10.7 cm); Depth: 3 3/8 in. (8.6 cm); Saucer: Height: 1 1/2 in. (3.8 cm); Diameter: 6 1/8 in. (15.6 cm)
Accession number 79.DE.62.a–.b

PROVENANCE
[Olivier Lévy, Paris]; [French and Co., New York, early 1970s]; Mrs. John W. Christner, Dallas (sold, Christie's, New York, June 9, 1979, lot 241).

BIBLIOGRAPHY
Wilson, "Acquisitions 1979 to mid-1980," p. 19, illus.; Savill, *Sèvres*, vol. 2, p. 675; notes 2b and 21, p. 685; Sassoon, *Vincennes and Sèvres Porcelain*, no. 15, pp. 78–80, illus. pp. 79–80; Bremer-David, *Summary*, no. 226, p. 135, illus.

238.
LIDDED BOWL ON DISH (*ÉCUELLE RONDE ET PLATEAU ROND*)
Sèvres manufactory, 1764
Painted by Pierre-Antoine Méreaud l'aîné
Soft-paste porcelain, polychrome enamel decoration, gilding
Bowl and stand are both painted underneath with the blue crossed L's of the Sèvres manufactory enclosing the date letter L for 1764, and with Méreaud's mark S. Bowl is incised with *DU* and *O* and the stand, with *I*.

Bowl: Height: 4 7/8 in. (12.4 cm); Width: 7 3/4 in. (19.7 cm); Depth: 6 in. (15.2 cm); Stand: Height: 1 9/16 in. (3.9 cm); Diameter: 8 5/16 in. (21.1 cm)
Accession number 78.DE.65.a–.c

PROVENANCE
Mme Louise of France (youngest daughter of Louis XV), 1764; Mrs. Lyne Stephens, Norfolk, London, and Paris (sold, Christie's, London, May 9 et seq., 1895, lot 733, to William Boore for £130); Mortimer L. Schiff, New York (sold by his heir John M. Schiff, Christie's, London, June 22, 1938, lot 25); purchased at that sale by J. Paul Getty; distributed by the estate of J. Paul Getty to the J. Paul Getty Museum.

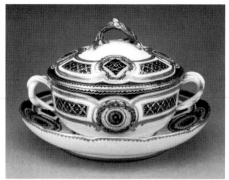

238

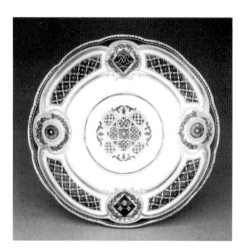

238 *Dish*

BIBLIOGRAPHY

Barry Shifman, "A Newly Discovered Piece
of Royal Sèvres Porcelain," *GettyMusJ* 6–7
(1978–1979), pp. 53–56, illus.; Wilson, *Selections*, no. 33, pp. 66–67, illus.; Barry Shifman,
"Eighteenth-Century Sèvres Porcelain in
America," *Madame de Pompadour et la floraison des
arts* (Montreal, 1988), pp. 118–123; Savill,
Sèvres, vol. 2, pp. 648, 800; note 33d, p. 663;
note 99c, p. 665; note 36, p. 804; Sassoon,
Vincennes and Sèvres Porcelain, no. 16, pp. 81–82,
illus. pp. 82–83; Bremer-David, *Summary*,
no. 227, p. 136, illus.; *Handbook* 2001, p. 218,
illus.

239.

COVERED CUP AND SAUCER (*GOBELET À LAIT
ET SOUCOUPE, DEUXIÈME GRANDEUR*)

Sèvres manufactory, circa 1765–1767
Painting attributed to Christian Gotthelf
Grossmann
Soft-paste porcelain, *camaïeu rose* enamel
decoration, gilding
The base of the cup is incised with a reverse
S above a dot.

Cup: Height: 3 9/16 in. (9.1 cm); Width:
5 1/2 in. (14 cm); Depth: 3 13/16 in. (9.7 cm);
Saucer: Height: 1 11/16 in. (4.3 cm); Diameter: 7 5/8 in. (19.3 cm)
Accession number 87.DE.134.a–.c

PROVENANCE

Isabella Anne Ingram-Shepherd (?), 2nd Marchioness of Hertford, Hertford House, London, before 1834; (sold, Christie's, London,
March 25, 1985, lot 9); [Winifred Williams,
Ltd., London].

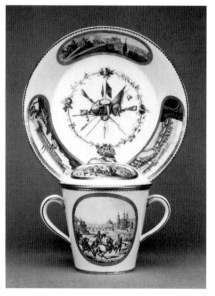

239

BIBLIOGRAPHY

"Acquisitions/1987," *GettyMusJ* 16 (1988),
no. 73, p. 178, illus.; Savill, *Sèvres*, vol. 2,
p. 668; notes 3n, 25, p. 672; Sassoon, *Vincennes and Sèvres Porcelain*, no. 17, pp. 84–86,
illus. pp. 85–87; Bremer-David, *Summary*,
no. 228, pp. 136–137, illus. p. 136; David
Peters, "Un peintre de Meissen à Sèvres,"
*Sèvres: Revue de la Société des Amis du Musée
National de Céramique* 6 (1997), pp. 7–14, illus.
p. 9, fig. 1.

240.

PAIR OF LIDDED VASES (*VASES À TÊTES DE BOUC*)

Sèvres manufactory, circa 1768
Possibly molded by Michel-Dorothée
Coudray; possibly finished by the *répareur*
Nantier
Soft-paste porcelain, *bleu nouveau* ground color,
gilding
Each is incised *c.d.* underneath for the *mouleur*.
Vase .1 is incised with N 1; Vase .2 is incised
with N 2 underneath for the *répareur*.

Height: 1 ft. 1 7/16 in. (34.2 cm); Width:
8 5/8 in. (21.9 cm); Depth: 6 5/8 in. (16.8 cm)
Accession number 82.DE.36.1–.2

PROVENANCE

Sold by the Sèvres manufactory to Henry
Pelham-Clinton (?), through Sir John Lambert, October 5, 1768, for 600 *livres* each;
Earls of Lincoln, by descent (sold, Christie's, London, June 9, 1937, part of lot 115);
[J. Rochelle Thomas, London]; private collection, New York (sold, Parke-Bernet, New
York, January 12, 1957, lot 247); Christian
Humann, New York (sold, Sotheby's, New
York, April 22, 1982, lot 41); [Armin B.
Allen, New York, 1982].

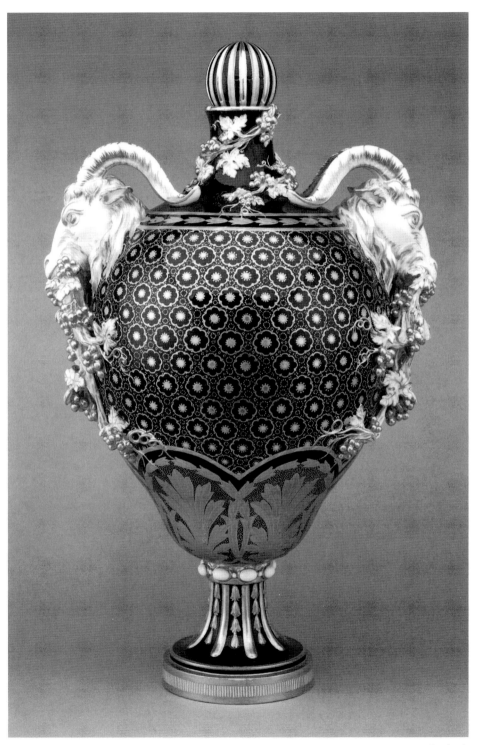

240 *One of a pair*

BIBLIOGRAPHY

"Some Acquisitions (1981–82) in the Department of Decorative Arts, The J. Paul Getty Museum," *Burlington Magazine* 125, no. 962 (May 1983), illus. p. 323; Sassoon, "Acquisitions 1982," no. 11, pp. 54–56, illus.; Savill, *Sèvres*, vol. 1, note 72, p. 31; note 12, p. 350; Sassoon, *Vincennes and Sèvres Porcelain*, no. 18, pp. 88–92, illus. pp. 89, 91, 93; Bremer-David, *Summary*, no. 229, pp. 137–138, illus. p. 137.

241.
PAIR OF VASES (VASES ŒUF [?])
 Sèvres manufactory, 1768–1769
 Figure painting attributed to Jean-Baptiste-Etienne Genest
 Soft-paste porcelain, *bleu Fallot* ground color, grisaille enamel decoration, gilding; gilt-bronze mounts
 Vase .1 is incised with 4 on its body, foot, and twice on its lid; Vase .2 is incised with 1 on the body [no illustration], with a reversed 3 (?) on its foot, and with 2 on its lid.

 Height: 1 ft. 5 3/4 in. (45.1 cm); Width: 9 1/2 in. (24.1 cm); Depth: 7 1/2 in. (19.1 cm)
 Accession number 86.DE.520.1–.2

PROVENANCE
Purchased by Sir Harry Fetherstonhaugh, Uppark, Sussex, from the *marchand-mercier* Rocheux, Paris, September 22, 1819; Alfred (Charles) de Rothschild (1842–1918), in the South Drawing Room, Halton, Buckinghamshire, 1884; by descent to Lionel (Nathan) de Rothschild (1882–1942), Exbury, Hampshire; by descent to Edmund (Leopold) de Rothschild (born 1916), Exbury House, Hampshire,

1942 (sold with a mounted *vase Hébert*, Christie's, London, July 4, 1946, lot 90, to [Frank Partridge, Ltd., London]); Seymour Egerton, 7th Earl of Wilton, London, 1947 (this pair of vases only, without the *vase Hébert*); Sir Charles Clore, London and Monaco (sold after his death, Christie's, Monaco, December 6, 1985, no. 6).

BIBLIOGRAPHY

James Sassoon, "The Art Market/Sèvres and Vincennes," *Apollo* 125, no. 304 (June 1987), pp. 440–441, illus. p. 440; "Acquisitions/ 1986," *GettyMusJ* 15 (1987), no. 107, p. 214, illus.; "J. Paul Getty Museum" *Ventura* (September–November 1988), p. 167, illus.; Savill, *Sèvres*, vol. 1, pp. 184, 377; note 2j, p. 190; note 16, p. 191; note 9, p. 383; Gillian Wilson, "Dalla Raccolta del Museo J. Paul Getty," Part 3, *Casa Vogue Antiques* 10 (November 1990), pp. 90–95, illus. p. 95; Sassoon, *Vincennes and Sèvres Porcelain*, no. 19, pp. 94–101, illus. pp. 95–96, 99–101; Bremer-David, *Summary*, no. 230, p. 138, illus.; Philip Jodidio, "Le Monastère de Brentwood," *Connaissance des arts* 511 (November 1994), p. 135, illus.; *Masterpieces*, no. 78, pp. 100–101, illus.; Marie-Laure de Rochebrune, "Acquisitions du Louvre: Sept nouveaux vases de la manufacture royale de porcelaine de Sèvres," *L'Estampille/L'Objet d'art* 344 (February 2000), p. 28; *Handbook* 2001, p. 221, illus.

242.
VASE (*VASE À CHAÎNE* OR *VASE À CÔTE DE MELON*)
Sèvres manufactory, circa 1765–1770
After a design attributed to Jean-Claude Duplessis *père*; modeled by Michel-Dorothé Coudray and possibly Roger *père*
Soft-paste porcelain, *bleu nouveau* ground color, gilding
Painted underneath with the blue crossed L's of the Sèvres manufactory; foot ring is incised with CD, and foot is incised with R.

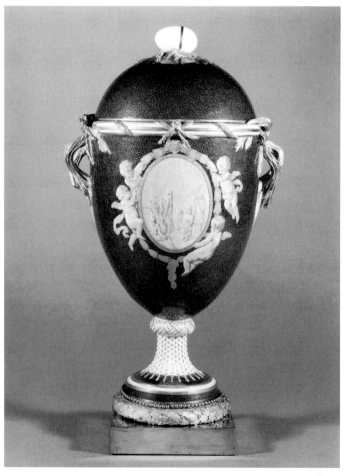

241 *Vase* .1

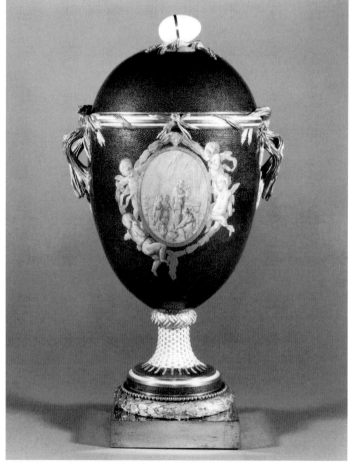

241 *Vase* .2

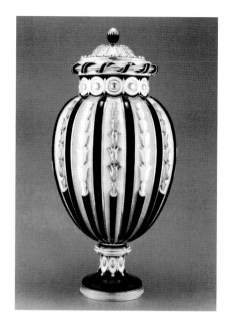

242

Height: 1 ft. 5 3/4 in. (45 cm); Diameter: 8 5/8 in. (22.2 cm)
Accession number 90.DE.113

PROVENANCE
The Earls of Sefton, Croxteth Hall (near Liverpool); by descent to Hugh William Osbert Molyneux, 7th Earl of Sexton (1898–1972); (sold postumously, Christie's at Croxteth Hall, September 18, 1973, lot 902); private collection, England; [Alexander and Berendt, Ltd., London, 1989].

BIBLIOGRAPHY
"Notas," *Vanidades Continental* 14 (July 9, 1991), p. 8, illus.; "Acquisitions/1990," *GettyMusJ* 19 (1991), no. 56, p. 161, illus.; Bremer-David, *Summary*, no. 231, p. 139, illus.; Adrian Sassoon, "A *Goût Grec* Sèvres Vase in the J. Paul Getty Museum," *Mélanges en souvenir d'Elisalex d'Albis* (Paris, 1999), pp. 92–94, p. 93, illus.

243.

TEA SERVICE (*DÉJEUNER RUBAN*)

Sèvres manufactory, circa 1765–1770
Gilded by Etienne-Henri Le Guay
Soft-paste porcelain, polychrome enamel decoration, gilding

Tray (*plateau ovale polylobé*) is painted underneath with the blue crossed L's of the Sèvres manufactory and with Le Guay's mark *LG* in gold; it also bears the original price label (no price indicated) and is incised with an oval crossed by a line. Teapot (*théière Calabre*) is incised with an arrow and an indecipherable mark ([?]901); lidded sugar bowl (*pot à sucre Calabre*) is incised with a square. One cup (*gobelet Bouillard*) is painted underneath with the blue crossed L's of the Sèvres manufactory and with the gilder's mark for Le Guay, *LG*, in gold. Second cup is incised with F and the same indecipherable mark as on the teapot. Both saucers (*soucoupes*) are painted underneath with the blue crossed L's of the Sèvres manufactory and with the gilder's mark for Le Guay, *LG*, in gold; one saucer is incised with a cross and two dots and the other with an *X* within a square.

Tray: Height: 1 7/8 in. (4.8 cm); Width: 1 ft. 3 1/4 in. (38.8 cm); Depth: 10 1/4 in. (26 cm); Teapot: Height: 4 7/8 in. (12.4 cm); Width: 6 1/2 in. (16.5 cm); Depth: 3 3/4 in. (9.5 cm); Lidded Sugar Bowl: Height: 2 7/16 in. (6.2 cm); Diameter: 3 in. (7.6 cm); Cups: Height: 2 5/16 in. (8.8 cm); Width: 3 5/8 in. (9.2 cm); Depth: 2 3/4 in. (7 cm); Saucers: Height: 1 1/4 in. (3.2 cm); Diameter: 5 1/4 in. (13.3 cm)
Accession number 89.DE.25.1–.5

PROVENANCE
[Michel Vandermeersch, Paris]; [Bernard Dragesco and Didier Cramoisan, Paris, 1988].

BIBLIOGRAPHY
"Acquisitions/1989," *GettyMusJ* 18 (1990), no. 50, p. 192, illus.; Bremer-David, *Summary*, no. 232, pp. 139–140, illus. p. 139.

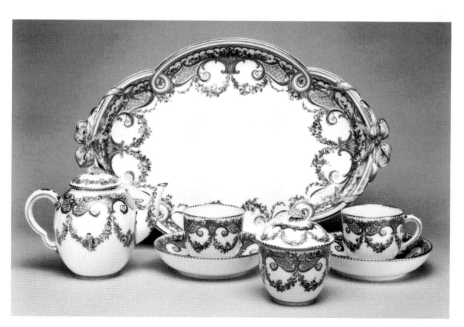

243

244.
LIDDED VASE (VASE À PANNEAUX, PREMIÈRE GRANDEUR)

Sèvres manufactory, circa 1766–1770
Reserve scene after a painting by Nicolas Berchem
Soft-paste porcelain, *beau bleu* ground color, polychrome enamel decoration, gilding; The interior of the lip is incised with 2.

Height (without base): 1 ft. 6³/₄ in. (47.5 cm); Width: 10¹/₄ in. (26 cm); Depth: 8¹/₁₆ in. (20.5 cm)
Accession number 85.DE.219.a–.b

PROVENANCE

Comte de Jarnac (?), Thomastown Castle, Ireland (sold, Christie's, London, June 23, 1876, lot 89); William Humble, 1st Earl of Dudley; possibly sold by his widow; Alfred (Charles) de Rothschild (1842–1918), Halton, Buckinghamshire, by 1884; by descent to Lionel (Nathan) de Rothschild (1882–1942), Exbury, Hampshire, 1918; by descent to

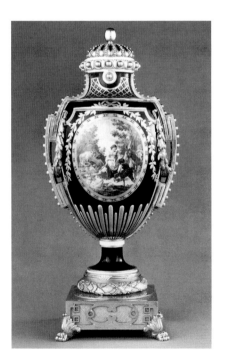

244

Edmund (Leopold) de Rothschild (born 1916), Exbury, Hampshire, 1942 (sold, Christie's, London, July 4, 1946, lot 87, to [Frank Partridge, Ltd., London]); Col. Norman Colville, England; private collection, California (sold, Christie's, New York, January 30, 1985, lot 137); [The Antique Porcelain Co., New York].

BIBLIOGRAPHY

C. Davis, *A Description of the Works of Art: Collection of Alfred de Rothschild* (London, 1884), vol. 2, fig. 87; C. Gay Nieda, "A Sèvres Vase à Panneaux," *GettyMusJ* 14 (1986), pp. 127–134, figs. 1–3, 8–9; "Acquisitions/1985," *GettyMusJ* 14 (1986), no. 199, p. 246, illus.; Savill, *Sèvres*, vol. 1, pp. 278, 325, and 380; note 31, p. 244; note 19, p. 281; note 3c, p. 332; note 21, p. 383; vol. 3, p. 1125; "Notas," *Vanidades Continental* 14 (July 9, 1991), p. 8, illus.; Sassoon, *Vincennes and Sèvres Porcelain*, no. 21, pp. 106–110, illus. pp. 107–108, 110–111; Bremer-David, *Summary*, no. 233, p. 140, illus.

245.
CUP AND SAUCER (GOBELET BOUILLARD ET SOUCOUPE)

Sèvres manufactory, 1770
Painted by Jacques Fontaine
Soft-paste porcelain, *bleu céleste* ground color, grisaille enamel decoration, gilding
Cup is painted with the blue crossed L's of the Sèvres manufactory enclosing the date letter r for 1770, and with Fontaine's mark of five dots. Cup is incised with C; saucer is incised with 6.

Cup: Height: 2¹/₂ in. (6.3 cm); Width: 3⁵/₈ in. (9.2 cm); Depth: 2¹³/₁₆ in. (7.1 cm); Saucer: Height: 1¹/₄ in. (3.2 cm); Diameter: 5⁵/₁₆ in. (13.5 cm)
Accession number 79.DE.65.a–.b

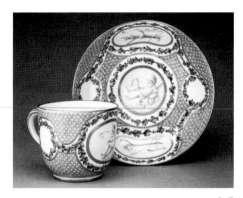

245

PROVENANCE

(Sold, Christie's, London, June 21, 1976, lot 151); Mrs. John W. Christner, Dallas (sold, Christie's, New York, June 9, 1979, lot 227).

BIBLIOGRAPHY

Wilson, "Acquisitions 1979 to mid-1980," item B, p. 19, illus.; Sassoon, *Vincennes and Sèvres Porcelain*, no. 20, pp. 102–105, illus. pp. 103–104; Bremer-David, *Summary*, no. 234, pp. 140–141, illus. p. 141.

246.
CUP AND SAUCER (GOBELET LITRON ET SOUCOUPE, DEUXIÈME GRANDEUR)

Sèvres manufactory, 1773
Painted by Etienne-Jean Chabry *fils*; gilded by Michel-Barnabé Chauveaux *l'aîné*
Soft-paste porcelain, *bleu céleste* ground color, polychrome enamel decoration, gilding
Cup and saucer are both painted underneath with the blue crossed L's of the Sèvres manufactory enclosing the date letter U for 1773, and with Chabry's mark *ch* in blue; also painted with Chauveaux's mark, #, in gold. Saucer is incised with *da* underneath.

Cup: Height: 2⁵/₈ in. (6.7 cm); Width: 3¹/₂ in. (8.9 cm); Depth: 2⁹/₁₆ in. (6.6 cm); Saucer: Height: 1⁹/₁₆ in. (3.9 cm); Diameter: 5⁷/₁₆ in. (13.9 cm)
Accession number 79.DE.64.a–.b

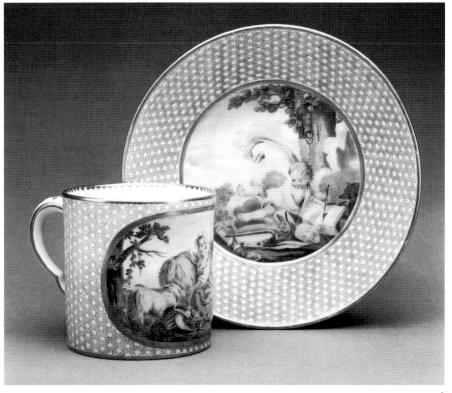

246

PROVENANCE

Sir Richard Wallace, Paris, probably acquired after 1870; Lady Wallace, Paris, by inheritance, 1890; Sir John Murray Scott, Paris, by inheritance, 1897; Victoria, Lady Sackville, Paris, by inheritance, 1912; [Jacques Seligmann, removed to New York, 1916–1917]; Mortimer L. Schiff, New York (sold by his heir John M. Schiff, Christie's, London, June 22, 1938, lot 26); purchased at that sale by J. Paul Getty.

BIBLIOGRAPHY

Rosalind Savill, "A Pair of Sèvres Vases: From the Collection of Sir Richard Wallace to the J. Paul Getty Museum," *GettyMusJ* 14 (1986), pp. 135–142, figs. 1a–c; Savill, *Sèvres*, vol. 1, p. 442; note 45, p. 446; vol. 3, note 2, p. 1022; Sassoon, *Vincennes and Sèvres Porcelain*, no. 23, pp. 115–118, illus. pp. 116–117; Bremer-David, *Summary*, no. 236, p. 142, illus.

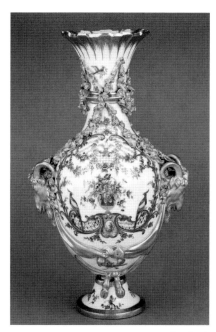

247 *One of a pair*

PROVENANCE

(Sold, Sotheby's, London, July 26, 1977, lot 345); Mrs. John W. Christner, Dallas (sold, Christie's, New York, June 9, 1979, lot 226).

BIBLIOGRAPHY

Wilson, "Acquisitions 1979 to mid-1980," item C, p. 19, illus.; Sassoon, *Vincennes and Sèvres Porcelain*, no. 22, pp. 112–114, illus. pp. 113–114; Bremer-David, *Summary*, no. 235, p. 141, illus.

247.
PAIR OF VASES (VASES BOUC DU BARRY B)
Sèvres manufactory, 1778
Painted by Fallot; gilded by Jean Chauveaux *le jeune*
Hard-paste porcelain, polychrome enamel decoration, silvering, gilding
Each vase is painted underneath with the gold crossed *L*'s of the Sèvres manufactory flanked by the date letters AA in gold for 1778, all under a crown for hard paste; each vase is also painted underneath with Chauveaux's mark *IN* in gold; one has an abraded F, perhaps for the painter Fallot.

Height: 11 5/8 in. (29.5 cm); Width: 7 in. (17.9 cm); Depth: 4 3/4 in. (12 cm)
Accession number 70.DE.99.1–.2

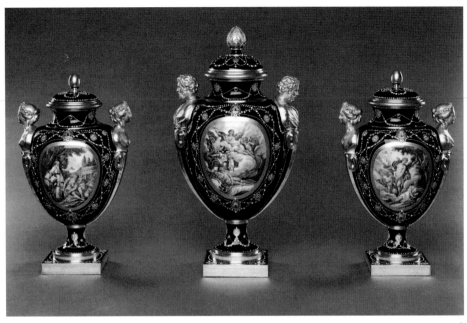

248

248.
GARNITURE OF THREE VASES (*VASES DES ÂGES:
VASE DES ÂGES À TÊTES DE VIEILLARDS, PREMIÈRE
GRANDEUR; VASES DES ÂGES À TÊTES DE JEUNES
FEMMES, DEUXIÈME GRANDEUR*)

Sèvres manufactory, 1781
After designs by Jacques François Deparis,
at least one vase modeled by Etienne-Henry
Bono, painted by Antoine Caton after
engravings by Jean-Baptiste Tilliard; enamel
jeweling by Philippe Parpette and gilding
by Etienne-Henri Le Guay *père*
Soft-paste porcelain, *beau bleu* ground color,
polychrome enamel decoration, opaque and
translucent enamels in imitation of jewels,
gilding, and gold foils
Vase .1 (with the scene "Minerva protects
Telemachus and preserves him from Cupid's
darts") is incised with *I O B age 1 e g* (for
première grandeur) on the base and *.IO.B* on
the neck.
Vase .2 (with the scene "Venus, in order to
satisfy her resentment against Telemachus,
brings Love to Calypso") is painted under-

neath with the gold crossed L's of the Sèvres
manufactory and with LG, the gilder's mark;
it is incised with *39 A* on the base and *A 16*
on the neck.
Vase .3 (with the scene "Telemachus, in the
deserts of Oasis, is consoled by Temosiris,
Priest of Apollo") is painted underneath with
the gold crossed L's of the Sèvres manufac-
tory and with LG; it is incised with *age 2e g*
(for *deuxième grandeur*) on the base and *Bono*
over B on the neck.

Vase .1: Height: 1 ft. 6 1/2 in. (49.6 cm);
Width: 10 7/8 in. (27.7 cm); Depth: 7 5/8 in.
(19.3 cm); Vase .2: Height: 1 ft. 4 in.
(40.8 cm); Width: 9 3/4 in. (24.8 cm);
Depth: 7 1/4 in. (18.4 cm); Vase .3: Height:
1 ft. 3 15/16 in. (40.5 cm); Width: 10 in.
(25.4 cm); Depth: 7 3/16 in. (18 cm)
Accession number 84.DE.718.1–.3

PROVENANCE
Louis XVI, in the *bibliothèque* at the Château
de Versailles, November 2, 1781; Alfred
(Charles) de Rothschild (1842–1918), Hal-
ton, Buckinghamshire; Lionel (Nathan) de
Rothschild (1882–1942), Exbury, Hamp-
shire; by descent to Edmund (Leopold) de
Rothschild (born 1916), Exbury, Hampshire,
1942 (sold, Christie's, London, July 4, 1946,
lot 89, for £1,575 to [Frank Partridge]); [The
Antique Porcelain Co., London, by 1951].

BIBLIOGRAPHY
Pierre Verlet, "Orders for Sèvres from the
French Court," *Burlington Magazine* 96 (July
1954), pp. 202–206; Adrian Sassoon, "Vin-
cennes and Sèvres Porcelain Acquired by the
J. Paul Getty Museum in 1984," *GettyMusJ* 13
(1985), no. 4, pp. 98–104, figs. 22–23, 25–
33; "Acquisitions/1984," *GettyMusJ* 13 (1985),
no. 64, p. 182, illus.; Geoffrey de Bellaigue,
*Sèvres Porcelain in the Collection of Her Majesty the
Queen: The Louis XVI Service* (Cambridge, 1985),
p. 12, fig. 8, and p. 24, no. 2; Svend Eriksen
and Geoffrey de Bellaigue, *Sèvres Porcelain:
Vincennes and Sèvres 1740–1800* (London and
Boston, 1987), p. 139, no. 147, p. 339, illus.
p. 338; Savill, *Sèvres*, vol. 1, p. 458; note 25,
p. 462, and vol. 3, pp. 1016 and 1056;
note 16, p. 1017; note 10, p. 1057; Sassoon,
Vincennes and Sèvres Porcelain, no. 25, pp. 126–
135, illus. pp. 127–134; Gillian Wilson,
"Dalla Raccolta del Museo J. Paul Getty,"
Part 3, *Casa Vogue Antiques* 10 (Novem-
ber 1990), pp. 90–95, illus. p. 92; Bremer-
David, *Summary*, no. 237, pp. 142–143, illus.
p. 143; *Masterpieces*, no. 88, p. 111; *Handbook
2001*, p. 226, illus.

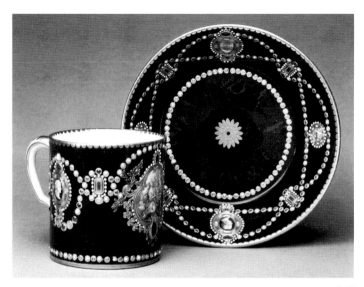

249

249.

CUP AND SAUCER (*GOBELET LITRON ET SOUCOUPE*)

Sèvres manufactory, 1781

Ground color painted by Antoine Capelle; the painted reserve and cameos attributed to Pierre-André Le Guay; flat gilding by Etienne-Henri Le Guay; enamel jeweling by Philippe Parpette

Soft-paste porcelain, brown ground color (*merde d'oie* [?]), polychrome enamel decoration, enamels in imitation of jewels, gilding and gold foils

Cup and saucer are both painted underneath with the blue crossed L's of the Sèvres manufactory enclosing the date letters DD for 1781, and with Capelle's blue triangular mark. Saucer is also painted with the gilder Le Guay's mark LG in blue. Saucer is incised with a 44; cup is incised with 36a and 6. Saucer bears a paper label under the base inked with *Colln. of the Marchioness of Conyngham 1908. R. M. Wood Esq.*

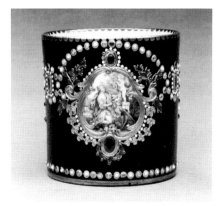

249 Cup, front view

Cup: Height: 2³/₄ in. (6.9 cm); Depth: 3¹¹/₁₆ in. (9.4 cm); Saucer: Height: 1³/₈ in. (3.6 cm); Diameter: 5⁵/₁₆ in. (13.5 cm)
Accession number 81.DE.28.a–.b

PROVENANCE

Jane, Marchioness of Conyngham (wife of the 3rd Marquess, married 1854, died 1907), London and Ascot, Berkshire (sold, Christie's, London, May 4, 1908, lot 289, to [Harding] for 162 guineas 15s); R. M. Wood, London (sold, Christie's, London, May 27, 1919, lot 96, to [Mallett's, London], for 152

guineas 12s); Henry Walters (1848–1931), New York (sold by his widow, Parke-Bernet, New York, November 30, 1943, lot 1009); private collection, New York (sold, Christie's, New York, December 3, 1977, lot 166); [Armin B. Allen, New York, 1977].

BIBLIOGRAPHY

Adrian Sassoon, "Two Acquisitions of Sèvres Porcelain," *GettyMusJ* 10 (1982), pp. 87–90, illus.; Wilson, *Selections*, no. 40, pp. 80–81, illus.; Adrian Sassoon, "Sèvres: Luxury for the Court," *Techniques of the World's Great Masters of Pottery and Ceramics*, Hugo Morley-Fletcher, ed. (Oxford, 1984), pp. 52–57, illus.; Sassoon, *Vincennes and Sèvres Porcelain*. no. 24, pp. 119–124, illus. pp. 120–121, 123, and 125; Jackson-Stops, "Boulle by the Beach," pp. 854–856; Bremer-David, *Summary*, no. 238, p. 144, illus.; Elizabeth L. Kate et al., *Themes and Foundations of Art* (St. Paul, 1995), p. 24, illus.

250.

PAIR OF VASES (*VASES BOLVRY À PERLES* or *VASES À CARTELS BOLVRY*)

Sèvres manufactory, 1781–1782

Painted by Vincent Taillandier, Mme Geneviève Taillandier, and Philippe Castel

Hard-paste porcelain, pink *fond pointillé* ground color, polychrome enamel decoration, gilding

Both vases are painted underneath with the crowned, blue crossed L's of the Sèvres manufactory enclosing the date letter ee for 1781–1782, and with the painter's mark for Vincent Taillandier, a fleur-de-lys. Vase .1 is incised with *gu* under the base.

Height: 1 ft. 4⁷/₈ in. (42.9 cm); Width: 9 in. (22.9 cm); Depth: 6⁵/₈ in. (16.8 cm)
Accession number 88.DE.137.1–.2

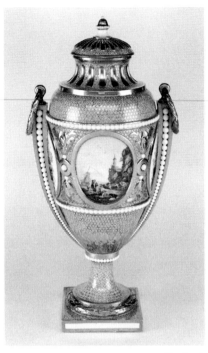

250 *One of a pair*

PROVENANCE
[Jacques Seligmann (1858–1923), Paris];
(anonymous sale, Nouveau Drouot,
Paris, June 16, 1987, no. 104); [Jean
Lupu, Paris, 1988].

BIBLIOGRAPHY
"Acquisitions/1988," *GettyMusJ* 17 (1989),
no. 76, pp. 143–144, illus.; Bremer-David,
Summary, no. 239, p. 145, illus.

251.
PLATE (*ASSIETTE D'ECHANTILLONS*)
 Sèvres manufactory, 1782
 Ground color painted by Antoine Capelle,
 flowers painted by Jacques-François-Louis
 de Laroche; gilded by Henri-Martin Pré-
 vost *jeune*
 Soft-paste porcelain, *fond Capelle* (?) ground
 color, polychrome enamel decoration, gilding
 Painted underneath with the blue crossed *L*'s
 of the Sèvres manufactory enclosing the date

letter EE for 1782, the painters' marks for
Capelle, a blue triangle, and Laroche, *Lr* in
script, and the gilder's mark, HP, in gold;
incised with *31a*.

Height: 1 in. (2.5 cm); Diameter: 9 5/16 in.
(23 cm)
Accession number 88.DE.2

PROVENANCE
[William J. Goode] (sold, Christie's, London,
July 17–18, 1895, lot 17, as "formerly the
property of the Director of the Sèvres Porce-
lain Factory," for 39 guineas to Gibson); pri-
vate collection, England; [Bernard Dragesco
and Didier Cramoisan, Paris, 1987].

BIBLIOGRAPHY
Edouard Garnier, *La Porcelaine tendre de Sèvres*
(Paris, 1889), pl. xxvi; "Acquisitions/1988,"
GettyMusJ 17 (1989), no. 77, p. 144, illus.; Sas-
soon, *Vincennes and Sèvres Porcelain*, no. 26,
pp. 136–137, illus. pp. 136–137; Bremer-David,
Summary, no. 240, p. 145, illus.

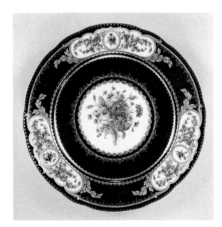

251

252 *One of a pair*

252.
PAIR OF VASES (*VASES HOLLANDOIS NOUVEAUX,
DEUXIÈME GRANDEUR* [?])
 Sèvres manufactory, 1785
 Painted by Jacques-François-Louis de
 Laroche; gilded by Antoine-Toussaint
 Cornaille
 Soft-paste porcelain, *bleu céleste* ground color,
 polychrome enamel decoration, gilding
 Each base is painted underneath with the
 blue crossed *L*'s of the Sèvres manufactory
 and Laroche's mark *Lr* in script. Base of each
 central section is incised with 25; one base
 section is incised with O.

Height: 10 in. (25.3 cm); Width: 8 7/8 in.
(22.5 cm); Depth: 6 1/4 in. (15.9 cm)
Accession number 83.DE.341.1–.2

PROVENANCE
The Rt. Hon. Lord Ashburton (?), Bucken-
ham, Norfolk (sold, Christie's, London, Feb-
ruary 24, 1869, lot 64, for 819 guineas to
Rhodes); Baronne Alexis de Goldschmidt-
Rothschild, Switzerland; [Lovice Reviczky
A. G., Zurich, 1983].

BIBLIOGRAPHY
Sassoon, "Acquisitions 1983," no. 12,
pp. 209–211, 214, illus.; "Acquisitions/1983,"
GettyMusJ 12 (1984), no. 14, p. 266, illus.;
"Some Acquisitions (1983–1984) in the
Department of Decorative Arts, the J. Paul
Getty Museum," *Burlington Magazine* 126
no. 975 (June 1984), pp. 384–388, illus.
p. 388, no. 79; Savill, *Sèvres*, vol. 1, p. 111;
note 2h, p. 116; vol. 3, note 5, p. 1040; Sas-
soon, *Vincennes and Sèvres Porcelain*, no. 27,
pp. 138–141, illus. pp. 139, 141; Bremer-
David, *Summary*, no. 241, p. 146, illus.

private collection, South America; [P. Cei
and E. Lugli, Florence]; [French and Co.,
New York, 1973]; purchased by J. Paul Getty.

BIBLIOGRAPHY
Ottomeyer and Pröschel, *Vergoldete Bronzen*,
vol. 1, p. 268, illus.; Savill, *Sèvres*, vol. 1,
note 17, p. 209; p. 476; note 51, p. 480; Sas-
soon, *Vincennes and Sèvres Porcelain*, no. 28,
pp. 142–145, illus. p. 143; Bremer-David,
Summary, no. 242, p. 146, illus.; Carolyn Sar-
gentson, *Merchants and Luxury Markets: The
Marchands Merciers of Eighteenth-Century Paris*
(Malibu, 1996), pp. 49, 182, illus. p. 51.

PROVENANCE
Baron Mayer (Amschel) de Rothschild (1818–
1874), Mentmore Towers, Buckinghamshire,
late nineteenth century; by descent to Hannah
de Rothschild (1851–1890) (Countess of
Rosebery, wife of the 5th Earl, married
1878), Mentmore Towers, Buckinghamshire;
by descent to (Albert) Harry Primrose,
6th Earl of Rosebery, Mentmore Towers,
Buckinghamshire; by descent to Neil Prim-
rose, 7th Earl of Rosebery, Mentmore Towers,
Buckinghamshire (sold, Sotheby's, London,
Mentmore Towers, May 24, 1977, lot 2090);
private collection, Los Angeles; Richard
Proudman, Los Angeles, 1987; given to the
J. Paul Getty Museum, 1996.

253 *One of a pair*

253.
PAIR OF LIDDED BOWLS (*VASES CASSOLETTES À MONTER*)
Paris and Sèvres manufactory, circa 1785
Mounts attributed to Pierre-Philippe
Thomire
Hard-paste porcelain, *bleu nouveau* ground
color; *rouge griotte* marble; gilt-bronze mounts
Height: 1 ft. 2 3/4 in. (37.5 cm); Width:
1 ft. 1 1/2 in. (34.3 cm); Depth: 10 1/4 in.
(26.1 cm)
Accession number 73.DI.77.1–.2

PROVENANCE
Mrs. H. Dupuy, New York (sold, Parke-
Bernet, New York, April 3, 1948, lot 404);

254.
FIGURE GROUP: CHARITY (*LA BIENFAISANCE*)
Sèvres manufactory, 1785
Model by Louis-Simon Boizot
Hard-paste biscuit porcelain
Incised with 13 on the base.

Height: 9 in. (23 cm); Width: 8 in. (20.3 cm);
Depth: 6 5/8 in. (16.8 cm)
Accession number 96.DE.343

254

255.
WINE BOTTLE COOLER (*SEAU À BOUTEILLE ORDINAIRE*)
Sèvres manufactory, 1790
Model designed by Jean-Claude Duplessis,
père; painted decoration attributed to Charles-
Eloi Asselin after engraved designs by Charles
Monnet and Jean-Baptiste-Marie Pierre; gild-
ing attributed to Etienne-Henri Le Guay
Soft-paste porcelain, *beau bleu* ground color,
polychrome enamel decoration, gilding
Bowl is incised with 38 underneath; foot ring
is incised with 5. Monogram WJG for the
owner William J. Goode is scratched on the
underside in two places.

Height: 7 7/16 in. (18.9 cm); Width: 10 3/16 in.
(25.8 cm)
Accession number 82.DE.5

PROVENANCE
Made for Louis XVI, ordered in 1783 for the
Château de Versailles and delivered in
December 1790; Musée National (?), Paris,
sold 1797–1798; Robert Napier, Glasgow, the
Shandon collection, by 1862 (sold, Christie's,
London, April 11, 1877, lot 347, for £262 10s
to Goode); [William J. Goode, London]

(sold, Christie's, London, July 17, 1895, lot
136, for 230 guineas to Waller); T. W.
Waller, Esq. (sold, Christie's, London, June 8,
1910, lot 171, for £630 to A. Wertheimer);
[Asher Wertheimer, London] (sold,
Christie's, London, June 16, 1920, lot 30, for
£84 to Clements); private collection (sold as
nineteenth century, Sotheby's, Begravia,
April 24, 1980, lot 162); private collection,
England (sold, Sotheby's, London, Octo-
ber 21, 1980, lot 207); [Winifred Williams,
Ltd., London, 1980].

EXHIBITIONS
London, The South Kensington Museum,
Special Loan Exhibition of Works of Art, June 1862,
no. 1323, p. 122; Leeds, England, Exhibition
Offices, *National Exhibition of Works of Art at
Leeds*, 1868, no. 2102 or 2103 under Ornamen-
tal Arts, p. 262, lent by Robert Napier;
Jackson, Mississippi, Mississippi Arts Pavil-
ion, *Splendors of Versailles*, Claire Constans
and Xavier Salmon, eds., April–August 1998,
no. 108, p. 207, illus.

BIBLIOGRAPHY
J. C. Robinson, *Catalogue of the Works of Art
Forming the Collection of Robert Napier* (London,
1865), no. 3501 or 3502, p. 260; Adrian
Sassoon, "Two Acquisitions of Sèvres Porce-
lain," *GettyMusJ* 10 (1982), pp. 91–94, illus.;
"Some Acquisitions (1981–82) in the Depart-
ment of Decorative Arts, The J. Paul Getty
Museum," *Burlington Magazine* 125, no. 962
(May 1983), illus. p. 323; Wilson, *Selections*,

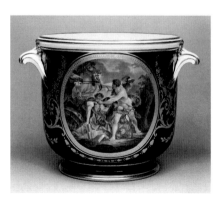

255

no. 48, pp. 96–97, illus.; Geoffrey de
Bellaigue, *Sèvres Porcelain in the Collection of Her
Majesty the Queen: The Louis XVI Service* (Cam-
bridge, 1986), no. 149, pp. 45, 52, 56, 259,
illus. p. 28, fig. 19, p. 222, figs. 1–2; Sassoon,
Vincennes and Sèvres Porcelain, no. 29, pp. 146–
150, illus. pp. 147, 149, 151; Bremer-David,
Summary, no. 243, p. 147, illus; *Handbook 1997*,
p 233, illus.

256.
PAIR OF WINE BOTTLE COOLERS (SEAUX À
DEMI-BOUTEILLES ORDINAIRES)
Sèvres manufactory, 1791
Model designed by Jean-Claude Duplessis,
père; gilded by Jean-Jacques Dieu
Hard-paste porcelain, black ground color,
platinum and gold decoration
Each cooler is painted underneath with the
gold crossed *L*'s of the Sèvres manufactory
and the date letters OO in gold for 1791–
1792, all under a crown for hard paste; each
cooler is also painted with Dieu's triangular
mark (abraded on one). One is incised
with the *répareur*'s mark AB; the other is
incised with BS.

Height: 6 7/16 in. (16.3 cm); Width: 9 3/16 in.
(23.4 cm); Depth: 7 5/16 in. (18.6 cm)
Accession number 72.DE.53.1–.2

PROVENANCE
[Dalva Brothers, Inc., New York, 1972]; pur-
chased by J. Paul Getty.

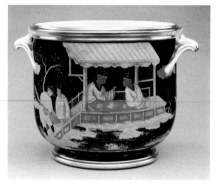

256 *Cooler .1*

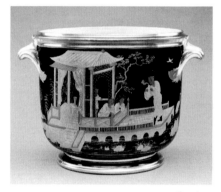

256 *Cooler .2*

EXHIBITIONS
New York, The Cooper-Hewitt Museum,
Wine: Celebration and Ceremony, June–October
1985, p. 97, illus. (one).

BIBLIOGRAPHY
Fredericksen et al., *Getty Museum*, p. 184,
illus.; Wilson, *Selections*, no. 49, pp. 98–99,
illus.; Sassoon, *Vincennes and Sèvres Porcelain*,
no. 30, pp. 152–156, illus. pp. 153, 155, 157;
Bremer-David, *Summary*, no. 244, pp. 147–
148, illus.

Mounted Oriental Porcelain

257.

Teapot (THÉIÈRE LITRON)

Sèvres maufactory, late eighteenth century, painted decoration later
Soft-paste porcelain, carmine red enamel decoration, gilding
Painted underneath with the blue crossed L's of the Sèvres manufactory. Incised with 26 and 48.

Height: 3 7/16 in. (8.8 cm); Width: 4 11/16 in. (11.9 cm); Depth: 2 11/16 in. (6.8 cm)
Accession number 79.DE.63.a–.b

PROVENANCE

Mrs. John W. Christner, Dallas (sold, Christie's, New York, June 9, 1979, lot 204).

BIBLIOGRAPHY

Wilson, "Acquisitions 1979 to mid-1980," item D, p. 19, illus.; Sassoon, *Vincennnes and Sèvres Porcelain*, no. 31, pp. 158–160, illus. pp. 159, 161; Bremer-David, *Summary*, no. 245, p. 148, illus.

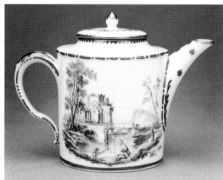

257

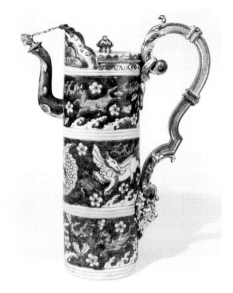

258

258.

Ewer

Porcelain: Chinese, Kangxi reign (1662–1722)
Mounts: Paris, circa 1700–1710
Hard-paste porcelain, polychrome enamel decoration; gilt-bronze mounts
Height: 1 ft. 6 1/8 in. (46.1 cm); Width: 1 ft. 1 7/8 in. (35.2 cm); Depth: 5 3/8 in. (13.8 cm)
Accession number 82.DI.3

PROVENANCE

Edward R. Bacon, New York, by 1919; [Gaston Bensimon, Paris] (sold, Hôtel Drouot, Paris, November 18–19, 1981, no. 103).

BIBLIOGRAPHY

John Getz, *Catalogue of Chinese Art Objects, Including Porcelains, Potteries, Jades, Bronzes, and Cloisonné Enamels, Collected by Edward R. Bacon* (New York, 1919), no. 65, p. 31, pl. XII; Wilson, "Acquisitions 1981," no. 6, pp. 85–86, illus.; "Some Acquisitions (1981–82) in the Department of Decorative Arts, The J. Paul Getty Museum," *Burlington Magazine* 125, no. 962 (May 1983), illus. p. 323; Bremer-David, *Summary*, no. 246, pp. 148–149, illus. p. 148; Wilson, *Mounted Oriental Porcelain*, no. 2, pp. 26–29, illus.; *Handbook* 2001, p. 192, illus.

259.

Pair of Lidded Jars

Porcelain: Chinese, Kangxi reign (1662–1722)
Mounts: Paris, circa 1710–1715
Hard-paste porcelain, underglaze blue and polychrome enamel decoration; gilt-bronze mounts
Height: 1 ft. 3 3/4 in. (40 cm); Diameter: 11 in. (27.9 cm)
Accession number 72.DI.50.1–.2

PROVENANCE

M. and Mme Louis Guiraud, Paris (sold, Palais Galliera, Paris, December 10, 1971, no. 1); [Alexander and Berendt, Ltd., London, 1971]; purchased by J. Paul Getty.

EXHIBITIONS

New York, The China Institute in America, *Chinese Porcelains in European Mounts*, F. J. B. Watson, October 1980–January 1981, no. 14, p. 38, illus.

BIBLIOGRAPHY

Fredericksen et al., *Getty Museum*, pp. 145, 147, illus.; Wilson, "Meubles 'Baroques,'" p. 106, illus.; D. F. Lunsingh Scheurleer, *Chinesisches and japanisches Porzellan in europäischen Fassungen* (Braunschweig, 1980), p. 60, illus. pp. 252–253, figs. 158a–b; Bremer-David, *Summary*, no. 247, p. 149, illus.; Wilson, *Mounted Oriental Porcelain*, no. 3, pp. 30–32, illus.

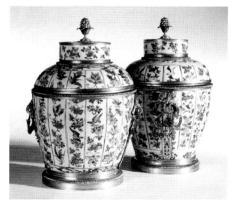

259

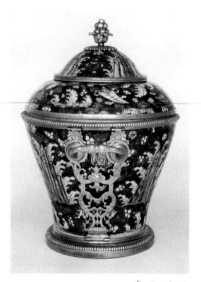

260 One of a pair

260.

PAIR OF LIDDED JARS

 Porcelain: Chinese, Kangxi reign
(1662–1722)
 Mounts: Paris, circa 1715–1720
 Hard-paste porcelain, underglaze blue and
polychrome enamel decoration; gilt-bronze
mounts.
 Mounts are stamped with the crowned C
for 1745–1749.
 Height: 1 ft. 1 1/2 in. (34.2 cm); Width:
1 ft. 3/4 in. (32.5 cm); Depth: 1 ft. 1 in.
(33 cm)
 Accession number 75.DI.5.1–.2

PROVENANCE

Bouvier collection, France, until 1938;
[Jacques Seligmann et Fils, Paris, 1938];
Mrs. Landon K. Thorne, New York, before
1940; [Matthew Schutz, Ltd., New York,
1975]; purchased by J. Paul Getty.

EXHIBITIONS

New York, The China Institute in America,
Chinese Porcelains in European Mounts, F. J. B.
Watson, October 1980–January 1981, no. 3,
p. 27, illus.

BIBLIOGRAPHY

D. F. Lunsingh Scheurleer, *Chinesisches und
japanisches Porzellan in europäischen Fassungen*
(Braunschweig, 1980), p. 59, illus., p. 250,
fig. 151; Bremer-David, *Summary*, no. 248,
p. 149, illus.; Wilson, *Mounted Oriental Porce-
lain*, no. 5, pp. 36–41, illus.

261.

LIDDED BOWL

 Porcelain: Japanese (Imari), circa 1700
 Mounts: Paris, circa 1717–1722
 Hard-paste porcelain, underglaze blue and
polychrome enamel decoration, gilding;
silver mounts
 Height: 11 in. (27.9 cm); Width: 1 ft. 1 3/8 in.
(34 cm); Depth: 10 7/8 in. (27.5 cm)
 Accession number 79.DI.123.a–.b

PROVENANCE

Mrs. Walter Hayes Burns (née Morgan, sister
of J. P. Morgan), North Mymms Park, Hert-
fordshire, by 1933; by inheritance to Walter
Spencer Morgan Burns, North Mymms Park,
Hertfordshire; by inheritance to Major Gen-
eral Sir George Burns, North Mymms Park
(sold, Christie's, North Mymms Park, Sep-
tember 24–26, 1979, lot 45).

EXHIBITIONS

London, 25 Park Lane, *Three French Reigns*,
February–April 1933, no. 226; New York,
The Frick Collection, *Mounted Oriental Porce-
lain*, F. J. B. Watson, December 1986–March
1987, no. 13, pp. 54–55, illus.

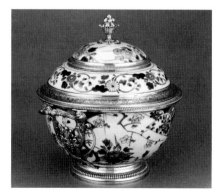

261

BIBLIOGRAPHY

Wilson, "Acquisitions 1979 to mid-1980,"
no. 5, pp. 8–9, illus.; *Handbook* 1991, p. 164,
illus.; Bremer-David, *Summary*, no. 249,
p. 150, illus.; Carolyn Sargentson, *Merchants
and Luxury Markets: The Marchands Merciers of
Eighteenth-Century Paris* (Malibu, 1996), illus.
pp. 174, pl. 12, and p. 186; Wilson, *Mounted
Oriental Porcelain*, no. 4, pp. 33–35, illus.

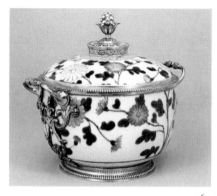

262

262.

LIDDED BOWL

 Porcelain: Japanese (Imari), early eighteenth
century
 Mounts: Paris, circa 1717–1727
 Hard-paste porcelain, underglaze blue and
enamel decoration, gilding; silver mounts
 Underside of bowl is painted with a double
circle mark in underglaze blue. Silver ele-
ments are marked variously with a fleur-de-
lys without a crown (the Paris discharge
mark for small silver works used between
October 23, 1717, and May 5, 1722); a but-
terfly (the countermark used between May 6,
1722, and September 2, 1727, under the *fermier*
Charles Cordier); a dog's head (the Paris
discharge mark for small works used between
December 22, 1732, and October 3, 1738);
and a salmon's head (the Paris discharge mark
for small silver works used between Octo-
ber 13, 1744, and October 9, 1750).
 Height: 8 3/4 in. (22.3 cm); Width: 10 5/8 in.
(27.1 cm); Depth: 8 3/8 in. (21.2 cm)
 Accession number 74.DI.27

PROVENANCE

Consuelo Vanderbilt (Mme Jacques Balsan);
[Matthew Schutz, Ltd., New York, 1974];
purchased by J. Paul Getty.

BIBLIOGRAPHY

D. F. Lunsingh Scheurleer, *Chinesisches und
japanisches Porzellan in europäischen Fassungen*
(Braunschweig, 1980), p. 114, illus., p. 403,
fig. 439; Bremer-David, *Summary*, no. 250,
p. 150, illus.; Wilson, *Mounted Oriental Porce-
lain*, no. 6, pp. 42–44, illus.

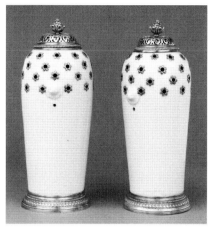

264

263.

LIDDED BOWL

Porcelain: Chinese, Kangxi reign (1662–
1722); Japanese (Arita), circa 1660
Mounts: Paris, circa 1722–1727
Hard-paste porcelain, enamel decoration,
gilding; silver mounts
Each silver mount bears a dove (the Paris
discharge mark for small silver works used
between May 6, 1722, and September 2, 1727,
under the *fermier* Charles Cordier).
Height: 8 in. (20.3 cm); Diameter: 9 7/8 in.
(25.1 cm)
Accession number 87.DI.4

PROVENANCE

[Jacques Kugel, Paris, 1986].

BIBLIOGRAPHY

"Acquisitions/1987," *GettyMusJ* 16 (1988),
no. 71, p. 178, illus.; Bremer-David, *Summary*,
no. 251, p. 151, illus.; Wilson, *Mounted Orien-
tal Porcelain*, no. 7, pp. 45–47.

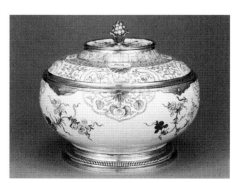

263

264.

PAIR OF LIDDED VASES

Porcelain: Chinese (Dehua), Kangxi reign
(1662–1722), circa 1700
Mounts: Paris, circa 1722–1727
Hard-paste porcelain; silver mounts
Each lid and base mount bears a dove (the
Paris discharge mark for small silver works
used between May 6, 1722, and September 2,
1727, under the *fermier* Charles Cordier); a
boar's head facing right (the Paris discharge
mark for small and old works used between
December 23, 1768, and September 1, 1775,
under the *fermier* Julien Alaterre); and the
profile head of Minerva (the mark for .800
standard silver works sold in France after
May 10, 1838).
Height: 7 5/8 in. (19.4 cm); Width: 3 3/8 in.
(8.6 cm); Depth: 3 in. (7.7 cm)
Accession number 91.DI.103.1–.2

PROVENANCE

Gift of Mme Simone Steinitz, Paris, 1991.

BIBLIOGRAPHY

"Acquisitions/1991," *GettyMusJ* 20 (1992),
no. 75, p. 174, illus. (one); Bremer-David,
Summary, no. 252, p. 151, illus.; Wilson,
Mounted Oriental Porcelain, no. 8, pp. 48–51.

265.

BOWL ON STAND

Bowl and Stand: Japanese (Imari), early
eighteenth century
Mounts: French, circa 1740
Hard-paste porcelain, underglaze blue and
enamel decoration, gilding; gilt-bronze mounts
Bowl is painted with an unidentified coat
of arms.
Height: 7 1/8 in. (18.7 cm); Diameter: 7 13/16
in. (19.9 cm)
Accession number 74.DI.28

PROVENANCE

Anne Beddard (sold, Sotheby's, London,
June 15, 1973, lot 36); [Partridge (Fine Arts),
Ltd., London, 1973]; purchased by J. Paul
Getty.

EXHIBITIONS

New York, The China Institute in America,
Chinese Porcelains in European Mounts, F. J. B.
Watson, October 1980–January 1981, no. 9,
p. 33, illus.

BIBLIOGRAPHY

D. F. Lunsingh Scheurleer, *Chinesisches und
japanisches Porzellan in europäischen Fassungen*
(Braunschweig, 1980), illus. p. 406, fig. 451;
Bremer-David, *Summary*, no. 254, p. 152, illus.;
Wilson, *Mounted Oriental Porcelain*, no. 9,
pp. 52–53, illus.

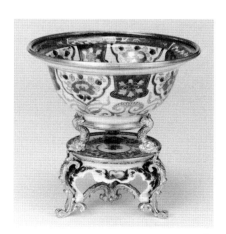

265

266.

PAIR OF DECORATIVE GROUPS

Figures, rockwork, and lions: Chinese, Kangxi reign (1662–1722)
Spheres: Chinese, Qianlong reign (1736–1795)
Flowers: Chantilly manufactory, circa 1740
Mounts: Paris, circa 1740–1745
Hard- and soft-paste porcelain, polychrome enamel decoration; gilt-bronze mounts
Height: 1 ft. (30.4 cm); Width: 9 in. (22.8 cm); Depth: 5 in. (12.7 cm)
Accession number 78.DI.4.1–.2

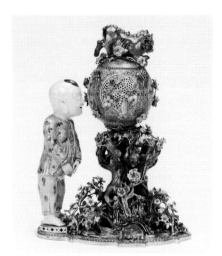

266 Group .1

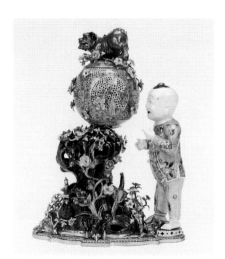

266 Group .2

PROVENANCE

H. J. King (sold, Christie's, London, February 17, 1921, lot 13, to [Duveen]); Edgar Worsch, New York, 1928; Robert Ellsworth (born 1929), New York, 1975; (sold, Robert C. Eldred Co., Inc., New York, August 29–30, 1975, lot 151); Alan Hartman, New York; [Matthew Schutz, Ltd., New York, 1977].

BIBLIOGRAPHY

Wilson, "Acquisitions 1977 to mid-1979," no. 5, pp. 40–41, illus.; F. J. B. Watson, "Rich Gets Richer," *House and Garden* 156, no. 4 (April 1984), p. 62, illus.; Deborah Silverman, *Selling Culture* (New York, 1986), illus. pp. 52–53; Bremer-David, *Summary*, no. 255, p. 152, illus.; Ann Friedman and Diane Brigham, "Art Transformed When West Meets East," *School Arts* (November 1994), pp. 25–28, pp. 26–27, illus.; Wilson, *Mounted Oriental Porcelain*, no. 10, pp. 54–57, illus.; *Handbook 2001*, p. 203, illus.

267.

PAIR OF LIDDED JARS

Porcelain: Chinese, Kangxi reign (1662–1722)
Mounts: Paris, circa 1745–1749
Hard-paste porcelain, underglaze blue and enamel decoration, gilding; gilt-bronze mounts
Mounts on vases are stamped with the crowned C for 1745–1749.
Height: 1 ft. 1/2 in. (31.8 cm); Width: 1 ft. 1/4 in. (31.2 cm); Depth: 8 1/2 in. (21.6 cm)
Accession number 72.DI.41.1–.2

PROVENANCE

Baronne Marguerite Marie van Zuylen van Nyevelt van de Haar (died 1970), Paris (sold, Palais Galliera, Paris, June 8, 1971, no. 42); [Michel Meyer, Paris]; [Rosenberg and Stiebel, Inc., New York, 1971]; purchased by J. Paul Getty.

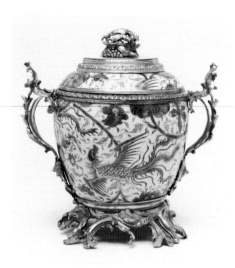

267 *One of a pair*

EXHIBITIONS

New York, The China Institute in America, *Chinese Porcelains in European Mounts*, F. J. B. Watson, October 1980–January 1981, no. 16, p. 40, illus.

BIBLIOGRAPHY

Wilson, "Meubles 'Baroques,'" p. 113, illus.; D. F. Lunsingh Scheurleer, *Chinesisches und japanisches Porzellan in europäischen Fassungen* (Braunschweig, 1980), p. 63, illus. p. 260, fig. 175; Bremer-David, *Summary*, no. 256, p. 153, illus.; Pratapaditya Pal, "Getty and Asian Art," *Orientations* (April 1998), pp. 58–63, p. 59, illus.; Wilson, *Mounted Oriental Porcelain*, no. 11, pp. 58–60, illus.

268.

PAIR OF EWERS

Porcelain: Chinese, Kangxi reign (1662–1722)
Mounts: Paris, circa 1745–1749
Hard-paste porcelain, celadon ground color, underglaze blue and copper red decoration; gilt-bronze mounts
Mounts are stamped with the crowned C for 1745–1749. Mounts of ewer .1 are also stamped with No and No 16 and painted

with B-27-a under the base in red. Mounts of
ewer .2 are stamped with No 16 and painted
with B-27-b under the base in red.
Height: 1 ft. 11 5/8 in. (60 cm); Width:
1 ft. 1 in. (33 cm); Depth: 8 1/2 in. (21.5 cm)
Accession number 78.DI.9.1–.2

PROVENANCE
Ives, comte de Cambacérès, Paris; Germaine
Ancel, Paris; [François-Gérard Seligmann,
Paris, after 1946]; [Jacques Helft, Paris, circa
1950]; [Hans Stiebel, Paris]; Henry Ford II,
Grosse Pointe Farms, Michigan (sold,
Sotheby Parke Bernet, New York, Febru-
ary 25, 1978, lot 56).

EXHIBITIONS
New York, The China Institute in America,
Chinese Porcelains in European Mounts, F. J. B.
Watson, October 1980–January 1981, no. 28,
p. 52, illus. p. 53; New York, The Frick Col-
lection, *Mounted Oriental Porcelain*, F. J. B. Wat-
son, December 1986–March 1987, no. 19,
pp. 66–67, illus.

BIBLIOGRAPHY
Wilson, "Acquisitions 1977 to mid-1979,"
no. 6, pp. 41–42, illus.; F. J. B. Watson,
"Chinese Porcelains in European Mounts,"
Orientations 12, no. 9 (September 1981),
pp. 26–33, illus. p. 29; F. J. B. Watson, "Rich
Gets Richer," *House and Garden*, vol. 156, no. 4
(April 1984), p. 58, illus.; Bremer-David,
Summary, no. 257, pp. 153–154, illus. p. 153;
Wilson, *Mounted Oriental Porcelain*, no. 12,
pp. 61–65, illus.; *Handbook* 2001, p. 201, illus.

269.
LIDDED BOWL
Porcelain: Chinese, Kangxi reign
(1662–1722)
Mounts: Paris, circa 1745–1749
Hard-paste porcelain, celadon ground color;
gilt-bronze mounts
Mounts are stamped with the crowned C for
1745–1749. Inside of bowl is incised with a
six-character Chinese reign mark of the Ming
emperor Xuande. Base is painted with the

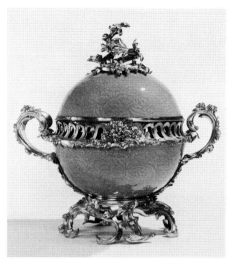

269

two characters *Tsen yu* (precious jade).
Height: 1 ft. 3 1/4 in. (40 cm); Width: 1 ft.
3 1/2 in. (39.3 cm); Depth: 11 in. (27.8 cm)
Accession number 74.DI.19

PROVENANCE
(Sold from the collection of Mme D. . . ,
Galerie Jean Charpentier, Paris, Decem-
ber 14, 1933, no. 107); Mme Henry Farman,
Paris, possibly bought at the Charpentier
December 14, 1933, sale (sold from her estate,
Palais Galliera, Paris, March 15, 1973,
no. 25); [Partridge (Fine Arts), Ltd., London,
1973]; purchased by J. Paul Getty.

EXHIBITIONS
New York, The China Institute in America,
Chinese Porcelains in European Mounts, F. J. B.
Watson, October 1980–January 1981, no. 19,
p. 42 illus.

BIBLIOGRAPHY
Wilson, "Meubles 'Baroques,'" p. 113, illus.;
Bremer-David, *Summary*, no. 258, p. 154,
illus.; Wilson, *Mounted Oriental Porcelain*,
no. 13, pp. 66–71, illus.

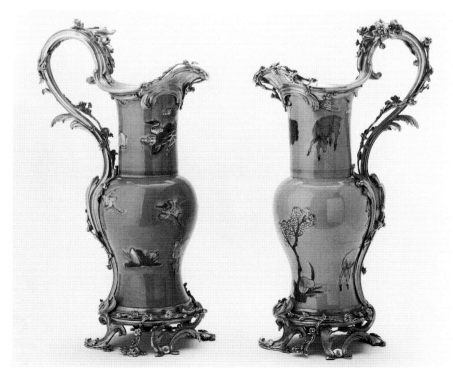

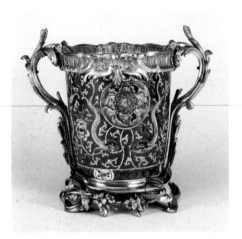

270 *One of a pair*

270.
PAIR OF VASES
Porcelain: Chinese, Kangxi reign
(1662–1722)
Mounts: Paris, circa 1745–1749
Hard-paste porcelain, polychrome enamel
decoration; gilt-bronze mounts
Mounts for each vase are stamped with the
crowned C for 1745–1749. Underside of
each vase is painted with a double circle in
underglaze blue.
Height: 1 ft. ¹/₂ in. (31.7 cm); Width:
1 ft. 2 in. (35.5 cm); Depth: 10¹/₂ in.
(26.7 cm)
Accession number 79.DI.121.1–.2

PROVENANCE
(Sold Galerie Georges Petit, Paris, Decem-
ber 20, 1932, no. 73); Mazurel family, France
(sold late 1970s); [Bernard Steinitz, Paris];
[Alexander and Berendt, Ltd., London, 1979].

EXHIBITIONS
New York, The China Institute in America,
Chinese Porcelains in European Mounts, F. J. B.
Watson, October 1980–January 1981, no. 20,
p. 44, illus. p. 45; New York, The Frick Col-
lection, *Mounted Oriental Porcelain*, F. J. B.
Watson, December 1986–March 1987, no. 18,
pp. 64–65, illus.

BIBLIOGRAPHY
Wilson, "Acquisitions 1979 to mid-1980,"
no. 6, pp. 9–10, illus.; F. J. B. Watson, "Chi-
nese Porcelains in European Mounts," *Orienta-
tions* 12, no. 9 (September 1981), pp. 26–33,
illus., p. 31; F. J. B. Watson, "Rich Gets
Richer," *House and Garden* 156, no. 4 (April
1984), p. 62, illus.; Bremer-David, *Summary*,
no. 259, p. 154, illus.; Carolyn Sargentson,
*Merchants and Luxury Markets: The Marchands
Merciers of Eighteenth-Century Paris* (Malibu,
1996), illus. p. 69; Wilson, *Mounted Oriental
Porcelain*, no. 14, pp. 72–75, illus.

271.
VASE
Porcelain: Chinese, Qianlong reign
(1736–1795), circa 1740
Mounts: Paris, circa 1745–1750
Hard-paste porcelain, celadon ground color;
gilt-bronze mounts
Height: 1 ft. 2¹/₂ in. (36.8 cm); Width: 6 in.
(15.2 cm); Depth: 4¹/₂ in. (11.5 cm)
Accession number 75.DI.69

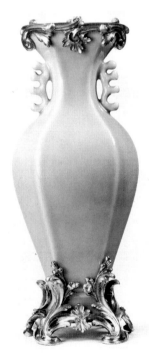

271

PROVENANCE
Trustees of Swinton Settled Estates (sold,
Christie's, London, December 4, 1975,
lot 46); purchased at that sale by J. Paul
Getty.

EXHIBITIONS
New York, The China Institute in America,
Chinese Porcelains in European Mounts, F. J. B.
Watson, October 1980–January 1981, no. 18,
p. 42, illus.

BIBLIOGRAPHY
D. F. Lunsingh Scheurleer, *Chinesisches und
japanisches Porzellan in europäischen Fassungen*
(Braunschweig, 1980), p. 94, illus. p. 330, fig.
318; Bremer-David, *Summary*, no. 260, p. 155,
illus.; Wilson, *Mounted Oriental Porcelain*, no.
15, pp. 76–79, illus.

272.
PAIR OF POT-POURRI BOWLS
Porcelain: Japanese (Arita), circa 1660–1680
Mounts: Paris, circa 1750
Hard-paste porcelain, celadon ground
color, polychrome enamel decoration; gilt-
bronze mounts
Height: 6 in. (15.2 cm); Width: 7³/₈ in.
(18.7 cm); Depth: 6¹/₂ in. (16.5 cm)
Accession number 77.DI.90.1–.2

272 *One of a pair*

PROVENANCE
Claude F. Julliot (?), Paris (sold, Paris, November 20, 1777, no. 331); [Didier Aaron and Claude Lévy, Paris, 1970s]; [Etienne Lévy, Paris, 1977].

EXHIBITIONS
New York, The Frick Collection, *Mounted Oriental Porcelain*, F. J. B. Watson, December 1986–March 1987, no. 27, pp. 82–83, illus.

BIBLIOGRAPHY
Wilson, "Acquisitions 1977 to mid-1979," no. 2, p. 37, illus.; Geneviève Mazel, "1777, La Vente Randon de Boisset et le marché de l'art au 18ᵉ s[iècle]," *L'Estampille* 202 (April 1987), p. 47, illus.; Michel Beurdeley, "Paris 1777: La Vente Randon de Boisset ou le méca-nisme secret des ventes publiques au XVIIIᵉ siècle," *Trois siècles des ventes publiques* (Fribourg, 1988), p. 53, illus.; Bruno Pons et al., *L'Art décoratif en Europe: Classique et baroque*, Alain Gru-ber, ed. (Paris, 1992), p. 400, illus.; Bremer-David, *Summary*, no. 261, p. 155, illus.; Carolyn Sargentson, *Merchants and Luxury Mar-kets: The Marchands Merciers of Eighteenth-Century Paris* (Malibu, 1996), pp. 173–174 and illus. pl. 10; Wilson, *Mounted Oriental Porcelain*, no. 16, pp. 80–84, illus.

273.
VASE
Porcelain: Chinese, Yongzheng reign (1723–1735)
Mounts: Paris, circa 1750–1755
Hard-paste porcelain, celadon ground color; gilt-bronze mounts
Height: 1 ft. 2 1/2 in. (36.9 cm); Width: 1 ft. 4 1/4 in. (41.2 cm); Depth: 11 in. (27.9 cm)
Accession number 72.DI.42

273

PROVENANCE
[Rosenberg and Stiebel, Inc., New York, 1972]; purchased by J. Paul Getty.

EXHIBITIONS
New York, The China Institute in America, *Chinese Porcelains in European Mounts*, October 1980–January 1981, no. 8, p. 32, illus.

BIBLIOGRAPHY
D. F. Lunsingh Scheurleer, *Chinesisches und japanisches Porzellan in europäischen Fassungen* (Braunschweig, 1980), p. 95, illus., p. 334, fig. 326; Bremer-David, *Summary*, no. 262, p. 156, illus.; Paul Mitchell and Lynn Rob-erts, *Frameworks: Form, Function and Ornament in European Portrait Frames* (London, 1996), fig. 174, pp. 229–230; Wilson, *Mounted Oriental Porcelain*, no. 18, pp. 88–92, illus.

274.
LIDDED POT
Porcelain: Chinese (Dehua), Kangxi reign (1662–1722)
Mounts: Paris, circa 1765–1770
Hard-paste porcelain; gilt-bronze mounts
Porcelain lid impressed with a seal mark.
Height: 9 7/8 in. (25.1 cm); Width: 7 3/8 in. (18.7 cm); Depth: 6 1/4 in. (15.9 cm)
Accession number 78.DI.359

PROVENANCE
[Kraemer et Cie, Paris, 1960s]; Henry Ford II, Grosse Pointe Farms, Michigan (sold, Sotheby Parke Bernet, New York, Febru-ary 25, 1978, lot 61); [Partridge (Fine Arts), Ltd., London, 1978].

274

PROVENANCE

Laurent Heliot, Paris (?), (sold, Hôtel Drouot, Paris, December 3, 1985, no. 55); [B. Fabre et Fils. Paris].

BIBLIOGRAPHY

Compagnie des Commissaires-Priseurs de Paris, *Drouot, 1985–1986, l'art et les enchères* (Paris, circa 1986), p. 302, illus. p. 210; "Acquisitions/1992," *GettyMusJ* 21 (1993), no. 64, p. 140, illus.; Bremer-David, *Summary*, no. 264, pp. 156–157, illus. p. 157; *Masterpieces*, no. 87, p. 110, illus.; Wilson, *Mounted Oriental Porcelain*, no. 20, pp. 96–101, illus.

EXHIBITIONS

New York, The China Institute in America, *Chinese Porcelains in European Mounts*, F. J. B. Watson, October 1980–January 1981, no. 11, p. 35. illus.

BIBLIOGRAPHY

Wilson, "Acquisitions 1977 to mid-1979," no. 9, pp. 45–46, illus.; F. J. B. Watson, "Chinese Porcelains in European Mounts," *Orientations* 2, no. 9 (September 1981), p. 30, illus.; Bremer-David, *Summary*, no. 263, p. 156, illus.; Wilson, *Mounted Oriental Porcelain*, no. 19, pp. 93–95, illus.

275.
PAIR OF VASES

Porcelain: Chinese, Kangxi reign (1662–1722)
Mounts: Paris, circa 1770–1775
Hard-paste porcelain, black ground color, gilding; gilt-bronze mounts
Vase .1 bears a paper label (torn) underneath reading HELIOT FILS. eIII..... Vase .2 is stamped once with LH on the base mount.
Height: 1 ft. 7 1/4 in. (49 cm); Width: 9 3/4 in. (24.7 cm); Depth: 7 7/8 in. (20 cm)
Accession number 92.DI.19.1–.2

276.
VASE

Porcelain: Chinese, Kangxi reign (1622–1722)
Mounts: Paris, circa 1770
Mounts attributed to Pierre Gouthière
Hard-paste porcelain, purple ground color; gilt-bronze mounts
Height: 1 ft. 9 1/4 in. (54.2 cm); Width: 10 5/8 in. (27 cm); Depth: 9 7/8 in. (25 cm)
Accession number 87.DI.137

PROVENANCE

[Michel Meyer, Paris, 1987].

275

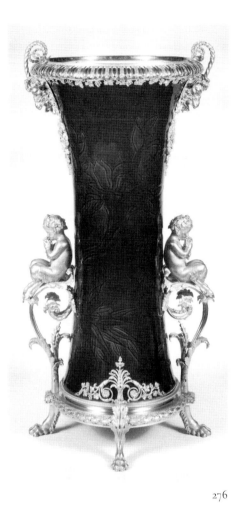

276

BIBLIOGRAPHY
"Acquisitions/1987," *GettyMus J* 16 (1988), no. 74, pp. 178–179, illus.; Bremer-David, *Summary*, no. 265, p. 157, illus.; Wilson, *Mounted Oriental Porcelain*, no. 22, pp. 106–109.

277.

STANDING BOWL

Porcelain: Chinese, Qianlong reign (1736–1795), mid-eighteenth century
Mounts: Paris, circa 1785
Mounts attributed to Pierre-Philippe Thomire
Hard-paste porcelain, blue ground color; gilt-bronze mounts; *rouge griotte* marble
Bowl is painted underneath with an indistinct date 178(?).
Height: 2 ft. 7³/₄ in. (81 cm); Diameter: 1 ft. 10¹/₄ in. (56.5 cm)
Accession number 70.DI.115

PROVENANCE
Princesse Isabella Lubormirska (?), after circa 1793; by descent to Count Alfred Potocki (great-great-grandson of Princess Isabella Lubormirska), Castle Lancut, Poland, removed by him in 1944 and taken to the United States; [Rosenberg and Stiebel, Inc., New York, 1953]; purchased by J. Paul Getty, 1953.

BIBLIOGRAPHY
Dr. Józef Piotrowski, *Zamek W Łańcucie: Zwiezty Opis Dziejów I Zbiorów* (1933), illus. fig. 65; J. Paul Getty, *Collector's Choice* (London, 1955), pp. 259–260, illus. unnumbered pl.

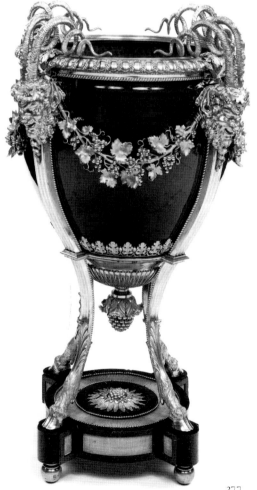

277

Mounted Hardstones and Glass

between pp. 88–89; Paul Weschler, "French Furniture of the Eighteenth Century in the J. Paul Getty Museum," *Art Quarterly* 18, no. 2 (Summer 1955), pp. 125–126, illus. p. 114; "Vingt Mille Lieues dans les musées," *Connaissance des arts* 57 (November 1956), pp. 76–81, illus. p. 76; Verlet et al., *Chefs d'oeuvre*, p. 132, illus.; Getty, *Collecting*, p. 162; Fredericksen et al., *Getty Museum*, p. 181, illus.; G. Wilson, "The J. Paul Getty Museum, 7ème partie: Le Mobilier Louis XVI," *Connaissance des arts* 280 (June 1975), p. 90, illus.; Geoffrey de Bellaigue, *Sèvres Porcelain from the Royal Collection: The Queen's Gallery* (London, 1979–1980), no. 11, pp. 31–32; D. F. Lunsingh Scheurleer, *Chinesisches und japanisches Porzellan in europäischen Fassungen* (Braunschweig, 1980), p. 86, illus. p. 308, fig. 275; Michel Beurdeley, *La France à l'encan 1789–1799* (Fribourg, 1981), p. 118, illus.; Wilson, *Selections*, no. 45, pp. 90–91, illus.; Ottomeyer and Pröschel, *Vergoldete Bronzen*, vol. 1, p. 269, illus. p. 268; Savill, *Sèvres*, vol. 1, p. 469; note 10, p. 475; *Carlton House: The Past Glories of George IV's Palace*, The Queen's Gallery, Buckingham Place (London, 1991), p. 97; Bremer-David, *Summary*, no. 266, p. 157, illus.; *Masterpieces*, no. 94, p. 119; *Handbook 1997*, pp. 228–229, illus.; Wilson, *Mounted Oriental Porcelain*, no. 21, pp. 102–105, illus.

278.
PAIR OF LIDDED VASES
Paris, circa 1700
Marble; gilt-bronze mounts
Height: 1 ft. 4 1/8 in. (41.3 cm); Width: 1 ft. 2 in. (35.6 cm); Depth: 9 1/2 in. (24.2 cm)
Accession number 93.DJ.43.1–.2

PROVENANCE

[Jacques Kugel, Paris]; (sold, Christie's, New York, November 24, 1987, lot 39); [Dalva Brothers, Inc., New York].

BIBLIOGRAPHY

"Acquisitions/1993," *GettyMusJ* 22 (1994), no. 11, p. 65, illus.

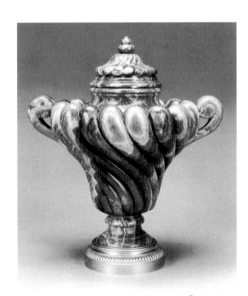

278 One of a pair

279.
PAIR OF LIDDED VASES
Paris, circa 1700
Marble
Height: 1 ft. 9 3/4 in. (55.3 cm); Width: 1 ft. 3 in. (38.1 cm); Depth: 1 ft. 1 in. (33 cm)
Accession number 95.DJ.84.1–.2

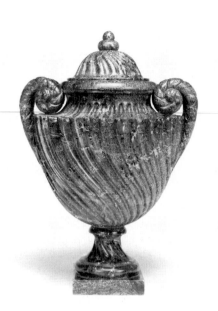

279 One of a pair

PROVENANCE

(Sold, Ader Tajan, Paris, Hôtel George V, December 15, 1993, no. 85); [Didier Aaron, Paris].

BIBLIOGRAPHY

"Acquisitions/1995," *GettyMusJ* 24 (1996), no. 11, p. 91, illus.; "Selected Acquisitions Made by the J. Paul Getty Museum, 1995–97," *Burlington Magazine* 139, no. 1136 (November 1997), p. 831, pl. 30.

280.
VASE
Stone: French (Pyrénéese)
Mounts: Paris, circa 1760
Bianco e nero antico breccia; gilt-bronze mounts
Height: 1 ft. 1/2 in. (31.7 cm); Width: 1 ft. 7 3/4 in. (50.2 cm); Depth: 11 1/8 in. (28.3 cm)
Accession number 79.DJ.183

PROVENANCE

(Sold, "Property of a Lady," Christie's, London, December 6, 1979, lot 4.)

BIBLIOGRAPHY

Wilson, "Acquisitions 1979 to mid-1980," no. 2, pp. 4–5, illus.; John Whitehead, *The French Interior in the Eighteenth Century* (London, 1992), p. 70, illus.; Bremer-David, *Summary*, no. 269, p. 159; *A Grand Design: The Art of the Victoria and Albert Museum*, Malcolm Baker and Brenda Richardson, eds. (New York, 1997), no. 84, pp. 215–216.

280

281.
PAIR OF VASES
Stone: Egyptian
Mounts: Paris (possibly Italian), circa 1765–1770
After an engraving by Benigno Bossi of a design by Ennemond-Alexandre Petitot
Porphyry, marble; gilt-bronze mounts
Height: 1 ft. 3 1/4 in. (38.7 cm); Width: 1 ft. 4 1/8 in. (41 cm); Depth: 10 7/8 in. (27.7 cm)
Accession number 83.DJ.16.1–.2

PROVENANCE

Sir Everard Joseph Radcliffe, 5th Bt. (1884–1969), Rudding Park, Yorkshire; [Lovice Reviczky A. G., Zurich, 1982].

EXHIBITIONS

Barnard Castle, County Durham, The Bowes Museum, *French Art of the Seventeenth and Eighteenth Centuries from Northern Collections*, July–August 1965, no. 37.

281 *One of a pair*

BIBLIOGRAPHY

Guide Book to Rudding Park (Yorkshire, n.d.), illus. p. 25; Wilson, "Acquisitions/1983," no. 9, pp. 199–201, illus. pp. 202–203 (one); "Acquisitions/1983," no. 11, p. 265, illus. (one); "Some Acquisitions (1983–1984) in the Department of Decorative Arts, the J. Paul Getty Museum," *Burlington Magazine* 975 (June 1984), no. 67, pp. 384–388, illus.; Alvar Gonzalez-Palacios, *Il Tempio del Gusto: Le Arti decorative in Italia fra Classicismi e barocco: Il Granducato di Toscana e gli stati settentrionali* (Milan, 1986), vol. 2, pp. 244–245, figs. 482–483, illus.; Bremer-David, *Summary*, no. 270, p. 159, illus. (one); *Masterpieces*, no. 85, p. 108, illus. (one); *Handbook 2001*, p. 217, illus. (one).

282.
VASE
Paris, circa 1770
Granite; gilt-bronze mounts
Height: 1 ft. 2 5/8 in. (37.2 cm); Width: 1 ft. 7 in. (48.2 cm); Depth: 8 1/2 in. (21.6 cm)
Accession number 89.DJ.31

PROVENANCE

Richard, 4th Marquess of Hertford (1800–1870), 2 rue Laffitte, Paris; Sir Richard Wallace (1818–1890), rue Laffitte, Paris, by inheritance; Lady Wallace (died 1897), rue Laffitte, Paris, by inheritance; Sir John Murray Scott, rue Laffitte, Paris, until 1912; Victoria, Lady Sackville, rue Laffitte, Paris, by inheritance; [Jacques Seligmann, Paris]; Baronne de Gunzburg, avenue Foch, Paris; [Maurice Segoura, Paris].

EXHIBITIONS

Paris, Petit Palais, *Exposition universelle de 1900, L'Exposition rétrospective de l'art l'histoire de l'art français des origines à 1800*, 1900, vol. 1, no. 2980, p. 300, illus. p. 188 (lent by Sir John Murray Scott).

BIBLIOGRAPHY

Émile Molinier and Frantz Marcou, *Exposition rétrospective de l'art français des origines à 1800* (Paris, 1901), illus. twice on two unnumbered pls.; *Exposition universelle de 1900, Le Mobilier à travers les âges au Grand et Petit Palais: Intérieurs XVIII^e et XIX^e siècles: Exposition centennale* (Paris, 1902), illus. no. 2, pl. 83; A. F. Morris, "Sir John Murray Scott's Collection in the Rue Lafitte," *Connoisseur* 28/18 (August 1910), pp. 231–240, illus. p. 231; *Connoisseur* 29/116 (April 1911), pp. 215–222, illus. p. 220; F. J. B. Watson, *Wallace Collection Catalogues: Furniture* (London, 1956), pl. 120; "Acquisitions/1989," *GettyMusJ* 18 (1990), no. 57, p. 195, illus.; Bremer-David, *Summary*, no. 271, pp. 159–160, illus. p. 160; Peter Hughes, *The Wallace Collection Catalogue of Furniture* (London, 1996), vol. 3, p. 1558, illus. p. 1538, fig. 1 and p. 1559, fig. 17; Pierre Kjellberg, *Objets montés du Moyen Âge à nos jours* (Paris, 2000), p. 156, illus.

282

283

283.
LIDDED BOWL
Stone: Egyptian
Mounts: Paris, circa 1770
Porphyry; gilt-bronze mounts
Height: 1 ft. 4 in. (40.6 cm); Width:
1 ft. 4 1/2 in. (41.9 cm); Depth: 9 1/2 in.
(24.1 cm)
Accession number 73.DJ.88

PROVENANCE
I. Rosenbaum, Frankfurt am Main; Merton
collection (sold, Parke-Bernet, New York,
December 5–6, 1946, lot 309); [Dalva Broth-
ers, Inc., New York, 1973]; purchased by
J. Paul Getty.

BIBLIOGRAPHY
Bremer-David, *Summary*, no. 272, p. 160, illus.

284.
PAIR OF LIDDED BOWLS
Paris, circa 1775
Glass; gilt-bronze mounts
Height: 8 7/8 in. (22.6 cm); Width: 6 1/8 in.
(15.6 cm); Diameter: 5 1/4 in. (13.3 cm)
Accession number 92.DK.1.1–.2

PROVENANCE
[Bernard Steinitz, Paris].

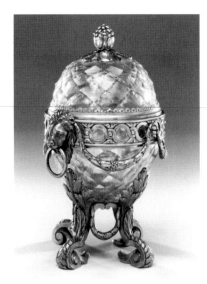

284 *One of a pair*

BIBLIOGRAPHY
"Acquisitions/1992," *GettyMusJ* 21 (1993),
no. 62, p. 139, illus.

285.
PAIR OF URNS
Stone: Egyptian
Mounts: Paris, circa 1780
Porphyry; gilt-bronze mounts

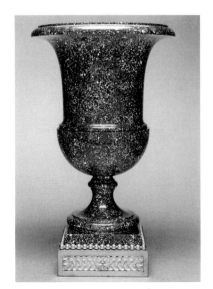

285 *One of a pair*

Height: 1 ft. 2 in. (35.6 cm); Diameter: 9 in.
(22.9 cm)
Accession number 74.DJ.24.1–.2

PROVENANCE
[Matthew Schutz, Ltd., New York, 1974];
purchased by J. Paul Getty.

BIBLIOGRAPHY
Bremer-David, *Summary*, no. 273, p. 160, illus.

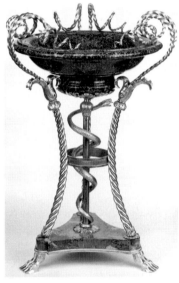

286 *One of a pair*

286.
PAIR OF STANDING TAZZAS
Paris, circa 1785
Jaune foncé marble and *brèche violette* (?); gilt-
bronze mounts
One mount, a replacement, is stamped with BY
for the *bronzier* Louis-Auguste-Alfred Beurdeley.
Height: 1 ft. 2 7/8 in. (37.8 cm); Width:
9 5/8 in. (24.3 cm); Depth: 9 7/8 in. (25.2 cm)
Accession number 74.DJ.4.1–.2

PROVENANCE
Madame la Maréchale de Lannes (?), duchesse
de Montebello (née Louise de Guéhéneuc,
died 1856), or Louis-Napoléon Lannes (?),
2nd duc de Montebello (1801–1874);

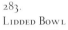

*T*EXTILES

by descent to Napoléon Lannes, 3rd duc de
Montebello (died 1876); Louis-Auguste-
Alfred Beurdeley (1808–1882), Paris; by
descent to Alfred-Emanuel-Louis Beurdeley
(1847–1919), Paris (sold, Hôtel Drouot, Paris,
May 19–20, 1899, no. 178); Lindon collection
(sold, Sotheby's, London, June 26, 1964,
lot 87; [R. L. Harrington, Ltd., London,
1967]; [Dalva Brothers, Inc., New York]; pur-
chased by J. Paul Getty.

BIBLIOGRAPHY
Bremer-David, *Summary*, no. 274, p. 160,
illus.; Peter Hughes, *The Wallace Collection:
Catalogue of Furniture* (London, 1996), vol. 3,
no. 292, p. 1405.

287.
PAIR OF VASES (*JARDINIÈRES*)
Paris, circa 1785
Brèche violette; gilt-bronze mounts; brass liners
Height: 8¼ in. (21 cm); Diameter: 7¼ in.
(18.5 cm)
Accession number 88.DJ.121.1–.2

PROVENANCE
[Mallett at Bourdon House, Ltd., London, 1988].

BIBLIOGRAPHY
"Acquisitions/1988," *GettyMusJ* 17 (1989),
no. 79, p. 144, illus.; Bremer-David, *Summary*,
no. 275, p. 161, illus.

288.
PAIR OF EMBROIDERED BED HANGINGS
(*BONNE-GRÂCES*)
Paris, circa 1680–1690
Design attributed to Daniel Marot
Linen embroidered with silk and wool;
linen lining
Height: 11 ft. 1 in. (343 cm); Width:
3 ft. 1 in. (91 cm)
Accession number 85.DD.266.1–.2

PROVENANCE
Lt. Col. A. Heywood-Lonsdale, Shavington
Hall, Salop; [Partridge (Fine Arts), Ltd.,
London, 1985].

BIBLIOGRAPHY
"Acquisitions/1985," *GettyMusJ* 14 (1986),
no. 189, p. 242, illus.; Sharon Shore et al.,
"The Technical Examination of a Pair of
Embroidered Panels," *GettyMusJ* 20 (1992),
pp. 107–112; Anne Ratzki-Kraatz, "Two
Embroidered Hangings in the Style of Daniel
Marot," *GettyMusJ* 20 (1992), pp. 89–106,
illus.; Bremer-David, *Summary*, no. 277,
pp. 161–162, illus. p. 161; Bremer-David,
French Tapestries, no. 17, pp. 164–171, illus.

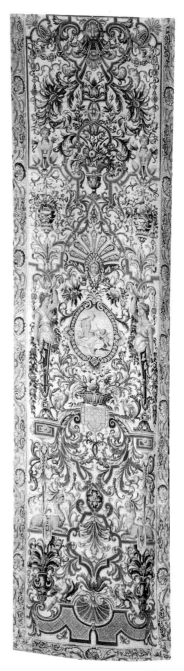

288 *One of a pair*

287 *One of a pair*

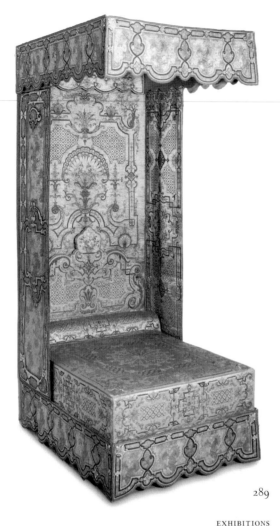

289.

290.

289.

HANGINGS FOR A BED

 French, circa 1690–1715
 Silk satin, silk lampas, silk taffeta, silk and
 metallic-wrapped silk thread; linen and bast
 backing; wool padding; paper
 Height: 13 ft. 8 1/2 in. (427.5 cm); Width:
 5 ft. 7 1/4 in. (170.8 cm); Depth: 6 ft. 8 in.
 (203.2 cm)
 Accession number 79.DD.3.1–.16

PROVENANCE

Château de Montbrian (?) (near Messimy),
Aix-en-Provence; [P. Bertrand et Cie, Paris,
1933]; [Gerald C. Paget, London and New
York, 1970s].

EXHIBITIONS

Paris, Salon des Arts Ménagers, Grand Palais,
L'Exposition rétrospective de la chambre à coucher,
Maurice Loyer, January–February 1933,
no. 129, pp. 45–47, illus.; Versailles, Château
de Versailles, Salon de la Guerre, June 1936.

BIBLIOGRAPHY

Wilson, "Acquisitions 1977 to mid-1979,"
no. 12, pp. 48–49, illus.; Anne Ratzki-
Kraatz, "A French Lit de Parade 'A la Duchesse'
1690–1715," *GettyMusJ* 14 (1986), pp. 81–104,
illus.; Bremer-David, *Summary*, no. 278,
p. 162, illus.; Bremer-David, *French Tapestries*,
no. 18, pp. 172–181, illus.

290.

GAMING PURSE

 Paris, early eighteenth century
 Velvet; silver metallic and silk embroidery
 threads
 Embroidered with the arms of the city of
 Paris.
 Height: 2 1/2 in. (6.3 cm); Diameter: 5 1/2 in.
 (14 cm)
 Accession number 97.DD.59

PROVENANCE

Gift of Kraemer et Cie, Paris, 1997.

291.

SIX PAINTED PANELS

 Paris, circa 1780
 Gouache on silk with gold paint
 One panel is painted with the monograms
 MJL and *LSX* of the comte and comtesse de
 Provence.
 Height: 4 ft. 9 in. (144.8 cm); Width: 7 in.
 (17.8 cm)
 Accession number 73.DH.89.1–.6

PROVENANCE

Made for Louis-Stanislas-Xavier and Marie-
Josephine-Louise, comte and comtesse de
Provence; (sold as part of a set of eight panels
from the "Bureaux des Bâtiments [du Roi],"
July 15, 1794 [27 *messidor, an* II], no. 16112,
for 150 *livres* to *citoyen* Bouchard; Baron Louis

291

Nathaniel von Rothschild (1882–1955) (sold, Parke-Bernet, New York, May 13, 1955, lot 165); [Dalva Brothers, Inc., New York, 1973]; purchased by J. Paul Getty.

BIBLIOGRAPHY
Wilson, *Selections*, no. 43, pp. 86–87, illus.; John Whitehead, *The French Interior in the Eighteenth Century* (London, 1992), p. 219;

Bremer-David, *Summary*, no. 279, pp. 162, illus. p. 163; Pierre Arizzoli-Clémentel, "Neoclassicisme," *L'Art décoratif en Europe du Néoclassicisme à L'Art Deco*, Alain Gruber, ed. (Paris, 1994), p. 110 (two panels illus.).

CARPETS AND SCREENS

292.
CARPET

Savonnerie manufactory, circa 1665–1667
Made in the Chaillot workshops of Simon
and Philippe Lourdet
Wool and linen; modern cotton lining
Length: 22 ft. (670.5 cm); Width:
14 ft. 5 1/4 in. (440.1 cm)
Accession number 70.DC.63

PROVENANCE

Garde Meuble de la Couronne, by 1667; Church of
Saint-André des-Arts, Paris, 1769; Parguez-
Perdreau, Paris, March 1914; [Arnold Selig-
mann, Paris, March–June 1914]; George A.
Kessler, June 1914; Mortimer L. Schiff,
New York (sold, by his heir John M. Schiff,
Christie's, London, June 22, 1938, lot 77);
purchased at that sale by J. Paul Getty.

292

BIBLIOGRAPHY

Jules Guiffrey, *Inventaire général du mobilier de la
couronne sous Louis XIV* (Paris, 1885–1886),
vol. 1, *Tapis*, no. 18 (?), p. 378; "Die Auktion
Der Kunstsammlungen Mortimer L. Schiff,"
*Pantheon, Monatsschrift für Freunde und Sammler der
Kunst* (August 1938), p. 258; J. Paul Getty,
Collector's Choice (London, 1955), p. 157; Gerald
Reitlinger, *The Economics of Taste* (New York,
1963), vol. 2, p. 308; Verlet et al., *Chefs d'oeu-
vre*, pp. 134–135, illus.; Fredericksen et al.,
Getty Museum, pp. 145, 148, illus.; Wilson,
"Meubles 'Baroques,'" p. 106, illus.; Pierre
Verlet, *The James A. de Rothschild Collection
at Waddesdon Manor: The Savonnerie* (Fribourg,
1982), p. 174; notes 5, 11, p. 421; Wilson,
Selections, no. 1, pp. 2–3, illus.; Jackson-Stops,
"Boulle by the Beach," pp. 854–856, illus.
p. 854, fig. 1; Bremer-David, *Summary*,
no. 280, p. 164, illus.; *Masterpieces*, no. 37,
p. 51, illus.; Bremer-David, *French Tapestries*,
no. 13, pp. 130–137, illus.

293.
PAIR OF THREE-PANEL SCREENS (PARAVENTS)

Savonnerie manufactory, circa 1714–1740
Made in the Chaillot workshop under
Bertrand-François Dupont or Jacques de
Noinville, woven after designs by Jean-
Baptiste Belin de Fontenay and Alexandre-
François Desportes
Wool and linen; modern velvet backing;
wooden frame
Height: 8 ft. 11 3/4 in. (273.6 cm); Width:
6 ft. 4 1/8 in. (193.2 cm); Depth: 1 1/2 in.
(3.81 cm).
Accession number 83.DD.260.1–.2

PROVENANCE

Garde Meuble de la Couronne (?), first half of the
eighteenth century; Mme d'Yvon (?), Paris
(sold, Galerie Georges Petit, Paris, May 30–
June 4, 1892, no. 673); [Jacques Seligmann,
Paris] (sold from the dissolution of the Soci-
été Seligmann, Galerie Georges Petit, Paris,
March 9–12, 1914, no. 343); [Germain Selig-
mann, Paris, from 1927]; [François-Gérard
Seligmann, Paris, before 1960] (sold, Sotheby's,
Monaco, June 14–15, 1981, no. 54); [Dalva
Brothers, Inc., New York, 1981].

EXHIBITIONS

Paris, Manufacture Nationale des Gobelins,
Tapis de la Savonnerie, December 1926–January
1927, no. 96; Paris, Bibliothèque Nationale,
Le Siècle de Louis XIV, February–April 1927,
no. 1268; Paris, Musée des Arts Décoratifs,
Louis XIV, Faste et décors, May–October 1960,
p. 155, no. 774, illus. (one) pl. 102; Rich-
mond, Virginia, *Experts' Choice: One Thousand
Years of the Art Trade*, April 22–June 12, 1983,
pp. 82–83, illus. [lent by Dalva Brothers, Inc.].

BIBLIOGRAPHY

"Les Paravents," *Connaissance des arts* 177
(November 1966), pp. 122–129, illus. p. 126;
J. W. Adams, *Decorative Folding Screens in the West
from 1600 to the Present Day* (New York, 1982),

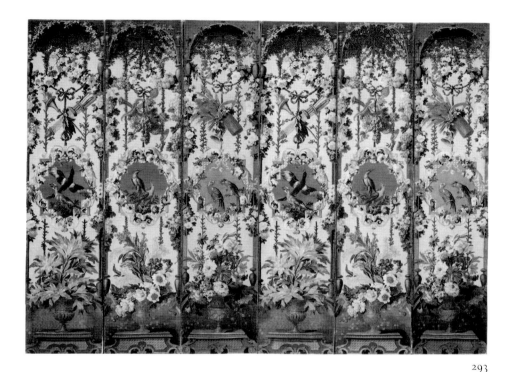

293

illus. p. 131, pl. 3; Pierre Verlet, *The James A. de Rothschild Collection at Waddesdon Manor: The Savonnerie* (Fribourg, 1982), p. 301; note 82, pp. 457–458; Wilson, "Acquisitions 1983," no. 2, pp. 180–183, illus. (one) pp. 182–183; "Acquisitions/1983," *GettyMus J* 12 (1984), no. 4, p. 262, illus. (one); "Some Acquisitions (1983–84) in the Department of Decorative Arts, the J. Paul Getty Museum," *Burlington Magazine* 126, no. 975 (June 1984), p. 385, illus.; Edith A. Standen, *European Post-Medieval Tapestries and Related Hangings in the Metropolitan Museum of Art* (New York, 1985) vol. 2, no. 112, p. 656; Catherine Hamrick, "European Folding Screens: Mirrors of an Enduring Past," *Southern Accents* (April 1990), pp. 30, 32, 34, 38, 40, illus. p. 34; John Whitehead, *The French Interior in the Eighteenth Century* (London, 1992), p. 200, illus. (one); Bremer-David, *Summary*, no. 282, p. 165, illus.; Bremer-David, *French Tapestries*, no. 15, pp. 146–153, illus.; *Masterpieces*, no. 50, pp. 68–69, illus. (one); *Handbook 2001*, p. 195, illus. (one).

294.
FOUR-PANEL SCREEN (PARAVENT)
 Savonnerie manufactory, circa 1719–1784
 Made in the Chaillot workshop under
 Jacques de Noinville, Pierre-Charles Duvivier
 or Nicolas-Cyprien Duvivier; woven after
 designs by Alexandre-François Desportes
 Wool and linen; modern cotton-twill gimp;

modern silk velvet; wooden frame; modern brass nails
Height: 6 ft. 1 in. (185.4 cm); Width: 8 ft. 4 in. (252.4 cm)
Accession number 75.DD.1

PROVENANCE
Garde-Meuble de la Couronne, eighteenth century; Earls of Caledon, Tyttenhanger Park, St. Albans, Hertfordshire, from before 1875; by descent to Denis James Alexander, 6th Earl of Caledon (born 1920), Tyttenhanger Park; [Alexander and Berendt, Ltd., London, 1973]; private collection, Australia; [Alexander and Berendt, Ltd., London, 1975]; purchased by J. Paul Getty.

BIBLIOGRAPHY
R. R. Wark, *French Decorative Art in the Huntington Collection* (San Marino, California, 1979), pp. 25–27; Pierre Verlet, *The James A. de Rothschild Collection at Waddesdon Manor: The Savonnerie* (Fribourg, 1982), no. 15, pp. 330–340, note 20, p. 467; Wilson, *Selections*, no. 12, pp. 24–25, illus.; M. Komanecky and V. F. Butera, *The Folding Image* (New Haven, 1984), p. 29, fig. 18; Edith A. Standen, *European Post-Medieval Tapestries and Related Hangings in the Metropolitan Museum of Art* (New York, 1985), vol. 2, no. 74, p. 490, and no. 111, pp. 652–654; Bremer-David, *Summary*, no. 283, p. 166, illus.; Bremer-David, *French Tapetries*, no. 16, pp. 154–161, illus.

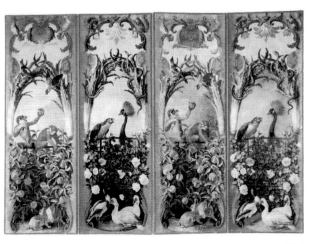

294

𝒯APESTRIES

295.

TAPESTRY, *THE OFFERING TO BACCHUS*, FROM THE *GROTESQUES* SERIES

> Beauvais manufactory, circa 1688–1732
> After a design by Jean-Baptiste Monnoyer and Guy-Louis Vernansal
> Wool (and silk?); modern cotton lining
> Height: 9 ft. 8 1/2 in. (295.3 cm); Width: 6 ft. 8 1/2 in. (204.5 cm)
> Accession number 86.DD.645

PROVENANCE

Baron A. de Rothschild, sold, London, 1929 (?); (one of four tapestries in an anonymous sale, Christie's, London, June 22, 1939, lot 159); [Frank Partridge and Sons, London, March 1949]; Mrs. John Dewar; (sold, Sotheby's, London, December 16, 1966, lot 15); (sold, Christie's, London, July 1, 1982, lot 3, to [Bernheimer Fine Arts, Ltd., London]).

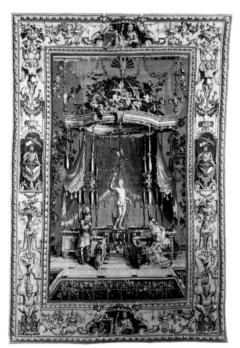

295

BIBLIOGRAPHY

Edith A. Standen, *European Post-Medieval Tapestries and Related Hangings in the Metropolitan Museum of Art* (New York, 1985), vol. 2, p. 450; David Coombs, "December 1986, From the Editor's Desk," The Antique Collector (December 1986), p. 39; "Acquisitions/ 1986," *GettyMusJ* 15 (1987), no. 99, pp. 210–211, illus.; Bremer-David, *Summary*, no. 285, p. 166, illus.; Bremer-David, *French Tapestries*, no. 8, pp. 72–79, illus.

296.

SEVEN TAPESTRIES FROM *THE STORY OF THE EMPEROR OF CHINA* SERIES

> Beauvais manufactory, circa 1697–1705
> Woven under the direction of Philippe Béhagle after designs by Guy-Louis Vernansal, Jean-Baptiste Monnoyer, and Jean-Baptiste Belin de Fontenay
> Wool and silk; modern cotton lining
> All woven with the monogram LA and with the arms of the comte de Toulouse (except 99.DD.29, which has had its arms removed).
> *The Collation:* VERNANSAL.INT.ET.PU woven at lower center of scene, in border of carpet. Height: 13 ft. 10 1/2 in. (423 cm); Width: 10 ft. 2 in. (310 cm)
> Accession number 83.DD.336
> *The Harvesting of Pineapples:* BEHAGLE woven at lower right.
> Height: 13 ft. 7 1/2 in. (415 cm); Width: 8 ft. 5 1/2 in. (258 cm)
> Accession number 83.DD.337
> *The Astronomers:* Height: 13 ft. 11 in. (424 cm); Width: 10 ft. 5 1/2 in. (319 cm)
> Accession number 83.DD.338
> *The Emperor on a Journey:* Height: 13 ft. 10 in. (421.4 cm); Width: 8 ft. 4 in. (254 cm)
> Accession number 83.DD.339
> *The Return from the Hunt:* BEHAGLE woven at lower right.
> Height: 13 ft. 10 in. (421.4 cm); Width: 9 ft. 6 in. (290 cm)
> Accession number 83.DD.340
> *The Empress's Tea:* Height: 13 ft. 9 in. (419.1 cm); Width: 6 ft. 3 in. (195 cm)
> Accession number 89.DD.62
> *The Empress Sailing:* Height: 11 ft. 9 3/4 in.

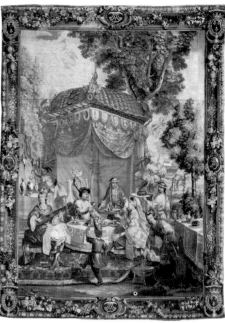

296 *The Collation*

(360 cm); Width: 10 ft. 2 in. (310 cm)
Accession number 99.DD.29

PROVENANCE

Louis-Alexandre de Bourbon, comte de Toulouse and duc de Penthièvre (1678–1737), at the Château de Rambouillet by 1718; by descent to his son, Louis-Jean-Marie de Bourbon (1725–1793), duc de Penthièvre; by descent to his only surviving child, Louise-Marie-Adélaïde de Bourbon (1753–1821); by descent to her son, Louis-Philippe d'Orléans (1773–1850), King of the French; 83.DD. 336–340 and 89.DD.62 only: (sold, Paris, January 25–27, 1852, no. 8); acquired at that sale by the duc d'Uzès and placed in the Château de Bonnelles, Seine-et-Oise; by descent to Thérèse d'Albert-Luynes d'Uzès, Château de Bonnelles, Seine-et-Oise; [Georges Haardt and Co., Inc., New York, 1925]; [French and Co., New York (stock nos. 27965–2 through 27965–6)]; John Thompson Dorrance, Sr., Newport Rhode Island; by descent to John Thompson Dorrance, Jr.; 83.DD. 336–340 only: [Rosenberg and Stiebel, Inc., New York, 1983]; 89.DD.62 only: The Preservation Society of Newport County, Château-sur-

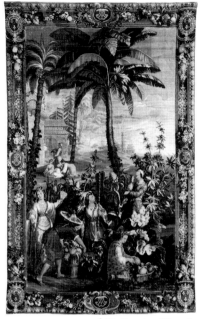

296 *The Harvesting of Pineapples*

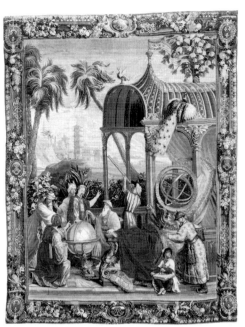

296 *The Astronomers*

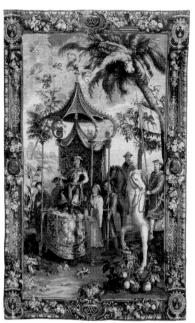

296 *The Emperor on a Journey*

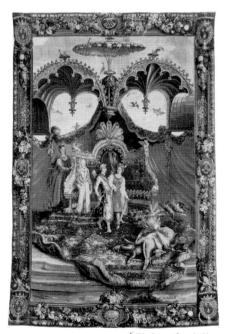

296 *The Return from the Hunt*

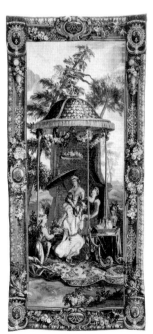

296 *The Empress's Tea*

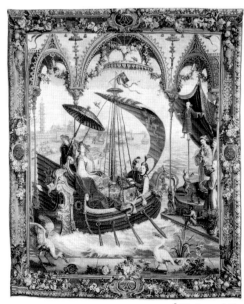

296 *The Empress Sailing*

Mer, Newport, Rhode Island, 1970s; 99.DD.29 only: (sold, Domaine de Monceaux, January 25–27, 1852, no. 13, as one of two tapestries); Baronne Miriam (Caroline) Alexandrine de Rothschild (1884–1965), France and Switzerland, confiscated by the Nazis after the German occupation of Paris in 1940 and later restituted; by descent to her nephew and heir, Baron Edmond (Adolphe Maurice Jules Jacques) de Rothschild (1926–1997) (sold, Palais Galliera, Paris, March 7, 1967, no. 152); [Galerie Achkar-Charrière, Paris, by 1990]; [Galerie Chevalier, Paris, 1998].

EXHIBITIONS

Musée des Arts Décoratifs, Paris, July 17–October 1, 1925 (lent by Georges Haardt and Co., Inc. [83.DD.336–340 and 89.DD.62]); American Art Galleries, New York, *A Private Exhibition of Beauvais Tapestries*, February 21–28, 1926, exhibited by Georges Haardt and Co., Inc. (83.DD.336–340 and 89.DD.62); The Preservation Society of Newport, Rhode Island, Château-sur-Mer, 1970s–1989 (89.DD.62 only).

BIBLIOGRAPHY

Montié and de Dion, "Quelques documents sur le Duchépairie de Rambouillet," *Mémoires et documents publiés par la Société archéologique de Rambouillet* 7 (1886), pp. 208, 227; Jules Badin, *La Manufacture de tapisseries de Beauvais depuis ses origines jusqu'à nos jours* (Paris, 1909), p. 13; George Leland Hunter, *The Practical Book of Tapestries* (Philadelphia, 1925), p. 162; Dr. Szokolny, "Vom amerikanischen Kunstmarkt," *Cicerone* 18 (1926), pp. 271–272; *Répertoire des biens spoliés en France durant la guerre 1939–1945* (Berlin, 1947), vol. 2, p. 355, no. 132, claim 32.141 (99.DD.29 only); M. Jarry, "Chinoiseries à la mode de Beauvais," *Plaisir de France* 429 (May 1975), pp. 54–59; Edith Standen, "The Story of the Emperor of China: A Beauvais Tapestry Series," *Metropolitan Museum of Art Journal* 2 (1976), pp. 103–117; M. Jarry, "La vision de la Chine dans les tapisseries de la manufacture royale de Beauvais: les premières tentures chinoises," *Les Rapports entre la Chine et l'Europe au temps des lumières: actes du II^e colloque international de sinologie 1977* (Paris, 1980), pp. 173–183; Bremer-David, "Acquisitions 1983," no. 1, pp. 173–181, illus.; "Acquisitions/1983," *GettyMusJ* 12 (1984), no. 3, pp. 261–262, illus.; "Some Acquisitions (1983–84) in the Department of Decorative Arts, the J. Paul Getty Museum," *Burlington Magazine* 126, no. 975 (June 1984), p. 385, illus.; Edith A. Standen, "The Audience of the Emperor from the series 'The Story of the Emperor of China,'" *European Post-Medieval Tapestries and Hangings in the Metropolitan Museum of Art* (New York, 1985), vol. 2, pp. 461–468; Pryce Jones, "The Golden Age of Newport," *House and Garden* (June 1987), p. 196 (89.DD.62 only); Jacqueline Boccara, "Voyages du grand siècle: Tapisseries de Beauvais, de Bruxelles et des Gobelins," *Les Antiquaires au Grand Palais: XIV^e biennale internationale* (Paris, 1988), pp. 112–118; Jacqueline Boccara, *Ames de Laine et de Soi* (Saint-Just-en-Chausée, 1988), p. 306, illus.; "Acquisitions/1989," *GettyMusJ* 18 (1990), no. 54, pp. 193–194, illus.; J. Coural and C. Gastinel-Coural, *Beauvais: Manufacture nationale de tapisserie* (Paris, 1992), p. 24; Bremer-David, *Summary*, no. 286, pp. 167, illus. p. 168; Noel Golvers, *The Astronomia European of Ferdinand Verbiest, S. J. (Dillingen, 1687) Monumenta Serica Monograph Series 27* (Nettetal, 1993), p. 9, illus., p. 453; Philip Jodidio, "Le Monastère de Brentwood," *Connaissance des arts* 511 (November 1994), p. 137, illus. p. 136; Bremer-David, *French Tapestries*, no. 9, pp. 80–97, illus.; *Masterpieces*, no. 44, p. 60, illus. (83.DD.338 only); *Handbook* 2001, p. 190, illus. (83.DD.338 only).

297.

TAPESTRY, *LE CHEVAL RAYÉ*, FROM
LES ANCIENNES INDES SERIES
Gobelins manufactory, circa 1692–1730
After a cartoon by Albert Eckhout and Frans Post and later altered by Jean-Baptiste Monnoyer, Jean-Baptiste Belin de Fontenay, René-Antoine Houasse, François Bonnemer, and Alexandre-François Desportes
Wool and silk; modern cotton lining
Woven with the arms of the Camus de Pontcarré de Viarmes de la Guibourgère family.
Height: 10 ft. 10 in. (326 cm); Width: 18 ft. 10 in. (580.2 cm)
Accession number 92.DD.21

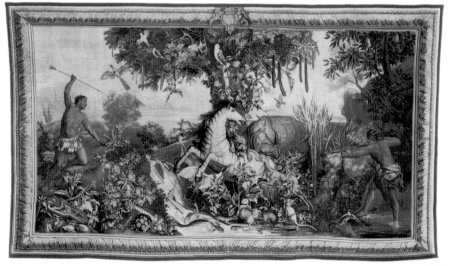

PROVENANCE

Jean-Baptiste-Elie Camus de Pontcarré (?), seigneur de Viarmes (1702–1775) and his wife Françoise-Louise Raoul de la Guibourgère; by descent to Louis-Jean-Népomucene-François-Marie Camus de la Guibourgère (1747–1794); by descent to Alexandre-Prosper Camus de la Guibourgère (1793–1853), Château de la Guibourgère, Bretagne; [French and Co., New York, circa 1930]; [Bernard Blondeel, Antwerp, Belgium, 1991].

BIBLIOGRAPHY

"Acquisitions/1992," GettyMusJ 21 (1993), no. 66, p. 141, illus.; "Museum Acquisitions in the Decorative Arts: Determination and Beneficence," Apollo 137, no. 371 (January 1993), pp. 36–37, illus.; Bremer-David, Summary, no. 287, p. 169, illus.; Charissa Bremer-David "Le Cheval Rayé: A French Tapestry Portraying Dutch Brazil," GettyMusJ 22 (1994), pp. 21–29, illus.; Christopher Scott, "Textile Experts Mend the Fabric of History," The Sun (Lowell, Mass., May 28, 1996), pp. 1, 4, illus. p. 1; Bremer-David, French Tapestries, no. 2, pp. 10–19, illus.

298.

TAPESTRY CARPET

French (Beauvais or Lille [?]) or Flemish (Brussels), circa 1690–1720
Wool and silk
Length: 12 ft. 3 3/8 in. (374.3 cm); Width: 8 ft. 2 1/4 in. (249.5 cm)
Accession number 86.DC.633

PROVENANCE

(Sold, Hôtel Drouot [?], Paris, May 27, 1910, one of four sold as nos. 131–134); [B. Fabre et Fils, Paris (?)]; Thenadey collection, Paris; [Mayorcas, Ltd., London, 1985].

298

BIBLIOGRAPHY

"Acquisitions/1986," GettyMusJ 15 (1987), no. 100, p. 211, illus.; Bremer-David, Summary, no. 288, p. 169, illus.; Bremer-David, French Tapestries, no. 10, pp. 98–105, illus.; Handbook 2001, p. 196, illus.

299.

TAPESTRY, THE MONTH OF DECEMBER, THE CHÂTEAU OF MONCEAUX, FROM LES MAISONS ROYALES SERIES

Gobelins manufactory, before 1712
The cartoon painted by François van der Meulen, Baudrain Yvart le père, Jean-Baptiste Monnoyer, Pierre (Boulle) Boëls, Guillaume Anguier, Abraham Genoëls, Jean-Baptiste Martin and others, after designs by Charles Le Brun. Woven under the direction of Jean de la Croix père
Wool and silk; linen lining
CHASTE[A]V DE MONCEAVX woven in the cartouch of lower border and the signature I.D.L. CROX woven in the lower right galon.
Height: 10 ft. 5 in. (317.5 cm); Width: 10 ft. 10 1/4 in. (330.8 cm)
Accession number 85.DD.309

PROVENANCE

Comte de Camondo, Paris (sold, Galerie Georges Petit, Paris, February 1–3, 1893, no. 291); Gaston Menier, Paris, by at least 1903 (sold after his death, Galerie Jean Charpentier, Paris, November 24, 1936, no. 111); Baron Gendebien-Salvay, Belgium; [Vincent Laloux, Brussels].

BIBLIOGRAPHY

Jules Guiffrey, Histoire de la tapisserie depuis le Moyen Âge jusqu'à nos jours (Tours, 1886), reproduced in outline p. 361; Pierre Dubois, "Ventes Prochaines-Tableaux, objets d'art et ameublement," Le Journal des arts (January 28, 1893) p. 2; "Revue des Ventes," Le Journal des arts (February 4, 1893), pp. 3–4; Maurice Fenaille, Etat général de tapisseries de la Manufacture des Gobelins, 1600–1900 (Paris, 1903), vol. 2, pp. 161–162; M. Meiss, French Painting in the Time of Jean de Berry, the Limbourgs and Their Contemporaries (New York, 1974), vol. 2, p. 206, illus. (detail) fig. 713; "La Chronique des arts: Principales acquisitions des museés en 1985," Gazette des beaux-arts 1406 (March 1986), no. 180, p. 29, illus.; Jackson-Stops, "Boulle by the Beach," pp. 854–856, illus. p. 855, fig. 3; Charissa Bremer-David, "Tapestry 'Le Château de Monceaux' from the series Les Maisons Royales," GettyMusJ 14 (1986), pp. 105–112, figs. 1a–b; "Acquisitions/1985," GettyMusJ 14 (1986), no. 192, pp. 242–243, illus.; Jacqueline Boccara, Ames de Laine et de Soie (Saint-Just-en-Chausée, 1988), p. 207, illus. p. 209; Gillian Wilson,

"Della Raccolta del Museo Paul Getty, une Selezione di pezzi acquisiti dal 1979," *Casa Vogue Antiques* 6 (November 1989), pp. 110–115, illus. p. 114; Edith A. Standen, "The Jardin des Plantes: An *Entrefenêtre* for the Maisons Royales Gobelins Tapestry Series," *Bulletin du Centre internationale d'études des textiles anciennes* 68 (1990), p. 49; illus. p. 51, fig. 4; Edith Standen, "The Garden of the Sun King: A Gobelins Tapestry in the Virginia Museum of Fine Arts," *Arts in Virginia* 30 (Fall/Winter 1992/93), p. 8, illus.; Bremer-David, *Summary*, no. 289, p. 170, illus.; Bremer-David, *French Tapestries*, no. 3, pp. 20–27, illus.; *Masterpieces*, no. 46, pp. 62–63, illus.; *Handbook* 2001, p. 194, illus.

300.

TAPESTRY, *PORTIÈRE DU CHAR DE TRIOMPHE*
Gobelins manufactory, circa 1699–1717
Woven from the cartoon by Beaudrin Yvart *le père* after a design by Charles Le Brun; woven under the direction of Jean de la Croix *père* and/or Jean de la Fraye or Jean Souet
Wool and silk; linen; modern linen lining
Woven with the arms of France and Navarre. Part of the original lining is inscribed in ink with *No. 194 Ports. Du Char, / 6: Sur 3: aus. [aunes]. de haut/ 2: au[aunes] de Cours* over *10–6 six pieces/ 8 520.*
Height: 11 ft. 8 3/4 in. (357.5 cm); Width: 9 ft. 1 3/8 in. (277.8 cm)
Accession number 83.DD.20

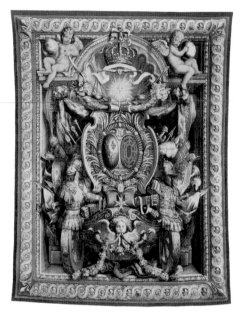

300

PROVENANCE
Delivered to the *Garde-Meuble de la Couronne* on October 27, 1717; Mme Fulco de Bourbon, Patterson, New York; by descent to her son Michael de Bourbon, Pikeville, Kentucky.

BIBLIOGRAPHY
Maurice Fenaille, *Etat général des tapisseries de la Manufacture des Gobelins* (Paris, 1903), vol. 2, pp. 16–22; Wilson, *Selections*, no. 8, pp. 16–17, illus.; Bremer-David, "Acquisitions 1983," no. 3, pp. 183, 185, 187, illus. pp. 184–185; "Acquisitions/1983," *GettyMus J* 12 (1984), no. 5, p. 263, illus.; "Some Acquisitions (1983–84) in the Department of Decorative Arts, the J. Paul Getty Museum," *Burlington Magazine* 126, no. 975 (June 1984), p. 385, illus.; Bremer-David, *Summary*, no. 290, pp. 170–171, illus. p. 171; *Handbook* 1986, p. 147, illus. (enlarged detail) p. 140; Bremer-David, *French Tapestries*, no. 1, pp. 2–9, illus.; *Masterpieces*, no. 36, pp. 50–51, illus. p. 50.

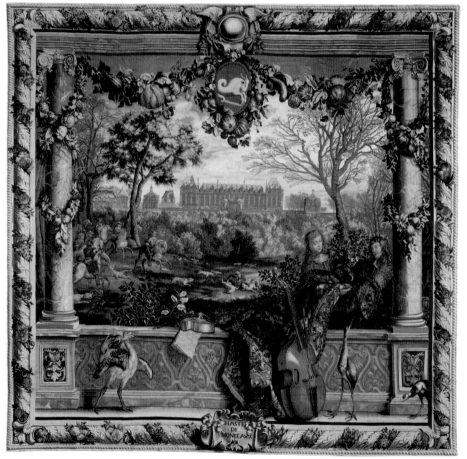

301

301.

TAPESTRY, *CHANCELLERIE*

Gobelins manufactory, circa 1728–1730
Woven after designs by Guy-Louis Vernansal
and Claude III Audran, under the direction
of Etienne-Claude Le Blond
Wool and silk; modern linen lining
Woven with the arms of France and Navarre,
with the arms of Germain-Louis Chauvelin,
a ✠, and G.LE.BLOND in lower right corner.
Height: 11 ft. 6 1/4 in. (351.5 cm); Width:
8 ft. 11 3/8 in. (272.7 cm)
Accession number 65.DD.5

PROVENANCE

Woven for Germain-Louis Chauvelin, mar-
quis de Grosbois and *Garde des Sceaux* (1685–
1762); Mortimer L. Schiff, New York (sold
by his heir John M. Schiff, Christie's, Lon-
don, June 22, 1938, lot 74); purchased at that
sale by J. Paul Getty.

BIBLIOGRAPHY

Maurice Fenaille, *Etat général des tapisseries de
la Manufacture des Gobelins, 1600–1900* (Paris,
1904), vol. 3, p. 139; Heinrich Göbel,
Wandteppiche (Leipzig, 1928), vol. 2, part 1,
pp. 172–173; J. Paul Getty, *Collector's Choice*
(London, 1955), pp. 170–171, illus. unnum-
bered pl. between pp. 176–177; Frederick-
sen et al., *Getty Museum*, p. 149, illus.; Verlet et al.,
Chefs d'oeuvre, p. 133, illus.; Edith A. Standen,
"Portière with the Chauvelin Arms," *European
Post-Medieval Tapestries and Hangings in the
Metropolitan Museum of Art* (New York, 1985),
vol. 1, pp. 361–364; Bremer-David, *Summary*,
no. 292, p. 172, illus.; Bremer-David, *French
Tapestries*, no. 4, pp. 28–33, illus.

302.

TAPESTRY, *NOUVELLE PORTIÈRE AUX
ARMES DE FRANCE*

Gobelins manufactory, circa 1730–1740
Woven from a cartoon by Pierre-Josse Perrot,
under the direction of Etienne-Claude Le
Blond
Wool and silk; modern cotton lining
Woven with the arms of France; a ✠, the
letter G, and part of an L [for Le Blond] are
woven into the *galon* of the lower right
corner.
Height: 11 ft. 10 7/8 in. (362.7 cm); Width:
9 ft. 2 1/2 in. (280.6 cm)
Accession number 85.DD.100

PROVENANCE

Richard, 4th Marquess of Hertford (1800–
1870), 2 rue Laffitte, Paris, before 1865; by
inheritance to Sir Richard Wallace (1818–
1890), rue Laffitte, Paris, before 1890; Lady
Wallace (died 1897), rue Laffitte, Paris; by
inheritance to Sir John Murray Scott, rue Laf-
fitte, Paris, 1897; Victoria, Lady Sackville,
rue Laffitte, Paris, 1912; [M. and Mme
Jacques Seligmann, Paris (sold in the late
1940s)]; private collection; [François-Gérard
Seligmann, Paris, 1953]; private collection;
[François-Gérard Seligmann, Paris, 1985].

EXHIBITIONS

Paris, Union Centrale des Beaux-Arts Appli-
qués à l'Industrie, *Musée rétrospectif*, 1865,
no. 5734; Paris, *Exposition d'art français du XVIII^e
siècle*, M. L. Roger-Miles, 1916, no. 113, p. 87,
illus.

BIBLIOGRAPHY

Maurice Fenaille, *Etat général des tapisseries de la
Manufacture des Gobelins, 1600–1900* (Paris,
1904), vol. 3, pp. 310–314; Heinrich Göbel,
Wandteppiche (Leipzig, 1928), vol. 2, part 1,
p. 156; "Acquisitions/1985," *GettyMus J* 14
(1986), no. 196, pp. 244–245, illus.; Bremer-
David, *Summary*, no. 293, p. 172, illus.; Peter
Hughes, *The Wallace Collection Catalogue of
Furniture* (London, 1996), vol. 3, p. 1530.
Bremer-David, *French Tapestries*, no. 5, pp. 34–
39, illus.; *Handbook 2001*, p. 199, illus.

302

303.

303.
TAPESTRY, *THE TOILET OF PSYCHE,* FROM
THE STORY OF PSYCHE SERIES
Beauvais manufactory, circa 1741–1742
Woven after a painting by François Boucher,
under the direction of Nicolas Besnier and
Jean-Baptiste Oudry
Wool and silk; modern cotton lining
Signature BESNIER & OVDRY–A
BEAVVAIS woven at lower right.
Height: 11 ft. 1 3/4 in. (339.7 cm); Width:
8 ft. 7 3/4 in. (263.5 cm)
Accession number 63.DD.2

PROVENANCE
Probably woven for M. d'Auriac, 1741–1742;
Sir Anthony (Nathan) de Rothschild, Bt.
(1810–1876), London; Henry Walters, Balti-
more (sold by his widow, Parke-Bernet Gal-
leries, New York, April 26, 1941, lot 739);
French and Co., New York]; purchased by J.
Paul Getty, 1941.

BIBLIOGRAPHY
Jules Badin, *La Manufacture de Tapisseries de
Beauvais depuis ses origines jusqu'à nos jours* (Paris,
1909), p. 60; J. Paul Getty, *Collector's Choice*
(London, 1955), pp. 64–65, 141, 151, illus.

unnumbered pl. between pp. 160–161;
P. Wescher, "French Furniture of the
Eighteenth Century in the J. Paul Getty
Museum," *Art Quarterly* 18, no. 2 (Summer
1955), p. 132; Madeleine Jarry, "A Wealth
of Boucher Tapestries in American Muse-
ums," *Antiques* (August 1972), pp. 222–231;
Fredericksen et al., *Getty Museum*, p. 168, illus.;
Wilson, "Meubles 'Baroques,'" p. 107, illus.
p. 106; Jackson-Stops, "Boulle by the Beach,"
pp. 854–856, illus. p. 854, fig. 1; Bremer-
David, *Summary*, no. 294, p. 173, illus.; N.
Forti-Grazzini, *Il Patrimonio artistico del Quiri-
nale: Gli Arazzi* (Rome, 1994), vol. 2, nos. 170–
173, pp. 492–511; Katie Scott, *The Rococo
Interior: Decoration and Social Spaces in Early
Eighteenth-Century Paris* (New Haven, 1995),
illus.; p. 25; Bremer-David, *French Tapestries,*
no. 11, pp. 106–119.

304.
TAPESTRY, *THE ABANDONMENT OF PSYCHE,*
FROM *THE STORY OF PSYCHE SERIES*
Beauvais manufactory, circa 1741–1742
Woven after a painting by François Boucher,
under the direction of Nicolas Besnier and
Jean-Baptiste Oudry
Wool and silk; modern cotton lining
Signature *f.Boucher* woven at lower left.
Height: 11 ft. 1 in. (337.8 cm); Width:
9 ft. 3 1/2 in. (282.2 cm)
Accession number 63.DD.3

PROVENANCE
Probably woven for M. d'Auriac, 1741–1742;
Sir Anthony (Nathan) de Rothschild, Bt.
(1810–1876), London; E. M. Hodgkins, Paris;
[French and Co., New York]; purchased by
J. Paul Getty, 1937.

BIBLIOGRAPHY
Jules Badin, *La Manufacture de tapisseries de Beau-
vais depuis ses origines jusqu'à nos jours* (Paris,
1909), p. 60; J. Paul Getty, *Europe in the Eigh-
teenth Century* (Chicago, 1949), illus. unnum-
bered pl. between pp. 66–67; J. Paul Getty,
Collector's Choice (London, 1955), pp. 64–65,
151; P. Wescher, "French Furniture of
the Eighteenth Century in the J. Paul Getty

Museum," *Art Quarterly* 18, no. 2 (Summer
1955), p. 132; Madeleine Jarry, "A Wealth of
Boucher Tapestries in American Museums,"
Antiques (August 1972), pp. 222–231; Wilson,
"Meubles 'Baroques,'" p. 107; Fredericksen
et al., *Getty Museum*, pp. 168–169, illus.;
Jackson-Stops, "Boulle by the Beach,"
pp. 854–856, illus. p. 854, fig. 1; Bremer-
David, *Summary*, no. 297, p. 174, illus.; N.
Forti-Grazzini, *Il Patrimonio artistico del Quiri-
nale: Gli Arazzi* (Rome, 1994) vol. 2, nos. 170–
173, pp. 492–511; Bremer-David, *French Tapes-
tries*, no. 11, pp. 106–119.

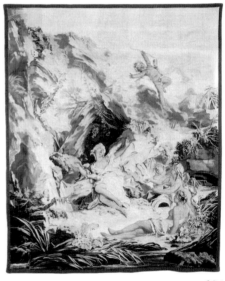

304.

305.
TAPESTRY, *PSYCHE AT CUPID'S PALACE,*
FROM *THE STORY OF PSYCHE SERIES*
Beauvais manufactory, circa 1741–1742
Woven after a painting by François Boucher,
under the direction of Nicolas Besnier and
Jean-Baptiste Oudry
Wool and silk; modern cotton lining
Height: 11 ft. 1/2 in. (336.5 cm); Width:
20 ft. 1/2 in. (610.9 cm)
Accession number 63.DD.5

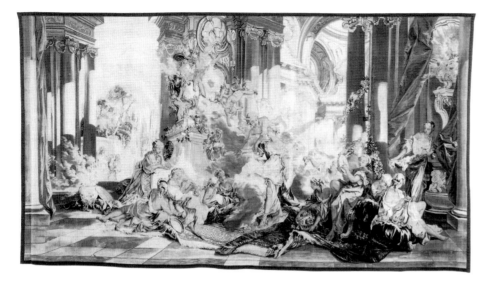

305

PROVENANCE
Probably woven for M. d'Auriac, 1741–1742;
Sir Anthony (Nathan) de Rothschild, Bt.
(1810–1876), London; E. M. Hodgkins, Paris;
[French and Co., New York]; purchased by
J. Paul Getty, 1937.

BIBLIOGRAPHY
Jules Badin, *La Manufacture de tapisseries de
Beauvais depuis ses origines jusqu'à nos jours* (Paris,
1909), p. 60; J. Paul Getty, *Europe in the Eigh-
teenth Century* (Chicago, 1949), illus. unnum-
bered pl. between pp. 66–67; J. Paul Getty,
Collector's Choice (London, 1955), pp. 64–65,
151; P. Wescher, "French Furniture of the
Eighteenth Century in the J. Paul Getty
Museum," *Art Quarterly* 18, no. 2 (Summer
1955), p. 132; Madeleine Jarry, "A Wealth of
Boucher Tapestries in American Museums,"
Antiques (August 1972), pp. 222–231; Wilson,
"Meubles 'Baroques,'" p. 107; Fredericksen
et al., *Getty Museum*, pp. 168–169, illus.; Bre-
mer-David, *Summary*, no. 299, p. 175, illus.;
N. Forti-Grazzini, *Il Patrimonio artistico del
Quirinale: Gli Arazzi* (Rome, 1994) vol. 2, nos.
170–173, pp. 492–511; Bremer-David, *French
Tapestries*, no. 11, pp. 106–119.

306.

TAPESTRY, *PSYCHE AT THE BASKETMAKERS*,
FROM *THE STORY OF PSYCHE* SERIES

Beauvais manufactory, circa 1741–1770
Woven after a painting by François Boucher,
under the direction of Nicolas Besnier and
Jean-Baptiste Oudry or André Charlemagne
Charron
Wool and silk; modern cotton lining
Signature *f.Boucher* woven at lower left and the
arms of France and Navarre at the top, center.
Height: 11 ft. 3 1/2 in. (344.1 cm); Width:
8 ft. 3 3/4 in. (253.3 cm)
Accession number 63.DD.4

PROVENANCE
Possibly one of a set of five tapestries
commissioned by Louis XV and delivered
to the *Département des Affaires Étrangères*;
Edward Cecil Guinness, 1st Earl of Iveagh
(1847–1927), London; Walter Guinness,
London; [Jacques Seligmann, Paris, by 1931];
purchased by J. Paul Getty, 1938.

BIBLIOGRAPHY
Jules Badin, *La Manufacture de tapisseries de
Beauvais depuis ses origines jusqu'à nos jours* (Paris,
1909), p. 60; J. Paul Getty, *Collector's Choice*
(London, 1955), pp. 64–65, 151, illus. unnum-
bered pl. between pp. 160–161; P. Wescher,

"French Furniture of the Eighteenth Century
in the J. Paul Getty Museum," *Art Quarterly*
18, no. 2 (Summer 1955), p. 132; Madeleine
Jarry, "A Wealth of Boucher Tapestries in
American Museums," *Antiques* (August 1972),
pp. 222–231; Wilson, "Meubles 'Baroques,'"
p. 107, illus. p. 106; Fredericksen et al., *Getty
Museum*, pp. 168–169; Geraldine C. Huss-
man, "Boucher's Psyche at the Basketmakers:
A Closer Look," *GettyMusJ* 4 (1977), pp. 45–
50; Jackson-Stops, "Boulle by the Beach,"
pp. 854–856, illus. p. 854, fig. 1; Bremer-
David, *Summary*, no. 298, p. 174, illus.; Katie
Scott, *The Rococo Interior: Decoration and Social
Spaces in Early Eighteenth-Century Paris* (New
Haven, 1995), illus. p. 25; N. Forti-Grazzini,
Il Patrimonio artistico del Quirinale: Gli Arazzi
(Rome, 1994) vol. 2, nos. 170–173, pp. 492–
511; Bremer-David, *French Tapestries*, no. 11,
pp. 106–119.

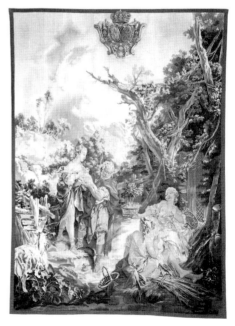

306

307.

Tapestry, Bacchus et Arianne, Bacchus changé
en raisin, from The Loves of the Gods Series
Beauvais manufactory, circa 1748–1770
Woven after cartoons by François Boucher,
under the direction of Jean-Baptiste Oudry
and Nicolas Besnier or André Charlemagne
Charron
Wool and silk; linen interface and cotton
lining
Height: 11 ft. 10 in. (360.7 cm); Width:
25 ft. ³/4 in. (764 cm)
Accession number 63.DD.6

PROVENANCE

Possibly one of a set commisioned by
Louis xv and delivered to the *Département
des Affaires Etrangères*; royal family of Portugal
(?); Jules Paul Porgès, Portugal and later
Paris; C. Ledyard Blair, New Jersey, by 1925;
[French and Co., New York, 1937]; purchased
by J. Paul Getty, 1937.

EXHIBITIONS

New York, Parke-Bernet Galleries, *French and
English Art Treasures of the United States*, December 20–30, 1942, no. 241, p. 39.

BIBLIOGRAPHY

M. Vaucaire, "Les Tapisseries de Beauvais,"
Les Arts (August 1902), p. 16, illus.; Jules
Badin, *La Manufacture de tapisseries de Beauvais
depuis ses origines jusqu'à nos jours* (Paris, 1909),
p. 61, illus.; George L. Hunter, "Beauvais-
Boucher's Tapestries," *Arts and Decoration*
(March 1919), p. 246; George L. Hunter,
The Practical Book of Tapestries (Philadelphia,
1925), p. 173; George L. Hunter, "America's
Beauvais-Boucher Tapestries," *International
Studio* (November 1926), pp. 26–28; Heinrich
Göbel, *Wandteppiche* (Leipzig, 1923), vol. 2,

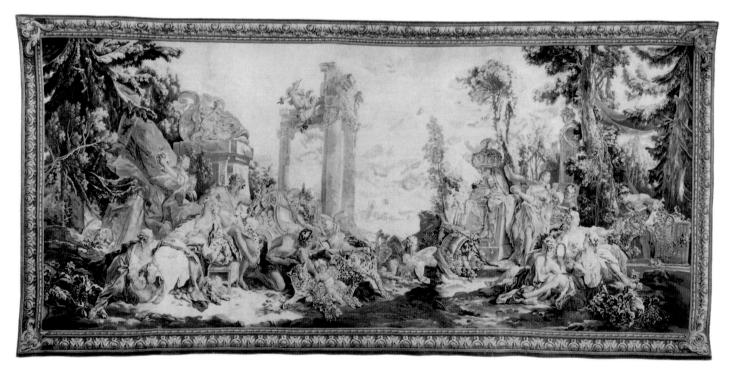

307

part 1, p. 227; J. Paul Getty, *Europe in the Eighteenth Century* (Chicago, 1949), illus. unnumbered pl. between pp. 66–67; J. Paul Getty, *Collector's Choice* (London, 1955), pp. 65–67, 151, illus. unnumbered pl. between pp. 208–209; P. Wescher, "French Furniture of the Eighteenth Century in the J. Paul Getty Museum," *Art Quarterly* 18, no. 2 (Summer 1955), p. 132, note 1; "Vingt Mille Lieues dans les musées," *Connaissance des arts* 57 (November 1956), pp. 76–81, illus. p. 81; Erik Zahle, "François Boucher's dobbelte billedavaening," *Det Danske Kunstindustrimuseum: Virksomhed* 3 (1959–1964), p. 68; Madeleine Jarry, "A Wealth of Boucher Tapestries in American Museums," *Antiques* (August 1972), p. 224, illus. p. 223, fig. 2; Fredericksen et al., *Getty Museum*, pp. 170–171, illus.; Wilson, "Meubles 'Baroques,'" p. 107; Edith A. Standen, "The Loves of the Gods," *European Post-Medieval Tapestries and Hangings in the Metropolitan Museum of Art* (New York, 1985), vol. 2, pp. 534–543; Edith Standen, "The Amours des Dieux: A Series of Beauvais Tapestries After Boucher," *Metropolitan Museum of Art Journal* 19/20 (1986), pp. 63–84, illus. p. 69; Bremer-David, *Summary*, no. 291, pp. 171–172, illus. p. 172; N. Forti-Grazzini, *Il Patrimonio artistico del Quirinale: Gli Arazzi* (Rome, 1994), vol. 2, nos. 174–177, pp. 512–530; C. J. Adelson, *European Tapestry in the Minneapolis Institute of Arts* (Minneapolis, 1994) no. 20, pp. 343–354; Bremer-David, *French Tapestries*, no. 12, pp. 120–127.

308.

FOUR TAPESTRIES FROM *THE STORY OF DON QUIXOTE* SERIES

Gobelins manufactory, 1770–1773
Central narrative panels designed by Charles-Antoine Coypel and the *alentours* designed by Jean-Baptiste Belin de Fontenay, Claude III Audran, Alexandre-François Desportes and Maurice Jacques; woven in the workshop of Michel Audran and Jean Audran
Wool and silk; modern cotton linings
DON QUIXOTTE GUERI DE SA FOLIE, PAR LA SAGES [sic]:
Signature AUDRAN woven at bottom right corner, and AUDRAN.G.1773 woven in the *galon*.
Height: 11 ft. 10 in. (361 cm); Width: 12 ft. 8 in. (386 cm)
Accession number 82.DD.66
LE REPAS DE SANCHO, DANS L'ILE DE BARATARIA: Signature AUDRAN and date 1772 woven at the bottom right corner, and AUDRAN.G✦1772 woven in the *galon*.
Height: 12 ft. 2 in. (371 cm); Width: 16 ft. 7 in. (507.5 cm)
Accession number 82.DD.67
ENTREE DE SANCHO DANS L'ILE DE BARATARIA [sic]: Signature AUDRAN woven at the bottom right corner, and AUDRAN.1772 woven in the *galon*.
Height: 12 ft. 1 in. (368 cm); Width: 13 ft. 7 in. (414 cm)
Accession number 82.DD.68
POLTRONERIE DE SANCHO A LA CHASSE [sic]: Signature AUDRAN woven in the bottom right corner, and AUDRAN.G.1772 woven in the *galon*.
Height: 12 ft. 1 in. (368 cm); Width: 13 ft. 4 in. (406 cm)
Accession number 82.DD.69

PROVENANCE
Given by Louis XVI on August 20, 1786, to Albert and Marie-Christine (sister of Marie Antoinette), Duke and Duchess of Saxe-Teschen, Joint Governors of the Austrian Netherlands; Karl Ludwig Johann Joseph Lorenz, Duke of Teschen, 1822; Albrecht Friedrich Rudolf, Duke of Teschen, 1847; Friedrick Maria Albrecht Wilhelm Karl, Duke of Teschen, Schloss Haltburn, Burgenland, Austria, 1895, and removed by him to London, 1936; Alice Bucher, Lucerne, Switzerland (offered for sale, Sotheby's, London, December 8, 1967, lot 1, bought in); [Galerie Römer, Zurich, 1981] (sold, Sotheby's, Monaco, June 14, 1982, no. 571).

BIBLIOGRAPHY
Maurice Fenaille, *Etat général des tapisseries de la Manufacture des Gobelins* (Paris, 1904), vol. 3, pp. 237 ff.; Heinrich Göbel, *Wandteppiche* (Leipzig, 1928), vol. 2, part 1, p. 163; "Aus dem kunsthandel," *Alte und Moderne Kunst* 97 (March/April 1968), no. 97, p. 55, illus.; Bremer-David, "Acquisitions 1982," no. 11, pp. 60–66, illus.; Wilson, *Selections*, no. 36, pp. 72–73, illus. (82.DD.68 only); Edith A. Standen, "The Memorable Judgment of Sancho," *European Post-Medieval Tapestries and Hangings in the Metropolitan Museum of Art* (New York, 1985), vol. 1, pp. 369–375; Jonathan Bourne and Vanessa Brett, *Lighting in the Domestic Interior: Renaissance to Art Nouveau* (London, 1991), illus. p. 114, fig. 369 (82.DD.67 only); Bremer-David, *Summary*, no. 300, p. 175, illus. p. 176; N. Forti-Grazzini, *Il Patrimonio artistico del Quirinale: Gli Arazzi* (Rome, 1994) vol. 2, nos. 143–149, pp. 392–415; Bremer-David, *French Tapestries*, no. 6, pp. 40–53, illus.; *Masterpieces*, no. 92, pp. 116–117, illus. (82.DD.68 only); *Handbook 2001*, p. 224, illus. (82.DD.67 only).

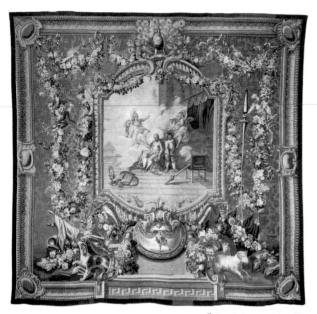

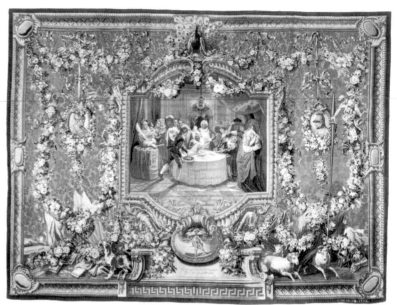

308 *Don Quixotte guéri de sa folie*

308 *Le Repas de Sancho*

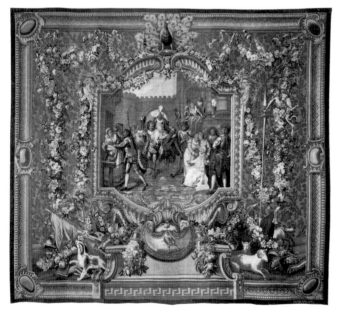

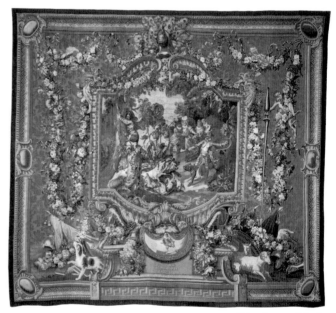

308 *L'Entrée de Sancho*

308 *La Poltronnerie de Sancho*

309.
FOUR HANGINGS FROM LES TENTURES
DE FRANÇOIS BOUCHER SERIES
Gobelins manufactory, circa 1775–1778
Central scenes after paintings by François
Boucher; *alentours* after designs by Maurice
Jacques and Louis Tessier; woven under the
direction of Jacques Neilson
Wool and silk; modern linen linings
Diana and Callisto, Vertumnus and Pomona: Sig-
nature *neilson.éx.* woven at lower right, and
f.Boucher in the medallion of *Vertumnus and
Pomona.*
Height: 12 ft. 7 7/8 in. (385.4 cm); Width:
20 ft. 7 3/4 in. (628.6 cm)
Accession number 71.DD.466
Venus on the Waters: Signature *neilson.éx.* woven
at lower right and *f.Boucher* above the date
1766 in the medallion.
Height: 12 ft. 6 7/8 in. (382.9 cm); Width:
10 ft. 4 3/4 in. (316.5 cm)
Accession number 71.DD.467
Venus and Vulcan: Signature *neilson,éx.* woven at
lower right.
Height: 12 ft. 7 1/2 in. (384.8 cm); Width:
16 ft. 3 3/4 in. (497.8 cm)
Accession number 71.DD.468
Aurora and Cephalus: Signature *neilson,éx.* woven
at lower right and *f.Boucher* in the medallion.
Height: 12 ft. 7 1/8 in. (383.5 cm); Width:
10 ft. 2 3/4 in. (311.5 cm)
Accession number 71.DD.469

PROVENANCE
Given by Louis XVI in 1782 to the Grand
Duke Paul Petrovitch (later Czar Paul I) and
Grand Duchess Maria Feodorovna of Russia;
hung at the Palace of Pavlovsk (near St. Peters-
burg) until circa 1931 (sold by the Soviet
government, 1931); [Duveen Brothers, New
York]; Norton Simon (sold, Parke-Bernet,
New York, May 8, 1971, lot 233); purchased
at that sale by J. Paul Getty.

EXHIBITIONS
Pennsylvania, The Allentown Art Museum,
Great Periods of Tapestry, February 1961
(71.DD.466 only).

BIBLIOGRAPHY
Maurice Fenaille, *Etat général des tapisseries de la
Manufacture des Gobelins* (Paris, 1907), vol. 4,
pp. 285–287, illus.; Grand Duchess Maria
Feodorovna, "Descriptions of the Grand Pal-
ace of Pavlovsk, 1795," *Les Trésors d'art en Russie*
(St. Petersburg, 1907), vol. 3, 1903, p. 375
illus., pls. 116–118, pp. 349–350; George
Leyland Hunter, *The Practical Book of Tapestries*
(Philadelphia, 1925), p. 190; Martin Conway,
Art Treasures in Soviet Russia (London, 1925),
p. 125; Phyllis Ackerman, *Tapestry: the Mirror of
Civilization* (New York, 1933), p. 277, pl. 45;
Edith Standen, "The Tapestry Room from
Croome Court," *Decorative Art from the Samuel H.
Kress Collection at the Metropolitan Museum of Art*
(London, 1964), p. 52; Madeleine Jarry, "A
Wealth of Boucher Tapestries in American
Museums," *Antiques* (August 1972), pp. 222–
231; Fredericksen et al., *Getty Museum,*
pp. 172–173, illus; Edward Fowles, *Memories of
Duveen Brothers* (London, 1976), pp. 195, 198,
illus. unnumbered pl. between pp. 104–105;
Wilson, *Selections,* no. 38, pp. 76–77, illus.;
Edith A. Standen, "Croome Court Tapes-
tries," *European Post-Medieval Tapestries and Hang-
ings in the Metropolitan Museum of Art* (New York,
1985), vol. 1, p. 397; Edith Standen, "Bou-
cher as a Tapestry Designer," *François Boucher
1703–1770* (Metropolitan Museum of Art,
New York, 1986), pp. 325–333; *Pavlosk: The
Palace and the Park,* E. Ducamp, ed. (Paris,
1993), p. 53, illus.; N. M. Verchinia, "Silks,
Tapestries, and Embroideries," *Pavlosk: The Col-
lections* (Paris, 1993), p. 120; Bremer-David,
Summary, no. 301, p. 177, illus. p. 178; Bremer-
David, *French Tapestries,* no. 7, pp. 54–69.

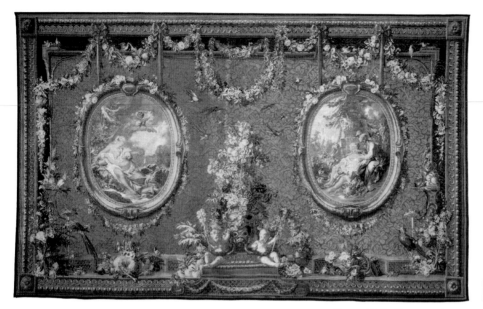

309 *Diana and Callisto, Vertumnus and Pomona*

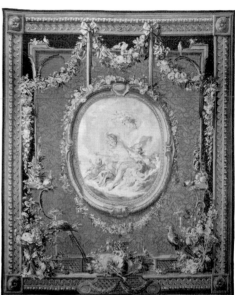

309 *Venus on the Waters*

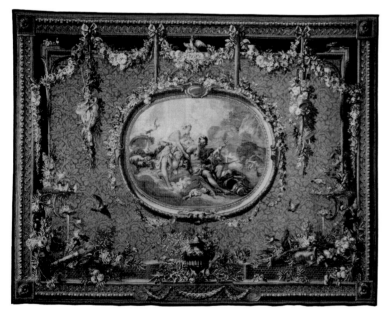

309 *Venus and Vulcan*

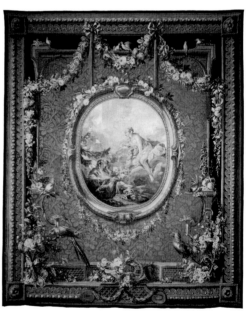

309 *Aurora and Cephalus*

Decorative Drawings

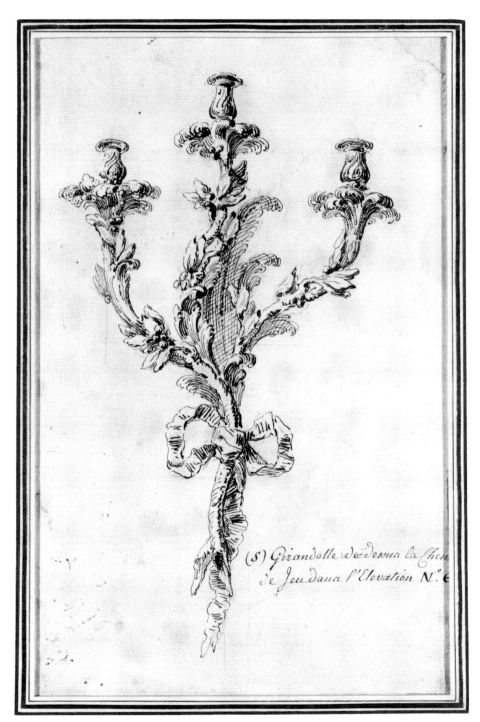

310.

Drawing for a Wall Light

Paris, circa 1760–1780
Attributed to Pierre Contant d'Ivry
Pen and ink on paper
Inscribed (recto) in ink in the lower right (S)
*Girandolle de dessus la chem[inée][...?]/ de Jeu dans
l'Elevation No. 6.…* Inscribed (verso) in graphite
Bachelier and below, in ink, *F. A. Maglin 1902.*
Inscribed in graphite on separate rectangles
glued to the reverse *lr* and *Thre Van Thulden.*
Unidentified watermark.
Height: 10 7/16 in. (26.5 cm); Width: 6 3/4 in.
(17.1 cm)
Accession number 86.GA.692

PROVENANCE
F. A. Maglin, 1902; [François-Gérard Selig-
mann, Paris].

BIBLIOGRAPHY
"Acquisitions/1986," *GettyMusJ* 15 (1987),
no. 105, p. 213, illus.; Bremer-David, *Sum-
mary,* no. 303, p. 179, illus.

311.

Drawing for a Wall Light

Paris, circa 1775
Attributed to Jean-Louis Prieur
Pen and black ink and wash on paper
Unidentified watermark.
Height: 11 3/4 in. (29.9 cm); Width: 8 1/4 in.
(20.7 cm)
Accession number 79.GA.179

PROVENANCE
Maison Odiot, Paris (sold, Sotheby's,
Monaco, November 26, 1979, no. 609).

BIBLIOGRAPHY
Wilson, "Acquisitions 1979 to mid-1980," item B, p. 12, illus.; Ottomeyer and Pröschel, *Vergoldete Bronzen*, vol. 1, pp. 173–174, fig. 3.5.3; Jonathan Bourne and Vanessa Brett, *Lighting in the Domestic Interior: Renaissance to Art Nouveau* (London, 1991), illus. p. 110, fig. 353; Bremer-David, *Summary*, no. 304, p. 180, illus.

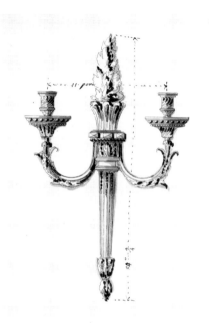

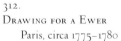

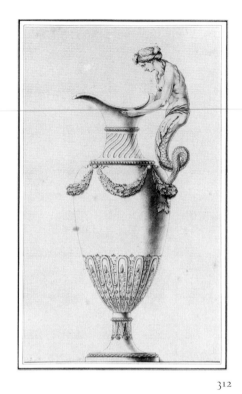

312

311

312.

DRAWING FOR A EWER
Paris, circa 1775–1780
Attributed to Robert-Joseph Auguste
Pen and brown ink and brown and gray wash on paper
Unidentified watermark.
Height: 1 ft. 3 ¹³/₁₆ in. (40.2 cm); Width: 10 ¹/₁₆ in. (25.6 cm)
Accession number 79.GA.180

PROVENANCE
Maison Odiot, Paris (sold, Sotheby's, Monaco, November 26, 1979, no. 610).

BIBLIOGRAPHY
Claude Frégnac et al., *Les Grands Orfèvres de Louis XIII à Charles X* (Collection Connaissance des arts, Paris, 1965), p. 194, illus.; Wilson, "Acquisitions 1979 to mid-1980," item B, p. 12, illus.; Savill, *Sèvres*, vol. 1, p. 469; note 7, p. 475; Bremer-David, *Summary*, no. 305, p. 180, illus.

313.

DRAWING FOR URNS AND VASES
Paris, circa 1780
Pen and black ink and gray, black, and brown wash on paper
Inscribed *Salembier* in pencil (perhaps a later attribution to Henri Salembier). Unidentified watermarks.
Height: 1 ft. 8 ¹³/₁₆ in. (52.9 cm); Width: 3 ft. 6 ¹⁵/₁₆ in. (109.5 cm)
Accession number 79.GA.178

PROVENANCE
Maison Odiot, Paris (sold, Sotheby's, Monaco, November 26, 1979, no. 584).

BIBLIOGRAPHY
Wilson, "Acquisitions 1979 to mid-1980," item A, p. 11, illus.; Bremer-David, *Summary*, no. 306, pp. 180–181, illus. p. 181.

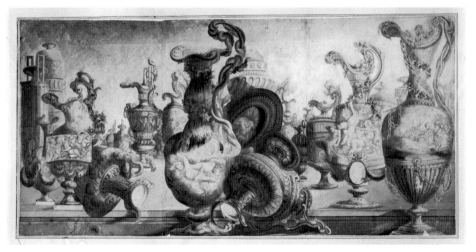

313

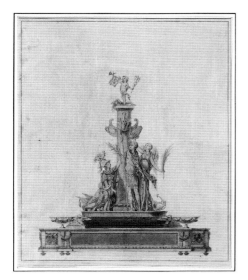

314

314.

DRAWING FOR AN INKSTAND

 Paris, circa 1780
 Attributed to Robert-Joseph Auguste
 Pen and black ink and blue and yellow wash
 on paper
 Unidentified watermark.
 Height: 1 ft. 5 $^5/_{16}$ in. (44 cm); Width:
 1 ft. 3 $^5/_{16}$ in. (38.9 cm)
 Accession number 79.GA.181

PROVENANCE

Maison Odiot, Paris (sold, Sotheby's,
Monaco, November 26, 1979, no. 612).

BIBLIOGRAPHY

Wilson, "Acquisitions 1979 to mid-1980,"
item E, p. 16, illus.; Bremer-David, *Summary*,
no. 307, p. 181, illus.

315.

DRAWING FOR A WINE COOLER

 Paris, circa 1785–1790
 Attributed to Jean-Guillaume Moitte
 Pen and black ink and gray wash on paper
 Stamped with *J.B.C.Odiot No.* at lower right
 and inked with *228.* Bears an unidentified
 watermark.
 Height: 1 ft. 2 $^7/_{16}$ in. (36.6 cm); Width:
 1 ft. $^1/_2$ in. (31.8 cm)
 Accession number 79.GA.182

PROVENANCE

Maison Odiot, Paris (sold, Sotheby's,
Monaco, November 26, 1979, no. 627).

BIBLIOGRAPHY

Wilson, "Acquisitions 1979 to mid-1980,"
item D, pp. 14–15, illus.; Bremer-David, *Summary*, no. 308, p. 182, illus.

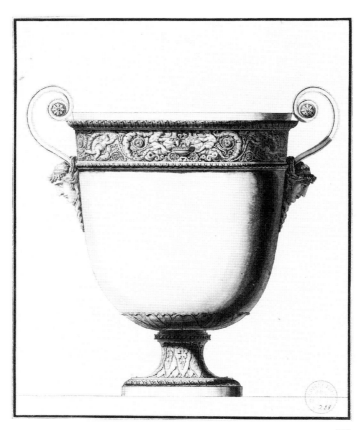

315

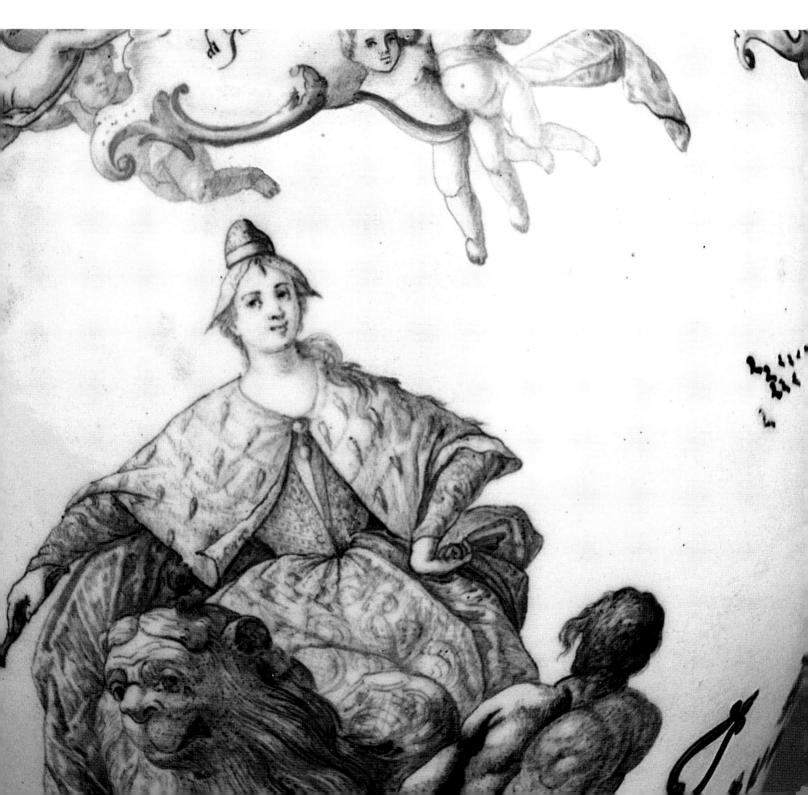

ARCHITECTURAL WOODWORK
German

316.
FLOOR
> German (?), circa 1725
> Pine veneered with kingwood, *bois satiné*,
> sycamore, tulipwood, and olive
> Length: 10 ft. 11 in. (332.7 cm);
> Width: 9 ft. 11 in. (302.2 cm)
> Accession number 78.DH.360.1–.4

PROVENANCE
The Metropolitan Museum of Art, New
York, deaccessioned, 1970; [Dalva Brothers,
Inc., New York, 1970].

BIBLIOGRAPHY
Wilson, "Acquisitions 1977 to mid-1979,"
no. 10, p. 46, illus.; Bremer-David, *Summary*,
no. 402, p. 232, illus.

CERAMICS
Austrian

317

317.
CUP AND SAUCER (*TREMBLEUSE*)
> Vienna, Du Paquier manufactory, circa 1740
> Hard-paste porcelain, black enamel decora-
> tion, gilding
> Cup: Height: 2 3/4 in. (7.1 cm); Width:
> 3 5/8 in. (9.2 cm); Depth: 2 7/16 in. (6.2 cm);
> Saucer: Height: 1 3/8 in. (3.5 cm); Width:
> 6 11/16 in. (17 cm); Depth: 4 3/4 in. (12.2 cm)
> Accession number 85.DE.375.1–.2

PROVENANCE
Sold, Christie's, London, December 5, 1983,
lot 177; [Winifred Williams, Ltd., London].

BIBLIOGRAPHY
"Acquisitions/1985," *GettyMus J* 14 (1986),
no. 181, p. 239, illus.; Bremer-David, *Sum-
mary*, no. 460, p. 262, illus.

316

Chinese

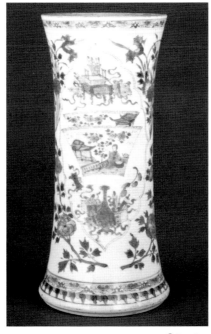

318 *One of three*

318 *One of two*

**GARNITURE OF THREE LIDDED VASES
AND TWO OPEN VASES**

Chinese, Kangxi reign (1662–1722)
Hard-paste porcelain, underglaze blue
decoration
Each vase marked underneath in underglaze
blue for the earlier Ming dynasty (Chenghua
reign, 1465–1487).
Lidded Vases: Height: 9 5/8 in. (24.4 cm);
Diameter: 7 13/16 in. (19.9 cm); Open Vases:
Height: 10 1/4 in. (26 cm); Diameter: 5 in.
(12.7 cm)
Accession number 93.DE.36.1–.5

PROVENANCE

[The Oriental Art Gallery, Ltd., London].

BIBLIOGRAPHY

"Acquisitions/1993," *GettyMusJ* 22 (1994),
no. 10, p. 65 illus.

318.
**GARNITURE OF THREE LIDDED VASES
AND TWO OPEN VASES**

Chinese, Kangxi reign (1662–1722)
Hard-paste porcelain, underglaze blue
decoration
Lidded Vases: Height: 1 ft. 1/2 in. (31.8 cm);
Diameter: 10 3/4 in. (27.3 cm); Open Vases:
Height: 11 1/8 in. (28.3 cm); Diameter: 5 in.
(12.7 cm)
Accession number 72.DE.72.1–.5

PROVENANCE

Dukes of Northumberland (probably sold
circa 1910); [Ralph Chait, New York
and London, 1970s]; [Neil Sellin, New York,
1972]; purchased by J. Paul Getty.

BIBLIOGRAPHY

Bremer-David, *Summary*, no. 490, p. 284,
illus.; Carolyn Sargentson, *Merchants and Lux-
ury Markets: The Marchands Merciers of Eighteenth-
Century Paris* (Malibu, 1996), pl. 35, p. 67.

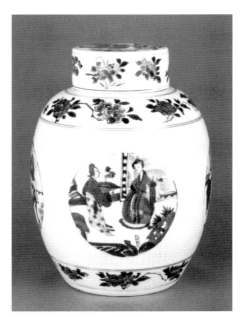

319 *One of three*

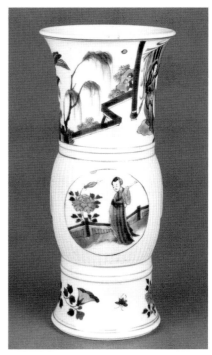

319 *One of two*

320.
LIDDED VASE
Chinese, Kangxi reign (1662–1722)
Hard-paste porcelain, polychrome enamel
decoration
Height: 11 ³/₈ in. (28.4 cm); Diameter:
9 ⁵/₈ in. (24.5 cm)
Accession number 97.DE.14

PROVENANCE
[The Oriental Art Gallery, Ltd., London,
1997]

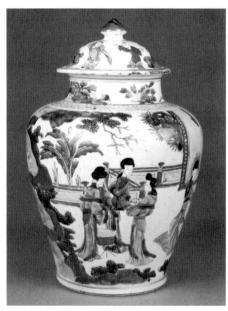

320

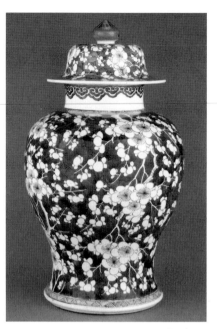

321 *One of a pair*

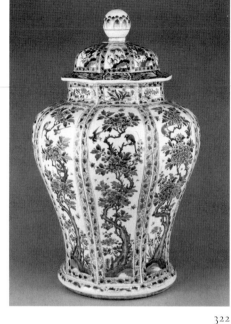

322

321.
PAIR OF LIDDED VASES
Chinese, Kangxi reign (1662–1722)
Hard-paste porcelain, underglaze blue
decoration
Height: 1 ft. 5 in. (43.2 cm); Diameter: 10 in.
(25.4 cm)
Accession number 72.DE.73.1–.2

PROVENANCE
Dukes of Northumberland (probably sold
circa 1910); [Ralph Chait, New York
and London, 1970s]; [Neil Sellin, New York,
1972]; purchased by J. Paul Getty.

BIBLIOGRAPHY
Wilson, "Meubles 'Baroques,'" p. 106, illus.;
Fredericksen et al., *Getty Museum*, p. 145,
illus.; Bremer-David, *Summary*, no. 491,
p. 284, illus.

322.
LIDDED VASE
Chinese, Kangxi reign (1662–1722)
Hard-paste porcelain, underglaze blue
decoration
Height: 1 ft. 11 ¹/₂ in. (59.7 cm); Diameter:
1 ft. 2 ³/₄ in. (37.5 cm)
Accession number 86.DE.629

PROVENANCE
[Spink and Son, Ltd., London].

BIBLIOGRAPHY
"Acquisitions/1986," *GettyMusJ* 15 (1987),
no. 97, p. 210, illus.; Bremer-David, *Summary*,
no. 492, p. 285, illus.

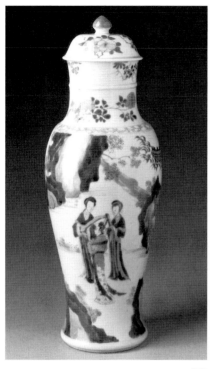

323

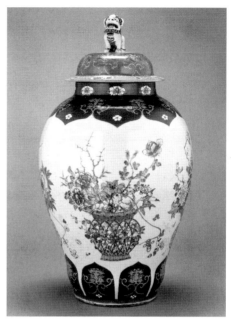

325 *One of a pair*

324.

LIDDED VASE

Chinese, Kangxi reign (1662–1722)
Hard-paste porcelain, underglaze blue
decoration
Painted underneath with a leaf in under-
glaze blue.
Height: 1 ft. 5 1/2 in. (44.5 cm); Diameter:
8 1/2 in. (21.6 cm)
Accession number 85.DE.46

PROVENANCE

[Spink and Son, Ltd., London, 1985].

BIBLIOGRAPHY

"Acquisitions/1985," *GettyMusJ* 14 (1986),
no. 182, p. 239, illus.; Bremer-David, *Sum-
mary*, no. 494, p. 285, illus.

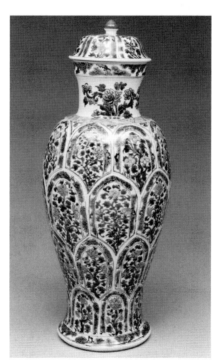

324

323.

LIDDED VASE

Chinese, Kangxi reign (1662–1722)
Hard-paste porcelain, underglaze blue
decoration
Painted underneath with a mark of the Ming
dynasty (Jiajing reign, 1522–1566) in under-
glaze blue.
Height: 11 7/8 in. (30.2 cm); Diameter:
4 1/2 in. (11.4 cm)
Accession number 85.DE.414

PROVENANCE

[Spink and Son, Ltd., London].

BIBLIOGRAPHY

"Acquisitions/1985," *GettyMusJ* 14 (1986),
no. 183, p. 239, illus.; Bremer-David, *Sum-
mary*, no. 493, p. 285, illus.

325.

PAIR OF LIDDED VASES

Chinese, Yongzheng reign, circa 1730
Hard-paste porcelain, polychrome enamel
decoration
Each vase bears a label, pasted within the
lip, printed with FONTHILL HEIRLOOMS
and with the inventory number 670/3.
Height: 2 ft. 3/4 in. (62.9 cm); Diameter:
1 ft. 1 in. (33 cm)
Accession number 72.DE.62.1–.2

PROVENANCE

Lord Loch of Drylawn (?), Edinburgh; Alfred
Morrison, Fonthill House, Wiltshire; John
Greville Morrison, Lord Margadale of Islay,
Fonthill House, by descent (sold, Christie's,
London, June 5, 1972, lot 29); purchased at
that sale by J. Paul Getty.

BIBLIOGRAPHY

Bremer-David, *Summary*, no. 496, p. 286, illus.

English

326.
FIGURE OF AN ELEPHANT
Chinese, Qianlong reign (1736–1795)
Hard-paste porcelain, polychrome enamel
decoration, gilding
Height: 1 ft. 9 3/4 in. (55.2 cm); Width:
1 ft. 1 1/2 in. (34.2 cm); Depth: 10 in.
(25.4 cm)
Accession number 72.DE.61

PROVENANCE
George Christie (sold, Christie's, London,
June 5, 1972, lot 24); purchased at that sale
by J. Paul Getty.

BIBLIOGRAPHY
Anthony du Boulay, *Christie's Pictorial History of
Chinese Ceramics* (New Jersey, 1984), p. 297,
fig. 7, illus.; "A J. Paul Getty Museum
Sampler," *Zooview* (Winter 1985/86), p. 11,
illus.; William R. Sargent, *The Copeland
Collection* (Salem, Massachusetts, 1991),
p. 244, fig. 123a, illus.; Bremer-David, *Sum-
mary*, no. 497, p. 286, illus.; Pratapaditya Pal,
"Getty and Asian Art," *Orientations* (April
1998), pp. 58–63, p. 58, illus.

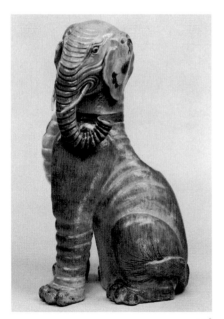

326

327

327.
A SHEPHERD WITH HIS DOG
Derby porcelain manufactory, circa 1795
Modeled by Johann Jakob Wilhelm Spängler
Biscuit porcelain
Incised with a crown, crossed batons, and the
D mark for the Derby manufactory (the manu-
factory's mark as of 1784), with *no.* 396, and
with a triangle for the repairer Joseph Hill.
Height: 1 ft. 1/2 in. (32 cm)
Accession number 99.DE.45

PROVENANCE
[E. and H. Manners, London].

German

328.
PAIR OF STOVE TILES
Tile .1: Alexander the Great; Tile .2: Nimrod
Nuremberg, mid-seventeenth century
By Georg Leupold
Lead-glazed earthenware
Inscribed with *ALEXAND MAG* and
NIMROD ASSYRIORUM.

Height: (each, framed): 2 ft. 4 in. (71.1 cm);
Width: 1 ft. 10 1/2 in. (57.2 cm); Height:
(each, unframed): 2 ft. 2 in. (66 cm); Width:
1 ft. 8 in. (51 cm); Depth: 3 1/8 in. (8 cm)
Accession number 98.DE.6.1–.2

PROVENANCE
Private collection, New York; [Blumka
Gallery, New York].

328 *Alexander the Great*

328 *Nimrod*

329.
WINE BOTTLE

Meissen manufactory, circa 1710–1715
By Johann Friedrich Böttger; modeled by
Johann Donner
Stoneware
Painted underneath with the black Johanneum
mark 232. over R. and impressed with the
modeler's mark.
Height: 6¹/₂ in. (16.5 cm); Width: 4³/₈ in.
(11.1 cm); Depth: 3³/₄ in. (9.5 cm)
Accession number 85.DE.231

PROVENANCE

Augustus the Strong, Elector of Saxony
(1670–1733), Japanese Palace, Dresden (sold,
Rudolph Lepke's Kunst-Auctions-Haus, Berlin,
October 12–14, 1920, no. 59 or 60); Ludwig
Neugass (died 1983), (sold by his daughter
Carolyn Neugass, William Doyle Galleries,
New York, January 25, 1984, lot 304, one of a
pair); [Kate Foster, Ltd., England, 1985].

EXHIBITIONS

The Los Angeles County Museum of Art,
September 1987–September 1993.

BIBLIOGRAPHY

"Acquisitions/1985," GettyMusJ 14 (1986),
no. 201, p. 247, illus.; Bremer-David, Summary,
no. 409, p. 236, illus.

330.
STANDING CUP AND COVER

Meissen manufactory, circa 1710–1715
Attributed to Johann Friedrich Böttger
Stoneware; silver-gilt mounts

330

Height: 9⁷/₈ in. (25 cm); Diameter: 4⁵/₁₆ in.
(11 cm)
Accession number 85.DI.286

PROVENANCE

[Bent Peter Bronée, Copenhagen].

BIBLIOGRAPHY

"Acquisitions/1985," GettyMusJ 14 (1986),
no. 202, p. 247, illus.; Bremer-David, Summary, no. 410, p. 236, illus.

331.
TEAPOT

Meissen manufactory, circa 1715–1720
Attributed to Johann Friedrich Böttger
Stoneware; silver-gilt mounts and chain
Height: 5¹/₂ in. (14 cm); Width: 6³/₁₆ in.
(15.4 cm); Depth: 4⁷/₈ in. (12.4 cm)
Accession number 85.DI.287

PROVENANCE

[Bent Peter Bronée, Copenhagen].

BIBLIOGRAPHY

"Acquisitions/1985," GettyMusJ 14 (1986),
no. 203, p. 247, illus.; Bremer-David, Summary, no. 411, p. 237, illus.

329

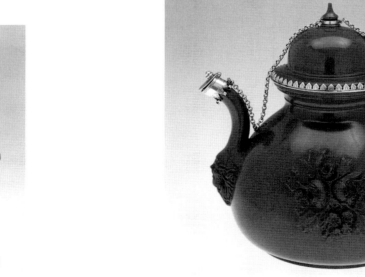

331

332.
LEAF-SHAPED DISH
 Porcelain: Meissen manufactory,
 circa 1715–1720
 Painted decoration: Breslau, circa 1715–1725
 Painting attributed to Ignaz Preissler
 Hard-paste porcelain, painted decoration,
 gilding
 Height: 1 9/16 in. (4 cm); Width: 3 1/4 in.
 (8.3 cm); Depth: 4 3/8 in. (11.1 cm)
 Accession number 86.DE.541

PROVENANCE
Dr. Marcel Nyffeler, Switzerland (sold,
Christie's, London, June 9, 1986, lot 183).

BIBLIOGRAPHY
Maureen Cassidy-Geiger, "Two Pieces of
Porcelain Decorated by Ignaz Preissler in the
J. Paul Getty Museum," *GettyMusJ* 15 (1987),
pp. 3552, figs. 10a–e; "Acquisitions/1986,"
GettyMusJ 15 (1987), no. 111, p. 215, illus.;
Bremer-David, *Summary*, no. 412, p. 237, illus.

332

333.
FIGURE (*BELTRAME DI MILANO* [?])
 Meissen manufactory, circa 1720
 Hard-paste porcelain
 Height: 6 1/2 in. (16.5 cm); Width: 2 11/16 in.
 (6.8 cm); Depth: 2 5/8 in. (6.5 cm)
 Accession number 86.DE.542

PROVENANCE
Dr. Marcel Nyffeler, Switzerland (sold,
Christie's, London, June 9, 1986, lot 21).

BIBLIOGRAPHY
"Acquisitions/1986," *GettyMusJ* 15 (1987),
no. 112, p. 215, illus.; Bremer-David, *Summary*,
no. 413, p. 237, illus.

333

334

334.
WINE POT
 Meissen manufactory, circa 1725
 Painting attributed to the studio of Johann
 Gregor Höroldt
 Hard-paste porcelain, polychrome enamel
 decoration, gilding
 Height: 5 1/2 in. (14 cm); Width: 6 11/16 in.
 (17 cm); Depth: 3 1/2 in. (8.9 cm)
 Accession number 85.DE.381

PROVENANCE
Private collection, Torquay, England (sold,
Bearne's Auction House, Torquay, May 2,
1984, lot 224); [Winifred Williams, Ltd.,
London].

BIBLIOGRAPHY
"Acquisitions/1985," *GettyMusJ* 14 (1986),
no. 204, pp. 247–248, illus.; Bremer-David,
Summary, no. 414, p. 238, illus.

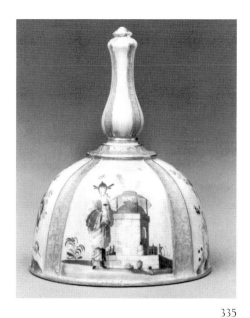

335

335.
BELL
 Meissen manufactory, circa 1725–1730
 Painting attributed to the studio of
 Johann Gregor Höroldt
 Hard-paste porcelain, mauve and pale green
 ground colors, polychrome enamel decoration,
 gilding

Height: 3 3/8 in. (8.6 cm); Diameter: 2 7/16
in. (6.5 cm)
Accession number 85.DE.203

PROVENANCE
Erich von Goldschmidt-Rothschild,
Frankfurt am Main; Christoph Hoffman-Frey,
Zurich, by 1982; [Lovice Reviczky A. G.,
Zurich].

BIBLIOGRAPHY
"Acquisitions/1985," GettyMusJ 14 (1986),
no. 205, p. 248, illus.; Bremer-David, Sum-
mary, no. 415, p. 238, illus.

336.
ASSEMBLED SET OF FIVE VASES
 Meissen manufactory, circa 1730
 Painting attributed to Johann Gregor
 Höroldt; largest vase molded by Andreas
 Schiefer
 Hard-paste porcelain, polychrome enamel
 decoration, gilding
 Each vase is painted under its base with the
 blue AR monogram of Augustus the Strong,
 Elector of Saxony (1670–1733). Largest lid-
 ded vase is incised with Schiefer's mark of
 a cross with four dots.

Lidded Vase .1: Height: 1 ft. 2 11/16 in.
(37.3 cm); Width: 9 1/2 in. (24.1 cm); Lidded
Vases .2–.3: Height: 1 ft. 11/16 in. (32.2 cm);
Width: 7 5/8 in. (19.4 cm); Open Vases .4–.5:
Height: 10 7/8 in. (27.6 cm); Width: 7 in.
(17.8 cm)
Accession number 83.DE.334.1–.5

PROVENANCE
Private collection (sold, Sotheby's, London,
March 5, 1957, lot 123); [The Antique Porce-
lain Co., London, 1957]; Alamagna family,
Milan, 1961–1982; [The Antique Porcelain
Co., London, 1982].

BIBLIOGRAPHY
Sassoon, "Acquisitions 1983," no. 16,
pp. 217–222, illus.; "Acquisitions/1983," Getty-
MusJ 12 (1984), no. 18, pp. 267–268, illus.;
Jackson-Stops, "Boulle by the Beach,"
pp. 854–856, illus. p. 854, fig. 1; Handbook
1986, p. 153, illus.; Bremer-David, Summary,
no. 416, pp. 238–239, illus. p. 239.

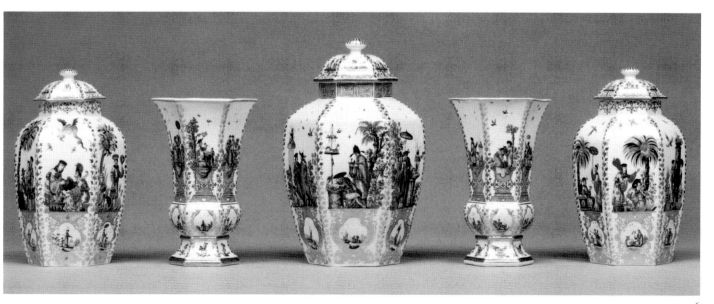

336

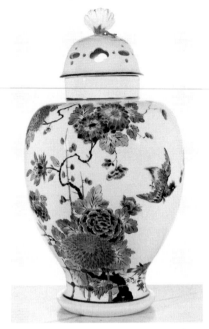

337 *One of a pair*

337.
Pair of Lidded Vases

Vases: Meissen manufactory, before 1733
Lids: Possibly Meissen porcelain replacements, circa 1760
One vase probably molded by Rehschuch
Hard-paste porcelain, polychrome enamel decoration, gilding
Each vase is painted under its base with the blue AR monogram of Augustus the Strong, Elector of Saxony (1670–1733); each is incised with a cross under the base; one vase is incised with a simple cross (probably the mark of the molder Rehschuch), the other with a cross hatched at each extension.
Height: 1 ft. 2 in. (35.5 cm); Diameter: 7 7/8 in. (20.1 cm)
Accession number 73.DE.65.1–.2

PROVENANCE

Private collection, Zurich (sold, Sotheby's, London, March 27, 1973, lot 39); purchased at that sale by J. Paul Getty.

BIBLIOGRAPHY

Bremer-David, *Summary*, no. 417, p. 239, illus.

338.
Ewer and Basin

Meissen manufactory, circa 1740
Painting attributed to the studio of Christian Frederich Herold
Hard-paste porcelain, polychrome enamel decoration, gilding
The ewer and basin are both painted beneath with the crossed swords in blue of the Meissen manufactory; both are impressed with the number 27.
Ewer: Height: 8 1/2 in. (21.2 cm); Width: 8 1/4 in. (20.6 cm); Depth: 4 1/4 in. (10.5 cm);
Basin: Height: 2 7/8 in. (7.3 cm); Width: 1 ft. 1/2 in. (31.8 cm); Depth: 10 in. (25.5 cm)
Accession number 84.DE.918.1–.2

PROVENANCE

Sir Hugh Smithson, 1st Duke of Northumberland and Earl Percy (1714–1786); by descent to Algernon Heber-Percy (sold, Christie's, London, October 30, 1967, lot 154); Dr. and Mrs. E. Pauls-Eisenbeiss (sold, Christie's, Geneva, November 12, 1976, no. 197); (anonymous sale, Christie's, London, June 25, 1979, lot 177); private collection, London

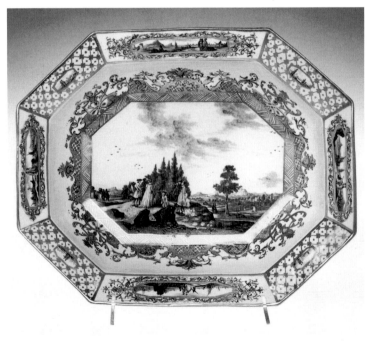

338 *Basin*

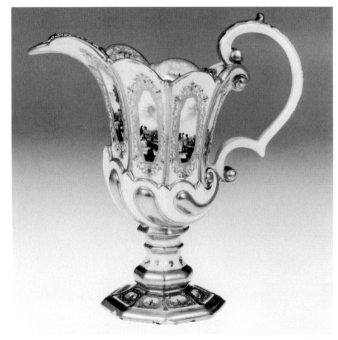

338 *Ewer*

(sold, Christie's, London, December 3, 1984, lot 275, to [The Antique Porcelain Co., London]).

BIBLIOGRAPHY
Dr. Erika Pauls-Eisenbeiss, *German Porcelain of the Eighteenth Century* (London, 1972), vol. 1, pp. 484–487; "Acquisitions/1984," *GettyMusJ* 13 (1985), no. 67, p. 183, illus.; Bremer-David, *Summary*, no. 418, p. 240, illus.

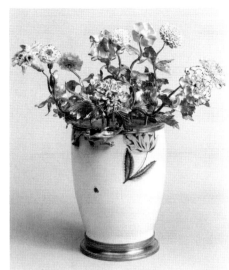

339 *Vase .2*

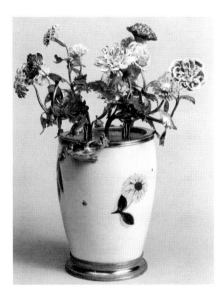

339 *Vase .1*

339.
PAIR OF VASES MOUNTED WITH FLOWERS
Vases: Meissen manufactory, before 1733
Flowers: French (Paris, possibly Vincennes manufactory), circa 1745–1750
Mounts: French (Paris), circa 1745–1749
Hard-paste porcelain vases and polychrome enamel decoration; soft-paste porcelain flowers; gilt-bronze mounts
Each vase is painted on the base with the blue AR monogram of Augustus the Strong, Elector of Saxony (1670–1733). Mounts struck with the crowned C for 1745–1749.
Height: 1 ft. 3 5/8 in. (39.7 cm); Width: 1 ft. 3 1/8 in. (38.3 cm); Depth: 1 ft. 1 3/8 in. (34 cm)
Accession number 79.DI.59.1–.2

PROVENANCE
Consuelo Vanderbilt (Mme Jacques Balsan); [Matthew Schutz, Ltd., New York].

BIBLIOGRAPHY
Bremer-David, *Summary*, no. 419, pp. 240–241, illus. p. 240.

340.
GROUP OF "JAPANESE" FIGURES
Meissen manufactory, circa 1745
Model by Johann Joachim Kändler
Hard-paste porcelain, polychrome enamel decoration, gilding; gilt-bronze mounts
Any marks that might be under the base are concealed by the irremovable gilt-bronze mount.
Height: 1 ft. 5 3/4 in. (45.1 cm); Width: 11 5/8 in. (29.5 cm); Depth: 8 9/16 in. (21.7 cm)
Accession number 83.DI.271

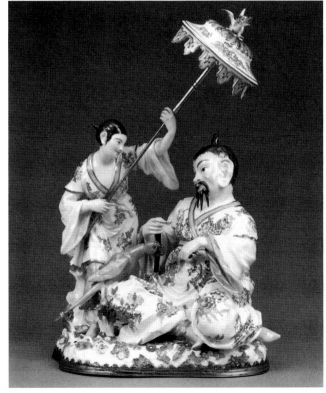

340

PROVENANCE

Figure group: private collection, Europe
(sold, Sotheby's, London, March 2, 1982,
lot 168); [Winifred Williams, Ltd., London,
1982]. Parasol: Paul Schnyder von Wartensee,
Switzerland; [Winifred Williams, Ltd., Lon-
don, 1982].

BIBLIOGRAPHY

M. A. Pfeiffer, "Ein Beitrag zur Quellen-
geschichte des Europäischen Porzellans,"
*Werden und Wirken: Ein Festgruss für Karl W.
Hiersemann* (Leipzig, 1924), pp. 267–287; Sas-
soon, "Acquisitions 1983," no. 17, pp. 222–
224, illus.; "Acquisitions/1983," *GettyMusJ* 12
(1984), no. 19, p. 268, illus.; "Some Acqui-
sitions (1983–1984) in the Department of
Decorative Arts, the J. Paul Getty Museum,"
Burlington Magazine 126, no. 975 (June 1984),
pp. 384–388, illus. p. 388, fig. 80; Bremer-
David, *Summary*, no. 420, p. 241, illus.; *Hand-
book* 2001, p. 202, illus.

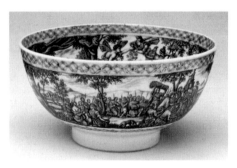

341.
BOWL
Porcelain: Chinese, Kangxi reign
(1662–1722), circa 1700
Painted decoration: German (Breslau),
circa 1715–1720
Painted decoration attributed to
Ignaz Preissler
Hard-paste porcelain, underglaze blue and
black enamel painted decoration, gilding
Height: 2⁷/₈ in. (7.3 cm); Diameter: 5⁷/₈ in.
(14.9 cm)
Accession number 86.DE.738

PROVENANCE

Octave du Sartel, Paris, before 1881 (sold,
Hôtel Drouot, Paris, June 4–9, 1894, no. 151);
Familie von Parpart (?), Berlin (sold, Lepke,
Berlin, March 18–22, 1912, no. 488, pl. 39);
Des Nordböhmischen Gewerbemuseums,
Reichenberg (now Liberec, Czech Republic),
1912; private collection, Germany; [Kate Fos-
ter, Ltd., London, 1986].

BIBLIOGRAPHY

*Zeitschrift des Nordböhmischen Gewerbemuseums:
Neue folge:* VII *Jahrgang*, no. 3, U. 4 (1912), no. 3,
p. 95; Gustave E. Pazaurek, *Deutsche Fayence-
und Porzellan-Hausmaler* (Leipzig, 1925), vol. 1,
p. 214; Maureen Cassidy-Geiger, "Two Pieces
of Porcelain Decorated by Ignaz Preissler in
the J. Paul Getty Museum," *GettyMusJ* 15
(1987), pp. 35–52, figs. 1a–h; "Acquisitions/
1986," *GettyMusJ* 15 (1987), no. 110, p. 215,
illus.; Bremer-David, *Summary*, no. 421,
pp. 241–242, illus. p. 241.

Italian

342.
GREEN-PAINTED JUG WITH A BIRD
Southern Tuscany or possibly Northern Lazio,
early fifteenth century
Tin-glazed earthenware
Height: 9⁷/₈ in. (25 cm); Diameter (at lip):
3¹/₄ in. (9.5 cm); Maximum Width: 6³/₈ in.
(16.2 cm)
Accession number 84.DE.95

PROVENANCE

Private collection, the Netherlands; [Rainer
Zietz, Ltd., London].

BIBLIOGRAPHY

"Acquisitions/1984," *GettyMusJ* 13 (1985),
no. 155, pp. 239–240, illus.; Hess, *Maiolica*,
no. 3, pp. 17–19; Bremer-David, *Sum-
mary*, no. 334, p. 197, illus.

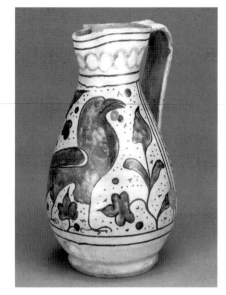

343.
RELIEF-BLUE JAR WITH HARPIES AND BIRDS
Florence or possibly Siena, circa 1420–1440
Possibly the workshop of Piero di Mazzeo
(Maseo, Mazeo)
Tin-glazed earthenware
Marked with a three-runged ladder sur-
mounted by a cross painted on each side and
what appears to be a P, possibly intertwined
with a backward C, below each handle.
Height: 1 ft. ¹/₄ in. (31.1 cm); Diameter (at
lip): 5⁵/₈ in. (14.3 cm); Maximum Width:
11³/₄ in. (29.8 cm)
Accession number 85.DE.56

PROVENANCE

Wilhelm von Bode, Berlin, by 1898, sold to
K. Glogowski; Kurt Glogowski, Berlin
(sold, Sotheby's, London, June 8, 1932, lot
58, to A. Lederer); August Lederer (died
1936), Vienna; by inheritance to his widow
Serena Lederer (died 1943), Vienna; confiscated
from Lederer's collection by the Nazis, 1938;
restituted to her son Erich Lederer by the
Austrian government, 1947; Erich Lederer
(1889–1985), Geneva; by inheritance to his
widow Elizabeth Lederer, 1985; Elizabeth
Lederer, Geneva.

EXHIBITIONS

Berlin, Kunstgeschichtliche Gesselschaft, *Austellung von Kunstwerken des Mittelalters under der Renaissance aus Berliner Privatbesitz*, May 20– July 3, 1808, pl. 48, fig. 2.

BIBLIOGRAPHY

Henry Wallis, *Oak-Leaf Jars: A Fifteenth-Century Italian Ware Showing Moresco Influence* (London, 1903), p. 35, illus. p. 9, fig. 7; Wilhelm von Bode, *Die Anfänge der Majolikakunst in Toskana* (Berlin, 1911), pl. 14; Joseph Chompret, *Répertoire de la majolique italienne*, vol. 2 (Paris, 1949), fig. 648; Galeazzo Cora, *Storia della maiolica di Firenze e del contado del xiv e del xv secolo* (Florence, 1973), vol. 1, p. 76; vol. 2, pls. 61–62, 63c; Giovanni Conti, *L'Arte della maiolica in Italia*, 2nd ed. (Milan, 1980), pls. 45–46; Anna Moore Valeri, "Florentine 'Zaffera a Rilievo' Maiolica: A New Look at the 'Oriental Influence,'" *Archaeologia Medievale* 2 (1984), pp. 477–500, fig. 4b; "Acquisitions/ 1985," *GettyMusJ* 14 (1986), no. 211, p. 251, illus.; *Handbook* 1991, p. 200, illus.; Giovanni Conti et al., *Zaffera et similia nella maiolica italiana* (Viterbo, 1991), pp. 17–18, and p. 265, fig. 151; Hess, *Maiolica*, no. 5, pp. 23–25; David H. Cohen and Catherine Hess, *Looking at European Ceramics: A Guide to Technical Terms* (Malibu and London, 1993), p. 47, illus.; Bremer-David, *Summary*, no. 335, p. 197, illus.

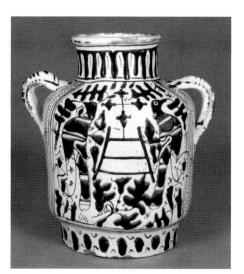

343

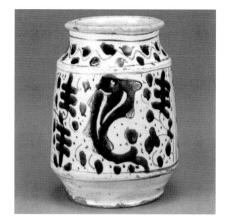

344

344.

RELIEF-BLUE JAR WITH A FISH

Florence, circa 1420–1440
Tin-glazed earthenware
Height: $6^{1}/_{2}$ in. (16.5 cm); Diameter (at lip): $3^{13}/_{16}$ in. (9.7 cm); Maximum Width: $4^{13}/_{16}$ in. (12.2 cm)
Accession number 85.DE.57

PROVENANCE

Luigi Grassi, Florence, sold to A. Lederer; August Lederer (died 1936), Vienna; by inheritance to his widow Serena Lederer (died 1943), Vienna; confiscated from Lederer's collection by the Nazis, 1938; restituted to her son Erich Lederer by the Austrian government, 1947; Erich Lederer (1889–1985), Geneva; by inheritance to his widow Elizabeth Lederer, 1985; Elizabeth Lederer, Geneva.

BIBLIOGRAPHY

John Rothenstein, "Shorter Notices: Two Pieces of Italian Pottery," *Burlington Magazine* 85 (August 1944), p. 205, pl. C; Galeazzo Cora, *Storia della maiolica di Firenze e del contado del xiv e del xv secolo* (Florence, 1973), vol. 1, p. 78; vol. 2, fig. 83c; Giovanni Conti, *L'Arte della maiolica in Italia*, 2nd ed. (Milan, 1980), no. 48; "Acquisitions/1985," *GettyMusJ* 14 (1986), no. 213, p. 251, illus.; Hess, *Maiolica*, no. 6, pp. 26–27; Giovanni Conti et al., *Zaffera et similia nella maiolica italiana* (Viterbo, 1991), p. 258, fig. 97; Bremer-David, *Summary*, no. 336, p. 198, illus.

345.

GREEN-PAINTED DISH WITH AN INTERLACE PATTERN

Florence area or Montelupo, circa 1425–1440
Tin-glazed earthenware
Height: $1^{3}/_{4}$ in. (4.4 cm); Diameter: $9^{15}/_{16}$ in. (25.3 cm)
Accession number 84.DE.94

PROVENANCE

Alfred Pringsheim, Munich, by 1913; confiscated from Pringsheim's collection by the Nazis and exported in 1938 to London in exchange for permitting Mr. and Mrs. Pringsheim to emigrate to Switzerland (sold, Sotheby's, London, July 19, 1939, lot 201, to E. L. Paget); E. L. Paget, London; A. Kauffmann, London; [Rainer Zietz, Ltd., London].

BIBLIOGRAPHY

Otto von Falke, *Majolikasammlung Pringsheim in München* (The Hague, 1914–1923), vol. 1, p. 4, fig. 4; Galeazzo Cora, *Storia della maiolica di Firenze e del contado del xiv e del xv secolo* (Florence, 1973), vol. 2, no. 50d, pl. 50; "Acquisitions/1984," *GettyMusJ* 13 (1985), no. 152, p. 239, illus.; Hess, *Maiolica*, no. 4, pp. 20–22; Bremer-David, *Summary*, no. 337, p. 198, illus.

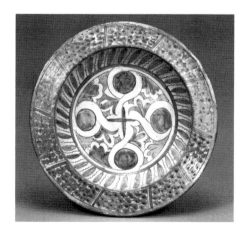

345

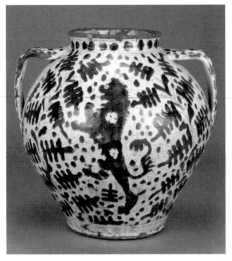

346

346.

RELIEF-BLUE JAR WITH RAMPANT LIONS

Florence, circa 1425–1450
Tin-glazed earthenware
Marked with a six-pointed asterisk below
each handle.
Height: 1 ft. 3 1/2 in. (39.4 cm); Diameter
(at lip): 7 5/8 in. (19.3 cm); Maximum Width:
1 ft. 3 3/4 in. (40 cm)
Accession number 84.DE.97

PROVENANCE

Count Alessandro Contini-Bonacossi, Villa
Vittoria, Florence, sold to N. Longari;
[Nella Longari, Milan, sold to R. Zietz];
[Rainer Zietz, Ltd., London].

BIBLIOGRAPHY

Galeazzo Cora, *Storia della maiolica di Firenze e
del contado del XIV e del XV secolo* (Florence, 1973),
vol. 1, pp. 83, 457; vol. 2, pl. 112; "Acquisi-
tions/1984," *GettyMusJ* 13 (1985), no. 157,
p. 240, illus.; Hess, *Maiolica*, no. 7, pp. 28–
30; Giovanni Conti et al., *Zaffera et similia
nella maiolica italiana* (Viterbo, 1991), p. 254,
fig. 59; Bremer-David, *Summary*, no. 338,
pp. 198–199, illus. p. 199; *Masterpieces*, no. 2,
p. 9, illus.

347.

RELIEF-BLUE JAR WITH RUNNING BOARS

Florence, circa 1430
Tin-glazed earthenware
Painted with a copper green and manganese
purple crutch on each handle and marked
with a six-pointed asterisk surrounded by
dots below each handle.
Height: 9 7/8 in. (25 cm); Diameter (at lip):
4 15/16 in. (12.5 cm); Maximum Width:
9 5/8 in. (24.5 cm)
Accession number 84.DE.98

PROVENANCE

According to Sir Thomas Ingilby, possibly
acquired by Sir John Ingilby while he was in
Italy in 1743, though certainly at Ripley
Castle for several generations; by inheritance
to Sir Joslan Ingilby, Bt., Ripley Castle,
Harrogate, North Yorkshire, England (offered
for sale, Sotheby's, London, July 2, 1974, lot
261, withdrawn because of the sudden death
of Sir Joslan Ingilby in June 1974); by inheri-
tance to Sir Thomas Ingilby, Ripley Castle,
North Yorkshire (sold, Sotheby's, London,
April 14, 1981, lot 13, to R. Zietz); [Rainer
Zietz, Ltd., London].

347

BIBLIOGRAPHY

G. Norman, "Documented History Helps Jar
to Make Fifty-Six Thousand Pounds," *Times*
(London), April 15, 1981; John Cuadrado,
"Prized Pottery Triumphs of the Italian
Renaissance," *Architectural Digest* 41 (February
1984), p. 127; "Acquisitions/1984," *GettyMusJ*
13 (1985), no. 158, p. 240, illus.; *Handbook
1986*, p. 182, illus.; Giovanni Conti et al.,
Zaffera et similia nella maiolica italiana (Viterbo,
1991), p. 255, fig. 71; Hess, *Maiolica*, no. 8,
pp. 31–33; David H. Cohen and Catherine
Hess, *Looking at European Ceramics: A Guide to
Technical Terms* (Malibu and London, 1993),
p. 29, illus.; Bremer-David, *Summary*, no. 339,
p. 199, illus.

348.

RELIEF-BLUE JAR WITH DOTS

Tuscany, probably Florence, circa 1430–1450
Tin-glazed earthenware
Marked below each handle with a six-
pointed asterisk surrounded by dots.
Height: 6 1/2 in. (16.5 cm); Diameter (at lip):
4 1/8 in. (10.5 cm); Maximum Width: 7 in.
(17.8 cm)
Accession number 85.DE.58

PROVENANCE

Palazzo Davanzati, Florence; Stefano Bardini,
Florence; Elie Volpi, Florence (sold, Jandolo
and Tavazzi, Rome, April 35–May 3, 1910,
no. 777, to Count H.-A. Harrach); Count
Hans-Albrecht Harrach, Rome, Munich, and
South Germany (sold, Lempertz, Cologne,

May 6, 1953, no. 414); Dr. Robert Bak, New York (sold, Sotheby's, New York, December 7, 1965, lot 15, to E. Lederer); Erich Lederer (1889–1985), Geneva; by inheritance to his widow Elizabeth Lederer, 1985; Elizabeth Lederer, Geneva.

BIBLIOGRAPHY

Galeazzo Cora, *Storia della maiolica di Firenze e del contado del XIV e del XV secolo* (Florence, 1973), vol. 1, p. 80; vol. 2, fig. 107b; "Acquisitions/1985," *GettyMusJ* 14 (1986), no. 212, p. 251, illus.; Hess, *Maiolica*, no. 9, pp. 34–35; Giovanni Conti et al., *Zaffera et similia nella maiolica italiana* (Viterbo, 1991), p. 47, fig. 17, and p. 261, fig. 120; Bremer-David, *Summary*, no. 340, p. 199, illus.

349

350

348

349.
JAR WITH FOLIATE DECORATION
Montelupo, mid-fifteenth century
Tin-glazed earthenware
Height: 7 5/16 in. (18.6 cm); Diameter (at rim): 4 1/8 in. (10.5 cm); Maximum Width: 4 5/8 in. (11.8 cm)
Accession number 84.DE.100

PROVENANCE

Sold, Sotheby's, London, November 22, 1983, lot 194, to R. Zietz; [Rainer Zietz, Ltd., London].

BIBLIOGRAPHY

"Acquisitions/1984," *GettyMusJ* 13 (1985), no. 153, p. 239, illus.; Hess, *Maiolica*, no. 11, p. 39; Bremer-David, *Summary*, no. 341, p. 200, illus.

350.
JAR WITH A KUFIC PATTERN
Montelupo, mid-fifteenth century
Tin-glazed earthenware
Inscribed marks on the underside (graduations?).
Height: 7 1/8 in. (18.1 cm); Diameter (at lip): 3 3/4 in. (9.5 cm); Maximum Width: 5 1/8 in. (13 cm)
Accession number 84.DE.96

PROVENANCE

Dr. Joseph Chompret, Paris (sold, Hôtel Drouot, Paris, December 15, 1976, no. 19, to R. Zietz); [Rainer Zietz, Ltd., London].

BIBLIOGRAPHY

"Acquisitions/1984," *GettyMusJ* 13 (1985), no. 156, p. 240, illus.; Hess, *Maiolica*, no. 10, pp. 36–38; Bremer-David, *Summary*, no. 342, p. 200, illus.

351.
ARMORIAL JAR
Deruta, circa 1460–1490
Tin-glazed earthenware
Painted with AMADIO on one side.
Height: 8 3/4 in. (22.2 cm); Diameter (at rim): 4 1/2 in. (11.4 cm); Maximum Width: 9 3/16 in. (23.4 cm)
Accession number 84.DE.99

PROVENANCE

Alfred Pringsheim, Munich; confiscated from Pringsheim's collection by the Nazis and exported in 1938 to London in exchange for permitting Mr. and Mrs. Pringsheim to emigrate to Switzerland (sold, Sotheby's, London, June 7, 1939, lot 3, to A. Spero); [Alfred Spero, London]; [Rainer Zietz, Ltd., London].

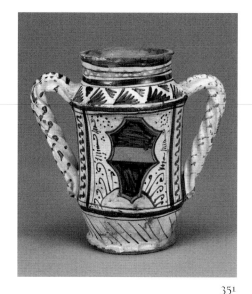

351

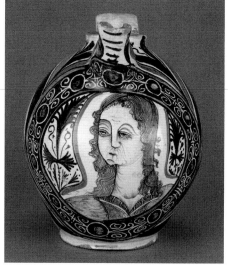

352

EXHIBITIONS
Los Angeles County Museum of Art, *Italian Renaissance Maiolica from the William A. Clark Collection*, March 5–May 17, 1986.

BIBLIOGRAPHY
Otto von Falke, *Majolikasammlung Pringsheim in München* (The Hague, 1914–1923), vol. 1, no. 11, pl. 8; Mario Bellini and Giovanni Conti, *Maioliche italiane del rinascimento* (Milan, 1964), p. 89, fig. A; "Acquisitions/1984," *GettyMusJ* 13 (1985), no. 159, p. 240. illus.; Hess, *Maiolica*, no. 12, pp. 40–42; Gian Carlo Bojani, *Ceramiche nelle Marche* (Bergamo, 1988), pp. 54–55, fig. 14; Carola Fiocco and Gabriella Gherardi, *Ceramiche Umbre dal Medioevo allo Storicismo* (Faenza, 1988), pp. 54–55, fig. 14; Guido Donatone, *La Maiolica Napoletana del Rinascimento* (Naples, 1993), pl. 162d; Bremer-David, *Summary*, no. 343, p. 200, illus.; Carola Fiocco and Gabriella Gherardi, *La Ceramica di Deruta dal XIII al XVIII secolo* (Perugia, 1994), p. 145, no. 6.

352.
JUG WITH BUST MEDALLION
Deruta or Montelupo, circa 1450–1490
Tin-glazed earthenware
Height: 1 ft. 1 5/8 in. (34.6 cm); Diameter (at rim): 3 7/8 in. (9.8 cm); Maximum Width: 1 ft. 1 in. (33 cm)
Accession number 84.DE.101

PROVENANCE
Ancestors of the Savile family, Rufford Abbey, Nottingham, active in collecting since the latter half of the seventeenth century; by inheritance to John Savile Lumley-Savile, 2nd Lord Savile (died 1931), Rufford Abbey, Nottingham; by inheritance to George Halifax Lumley-Savile (born 1919), 3rd Lord Savile, Rufford Abbey, Nottingham (sold, Knight, Frank, and Rutley in association with Christie's, London, on Rufford Abbey premises, October 11–20, 1938, lot 879); [Alfred Spero, London]; (sold, Sotheby's, London, December 4, 1956, lot 24); Robert Strauss, England (sold, Christie's, London, June 21, 1976, lot 7); [Rainer Zietz, Ltd., London].

BIBLIOGRAPHY
Christie's Review of the Season 1975 (London and New York, 1976), p. 394; Morley-Fletcher and McIlroy, *European Pottery*, p. 26, fig. 3;

"Acquisitions/1984," *GettyMusJ* 13 (1985), no. 154, p. 239, illus.; Hess, *Maiolica*, no. 13, pp. 43–45; Bremer-David, *Summary*, no. 344, p. 201, illus.; Carola Fiocco and Gabriella Gherardi, *La Ceramica di Deruta dal XIII al XVIII secolo* (Perugia, 1994), p. 154, nos. 18a–18b.

353.
JAR WITH THE PROFILE OF A YOUNG MAN
Deruta or Montelupo, circa 1460–1480
Tin-glazed earthenware
Inscribed marks under the foot (graduations?).
Height: 9 in. (22.9 cm); Diameter (at lip): 4 7/16 in. (11.2 cm); Maximum Width: 9 3/8 in. (23.8 cm)
Accession number 84.DE.102

PROVENANCE
Sold, Christie's, London, October 3, 1983, lot 237, to R. Zietz; [Rainer Zietz, Ltd., London].

BIBLIOGRAPHY
"Acquisitions/1984," *GettyMusJ* 13 (1985), no. 160, p. 240, illus.; Hess, *Maiolica*, no. 14, pp. 46–48; Guido Donatone, *La Maiolica Napoletana del Rinascimento* (Naples, 1993), pls. 47 and 152; Bremer-David, *Summary*, no. 345, pp. 201–202, illus. p. 201

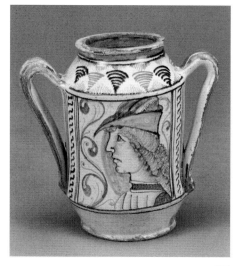

353

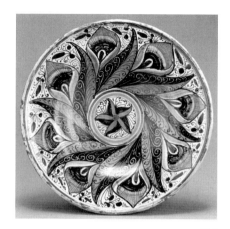

354

354.
DISH WITH A PEACOCK FEATHER PATTERN
Probably Deruta, circa 1470–1500
Tin-glazed earthenware
Height: 2 1/2 in. (6.3 cm); Diameter:
1 ft. 3 3/8 in. (39 cm)
Accession number 84.DE.103

PROVENANCE

Sir William Stirling-Maxwell (1818–1878),
Bt., K. T., Keir, Scotland; by inheritance to
Lt. Col. W. J. Stirling, Keir, Scotland;
Thomas A. Berney, London (sold, Sotheby's,
London, June 18, 1946, lot 79, to F. D. Lycett-
Green); F. D. Lycett-Green, Goundhurst,
Kent (sold, Sotheby's, London, October 14,
1960, lot 24, to R. Strauss); Robert Strauss,
England (sold, Christie's, London, June 21,
1976, lot 14, to C. Humphris); [Cyril
Humphris, London, acquired by R. Zietz];
[Rainer Zietz, Ltd., London].

EXHIBITIONS

Los Angeles County Museum of Art, *Italian
Renaissance Maiolica from the William A. Clark Col-
lection*, March 5–May 17, 1986.

BIBLIOGRAPHY

Jörg Rasmussen, *Italienische Majolika* (Hamburg,
1984), p. 71, note 1; "Acquisitions/1984,"
GettyMusJ 13 (1985), no. 162, p. 241, illus.;
Hess, *Maiolica*, no. 15, pp. 49–51; Bremer-
David, *Summary*, no. 346, p. 202, illus.

355.
DRUG JAR FOR SYRUP OF LEMON JUICE
Probably Pesaro or possibly Kingdom of
Naples (Naples or Sciacca), circa 1480
Tin-glazed earthenware
Painted with *S. ACETOSITATI CIT[RUS]* on
the banderole.
Height: 1 ft. 3/8 in. (31.5 cm); Diameter (at
lip): 4 3/8 in. (11.1 cm); Maximum Width:
4 7/8 in. (12.4 cm)
Accession number 84.DE.104

PROVENANCE

Alfred Pringsheim, Munich; confiscated from
Pringsheim's collection by the Nazis and
exported in 1938 to London in exchange
for permitting Mr. and Mrs. Pringsheim to
emigrate to Switzerland (sold, Sotheby's,
London, June 7, 1939, lot 9, to "A. Recher");
A. Recher; Charles Damiron, Lyons, by 1944;
by inheritance to Paul Damiron; (sold,
Sotheby's, London, November 22, 1983,
lot 212); [Rainer Zietz, Ltd., London].

BIBLIOGRAPHY

Otto von Falke, *Majolikasammlung Pringsheim
in München* (The Hague, 1914–1923), vol. 1,

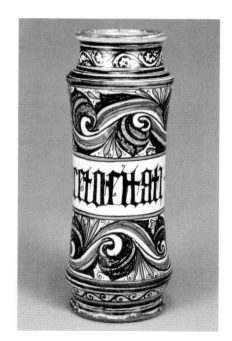

355

no. 22, pl. 15; Emil Hannover, *Pottery and Por-
celain* (London, 1925), fig. 117; Charles
Damiron, *Majoliques italiennes* (privately
printed, 1944), no. 27; "Acquisitions/ 1984,"
GettyMusJ 13 (1985), no. 161, p. 241, illus.;
Hess, *Maiolica*, no. 17, pp. 55–57; David H.
Cohen and Catherine Hess, *Looking at European
Ceramics: A Guide to Technical Terms* (Malibu
and London, 1993), p. 27, illus.; Bremer-
David, *Summary*, no. 347, p. 202, illus.; *Hand-
book* 2001, p. 237, illus.

356
BUST OF CHRIST
Montelupo, circa 1500
Tin-glazed earthenware
Height: 1 ft. 11 3/4 in. (60.3 cm); Width:
1 ft. 11 1/2 in. (59.7 cm); Depth: 10 1/4 in.
(26 cm)
Accession number 87.SE.148

PROVENANCE

Private collection, Belgium; (sold, Sotheby's,
London, April 7, 1987, lot 44, to R. Zietz);
[Rainer Zietz, Ltd., London].

BIBLIOGRAPHY

Burlington Magazine 129 (March 1987), p. 1,
illus.; *Il Giornale dell'arte*, no. 45 (1987), p. 90,
fig. 50; "Acquisitions/1987," *GettyMusJ* 16

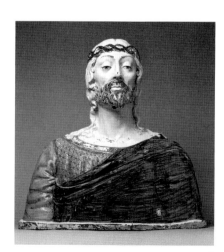

356

(1988), no. 77, p. 180, illus.; Hess, *Maiolica*, no. 16, pp. 52–54; Bremer-David, *Summary*, no. 349, p. 203, illus.; Peter Fusco, *Summary Catalogue of European Sculpture in the J. Paul Getty Museum* (Los Angeles, 1997), p. 67, illus.

357.
DISH WITH SAINT PETER
Probably Faenza, circa 1500–1520
Tin-glazed earthenware
Height: 1 7/8 in. (4.8 cm); Diameter: 10 1/4 in. (27.3 cm)
Accession number 84.DE.108

PROVENANCE
Private collection, Switzerland; [Rainer Zietz, Ltd., London].

BIBLIOGRAPHY
"Acquisitions/1984," *GettyMusJ* 13 (1985), no. 170, p. 242, illus.; Hess, *Maiolica*, no. 20, pp. 64–65; Bremer-David, *Summary*, no. 348, p. 203, illus.

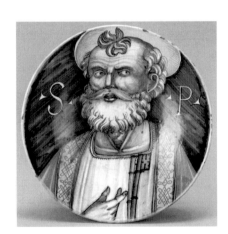

357

358.
BLUE AND WHITE DISH WITH A MERCHANT SHIP
Cafaggiolo, circa 1510
Tin-glazed earthenware
Signed on the reverse, *J° chafagguolo* in blue.
Height: 1 7/8 in. (4.8 cm); Diameter: 9 9/16 in. (24.3 cm)
Accession number 84.DE.109

PROVENANCE
Charles Loeser, Torri Gattaia, Tuscany (sold, Sotheby's, London, December 8, 1959, lot 55, to A. Spero); [Alfred Spero, London]; Robert Strauss, England (sold, Christie's, London, June 21, 1976, lot 19, to R. Zietz); [Rainer Zietz, Ltd., London].

EXHIBITIONS
Los Angeles County Museum of Art, *Italian Renaissance Maiolica from the William A. Clark Collection*, March 5–May 17, 1986.

BIBLIOGRAPHY
Galeazzo Cora and Angiolo Fanfani, *La maiolica di Cafaggiolo* (Florence, 1982), p. 66, fig. 48; Morley-Fletcher and McIlroy, *European Pottery*, p. 44, fig. 1; "Acquisitions/1984," *GettyMusJ* 13 (1985), no. 171, p. 242, illus.; Hess, *Maiolica*, no. 21, pp. 66–68; Bremer-David, *Summary*, no. 350, pp. 203–204, illus. p. 203; Pierre-Alain Mariaux, *La Majolique, La Faïence Italienne et son Décor* (Geneva, 1995), p. 80.

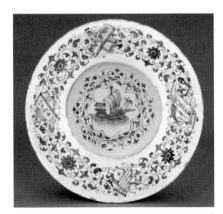

358

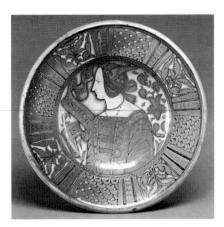

359

359.
LUSTERED PLATE WITH A FEMALE BUST
Deruta, circa 1510–1540
Tin-glazed earthenware with copper luster
Inscribed *VIVIS ERO VIV[U]S E MORTV[U]S ERO VIV[U]S* on the scroll.
Height: 3 1/2 in. (8.8 cm); Diameter: 1 ft. 4 7/8 in. (42.8 cm)
Accession number 84.DE.110

PROVENANCE
R.W. M. Walker, London (sold, Christie's, London, July 25, 1945, lot 73, to "Nyburg"); Nyburg; Adda collection, Paris; (sold, Christie's, London, November 20, 1967, lot 87); [Rainer Zietz, Ltd., London].

BIBLIOGRAPHY
Bernard Rackham, *Islamic Pottery and Italian Maiolica* (London, 1959), no. 34b, p. 143, pl. 231; Morley-Fletcher and McIlroy, *European Pottery*, p. 52, fig. 7; "Acquisitions/1984," *GettyMusJ* 13 (1985), no. 172, p. 243, illus.; Hess, *Maiolica*, no. 22, pp. 69–71; David H. Cohen and Catherine Hess, *Looking at European Ceramics: A Guide to Technical Terms* (Malibu and London, 1993), p. 92, illus. inside back cover; Bremer-David, *Summary*, no. 351, p. 204, illus.; *Masterpieces*, no. 4, p. 11, illus.

360.

TWO JARS

Jar .1: with a Lame Peasant; Jar .2: with a
Woman and Geese
Deruta or Montelupo, early sixteenth century
Tin-glazed earthenware
Marked on the back of each jar, *B°*.
Height (each): 9 ³/₄ in. (24.8 cm); Diameter
(at lip): 5 ¹/₁₆ in. (12.9 cm); Jar .1: Maximum
Width: 6 ¹/₄ in. (15.9 cm); Jar .2: Maximum
Width: 6 ⁵/₈ in. (16.8 cm)
Accession number 84.DE.112.1–.2

PROVENANCE

J. Pierpont Morgan, Sr. (1837–1913), New
York, passed to Duveen, 1916; [Duveen Broth-
ers, New York, sold to J. E. Widener, 1916];
Joseph E. Widener, Elkins Park, Pennsylvania
(sold, Samuel T. Freeman and Co., Philadel-
phia, June 20, 1944, lots 326–327); [French
and Co., New York]; Dr. Robert Bak, New
York, as of 1957 (sold, Sotheby's, London,
December 7, 1965, lot 54, to "Goldbaum");
Goldbaum; Benjamin Sonnenberg, New York
(sold, Sotheby's, New York, June 5, 1979, lot
356); [Rainer Zietz, Ltd., London].

EXHIBITIONS

Purportedly in the Metropolitan Museum
of Art, New York, 1913–1916; Los Angeles
County Museum of Art, *Italian Renaissance
Maiolica from the William A. Clark Collection*,
March 5–May 17, 1986.

BIBLIOGRAPHY

Bernard Rackham, "A New Chapter in the
History of Italian Maiolica," *Burlington Maga-
zine* 27 (May 1915), p. 50; *Inventory of the Objets
d'Art at Lynnewood Hall, Elkins Park, Estate of the
Late P. A. B. Widener* (privately printed, Phila-
delphia, 1935), pp. 67–68; Mario Bellini and
Giovanni Conti, *Maioliche italiane del rinascimento*
(Milan, 1964), p. 100, pls. A, C; Jörg Ras-
mussen, *Italienische Majolika* (Hamburg, 1984),
pp. 84, 86; "Acquisitions/1984," *GettyMusJ* 13
(1985), no. 163, p. 241, illus.; Hess, *Maiolica*,
no. 24, pp. 75–81; Bremer-David, *Summary*,
no. 352, pp. 204–205, illus. p. 204.

361.

PLATE WITH CUPID ON A HOBBYHORSE

Possibly Urbino area, Venice, or Pesaro,
circa 1510–1520
Tin-glazed earthenware
Height: ¹⁵/₁₆ in. (2.4 cm); Diameter: 9 ¹/₄ in.
(23.5 cm)
Accession number 84.DE.116

PROVENANCE

Alessandro Castellani, Rome (sold, Hôtel
Drouot, Paris, May 27, 1878, lot 34, to
"Fanien"); Fanien; [Duveen Brothers, Paris
(stock no. 3275), 1914–1916, transferred to
Duveen Brothers, New York, 1916 (stock no.
25892), sold 1923 to A. Seligmann, Rey and
Co.]; [Arnold Seligmann, Rey and Co., New
York]; Charles Damiron, Lyons (sold, Sotheby's,
London, June 16, 1938, lot 60, to M. and R.
Stora); [M. and R. Stora, Paris]; Luzarche
d'Azay, Paris (sold, Palais Galliera, Paris,
December 6, 1962, lot 24); Robert Strauss,
England (sold, Christie's, London, June 21,
1976, lot 22); [Cyril Humphris, London];
[Rainer Zietz, Ltd., London].

BIBLIOGRAPHY

Bernard Rackham, "The Damiron Collection,"
Apollo 25 (1937), p. 256, fig. 7; Joseph Chom-
pret, *Répertoire de la majolique italienne*, vol. 2
(Paris, 1949), pl. 13, fig. 93; *Christie's Review of
the Season 1975* (London and New York, 1976),
p. 396; Morley-Fletcher and McIlroy, *European
Pottery*, p. 66, fig. 3; "Acquisitions/1984," *Get-
tyMusJ* 13 (1985), no. 174, p. 243, illus.; Hess,
Maiolica, no. 29, pp. 29–31; Bremer-David,
Summary, no. 353, p. 205, illus.

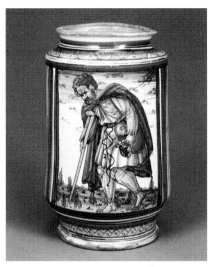

360 *Lame Peasant*

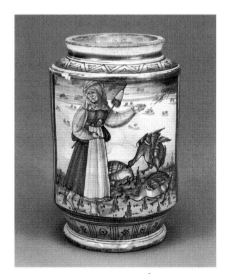

360 *Woman and Geese*

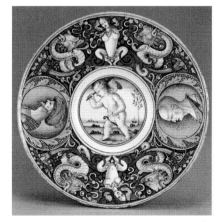

361

362.

DISH WITH AMATA AND TURNUS

Probably Faenza, circa 1515–1525
Tin-glazed earthenware
Marked on the underside with a crossed circle with a smaller circle in each of the four quarters.
Height: 2 1/8 in. (5.4 cm); Diameter: 9 11/16 in. (24.6 cm)
Accession number 84.DE.106

PROVENANCE

Sold, Sotheby's, London, November 21, 1987, lot 42, to R. Zietz; [Rainer Zietz, Ltd., London].

BIBLIOGRAPHY

"Acquisitions/1984," *GettyMusJ* 13 (1985), no. 164, p. 241, illus.; Hess, *Maiolica*, no. 18, pp. 58–60; Bremer-David, *Summary*, no. 354, p. 205, illus.

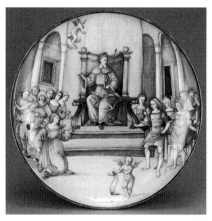

362

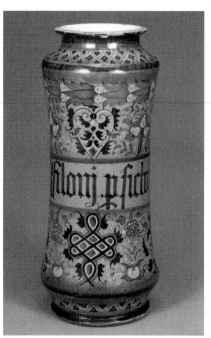

363

PROVENANCE

[M. and R. Stora, Paris, acquired by W. Warren]; Whitney Warren, New York, by inheritance to his widow, New York (sold, Parke-Bernet, New York, October 7, 1943, lot 418); (sold, Sotheby's, London, November 22, 1983, lot 197); [Rainer Zietz, Ltd., London].

BIBLIOGRAPHY

"Acquisitions/1984," *GettyMusJ* 13 (1985), no. 166, p. 242, illus.; Hess, *Maiolica*, no. 25, pp. 82–84; Bremer-David, *Summary*, no. 355, p. 206, illus.

363.

DRUG JAR FOR PERSIAN PHILONIUM

Faenza, circa 1520–1540
Tin-glazed earthenware
Painted with *FILONIJ P[ER]SICHI* on the banderole label.
Height: 1 ft. 2 9/16 in. (37 cm); Diameter (at lip): 4 15/16 in. (12.5 cm); Maximum Width: 6 1/2 in. (16.5 cm)
Accession number 84.DE.105

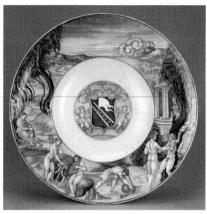

364

PROVENANCE

Ralph Bernal, London (sold, Christie's, London, March 5, 1855, lot 1767, to "Wareham" for Baron Gustave de Rothschild); Baron Gustave (Samuel James) de Rothschild (1829–1911), London; (sold, Christie's, London, April 12, 1976, lot 179, pl. 13); [Rainer Zietz, Ltd., London].

BIBLIOGRAPHY

Morley-Fletcher and McIlroy, *European Pottery*, p. 65, fig. 8; "Acquisitions/1984," *GettyMusJ* 13 (1985), no. 175, p. 243, illus.; Hess, *Maiolica*, no. 30, pp. 97–100; David H. Cohen and Catherine Hess, *Looking at European Ceramics: A Guide to Technical Terms* (Malibu and London, 1993), p. 10, illus.; Bremer-David, *Summary*, no. 356, p. 206, illus.; *Masterpieces*, no. 14, p. 22, illus.

365.

LUSTERED ARMORIAL PLATE

Gubbio, 1524
From the workshop of Giorgio di Pietro Andreoli, called Maestro Giorgio
Tin-glazed earthenware with silver luster
Signed and dated M° G° 1524 on the reverse.
Height: 2 7/8 in. (7.3 cm); Diameter: 1 ft. 3 11/16 in. (39.9 cm)
Accession number 84.DE.111

364.

ARMORIAL DISH WITH THE FLAYING OF MARSYAS

Urbino, mid-1520s
By Nicola di Gabriele Sbraghe (or Sbraga), known as Nicola da Urbino
Tin-glazed earthenware
Height: 2 1/4 in. (5.7 cm); Diameter: 1 ft. 4 5/16 in. (41.4 cm)
Accession number 84.DE.117

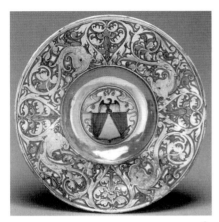

365

PROVENANCE

Sold, Sotheby's, London, November 21, 1978, lot 41, to C. Humphris; [Cyril Humphris, London]; [Rainer Zietz, Ltd., London].

BIBLIOGRAPHY

"Acquisitions/1984," *GettyMusJ* 13 (1985), no. 173, p. 243, illus.; Hess, *Maiolica*, no. 23, pp. 72–74; Bremer-David, *Summary*, no. 357, pp. 206–207, illus. p. 206; Pietro Mattei and Tonina Cecchetti, *Mastro Giorgio: L'uomo, l'artist, l'imprenditore* (Perugia, 1995), p. 181.

366.
PLATE WITH *HERO AND LEANDER*
 Faenza, circa 1525
 Tin-glazed earthenware
 Marked with a swan on the reverse.
 Height: 1 1/2 in. (3.8 cm); Diameter:
 1 ft. 5 5/16 in. (44 cm)
 Accession number 84.DE.113

PROVENANCE

Henri Gautier, Paris (sold, Hôtel Drouot, Paris, May 4, 1929, no. 28, to G. Durlacher); [Durlacher Bros., London] (sold, Christie's, London, April 6–7, 1938, lot 26, to H. S. Reitlinger); Henry S. Reitlinger, Maidenhead (sold by his executors, Sotheby's, London, April 27, 1959, lot 142, to R. Strauss); Robert Strauss, London (sold, Christie's, London, June 21, 1976, lot 24); [Rainer Zietz, Ltd., London].

BIBLIOGRAPHY

Joseph Chompret, *Répertoire de la majolique italienne*, vol. 2 (Paris, 1949), fig. 458; *Christie's Review of the Season 1975* (London and New York, 1976), p. 397; Morley-Fletcher and McIlroy, *European Pottery*, p. 36, fig. 5; "Acquisitions/1984," *GettyMusJ* 13 (1985), no. 165, p. 241, illus.; Hess, *Maiolica*, no. 26, pp. 85–87; Bremer-David, *Summary*, no. 358, p. 207, illus.

366

367.
PLATE WITH *THE ABDUCTION OF HELEN*
 Urbino, 1534
 By Francesco Xanto Avelli
 Tin-glazed earthenware
 Dated and inscribed on the reverse,
 .M.D.XXXIIII / *Quest'è'l pastor che mal mirò l bel/ volto / D'Helena Greca, e, quel famoso rapto / pel qual fu'l mondo sotto sopra volto. / .Fra[ncesco]:Xa[n]to. A[velli]./da Rovigo, i[n]/Urbino.*
 Height: 2 1/2 in. (6.3 cm); Diameter:
 1 ft. 6 1/8 in. (46.1 cm)
 Accession number 84.DE.118

PROVENANCE

Sold, Sotheby's, London, November 21, 1978, lot 44) [Rainer Zietz, Ltd., London].

367

EXHIBITIONS

London, P. and D. Colnaghi and Co., *Objects for a "Wunderkammer,"* 1981, no. 65, pp. 124–125.

BIBLIOGRAPHY

Christie's Review of the Season 1975 (London and New York, 1976), p. 397; "Acquisitions/ 1984," *GettyMusJ* 13 (1985), no. 176, p. 243, illus.; *Handbook 1986*, p. 184, illus.; Hess, *Maiolica*, no. 31, pp. 101–103; Gian Carlo Bojani, *Ceramiche nelle Marche* (Bergamo, 1988), p. 129; Bremer-David, *Summary*, no. 359, p. 207, illus.; P. Roseo, "Gli istoriati della collezione Doria-Pamphilj," *CeramicAntica* 5 (November 1995), fig. 19.

368.
DISH WITH *SAINT CLARE*
 Faenza, circa 1535
 By Baldassare Manara
 Tin-glazed earthenware
 Obverse is painted with a shield containing a holy cross flanked by M and C below annulets; inscribed on the scroll *PETRE DILIGIS ME* and signed on the reverse, *Baldasara Manara fa[e]n[tino]* or *Baldasara Manara fa[e]n[za].*
 Height: 1 1/2 in. (3.8 cm); Diameter: 8 7/16 in. (21.5 cm)
 Accession number 84.DE.107

368

369

370.

JUG WITH A MUSICAL THEME
Faenza, 1536
Tin-glazed earthenware
Dated 1536 on each of four tablets under the medallions and marked *Elixeo* beside a bearded and turbaned old man.
Height: 1 ft. ¹³/₁₆ in. (32.5 cm); Diameter (at lip): 5¹/₄ in. (13.3 cm); Maximum Width: 10¹/₄ in. (26 cm)
Accession number 84.DE.115

PROVENANCE
Alessandro Castellani, Rome (sold, Hôtel Drouot, Paris, May 27–29, 1878, lot 230); J. Pierpont Morgan, Sr. (1837–1913), New York, passed to Duveen, 1916; [Duveen Brothers, New York, sold to C. W. Hamilton, 1919]; Carl W. Hamilton, New York, at least until 1936; George R. Hann, Sewickley Heights, Pennsylvania (sold, Christie's, on the Hann premises, Treetops, Sewickley Heights, May 19, 1980, lot 91, to R. Zietz); [Rainer Zietz, Ltd., London].

PROVENANCE
[M. and R. Stora, Paris, acquired by C. Damiron]; Charles Damiron, Lyons (sold, Sotheby's, London, June 16, 1938, lot 20, to "Recher"); Recher; Paul Damiron (sold, Sotheby's, London, November 22, 1983, lot 209); [Rainer Zietz, Ltd., London].

EXHIBITIONS
Los Angeles County Museum of Art, *Italian Renaissance Maiolica from the William A. Clark Collection*, March 5–May 17, 1986.

BIBLIOGRAPHY
Charles Damiron, *Majoliques italiennes* (privately printed, 1944), no. 79; Joseph Chompret, *Répertoire de la majolique italienne*, vol. 1 (Paris, 1949), p. 77, illus. p. 2, fig. 500; *Art at Auction: The Year at Sotheby's* (London, 1983–1984), p. 290; "Acquisitions/ 1984," *GettyMusJ* 13 (1985), no. 167, p. 242, illus.; Hess, *Maiolica*, no. 19, pp. 61–63; Carmen Ravanelli Guidotti, "Da un'idea di Giuseppe Liverani, la proposta per una monografia su 'Baldassare Manara figulo faentino del XVI secolo,'" *Faenza* 77 (1991), figs. XXIXD, XXXVID, XXXVIIIE, XLIA; Bremer-David, *Summary*, no. 360, p. 208, illus.; Carmen Ravanelli Guidotti, *Baldassare Manara Faentino, pittore di maioliche nel Cinquecento* (Ferrara, 1996), pp. 206–209, figs. 34a, b, c, f.

369.

MOLDED DISH WITH AN ALLEGORY OF LOVE
Faenza, circa 1535
Tin-glazed earthenware
Height: 2⁷/₈ in. (7.3 cm); Diameter: 11 in. (28 cm)
Accession number 84.DE.114

PROVENANCE
Prince Thibaut d'Orléans, Paris (sold, Sotheby's, London, February 5, 1974, lot 30); [Rainer Zietz, Ltd., London].

BIBLIOGRAPHY
"Acquisitions/1984," *GettyMusJ* 13 (1985), no. 168, p. 242, illus.; Hess, *Maiolica*, no. 27, pp. 88–90; David H. Cohen and Catherine Hess, *Looking at European Ceramics: A Guide to Technical Terms* (Malibu and London, 1993), p. 62, illus.; Bremer-David, *Summary*, no. 361, p. 208, illus.

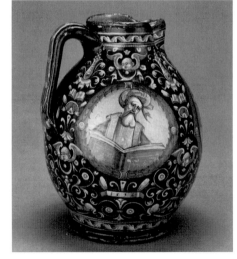

370

EXHIBITIONS

New York, The Metropolitan Museum of
Art, 1913–1916; San Francisco, California
Palace of the Legion of Honor, *A Group of
Old Masters, Renaissance Italian Furniture, Majolica
Vases and Other Art Objects from the Collection of
Carl W. Hamilton*, New York, September 1, 1927–
January 6, 1928, no. 11, p. 15, illus.

BIBLIOGRAPHY

*Guide to the Loan Exhibition of the J. Pierpont
Morgan Collection*, Metropolitan Museum of
Art (New York, 1914), pp. 56–57, illus.;
"Acquisitions/1984," *GettyMusJ* 13 (1985), no.
169, p. 242, illus.; Hess, *Maiolica*, no. 28,
pp. 91–93; Bremer-David, *Summary*, no. 362,
pp. 208–209, illus. p. 208; Carmen
Ravanelli Guidotti, *Thesaurus di opere della
tradizione di Faenza* (Faenza, 1998), pp. 289–
290, fig. 20.

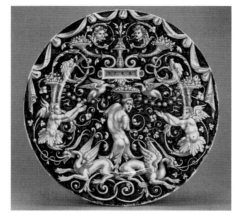

371

BIBLIOGRAPHY

Joseph Marryat, *A History of Pottery and Porcelain*
(London, 1857), p. 34, fig. 18; C. Drury E.
Fortnum, *Descriptive Catalogue of the Maiolica,
Hispano-Moresco, Persian, Damascus, and Rhodian
Wares in the South Kenington Museum* (London,
1873), p. 596; *Christie's Review of the Season 1975*
(London and New York, 1976), p. 400; Mor-
ley-Fletcher and McIlroy, *European Pottery*,
p. 86, fig. 1; "Acquisitions/ 1984," *GettyMusJ*
13 (1985), no. 178, p. 244, illus.; Hess,
Maiolica, no. 33, pp. 108–111; Giovanni
Conti and Gilda Cefariello Grosso, *La
Maiolica Cantagalli e le manufatture ceramiche fioren-
tine* (Rome, 1990), fig. 54; Bremer-David,
Summary, no. 363, p. 209, illus.; Pierre-Alain
Mariaux, *La Majolique, La Faïence Italienne et
son Décor* (Geneva, 1995), p. 82, illus.; Luca
Melegati, *Ceramica* (Milan, 1996), p. 42; *Mas-
terpieces*, no. 16, pp. 24–25, illus.

371.

PLATE WITH GROTESQUES

Venice, circa 1540–1560
Tin-glazed earthenware
Marked on the obverse *S.P.Q.R.*
Height: 2 1/4 in. (5.7 cm); Diameter:
1 ft. 6 3/4 in. (47.7 cm)
Accession number 84.DE.120

PROVENANCE

Collection of Victoria, Queen of England
(1819–1901), London, until at least 1857;
Robert Strauss, England (sold, Christie's,
London, June 21, 1976, lot 52); [Rainer Zietz,
Ltd., London].

EXHIBITIONS

On loan to the Victoria and Albert (South
Kensington) Museum, London, by 1873.

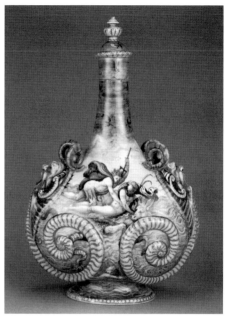

372

372.

PILGRIM FLASK WITH MARINE SCENES

Urbino, circa 1565–1570
From the Fontana workshop (possibly
Orazio)
Tin-glazed earthenware
Height: 1 ft. 5 3/8 in. (44.1 cm); Maximum
Width: 11 3/4 in. (28.6 cm)
Accession number 84.DE.119.1–.2

PROVENANCE

Thomas F. Flannery, Jr. (1926–1980),
Winnetka, Illinois; by inheritance to his
widow, Joanna Flannery, Winnetka, Illinois
(sold, Sotheby's, London, November 22, 1983,
lot 160, to E. Lubin); [Edward Lubin, New
York, sold to R. Zietz]; [Rainer Zietz, Ltd.,
London].

BIBLIOGRAPHY

"Acquisitions/1984," *GettyMusJ* 13 (1985),
no. 177, pp. 243–244, illus.; Hess,
Maiolica, no. 32, pp. 104–107; Bremer-David,
Summary, no. 364, p. 209, illus.

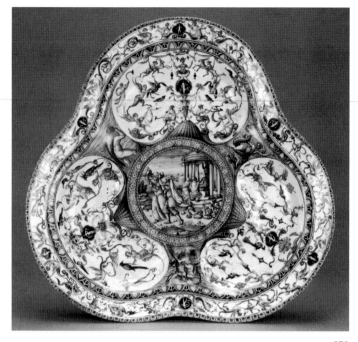

373

373.
BASIN WITH DEUCALION AND PYRRHA
Urbino, 1565–1575
From the Fontana workshop (Orazio or Flaminio)
Tin-glazed earthenware
Height: $2\,^1/_2$ in. (6.3 cm); Diameter:
1 ft. $6\,^1/_4$ in. (46.3 cm)
Accession number 86.DE.539

PROVENANCE
Baron Adolphe (Carl) de Rothschild (1823–1900), Paris, between 1870 and 1890; by inheritance to Baron Maurice (Edmond Charles) de Rothschild (1881–1957), Paris, sold to Duveen, 1913/1914; [Duveen Brothers, New York; sold to N. Simon, 1965]; Norton Simon Foundation, Fullerton (sold, Parke-Bernet, New York, 1971, lot 81); private collection, Stuttgart (sold, Reimann and Monatsberger, Stuttgart, January 1986); [Alain Moatti, Paris].

EXHIBITIONS
Los Angeles County Museum of Art, *Italian Renaissance Maiolica from the William A. Clark Collection*, March 5–May 17, 1986.

BIBLIOGRAPHY
Antiquitäten-Zeitung 25 (1985), p. 611; "Acquisitions/1986," *GettyMus J* 15 (1987), no. 114, p. 216, illus.; Hess, *Maiolica*, no. 34, pp. 112–115, illus.; Bremer-David, *Summary*, no. 365, p. 210, illus.; Pierre-Alain Mariaux, *La Majolique, La Faience Italienne et son Décor* (Geneva, 1995), p. 130, illus.; *Masterpieces*, no. 13, p. 21, illus., detail on p. 20; *Handbook* 2001, p. 243, illus.

374.
PILGRIM FLASK
Florence, 1580s
Medici porcelain manufactory
Soft-paste porcelain
Marked on the underside with the dome of Santa Maria del Fiore accompanied by an F; a mark resembling a 3 is scratched under the glaze and painted with blue glaze; on the rim, three hatch marks were inscribed before glaze firing.
Height: $10\,^3/_8$ in. (26.4 cm); Diameter (at lip): $1\,^9/_{16}$ in. (4 cm); Maximum Width: $7\,^7/_8$ in. (20 cm)
Accession number 86.DE.630

PROVENANCE
William Blundell Spence, Florence, sold to A. Foresi, 1857; Alessandro Foresi, Florence, sold to G. Freppa; [Giovanni Freppa, Florence, sold to E. Piot]; Eugène Piot, Paris (sold, Hôtel des Comissaires-Priseurs, Paris, March 19, 1860, no. 82, to M. A. de Rothschild); Baron (Mayer) Alphonse de Rothschild (1827–1905), Paris; by inheritance to Baron Edouard (Alphonse James) de Rothschild (1868–1949), Paris, appears to have been confiscated from Rothschild's collection by the Nazis and then restituted after the war by the French government; by inheritance to Baron Guy (Edouard Alphonse Paul) de Rothschild (born 1909) and Baronne Marie-Hélène de Rothschild (1927–1996), Paris; [Curarrow Corporation N. V., Curaçaio, Antilles].

EXHIBITIONS
Paris, *Exposition rétrospective du Trocadéro*, 1878.

BIBLIOGRAPHY
Albert Jacquemart, "La porcelaine des Médicis," *Gazette des beaux-arts* 3 (December 1859), p. 276; Albert Jacquemart and Edmond Le Blant, *Histoire artistique: Industrielle et commerciale de la porcelaine* (Paris, 1862), p. 644, no. 5;

374

Alessandro Foresi, *Sulle porcellane medicee* (Florence, 1869), pp. 15ff., 29, reprint from Piovani Arlotto (July 1859); Alfred Darcel, "Les faïences français et les porcelaines au Trocadéro," *Gazette des beaux-arts* 18 (November 1878), p. 762; Jean Charles Davillier, *Les Origines de la porcelaine en Europe* (Paris, 1882), no. 29, pp. 39–41, 114–115; Charles de Grollier, *Manuel de l'amateur de porcelaine* (Paris, 1914), no. 2309; Seymour de Ricci, "La porcelaine des Medicis," *Faenza, Museo Internazionale delle Ceramiche: L'opera d'un decennio, 1908–1918* (Faenza, 1918), p. 29, no. 22; Giuseppe Liverani, *Catalogo delle porcellane dei Medici* (Faenza, 1936), no. 28, p. 31; Arthur Lane, *Italian Porcelain* (London, 1954), p. 5, pl. 3c; "Acquisitions/1986," *GettyMus J* 15 (1987), no. 115, pp. 216–217, illus.; Clare le Corbeiller, "A Medici Porcelain Pilgrim Flask," *GettyMus J* 16 (1988), pp. 119–126, illus.; Hess, *Maiolica*, no. 36, pp. 120–123, illus.; Bremer-David, *Summary*, no. 366, pp. 210–211, illus. p. 210; Pierre-Alain Mariaux, *La Majolique, La Faïence Italienne et son Décor* (Geneva, 1995), p. 118; Peter Thornton, *Form and Decoration: Innovation in the Decorative Arts 1470–1870* (London, 1998), pl. 47; *Masterpieces*, no. 18, p. 27, illus.; *Handbook 2001*, p. 244, illus.

375.
PAIR OF DRUG JARS
 Jar .1: Drug Jar for Mithridatum; Jar .2: Drug Jar for Theriac
 Northern Italy (possibly Milan), circa 1580

Attributed to Annibale Fontana
Terracotta with white paint; gilt exterior and lead-glazed interior
Height: 1 ft. 11 ³/₅ in. (60 cm); Maximum Width: 1 ft. 3 ¹/₂ in. (39.4 cm)
Accession number 90.SC.42.1–.2

PROVENANCE
[Maria Tazzoli, London]; [Siran Holding Co., Geneva].

BIBLIOGRAPHY
"Acquisitions/1990," *GettyMus J* 19 (1991), no. 57, p. 164, illus.; Bremer-David, *Summary*, no. 367, p. 211, illus.; *Masterpieces*, no. 15, p. 23, illus.; Peter Fusco, *Summary Catalogue of European Sculpture in the J. Paul Getty Museum* (Los Angeles, 1997), p. 23, illus.

375 Jar .1

375 Jar .2

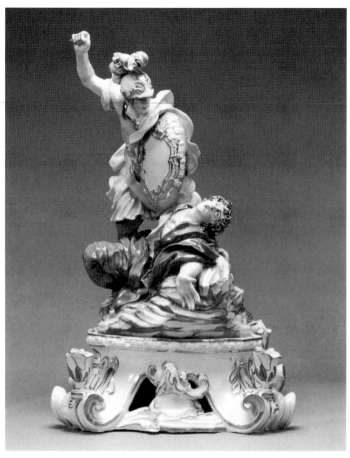

376 *Mercury and Argus*

376 *Perseus and Medusa*

376.

PAIR OF CANDELABRA
Candelabra .1: with Mercury and Argus;
Candelabra .2: with Perseus and Medusa
Doccio, circa 1750
Ginori manufactory, called Doccia
By Gasparo Bruschi after a model by
Giovanni Battista Foggini
Partially gilt hard-paste porcelain
Undersides marked l and ll, respectively.
Height: 1 ft. 1 3/4 in. (35 cm); Width:
11 7/16 in. (29 cm); Depth: 8 1/4 in. (20.1 cm)
Accession number 94.SE.76.1–.2

PROVENANCE
Private collection, England; [Daniel Katz,
Ltd., London, sold to A. Moatti]; [Alain
Moatti, Paris].

BIBLIOGRAPHY
"Acquisitions/1994," *GettyMusJ* 23 (1995),
no. 101, p. 122, illus.; Luca Melegati, "Scul-
tura e porcellana nella manifattura di Doccia,"
Ceramic Antica (Ferrara, 1996), vol. 6, no. 2,
pp. 26–37, figs. 1a, b and 2a, b; *Master-
pieces*, no. 64, p. 84, illus. (94.SE.76.2); Peter
Fusco, *Summary Catalogue of European Sculpture in
the J. Paul Getty Museum* (Los Angeles, 1997),
p. 22, illus.

377.

TABLETOP WITH HUNTING SCENES
Castelli, circa 1760
By Francesco (or Filippo) Saverio Maria
Grue, called Saverio Grue
Tin-glazed earthenware
Inscribed on the obverse, in two cartouches,
*FLAVA CERES TENUS SPICIS REDEMITA
CAPILLOS* and *FORTUNAE SUAE
QUISQUE FABER*; signed on the horse's
haunch in scene of Europeans hunting a
deer, *SG*; and signed on the horse's haunch in
scene of Moors hunting ostriches, *FSG*.
Height: 1 1/4 in. (3.2 cm); Diameter:
1 ft. 11 1/2 in. (59.7 cm)
Accession number 86.DE.533

PROVENANCE

Most likely acquired in Italy and brought to Warwick Castle, Warwickshire, England, by George Greville, 2nd Earl of Warwick (1746–1816), or his son Henry Greville, 3rd Earl of Warwick (1779–1853); removed from Warwick Castle and placed in another residence of the Earls of Warwick; by inheritance to David Greville, 8th Earl of Warwick, Warwickshire (sold, Sotheby's, London, March 4, 1986, lot 24, to W. Williams); [Winifred Williams, Ltd., London].

BIBLIOGRAPHY

Jacqueline Guillaumin, "Majoliques tardives: à prospecter," *Connaissance des arts* 419 (1987), p. 12, fig. 4; "Acquisitions/1986," *GettyMusJ* 15 (1987), no. 116, p. 217, illus.; Guido Donatone, "Pasquale Criscuolo e la Maiolica Napoletana dell'Età Rococò," *Centro Studi per la Storia della Ceramica Meridionale: Quaderno* (1988), fig. 1; Hess, *Maiolica*, pp. 116–119, illus.; Catherine Hess, "Una maiolica di Saverio Grue al Paul Getty Museum, Malibu," *Semestrale del Museo delle Ceramiche* 1, no. 2 (July–December 1989), pp. 17–28; Bremer-David, *Summary*, no. 368, no. 368, p. 212, illus.; *Masterpieces*, no. 66, p. 87, illus.

378.

PAIR OF VASES

Vase .1: Vase with Neptune; Vase .2: Vase with an Allegory of Venice
Venice, 1769
Manufactory of Geminiano Cozzi
Hybrid soft-paste porcelain
Vase .2 is inscribed and dated *Primo Esperimento in Grande fatto li 15 Maggio 1769 Nella Privil[egiata] fabbrica di Geminiano Cozzi in Canalregio*; it also bears the Cozzi manufactory mark—an anchor—on one side.
Vase .1: Height: 11 13/16 in. (30 cm); Diameter: 10 1/2 in. (26.7 cm); .Vase 2: Height: 11 3/4 in. (29.8 cm); Diameter: 10 3/4 in. (27.3 cm)
Accession number 88.DE.9.1–.2

PROVENANCE

Centanini, Venice, by 1889; private collection, Budapest, until the end of the 1930s, and then stored in Switzerland during World War II; recovered by the owners after World War II and brought to Rome; by inheritance in the same family, Rome, sold to E. de Unger, 1988; [Edmund de Unger, The Manor House, Surrey].

EXHIBITIONS

Rome, Museo Artistico-Industriale, *Atre ceramica e vetraria*, IV Esposizione 1889, Raffaele Erculei, ed., see U. de Gheltof, "Note storiche ed artistiche sulla ceramica italiana," p. 151.

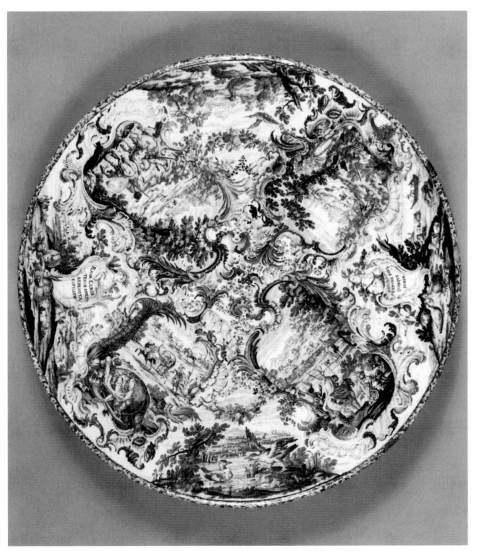

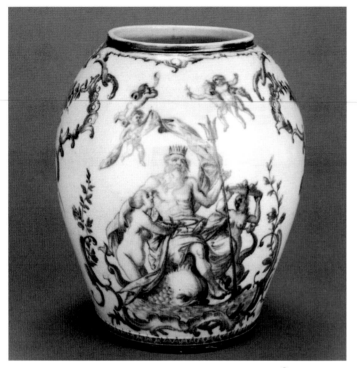

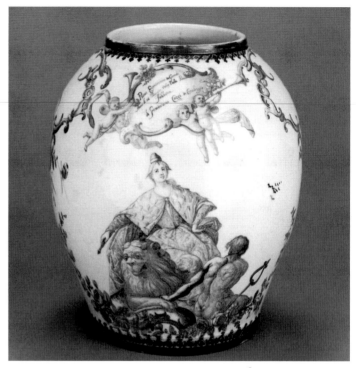

378 *Vase with Neptune*

378 *Vase with an Allegory of Venice*

BIBLIOGRAPHY

Alessandra Mottola Molfino, *L'Arte della porcel-lana in Italia* (Milan, 1976), p. 27; Francesco Stazzi, *Le porcellane veneziane di Geminiano e Vincenzo Cozzi* (Venice, 1982), p. 53; "Acquisitions/ 1988," *GettyMusJ* 17 (1989), no. 85, p. 146, illus.; *Sotheby's Concise Encyclopedia of Porcelain*, David Battie, ed. (London, 1990), pp. 9–10; Catherine Hess, "'Primo Esperimento in Grande': A Pair of Vases from the Factory of Geminiano Cozzi," *GettyMusJ* 18 (1990), pp. 141–156, illus.; Bremer-David, *Summary*, no. 369, p. 213, illus.; *Handbook* 2001, pp. 266–267, illus. (88.DE.9.2).

379.
SKETCH FOR A FIREPLACE OVERMANTEL
Rome, circa 1789
By Francesco Antonio Franzoni
Terracotta
Height: 1 ft. 9 1/16 in. (53.5 cm); Width:
1 ft. 4 3/4 in. (42.5 cm)
Accession number 95.SC.77

PROVENANCE

Purportedly from the workshop of Giuseppe Valadier, Rome; private collection, Germany; [Trinity Fine Art, Ltd., London].

EXHIBITIONS

New York, Newhouse Galleries, *Old Master Drawings and European Works of Art*, May 4– May 18, 1995, no. 113, pp. 212–213.

BIBLIOGRAPHY

Rosella Carloni, "Francesco Antonio Fran-zoni tra virtuosismo tecnico e restauro integra-tivo," *Labyrinthos* 19/20, 1991, pp. 190 and 211; Rosella Carloni, "Francesco Antonio Franzoni: Il Camino Braschi," *Antologia di Belle Arti: Il Neoclassico*, vol. IV (Turin, 1993), pp. 67–70, fig. 1; "Acquisitions/1995," *GettyMusJ* 24 (1996), no. 90, p. 139, illus.

379

380.

SAINT JOSEPH WITH THE CHRIST CHILD
Naples, 1790s
Attributed to Gennaro Laudato, after a model
by Giuseppe Sanmartino
Lead-glazed white-bodied earthenware
(*terraglia*)
Height: 1 ft. 9 3/4 in. (54.3 cm); Maximum
Width: 8 1/8 in. (20.6 cm)
Accession number 91.SE.74

PROVENANCE

Possibly William Charlesworth, Naples (sold,
Galleria Sangiorgi, Rome, January 28–Febru-
ary 3, 1901, no. 631); Bauzà, Madrid, by
1953, sold to Same Art, Ltd., 1990; [Same
Art, Ltd., Zurich].

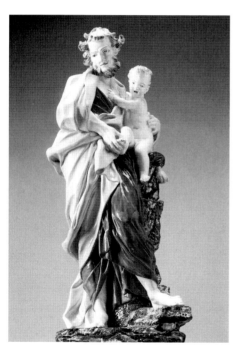

380

BIBLIOGRAPHY

"Acquisitions/1991," *GettyMusJ* 20 (1992),
no. 78, p. 179, illus.; Guido Donatone, *La
terraglia italiana* (Naples, 1991), fig. 4; Guido
Donatone, "Aggiunte a Gennaro Laudato
ed alla Produzione di Terraglia della Real
Fabbrica di Napoli," *Centro Studi per la Storia
della Ceramica Meridionale: Quaderno* 1995, p. 32,
fig. 4; 1996, pp. 49–50; *Masterpieces*, no. 70,
p. 91, illus.; Peter Fusco, *Summary Catalogue of
European Sculpture in the J. Paul Getty Museum*
(Los Angeles, 1997), p. 45, illus.; *Handbook*
2001, p. 261, illus.

Japanese

381.

GARNITURE OF THREE VASES
Japanese (Arita), first half of the eighteenth
century
Hard-paste porcelain, underglaze blue decora-
tion, polychrome enamel, gilding
Vase .1: Height: 1 ft. 5/8 in. (32.1 cm);
Diameter: 7 in. (17.8 cm); Vase .2: Height:
1 ft. 5/8 in. (31.1 cm); Diameter: 7 1/8 in.
(18 cm); Vase .3: Height: 1 ft. 1/4 in.

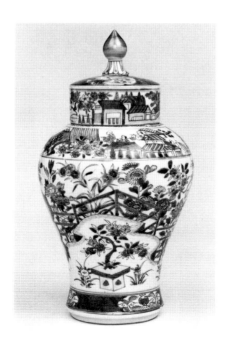

(32.4 cm); Diameter: 7 in. (17.8 cm)
Accession number 87.DE.26.1–.3

PROVENANCE

[Spink and Son, Ltd., London, 1986].

BIBLIOGRAPHY

"Acquisitions/1987," *GettyMusJ* 16 (1988),
no. 76, p. 179, illus.; Bremer-David,
Summary, no. 499, p. 287, illus.; Carolyn Sar-
gentson, *Merchants and Luxury Markets: The
Marchands Merciers of Eighteenth-Century Paris*
(London, 1996), p. 90, illus. p. 68, pl. 36.

Spanish

382.

TILE FLOOR
Spanish, Valencia region (probably Manises),
circa 1425–1450
Tin-glazed earthenware
Inscribed with *Speratens* and *ne oblyer* on the
hexagonal tiles; painted with a coat of arms,
of *barry of six argent and gules*, on the square tiles.
Length: 7 ft. 1 1/4 in. (220 cm); Width:
3 ft. 6 7/8 in. (110 cm); Square Tiles: Length:
4 7/16 in. to 4 7/8 in. (11.2 to 12.4 cm); Hexag-
onal Tiles: Length: 8 1/4 in. to 8 9/16 in. (21 to
21.8 cm); Width: 4 1/4 in. to 4 3/8 in. (10.8 to
11.1 cm)
Accession number 84.DE.747.1.a.–.4.j

PROVENANCE

[Luigi Grassi, Florence, before 1920,
acquired by R. Blumka, 1960]; [Ruth Blumka,
New York].

382

PROVENANCE

[Leonardo Lapiccirella, Florence]; (sold, Christie's, London, July 1, 1985, lot 270, to R. Zietz); [Rainer Zietz, Ltd., London].

EXHIBITIONS

Los Angeles County Museum of Art, *Italian Renaissance Maiolica from the William A. Clark Collection*, March 5–May 17, 1986.

BIBLIOGRAPHY

Giovanni Conti, *L'Arte della Maiolica in Italia* (Milan, 1973), pl. 8; *Apollo* 122 (1985), no. 5, p. 405; "Acquisitions/1985," *GettyMus J* 14 (1986), no. 214, p. 252, illus.; Hess, *Maiolica*, no. 2, pp. 14–15, illus.; David H. Cohen and Catherine Hess, *Looking at European Ceramics: A Guide to Technical Terms* (Malibu and London, 1993), p. 46, illus.; Bremer-David, *Summary*, no. 487, p. 280, illus.; *Masterpieces*, no. 1, p. 8, illus.; *Handbook* 2001, p. 236, illus.

EXHIBITIONS

Allentown Art Museum, *Beyond Nobility: Art for the Private Citizen in the Early Renaissance*, Ellen Callman, September 1980–January 1981, no. 122, pp. 115–116; Los Angeles County Museum of Art, *Maiolica from the William A. Clark Collection*, March 10–May 17, 1986.

BIBLIOGRAPHY

Anna Berendsen et al., *Tiles* (London, 1967), p. 76; "Acquisitions/1984," *GettyMus J* 13 (1985), no. 151, p. 239, illus.; Hess, *Maiolica*, no. 1, pp. 12–13, illus.; Bremer-David, *Summary*, no. 488, p. 281, illus.

383.
HISPANO-MORESQUE BASIN
Spanish, Valencia region (Manises), mid-fifteenth century
Tin-glazed earthenware
Ihs in the center of the obverse.
Height: 4¼ in. (10.8 cm); Diameter: 1 ft. 7½ in. (49.5 cm)
Accession number 85.DE.441

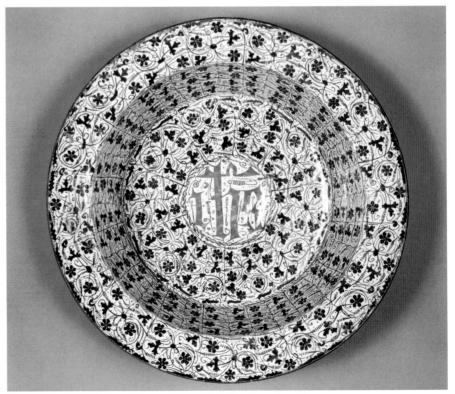

383

CLOCKS
German

384.
PLAQUE WITH JACOB CHOOSING RACHEL
TO BE HIS BRIDE
 Spanish (Alcora), circa 1755
 After Jacopo Amigoni
 Faïence
 Inscribed in cartouche: *En! Suis cum ovibus per-*
 pulchram Rachelem, quam propter servita sponsam
 Jacobus elegit.
 Height: 3 ft. 1 in. (94 cm); Width:
 1 ft. 6 3/4 in. (48 cm)
 Accession number 99.DE.10

PROVENANCE
Private collection, United States (sold, Hart
Galleries, Houston, September 20, 1997,
lot 602, to E. and H. Manners); [E. and H.
Manners, London].

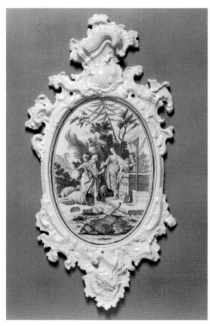

384

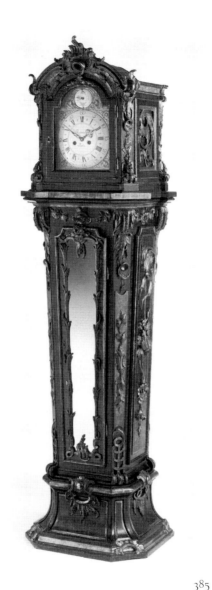

385

385.
LONG-CASE CLOCK
 Berlin, circa 1755
 Painted, silvered, and lacquered Scots pine
 and oak with limewood carvings; gilt bronze;
 mirror glass; enameled metal
 Dial is inscribed with *Rehnisch Berlin.*
 Height: 8 ft. 3 1/2 in. (252 cm); Width:
 2 ft. 5 1/2 in. (76 cm); Depth: 1 ft. 10 1/2 in.
 (57 cm)
 Accession number 86.DB.695

PROVENANCE
Michael Konig, Munich; [Alexander and
Berendt, Ltd., London, 1985].

BIBLIOGRAPHY
"Acquistions/1986," *GettyMusJ* 15 (1987),
no. 113, p. 215, illus.; Bremer-David, *Summary,*
no. 403, p. 233, illus.

386.
LONG-CASE MUSICAL CLOCK
 Neuwied, 1786
 Case by David Roentgen; the clock move-
 ment by Peter Kinzing; musical mechanism
 by Johann Wilhelm (Jean Guillaume) Weyl;
 mounts by François Rémond
 Ash, maple, oak and walnut veneered with
 maple and walnut; bronze; gilt-bronze
 mounts; enamel dial; glass; blued steel
 The movement is inscribed with *Roentgen &*
 Kinzing à Neuwied. Inside the chest of bellows
 is the penciled inscription *Jean Guillaume Weyl*
 Fait a Neuwied le 16 May 178 [?] No. 18.
 Height: 6 ft. 3 1/2 in. (192 cm); Width:
 2 ft. 1 1/2 in. (64 cm); Depth: 1 ft. 11 1/2 in.
 (54.5 cm)
 Accession number 85.DB.116

PROVENANCE
Edward Joseph, London (sold, Christie's,
London, May 1890, lot 374, to "Payne");
private collection, France; [Aveline et Cie,
Paris, 1984].

Italian

BIBLIOGRAPHY

Dietrich Fabian, *Kinzing und Roentgen Uhren aus Neuwied* (Bad Neustadt, 1984), no. 51, p. 235; "Acquisitions/1985," *GettyMusJ* 14 (1986), no. 208, p. 249, illus.; Bremer-David, *Summary*, no. 404, p. 233, illus.; Christian Baulez, "David Roentgen et François Rémond, une collaboration majeure dans l'histoire du mobilier européen," *L'Estampille /L'Objet d'art* 305 (September 1996) 96–118, fig. 21, p. 113; Wilson, *Clocks*, no. 20, pp. 132–139, illus.; *Masterpieces*, no. 96, p. 121, illus.

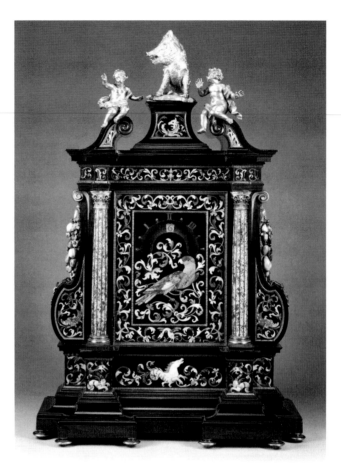

387

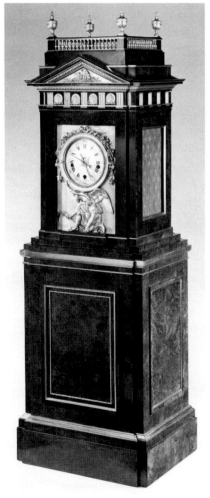

386

387.

NIGHT CLOCK

Florence, 1704/1705
Case and hardstone mosaics: Giovanni Battista Foggini and Leonard van der Vinne; bronze figures: attributed to Massimiliano Soldani; mechanism: Francesco Papillion
Ebony, gilt bronze, and semiprecious stones including chalcedony, jasper, lapis lazuli, and *verde d'Arno*
Signed *Francesco Papillion in Firenze* on the mechanism.
Height: 3 ft. 1 3/8 in. (95 cm); Width: 2 ft. 13/16 in. (63 cm); Depth: 11 in. (28 cm)
Accession number 97.DB.37

PROVENANCE
Private collection, Switzerland; [Bruno Scardeoni, Lugano].

BIBLIOGRAPHY
Handbook 2001, p. 262, illus.

FURNITURE

English
Cabinets

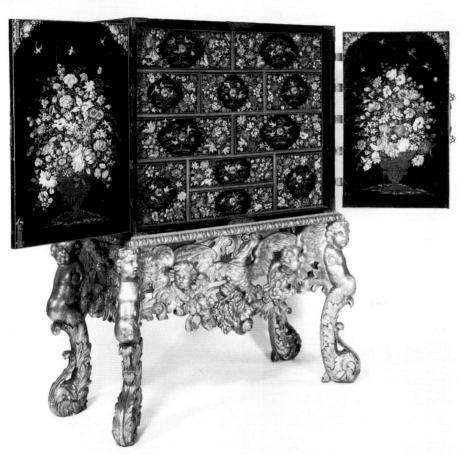

388

111 (June 1943), illus. p. 125; Horace Shipp, "A Home and Its Treasures: Mrs. Geoffrey Hart's Collection at Hyde Park Gardens," *Apollo* 62 (December 1955), illus. p. 181; R.W.P. Luff, "Oriental Lacquer and English Japan: Some Cabinets from the Collection of Mr. J. Paul Getty at Sutton Place, Surrey," *Antique Collector* (December 1962), pp. 256–261, illus. p. 259, fig. 5; Bremer-David, *Summary*, no. 469, p. 268, illus.

Seat Furniture

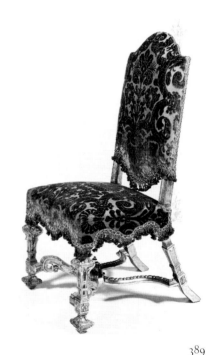

389

388.
CABINET ON STAND
 English, circa 1690–1700
 Painted, gessoed, and silvered wood; brass mounts
 Cabinet: Height: 2 ft. 8 1/2 in. (82.5 cm); Width: 3 ft. 1 in. (93.9 cm); Depth: 1 ft. 7 1/2 in. (49.5 cm); Stand: Height: 2 ft. 7 1/4 in. (79.3 cm); Width: 3 ft. 5 1/4 in. (104.7 cm); Depth: 1 ft. 11 1/2 in. (59.6 cm)
 Accession number 78.DA.117

PROVENANCE
Mrs. Geoffrey Hart, London; purchased by J. Paul Getty, 1961; distributed by the estate of J. Paul Getty to the J. Paul Getty Museum.

EXHIBITIONS
London, The Victoria and Albert Museum, *The Orange and the Rose: Holland and Britain in the Age of Observation, 1600–1750*, October 1964–January 1965, no. 220, p. 68; New York, The Cooper-Hewitt Museum and Pittsburgh, The Carnegie Museum, *Courts and Colonies: The William and Mary Style in Holland, England, and America*, November 1988–May 1989, no. 107, p. 157, illus.

BIBLIOGRAPHY
R.W. Symonds, "The City of Westminster and Its Furniture Makers," *Connoisseur* 100 (July 1937), pp. 3–9, illus. pp. 2, 9; R.W. Symonds, "The Age of Charles II," *Connoisseur*

389.
SIDE CHAIR
 London, late seventeenth century
 Gessoed and gilded walnut; modern upholstery
 Height: 3 ft. 10 in. (116.8 cm); Width: 1 ft. 10 1/2 in. (57.1 cm); Depth: 2 ft. 1 in. (63.5 cm)
 Accession number 75.DA.62

PROVENANCE
[Frederick Victoria, Inc., New York]; Nicolas
Landau, Paris; purchased by J. Paul Getty;
distributed by the estate of J. Paul Getty to
the J. Paul Getty Museum.

BIBLIOGRAPHY
Bremer-David, *Summary*, no. 470, p. 269, illus.

390.
PAIR OF ARMCHAIRS
London, circa 1740–1745
In the style of William Bradshaw
Gessoed and parcel-gilt pine; modern silk
upholstery
Height: 3 ft. 2 1/2 in. (97.9 cm); Width:
2 ft. 3 1/4 in. (69.3 cm); Depth: 2 ft. 7 3/8 in.
(79.7 cm)
Accession number 78.DA.96.1–.2

PROVENANCE
R.W. Miller (sold, Christie's, London, Janu-
ary 21, 1960, lot 43, to Pallot); [A. Cook,
London]; purchased by J. Paul Getty, 1960;
distributed by the estate of J. Paul Getty to
the J. Paul Getty Museum.

BIBLIOGRAPHY
Bremer-David, *Summary*, no. 471, p. 269, illus.

391

391.
ARMCHAIR
London, circa 1750–1760
Walnut with pine and oak; traces of gesso,
paint, gilding; remnants of original wool
upholstery
Height: 3 ft. 3 in. (99 cm); Width:
2 ft. 1 1/2 in. (64.7 cm); Depth: 2 ft. 1 in.
(63.5 cm)
Accession number 85.DA.120

PROVENANCE
David Garrick (?), London (1717–1779); an
upholsterer, outside Philadelphia; [Glenn
Randall, New York, 1984].

BIBLIOGRAPHY
"Acquisitions/1985," *GettyMusJ* 14 (1986),
no. 186, p. 240, illus.; Bremer-David, *Sum-
mary*, no. 472, p. 269, illus.

German
Cabinets, Caskets, and Commodes

392.
DISPLAY CABINET (*KABINETTSCHRANK*)
Augsburg, circa 1620–1630
Several carvings by Albert Janszoon
Vinckenbrinck
Ebony; pearwood; boxwood; walnut, chest-
nut; palm wood; marble; ivory; semiprecious
stones; tortoiseshell; snakeskin; enamel;
miniature painting
Height: 2 ft. 4 3/4 in. (73 cm); Width:
1 ft. 10 13/16 in. (58 cm); Depth: 1 ft. 11 1/4 in.
(59 cm)
Accession number 89.DA.28

PROVENANCE
Private collection, Sweden; [Jacques Kugel,
Paris, since the mid-1970s].

EXHIBITIONS
Paris, XIV' *Biennale des Antiquaires*, Septem-
ber 22–October 9, 1988; Los Angeles, J. Paul
Getty Museum, *Devices of Wonder*, Novem-
ber 13, 2001–February 3, 2002.

390 *One of a pair*

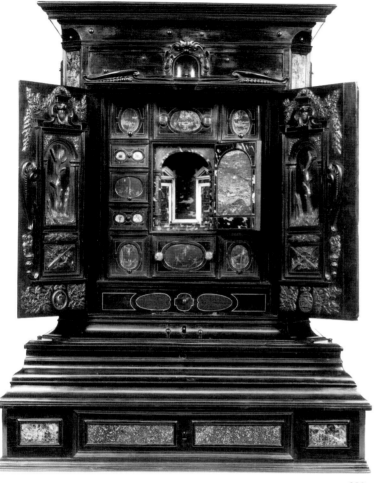

392

BIBLIOGRAPHY

Dieter Alfter, *Die Geschichte des Augsburger Kabinettschranks* (Augsburg, 1986), no. 23, pp. 69–70, pls. 56–58; "Acquisitions/1989," *GettyMusJ* 18 (1990), no. 58, pp. 196–197, illus.; Bremer-David, *Summary*, no. 393, p. 226, illus.; *Masterpieces*, no. 32, p. 45, illus.; *Handbook* 2001, p. 257, illus.

393.
CASKET

Southern German, circa 1680–1690
Wood veneered with brass, mother-of-pearl, pewter, copper, stained and painted horn, rosewood; gilt-bronze mounts
One foot is stamped with the crowned C for 1745–1749.
Height: 5 1/8 in. (12.9 cm); Width: 1 ft. 5/8 in. (32.1 cm); Depth: 10 1/4 in. (26.1 cm)
Accession number 88.DA.111

PROVENANCE

William, 12th Duke of Hamilton and 9th Duke of Brandon, Hamilton Palace, Lanarkshire, Scotland (sold, Christie's, London, June 19, 1882, lot 2185, to William King for £242, 10s); Christopher Beckett-Denison, Esq. (sold, Christie's, London, June 6, 1885, lot 685); Arturo Lopez-Willshaw, by 1958 (sold, Sotheby's, Monaco, June 24, 1976, no. 21); purchased at that sale by The British Rail Pension Fund.

EXHIBITIONS

Malibu, The J. Paul Getty Museum, on loan, 1982–1988.

BIBLIOGRAPHY

Stéphane Faniel et al., *Le XVII͏e siècle français* (Collection Connaissance des arts, Paris, 1958), p. 206; "Acquisitions/1988," *GettyMusJ* 17 (1989), no. 81, p. 145, illus.; Bremer-David, *Summary*, no. 394, p. 227, illus.

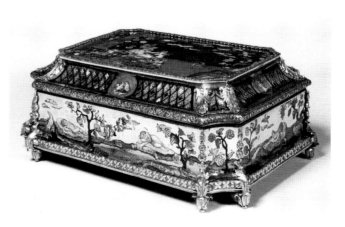

393

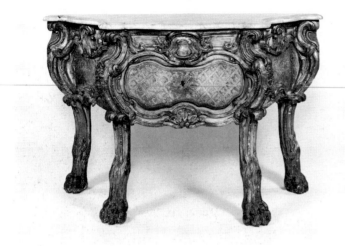

394

marble tops
Height: 2 ft. 8 ³/₄ in. (83.2 cm); Width:
4 ft. 1 ³/₄ in. (126.4 cm); Depth: 2 ft. ³/₈ in.
(61.9 cm)
Accession number 72.DA.63.1–.2

PROVENANCE

(Anonymous sale [?], Christie's, London,
March 1, 1882, lot 165, for 210 guineas);
[Jacques Helft, New York, 1940–1948];
Georges Lurcy (1891–1953), New York (sold
by the executors of his estate, Parke-Bernet,
New York, November 9, 1957, lot 383);
[Frank Partridge, Ltd., London]; Maharanee
of Baroda, Paris; [Frank Partridge, Ltd.,
London]; purchased by J. Paul Getty.

BIBLIOGRAPHY

*Sammlung Georg Hirth: Antiquitäten, Möbel und Ver-
täfelungen (16.–18. Jahrhundert), Gobelins, Teppiche,
Gemälde Alter Mesiter Farbstiche U. Anderes Aus der
Sammlung Georg Hirth* (Munich, 1928), no. 239,
pl. 48, illus.; Wesley Towner, *The Elegant
Auctioneers* (New York, 1970), p. 579, illus.;

394.
COMMODE

German, circa 1735–1740
Gessoed, painted, and gilded pine;
marble top
Height: 2 ft. 9 in. (83.8 cm); Width:
4 ft. 6 ¹/₂ in. (138.5 cm); Depth: 1 ft. 9 ¹/₂ in.
(54.5 cm)
Accession number 87.DA.47

PROVENANCE

[Pascal Zangarini, Venice, 1974]; Michael
Taylor, San Francisco (sold, Butterfield's, San
Francisco, April 7, 1987, lot 340).

BIBLIOGRAPHY

Tesori d'arte a Venezia, Mostra Mercato Inter-
nazionale dell'Antiquariato (Venice, 1974),
unnumbered page; "Acquisitions/1987"
GettyMusJ 16 (1988), no. 75, p. 179, illus.;
Bremer-David, *Summary*, no. 395, p. 227, illus.

395.
PAIR OF COMMODES

Munich, circa 1745
Carving attributed to Joachim Dietrich; side
panels after engraved designs by François de
Cuvilliés
Gessoed, painted, and gilded pine;
gilt-bronze mounts; *jaune rosé de Brignolles*

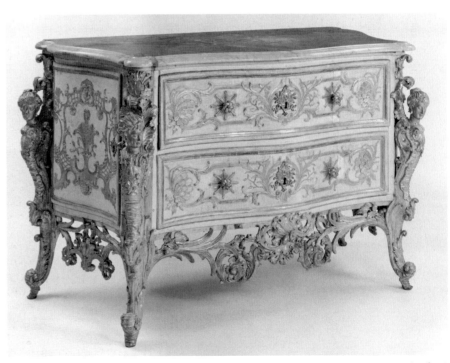

395 *One of a pair*

Thomas E. Norton, *One Hundred Years of Collecting in America: The Story of Sotheby Parke Bernet* (New York, 1984), p. 166, illus. (one); Bremer-David, *Summary*, no. 396, p. 228, illus.; *Masterpieces*, no. 62, p. 82, illus.; Afra Schick, "Möbel nach Entwürfen von François de Cuvilliés d. Ä," *Müncher Jahrbuch der bildenden Kunst* 49 (1998), pp. 123–162, illus. p. 140, fig. 21; *Handbook 2001*, p. 204, illus.

Desks and Secrétaires

396.
ROLLTOP DESK

Neuwied, 1787–1788
Attributed to David Roentgen; some gilt-bronze mounts by François Rémond
Fir, Scots pine, maple, and oak veneered with mahogany and maple; steel fittings; gilt-bronze mounts
Height: 5 ft. 6 1/4 in. (168.3 cm); Width: 5 ft. 1 3/8 in. (155.9 cm); Depth (open): 4 ft. 1 7/8 in. (126.7 cm); Depth (closed): 2 ft. 11 1/8 in. (89.3 cm)
Accession number 72.DA.47

PROVENANCE
Louis XVI (?), *cabinet du Roi*, Palais des Tuileries; later moved to the Château de Versailles; removed in 1793 to Russia; Count Iljinski (?), Castle of Romanova (near St. Petersburg), 1793–1852; [M. Court, rue de la Madeleine, Paris, 1857] (sold, M. le comte de M..., Paris, November 12, 1859, no. 1, to Migeon); [Samson Wertheimer (?), London] (sold, Christie's, London, March 15, 1892, lot 637, to Jackson); Count János Pálffy (1829–1908), Palais Pálffy, Vienna (sold, Glückselig und Warndorfer, Vienna, March 7, 1921, no. 209, to Castiglione); Baronne Marie de Reitz, Vienna; [French and Co., New York, 1960s]; purchased by J. Paul Getty.

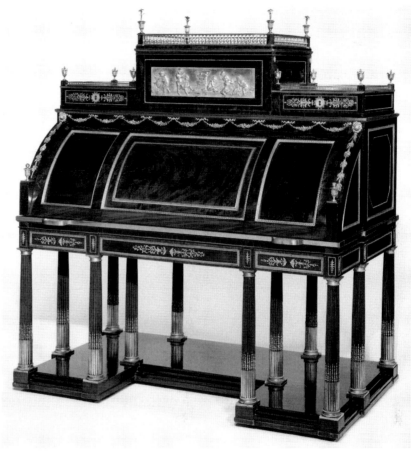

396

EXHIBITIONS
Washington, D.C., The State Department, on loan, 1960s.

BIBLIOGRAPHY
La Gazette de France (October 30, 1857); Alois C. Riegel, *Der Wiener Congress* (Vienna, 1898), fig. x; Heinrich Kreisel, *Die Kunst des deutschen Möbels* (Munich, 1973), vol. 3, fig. 17; Hans Huth, *Roentgen Furniture: Abraham and David Roentgen: European Cabinetmakers* (London and New York, 1974), illus. pp. 64–68; Josef Maria Greber, *Abraham und David Roentgen: Möbel für Europa* (Starnberg, 1980), vol. 2, figs. 683, 684; Dietrich Fabian, *Die Entwicklung der Roentgen-Schreibmöbel* (Bad Neustadt, 1982), p. 45, figs. 66–67; Wilson, *Selections*, no. 44, pp. 88–89, illus.; Dietrich Fabian,

Roentgenmöbel aus Neuwied: Leben und Werk von Abraham und David Roentgen (Bad Neustadt, 1986), p. 96, illus. p. 134, figs. 307–310; Pradère, *Les Ebénistes*, illus. p. 417, fig. 514; Kjellberg, *Dictionnaire*, p. 727; Bremer-David, *Summary*, no. 397, pp. 228–229, illus. p. 229; Christian Baulez, "David Roentgen et François Rémond, une collaboration majeure dans l'histoire du mobilier européen," *L'Estampille/ L'Objet d'art* 305 (September 1996), pp. 96–118, illus. p. 116, fig. 26, and p. 117, figs. 29, 32, 33; *Masterpieces*, no. 95, p. 120, illus.; Rosemarie Stratman-Döhler, *Mecanische Wunder Edles Holz: Roentgen-Möbel des 18. Jahrhundertz in Baden und Württenberg* (Badisches Landesmuseum, Karlsruhe, 1998), p. 119; *Handbook 2001*, p. 227, illus.

397.
SECRÉTAIRE
Berlin, circa 1798–1799
By Johann Andreas Beo; clock movement by
Christian Möllinger
Oak, spruce, and Scots pine veneered with
mahogany, maple, Ceylon satinwood, rose-
wood, ebony, and holly; drawer sides of lime-
wood; white marble; bronze; enameled metal;
gilt-bronze mounts
Clock face is painted with *Möllinger à Berlin.*
Height: 8 ft. (243.8 cm); Width: 3 ft. 8 in.
(111.8 cm); Depth: 2 ft. (60.9 cm)
Accession number 84.DA.87

PROVENANCE
Purchased by Frederick William III, King
of Prussia (1770–1840), for Schloss Potsdam
(near Berlin), circa 1802; private collection,
Berlin; [Ragaller, Berlin]; (sold, Weinmüller,
Munich, May 2–5, 1956, no. 1111); (sold,
Weinmüller [Neumeister], Munich, Octo-
ber 23–24, 1974, no. 861); private collection,
Munich; [Juan Portela, New York].

EXHIBITIONS
New York, Seventh Regiment Armory, *East
Side House Settlement Winter Antiques Show*, Janu-
ary 1984, p. 254.

BIBLIOGRAPHY
Art-Price Annual 1974–1975 (Munich, 1975),
p. 91; Claudia Freytag, *Bruckmann's Möbel-
Lexikon* (Munich, circa 1978), p. 299, illus.
p. 214, fig. 86; Michael Stürmer, *Handwerk
und höfische Kultur Europäische Möbelkunst im 18.
Jahrhundert* (Munich, 1982), p. 193, pl. 102;
Dietrich Fabian, *Die Entwicklung der Roentgen-
Schreibmöbel* (Bad Neustadt, 1982), pp. 54–55,
figs. 77d–g; Heinrich Kreisel and George
Himmelheber, *Die Kunst des deutschen Möbels*
(Munich, 1983), vol. 3, p. 369 and illus.
fig. 264; Dietrich Fabian, *Kinzing und Roentgen
Uhren aus Neuwied* (Bad Neustadt, 1984),
p. 147; Wilson, "Acquisitions 1984," no. 5,
pp. 83–88, illus.; "Acquisitions/1984,"
GettyMusJ 13 (1985), no. 68, p. 184, illus.;
Dietrich Fabian, *Roentgenmöbel aus Neuwied*
(Bad Neustadt, 1986), p. 312, illus. p. 305,
figs. 724–727; Bremer-David, *Summary*,
no. 398, p. 230, illus.; Wilson, *Clocks*, no. 20,
pp. 148–151, illus.

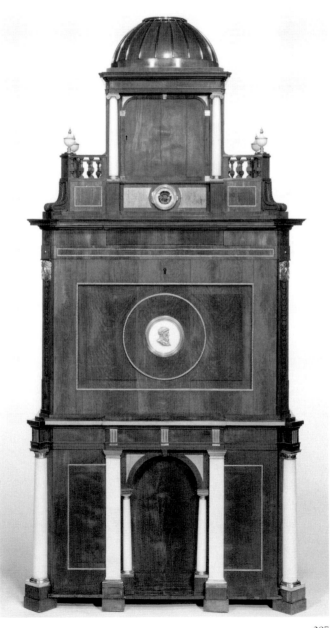

397

Tables

398.
Console Table
Munich, circa 1730
Design attributed to Joseph Effner; carving attributed to Johann Adam Pichler
Limewood; modern gesso and gilding; Tegernsee marble top
Height: 2 ft. 9 3/4 in. (86.5 cm); Width: 5 ft. 1 1/2 in. (156 cm); Depth: 2 ft. 1 1/4 in. (64 cm)
Accession number 88.DA.88

PROVENANCE
Karl Albrecht (?) (Charles VII, 1697–1745, Elector of Bavaria, 1726, and Holy Roman Emperor, 1742), in the *Kaisersaal* at Kloster Ettal; Paris (art market or private collection), 1960s; private collection, Germany (sold, Nouveau Drouot, Paris, December 5, 1980, no. 99); [Bernheimer Fine Arts, Ltd., London, 1988].

BIBLIOGRAPHY
"Acquisitions/1988," *GettyMusJ* 17 (1989), no. 82, p. 145, illus.; Bremer-David, *Summary*, no. 399, p. 230, illus. p. 231.

399

399.
Console Table
German, circa 1735–1745
Gessoed and gilded spruce; *brèche d'Alep* top
Height: 3 ft. (91.4 cm); Width: 3 ft. 6 3/4 in. (108.6 cm); Depth: 1 ft. 9 in. (53.3 cm)
Accession number 85.DA.319

PROVENANCE
Private collection, Germany; [Capricorn Art International, S.A., Panama].

BIBLIOGRAPHY
"Acquisitions/1985," *GettyMusJ* 14 (1986), no. 206, p. 248, illus.; Bremer-David, *Summary*, no. 400, p. 231, illus.; *Handbook 2001*, p. 201, illus.

400

400.
Reading and Writing Stand
Neuwied, circa 1760–1765
By Abraham Roentgen
Pine, oak, and walnut veneered with palisander, alder, rosewood, ebony, ivory, and mother-of-pearl; gilded metal fittings
The tabletop bears the archiepiscopal coat of arms and the monogram *JPC* for Johann Philipp Churfurst.
Height: 2 ft. 6 1/2 in. (77.5 cm); Width: 2 ft. 4 1/4 in. (71.7 cm); Depth: 1 ft. 7 1/4 in. (48.8 cm)
Accession number 85.DA.216

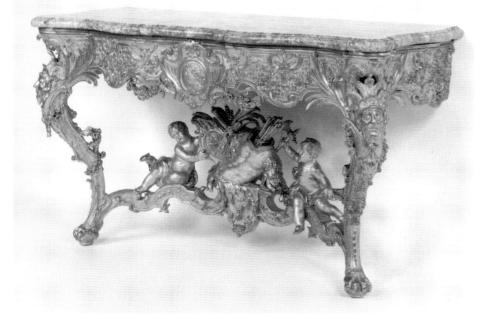

398

Italian
Cassoni, Credenze, and Chest of Drawers

PROVENANCE

Johann Philipp von Walderdorff, Prince Archbishop and Elector of Trier; by descent to Count Emanuel von Walderdorff.

BIBLIOGRAPHY

Heinrich Kreisel, *Die Kunst des deutschen Möbels-Spätbarok und Rokoko* (Munich, 1970), vol. 2, pp. 294, 428, fig. 992; Hans Huth, *Roentgen Furniture: Abraham and David Roentgen, European Cabinetmakers* (London and New York, 1974), fig. 110; Josef Maria Greber, *Abraham und David Roentgen: Möbel für Europa* (Starnberg, 1980), vol. 2, pp. 32–33, pls. 57–58; Dietrich Fabian, "Entwicklung der Roentgen: Mehrzwecktische-Funktion, Konstruktion, Oberflachenschmuck, Einrichtung," *Alte und moderne Kunst* 174–175 (1981), pp. 18–26, figs. 14, 14a; Georg Himmelheber, "Abraham Roentgen and the Archbishop of Trier," *Antiques* 127 (January 1985), pp. 245–259, fig. 12; "Acquisitions/1985," *GettyMusJ* 14 (1986), no. 207, p. 248, illus.; Dietrich Fabian, *Roentgenmöbel aus Neuwied* (Bad Neustadt, 1986), p. 29, illus. p. 33, figs. 11–14; Bremer-David, *Summary*, no. 401, p. 232, illus.; *Masterpieces*, no. 74, illus. p. 96; Ramond, *Chefs d'oeuvre* III, pp. 83–84, unnumbered front page, illus.; *Handbook* 2001, p. 213, illus.

401.
PAIR OF CASSONI

Umbria, mid-sixteenth century
Attributed to Antonio Maffei
Walnut, originally may have been partially gilt
Cassone .1: Height: 2 ft. 5 1/2 in. (75 cm); Width: 5 ft. 11 1/2 in. (181.5 cm); Depth (at top): 1 ft. 11 1/4 in. (59 cm); Depth (at feet): 3 ft. 6 in. (106.7 cm); *Cassone .2:* Height: 2 ft. 5 in. (73.5 cm); Width: 5 ft. 11 3/8 in. (181.3 cm); Depth (at top): 1 ft. 11 1/4 in. (59 cm); Depth (at feet): 2 ft. 5 in. (73.75 cm)
Accession number 88.DA.7.1–.2

PROVENANCE

Private collection, England; [Same Art, Ltd., Zurich].

BIBLIOGRAPHY

"Acquisitions/1988," *GettyMusJ* 17 (1989), no. 87, pp. 147–148, illus.; Bremer-David, *Summary*, no. 311, p. 185, illus.; Ettore A. Sannipoli, "I cassoni 'De Comitibus' del J. Paul Getty Museum (una scheda preliminare)," *Bollettino Storico della Città di Foligno* 20–21 (1996–1997), pp. 823–830; *Masterpieces*, no. 12, p. 19, illus.; Jeffrey Collins, "In Vino Veritas? Death and the Cellarette in Empire New York," in *American Artifacts: Essays in Material Culture*, J. D. Prown and K. Haltman, eds. (East Lansing, 2000), p. 56, fig. 3.8.

402.
CASSONE

Possibly Milan, late sixteenth century
Walnut, poplar, and spruce; partially gilt
Height: 2 ft. 5 1/8 in. (73.9 cm); Width: 5 ft. 5 3/4 in. (167 cm); Depth: 2 ft. 1/8 in. (61.3 cm)
Accession number 68.DA.8

PROVENANCE

Earls of Warwick, Warwick Castle, Great Hall, Warwickshire, England, at least since 1880; by inheritance in the same family until at least 1961; [Frank Partridge and Sons, Ltd., London]; purchased by J. Paul Getty on October 9, 1968; distributed by the estate of J. Paul Getty to the J. Paul Getty Museum.

EXHIBITIONS

The Fine Arts Museums of San Francisco, *The Triumph of Humanism*, September 29, 1977–January 18, 1978, p. 91, fig. 107; Tulsa, The Philbrook Art Center, *Gloria dell'arte: A Renaissance Perspective*, October 26, 1979–January 27, 1980, no. 85, p. 53, illus.

BIBLIOGRAPHY

Bremer-David, *Summary*, no. 309, p. 184, illus.

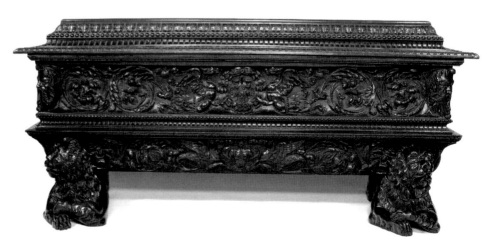

401 *One of a pair*

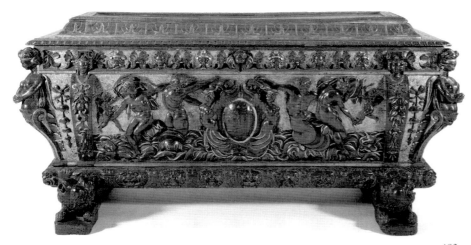

402

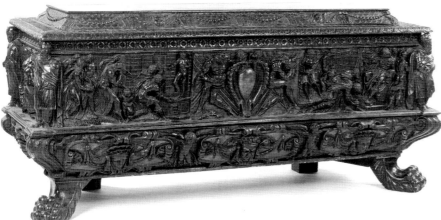

403

404.
CREDENZA

Florence, circa 1600–1650
Walnut
Height: 3 ft. 9¼ in. (114.9 cm); Width:
6 ft. 7¾ in. (202.6 cm); Depth: 1 ft. 9½ in.
(54.6 cm)
Accession number 78.DA.107

PROVENANCE
[Ugo Bardini, Italy, purchased by J. Paul
Getty, 1960]; J. Paul Getty, Sutton Place, Sur-
rey; distributed by the estate of J. Paul Getty
to the J. Paul Getty Museum.

EXHIBITIONS
Woodside, California, Filoli House, on loan,
1983–1992.

BIBLIOGRAPHY
Bremer-David, *Summary*, no. 312, p. 185, illus.

404

403.
CASSONE

Possibly Rome, late sixteenth century
Walnut, ash, and limewood; partially gilt
Height: 2 ft. 5⅛ in. (74 cm); Width:
5 ft. 5⅜ in. (166.6 cm); Depth: 2 ft. ¼ in.
(61.8 cm)
Accession number 78.DA.120

PROVENANCE
Private collection, Cleveland; [H. Blairman

and Sons, London, purchased by J. Paul
Getty, 1963]; J. Paul Getty, Sutton Place,
Surrey; distributed by the estate of J. Paul
Getty to the J. Paul Getty Museum.

EXHIBITIONS
Tulsa, The Philbrook Art Center, *Gloria
dell'arte: A Renaissance Perspective*, October 26,
1979–January 27, 1980, no. 86, p. 53, illus.

BIBLIOGRAPHY
Bremer-David, *Summary*, no. 310, pp. 184–
185, illus. p. 184.

405.
CREDENZA
Possibly Umbria, late seventeenth century
(later remade)
Walnut
Height: 3 ft. 10 3/4 in. (118.7 cm); Width:
4 ft. 1 1/4 in. (124.5 cm); Depth: 1 ft. 10 1/2 in.
(57.2 cm)
Accession number 78.DA.109

PROVENANCE
[Ugo Bardini, Italy, purchased by J. Paul
Getty, 1960]; J. Paul Getty, Sutton Place,
Surrey; distributed by the estate of J. Paul
Getty to the J. Paul Getty Museum.

BIBLIOGRAPHY
Bremer-David, *Summary*, no. 313, p. 186, illus.

406

405

406.
CHEST OF DRAWERS
Venice, circa 1745–1750
Painted, gilt, and silver-gilt spruce and
walnut; some pine
Height: 2 ft. 8 1/8 in. (81.5 cm); Width:
4 ft. 9 7/8 in. (147 cm); Depth: 2 ft. 5/8 in.
(62.5 cm)
Accession number 83.DA.282

PROVENANCE
Possibly Orsini Family, Italy; (sold, Saint-
Malò, France, 1982) [Didier Aaron, Paris];
(sold, Sotheby's, London, July 15, 1983,
lot 114); [Alexander and Berendt, London].

BIBLIOGRAPHY
"Acquisitions/1983," *GettyMusJ* 12 (1984),
no. 17, p. 267, illus.; *Handbook* 1986, p. 191,
illus.; Bremer-David, *Summary*, no. 314,
p. 186, illus.

Mirrors

407.
MIRROR AND FRAME
Rome, circa 1750–1775
Gilt and ebonized pearwood with silvered
mirror glass
Height: 6 ft. 9 in. (206 cm); Width: 4 ft. 1 in.
(124.5 cm)
Accession number 97.DH.66

PROVENANCE
Private collection, Midlands, England;
[Carlton Hobbs, Ltd., London].

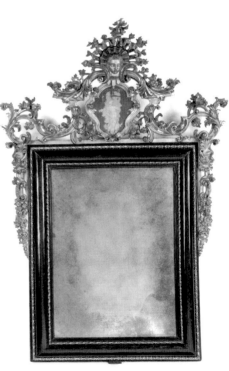

407

Tables

408.
TABLE

Tuscany, sixteenth century
Walnut
Height: 2 ft. 10 in. (86.4 cm); Width:
8 ft. 6 in. (259 cm); Depth: 2 ft. 10 in.
(86.4 cm)
Accession number 78.DA.121

PROVENANCE
[Ugo Bardini, Italy, purchased by J. Paul
Getty, 1963]; J. Paul Getty, Sutton Place, Sur-
rey; distributed by the estate of J. Paul Getty
to the J. Paul Getty Museum.

BIBLIOGRAPHY
Bremer-David, *Summary*, no. 315, p. 187, illus.

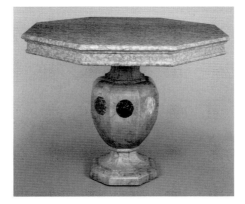

409

EXHIBITIONS
Amsterdam, Stedelijk Museum, *Italiaansche
Kunst in Nederlandsch Bezit*, July 1–October 1,
1934, no. 1008.

BIBLIOGRAPHY
"Acquisitions/1990," *GettyMusJ* 19 (1991),
no. 58, p. 165, illus.; Bremer-David, *Summary*,
no. 316, p. 187, illus.

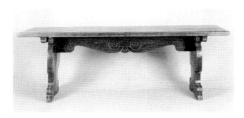

408

409.
OCTAGONAL TABLE

Northern Italian (possibly Mantua), circa
1550
Rosso di Verona inlaid with *nero antico* and
cipollina marble
Height: 2 ft. 9 1/4 in. (84.5 cm); Width (at
top): 3 ft. 9 1/2 in. (115.5 cm)
Accession number 90.DA.33.1–.2

PROVENANCE
Possibly Palazzo Gonzaga, Mantua (as cited
in exh. cat., Stedelijk Museum, below);
private collection, the Netherlands, by 1934;
private collection, Paris, since 1975; [Alain
Moatti, Paris].

410.
TABLE

The Veneto, late sixteenth century
Rosso di Verona marble
Height: 2 ft. 7 7/8 in. (81 cm); Width:
9 ft. 11 5/8 in. (308 cm); Depth: 4 ft. 5/8 in.
(123.5 cm)
Accession number 86.DA.489.1–.2

PROVENANCE
[Same Art, Ltd., Zurich].

BIBLIOGRAPHY
"Acquisitions/1986," *GettyMusJ* 15 (1987),
no. 117, pp. 217–218, illus.; Bremer-David,
Summary, no. 317, p. 187, illus.

410 *Side view*

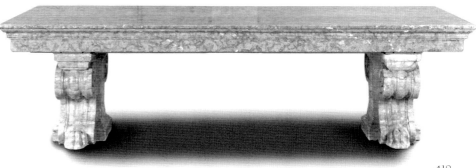

410

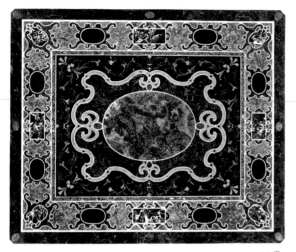

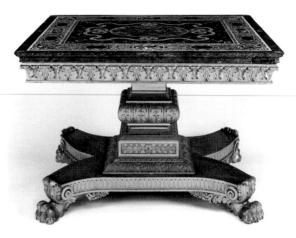

411 *Top*

411

411.

PIETRE DURE TABLE

 Florence or Rome

 Tabletop: circa 1580–1600, Base: circa 1825

 Pietre dure and marble mosaic including
breccia di Tivoli (or *Quintilina*), *giallo antico*, *nero antico*, *breccia rossa*, *breccia cenerina*, *breccia verde*, *broccatello*, *bianco e nero antico*, serpentine, alabaster *fiorito* and alabaster *a tartaruga*, lapis lazuli, coral, rock crystal, and yellow and black jasper

 Height: 2 1/4 in. (5.7 cm); Width:
4 ft. 5 3/4 in. (136.5 cm); Depth: 3 ft. 8 1/2 in. (113 cm); Base: Gilt wood; Height: 35 3/8 in. (89.9 cm)

 Accession number 92.DA.70.1–.2

PROVENANCE

Corsini, Florence, by at least the nineteenth century; by inheritance in the Corsini family until the second half of the twentieth century, sold to Same Art, Ltd.; [Same Art, Ltd., Zurich, 1991].

BIBLIOGRAPHY

Leonardo Ginori Lisci, *I Palazzi di Firenze nella storia dell'arte* (Florence, 1972), vol. 1, p. 152 (reproduces nineteenth-century archival photograph of object); Alessandra Guicciardini Corsi Salviati, *Affreschi di Palazzo Corsini a Firenze 1650–1700* (Florence, 1989), pl. 23 (reproduces same photograph as above);

"Acquisitions/1992," *GettyMusJ* 21 (1993), p. 145, illus.; Bremer-David, *Summary*, no. 318, p. 188, illus.; *Masterpieces*, no. 19, pp. 28–29, illus.; *Handbook* 2001, p. 248, illus.

412.

PIETRE DURE TABLETOP

 Florence or Rome, circa 1600–1620

 Base: See entry no. 81 in the French
Furniture section

 Pietre dure and marble mosaic including
bianco e nero antico, *paragone*, *brocatello*, *rosso antico*, lapis lazuli, and onyx

Height: Width: 6 ft. 5 5/8 in. (197.1 cm); Depth: 5 ft. 3 5/8 in. (115.8 cm)

Accession number 72.DA.58.2

PROVENANCE

Possibly Charlotte de Rothschild (1819–1884) (Baroness Lionel Nathan, née von Rothschild), Gunnersbury Park, Middlesex; Alfred (Charles) de Rothschild (1842–1918), Halton, Buckinghamshire, by 1884; by inheritance to Edmund (Leopold) de Rothschild (born 1916), Exbury, Hampshire; [Frank Partridge and Sons, Ltd., London, 1972]; purchased by J. Paul Getty.

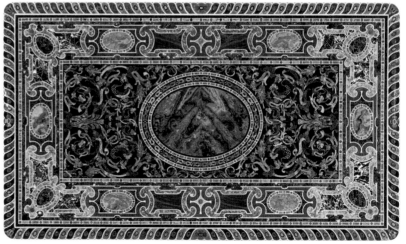

BIBLIOGRAPHY

Anna Maria Giusti, *Pietre Dure: Hardstone in Furniture and Decorations* (London, 1992), p. 29, fig. 13, pp. 30–31; Bremer-David, *Summary*, no. 320, p. 189, illus.; Leora Auslander, *Taste and Power: Furnishing Modern France* (Berkeley, 1996), p. 57, illus.; Nattale Maffioli, "Una scoperta nei Santuario Torinese della Consolata," *Arte Cristiana* 86, no. 799 (July/August 2000), p. 299, fig. 3.

413.
TABLE

Probably Tuscany, seventeenth century
Ebonized walnut with an inset of "flowering" alabaster (*albastro fiorito*) top
Height: 2 ft. 8 1/4 in. (82 cm); Width: 4 ft. 1 1/4 in. (125 cm); Depth: 2 ft. 1 5/8 in. (65.3 cm)
Accession number 97.DA.64

PROVENANCE

Possibly Palazzo Serristori, Florence; possibly Jacques Petit-Horry, Paris; [Alain Moatti, Paris].

413

414.
SIDE TABLE

Rome, circa 1670
Design attributed to Johann Paul Schor, called Giovanni Paolo Tedesco
Gilt poplar
Height: 5 ft. 6 15/16 in. (170 cm); Width: 7 ft. 4 1/2 in. (225 cm); Depth: 2 ft. 9 7/16 in. (85 cm)
Accession number 86.DA.7

414

PROVENANCE

Rudolph Hegetschweile, Zurich, since 1947; [International Patent Trust Reg., Vaduz, Liechtenstein].

BIBLIOGRAPHY

Bremer-David, *Summary*, no. 321, p. 190, illus.; *Masterpieces*, no. 34, p. 48, illus.

415.
SIDE TABLE

Rome, circa 1720–1730
Gilt limewood; modern top veneered with *brocatello violetto* marble

Height: 3 ft. 1 in. (93.9 cm); Width: 6 ft. 3 in. (190.5 cm); Depth: 3 ft. 2 in. (96.5 cm)
Accession number 82.DA.8.1–.2

PROVENANCE

Private collection, England; [Belgian art market]; [Jacques Kugel, Paris, 1981].

BIBLIOGRAPHY

Bremer-David, *Summary*, no. 322, p. 190, illus.; *Masterpieces*, no. 51, p. 70, illus.; *Handbook* 2001, pp. 264–265, illus.

415

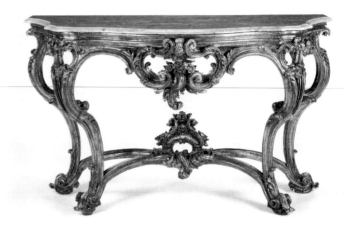

416

417

416.
Console Table

Possibly Piedmont, circa 1730
Gilt and painted limewood and spruce;
sarrancolin de Pyrénées marble top
Height: 2 ft. 10 1/4 in. (86.9 cm); Width:
6 ft. 5 1/4 in. (196.2 cm); Depth: 3 ft. 6 3/4 in.
(78.1 cm)
Accession number 78.DA.118.1–.2

PROVENANCE

Elsie de Wolfe (Lady Mendl), New York, sold
to J. Paul Getty, October 1949; J. Paul Getty,
Sutton Place, Surrey; distributed by the estate
of J. Paul Getty to the J. Paul Getty Museum.

BIBLIOGRAPHY

Bremer-David, *Summary*, no. 319, pp. 188–
189, illus. p. 189.

417.
Side Table

Sicily, mid-eighteenth century
Limewood gilt with *mecca* (golden-colored
varnish); yellow marble (*giallo di Verona*) top
Height: 3 ft. 5 in. (104 cm); Width: 6 ft. (183
cm) Depth: 2 ft. 6 3/4 in. (78 cm)
Accession number 95.DA.6.1–.2

PROVENANCE

Private collection, Sicily, from at least the
nineteenth century until the 1990s; purport-
edly private collection, London; [John Hobbs,
London].

BIBLIOGRAPHY

"Acquisitions/1995," *GettyMusJ* 24 (1996),
no. 82, p. 134, illus.; *Masterpieces*, no. 69,
p. 90, illus.

418.
Table

Northern Italian, late eighteenth century
By Giuseppe Maggiolini
Walnut and rare wood veneer
Inscribed *Di Laura Visconti* on the table top
Height: 2 ft. 9 in. (84 cm); Width:
3 ft. 7 5/16 in. (110 cm); Length: 2 ft. 5 1/8 in.
(74 cm).
Accession number 95.DA.81

PROVENANCE

Possibly Laura Visconti di Modrone,
mid-eighteenth century; private col-
lection, Lugano; [Picket Anstalt, Vaduz,
Liechtenstein]

BIBLIOGRAPHY

Alvar González-Palacios, "Tre tavoli impor-
tanti," *Scritti in Onore di Giuliano Briganti*
(Milan 1990), pp. 257–258, figs. 6–8; Alvar
González-Palacios, *Il Gusto dei Principi* (Milan,
1993), pp. 340–341, pl. LVII, figs. 602–604;
"Acquisitions/1995," *GettyMusJ* 24 (1996),
no. 80, p. 145, illus.

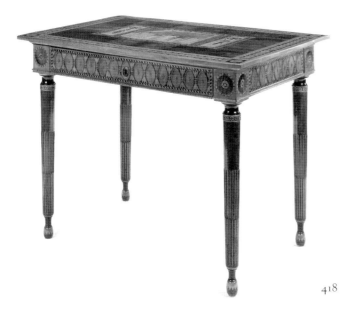

418

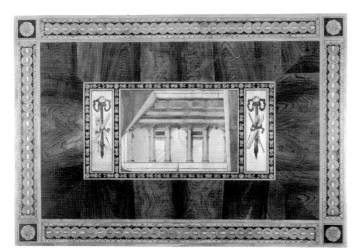

418 *Top*

419.
SIDE TABLE
 Italian, circa 1760–1770
 Gilt-limewood and spruce base;
 French *calcare* marble top
 Height: 3 ft. 5 5/16 in. (105 cm); Width:
 5 ft. 1/4 in. (153 cm); Depth: 2 ft. 5 1/8 in.
 (74 cm)
 Accession number 87.DA.135.1–.2

PROVENANCE
Private collection, Switzerland; [Danae Art
International, S.A., Panama].

BIBLIOGRAPHY
"Acquisitions/1987," *GettyMus J* 16 (1988),
no. 79, p. 181, illus.; *Masterpieces*, no. 86,
p. 109, illus.; Bremer-David, *Summary*,
no. 323, pp. 190–191, illus. p. 191; *Handbook*
2001, p. 266, illus.

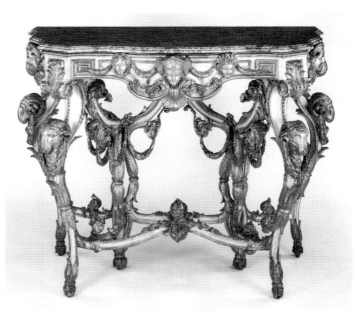

419

420.
TABLE

Rome, circa 1780
By Francesco Antonio Franzoni
Marble with a *breccia Medicea* top
Height: 3 ft. 3 1/2 in. (100 cm); Width:
6 ft. 7 in. (200 cm); Depth: 2 ft. 8 in. (81 cm)
Accession number 93.DA.18.1–.2

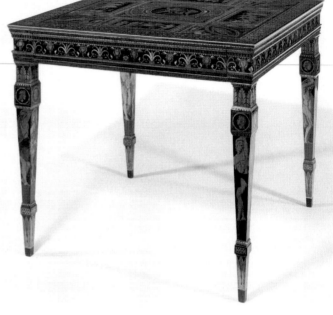

421

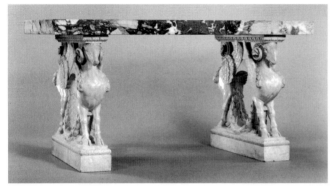

420

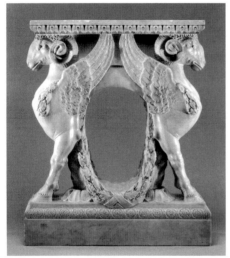

420 *Side view*

PROVENANCE
[Pelham Galleries, London]; [Carlton Hobbs, London].

BIBLIOGRAPHY
P. Massi, *Catalogue indicatif des Antiquités composant le musée Pio-Clementin au Vatican* (Rome, 1792), p. 60; G. Lizzani, *Il Mobile Romano* (Milan, 1970), pl. LXXII; *Glyptothek München, 1830–1980* (Munich, 1980) p. 608; A. González-Palacios, *Il Tempo del gusto: Roma e il Regna delle Due Sicilie* (Milan, 1984), pp. 14, 70, 124, 126, fig. 157; C. Pietrangeli, *I Musei Vaticani* (Rome, 1985), pp. 87, 94; *Apollo* 136 (December 1992), p. 414; Carlton Hobbs, *Catalogue Number Four* (London, 1993), no. 14; "Acquisitions/1993," *GettyMusJ* 22 (1994), no. 68, p. 100, illus.; *Masterpieces*, no. 91, pp. 115–116, illus.; *Handbook* 2001, p. 268.

421.
TABLE

Possibly Naples, 177(9?)
By Francesco Abbiati
Oak, walnut, and poplar veneered with purplewood, satinwood, ebony, and various fruitwoods
Signed and dated in the central roundel of marquetry on the top, FRAN^CO ABBIATI / 177(9?)
Height: 2 ft. 5/8 in. (77.8 cm); Width: 2 ft. 10 7/16 in. (87.5 cm); Depth: 2 ft. 10 7/16 in. (87.5 cm)
Accession number 84.DA.77

PROVENANCE
Purportedly private collection, Cleveland, Ohio; [Dalva Brothers, Inc., New York].

BIBLIOGRAPHY

"Acquisitions/1984," *GettyMusJ* 13 (1985), no. 254, p. 258, illus.; Alvar González-Palacios, *Il Gusto dei Principi: Arte di Corte del XVII* *del XVIII Secolo* (Milan, 1993), vol. 1, pp. 352–353; vol. 2, pp. 318–324, nos. 629–640; Bremer-David, *Summary*, no. 324, p. 191, illus.

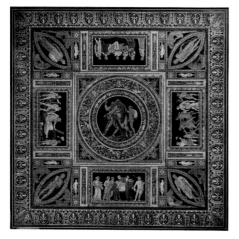

421 *Top*

Seat Furniture

422.

SET OF SIX ARMCHAIRS

Probably Tuscany, circa 1620–30
Mahogany with inlaid white oak, spindle tree, lignum vitae, and possibly West Indian satinwood; some poplar; modern velvet upholstery
Armchairs .1, .3, .4, and .6: Height: 3 ft. 3 in. (100 cm); Width: 2 ft. ³/₈ in. (51.7 cm); Depth: 1 ft. 8³/₈ in. (51.7 cm)
Armchairs .2 and .5: Height: 3 ft. 4³/₈ in. (102 cm); Width: 2 ft ³/₈ in. (62 cm); Depth: 1 ft. 8 in. (51.7 cm)
Accession number 95.DA.22.1–.6

422 *One of six*

PROVENANCE

Descendants of Cardinal Silvio Passerini (died 1529) (near Cortona); private collection, Switzerland; [Rosenblatt Investment, S. A., Panama].

BIBLIOGRAPHY

"Acquisitions/1995," *GettyMusJ* 24 (1996), no. 81, p. 134, illus.

423.

SIDE CHAIR

Turin, circa 1710–1715
Gilt walnut and beech with modern silk upholstery copying the original silk
Height: 4 ft. 2⁵/₈ in. (118.5 cm); Width: 1 ft. 9⁷/₈ in. (55.6 cm); Depth: 2 ft. 3³/₈ in. (69.5 cm)
Accession number 83.DA.281

PROVENANCE

Royal House of Savoy, Racconigi Palace (near Turin); Mrs. Walter Hayes Burns (née Morgan), North Mymms Park, Hertfordshire, England; by inheritance through her son Walter Spencer Morgan Burns and his wife Evelyn Ruth to Major-General Sir George Burns, North Mymms Park, Hertfordshire, England (sold, Christie's, North Mymms Park, September 24–25, 1979, lot 215 [one of five], to Partridge); [Partridge (Fine Arts), Ltd., London].

BIBLIOGRAPHY

"Acquisitions/1983," *GettyMusJ* 12 (1984), no. 16, p. 267, illus.; Bremer-David, *Summary*, no. 325, p. 192, illus.

423

424 *One of four*

424.
SET OF FOUR ARMCHAIRS

Venice, circa 1730–1740
Gilt walnut, with some pine; upholstered in
modern cut velvet
Armchair .1: Height: 2 ft. 10³/4 in.
(88.3 cm); Width: 2 ft. 9¹/2 in. (85.1 cm);
Depth: 2 ft. 10³/4 in. (88.3 cm); Armchair .2:
Height: 4 ft. 7¹/8 in. (140 cm); Width:
2 ft. 9⁷/8 in. (86 cm); Depth: 2 ft. 10¹/4 in.
(87.3 cm); Armchair .3: Height: 4 ft. 6¹/2 in.
(138.5 cm); Width: 2 ft. 9³/4 in. (85.8 cm);
Depth: 2 ft. 11³/4 in. (89.8 cm); Armchair .4:
Height: 4 ft. 7¹/4 in. (140.3 cm); Width:
2 ft. 9⁷/8 in. (86 cm); Depth: 2 ft. 9¹/4 in.
(84.5 cm)
Accession number 87.DA.2.1–.4

PROVENANCE

Private collection, England, since the eigh-
teenth century; [Alexander and Berendt, Ltd.,
London, 1984].

BIBLIOGRAPHY

"Acquisitions/1987," *GettyMusJ* 16 (1988),
no. 78, pp. 180–181, illus.; Bremer-David,
Summary, no. 326, p. 192, illus.; *Handbook*
1997, pp. 264–265, illus. p. 264; *Masterpieces*,
no. 57, p. 76, illus.

425.
FOLDING STOOL

Turin, circa 1735
Gilt walnut upholstered in modern silk velvet
Branded twice with three fleurs-de-lys
and with the letters FON for the Palais de
Fontainebleau.
Height: 1 ft. 4¹/4 in. (41.3 cm); Width:
2 ft. 3¹/8 in. (68.9 cm); Depth: 1 ft. 5¹/8 in.
(43.5 cm)
Accession number 74.DA.26

PROVENANCE

Palais de Fontainebleau during the nineteenth
century; [Matthew Schutz, Ltd., New York].

EXHIBITIONS

The Detroit Institute of Arts, March 7–
June 13, 1975.

BIBLIOGRAPHY

Gillian Wilson, *Decorative Arts in the J. Paul
Getty Museum*, 1977, p. 33, no. 42, illus.;
Bremer-David, *Summary*, no. 327, p. 193, illus.

425

426.
ARMCHAIR

Possibly Naples, circa 1790
Marquetry of rosewood and kingwood;
upholstered in modern horsehair fabric
Height: 4 ft. (122 cm); Width: 2 ft. 1 in.
(64 cm); Depth: 1 ft 5¹/2 in. (44 cm)
Accession number 95.DA.76

PROVENANCE

Private collection, Basel, Switzerland, sold in
1988; private collection, London; [Antoine
Chenevière, London].

BIBLIOGRAPHY

"Acquisitions/1995," *GettyMusJ* 24 (1996),
no. 83, p. 135, illus.

426

427.
DAYBED (ORIGINALLY A SETTEE)

Turin, designed between 1832–1835
By Filippo Pelagio Palagi
Maple inlaid with mahogany, with
modern silk upholstery copying the
original upholstery
On back of frame, stenciled with 3421 in
green paint from Racconigi inventory of 1900
(obscured by upholstery), stamped with
Dazio Verificato in ink, and incised with the
stamp PPR 3421. On frame of upholstered
seat, stamped with *Dazio Verificato* in ink
and *Racconigi Camera da letto degli Augusti Sposi* in
pencil across front. On frame structure 37
in ink on part of a label, a pencil design
for inlay.

PROVENANCE

Prince d'Arenberg, Egmont Palace, Brussels; [Axel Vervoordt, 's Gravenwezel, Belgium].

BIBLIOGRAPHY

"Acquisitions/1988," GettyMusJ 17 (1989), no. 86, pp. 146-147, illus.; Bremer-David, Summary, no. 478, p. 274, illus.; Masterpieces, no. 31, p. 44; Handbook 2001, p. 250, illus.

427

Height: 2 ft. 1 1/2 in. (80 cm); Width: 7 ft. 4 1/8 in. (224 cm); Depth: 2 ft. 3 1/8 in. (69 cm)
Accession number 86.DA.511

PROVENANCE

King Carlo Alberto of Savoy (1798–1849), Racconigi Palace (near Turin); remained at Racconigi until 1922; private collection, Switzerland, 1938–1980; [Heim Gallery, Ltd., London, 1980–1986].

BIBLIOGRAPHY

"Acquisitions/1986," GettyMusJ 15 (1987), no. 118, p. 218, illus.; Handbook 1991, p. 219, illus.; Bremer-David, Summary, no. 328, p. 193, illus.

Netherlandish

428.
DISPLAY CABINET (TOONKAST)
 Flemish (probably Antwerp), early seventeenth century
 Walnut, cedar, and white oak veneered with ebony, tortoiseshell, African padouk, snakewood; pearwood carvings
 Height: 6 ft. 10 3/4 in. (210 cm); Width: 5 ft. 2 1/4 in. (158 cm); Depth: 2 ft. 5 3/8 in. (74.5 cm)
 Accession number 88.DA.10

428

429.
PAIR OF TORCHÈRES
Dutch, circa 1740–1750
Possibly by the Italian carver Agostino
Carlini
Gessoed, painted, and gilded wood; crushed
glass
Height: 6 ft. 11 5/8 in. (212.4 cm); Width:
2 ft. 3 in. (68.6 cm); Depth: 1 ft. 10 in.
(55.9 cm)
Accession number 79.DA.5.1–.2

PROVENANCE
Sold, Palais Galliera, Paris, December 9,
1963, no. 93; [Fabius Frères, Paris, 1970s].

EXHIBITIONS
Los Angeles, The J. Paul Getty Museum,
"Adrian Saxe, 1-900-ZEITGEIST," *Departures:
Eleven Artists at the Getty*, Lisa Lyons, February
29–May 7, 2000, pp. 52–53, illus. p. 52.

BIBLIOGRAPHY
Wilson, "Acquisitions 1977 to mid-1979,"
no. 13, pp. 49–51, illus. (one); Marten Loonstra, *The Royal Palace Huis ten Bosch in a Historical
View* (Zutphen, 1985), p. 75, illus. p. 74;
Bremer-David, *Summary*, no. 479, p. 275,
illus.; Reinier Baarsen, "High Rococo in Holland's William IV and Agostino Carlini,"
Burlington Magazine 140, no. 1140 (March
1998), pp. 172–183, illus. fig. 29.

South Indian

430.
SET OF TWELVE CHAIRS (FIVE ARMCHAIRS
AND SEVEN SIDE CHAIRS)
South Indian (Coromandel Coast) for a
Dutch client, circa 1680–1720
Ebony and ebonized wood, some details
inlaid with ivory; caned seat
Armchairs: Height: 3 ft. 6 in. (106.7 cm);
Width (at front): 2 ft. (61 cm); Width
(at back): 1 ft. 8 in. (50.8 cm); Depth:
1 ft. 7 7/16 in. (49.4 cm); Side Chairs: Height:
3 ft. 4 in. (101.6 cm); Width: 1 ft. 9 3/4 in.
(55.2 cm); Depth: 1 ft. 6 11/16 in. (47.5 cm)
Accession number 92.DA.24.1–.12

PROVENANCE
Possibly Thomas Thynne, 1st Viscount Weymouth, Longleat Castle, Wiltshire, about
1700; by inheritance to the Marquess of Bath,
Longleat Castle, Wiltshire (sold, Christie's, London, November 17, 1988, lot 75, to
R. Miles); [Richard Miles, London]; [Rainer
Zietz, Ltd., London].

BIBLIOGRAPHY
"Acquisitions/1992" *GettyMusJ* 21 (1993),
no. 68, p. 143, illus.; Bremer-David, *Summary*,
no. 502, p. 288, illus.

430 *Side Chair*

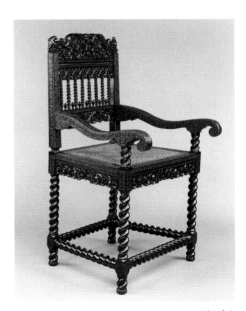

430 *Armchair*

429 *One of a pair*

Glass
Austrian

431.
UMBO VASE

Hall or Murano, circa 1534–1536
Façon de Venise, possibly the workshop of
Wolfgang Vitl
Free- and mold-blown colorless glass with
gilding and cold-painted decoration
Arms, on rim, in cold paint, *per fesse argent a
demi wheel gules, and azure a fleur-de-lis argent; on
the opposite side, on a mount or a triple-turreted
tower argent.*
Height: 8 5/16 in. (21.1 cm); Diameter (at lip):
3 7/8 in. (9.9 cm); Maximum Diameter:
5 1/8 in. (13 cm)
Accession number 84.DK.546

PROVENANCE

Mrs. André Wormser, Paris; [Ruth and
Leopold Blumka, New York].

BIBLIOGRAPHY

"Acquisitions/1984," *GettyMusJ* 13 (1985),
no. 218, pp. 250–251, illus.; "Recent Impor-
tant Acquisitions Made in Public and Private
Collections in the United States and
Abroad," *Journal of Glass Studies* 28 (1986),
no. 28, p. 106; Bremer-David, *Summary*,
no. 461, pp. 262–263, illus. p. 262; Hess
and Husband, *European Glass*, no. 35, pp. 138–
141, illus.

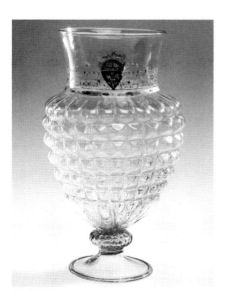

431

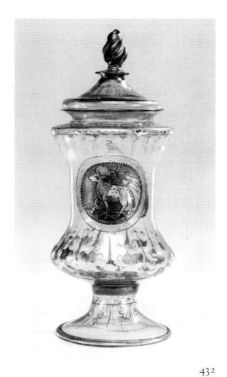

432

432.
COVERED VESSEL

Hall, circa 1536–1540
Façon de Venise, possibly the workshop of
Wolfgang Vitl
Free-blown colorless glass with applied deco-
ration, gilding, and cold-painted decoration
Arms on one side of the central zone of the
vessel canted toward each other, below a
bishop's miter, in cold paint, *two escutcheons,
dexter, or a Moor's head in profile proper crowned and
sinister, quarterly one and four sable a lion or crowned
gules and two and three lozengy argent and azure.*
Height (with lid): 7 1/2 in. (19 cm); Height
(without lid): 5 9/16 in. (14.2 cm); Maximum
Diameter: 3 5/16 in. (8.5 cm)
Accession number 84.DK.548.1–.2

PROVENANCE

[Ruth and Leopold Blumka, New York.]

EXHIBITIONS

New York, The Corning Museum of Glass,
Three Great Centuries of Venetian Glass, 1958,
no. 59, pp. 68–69.

BIBLIOGRAPHY

"Acquisitions/1984," *GettyMusJ* 13 (1985),
no. 219, p. 251, illus.; "Recent Important
Acquisitions Made in Public and Private
Collections in the United States and
Abroad," *Journal of Glass Studies* 28 (1986),
no. 30, p. 107; Bremer-David, *Summary*,
no. 462, p. 263, illus.; Hess and Husband,
European Glass, no. 36, pp. 142–146, illus.

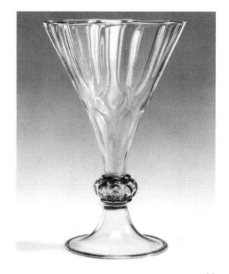

433

433.
GOBLET (*KELCHPOKAL*)

Hall, 1535–1555
Façon de Venise, possibly the workshop of Wolf-
gang Vitl or of Sebastian Höchstetter
Free- and mold-blown colorless glass with
gilding
Height: 7 7/16 in. (18.9 cm); Diameter (at lip):
4 7/8 in. (12.5 cm)
Accession number 84.DK.542

PROVENANCE

[Ruth and Leopold Blumka, New York.]

BIBLIOGRAPHY

"Acquisitions/1984," *GettyMusJ* 13 (1985),
no. 212, pp. 249–250, illus.; Bremer-David,
Summary, no. 463, p. 264, illus.; Hess and Hus-
band, *European Glass*, no. 37, pp. 147–149, illus.

434.
GOBLET (*KELCHPOKAL*)

Hall, 1540–1560

Façon de Venise, possibly the workshop of
Sebastian Höchstetter

Free- and mold-blown colorless glass with
gilding

Height: 6 $^{15}/_{16}$ in. (17.6 cm); Diameter (at
lip): 5 $^{1}/_{4}$ in. (13.3 cm)

Accession number 84.DK.543

PROVENANCE

[Ruth and Leopold Blumka, New York.]

BIBLIOGRAPHY

"Acquisitions/1984," *GettyMus J* 13 (1985),
no. 213, p. 250, illus.; Bremer-David, *Summary*,
no. 464, p. 264, illus.; Hess and Husband,
European Glass, no. 38, pp. 150–151, illus.

434

435.
GOBLET

Hall, 1540–1560

Façon de Venise, possibly the workshop of
Sebastian Höchstetter

Free- and mold-blown colorless glass with
gilding and cold-painted and applied decora-
tion

Height: 10 in. (25.4 cm); Diameter (at lip):
6 $^{7}/_{16}$ in. (16.3 cm)

Accession number 84.DK.544

PROVENANCE

[Ruth and Leopold Blumka, New York.]

BIBLIOGRAPHY

Possibly E. Barrington Haynes, *Glass Through
the Ages*, revised ed. (Harmondsworth, 1948),
pl. 16c, where an uncredited glass is repro-
duced that is identical to, possibly the same
as, the Getty piece; "Acquisitions/1984,"
GettyMus J 13 (1985), no. 216, p. 250, illus.;
Bremer-David, *Summary*, no. 465, p. 264,
illus.; Hess and Husband, *European Glass*,
no. 39, pp. 152, 153, illus.

435

436

436.
GOBLET (*TRICHTERPOKAL*)

Hall, 1550–1560

Façon de Venise, possibly the workshop of
Sebastian Höchstetter

Free- and mold-blown colorless glass with
gilt applied decoration

Height: 1 ft. 3 in. (38.3 cm); Diameter (at
lip): 6 $^{3}/_{8}$ in. (16.2 cm)

Accession number 84.DK.545

PROVENANCE

Purportedly Count Hans Wilczek, Burg
Kreuzenstein, Austria; [Ruth and Leopold
Blumka, New York].

BIBLIOGRAPHY

"Acquisitions/1984," *GettyMus J* 13 (1985),
no. 217, p. 250, illus.; "Recent Important
Acquisitions Made in Public and Private
Collections in the United States and
Abroad," *Journal of Glass Studies* 28 (1986),
no. 27, p. 106; Bremer-David, *Summary*,
no. 466, p. 265, illus.; Hess and Husband,
European Glass, no. 40, pp. 154–155, illus.

437

437.
COVERED WELCOME BEAKER (WILKOMMGLAS)
Hall, 1550–1554
Façon de Venise, possibly the workshop of
Sebastian Höchstetter
Free-blown colorless glass with diamond-
point engraving, gilding, and enamel
decoration
Arms, on the center of the vessel wall and
repeated on the opposite side, in enamel,
*argent a fesse dancetty gules; crest, on a helm argent a
coronet or and a panache of peacock's plumes argent and
gules.* Engraved over the vessel wall with the
names or initials of various people and dates.
Height (with lid): 1 ft. 2 9/16 in. (37 cm);
Height (without lid): 11 1/4 in. (28.5 cm);
Diameter (at lip): 4 7/8 in. (12.4 cm)
Accession number 84.DK.515.1–.2

PROVENANCE
Count von Trautmannstorff, Gleichenberg
Castle (near Graz), Austria; E. and A. Silber-
man, Vienna, sold to Oscar Bondy, May 11,
1932; confiscated from Bondy's collection by
the Nazis, 1938; restituted by the Austrian
government to Bondy's widow, Elisabeth
Bondy, 1945; Elisabeth Bondy, New York,
sold to R. and L. Blumka, 1949; [Ruth and
Leopold Blumka, New York].

EXHIBITIONS
New York, The Metropolitan Museum of Art,
The Cloisters, *The Secular Spirit: Life and Art at
the End of the Middle Ages*, 1975, p. 277, no. 279.

BIBLIOGRAPHY
Oswald Trapp, "Die Geschichte eines Trap-
pisches Wilkommglas," *Der Schlern* 40 (1966),
pp. 120–122; Rainer Rückert, *Die Glassamm-
lung des Bayerischen Nationalmuseums München I*
(Munich, 1982), p. 79; "Acquisitions/1984,"
GettyMusJ 13 (1985), no. 214, p. 250; "Recent
Important Acquisitions Made in Pubic and
Private Collections in the United States and
Abroad," *Journal of Glass Studies*, no. 21, p. 104;
Bremer-David, *Summary*, no. 467, p. 265,
illus.; Hess and Husband, *European Glass*,
no. 41, pp. 156–159, illus.; *Masterpieces*, no. 6,
p. 12, illus.

438.
BOWL
Innsbruck, 1570–1591
Façon de Venise
Colorless glass with diamond-point engraving,
gilding (including silver), and cold-painted
decoration
Height: 6 5/16 in. (16 cm); Diameter (at lip):
15 15/16 in. (40.4 cm)
Accession number 84.DK.653

PROVENANCE
Sir John Drummond Erskine, Dunimarle
Castle, Culross, Fife, Scotland, by the second
quarter of the nineteenth century; by inheri-
tance to Magdelene Sharpe Erskine, Duni-
marle Castle, Culross, Fife, Scotland (sold,
Sotheby's, London, June 26, 1978, lot 26, to
David, Inc.); [David, Inc., Vaduz].

BIBLIOGRAPHY
Brian J. R. Blench, letter to the editor, *Journal
of Glass Studies* 26 (1984), pp. 155–157; "Acqui-
sitions/1984," *GettyMusJ* 13 (1985), no. 215,
p. 250, illus.; "Recent Important Acquisitions
Made in Public and Private Collections in
the United States," *Journal of Glass Studies* 28
(1986), no. 29, p. 107; Bremer-David, *Sum-
mary*, no. 468, p. 266, illus.; Hess and Hus-
band, *European Glass*, no. 43, pp. 164–166,
illus.; *Masterpieces*, no. 22, p. 31, illus.

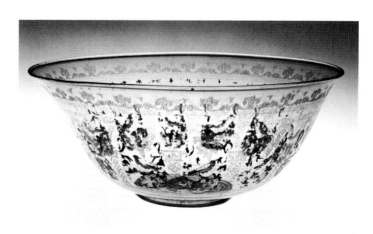

438

Bohemian

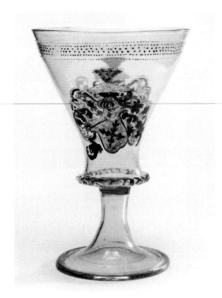

439

439.
GOBLET WITH THE ARMS OF LIECHTENBERG
Probably southern Bohemian, 1500–1530
Façon de Venise
Free-blown colorless glass with gold leaf and enamel decoration
Arms, on the center of the bowl, in enamel, *or two ragged staves in saltire, sable; the crest, upon a cushion gules, tasseled or, a fish argent, in front of a panache of peacock's feather proper.*
Height: 9 1/4 in. (23.5 cm); Diameter (at lip): 6 3/8 in. (16.2 cm)
Accession number 84.DK.537

PROVENANCE
Dr. Franz Kieslinger, Vienna; [Ruth and Leopold Blumka, New York].

EXHIBITIONS
New York, The Corning Museum of Glass, *Three Great Centuries of Venetian Glass*, 1958, p. 41, no. 19; New York, The Metropolitan Museum of Art, The Cloisters, *The Secular Spirit: Life and Art at the End of the Middle Ages*, 1975, p. 267, no. 263.

BIBLIOGRAPHY
"Acquisitions/1984," *GettyMus J* 13 (1985), no. 186, p. 245, illus.; "Recent Important Acquisitions Made in Public and Private Collections in the United States and Abroad," *Journal of Glass Studies* 28 (1986), no. 14, p. 102; Bremer-David, *Summary*, no. 450, p. 255, illus.; Hess and Husband, *European Glass*, no. 33, pp. 130–133, illus.

440.
BOWL OF A FOOTED BEAKER
Probably Bohemian or Italian (Murano), 1525–1575
Façon de Venise
Free-blown colorless glass with gold leaf enamel, and diamond-point engraved decoration
Height: 8 7/8 in. (21.5 cm); Diameter (at lip): 7 1/2 in. (19 cm); Diameter (at base): 3 1/16 in. (7.8 cm)
Accession number 84.DK.547

PROVENANCE
Robert von Hirsch, Basel (sold, Sotheby's, London, June 22, 1978, lot 256); [Ruth Blumka, New York].

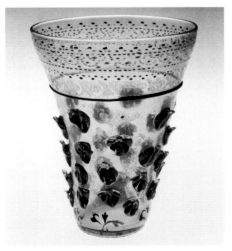

440

BIBLIOGRAPHY
The History of Glass, Dan Klein and Ward Lloyd, eds. (London, 1984), p. 74, illus.; "Acquisitions 1984," *GettyMus J* 13 (1985), no. 211, p. 249. illus.; "Recent Important Acquisitions Made by Public and Private Collections in the United States and Abroad," *Journal of Glass Studies* 28 (1986), no. 22, p. 10; Bremer-David, *Summary*, no. 447, p. 254, illus.; Hess and Husband, *European Glass*, no. 34, pp. 134–137, illus.; *Masterpieces*, no. 5, p. 12, illus.

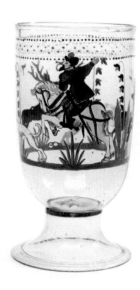

441

441.
GOBLET
Bohemian, 1576
Free-blown colorless glass with gold leaf and enamel decoration
Height: 8 7/8 in. (22.5 cm); Diameter (at lip): 4 13/16 in. (12.2 cm)
Accession number 84.DK.552

PROVENANCE
Prince of Liechtenstein, Vaduz; Francis S. McNalty, England (sold by his executors, Christie's, London, July 15, 1970, lot 247, to "Bier" for R. and L. Blumka); [Ruth and Leopold Blumka, New York].

BIBLIOGRAPHY

"Acquisitions/1984," *GettyMusJ* 13 (1985), no. 234, pp. 253–254, illus.; "Recent Important Acquisitions Made in Public and Private Collections in the United States and Abroad," *Journal of Glass Studies* 28 (1986), no. 23, p. 105; Bremer-David, *Summary*, no. 448, p. 254, illus.; Hess and Husband, *European Glass*, no. 53, pp. 196–198, illus.

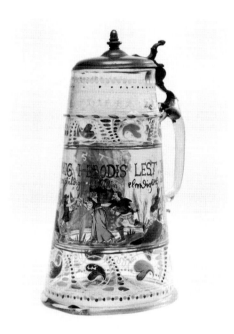

442

442.

COVERED TANKARD

Possibly northern Bohemian, 1578
Free-blown colorless glass with enamel and applied decoration and pewter mounts
Inscribed around central zone of vessel, *KÖNIG·HERODIS·LEST·DIE/unschuldigen kindlein elendiglich todten,1578*.
Height: 10⁵/₈ in. (27 cm); Diameter (at base): 5⁷/₈ in. (14.5 cm)
Accession number 84.DK.553

PROVENANCE

Collection Wilczek, Schloss Eisgrub (obj.-Nr. 1/22, Inv. Nr. 224), Austria; [Ruth and Leopold Blumka, New York].

BIBLIOGRAPHY

Axel von Saldern, *German Enameled Glass* (Corning, 1965), p. 92, fig. 114; "Acquisitions/1984," *GettyMusJ* 13 (1985), no. 220, p. 251, illus.; "Recent Important Acquisitions Made in Public and Private Collections in the United States and Abroad," *Journal of Glass Studies* 28 (1986), no. 24, p. 105; Bremer-David, *Summary*, no. 449, pp. 254–255, illus. p. 254; Hess and Husband, *European Glass*, no. 54, pp. 199–201, illus.

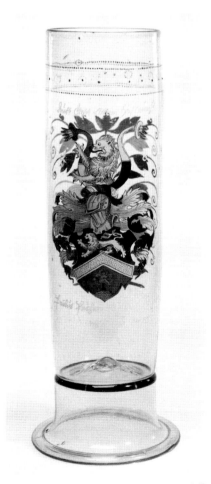

443

443.

BEAKER WITH THE ARMS OF PUCHNER
(*STANGENGLAS*)

Probably Northwest Bohemian or German, possibly Saxon (Erzgebirge), 1587
Free-blown colorless glass with gold leaf and enamel decoration
Arms, on the central zone of the vessel wall, in enamel, *tierced per chevron or, in chief sable a lion or, armed and langued gules and in base azure, on a mount vert a tree [beech] proper; crest, lion issuant between two buffaloes' horns, coupged dexter azure and or, sinister or and sable, issuant from each flames gules.*
Inscribed on upper and lower vessel wall, in enamel, *Auff Gott mein hoffnung/Paulus Puchner Chur:S:Zeug/meister zu dresden*; around the upper vessel wall, 1587.
Height: 12⁵/₁₆ in. (31.3 cm); Diameter (at base): 4⁹/₁₆ in. (11.7 cm)
Accession number 84.DK.555

PROVENANCE

[Ruth and Leopold Blumka, New York.]

BIBLIOGRAPHY

Brigitte Klesse and Axel von Saldern, *500 Jahre Glaskunst: Sammlung Biemann* (Zurich, 1978), p. 309; "Acquisitions/1984," *GettyMusJ* 13 (1985), no. 206, p. 248, illus.; "Recent Important Acquisitions Made in Public and Private Collections in the United States and Abroad," *Journal of Glass Studies* 28 (1986), no. 26, p. 106; Bremer-David, *Summary*, no. 451, p. 255, illus.; Hess and Husband, *European Glass*, no. 56, pp. 205–207, illus.

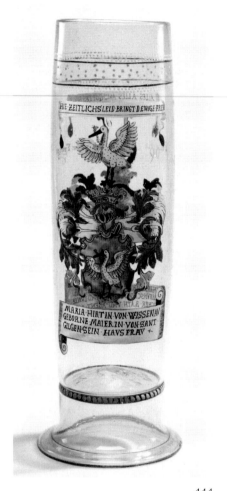

444

444.
BEAKER WITH THE ARMS OF HIRT AND MAIER (*STANGENGLAS*)

> Probably south Bohemian or from the Böhmerwald, 1590
> Free-blown colorless glass with gold leaf and enamel decoration
> Arms, *gules, a pale argent, three rosettes gules*; on the opposite side, *azure, a stork argent*. Inscribed on band above the cresting, in enamel, *ALLES ALLES MIT GOTTES HVLF*; below the arms, *HANS HIRT V WEISSENAV FVRST/BRAVNSCHWEIGIS CHER VND LVNEBVRG/ISCHER RATH VND AGENT AM KAYs/HOFF*; on the opposite side above the cresting, *HIE ZEITLICHS LEID BRINGT*

D EWIGE FREVD; below the arms, *MARIA HIRTIN VON WEISSENAU/GEBORNE MAIERIN VON SANT/GILGEN SEIN HAVSFRAV ALLES ALLES MIT GOTTES HVLF*; and just below the upper bands, *Patientia Durum Frango 1590*.
Height: 11 9/16 in. (29.3 cm); Diameter (at base): 4 1/8 in. (10.5 cm)
Accession number 85.DK.214

PROVENANCE
Viktor Schick, Prague; by inheritance to Shick's widow, Hedwig Schick, Prague (sold, Sotheby's, London, May 4, 1939, lot 17); (sold, Palais Galliera, Paris, November 29–December 3, 1965, no. 151); [Ruth and Leopold Blumka, New York].

BIBLIOGRAPHY
L. Fusch, "Die frühen süddeutschen Wappenhumpen," *Münchener Jahrbuch der bildenden Kunst* 12, n.s. (1937–1938), p. 224; p. 226, fig. 6; "Acquisitions/1985," *GettyMusJ* 14 (1986), no. 215, p. 252, illus.; Bremer-David, *Summary*, no. 452, p. 256, illus.; Hess and Husband, *European Glass*, no. 57, pp. 208–213, illus.

445.
HUNT BEAKER (*JAGDHUMPEN*)

> Bohemian or central German, 1593
> Free-blown colorless glass with gold leaf and enamel decoration, 1593.
> Height: 11 3/8 in. (28.9 cm); Diameter (at base): 5 5/16 in. (13.5 cm)
> Accession number 84.DK.556

PROVENANCE
Count Hans Wilczek, Burg Kreuzenstein, Austria, sold to E. and A. Silberman; E. and A. Silberman, Vienna, sold to O. Bondy; Oscar Bondy (died 1943), Vienna; confiscated from Bondy's collection by the Nazis, 1938; restituted by the Austrian government to Bondy's widow, Elisabeth Bondy, 1945; Elisabeth Bondy, New York, sold to R. and L. Blumka, 1949; [Ruth and Leopold Blumka, New York].

BIBLIOGRAPHY
"Acquisitions/1984," *GettyMusJ* 13 (1985), no. 235, p. 254, illus.; Bremer-David, *Summary*, no. 453, pp. 256–257, illus. p. 256; Hess and Husband, *European Glass*; no. 58, pp. 211–213, illus.

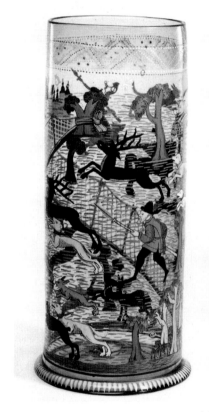

445

446.
IMPERIAL EAGLE BEAKER (*REICHSADLERHUMPEN*)

> Probably Bohemian, possibly central German, 1599
> Free-blown colorless glass with gold leaf and enamel decoration
> Inscribed on the vessel wall below the decorative band, in enamel, *Das heÿlige Romisch Reich Mit Sampt Seinen gliedern 1599*; on the four heraldic shields along the top of the eagle's dexter wing, *TRIER / COLN / MENTZ / POTESTAT ZV ROM*; on the sinister wing,

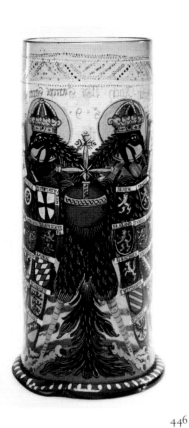

446

BEHEN / PFALTA / SACHSEN / BRANDEN
BVRG; on the banderoles attached to each
feather and on the bands over the shields in
six vertical ranks on the dexter wing, from
left to right and top to bottom, 4 BAVRN /
COLN / REGENSPVRG / COSENITZ /
SALTZBVRG / 4 STETT / AVGSBVRG /
METZ / ACH / LVBECK / 4 SEMPER-
FREIEN / LVNDBVRG / WESTERBVRG /
THVS-SIS / ALTWALTEN / 4 BVRGGRAVEN
/ MAIDBVRG / NVRNBERG / REMECK /
STRANBERG / 4 MARGRAVEN / MER-
CHERN / BRANDENBVRG / MEISCHEN /
BADEN / 4 SEIL / BRVANSCHWEIG /
BAIRN / SCHWABEN / LVTRING; and on
the sinister wing, 4 VICARI / BRABAND /
N. SACHSEN / WESTERBVRG SCHLEST /
4 LAND GRAVEN / DVRING / EDELSAS /
HESSEN / LEVCHTENBERG / 4 GRAVEN /
CLEVE / SAPHOY / SCHWARZBVRG /
ZILLI / 4 RITTER / ANNDELAW / WEIS-
SENBACH / FRAAENBERG / STTVNDECK

/ 4 DORFFER / BAMBERG / VLM / HAGE-
NAW / SLETSTAT / 4 BIRG / MADABVRG /
LVTZELBVRG / ROTTENBVRG /
ALTENBVRG.
Height: 11 1/2 in. (29.2 cm); Diameter (at
base): 5 3/8 in. (13.8 cm)
Accession number 84.DK.558

PROVENANCE
[Ruth and Leopold Blumka, New York.]

BIBLIOGRAPHY
"Acquisitions/1984," GettyMusJ 13 (1985),
no. 236, p. 254, illus.; Bremer-David,
Summary, no. 454, p. 257, illus.; Hess and
Husband, European Glass, no. 59, pp. 214–217,
illus.

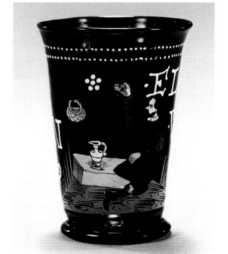

447

447.
BEAKER
Probably northern Bohemian or from the
Erzgebirge, 1599
Free-blown cobalt-blue glass with gold leaf
and enamel decoration
Inscribed and dated
ELIAS.IN.DER/WUSTEN.AN/NO.1.5.9.9.
Height: 4 1/2 in. (11.4 cm); Diameter (at lip):
3 3/8 in. (8.6 cm)
Accession number 84.DK.557

PROVENANCE
Aäron Vecht, Amsterdam; Lucien Sauphar,
Paris; Count Dr. Alexander von Frey, Paris,
sold to O. Bondy; Oscar Bondy (died 1943),
Vienna; confiscated from Bondy's collection by
the Nazis, 1938; restituted by the Austrian
government to Bondy's widow, Elisabeth
Bondy, 1945; Elisabeth Bondy, New York,
sold to R. and L. Blumka, 1949; [Ruth and
Leopold Blumka, New York].

BIBLIOGRAPHY
Axel van Saldern, German Enameled Glass
(Corning, 1965), p. 446; "Acquisitions/1984,"
GettyMusJ 13 (1985), no. 221, p. 251, illus.;
Bremer-David, Summary, no. 455, p. 257,
illus.; Hess and Husband, European Glass, no.
60, pp. 218–220, illus.

448.
FOOTED BEAKER (STANGENGLAS)
South Bohemian, 1600
Free-blown colorless glass with diamond-
point engraving
Inscribed in the upper parallel bands,
FRISCHAUF·JUNG·GESEL·WOL·
GEMUNDT·GAR·WOL/MIR·DAS·
FIEDELN·THUT. Inscribed over the couple,
Lieb haben und nicht genissenn/Thut manchen gar
sehr ver/driessen/. Inscription flanking the cou-
ple, 1600/Ich aber thu genissen/dass thut ganz nicht
vordriessen. Inscribed over the naked woman,
Halte feste, es kom/men frembde geste/Frisch auff;
and in the lower band 1600.
Height: 1 ft. 1 9/16 in. (34.5 cm); Diameter (at
base): 4 1/4 in. (10.7 cm)
Accession number 84.DK.559

PROVENANCE
Richard Leitner, Vienna, sold to O. Bondy,
June 16, 1922; Oscar Bondy (died 1943),
Vienna; confiscated from Bondy's collection
by the Nazis, 1938; restituted by the Aus-
trian government to Bondy's widow, Elisa-
beth Bondy, 1945; Elisabeth Bondy, New
York, sold to R. and L. Blumka, 1949; [Ruth
and Leopold Blumka, New York].

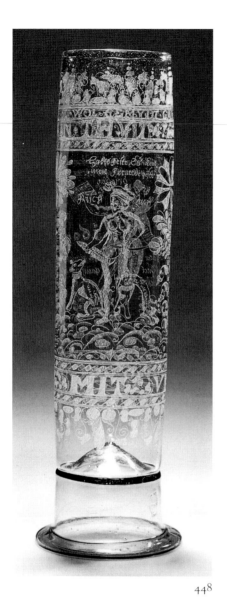

448

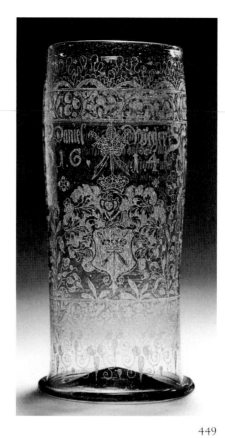

449

p. 251, illus.; "Recent Important Acquisitions Made in Public and Private Collections in the United States and Abroad," *Journal of Glass Studies* 28 (1986), no. 32, p. 108; Bremer-David, *Summary*, no. 456, p. 258, illus.; Hess and Husband, *European Glass*, no. 61, pp. 221–223, illus.; *Masterpieces*, no. 27, p. 38, illus.

BIBLIOGRAPHY

Hans Zedinek, "Die Glashütte zu Hall in Tirol," *Altes Kunsthandwerk* 1 (1927), pp. 98–117, pl. 89; Wilfred Buckley, *Diamond Engraved Glasses of the Sixteenth Century with Particular Reference to Five Attributed to Giacomo Verzelini* (London, 1929), p. 16, pl. 31; Erich Egg, "Die Glashütte zu Hall und Innsbruck in 16. Jahrhundert," *Tiroler Wirtschaftsstudien* 15 (Innsbruck, 1962), p. 80; "Acquisitions/1984," *GettyMus J* 13 (1985), no. 222,

449.
LARGE BEAKER (HUMPEN)
 Bohemian or Silesian, 1614
 Free-blown colorless glass with diamond-point engraving
 Arms, *gules (?) three swords, a right one in pale, between two others of different shape, hilt and pommel or, together enfiled in a coronet or; the charges of the shield, repeated.* Engraved on one side with *Daniel Weger 1.6.1.4.,* and on the other side with *Fein land ficht dü zü mir her/ein. Und lass dein*

Kürschneri/schen Laüffen sein. Mich dünckt dü/forcht dich für den treichenn. Drümb wirdt dass/glass am dich Nicht reichnn; engraved with 1614 on central zone of vessel wall.
 Height: 10 3/8 in. (26.3 cm); Diameter (at base): 4 7/8 in. (12.3 cm)
 Accession number 84.DK.560

PROVENANCE

Dr. Karl Ruhmann, Vienna, by 1956, sold to R. and L. Blumka; [Ruth and Leopold Blumka, New York].

BIBLIOGRAPHY

Ignaz Schlosser, *Das alte Glas: ein Handbuch für Sammler und Liebhaber* (Brunswick, 1956), pp. 152, 159, fig. 131; Erich Egg, "Die Glashütte zu Hall und Innsbruck im 16. Jahrhundert," *Tiroler Wirtschaftsstudien* 15 (Innsbruck, 1962), p. 80; "Acquisitions/1984," *GettyMus J* 13 (1985), no. 242, p. 255, illus.; "Recent Important Acquisitions Made in Public and Private Collections in the United States and Abroad," *Journal of Glass Studies* 28 (1986), no. 33, p. 108; Bremer-David, *Summary*, no. 457, pp. 258–259, illus. p. 259; Hess and Husband, *European Glass*, no. 62, pp. 224–227, illus.

450.
LARGE BEAKER (HUMPEN)
 South Bohemian, early seventeenth century
 Free-blown colorless glass with diamond-point engraving
 Height: 1 ft. 5 15/16 in. (44.6 cm); Diameter (at lip): 4 13/16 in. (12.2 cm)
 Accession number 84.DK.659

PROVENANCE

[Curt Berndorff, Copenhagen, sold to F. Biemann, January 1, 1973]; Fritz Biemann, Zurich (sold, Sotheby's, London, June 16, 1984, lot 46, to David, Inc.); [David, Inc., Vaduz].

EXHIBITIONS

Cologne, Kunstgewerbemuseum, Berlin, Kunstgewerbemuseum, and Zurich, Museum Bellerive, *Sammlung Biemann Ausstellung 500*

Jahre Glaskunst, B. Klesse and A. von Saldern, 1978–1979, p. 15, fig. 12, and p. 118, no. 65; Lucerne, Kunsthalle, *3000 Jahre Glaskunst von der Antike bis zum Jugendstil*, 1981, p. 161, no. 705.

BIBLIOGRAPHY
Dagmar Hnikova, "Böhmisches Glas," *Orbis Pictus* 61 (Bern and Stuttgart, 1974); "Acquisitions/1984," *GettyMus J* 13 (1985), no. 223, p. 251, illus.; Bremer-David, *Summary*, no. 458, p. 259, illus.; Hess and Husband, *European Glass*, no. 64, pp. 232–233, illus.

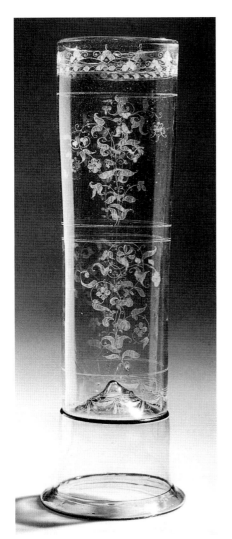

450

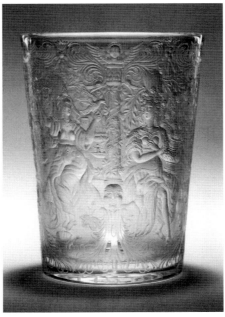

451

451.
BEAKER WITH PERSONIFICATIONS OF THE SENSES
Riesengebirge, late seventeenth century
By the Master of the Koula Beaker after prints by Marten de Vos
Free-blown glass with wheel-engraved decoration
Height: 4 3/4 in. (12.8 cm); Diameter (at lip): 4 in. (10.2 cm)
Accession number 84.DK.567

PROVENANCE
Leopold Blumka, Vienna, sold to O. Bondy, 1919; Oscar Bondy (died 1943), Vienna; confiscated from Bondy's collection by the Nazis, 1938; restituted by the Austrian government to Bondy's widow, Elisabeth Bondy, 1945; Elisabeth Bondy, New York, sold to R. and L. Blumka, 1949; [Ruth and Leopold Blumka, New York].

BIBLIOGRAPHY
Olga Drahotová, "Dans le sphère du maître graveur du goblet dit de Koula," *Cristal de Bohême* (1965), pp. 29–32; "Acquisitions/1984," *GettyMus J* 13 (1985), no. 224, p. 252, illus.; Bremer-David, *Summary*, no. 459, p. 260, illus.

French

452.
FLASK
Possibly French, circa 1550–1600
Façon de Venise
Free-blown dichroic glass with pewter mounts
Height: 1 ft. 1 3/16 in. (33.5 cm); Width: 8 7/8 in. (22.8 cm)
Accession number 84.DK.519

PROVENANCE
[Ruth and Leopold Blumka, New York.]

BIBLIOGRAPHY
"Acquisitions/1984," *GettyMus J* 13 (1985), no. 229, p. 253; "Recent Important Acquisitions Made in Public and Private Collections in the United States and Abroad," *Journal of Glass Studies* 28 (1986), no. 18, p. 103; Hess and Husband, *European Glass*, pp. 172–173, illus.

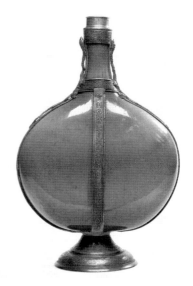

452

German

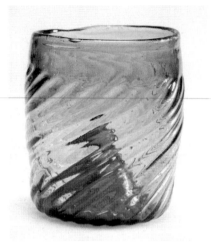

453

453·
BEAKER
Lower Rhineland, Hesse or possibly Franconia, 1400–1450
Mold-blown dark yellowish-green glass
Height: 2 13/$_{16}$ in. (7.1 cm); Maximum Diameter: 2 3/$_{4}$ in. (7 cm)
Accession number 84.DK.522

PROVENANCE
Leopold H. Seligmann, Cologne (sold, Sotheby's, London, June 30, 1932, lot 35); Baron Maurice (Edmond Charles) de Rothschild, Paris (1881–1957); Count Dr. Alexander von Frey, Paris, sold to O. Bondy; Oscar Bondy (died 1943), Vienna; confiscated from Bondy's collection by the Nazis, 1938; restituted by the Austrian government to Bondy's widow, Elisabeth Bondy, 1945; Elisabeth Bondy, New York, sold to R. and L. Blumka, 1949; [Ruth and Leopold Blumka, New York].

BIBLIOGRAPHY
Franz Rademacher, "Die gotischen Gläser der Sammlung Seligmann-Köln," *Pantheon* 8 (1931), pp. 290–294, fig. 3 (lower left); Franz Rademacher, *Die deutschen Gläser des Mittelalters* (Berlin, 1933), pp. 94ff, pl. 24c; "Acquisitions/1984," *GettyMusJ* 13 (1985), no. 200, p. 247, illus.; Bremer-David, *Summary*, no. 422, p. 242, illus.; Hess and Husband, *European Glass*, no. 1, pp. 28–29, illus.

454·
DRINKING BOWL (*MAIGELEIN*)
German, fifteenth century
Mold-blown dark green glass
Height: 1 15/$_{16}$ in. (4.9 cm); Diameter (at lip): 3 9/$_{16}$ in. (9 cm)
Accession number 84.DK.521

PROVENANCE
Leopold H. Seligmann, Cologne (sold, Sotheby's, London, June 30, 1932, lot 33, to "Buckely" [possibly Wilfred Buckley, London]); Buckley; Count Dr. Alexander von Frey, Paris, at least until 1936; probably Oscar Bondy (died 1943), Vienna; Dr. Karl Ruhmann, Vienna, sold to R. and L. Blumka; [Ruth and Leopold Blumka, New York].

BIBLIOGRAPHY
Franz Rademacher, "Die gotischen Gläser der Sammlung Seligmann-Köln," *Pantheon* 8 (1931), pp. 290–294, fig. 3 (upper left); Franz Rademacher, *Die deutschen Gläser des Mittelalters* (Berlin, 1933), pp. 94ff., pl. 22c; Jaroslave Vávra, *Das Glas und die Jahrtausende* (Prague, 1951), no. 95, pl. 38; "Acquisitions/1984," *GettyMusJ* 13 (1985), no. 199, p. 247, illus.; Bremer-David, *Summary*, no. 423, p. 242, illus.; Hess and Husband, *European Glass*, no. 2, pp. 30–31, illus.

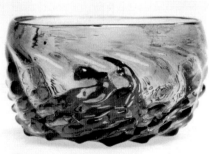

454

455·
PRUNTED BEAKER (*KRAUTSTRUNK*)
German, late fifteenth or early sixteenth century
Free-blown pale blue-green glass with applied decoration
Height: 3 7/$_{8}$ in. (9.9 cm); Maximum Diameter: 3 1/$_{4}$ in. (8.4 cm)
Accession number 84.DK.526

PROVENANCE
Hohenzollern Museum, Sigmaringen, Germany; Leopold H. Seligmann, Cologne (sold, Sotheby's London, June 30, 1932, lot 24, to "Kreitz"); Kreitz; Aäron Vecht (1886–1965), Amsterdam (sold, Sotheby's, London, November 10, 1938, lot 56, unsold); stored in London during the war; recovered by Vecht after 1945 and brought back to the Netherlands; purportedly Count Dr. Alexander von Frey, Paris; [Ruth and Leopold Blumka, New York].

EXHIBITIONS
Amsterdam, Rijksmuseum, *Tentoonstelling van oude Kunst uit het bezit van den internationalen Handel*, 1936, no. 687.

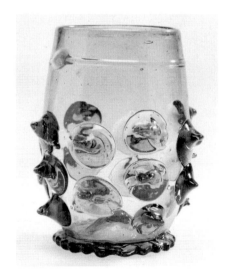

455

BIBLIOGRAPHY

Franz Rademacher, "Die gotischen Gläser der Sammlung Seligmann-Köln," *Pantheon* 8 (1931), pp. 290–294, fig. A (upper right); Franz Rademacher, *Die deutschen Gläser des Mittelalters* (Berlin, 1933), p. 113, pl. 45b; "Acquisitions/1984," *GettyMusJ* 13 (1985), no. 203, p. 248, illus.; Bremer-David, *Summary*, no. 426, p. 243, illus.; Hess and Husband, *European Glass*, no. 3, pp. 32–33, illus.

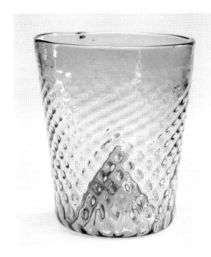

456

456.
BEAKER (MAIGELBECHER)

German, circa 1450–1525
Mold-blown pale blue-green glass
Height: 3 7/16 in. (8.8 cm); Diameter (at lip): 3 1/4 in. (8 cm)
Accession number 84.DK.523

PROVENANCE

Count Dr. Alexander von Frey, Paris, sold to O. Bondy, after 1936; Oscar Bondy (died 1943), Vienna; confiscated from Bondy's collection by the Nazis, 1938; restituted by the Austrian government to Bondy's widow, Elisabeth Bondy, 1945; Elisabeth Bondy, New York, sold to R. and L. Blumka, 1949; [Ruth and Leopold Blumka, New York].

BIBLIOGRAPHY

"Acquisitions/1984," *GettyMusJ* 13 (1985), no. 202, p. 248, illus.; Bremer-David, *Summary*, no. 424, p. 243, illus.; Hess and Husband, *European Glass*, no. 5, pp. 37–39, illus.

457.
PRUNTED BEAKER (KRAUTSTRUNK)

German, 1480–1520
Free-blown dark green glass with applied decoration
Height: 2 7/15 in. (6.3 cm); Diameter (at lip): 2 3/8 in. (6.1 cm)
Accession number 84.DK.524

PROVENANCE

[Ruth and Leopold Blumka, New York.]

BIBLIOGRAPHY

"Acquisitions/1984," *GettyMusJ* 13 (1985), no. 201, p. 247, illus.; Bremer-David, *Summary*, no. 425, p. 243, illus.; Hess and Husband, *European Glass*, no. 4, pp. 34–36, illus.

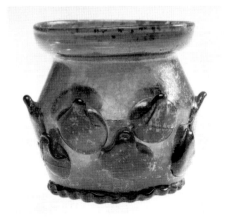

457

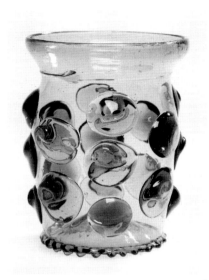

458

458.
PRUNTED BEAKER (KRAUTSTRUNK)

Southern German or Swiss, circa 1490–1530
Free-blown blue-green glass with applied decoration
Height: 4 1/8 in. (10.5 cm); Diameter (at lip): 3 7/16 in. (8.7 cm)
Accession number 84.DK.525

PROVENANCE

Hohenzollern Museum, Sigmaringen, Germany; sold to L. H. Seligmann; Leopold H. Seligmann, Cologne (sold, Sotheby's, London, June 30, 1932, lot 23); Count Dr. Alexander von Frey, Paris, sold to R. and L. Blumka; [Ruth and Leopold Blumka, New York].

BIBLIOGRAPHY

Franz Rademacher, "Die Gläser der Sammlung Seligmann-Köln," *Pantheon* 8 (1931), pp. 290–294, fig. 4 (lower right); Franz Rademacher, *Die deutschen Gläser des Mittelalters* (Berlin, 1933), pp. 111ff., pl. 42d; "Acquisitions/1984," *GettyMusJ* 13 (1985), no. 232, p. 253, illus.; Bremer-David, *Summary*, no. 427, p. 244, illus.; Hess and Husband, *European Glass*, no. 6, pp. 40–42, illus.

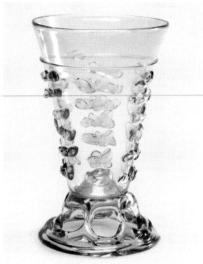

459

459.
FOOTED BEAKER

Possibly from the lower Rhineland, circa
1500–1550
Free-blown pale yellow-green glass with
applied decoration
Height: 4 ⁵/₈ in. (11.8 cm); Diameter (at lip):
3 ¹/₈ in. (7.9 cm)
Accession number 84.DK.532

PROVENANCE

Count Dr. Alexander von Frey, Paris, at least
until 1936; Oscar Bondy Vienna (died 1943);
confiscated from Bondy's collection by the
Nazis, 1938; restituted by the Austrian gov-
ernment to Bondy's widow, Elisabeth Bondy,
1945; Elisabeth Bondy, New York, sold to R.
and L. Blumka, 1949; [Ruth and Leopold
Blumka, New York].

BIBLIOGRAPHY

"Acquisitions/1984," *GettyMusJ* 13 (1985),
no. 241, p. 255, illus.; Bremer-David, *Sum-
mary*, no. 428, p. 244, illus.; Hess and Hus-
band, *European Glass*, no. 7, pp. 43–45, illus.

460.
PRUNTED BEAKER (BERKEMEYER)

Southern German (lower Rhineland), 1500–
1550
Free-blown blue-green glass with applied
decoration
Height: 5 ⁵/₁₆ in. (13.5 cm); Diameter (at lip):
5 ¹/₁₆ in. (12.9 cm)
Accession number 84.DK.527

PROVENANCE

[Ruth and Leopold Blumka, New York.]

BIBLIOGRAPHY

"Acquisitions/1984," *GettyMusJ* 13 (1985),
no. 237, p. 254, illus.; Bremer-David, *Sum-
mary*, no. 430, p. 245, illus.; Hess and Hus-
band, *European Glass*, no. 8, pp. 46–49, illus.;
Masterpieces, no. 21, p. 30, illus.

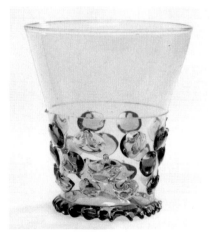

460

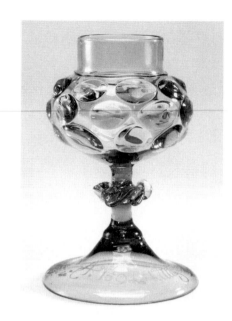

461

461.
STEMMED AND PRUNTED GOBLET

Lower Rhineland (possibly Cologne), circa
1500–1550
Free-blown blue-green glass with applied
and diamond-point engraved decoration
Engraved with 4 . augustus . was Ick Out . 100 .
Jaer . A 1594 . on the foot.
Height: 5 ³/₄ in. (14.6 cm); Diameter (at lip):
2 ¹/₈ in. (5.4 cm); Diameter (at base): 3 ¹³/₁₆
in. (9.7 cm)
Accession number 84.DK.509

PROVENANCE

[Ruth and Leopold Blumka, New York.]

BIBLIOGRAPHY

"Acquisitions/1984," *GettyMusJ* 13 (1985),
no. 231, p. 253, illus.; "Recent Important
Acquisitions Made by Public and Private
Collections in the United States and
Abroad," *Journal of Glass Studies* 28 (1986),
p. 99, fig. 6; Bremer-David, *Summary*, no. 431,
p. 245, illus.; Hess and Husband, *European
Glass*, no. 9, pp. 50–53, illus.

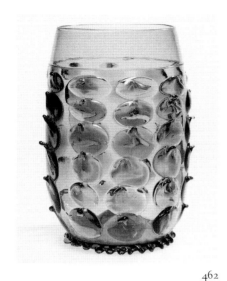

462

462.
PRUNTED BEAKER
German, sixteenth century
Free-blown dark blue-green glass with
applied decoration
Height: 9¹⁵/₁₆ in. (25.2 cm); Diameter (at
lip): 5¹¹/₁₆ in. (14.5 cm)
Accession number 84.DK.510

PROVENANCE
Count Hans Wilczek, Burg Kreuzenstein,
Austria, by 1926, sold to F. Ruhmann;
Franz Ruhmann, Vienna, by 1938; by
inheritance to Dr. Karl Ruhmann, Vienna,
sold to R. and L. Blumka; [Ruth and
Leopold Blumka, New York].

BIBLIOGRAPHY
Alfred Walcher-Molthein, "Die deutschen
Renaissancegläser auf Burg Kreuzenstein, 1,"
Belvedere 45 (March 1926), p. 41, fig. 18;
Wolfgang Born, "Five Centuries of Glass: 1,
The Franz Ruhmann Collection at Vienna,"
Connoisseur 101 (January 1938), pp. 12–13,
fig. 6; "Acquisitions/1984," *GettyMusJ* 13
(1985), no. 204, p. 248, illus.; "Recent

Important Acquisitions Made by Public and
Private Collections in the United States and
Abroad," *Journal of Glass Studies* 28 (1986),
p. 100, fig. 8; Bremer-David, *Summary*,
no. 429, pp. 244–245, illus. p. 244; Hess
and Husband, *European Glass*, no. 10, pp. 54–
55, illus.

463.
COVERED FILIGRANA BEAKER (*STANGENGLAS*)
German or Italian (Murano), 1550–1600
Façon de Venise
Free- and mold-blown colorless glass with
opaque white (*lattimo*) canes
Mounts: German (Augsburg), circa 1685
Silver gilt
Engraved with *SEI WILLKUMEN MEIN*

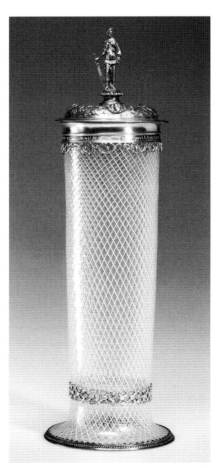

463

*HAUS-SEZ AN UND TRINK AUS–TRAG
FRID NIT HINAUS* on the lip mount.
Stamped on the brim of the cove with a pine-
cone for the city of Augsburg and the mono-
gram MB, the maker's mark of Martin Bair.
Height (with lid): 1 ft. (30.5 cm); Height
(without lid): 9¹/₂ in. (24.2 cm); Diameter (at
base): 4 in. (10.1 cm)
Accession number 84.DK.513.1–.2

PROVENANCE
[Ruth and Leopold Blumka, New York.]

BIBLIOGRAPHY
"Acquisitions/1984," *GettyMusJ* 13 (1985),
no. 193, p. 246, illus.; Bremer-David, *Summary*,
no. 385, p. 220, illus.; Hess and Husband,
European Glass, no. 44, pp. 167–169, illus.;
Handbook 2001, p. 246, illus.

464.
GOBLET
Central German or Bohemian, second half of
the sixteenth century
Free- and mold-blown light cobalt-blue glass
with gold leaf enamel decoration
Height: 8¹/₁₆ in. (20.5 cm); Diameter (at lip):
3¹/₁₆ in. (7.8 cm)
Accession number 84.DK.550

PROVENANCE
Count Dr. Alexander von Frey, Paris, sold to
R. and L. Blumka; [Ruth and Leopold Blumka,
New York].

EXHIBITIONS
New York, The Corning Museum of Glass,
Three Great Centuries of Venetian Glass, 1958,
pp. 102–103, no. 111.

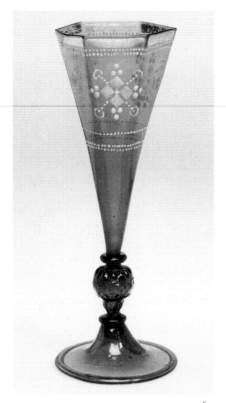

464

azure; on the center section of the opposite side, *azure, a fallow deer salient with tail, armed or; crest, a demi-fallow deer salient*, as in the shield. Dated on the side of the vessel, in enamel, 1586.
Height: 8 in. (20.4 cm); Diameter (at lip): 5 1/8 in. (13 cm)
Accession number 84.DK.554

PROVENANCE
Count Hans Wilczek, Burg Kreuzenstein, Austria, by 1926; [Ruth and Leopold Blumka, New York].

BIBLIOGRAPHY
Alfred Walcher-Molthein, "Deutschen Renaissancegläser auf Burg Kreuzenstein 1," *Belvedere* no. 45 (March, 1926), p. 57, fig. 28; "Acquisitions/1984," *GettyMusJ* 13 (1985), no. 205, p. 248, illus.; "Recent Important Acquisitions Made by Public and Private Collections in the United States and Abroad" *Journal of Glass Studies* 28 (1986), no. 25, p. 105; Bremer-David, *Summary*, no. 434, p. 246, illus.; Hess and Husband, *European Glass*, no. 55, pp. 202–204, illus.

BIBLIOGRAPHY
"Acquisitions/1984," *GettyMusJ* 13 (1985), no. 233, p. 253, illus.; Bremer-David, *Summary*, no. 433, p. 246, illus.; Hess and Husband, *European Glass*, no. 52, pp. 194–195, illus.

465.
BEAKER WITH THE ARMS OF SCHILTL AND PORTNER VON THEUERN
Southern German, possibly Bavarian, 1586
Free-blown colorless glass with gold leaf and enamel decoration
Arms, on the center section of one side, in enamel, *per bend azure, a lion passant crowned or, grasping a scimitar, and per bend or, three escutcheons azure, and gules; crest, out of a coronet or, a demi-lion with the scimitar as in the shield, between two eagles' wings gules, each ensigned with a bend—dexter transformed into a bar—or, charged with three escutcheons*

466.
STANDING COVERED FILIGRANA CUP
German or Italian (Murano), late sixteenth or early seventeenth century
Façon de Venise
Free- and mold-blown colorless glass with opaque white (*lattimo*) canes
Mounts: German (Augsburg), circa 1580–1600
Silver gilt
Stamped on the edge of the lip mount with a pinecone for the city of Augsburg and a tree on a mount, the maker's mark of Mattäus Wallbaum.
Height (with lid): 8 5/16 in. (21.1 cm); Height (without lid): 5 11/16 in. (14.5 cm); Diameter (at lip): 2 1/4 in. (5.8 cm)
Accession number 84.DK.514.1–.2

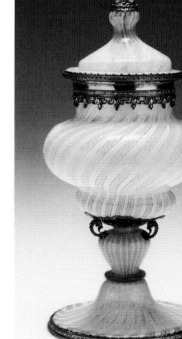

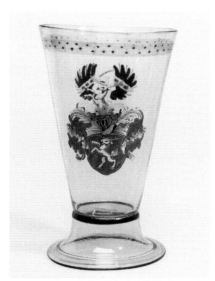

465

466

PROVENANCE

[Ruth and Leopold Blumka, New York].

BIBLIOGRAPHY

"Acquisitions/1984," *GettyMusJ* 13 (1985),
no. 190, p. 246, illus.; "Recent Important
Acquisitions Made in Public and Private Col-
lections in the United States and Abroad,"
Journal of Glass Studies 28 (1986), no. 15,
pp. 102–103; Bremer-David, *Summary*,
no. 384, p. 219, illus.; Hess and Husband,
European Glass, no. 42, pp. 160–163, illus.;
Masterpieces, no. 23, p. 32, illus.

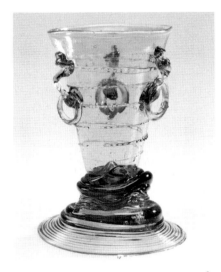

467.

RING BEAKER (*RINGBECHER*)

German, early seventeenth century
Free-blown blue-green glass with applied
decoration
Height: 4 3/4 in. (12.1 cm); Diameter (at
lip): 3 1/16 in. (7.7 cm); Diameter (at base):
3 7/16 in. (8.8 cm)
Accession number 84.DK.531

PROVENANCE

Gabriel Pichler, Vienna, sold to O. Bondy,
November 29, 1927; Oscar Bondy (died
1943), Vienna; confiscated from Bondy's col-
lection by the Nazis, 1938; restituted by the
Austrian government to Bondy's widow, Elis-
abeth Bondy, 1945; Elisabeth Bondy, New
York, sold to R. and L. Blumka, 1949; [Ruth
and Leopold Blumka, New York].

BIBLIOGRAPHY

"Acquisitions/1984," *GettyMusJ* 13 (1985),
no. 240, p. 254, illus.; Bremer-David, *Sum-
mary*, no. 432, p. 245, illus.; Hess and Hus-
band, *European Glass*, no. 11, pp. 56–58, illus.

468.

GOBLET WITH THE ARMS OF BREGENZ AND OF LOCAL PATRICIANS

Southwestern German (Baden, probably
the southern Schwarzwald), after 1621–
circa 1635
Free-blown colorless glass with diamond-
point engraving
Arms, engraved in three rows across the sur-
face of the vessel twenty-one shields, seven
per row, several blank, not all numbered, a
patchwork of pelts, a pale ermine; (1) a swan with wings
opened; (2) quarterly one and four on a mount a lion
rampant holding a gem ring and two and three on a pale
three bezants; (3) an ox rampant armed; (4) a pale
three trees; (5) issuant from a mount vert, a cross
between two arms, vested, each holding a stone; (6) quar-
terly one and four, a rose and two and three lozengy in
bend sinister, on an inescutcheon gules and on a pale the
lettering "SMD" in pale, sable; (7) a gem ring; (8) as
3; (9) a stag standing in profile; (10) flanking a tree
a goat rampant and a man; (11) as 2; (12) as 7;
(13) quarterly one and four a bendy with tree and two

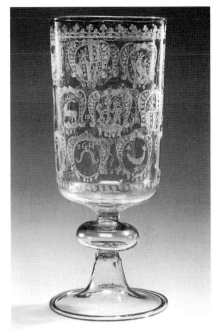

468

and three a chevron with three bezants; (14) a shield
tripart the florettes; (15) as 2 and 11; (16) Forstmarke
"MS"; (17) Hausmark "IGH"; (18) a crescent between
three mullets; (19) blank; (20) blank.
Height: 10 3/4 in. (27.4 cm); Diameter (at lip):
4 9/16 in. (11.6 cm)
Accession number 84.DK.551

PROVENANCE

[Ruth and Leopold Blumka, New York.]

BIBLIOGRAPHY

"Acquisitions/1984," *GettyMusJ* 13 (1985),
no. 249, p. 256, illus.; Bremer-David,
Summary, no. 435, p. 247, illus.; Hess and Hus-
band, *European Glass*, no. 63, pp. 228–231, illus.

469.

TUMBLER (*STEHAUFBECHER*)

Central German (possibly the Fichtelgebirge)
or northwestern Bohemia, 1631
Free-blown dark cobalt-blue glass with
enamel decoration
Inscribed around the vessel wall, painted in
enamel, *Drinckh mich aus undt leg mich nid[er] Steh
ich auff so vil mich wider. gib mich deinen/nechsten
wider. ich lieb was wein ist obs gleich nicht mein ist.
unndt mier nicht wertten khan/so hab ich glich wol
mein vreidt daran. liebt ihr mich wie ich eich nicht mehr
veger ich/von eich. vil sint lieblich aber nur ihr ehr
vreidt mich ich lieb eich aus hertzen/grundt. wollt godt
eur maul unndt mein maul war ein mundt. ich lieb
eich/noch von grundt meinnes hertzen ob ich so[llt]
nicht mitt eich darff schertzn/drink allen valschen
hertzen. Ich wolt sie miesten alle ehr hengen./die mier
undt eich nichts ginnen.*; at the end of the
inscription, *1631*.
Height: 2 3/4 in. (7 cm); Diameter (at lip):
4 in. (10.2 cm)
Accession number 84.DK.561

PROVENANCE

Count Hans Wilczek, Burg Kreuzenstein,
Austria, by 1926, sold to F. Ruhmann; Franz
Ruhmann, Vienna, sold to R. and L. Blumka,
presumably by his son, Dr. Karl Ruhmann,
Vienna; [Ruth and Leopold Blumka, New York].

BIBLIOGRAPHY

Alfred Walcher-Molthein, "Deutschen
Renaissancegläser auf Burg Kreuzenstein II,"
Belvedere 9–10, no. 46 (April 1926), p. 64,
fig. 41; Tilde Ostertag, *Das Fichtelgebirgsglas,
Beiträge zur Fränkischen Kunstgeschichte* 2 (Erlan-

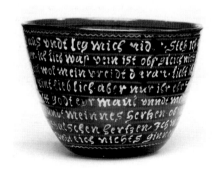

469

gen, 1933)', pl. 22a; Axel von Saldern, *German
Enameled Glass*, p. 149, fig. 266; "Acquisitions/
1984," *GettyMusJ* 13 (1985), no. 243, p. 255,
illus.; Bremer-David, *Summary*, no. 436,
p. 247, illus.; Hess and Husband, *European
Glass*, no. 65, pp. 234–236, illus.

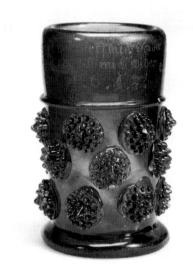

470

470.

THICK-WALLED BEAKER
(*UNZERBRECHLICHER BECHER*)

Possibly central German, 1643
Free-blown emerald green glass with applied
and diamond-point engraved decoration
Engraved with *Trinck mich auss und wirff mich
Nider /Hebb mich auff und vill mich wider Anno
1643* around the lip in diamond-point.
Height: 4 7/8 in. (12.4 cm); Diameter (at lip):
1 1/8 in. (2.8 cm)
Accession number 84.DK.529

PROVENANCE

[Ruth and Leopold Blumka, New York.]

BIBLIOGRAPHY

"Acquisitions/1984," *GettyMusJ* 13 (1985),
no. 207, p. 248, illus.; Bremer-David, *Sum-
mary*, no. 440, p. 249, illus.; Hess and Hus-
band, *European Glass*, no. 13, pp. 62–65, illus.

471.

JOKE GLASS (*SCHERZGEFÄSS*)

German or Netherlandish, seventeenth
century
Free-blown pale green glass with applied
decoration and silver and silver-gilt mounts
Height: 1 ft. 1 1/4 in. (33.7 cm); Maximum
width: 3 5/8 in. (9.2 cm)
Accession number 84.DK.520.1–.3

PROVENANCE

[Ruth and Leopold Blumka, New York.]

BIBLIOGRAPHY

"Acquisitions/1984," *GettyMusJ* 13 (1985),
no. 239, p. 254, illus.; Bremer-David, *Sum-
mary*, no. 437, p. 248, illus.; Hess and Hus-
band, *European Glass*, no. 14, pp. 66–68, illus.;
Masterpieces, no. 28, p. 39, illus.

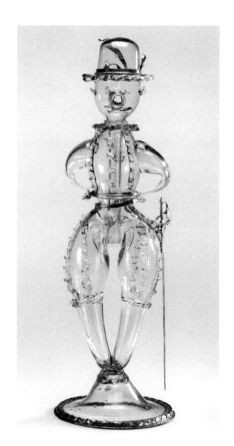

471

472.
PATTERN-MOLDED BEAKER (WARZENGLAS)
Possibly German, seventeenth century
Mold-blown dark green glass with applied
decoration
Height: 5¹⁵/₁₆ in. (15.1 cm); Diameter (at
lip): 3⁷/₁₆ in. (8.8 cm)
Accession number 84.DK.530

PROVENANCE
[Ruth and Leopold Blumka, New York.]

BIBLIOGRAPHY
"Acquisitions/1984," *GettyMusJ* 13 (1985),
no. 247, p. 256, illus.; Bremer-David, *Summary*, no. 438, p. 248, illus.; Hess and Husband, *European Glass*, no. 15, pp. 69–71, illus.

473

472

473.
PRUNTED BEAKER (BERKEMEYER)
German or Netherlandish, 1650–1675
Free-blown dark yellow-green glass with
applied decoration
Height: 7³/₈ in. (18.8 cm); Diameter (at lip):
6⁷/₁₆ in. (16.4 cm)
Accession number 84.DK.528

PROVENANCE
W. J. Snouck Hurgronje, The Hague (sold,
Frederik Muller and Co. [Mensing et Fils],
Amsterdam, July 8, 1931, lot 556, to
A. Vecht); Aäron Vecht, Amsterdam (offered
for sale, Sotheby's, London, November 10,
1938, lot 60, unsold); stored in London during World War II; recovered and brought
back to the Netherlands by the same; purportedly Count Dr. Alexander von Frey,
Paris; [Ruth and Leopold Blumka, New York].

EXHIBITIONS
Amsterdam, Rijksmuseum, *Tentoonstelling van
oude Kunst uit het Bezit van den internationlen Handel*, 1936, no. 692.

BIBLIOGRAPHY
"Acquisitions/1984," *GettyMusJ* 13 (1985),
no. 246, p. 256, illus.; Bremer-David, *Summary*, no. 438, pp. 248–249, illus. p. 248;
Hess and Husband, *European Glass*, no. 12,
pp. 59–61, illus.

474

474.
SATIRICAL BEAKER
Northern German, 1660
Free-blown colorless glass with gold leaf and
enamel decoration
Inscribed on the vessel wall, in enamel, *Hilff
Gott! wie muss sich doch der gutte Tilly leyden / Wie
kann doch mancher Geld auss seinem schimpfe schneiden
/ Wie zeucht er doch vorbey, wie musser sich doch bücken
/ Wie drückt ihn doch die Butt auf seinem alten
Rücken / Der kaum geheyletist von Puffen, die kriegt /
Bey Leypsischem confeckt. Der Korb fast uberwiegt /
Mehr als er tragen kann. So wandert er geschwinde /
Mit sich und seinem Stab in Regen, Schnee und Winde
/ Doch geht er nicht allein, sein alte Geyss leufst mitte /
Und zettert bey ihm her mit eben leisen Tritte / Sie
meckert dass sie muss mit dem zu fusse fort / Mit dem
sie vor stets fuhr an inede Stell und Ort /;* from Tilly's
mouth *O miserere mei*; on the basket *Nimiae
Exaction*; on the barrel *Mea Constientia*; on his
staff *Unicum et fragile*; from the personification of the wind *Vindicta divina / Vindicta divina*; below the lip, *1.6.6.0*; on the
bottom, painted in a modern hand, *3822* and
1180.
Height: 8⁹/₁₆ in. (21.5 cm); Diameter (at lip):
5¹/₈ in. (13.1 cm)
Accession number 84.DK.562

PROVENANCE
[Ruth and Leopold Blumka, New York.]

BIBLIOGRAPHY
"Acquisitions/1984," *GettyMusJ* 13 (1985), no. 209, p. 249, illus.; Bremer-David, *Summary*, no. 441, p. 249, illus.; Hess and Husband, *European Glass*, no. 66, pp. 237–239, illus.

475

475.
COVERED JUG
Thuringian, 1671
Free-blown green glass with enamel decoration and unmarked pewter mounts
Inscribed around the vessel wall, in enamel, *Wirtt komt die ein Gast so drag ihm fur wass du hast, ist er Erbau und Wohlgemutt / so nimbt er mitt einen drunckt und Brodt ver gutt ist er aber ein schalckin / der hautt geborhn so ist alle gutt thut an ihm verlohrn, Gott behütte und erhalte / Dass gantze lübliche*

handtwerck der kü[rsch]ner; below the inscription 1671; on the arcade over the figures, inscribed *Drinckt und est Gott / nich vergest.*
Height: 10 3/4 in. (27.3 cm)
Accession number 84.DK.563

PROVENANCE
Leitner, Vienna, sold to O. Bondy, 1921; Oscar Bondy (died 1943), Vienna; confiscated from Bondy's collection by the Nazis, 1938; restituted by the Austrian government to Bondy's widow, Elisabeth Bondy, 1945; Elisabeth Bondy, New York, sold to R. and L. Blumka, 1949; [Ruth and Leopold Blumka, New York].

BIBLIOGRAPHY
"Acquisitions/1984," *GettyMusJ* 13 (1985), no. 210, p. 249, illus.; Bremer-David, *Summary*, no. 442, p. 250, illus.

476.
GOBLET WITH A PORTRAIT OF
EMPEROR LEOPOLD I
German (Nuremberg), 1676–1683
By Hermann Schwinger
Free-blown glass with wheel-engraved decoration
Height: 11 1/2 in. (29.6 cm)
Accession number 84.DK.566

PROVENANCE
Viktor Schick, Prague; by inheritance to Schick's widow, Hedwig Schick, Prague (sold, Sotheby's, London, May 4, 1939, lot 34); [Ruth and Leopold Blumka, New York].

BIBLIOGRAPHY
"Acquisitions/1984," *GettyMusJ* 13 (1985), no. 208, p. 249, illus.; "Recent Important Acquisitions Made in Public and Private Collections in the United States and Abroad," *Journal of Glass Studies* 28 (1986), no. 37, p. 109.; Bremer-David, *Summary*, no. 443, p. 250, illus.

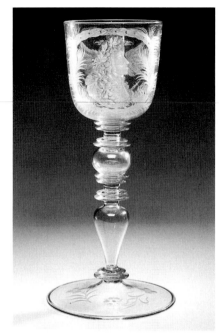

476

477.
GOBLET
Silesian (Hermsdorf), circa 1691–1694
By Friedrich Winter in the Schaffgotsch workshop
Colorless glass with wheel-engraved, high-relief decoration
Height (with lid): 1 ft. 3/16 in. (31 cm);
Height (without lid): 8 5/8 in. (21.9 cm);
Diameter (at lip): 3 13/16 in. (9.7 cm)
Accession number: 84.DK.568.1–.2

PROVENANCE
Franz Ruhmann, Vienna, by 1938; by inheritance to Dr. Karl Ruhmann, Vienna, sold to R. and L. Blumka; [Ruth and Leopold Blumka, New York].

BIBLIOGRAPHY
Wolfgang Born, "Five Centuries of Glass: II," *Connoisseur* 101 (March 1938), p. 121, fig. 1; Ignaz Schlosser, *Das alte Glas* (Brunswick, 1956), p. 137, fig. 103; Axel von Saldern, "Unbekannte Gläser von Johann Wolfgang

Italian

Schmidt, Friedrich Winter and Franz Gondelach," *Anzeiger des Germanischen National-museums* (Nuremberg, 1970), p. 110; "Recent Important Acquisitions Made in Public and Private Collections in the United States and Abroad," *Journal of Glass Studies* 28 (1986), no. 38, p. 109; Bremer-David, *Summary,* no. 444, pp. 250–251, illus. p. 251; Hess and Husband, *European Glass,* no. 68, pp. 244–251, illus.

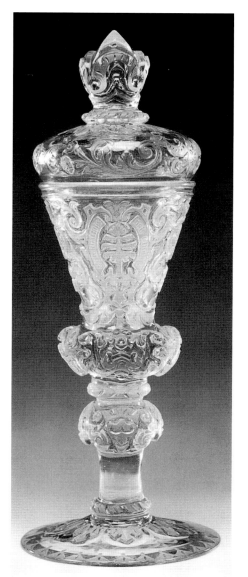

477

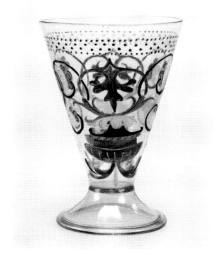

478

478.
GOBLET

Murano, late fifteenth or early sixteenth century
Free-blown colorless glass with gold leaf and enamel decoration
Height: 5⁷/₁₆ in. (13.5 cm); Diameter (at lip): 3¹⁵/₁₆ in. (10 cm); Diameter (at base): 2⁷/₈ in. (7.3 cm)
Accession number 84.DK.540

PROVENANCE

Francis S. McNalty, England (sold by his executors, Christie's, London, July 15, 1970, lot 248, to "Bier" for R. and L. Blumka); [Ruth and Leopold Blumka, New York].

BIBLIOGRAPHY

"Acquisitions/1984," *GettyMus J* 13 (1985), no. 192, p. 246, illus.; Bremer-David, *Summary,* no. 372, pp. 214–215, illus. p. 214; Hess and Husband, *European Glass,* no. 16, pp. 76–77, illus.

479.
GOBLET

Murano, circa 1475–1500
Free- and mold-blown colorless and cobalt blue glass with gold leaf, enamel and applied decoration.
Height: 7¹/₄ in. (18.4 cm); Diameter (at lip): 3⁹/₁₆ in. (9 cm)
Accession number 84.DK.533

PROVENANCE

Spitzer, Paris (sold, Paris, April 17–June 16, 1893, vol. 2, no. 1977); John Edward Taylor, London (sold, Christie's, London, July 4, 1912, lot 346, to G. Durlacher); George Durlacher, London; [Ruth and Leopold Blumka, New York, by 1958].

EXHIBITIONS

New York, The Corning Museum of Glass, *Three Great Centuries of Venetian Glass,* 1958, no. 7, p. 32.

BIBLIOGRAPHY

"Acquisitions/1984," *GettyMus J* 13 (1985), no. 181, p. 244, illus.; Bremer-David, *Summary,* no. 370, p. 214, illus.; Hess and Husband, *European Glass,* no. 17, pp. 78–79, illus.

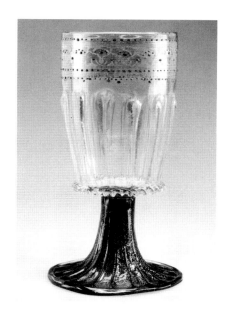

479

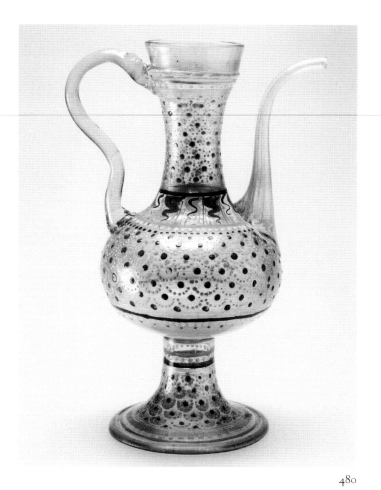

480

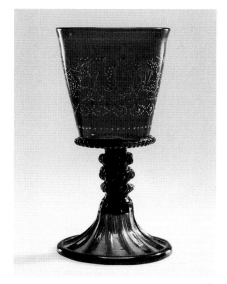

481

p. 244, illus.; "Recent Important Acquisitions Made by Public and Private Collections in the United States and Abroad," *Journal of Glass Studies* 28 (1986), no. 10, p. 101; Bremer-David, *Summary*, no. 377, p. 217, illus.; Hess and Husband, *European Glass*, no. 18, pp. 81–83, illus.; *Masterpieces*, no. 3, p. 10, illus.; *Handbook* 2001, p. 237, illus.

480.
EWER

Murano, late fifteenth or early sixteenth century
Free-blown colorless glass with gold leaf and enamel decoration
Height: 10 11/16 in. (27.2 cm); Maximum Width: 7 5/8 in. (19.3 cm)
Accession number 84.DK.512

PROVENANCE
Émile Gavet, Paris (sold, Galerie Georges Petit, Paris, May 31–June 9, 1897, no. 592 to J. E. Taylor); John Edward Taylor, London (sold, Christie's, London, July 4, 1912, lot 340 to G. Eumorfopoulos); George Eumorfopoulos, London (sold, Sotheby's, London, May 28–31, 1940, lot 223, to R. and L. Blumka); [Ruth and Leopold Blumka, New York].

EXHIBITIONS
London, Royal Academy of Arts, *Exhibition of Italian Art, 1200–1900*, January–March 1930, pp. 437–438, no. 955L; New York, The Corning Museum of Glass, *Three Great Centuries of Venetian Glass*, 1958, no. 7, p. 32.

BIBLIOGRAPHY
E. Garnier, "La verrerie," *La Collection Spitzer*, vol. 3 (Paris, 1891), p. 98, no. 44; R. Barovier Mentasti et al., *Mille anni di arte del vetro a Venezia* (Venice, 1982), p. 79, no. 69; "Acquisitions/1984," *GettyMusJ* 13 (1985), no. 179,

481.
GOBLET

Murano, circa 1500
Free- and mold-blown cobalt blue glass with gold leaf, enamel, and applied decoration
Incised with *VIRTUS LAUDATA CRESCIT* in the gilding around the lip.
Height: 7 1/16 in. (18 cm): Diameter (at lip): 3 13/16 in. (9.7 cm)
Accession number 84.DK.534

PROVENANCE
[Ruth and Leopold Blumka, New York.]

EXHIBITIONS
New York, The Corning Museum of Glass, *Three Great Centuries of Venetian Glass*, 1958, no. 17, p. 39.

BIBLIOGRAPHY

"Acquisitions/1984," *GettyMusJ* 13 (1985), no. 182, p. 244, illus.; "Recent Important Acquisitions Made by Public and Private Collections in the United States and Abroad," *Journal of Glass Studies* 28 (1986), no. 12, p. 101; Bremer-David, *Summary*, no. 371, p. 214, illus.; Hess and Husband, *European Glass*, no. 19, pp. 84–86, illus.

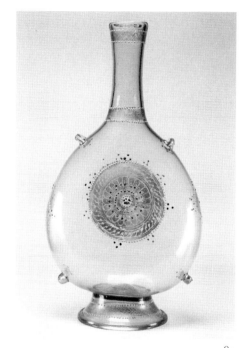

482

482.
PILGRIM FLASK
Murano, late fifteenth or early sixteenth century
Free-blown colorless glass with gold leaf, enamel, and applied decoration
Height: 1 ft. 2 13/16 in. (37.7 cm); Maximum Width: 7 7/8 in. (20 cm)
Accession number 84.DK.538

PROVENANCE
[Ruth and Leopold Blumka, New York.]

EXHIBITIONS

New York, The Corning Museum of Glass, *Three Great Centuries of Venetian Glass*, 1958, p. 55, no. 39; New York, The Metropolitan Museum of Art, The Cloisters, *The Secular Spirit: Life and Art at the End of the Middle Ages*, 1975, p. 47, no. 45, pl. 2.

BIBLIOGRAPHY

R. J. Charleston and M. Archer, "Glass and Stained Glass," *The James A. de Rothschild Collection at Waddeston Manor* (Fribourg, 1977), pp. 91–93, no. 17; "Acquisitions/1984," *GettyMusJ* 13 (1985), p. 245, no. 180; F.-A. Dreier, *Venezianische Gläser und Façon de Venise: Katalog des Kunstgewerbemuseums Berlin* (Berlin, 1989), p. 49, no. 17; P. C. Ritsema van Eck and H. M. Zijlstra-Zweens, *Glass in the Rijksmuseum*, vol. 1 (Amsterdam/Zwolle, 1993), no. 3; Bremer-David, *Summary*, no. 378, p. 217, illus.; Hess and Husband, *European Glass*, no. 20, pp. 87–89, illus.

483.
FOOTED BOWL (COPPA)
Murano, circa 1500
Free-blown chalcedony glass
Height: 4 7/8 in. (12.3 cm); Diameter (at lip): 7 3/4 in. (19.7 cm); Diameter (at base): 4 3/16 in. (10.6 cm)
Accession number 84.DK.660

PROVENANCE
[Bonetti, Lugano, sold to F. Biemann, August 9, 1967]; Fritz Biemann, Zurich (sold, Sotheby's, London, June 16, 1984, lot 48); [David, Inc., Vaduz].

EXHIBITIONS

Düsseldorf, Städtische Kunsthalle, *Meisterwerke der Glaskunst aus internationalem Privatbesitz*, A. von Saldern, ed., 1968, p. 28, no. 59; Cologne, Kunstgewerbemuseum, Berlin, Kunstgewerbemuseum, and Zurich, Museum Bellerive, *Sammlung Biemann Ausstellung 500 Jahre Glaskunst*, B. Kless and A. von Saldern, 1978–1979, pp. 106–107, no. 43;

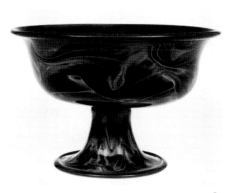

483

Lucerne, Kunsthalle, *3000 Jahre Glaskunst von der Antike bis zum Jugendstil*, B. Rütti et al., 1981, p. 157, no. 661; Venice, Palazzo Ducale, Museo Correr, *Mille anni di arte del vetro a Venezia*, R. Barovier Mentasti, 1982, p. 94, no. 93.

BIBLIOGRAPHY

J.-C. Gateau, *La Verrerie* (Geneva, 1974), pp. 65; "Acquisitions/1984," *GettyMusJ* 13 (1985), p. 245, no. 184; Bremer-David, *Summary*, no. 374, pp. 215–216, illus. p. 215; Hess and Husband, *European Glass*, no. 21, pp. 90–91, illus.; *Masterpieces*, no. 20, p. 30, illus.; *Handbook* 2001, p. 244, illus.

484.
FOOTED BOWL (COPPA)
 Murano, circa 1500
 Free- and mold-blown cobalt-blue glass with
 gold leaf and enamel decoration
 Height: 7 in. (17.8 cm); Diameter (at lip):
 9 1/2 in. (24.1 cm)
 Accession number 84.DK.535

PROVENANCE
Prince of Liechtenstein, Vaduz, sold to R.
and L. Blumka; [Ruth and Leopold Blumka,
New York].

EXHIBITIONS
New York, The Corning Museum of Glass,
Three Great Centuries of Venetian Glass, 1958,
no. 42, p. 57.

BIBLIOGRAPHY
"Acquisitions/1984," *GettyMusJ* 13 (1985),
no. 189, p. 245, illus.; Bremer-David, *Summary*, no. 375, p. 216, illus.; Hess and Husband, *European Glass*, no. 22, pp. 92, 93, illus.

485
PILGRIM FLASK
 Murano, circa 1500–1520
 Free-blown, colorless glass with gold leaf and
 enamel decoration
 Height: 1 ft. 5/16 in. (31.3 cm); Maximum
 Width: 6 7/8 in. (17.5 cm)
 Accession number 84.DK.539

PROVENANCE
Hollingworth Magniac, Colworth (sold,
Christie's, London, July 2–4, 1892, lot 868);
[Durlacher Brothers, London]; Edward Steinkopff, London (sold, Christie's, London,
May 22–23, 1935, lot 72); possibly Riddell,
London; possibly Count Dr. Alexander von
Frey, Paris; private collection, Paris (sold,
Palais Galliera, Paris, November 29–December 3, 1965, no. 157); [Ruth and Leopold
Blumka, New York].

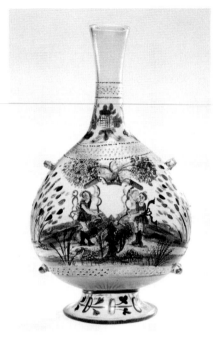

485

BIBLIOGRAPHY
Sir John Charles Robinson, *Notice of the Principal
Works of Art in the Collection of Hollingworth Magniac, Esq.* (London, 1861), no. 152, p. 82;
"Acquisitions/1984," *GettyMusJ* 13 (1985),
no. 185, p. 245, illus.; "Recent Important
Acquisitions Made by Public and Private Collections in the United States and Abroad,"
Journal of Glass Studies 28 (1986), no. 13,
pp. 102–103; Bremer-David, *Summary*, no. 380,
p. 218, illus.; Hess and Husband, *European
Glass*, no. 23, pp. 96–98, illus.

484

486.
FOOTED BOWL WITH PAPAL ARMS (COPPA)
 Murano, circa 1513–1534
 Free-blown colorless glass with gold leaf and
 enamel decoration
 Arms on the interior, in enamel, *or six balls gules
 surmounted by a papal miter.*
 Height: 6 5/16 in. (16 cm); Diameter (at lip):
 11 13/16 in. (30 cm)
 Accession number 84.DK.655

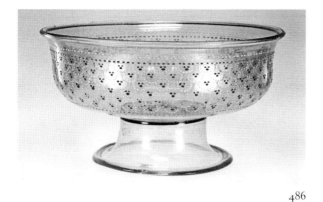

486

488

PROVENANCE

Sold, Sotheby's, London, February 23, 1976, lot 175 (with erroneous metric measurement), to David, Inc.; [David, Inc., Vaduz].

EXHIBITIONS

Venice, Palazzo Ducale, Museo Correr, *Mille anni di arte del vetro a Venezia*, R. Barovier Mentasti, 1982, pp. 107–108, no. 122.

BIBLIOGRAPHY

"Acquisitions/ 1984," *GerryMus J* 13 (1985), p. 245, no. 189; Bremer-David, *Summary*, no. 376, p. 216, illus.; Hess and Husband, *European Glass*, no. 24, pp. 99–101, illus.

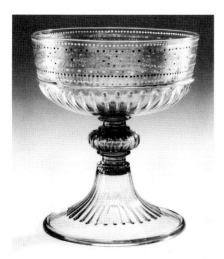

487

487.
FOOTED BOWL (COPPA)

Murano, early sixteenth century
Free- and mold-blown colorless glass with gold leaf and enamel decoration
Height: 9 1/2 in. (21.4 cm); Diameter (at lip): 8 1/4 in. (21.5 cm)
Accession number 84.DK.511

PROVENANCE

Prince of Liechtenstein, Vaduz; [Ruth and Leopold Blumka, New York].

EXHIBITIONS

New York, The Corning Museum of Glass, *Three Great Centuries of Venetian Glass*, 1958, no. 29, pp. 48–49.

BIBLIOGRAPHY

"Acquisitions/1984," *GettyMus J* 13 (1985), no. 188, p. 245, illus.; "Recent Important Acquisitions Made by Public and Private Collections in the United States and Abroad," *Journal of Glass Studies* 28 (1986), no. 11, p. 101; Bremer-David, *Summary*, no. 379, pp. 217–218, illus. p. 217; Hess and Husband, *European Glass*, no. 25, p. 102, illus.

488.
PLATE

Murano, early sixteenth century
Free- and mold-blown colorless glass with gilding and enamel decoration
Height: 1 3/4 in. (4.5 cm); Diameter: 1 ft. (30.5 cm)
Accession number 84.DK.536

PROVENANCE

[Ruth and Leopold Blumka, New York.]

BIBLIOGRAPHY

"Acquisitions/1984," *GettyMus J* 13 (1985), no. 189, p. 245, illus.; Bremer-David, *Summary*, no. 373, p. 215, illus.; Hess and Husband, *European Glass*, no. 26, pp. 104–106, illus.

489.

Double-handled Filigrana Vase

Possibly Murano or *façon de Venise* (possibly Northern Europe), circa 1550–1570

Free-blown colorless glass with opaque white (*lattimo*) canes and applied decoration

Height: 8 7/8 in. (22.5 cm); Maximum Width: 5 3/4 in. (14.5 cm)

Accession number 84.DK.654

PROVENANCE

[David, Inc., Vaduz].

BIBLIOGRAPHY

"Acquisitions/1984," *GettyMusJ* 13 (1985), no. 191, p. 246, illus.; Bremer-David, *Summary*, no. 381, p. 218, illus.; Hess and Husband, *European Glass*, no. 27, pp. 107–109, illus.

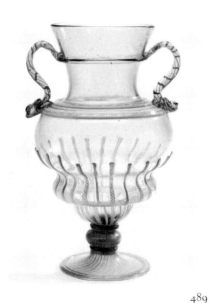

489

490.

Ice-glass Situla (*secchiello*)

Murano or *façon de Venise*, the Netherlands, circa 1550–1600

Free-blown colorless glass with applied decoration

Height: 4 in. (10.1 cm); Maximum Diameter: 7 7/8 in. (20 cm)

Accession number 84.DK.657

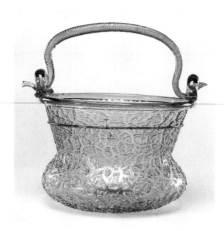

490

PROVENANCE

[Rainer Zietz, Ltd., London, to David, Inc.]; [David, Inc., Vaduz].

BIBLIOGRAPHY

"Acquisitions/1984," *GettyMusJ* 13 (1985), no. 198, p. 247, illus.; Bremer-David, *Summary*, no. 382, pp. 218–219, illus. p. 219; Hess and Husband, *European Glass*; no. 28, pp. 110–112, illus.

491.

Filigrana Bottle (*Kuttrolf*)

Murano, late sixteenth or early seventeenth century

Free- and mold-blown colorless glass with opaque white (*lattimo*) canes

Height: 9 3/8 in. (23.9 cm); Diameter (at base): 2 13/16 in. (7.2 cm)

Accession number 84.DK.661

PROVENANCE

Dr. Johannes Jantzen, Bremen, sold to F. Biemann, 1964; Fritz Biemann, Zurich (sold, Sotheby's, London, June 16, 1984, lot 58); [Rainer Zietz, Ltd., London, to David, Inc.]; [David, Inc., Vaduz].

EXHIBITIONS

Düsseldorf, Städtische Kunsthalle, *Meisterwerke der Glaskunst aus internationalem Privatbesitz*, A. von Saldern, ed., 1968, p. 29, no. 65;

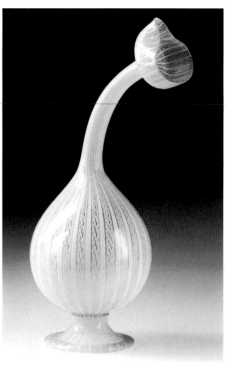

491

Cologne, Kunstgewerbemuseum, Berlin, Kunstgewerbemuseum, and Zurich, Museum Bellerive, *Sammlung Biemann Ausstellung 500 Jahre Glaskunst*, B. Klesse and A. von Saldern, 1978–1979, p. 113, no. 55; Lucerne, Kunsthalle, *3000 Jahre Glaskunst von der Antike bis zum Jugendstil*, B. Rütti et al., 1981, p. 159, no. 668.

BIBLIOGRAPHY

F. Biemann, "Der Kuttrolf: Sonderling unter den Glasgefässen," *Keramik-Freunde der Schweiz, Mitteilungsblatt* 76 (April 1968), p. 13, pl. 10; "Acquisitions/1984," *GettyMusJ* 13 (1985), p. 247, no. 196; "Recent Important Acquisitions Made by Public and Private Collections in the United States and Abroad," *Journal of Glass Studies* 28 (1986), pp. 102–103, no. 16; P. C. Ritsema van Eck and H. M. Zijlstra-Zweens, *Glass in the Rijksmuseum*, vol. 1 (Amsterdam/Zwolle, 1993), no. 75; Bremer-David, *Summary*, no. 387, p. 221, illus.; Hess and Husband, *European Glass*, no. 29, pp. 113–115, illus.; *Masterpieces*, no. 24, p. 33, illus.

492.

FILIGRANA UMBO VASE

Probably Murano, 1580–1600
Free- and mold-blown colorless glass with opaque white (*lattimo*) and canes
Height: 8 1/3 in. (21.6 cm); Maximum Width: 4 3/8 in. (12.1 cm)
Accession number 84.DK.656

PROVENANCE

John Malcolm (1805–1893), Poltallach, Scotland; by inheritance to George Malcolm, Poltallach, Scotland (sold, Christie's, London, February 8, 1977, lot 241, to R. Zietz); [Rainer Zietz Ltd, London, to David, Inc.]; [David, Inc., Vaduz].

EXHIBITIONS

Hannover-Herrenhausen, Galerie und Orangerie, *Kunst und Antiquitäten*, 1977; Venice, Museo Correr, Palazzo Ducale, *Mille anni di arte del vetro a Venezia*, R. Barovier Mentasti, 1982, no. 163, pp. 31, 124.

BIBLIOGRAPHY

Johanna Lessmann, "Meisterwerke der Glaskunst aus Renaissance und Barock," *Weltkunst*

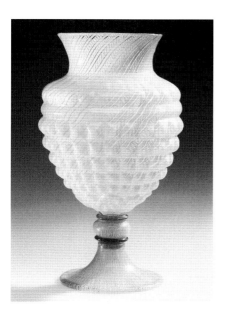

492

47, no. 8 (April 15, 1977), p. 791; "Acquisitions/1984," *GettyMusJ* 13 (1985), p. 246, no. 194; Bremer-David, *Summary*, no. 386, p. 220, illus.; Hess and Husband, *European Glass*, no. 35, pp. 138–141, illus.

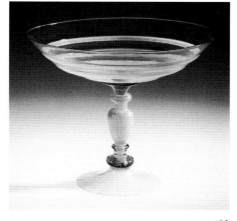

493

493.

STEMMED *FILIGRANA* WINEGLASS (*TAZZA*)

Probably Murano, late sixteenth to early seventeenth century
Free- and mold-blown colorless glass with opaque white (*lattimo*) canes
Height: 4 3/4 in. (12 cm); Diameter (at lip): 5 7/8 in. (15 cm); Diameter (at base): 2 13/16 in. (7.1 cm)
Accession number 84.DK.652

PROVENANCE

Sold, Sotheby's, London, February 23, 1976, lot 175, to David, Inc.; [David, Inc., Vaduz].

BIBLIOGRAPHY

Ada Polak, "Venetian Renaissance Glass: The Problems of Dating *Vetro a Filigrana*," *Connoisseur* 192, no. 774 (August 1976), p. 3; "Acquisitions/1984," *GettyMusJ* 13 (1985), no. 197, p. 247, illus.; Bremer-David, *Summary*, no. 388, p. 222, illus.; Hess and Husband, *European Glass*, no. 31, pp. 118–121, illus.

494.

WINEGLASS

Murano or *façon de Venise* (Tuscany), circa 1600–1650
Free-blown colorless glass with diamond-point engraving
Engraved with *SIG. DOTTORE D. LESSIO* around the lip.
Height: 5 7/8 in. (15 cm); Diameter: 5 1/8 in. (13 cm)
Accession number 84.DK.541

PROVENANCE

E. and A. Silberman, Vienna (sold to O. Bondy, November 23, 1933); Oscar Bondy, Vienna; confiscated from Bondy's collection by the Nazis, 1938; restituted to his widow, Elisabeth Bondy, by the Austrian government, 1945; Elisabeth Bondy, New York, sold to R. and L. Blumka, 1949; [Ruth and Leopold Blumka, New York].

EXHIBITIONS

New York, The Corning Museum of Glass, *Three Great Centuries of Venetian Glass*, 1958, no. 92, p. 90.

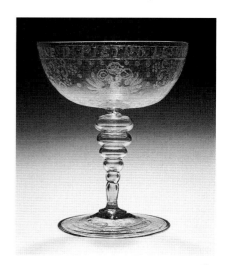

494

Netherlandish

BIBLIOGRAPHY

"Acquisitions/1984," *GettyMusJ* 13 (1985), p. 246, no. 195; "Recent Important Acquisitions Made by Public and Private Collections in the United States and Abroad," *Journal of Glass Studies* 28 (1986), p. 107, no. 31; D. Lanmon, *The Robert Lehman Collection, vol. II: Glass* (New York, 1993), no. 69, fig. 1; Bremer-David, *Summary*, no. 383, p. 219, illus.; E. Theuerkauff-Liederwald, *Venezianisches Glas der Veste Coburg* (Lingen, 1994), pp. 309, 318; Hess and Husband, *European Glass*, no. 32, pp. 122–125, illus.

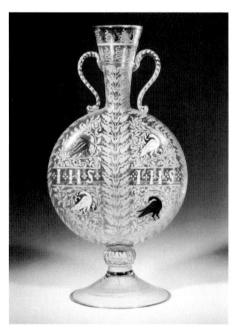

495

495.
FLASK

Murano, imitation of a Spanish (Catalonia) piece in the Museo Vetrario (Venice), nineteenth or twentieth century
Free-blown soda glass with enamel decoration
Inscribed on both sides, in enamel, *IHS/IHS*.
Height: 10¼ in. (20.6 cm); Width: 5 in. (12.7 cm)
Accession number 84.DK.518

PROVENANCE

[Ruth and Leopold Blumka, New York.]

BIBLIOGRAPHY

"Acquisitions/1984," *GettyMusJ* 13 (1985), no. 227, p. 252, illus.; "Recent Important Acquisitions Made in Public and Private Collections in the United States and Abroad," *Journal of Glass Studies* 28 (1986), p. 103.; Bremer-David, *Summary*, no. 489, p. 282, illus.

496.
HORN AND CASE

Façon de Venise, possibly Spanish, seventeenth or eighteenth century
Free-blown amber glass with opaque white (*lattimo*) threads and applied decoration; leather case
Diameter (at terminus): 2³⁄₈ in. (6.1 cm); Length (along the piece): 1 ft. 10⁹⁄₁₆ in. (57.3 cm)
Accession number 84.DK.565.1–.2

PROVENANCE

[Ruth and Leopold Blumka, New York.]

BIBLIOGRAPHY

"Acquisitions/1984," *GettyMusJ* 13 (1985), no. 228, p. 252, illus.; Bremer-David, *Summary*, no. 389, p. 222, illus.; Hess and Husband, *European Glass*, no. 51, pp. 187–189, illus.

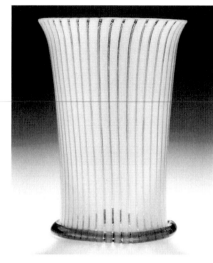

497

497.
FILIGRANA BEAKER

Façon de Venise, probably Netherlandish, 1550–1625
Free-blown colorless glass with opaque (*lattimo*) canes
Height: 5⁷⁄₁₆ in. (13.9 cm); Diameter (at lip): 4 in. (10.1 cm)
Accession number 84.DK.658

496

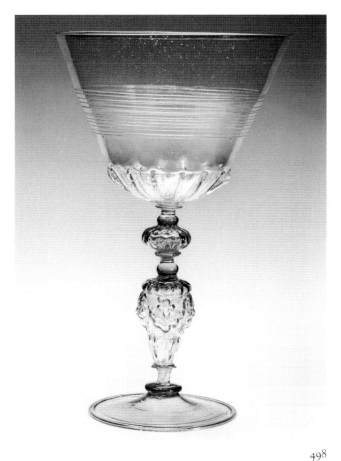

498

PROVENANCE
[David, Inc., Vaduz].

BIBLIOGRAPHY
"Acquisitions/1984," *GettyMusJ* 13 (1985),
no. 244, p. 255, illus.; Bremer-David, *Summary*, no. 485, p. 278, illus.; Hess and Husband, *European Glass*, no. 46, p. 174–175, illus.

498.
GOBLET
Façon de Venise, possibly southern Netherlandish, 1560–1625
Free- and mold-blown colorless glass
Height: 8 3/8 in. (21.8 cm); Diameter (at lip):
5 1/2 in. (14 cm)
Accession number 84.DK.549

PROVENANCE
[Ruth and Leopold Blumka, New York.]

EXHIBITIONS
New York, The Corning Museum of Glass,
Three Great Centuries of Venetian Glass, 1958,
pp. 104–105, no. 115.

BIBLIOGRAPHY
"Acquisitions/1984," *GettyMusJ* 13 (1985),
no. 248, p. 256, illus.; Bremer-David,
Summary, no. 481, p. 276, illus.; Hess and Husband, *European Glass*, no. 47, pp. 176–177, illus.

499.
ICE-GLASS BEAKER
Façon de Venise, Netherlandish, late sixteenth
or early seventeenth century
Free-blown colorless glass with gilding and
applied decoration
Height: 8 7/16 in. (21.4 cm); Diameter (at lip):
5 9/16 (14.1 cm)
Accession number 84.DK.564

PROVENANCE
[Rainer Zietz, Ltd., London, sold to R. and
L. Blumka; [Ruth and Leopold Blumka, New
York].

BIBLIOGRAPHY
"Acquisitions/1984," *GettyMusJ* 13 (1985),
no. 225, p. 252, illus.; Bremer-David, *Summary*, no. 482, p. 276, illus.; Hess and Husband, *European Glass*, no. 48, p. 178–179, illus.

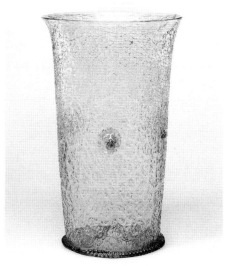

499

500.
GOBLET

Façon de Venise, possibly Netherlandish, late
sixteenth or early seventeenth century
Free- and mold-blown light cobalt-blue glass
Height: 8 9/16 in. (21.8 cm); Diameter (at lip):
5 1/16 in. (12.9 cm)
Accession number 84.DK.517

PROVENANCE
Count Dr. Alexander von Frey, Paris; [Ruth
and Leopold Blumka, New York].

EXHIBITIONS
New York, The Corning Museum of Glass,
Three Great Centuries of Venetian Glass, 1958,
no. 112, p. 103.

BIBLIOGRAPHY
"Acquisitions/1984," *GettyMusJ* 13 (1985),
no. 238, p. 254, illus.; Bremer-David, *Sum-
mary*, no. 483, p. 277, illus.; Hess and Hus-
band, *European Glass*, no. 49, p. 180–181, illus.

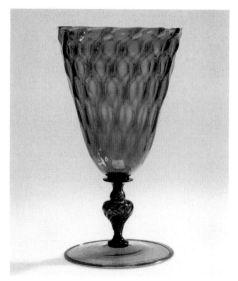

500

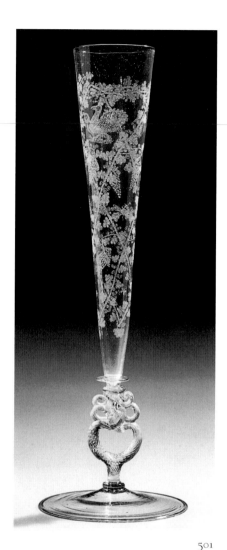

501

501.
FLUTE GLASS

Façon de Venise, Netherlandish or German, late
sixteenth or early seventeenth century
Free-blown colorless glass with diamond-
point engraving
Height: 12 3/8 in. (31.4 cm); Diameter (at lip):
2 1/4 in. (5.8 cm)
Accession number 84.DK.516

PROVENANCE
Purportedly Aäron Vecht, Amsterdam; Dr.
Karl Ruhmann, Vienna, by 1956; [Ruth and
Leopold Blumka, New York].

BIBLIOGRAPHY
Ignaz Schlosser, *Das altes Glas: Ein Handbuch
für Sammler und Liebhaber* (Brunswick, 1956),
p. 210, pl. 161; "Acquisitions/1984,"
GettyMusJ 13 (1985), no. 245, p. 255, illus.;
"Recent Important Acquisitions Made in
Public and Private Collections in the United
States and Abroad," *Journal of Glass Studies* 28
(1986), no. 34, p. 108; Bremer-David, *Sum-
mary*, no. 484, p. 277, illus.; Hess and Hus-
band, *European Glass*, no. 50, p. 182–186, illus.

502.
BOTTLE

North Netherlandish (Leiden), 1675–1685
By Willem Jacobszoon van Heemskerk
Dark green glass with diamond-point
engraving; gilt-metal neck ring and cork mount
The body of the vessel is engraved with *Pan e
vin e va cantando*; the underside of the vessel
between the foot ring and the pontil mark is
engraved with *Kan't Brood en [...] Wijn niet doen?
Wat Zouts kan't Mael vergoên*. The center of the
pontil mark is engraved with *W. van Heemskerk*.
Height (without stopper): 9 1/16 in. (23 cm);
Maximum Diameter: 5 5/16 in. (15 cm)
Accession number 84.DK.662

PROVENANCE
[Southhampton, England, art market, sold to
Mrs. Eshelby, 1940s]; Mrs. D. C. Eshelby,
Cumberworth (sold, Sotheby's, London,
November 27, 1967, lot 47); [Dr. Torré,
Zurich, sold to F. Biemann]; Fritz Biemann,
Zurich (sold, Sotheby's, London, June 16,
1984, lot 153, to David, Inc.); [David Inc.,
Vaduz].

EXHIBITIONS
Düsseldorf, Kunstmuseum, *Meisterwerke der
Glaskunst aus internationalem Privatbesitz*, A. von
Saldern, ed., 1968, pp. 46–47, no. 117;
Lucerne, Kunsthalle, *3000 Jahre Glaskunst
von der Antike bis zum Jugendstil*, B. Rütti et al.,
1981, p. 166, no. 708.

Hardstones

English

Italian

BIBLIOGRAPHY

London Times, November 28, 1967; *Art at Auction: The Year at Sotheby's 1967–1968* (London, 1968), p. 416; "Recent Important Acquisitions Made by Public and Private Collections in the United States and Abroad," *Journal of Glass Studies* 10 (1968), p. 186, no. 35 (acquired by Fritz Biemann); F. Biemann, "Die holländischen Gläser des 17. und 18. Jahrhunderts der Sammlung Fritz Biemann, Zurich," *Alte und moderne Kunst* 12, no. 101 (November–December 1968), pp. 13–18; C. Munsey, *The Illustrated Guide to Collecting Bottles* (New York, 1970), p. 16; B. Klesse and A. von Saldern, *500 Jahre Glaskunst: Sammlung Biemann* (Zurich, 1978), no. 75; "Acquisitions/1984," *GettyMusJ* 13 (1985), p. 252, no. 226; "Recent Important Acquisitions Made by Public and Private Collections in the United States and Abroad," *Journal of Glass Studies* 28 (1986), p. 108, fig. 35; F. G. A. M. Smit, *Inscriptions in Calligraphy on Glass: Uniquely Dutch Seventeenth-Century Calligraphy on Glass: A Preliminary Catalogue*, photocopy, published privately (Peterborough, England, 1989), p. 102, no. P4.

503 *One of four*

503.
FOUR FRAMED HARDSTONE PANELS
English (in imitation of an Italian typology), 1992, antique stones in modern frames
Frames: ebony; panels: hardstones
Diameter (each): 2 ft. 6¹/₂ in. (77.5 cm)
Accession number 95.SE.57.1–.4

PROVENANCE
Fabricated in London, 1970s; private collection, Rome; private collection, Paris; [Galerie Jacques Ollier, Paris].

BIBLIOGRAPHY
"Acquisitions/1995," *GettyMusJ* 24 (1996), no. 84, p. 135, illus.

504.
PAIR OF VASES
Italian, early seventeenth century
Golden alabaster (*alabastro dorato*); *paragone* marble bases
Height (with lid): 1 ft. 2 in. (35.5 cm);
Height (without lid): 9¹/₂ in. (24 cm);
Width: 1 ft. 4³/₄ in. (42.7 cm)
Accession number 92.DJ.68.1–.2

PROVENANCE
Sold, Sotheby's, Monaco, March 3, 1990, no. 70; [Didier Aaron, Paris, sold to Same Art]; [Same Art, Ltd., Zurich].

BIBLIOGRAPHY
"Acquisitions/1992," *GettyMusJ* 21 (1993), no. 70, p. 144, illus.; Bremer-David, *Summary*, no. 390, p. 223, illus.

504 *One of a pair*

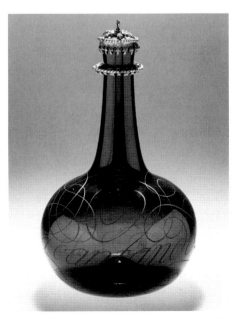

502

Ivory
German

505.
**Pendant with a Seated Female Figure
Holding a Falcon (possibly an imitation
of a Hohenstaufen object)**

Possibly southern Italy, either thirteenth or
nineteenth century
Chalcedony or jasper mounted on gold
Height: 3 9/16 in. (9 cm)
Accession number 85.SE.54

PROVENANCE
Pico Cellini, Rome; August Lederer (died
1936), Vienna; by inheritance to his widow
Serena Lederer (died 1943), Vienna;
confiscated from Lederer's collection by the
Nazis, 1938; restituted to her son Erich
Lederer by the Austrian government, 1947;
Erich Lederer (1889–1985), Geneva; by
inheritance to his widow Elizabeth Lederer,
1985; Elizabeth Lederer, Geneva.

BIBLIOGRAPHY
"Acquisitions/1985," *GettyMusJ* 14 (1986),
p. 259, no. 236; Pico Cellini, *Tra Roma e
Umbria. Studi e ricerche di storia dell'arte* (Rome,
1996), pp. 24 and 191, note 24, fig. 32.

505

506

506
Covered Standing Cup

German (Coburg), 1631
By Marcus Heiden
Marked with *MARCUS HEIDEN.
COBURGENSIS.FECIT.1631* under the base.
Ivory
Height: 2 ft. 1 in. (63.5 cm)
Accession number 91.DH.75.1–.2

PROVENANCE
Presumed to have been made for Duke Johann
Casmir (1572–1633) of Saxe-Coburg and
seized by Colonel Giovanni Giovacchino
Keller of Schaikaine during the sack of
Coburg in 1632; private collection, Germany,
acquired by Same Art, Ltd., 1990; [Same
Art, Ltd., Zurich].

BIBLIOGRAPHY
Burlington Magazine 118 (December 1976),
p. XXXV; E. von Philippovich, "Ivory," *Biblio-
thek für Kunst und Antiquitätenfreunde* 17 (1982),
p. 422, fig. 372; C. Theuerkauff, "Jacob Auer,
'Bildhauer in Grins,'" *Pantheon* 41, no. 3
(1983), p. 195, note 18; K. Maurice, *Der drech-
selnde Souverän, Materialien zu einer fürstlichen
Maschinenkunst* (Zurich, 1985), p. 56, fig. 78;
C. Theuerkauff, "Ivory," *J. Pierpont Morgan, Col-
lector: European Decorative Arts from the Wadsworth
Atheneum*, L. Horvitz Roth, ed. (Hartford,
1987), p. 108, note 12; "Acquisitions/1991,"
GettyMusJ 20 (1992), no. 79, p. 180, illus.;
Bremer-David, *Summary*, no. 445, p. 251,
illus.; *Masterpieces*, no. 29, pp. 40–41, illus.;
Sabine Haag, "A Signed and Dated Ivory
Goblet by Marcus Heiden," *GettyMusJ* vol. 24
(1996), pp. 45–59; Peter Fusco, *Summary Cata-
logue of European Sculpture in the J. Paul Getty
Museum* (Los Angeles, 1997), p. 28; *Master-
pieces of the J. Paul Getty Museum: European Sculpture*
(Los Angeles, 1998), no. 18, pp. 60–61, illus.;
Handbook 2001, p. 258, illus.

ᴹETALWORK
English

507 *One of a pair*

507.

PAIR OF SUGAR CASTORS

London, 1730
By Paul de Lamerie
Silver gilt
Bodies and lids marked with the maker's
stamp of *L.A.* between an arched crown with
a star and a fleur-de-lys (in use around 1720–
1732); a lion's head erased (the assay mark of
London); the figure of Britannia (the standard
mark indicating .9583 silver content); the
letter P (the date letter for 1730).
Castor .1 is engraved with 1730 and
N°2=27–12; Castor .2 is engraved with
1730 and N°1 = 27; both engraved with
Garter coat of arms and the Howard crest.
Height: 9 3/8 in. (23.8 cm); Diameter: 3 7/8 in.
(9.9 cm)
Accession number 78.DG.180.1–.2

PROVENANCE

Dukes of Northumberland; [S.J. Phillips, Lon-
don]; purchased by J. Paul Getty around
1938; distributed by the estate of J. Paul
Getty to the J. Paul Getty Museum.

EXHIBITIONS

The Minneapolis Institute of Art, on loan,
1980–1981; The Los Angeles County
Museum of Art, on loan, 1982–1988; London,
Goldsmith's Hall, *Paul de Lamerie*, May 16–
June 22, 1990, no. 65, p. 109, illus.

BIBLIOGRAPHY

Bremer-David, *Summary*, no. 475, pp. 270–
271, illus. p. 271; Declan Anderson, *Introduc-
ing Silver* (Sussex, 2000), pp. 67–70, illus., no.
37, p. 72.

508.

PAIR OF LIDDED TUREENS, LINERS, AND STANDS

London, 1807
By Paul Storr
Silver
Variously marked with the maker's stamp of
P.S.; a lion passant (the standard mark of ster-
ling quality); the crowned leopard's head (the
assay mark of London); the Sovereign's head
of George III (the duty mark); and the letter
M (the date letter for 1807). Each tureen is
engraved with the arms of the Dukes of
Richmond and Lennox and with the motto
EN LA ROSE LE FLURIE.
Height: 11 1/4 in. (28.6 cm); Width: 1 ft. 6
in. (45.7 cm); Depth: 1 ft. 3/4 in. (32.4 cm)
Accession number 78.DG.130.1–.2

PROVENANCE

Charles, 4th Duke of Richmond and Lennox
(succeeded 1806, Lord Lieutenant of Ireland
1807–1813); Dukes of Richmond and Gor-
don, Goodwood House, Sussex, by descent
(sold, Christie's, London, July 20, 1938,
lot 114); purchased by J. Paul Getty; distrib-
uted by the estate of J. Paul Getty to the J.
Paul Getty Museum.

EXHIBITIONS

The Minneapolis Institute of Art, on loan,
1980–1981; Williamstown, Massachusetts,
Sterling and Francine Clark Art Institute, on
loan, 1983–1988.

BIBLIOGRAPHY

Bremer-David, *Summary*, no. 476, p. 271, illus.

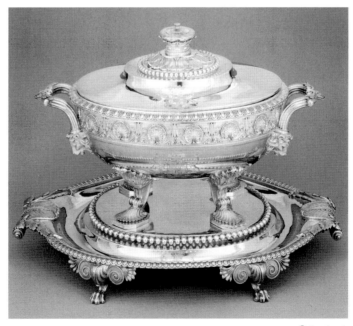

508 *One of a pair*

509.
PAIR OF LIDDED BOWLS
Porcelain: Japanese (Arita), late seventeenth century
Mounts: English (London), circa 1680
Mounts attributed to Wolfgang Howzer
Hard-paste porcelain, underglaze blue decoration; gilt-metal mounts
Height: 1 ft. 1 9/16 in. (34.5 cm); Width: 1 ft. 3 in. (38 cm); Depth: 10 1/16 in. (25.5 cm)
Accession number 85.DI.178.1–.2

PROVENANCE
Joseph Downs, Winterthur, Delaware; William Heere (sold, Christie's, New York, October 29, 1983, lot 32); [Aveline et Cie, Paris].

EXHIBITIONS
New York, The Frick Collection, *Mounted Oriental Porcelain*, F. J. B. Watson, December 1986–March 1987, no. 9, pp. 46–47, illus.

BIBLIOGRAPHY
"Acquisitions/1985," GettyMusJ 14 (1986), no. 185, p. 240, illus.; F. J. B. Watson, "Mounted Oriental Porcelain," *Magazine Antiques* 131 (April 1987), pp. 813–823, illus. p. 823; Bremer-David, *Summary*, no. 477, p. 272, illus.; Wilson, *Mounted Oriental Porcelain*, no. 1, pp. 22–25, illus.

German

510.
CAROLINGIAN RELIQUARY
Upper Rhine, modern reconstruction of elements attributed to the eighth century
Gilt copper, silver, cabochon hardstones, and glass pastes
Height: 5 1/8 in. (13 cm); Width: 4 3/4 in. (12.1 cm)
Accession number 85.SE.53

PROVENANCE
Richard von Kaufmann, Berlin; August Lederer (died 1936), Vienna; by inheritance to his widow Serena Lederer (died 1943), Vienna; confiscated from Lederer's collection by the Nazis, 1938; restituted to her son Erich Lederer by the Austrian government, 1947; Erich Lederer (1889–1985), Geneva; by inheritance to his widow Elizabeth Lederer, 1985; Elizabeth Lederer, Geneva.

EXHIBITIONS
Berlin, *Ausstellung von Kunstwerken des Mittelalters und der Renaissance aus Berliner Privatbesitz*, May 20–July 3, 1898, pl. 46, fig. 2.

BIBLIOGRAPHY
Otto von Falke, *Die Sammlung Richard von Kauffmann* (Berlin, 1917), no. 413, pp. 63–64; "Acquisitions/1985," GettyMusJ 14 (1986), no. 219, p. 253, illus.; Bremer-David, *Summary*, no. 405, p. 234, illus.

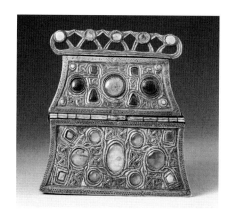

510

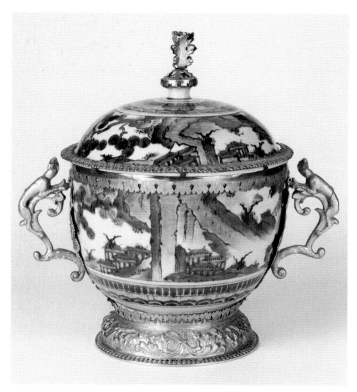

509 *One of a pair*

511.
EWER AND BASIN
Augsburg, 1583
By Abraham 1 Pfleger
Silver, partially gilt, with enamel plaques and engraving
Coat of arms of Pálffy di Erdöd and Fugger families on basin, base, and cover of ewer.

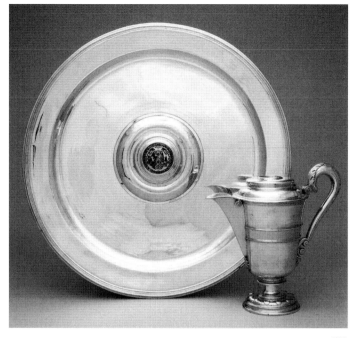

511

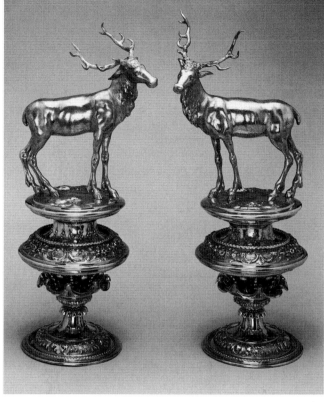

512

Ewer: Height: 9 7/8 in. (25 cm); Basin: Diameter: 1 ft. 7 7/8 in. (50.5 cm)
Accession number 85.DG.33.1–.2

PROVENANCE

Sold, Christie's, Geneva, November 15, 1984, no. 606, to David, Inc.; [David, Inc., Vaduz].

BIBLIOGRAPHY

"Acquisitions/1985," *GettyMus J* 14 (1986), no. 220, p. 254, illus.; Bremer-David, *Summary*, no. 407, pp. 234–235, illus. p. 235; *Masterpieces*, no. 17, p. 26, illus.; *Handbook 2001*, p. 245, illus.

512.

PAIR OF STAGS

Augsburg, circa 1680–1700
By Johann Ludwig Biller the Elder
Silver gilt
Stamped with *ILB* on one antler of each model; stamped with *ILB* and Augsburg mark five times on each base: (1) on top border of

upper rim of spool; (2) on underside of same; (3) on top border of lower rim of spool; (4) on underside of same; (5) on top of border around foot of base.
Stag .1 (with head bent over proper left shoulder): Height: 2 ft. 1 in. (63.5 cm); Width: 11 1/4 in. (28.5 cm); Depth: 8 1/2 in. (21.5 cm); Stag .2 (with head bent over proper right shoulder): Height: 2 ft. 2 3/16 in. (66.5 cm); Width: 10 5/8 in. (27 cm); Depth: 8 5/8 in. (22 cm)
Accession number: 85.SE.442.1–.2

PROVENANCE

King Fernando II, Portugal, by 1882; (sold, Sotheby's, Geneva, May 15, 1984, no. 66, to A. Neuhaus); [Albrecht Neuhaus, Würzburg].

EXHIBITIONS

Lisbon, *Exposição Retrospectiva de Arte Ornamental*, 1882, vol. 1, no. 57, p. 245; vol. 2, fig. 37.

BIBLIOGRAPHY

Art at Auction: The Year at Sotheby's 1983–1984 (London, 1984), p. 288; *Deutscher Kunsthandel im Schloss Charlottenburg* (Berlin, 1985), pp. 74–75; "Acquisitions/1985," *GettyMus J* 14 (1986), no. 221, p. 254, illus.; Lorenz Seelig, "Jagdliche Motive in der Goldschmiedekunst des. 16 bis 18 Jahrhunderts," *Weltkunst* 59 (February 1989), p. 234, pl. 2.; Bremer-David, *Summary*, no. 408, p. 235, illus.; Peter Fusco, *Summary Catalogue of European Sculpture in the J. Paul Getty Museum* (Los Angeles, 1997), p. 6, illus.

Italian

513.
CHANDELIER

German (?) (Würzburg), circa 1710–1715
Colored and plain glass; silvered foils lacquered with pink and green translucent varnish; paktong; gilt and silvered bronze; rock crystal
Height: 6 ft. 6 1/2 in. (199.4 cm); Diameter: 3 ft. 10 in. (116.8 cm)
Accession number 74.DH.29

PROVENANCE
Private Collection, Turin; [Jacques Kugel, Paris]; [Michel Meyer, Paris]; [Kraemer et Cie, Paris]; purchased by J. Paul Getty.

BIBLIOGRAPHY
Bremer-David, *Summary*, no. 159, p. 99, illus.

514.
MORTAR

Probably Venice or possibly Padua, circa 1550
Bronze
Height: 1 ft. 7 1/4 in. (48.9 cm); Diameter: 1 ft. 11 1/2 in. (59.7 cm)
Accession number 85.SB.179

PROVENANCE
Private collection, France (sold Sotheby's, London, July 14, 1977, lot 156, to R. Zietz); [Rainer Zietz, Ltd., London, sold to Rosenberg and Stiebel, Inc.]; [Rosenberg and Stiebel, Inc., New York, sold to B. Piasecka Johnson, 1982]; Barbara Piasecka Johnson, Princeton, New Jersey, sold to Rosenberg and Stiebel, Inc., 1985; [Rosenberg and Stiebel, Inc., New York].

BIBLIOGRAPHY
Acquisitions/1985," *GettyMusJ* 14 (1986), no. 222, p. 254, illus.; Bremer-David, *Summary*, no. 329, p. 194, illus.; Peter Fusco, *Summary Catalogue of European Sculpture in the J. Paul Getty Museum* (Los Angeles, 1997), p. 68, illus.

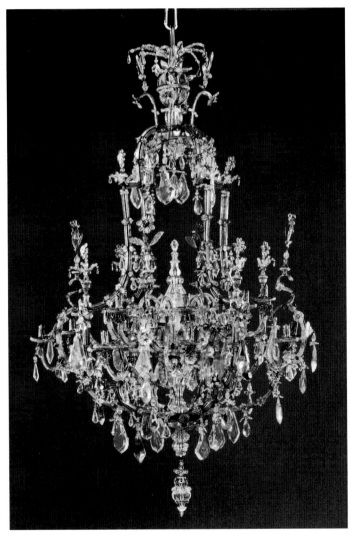

513

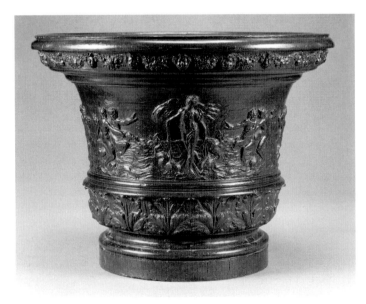

514

515.
BASIN WITH SCENES FROM THE LIFE OF CLEOPATRA

Genoa, circa 1620–1625
Possibly modeled by Francesco Fanelli after
a sketch by Bernardo Strozzi; probably exe-
cuted by a Dutch or Flemish silversmith
Silver
Diameter: 2 ft. 5 3/4 in. (75.5 cm); Depth:
2 1/4 in. (5.7 cm)
Accession number 85.DG.81

PROVENANCE

Possibly commissioned by the Genoese
Doge Alessandro Giustiniani-Longo di Luca,
Genoa (1544–1624); Longhi Giustiniani;
Giovanna Musso Piantelli, by 1892; Musso-
Piantelli collection, Santa Margherita
Ligure, near Genoa, Italy; [Aetas Antiqua,
S.A., Panama].

EXHIBITIONS

Genoa, *Esposizione artistica archeologica industriale
aperta nelle Sale dell'Accademia Linguistica*, 1868,
no. 55, p. 115; Genoa, Palazzo Bianco, *Mostra
d'Arte Antica*, 1892, no. 86, p. 75; Genoa,
Palazzo Spinola and Palazzo Reale, *Genova nel-
l'Età Barocca*, May 2–July 26, 1992, pp. 349–
350, no. 223; Frankfurt, Schirn Kunsthalle,
Kunst in der Republik Genua, September 4–
November 8, 1992, pp. 285–286, no. 152, pl.
158.

BIBLIOGRAPHY

Hugh Macandrew, "A Silver Basin Designed
by Strozzi," *Burlington Magazine* 113 (January
1971), pp. 4–11; Ronald W. Lightbown, "A
Note on the Silver Basin," *Burlington Magazine*
113 (January 1971), p. 11; Hugh Macandrew,
"Genoese Silver on Loan to the Ashmolean
Museum," *Burlington Magazine* 114 (September
1972), pp. 611–620; Carl Hernmarck, *The Art
of the European Silversmith 1430–1830* (London
and New York, 1977), vol. 1, p. 233; David A.
Scott, "Technological, Analytical, and Micro-
structural Studies of a Renaissance Silver

Basin," *Archeomaterials* 5, no. 1 (Winter 1991),
pp. 21–45; Franco Boggero and Farida Simon-
etti, *Argenti Genovesi da parata tra cinque e seicento*
(Turin, 1992), no. 7, p. 233, pls. 20–23, and
pp. 132, 135–143; Bremer-David, *Summary*,
no. 331, pp. 194–195, illus. p. 195; *Master-
pieces*, no. 33, pp. 46–47, illus.; Peter Fusco,
*Summary Catalogue of European Sculpture in the
J. Paul Getty Museum* (Los Angeles, 1997), p. 20,
illus.; *Handbook* 2001, p. 251, illus.

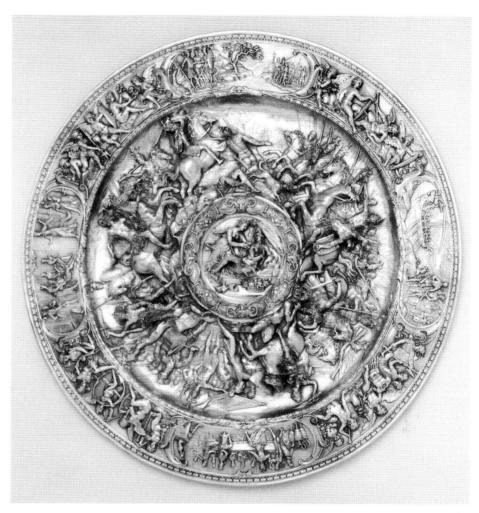

515

516.
PAIR OF ALTAR CANDLESTICKS

Rome, early eighteenth century
Bronze, partially gilded
Height: 2 ft. 8 3/4 in. (83.3 cm);
Maximum Width: 11 3/4 in. (29.8 cm)
Accession number 93.DF.20.1–.2

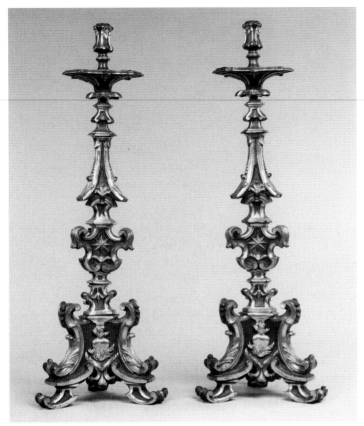

516

517

PROVENANCE
Private collection, Switzerland, sold to D. Katz; [Daniel Katz, London]; sold to B. Piasecka Johnson; Barbara Piasecka Johnson, Monte Carlo, Monaco, since 1984.

BIBLIOGRAPHY
Opus Sacrum: Catalogue of the Exhibition from the Collection of Barbara Piasecka Johnson, J. Grabski, ed. (Warsaw, 1990), pp. 342–344; "Acquisitions/1993," *GettyMusJ* 22 (1994), no. 67, p. 99, illus.; *Masterpieces*, no. 52, p. 71, illus.

517.
WALL PLAQUE
 Southern Italy, 1730–1740
 By Francesco Natale Juvara
 Silver and lapis lazuli
 Height: 2 ft. 3 7/16 in. (70 cm); Width: 1 ft. 8 1/2 in. (52 cm)
 Accession number 85.SE.127

PROVENANCE
Possibly from the House of Savoy, Italy; [Siran Holding Co., Geneva].

BIBLIOGRAPHY
"Acquisitions/1985," *GettyMusJ* 14 (1986), no. 223, p. 254, illus.; *Handbook* 1991, p. 216, illus.; Bremer-David, *Summary*, no. 332, p. 196, illus.; *Masterpieces*, no. 58, p. 77, illus.

518.
PAIR OF CANDELABRA
 Northern Italy, circa 1830–1840
 By Filippo Pelagio Palagi
 Gilt bronze
 Height: 2 ft. 11 1/2 in. (90 cm); Maximum Width: 1 ft. 4 3/4 in. (42.6 cm)
 Accession number 85.DF.22.1–.2

Netherlandish

PROVENANCE
Possibly House of Savoy, Palazzo Reale, Turin; (Nathaniel Charles) Jacob, 4th Lord Rothschild (born 1936), London, acquired by Colnaghi, 1983; [P. and D. Colnaghi and Co., London].

EXHIBITIONS
London, P. and D. Colnaghi and Co., *The Adjectives of History: Furniture and Works of Art 1550–1870*, 1983, no. 47.

BIBLIOGRAPHY
"Acquisitions/1985," *GettyMusJ* 14 (1986), no. 224, p. 255, illus.; *Masterpieces*, no. 100, p. 127, illus.; Bremer-David, *Summary*, no. 333, pp. 196–197, illus. p. 196.

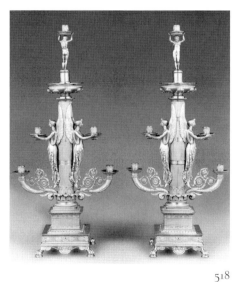

518

519.
PAIR OF ALTAR CANDLESTICKS
Netherlandish, 1600–1650
Bronze
Height: 5 ft. 7 3/8 in. (171.1 cm)
Accession number 99.DF.59.1–.2

PROVENANCE
Sold, Sotheby's, New York, January 31, 1997, lot 322, to L. and P. Fusco; Laurie and Peter Fusco, Los Angeles.

519 *One of a pair*

520.
CHANDELIER
Netherlandish, circa 1645–1675
Brass and oil-gilt wrought iron
Height: approx. 5 ft. (153 cm); Width: approx. 5 ft. (153 cm)
Accession number 88.DH.62

PROVENANCE
Count Moretus-Plantin, Stabroek, Belgium (until at least 1930); Count G. della Faille de Leverghem, Schoten, Belgium (by 1961); [Axel Vervoordt, 's Gravenwezel, Belgium].

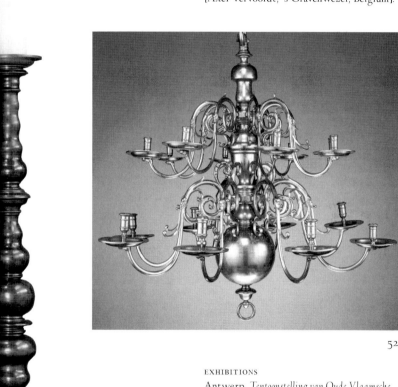

520

EXHIBITIONS
Antwerp, *Tentoonstelling van Oude Vlaamsche Kunst*, 1930, no. D178; Duerne, Provinciaal Museum voor Kunstambachten, *Tentoonstelling Kunstvoorwerpen uit Verzamelingen in de Provincie Antwerpen*, April 23–July 2, 1961, no. 245, p. 34.

BIBLIOGRAPHY
"Acquisitions/1988," *GettyMusJ* 17 (1989), no. 88, p. 148, illus.; Bremer-David, *Summary*, no. 480, p. 275, illus.

Spanish

521

522

521.
PAIR OF CANDLESTICKS
Spanish, circa 1650–1700
Bronze
Height: 5 ft. 8 7/8 in. (175 cm); Maximum
Width: 1 ft. 10 1/4 in. (56.5 cm)
Accession number 86.DH.601.1–.2

PROVENANCE
Commissioned by the Pimentel family, Counts
of Benavente, Zamora, Spain; (offered for sale,

Christie's, London, April 24, 1986, lot 34,
withdrawn); [Rainer Zietz, Ltd., London].

BIBLIOGRAPHY
"Acquisitions/1986," *GettyMusJ* 15 (1987),
no. 120, p. 219, illus.; Bremer-David, *Summary*, no. 486, p. 280, illus.

522.
PORTRAIT OF POPE CLEMENT VIII
(IPPOLITO ALDOBRANDINI)
Florence, circa 1600–1601
Designed by Jacopo Ligozzi; produced in
the *Galleria de' Lavori in pietre dure* by Romolo
di Francesco Ferrucci, called del Tadda
Marble, lapis lazuli, mother-of-pearl, limestone, and calcite (some over painted paper or
fabric cartouches) on a silicate black stone in

its original gilt-bronze frame
Height (with frame): 3 ft. 3^{13}/$_{16}$ in.
(101.7 cm); Width (with frame): 2 ft. 5^{5}/$_{8}$ in.
(75.2 cm); Height (without frame): 3 ft.
2^{3}/$_{16}$ in. (97 cm); Width (without frame):
2 ft. 2^{3}/$_{4}$ in. (68 cm)
Accession number 92.SE.67

PROVENANCE
Given by Grand Duke Ferdinando I de'
Medici (1549–1609) to Giovanni Bardi in
1601; Corsini family, Rome, from at least
1853; by inheritance in the same family until
the second half of the twentieth century;
[Same Art, Ltd., Zurich, 1991].

BIBLIOGRAPHY
Antonio Zobi, *Notizie storiche sull'origine e progressi dei lavori di commesso in pietre dure nell'I. e R. stabilimento di Firenze* (Florence, 1853), pp. 184–186; *Guida delle RR. Cappelle Medicee e R. Opificio delle Pietre Dure in Firenze*, Edoardo Marchionni, ed. (Florence, 1891), pp. 99–100; Ludwig von Pastor, *The History of the Popes* (London, 1952), vol. 23, p. 32; Anna Maria Giusti et al., *Il Museo dell'Opificio delle Pietre Dure* (Florence, 1978), p. 282; Anna Maria Giusti, *Palazzo Vecchio: Committenze e collezionismo medicei* (Florence, 1980), p. 239; "Acquisitions/1992," *GettyMusJ* 21 (1993), no. 69, p. 144, illus.; "La Chronique des Arts: Principales Acquisitions des Musées en 1992," *Gazette des beaux-Arts* (March 1993), p. 49, fig. 232; Alvar González-Palacios, "Jacopo Ligozzi e il Ritratto in Commesso di Clemente VIII," *Paragone* 505–507 (1992), pp. 31–37; Alvar González-Palacios, *Il Gusto dei Principi: Arte di Corte del XVII e del XVIII Secolo* (Milan, 1993), vol. 1, pp. 393–399 and pl. LXVII, vol. 2, fig. 714, p. 368; Bremer-David, *Summary*, no. 391, pp. 223–224, illus. p. 223; *Masterpieces*, no. 25, pp. 34–35, illus.; *Handbook* 2001, p. 249, illus.

523.
PORTRAIT OF CAMILLO ROSPIGLIOSI
Rome, circa 1630–1640
By Giovanni Battista Calandra
Ceramic tile mosaic in a gilt-wood frame
Inscribed on a paper label attached to the gilt frame, *Questo ritratto in mosaico del Bali Camillo Rospigliosi fratello del Papa Clem. IX e di proprietà di mio nipote [Don?] Giov. Battista Rospigliosi.*
Height (without frame): 2 ft. 3/$_{8}$ in. (62 cm);
Width (without frame): 1 ft. 7^{1}/$_{16}$ in.
(48.5 cm)
Accession number 87.SE.132

PROVENANCE
Purportedly in the collection of the nephew of Giovanni Battista Rospigliosi (1646–1722), Rome; private collection, Zurich, sold to Danae Art International; [Danae Art International, S.A., Panama].

BIBLIOGRAPHY
"Acquisitions/1987," *GettyMusJ* 16, 1988, no. 88, p. 185, illus.; Bremer-David, *Summary*, no. 392, p. 224, illus.; *Masterpieces*, no. 30, pp. 42–43, illus.; *Handbook* 2001, p. 256, illus.

523

SCAGLIOLA

German

524

TEXTILES AND CARPETS

Chinese

525

524.
ARCHITECTURAL SCENE AND FRAME
 Plaque: Southern German, circa 1630–1670
 Workshop of Blausius Fistulator
 Scagliola
 Frame: Italian, circa 1730–1740
 Ebonized wood; gilt-bronze mounts
 Plaque: Height: 1 ft. 5 $^1/_8$ in. (43.5 cm);
 Width: 1 ft. 7 $^{11}/_{16}$ in. (50 cm); Frame:
 Height: 2 ft. 4 $^3/_4$ in. (73 cm); Width:
 2 ft. 4 $^3/_8$ in. (67 cm)
 Accession number 92.SE.69

PROVENANCE
Corsini family, Florence, by 1730; by inheri-
tance in the same family until the second half
of the twentieth century; [Same Art, Ltd.,
Zurich, 1991].

BIBLIOGRAPHY
"Acquisitions/1992," GettyMusJ 21 (1993),
no. 72, p. 146, illus.; "The Decorative Arts:
Recent Museum Acquisitions," Apollo 137
(1993), p. 34; "La Chronique des Arts: Prin-
cipales Acquisitions des Musées en 1992,"
Gazette des beaux-arts 121 (1993), no. 236,
p. 50; "Acquisitions/1992," GettyMusJ 21
(1993), no. 72, p. 146, illus.; Bremer-David,
Summary, no. 446, p. 252, illus.; Masterpieces,
no. 26, pp. 36–37, illus.; Handbook 2001,
p. 255, illus.

525.
WALL HANGING
 Made in China for Italian export, late seven-
 teenth to early eighteenth century
 Silk brocade
 Length: 11 ft. 10 in. (360.7 cm); Width:
 7 ft. 4 $^3/_4$ in. (225.5 cm)
 Accession number 87.DD.37

PROVENANCE
Private collection, Germany; [Rainer Zietz,
Ltd., London].

BIBLIOGRAPHY
"Acquisitions/1987," GettyMusJ 16 (1988),
no. 87, p. 185, illus.; Bremer-David, Summary,
no. 498, p. 287, illus.

Persian

526.
CARPET
Herat or Isfahan, late sixteenth-century
Wool
Length: 25 ft. 10 1/4 in. (788 cm); Width:
10 ft. 3 1/4 in. (313 cm)
Accession number 78.DC.91

PROVENANCE
Hagop Kevorkian (sold, Sotheby's, London,
December 5, 1969, lot 20); purchased at
that sale by J. Paul Getty for Sutton Place,
Survey; distributed by the estate of J. Paul
Getty to the J. Paul Getty Museum.

EXHIBITIONS
New York, The Metropolitan Museum of Art,
Collection of Rare and Magnificent Oriental Carpets
(1966), no. 5, pl. 3.

BIBLIOGRAPHY
Bremer-David, *Summary*, no. 500, p. 287, illus.

PROVENANCE
Baron Edmond (Adolphe Maurice Jules
Jacques) de Rothschild (1926–1997), Paris
(sold, Palais Galliera, Paris, March 18,
1968, no. 104); purchased at that sale by
J. Paul Getty.

BIBLIOGRAPHY
Walter Denny, "Oriental Carpets from
the J. Paul Getty Museum," *Sotheby's Preview*
(November/December 1990), p. 25, illus.; Ian
Bennett, "Oriental Rugs and the Collection
of the J. Paul Getty Museum," *Sotheby's Art at
Auction 1990–91* (London, 1991), p. 179, fig. 1,
illus.; Bremer-David., *Summary*, no. 501,
p. 288, illus.

526 *Detail*

527.
"POLONAISE" CARPET
Kashan, circa 1620
Silk with metallic thread
Length: 9 ft. 1 in. (277 cm); Width:
5 ft. 7 in. (170 cm)
Accession number 68.DC.6

527

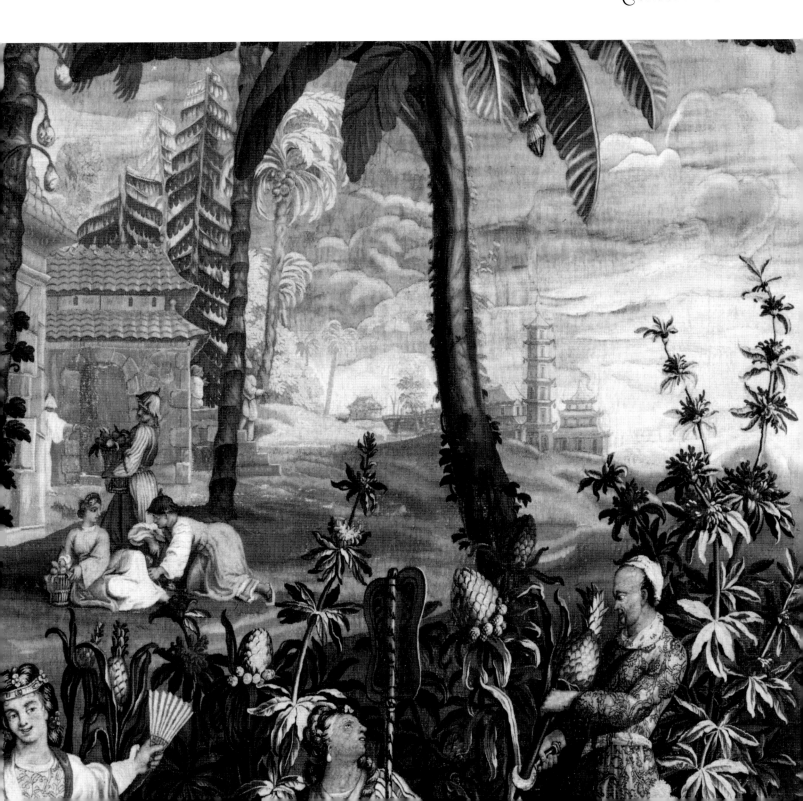

GLOSSARY OF WOODS

This is a glossary of woods in the Decorative Arts collection of the J. Paul Getty Museum.

English	Latin	French
alder	*Alnus sp.*	aune
amaranth (purple heart)	*Peltogyne sp.*	amarante
ash	*Fraxinus sp.*	frêne
barberry	*Berberis sp.*	épine-vinette
beech	*Fagus sp.*	hêtre
birch	*Betula sp.*	bouleau
bloodwood	*Brosimum paraense*	satiné
ceylon satinwood	*Chloroxylon swietenia*	citronnier
cherry	*Prunus sp.*	cerisier
chestnut	*Castanea sativa*	châtaignier
cururu	*Dialium guianense*	
ebony	*Diospyros sp.*	ébène
fir	*Abies sp.*	sapin
fruitwood	*Rosaceae family*	tribu du pommier
holly	*Ilex aquifolium*	houx
hornbeam	*Carpinus sp.*	charme
Japanese arborvitae	*Thuja standishii*	
Japanese cedar	*Cryptomeria japonica*	sugi (japanese)
juniper	*Juniperus sp.*	genévrier
kingwood	*Dalbergia cearensis*	bois de violette
lignum vitae	*Guaiacum sp.*	gaïac
limewood	*Tilia sp.*	tilleul
mahogany	*Swietenia sp.*	acajou
maple	*Acer sp.*	érable
Mediterranean cypress	*Cupressus sempervirens*	cyprès
oak	*Quercus sp.*	chêne
olive	*Olea europaea*	olivier
padouk	*Pterocarpus sp.*	padouk or corail
pearwood	*Pyrus sp.*	poirier
poplar	*Populus sp.*	peuplier
rosewood	*Dalbergia sp.*	palissandre
Scots pine	*Pinus sylvestris*	pin Sylvestre
snakewood	*Piratinera guianensis*	amourette
Spanish cedar	*Cedrela sp.*	cedro
spindle tree wood	*Euonymus sp.*	fusain
spruce	*Picea sp.*	épicéa
stone pine	*Pinus cembra*	arole
tulipwood	*Dalbergia sp.*	bois de rose
walnut	*Juglans sp.*	noyer
West Indian satinwood	*Zanthoxylum sp.*	citronnier
willow	*Salix sp.*	saule
yew	*Taxus baccata*	if

INDEX OF MAKERS

The following index includes the names of makers and artists. Please note that references are to entry numbers rather than page numbers.

INDEX OF PREVIOUS OWNERS

The following index includes the names of private owners and dealers. Named residences are also listed.
Please note that references are to entry numbers, not page numbers.

CONCORDANCE

This is a concordance between J. Paul Getty Museum accession numbers and Summary Catalogue of
European Decorative Arts entry numbers.

Accession no.	Entry no.	Accession no.	Entry no.	Accession no.	Entry no.
55.DA.2	29	71.DA.96.1–.2	28	72.DE.65	235
55.DA.3	60	71.DH.97	188	72.DA.66	22
55.DA.4	72	71.DA.98.1–.2	108	72.DA.67	74
55.DA.5	32	71.DF.99.1–.2	157	72.DA.68	78
62.DF.1.1–.2	184	71.DA.100	55	72.DA.69.1–.2	37
63.DD.2	303	71.DA.102	73	72.DA.71	15
63.DD.3	304	71.DA.103	64	72.DE.72.1–.5	318
63.DD.4	306	71.DA.104	52	72.DE.73.1–.2	321
63.DD.5	305	71.DA.105	67	72.DE.74.1–.2	229
63.DD.6	307	71.DF.114.1–.2	181	72.DE.75	228
65.DA.1	65	71.DB.115	139	72.DB.89	133
65.DA.2	47	71.DB.116	138	73.DI.62	234
65.DA.3	43	71.DH.118	121	73.DF.63.1–.2	182
65.DA.4	24	71.DD.466	309	73.DE.64	223
65.DD.5	301	71.DD.467	309	73.DE.65.1–.2	337
67.DA.6.1–.11	102	71.DD.468	309	73.DA.66	20
67.DA.9	42	71.DD.469	309	73.DJ.67	187
67.DA.10	58	72.DA.39.1–.2	36	73.DB.74	130
68.DC.6	527	72.DB.40	131	73.DH.76	161
68.DA.8	402	72.DI.41.1–.2	267	73.DI.77.1–.2	253
70.DC.63	292	72.DI.42	273	73.DB.78	142
70.DA.70.1–.2	94	72.DF.43.1–.2	155	73.DB.85	140
70.DA.74	70	72.DA.44.1–.2	33	73.DJ.88	283
70.DA.75	71	72.DB.45	136	73.DH.89.1–.6	291
70.DA.79	30	72.DA.46	26	73.DH.107	124
70.DA.80	21	72.DA.47	396	74.DB.2	137
70.DA.81	14	72.DF.48.1–.2	153	74.DF.3.1–.2	174
70.DA.82	23	72.DA.49	68	74.DJ.4.1–.2	286
70.DA.83	50	72.DI.50.1–.2	259	74.DF.5.1–.2	175
70.DA.84	63	72.DA.51	100	74.DI.19	269
70.DA.85	236	72.DB.52	129	74.DJ.24.1–.2	285
70.DA.87	41	72.DE.53.1–.2	256	74.DA.26	425
70.DE.98.1–.2	227	72.DA.54	31	74.DI.27	262
70.DE.99.1–.2	247	72.DB.55	132	74.DI.28	265
70.DI.115	277	72.DF.56.1–.2	150	74.DH.29	513
71.DG.76.1–.2	198	72.DB.57	145	75.DD.1	294
71.DG.77.a–.b	193	72.DA.58.1	81	75.DA.2	59
71.DG.78	197	72.DA.58.2	412	75.DF.4.1–.4	168
71.DA.89	6	72.DA.59	17	75.DI.5.1–.2	260
71.DA.91	88	72.DA.60	48	75.DF.6.1–.3	185
71.DA.92.1–.2	96	72.DE.61	326	75.DB.7	141
71.DA.93.1–.4	98	72.DE.62.1–.2	325	75.DA.8.1–.4	87
71.DA.94.1–.2	99	72.DA.63.1–.2	395	75.DE.11.a–.b	231
71.DA.95	61	72.DA.64	66	75.DF.53.1–.2	152

Accession no.	Entry no.	Accession no.	Entry no.	Accession no.	Entry no.
75.DA.62	389	79.DA.66	35	83.DA.282	406
75.DE.65.1–.2	230	79.DA.68	80	83.DE.334.1–.5	336
75.DI.68.1–.2	154	79.DI.121.1–.2	270	83.DD.336	296
75.DI.69	271	79.DI.123.a–.b	261	83.DD.337	296
76.DA.9.1–.2	18	79.DH.164	127	83.DD.338	296
76.DI.12	186	79.GA.178	313	83.DD.339	296
76.DF.13	160	79.GA.179	311	83.DD.340	296
76.DA.15	25	79.GA.180	312	83.DE.341.1–.2	252
77.DA.1	7	79.GA.181	314	83.DA.356	27
77.DF.29.1–.4	174	79.GA.182	315	83.DA.385	75
77.DI.90.1–.2	272	79.DJ.183	280	84.DE.3.1–.2	224
77.DA.91	11	81.DE.28.a–.b	249	84.DA.24.1–.2	12
78.DI.4.1–.2	266	81.DA.80	49	84.DF.41.1–.4	170
78.DI.9.1–.2	268	81.DB.81	134	84.DG.42.1–.2	199
78.DE.65.a–.c	238	81.DA.82.1–.2	39	84.DE.46	217
78.DA.84	62	81.DF.96.1–.2	171	84.DH.52.1–.11	122
78.DA.87	19	82.DB.2	144	84.DA.58	8
78.DF.89.1–.2	166	82.DI.3	258	84.DA.69	92
78.DF.90.1–.2	178	82.DE.5	255	84.DA.70	91
78.DC.91	526	82.DA.8.1–.2	415	84.DH.74.1–.2	194
78.DA.96.1–.2	390	82.DE.9	214	84.SD.76	111
78.DA.99.1–.5	97	82.DG.12.1–.2	192	84.DA.77	421
78.DA.100.1–.2	85	82.DG.13.1–.2	196	84.DH.86	107
78.DA.107	404	82.DG.17	191	84.DA.87	397
78.DA.108	1	82.DA.34	54	84.DE.88.a–.b	226
78.DA.109	405	82.DF.35.1–.2	172	84.DE.89	222
78.DA.117	388	82.DE.36.1–.2	240	84.DE.94	345
78.DA.118.1–.2	416	82.DD.66	308	84.DE.95	342
78.DA.119.1–.2	38	82.DD.67	308	84.DE.96	350
78.DA.120	403	82.DD.68	308	84.DE.97	346
78.DA.121	408	82.DD.69	308	84.DE.98	347
78.DA.124	2	82.DA.81	45	84.DE.99	351
78.DG.130.1–.2	508	82.DE.92	225	84.DE.100	349
78.DG.180.1–.2	507	82.DA.95.1–.4	90	84.DE.101	352
78.DF.263.1–.4	172	82.DA.109.1–.2	4	84.DE.102	353
78.DE.358.1–.2	232	82.DE.167.1–.5	212	84.DE.103	354
78.DI.359	274	82.DE.171.1–.2	233	84.DE.104	355
78.DH.360.1–.4	316	83.DJ.16.1–.2	281	84.DE.105	363
78.DA.361	16	83.DD.20	300	84.DE.106	362
79.DA.2.1–.2	34	83.DA.21	53	84.DE.107	368
79.DD.3.1–.16	289	83.DA.22	56	84.DE.108	357
79.DB.4	135	83.DF.23.1–.2	177	84.DE.109	358
79.DA.5.1–.2	429	83.DE.36	207	84.DE.110	359
79.DA.58	13	83.DF.195.1–.2	164	84.DE.111	365
79.DI.59.1–.2	339	83.DA.230.1–2	91	84.DE.112.1–.2	360
79.DE.62.a–.b	237	83.DD.260.1–.2	293	84.DE.113	366
79.DE.63.a–.b	257	83.DI.271	340	84.DE.114	369
79.DE.64.a–.b	246	83.DA.280	10	84.DE.115	370
79.DE.65.a–.b	245	83.DA.281	423	84.DE.116	361

Accession no.	Entry no.	Accession no.	Entry no.	Accession no.	Entry no.
84.DE.117	364	84.DK.553	442	85.DB.116	386
84.DE.118	367	84.DK.554	465	85.DA.120	391
84.DE.119.1–.2	372	84.DK.555	443	85.DA.125	79
84.DE.120	371	84.DK.556	445	85.SE.127	517
84.SD.194	112	84.DK.557	447	85.DA.147	51
84.DK.509	461	84.DK.558	446	85.DI.178.1–.2	509
84.DK.510	462	84.DK.559	448	85.SB.179	514
84.DK.511	487	84.DK.560	449	85.DE.203	335
84.DK.512	480	84.DK.561	469	85.DK.214	444
84.DK.513.1–.2	463	84.DK.562	474	85.DA.216	400
84.DK.514.1–.2	466	84.DK.563	475	85.DE.219.a–.b	244
84.DK.515.1–.2	437	84.DK.564	499	85.DE.231	329
84.DK.516	501	84.DK.565.1–.2	496	85.SE.237	200
84.DK.517	500	84.DK.566	476	85.SE.238	201
84.DK.518	495	84.DK.567	451	85.DD.266.1–.2	288
84.DK.519	452	84.DK.568.1–.2	477	85.DH.284	126
84.DK.520.1–.3	471	84.DK.652	493	85.DI.286	330
84.DK.521	454	84.DK.653	438	85.DI.287	331
84.DK.522	453	84.DK.654	489	85.DD.309	299
84.DK.523	456	84.DK.655	486	85.DA.319	399
84.DK.524	457	84.DK.656	492	85.DE.347	220
84.DK.525	458	84.DK.657	490	85.DE.375.1–.2	317
84.DK.526	455	84.DK.658	497	85.DA.378	46
84.DK.527	460	84.DK.659	450	85.DI.380.1–.2	213
84.DK.528	473	84.DK.660	483	85.DE.381	334
84.DK.529	470	84.DK.661	491	85.DF.382.1–.2	149
84.DK.530	472	84.DK.662	502	85.DF.383.1–.2	163
84.DK.531	467	84.DE.718.1–.3	248	85.DE.414	323
84.DK.532	459	84.DG.744.1–.2	195	85.DE.441	383
84.DK.533	479	84.DE.747.1a–.4j	382	85.SE.442.1–.2	512
84.DK.534	481	84.DA.852	9	86.DA.7	414
84.DK.535	484	84.DE.917.a–.b	210	86.DE.473	218
84.DK.536	488	84.DE.918.1–.2	338	86.DA.489.1–.2	410
84.DK.537	439	84.DA.969	44	86.DA.511	427
84.DK.538	482	84.DA.970	86	86.DE.520.1–.2	241
84.DK.539	485	84.DA.971	3	86.DF.521.1–.2	156
84.DK.540	478	85.DF.22.1–.2	518	86.DA.535	103
84.DK.541	494	85.DA.23	57	86.DE.533	377
84.DK.542	433	85.DG.33.1–.2	511	86.SE.536.1–.2	203
84.DK.543	434	85.DE.46	324	86.DE.539	373
84.DK.544	435	85.DG.49.1–.2	162	86.DE.541	332
84.DK.545	436	85.SE.53	510	86.DE.542	333
84.DK.546	431	85.SE.54	505	86.DH.601.1–.2	521
84.DK.547	440	85.DE.56	343	86.DE.629	322
84.DK.548.1–.2	432	85.DE.57	344	86.DE.630	374
84.DK.549	498	85.DE.58	348	86.DB.632	143
84.DK.550	464	85.DG.81	515	86.DC.633	298
84.DK.551	468	85.DH.92	123	86.DD.645	295
84.DK.552	441	85.DD.100	302	86.DE.668.1–.2	215

Accession no.	Entry no.	Accession no.	Entry no.	Accession no.	Entry no.
86.GA.692	310	89.DF.26.1–.2	169	97.DH.2	120
86.DH.694	147	89.DA.28	392	97.DH.4	115
86.DB.695	385	89.DA.29	83	97.DH.5	114
86.DH.705.1–.2	146	89.DH.30	119	97.DE.14	320
86.DE.738	341	89.DJ.31	282	97.DF.15.1–.2	183
87.DA.2.1–.4	424	89.DE.44.a–.b	221	97.DF.16.1–.2	165
87.DI.4	263	89.DD.62	296	97.DB.37	387
87.DA.5.1–.2	105	90.DA.23	77	97.DE.46	206
87.DA.7	76	90.DA.33.1–.2	409	97.DD.59	290
87.DE.25	211	90.SC.42.1–.2	375	97.DA.64	413
87.DE.26.1–.3	381	90.DE.113	242	97.DH.66	407
87.DF.28	159	91.DA.15.1–.2	101	98.DE.6.1–.2	328
87.DD.37	525	91.DA.16	84	98.DH.149	125
87.DA.47	394	91.DH.18.1–.10	118	99.DE.10	384
87.DA.77	40	91.DA.21	82	99.DE.11	219
87.DH.78	113	91.DH.60	125	99.DF.20.1–.4	176
87.SE.132	523	91.SE.74	380	99.DD.29	296
87.DE.134.a–.c	239	91.DH.75.1–.2	506	99.DE.45	327
87.DA.135.1–.2	419	91.DI.103.1–.2	264	99.DF.46.1–.2	151
87.DF.136	167	92.DK.1.1–.2	284	99.DF.59.1–.2	519
87.DI.137	276	92.DF.18.1–.4	173	2000.20	216
87.SE.148	356	92.DI.19.1–.2	275		
88.DE.2	251	92.DH.20	117		
88.SE.4.1–.12	202	92.DD.21	297		
88.DA.7.1–.2	401	92.DA.24.1–.12	430		
88.DE.9.1–.2	378	92.SE.67	522		
88.DA.10	428	92.DJ.68.1–.2	504		
88.DB.16	128	92.SE.69	524		
88.DH.17	158	92.DA.70.1–.2	411		
88.DA.49	116	92.DH.75	148		
88.DH.59	121	93.DA.18.1–.2	420		
88.DA.61	5	93.DF.20.1–.2	516		
88.DH.62	520	93.DE.36.1–.5	319		
88.DE.63	205	93.DJ.43.1–.2	278		
88.DA.75.1–.2	106	93.DF.49.1–.2	180		
88.DA.88	398	94.DA.10.1–.2	89		
88.DA.111	393	94.DA.72	104		
88.DI.112.1–.2	209	94.SE.76.1–.2	376		
88.SB.113.1–.2	189	94.SB.77.1–.2	179		
88.DF.118	69	95.DE.1	204		
88.DJ.121.1–.2	287	95.DA.6.1–.2	417		
88.DA.123	95	95.DA.22.1–.6	422		
88.DA.124	110	95.SE.57.1–.4	503		
88.DE.126	208	95.DA.76	426		
88.DH.127.1–.2	190	95.SC.77	379		
88.DE.137.1–.2	250	95.DA.81	418		
88.DK.539	485	95.DJ.84.1–.2	279		
89.DA.2.1–.2	109	95.DA.90.1–.2	93		
89.DE.25.1–.5	243	96.DE.343	254		

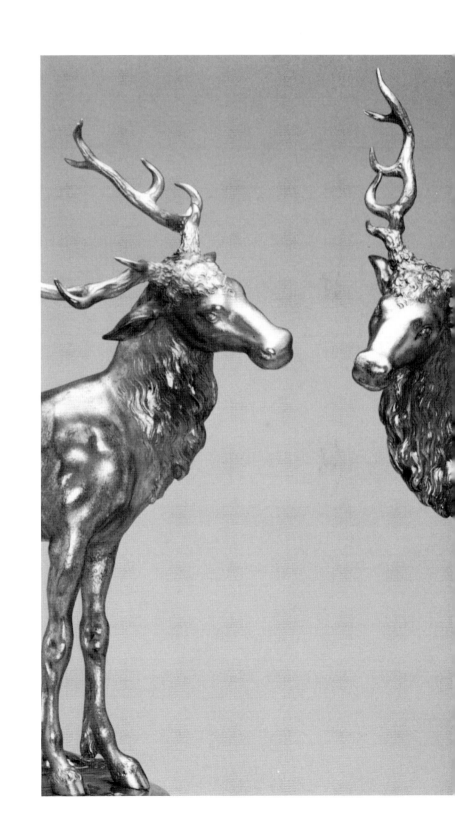